Volume 22

DIRECTORY OF WORLD CINEMA
BELGIUM

Edited by Marcelline Block and Jeremi Szaniawski

intellect Bristol, UK / Chicago, USA

First published in the UK in 2013 by
Intellect Books, The Mill, Parnall Road, Fishponds, Bristol, BS16 3JG, UK

First published in the USA in 2013 by Intellect Books, The University of Chicago Press,
1427 E. 60th Street, Chicago, IL 60637, USA

Copyright © 2013 Intellect Ltd

All rights reserved. No part of this publication may be reproduced, stored in a retrieval system, or transmitted, in any form or by any means, electronic, mechanical, photocopying, recording, or otherwise, without written permission.

A catalogue record for this book is available from the British Library.

Publisher: May Yao
Publishing Manager: Jelena Stanovnik

Cover photograph: *Toto the Hero/Toto le héros* (1991) © Jaco Van Dormael. With kind permission by the film-maker.
Cover designer: Holly Rose
Copy-editor by Emma Rhys
Typesetter: John Teehan

Directory of World Cinema ISSN 2040-7971
Directory of World Cinema eISSN 2040-798X

Directory of World Cinema: Belgium ISBN 978-1-78320-008-5
Directory of World Cinema: Belgium eISBN 978-1-78320-322-2

Printed and bound by Gomer Press, UK.

DIRECTORY OF WORLD CINEMA

BELGIUM

Acknowledgements	5
Introduction	6
Film of the Year Almayer's Folly	12
Award of the Year Our Children	15
Small Country, Great Cinema? Essays	20
Film Culture Focus: The Royal Belgian Film Archive Essays	29
Directors 1. The Pioneers Essays	38
2. Intermediate Figures Essays Review	50
3. Modern Belgian Directors: 3A. André Delvaux Essay Reviews	58
3B. Chantal Akerman Essay Reviews	71
3C. Jaco Van Dormael Essay Reviews	102
3D. The Dardenne Brothers Essay Reviews	111
Other Belgian Auteurs Essay Reviews	129
Box Office Successes Reviews	158
Documentary and Beyond Essay Reviews	165
Women Directors In Belgian Cinema Essays Reviews	181
Francophone Belgian Cinema Since 1990 Reviews	191
Flanders Essay Reviews Essays	199
Exiles and Transits Reviews Essay	219
Alternative Figures in Belgian Cinema Essays Reviews	231
Animation Essay Reviews	243
Belgian Cinema and the Other Arts Essays	255
Belgian Cinema Confidential Essay Reviews	271
Interviews Chantal Akerman Boris Lehman	282
Jean-Claude Van Damme Essay	296
On Location Essays	301
References & Recommended Reading	306
Test Your Knowledge	316
Notes On Contributors	321
Filmography	330

Directory of World Cinema

We wish to express all our gratitude to Melanie Marshall and May Yao of Intellect Books for their kind encouragement and professional guidance at every step of the publication process. We furthermore wish to thank Jelena Stanovnik and all Intellect personnel involved at every phase of the production of this book. Without their dedication and unwavering support this work would not have come to fruition.

The editors express their appreciation to the Schoff Fund at the University Seminars at Columbia University for their help with the publication of this volume. The ideas presented in this work have benefited from discussions in the University Seminars on Cinema and Interdisciplinary Interpretation.

We are most grateful to the outstanding contributors whose work we are delighted to present in this collection, as well as to Edward Lybeer for his translation; Zachary Ingle for his helpful bibliographical suggestions; Elan Lipson and Jaco Van Dormael for their input and contributions to the cover design; Michael Sarnoski for his invaluable help with several aspects of the volume's visual design; Heather Owens and Stephanie Sarlos for proofreading and graphics; and Amanda Bermudez, Michael Cramer, Edward Lybeer and Jennifer Stob for their help in copy-editing some of the volume's pieces. Particular thanks go to Michael J Anderson for his invaluable editorial insight and assistance on several entries of the book. Finally, we are much obliged to our peer reviewers: Michael J Anderson, Amanda Bermudez, Adam Bingham, Michael Cramer, Daniel Fairfax, Edward Lybeer, John Pitseys, Patrick Reagan, Noëlle Rouxel-Cubberly, Jennifer Stob, and Sandrine Zicot.

Marcelline Block would like to dedicate this book to the late Elisabeth of Bavaria, Queen of Belgium (1876-1965) who had personally impacted Marcelline's mother's life and encouraged her, at an early age, to continue exploring music, writing, and art.

Jeremi Szaniawski wishes to personally dedicate this book to Betty and Emile Boulpaep, for their steadfast work in forging unity in Belgium through Emile's long-standing efforts as the head of the Belgian-American Educational Foundation.

Marcelline Block and Jeremi Szaniawski

INTRODUCTION
BY THE EDITORS

Extraordinarily rich in its history, diversity and idiosyncrasies, Belgian cinema has secured a coveted place at the forefront of the international film scene. In spite of the fact that it possesses neither a fully developed film industry nor studio system, Belgium has become a country of cinema, boasting the unlikely statistic of having the highest number of film-makers per capita in the world. This volume explores the nation's cinematic output as a whole, highlighting its points of convergence in order to identify what defines *Belgian-ness*, in light of the cultural and linguistic divide between cinematic productions of the Dutch-speaking North (Flanders) and French-speaking South (Brussels and Wallonia). This is particularly significant insofar as the country's unity is at this time challenged by opposing socio-political/cultural forces.

Belgium's political vulnerability is inversely proportional to the success of its cinematic production. In the past decade alone, in the wake of Jean-Pierre and Luc Dardenne's *Rosetta* receiving the Palme d'Or at the 1999 Cannes film festival – a triumph they would repeat in 2005 with *The Child/L'enfant* – Belgium has produced an average of forty feature fiction films per year (majority and minority productions combined), which is impressive for a country of only approximately eleven million inhabitants. Consider the exponential growth of this production during the last twenty years: on the francophone side, cinematic output was only 57 films between 1980-1990, doubling to more than 114 from 1990-2000, then growing to a staggering 204 between 2000-2010, of which 126 were majority productions. This steady growth also occurs in Flanders, although the Northern region has enjoyed less international visibility and distribution, a trend that may change in the future. The impressive growth of francophone film production was bolstered by the founding of the Centre du Cinéma et de l'Audiovisuel in 1994. It was further helped by the creation of Wallimage in 2001 and tax shelters in 2003, which attracted many investments from corporate firms, but also French productions – TV as well as cinema – thus encouraging collaboration between the two neighbouring countries.

Yet within the country itself, such collaboration between Belgium's Northern and Southern regions is rather rare. André Delvaux (1926-2002), founder of modern Belgian cinema, fluent in both French and Dutch, received support from these two linguistic entities, but his example is unique. The linguistic divide, which Delvaux deplored and depicted in his critically acclaimed second feature film *One Night… a Train/Un Soir, un train* (1968), has thus rarely been bridged by national production, which means that most Belgian films are either francophone *or* Flemish, with very few films produced with combined support from both sides – a separation increasingly reflected in the country's complex politics. However, during its century-long existence, the nation has produced three major identifiable idioms across the linguistic border: in chronological order, first, the surrealist tradition, informed by the enthusiasm of young, independently-wealthy

Belgian cinephiles, gathered around the works of artists Marcel Broodthaers (1924-1976), Paul Delvaux (1897-1994), René Magritte (1898-1967), and Marcel Mariën (1920-1993). Second, and most importantly, we find the documentary school (in particular, Henri Storck and Paul Meyer), which later led to the emergence of a cinema concerned with social justice. Third, heir to both previous traditions is the school of magical realism, with an accent on uncertainty and the blurring of generic boundaries, of which André Delvaux is the champion. Much of subsequent Belgian cinema combines these three components – surrealism and visual culture, documentary sensibility, and magical realism – in auspicious and creative ways.

However, these three broad categories cannot alone explain the complexity of Belgian cinema. In spite of the image that it likes to project of itself, Belgian culture features many darker undercurrents, and in recent years Belgian film scholars have unearthed other important aspects which unify it: a certain unease or even unwillingness to define itself beyond entrenched stereotypes (Belgian 'Burgundian' savoir-vivre, beer, lace, and chocolate), as well as the questions of national, cultural, and linguistic boundaries/borders, displacement and exile, and a specific relationship to landscape (both natural and urban/post-industrial). In short, the identity of Belgian cinema is often investigated through the very notion of identity itself, one that many have elected to refer to as splintered, fragmented, or even schizophrenic. This may be a strong term, perhaps, but it certainly underscores the country's divided linguistic nature, as well, and perhaps much more importantly, as its culture's tendency to stretch both down into the underbelly of the earth and reach high above to the stars, between humanism and surrealism, socialism and colonial heritage, the antithetic legacies of both Catholicism and Secularism (Belgium being one of the strongholds of European Freemasonry), nationalisms and Communism... a list of "isms" that goes on.

Keeping this notion of cultural identity and its many intricacies in mind, Belgian cinema has opened itself not only to the independently wealthy/upper class, but also to a range of film-makers from the pool of immigrants and/or ethnic/cultural minorities who have come to reside in Belgium: Chantal Akerman (b. 1950), one of the country's foremost cinematic and artistic figures, is the daughter of Polish Jewish immigrants, and several film-makers of the post-World War II generation come from North African and Middle Eastern communities (as attested to by the success of Nabil Ben Yadir's comedy *The Barons/Les Barons*, 2009). Belgium was also the place where a score of talented directors from all over the world elected to work on at least one of their films: Jerzy Skolimowski (*Le Départ*, 1967), Alain Resnais (*Je t'aime, je t'aime*, 1968), Claude Chabrol (*The Breach/La Rupture*, 1970), or Lars von Trier (*The Five Obstructions*, 2003), to name a few.

Belgian cinema seems to be reminiscent of a 'Sunday orchestra'/'*orchestre du dimanche*' in which people from the community – some, self-taught, others consummate professionals, and still many others passionate dilettantes – gather together to play music. Lacking financial support, they frequently perform outdoors, even in inclement weather. Belgian cinema has thrived against similar odds, producing endearing and sublime works, even if occasionally flawed ones. Thierry Zéno's bizarre *chef d'oeuvre*, *Wedding Trough/Vase de noces* (1974), made practically without a budget or crew, serves as a prime example of this predicament. With time, however, Belgian cinema has slowly but surely earned the international community's acclaim, perhaps to the detriment of what gave 'Belgian-ness' its elusive charm: a mix of Dionysian joy, quaintness, and down-to-earthness offset by surrealist bouts of eccentricity.

In this context, hospitable to bricolage, many thought that no Belgian film-maker could earn a living from their craft. With the exceptions of some directors of popular comedies, it was not until André Delvaux's arrival that a Belgian director was able to impose a cinematic vision over the course of numerous decades and achieve both commercial and critical success with feature fiction films. In spite of the 1990 *Encyclopedia of the Cinemas of Belgium/Encyclopédie des cinémas de Belgique* (Guy

Jungblut, Patrick Leboutte, and Dominique Païni) accusing Delvaux of being overly academic, and favouring instead 'meteorite' films – in other words, unique offerings without a following – a host of talented directors, over the past twenty years, on either side of the linguistic divide continue to emulate the Delvaux model, with successful careers spanning several decades. Most of them are featured in the present volume.

This volume's opening section, 'Small Country, Great Cinema?' contains two articles by Frédéric Sojcher, a leading historian of Belgian cinema, as well as a film-maker, who examines the obstacles it had to overcome in its rise to prominence. Sojcher's two essays are followed by a discussion of Richard Olivier's *Big Memory* video project, which is a comprehensive catalogue of interviews with as many Belgian cineastes as possible.

The Royal Belgian Film Archive/CINEMATEK, located in Brussels, is a major (inter)national institution. In the two articles about it in the following section, 'Film Culture Focus: the Royal Belgian Film Archive,' long-time lead CINEMATEK curator Gabrielle Claes and film/theatre scholar Serge Goriely offer their reflections on this worldwide cinematic landmark. While Goriely presents an external overview of CINEMATEK's history, Claes, who had worked at the Royal Film Archive for over forty years, offers the insider's privileged perspective. These two texts echo one another, as an informed celebration of this cinephile's paradise situated in the heart of the European capital.

The following section entitled 'Directors' covers the major names who have shaped an image of Belgian cinema through sustained and often prolific careers. It is divided into numerous sub-categories, starting with the 'Pioneers' of Belgian cinema: Alfred Machin (1877-1929), Charles Dekeukeleire (1905-1971), and Henri Storck (1907-1999). A consideration of Belgian cinema's 'Intermediate Figures' follows: Brussels low-budget comedy hero Gaston Schoukens (1901-1961) – who inspired Marcel Pagnol to adapt his plays to the big screen, which in the 1930s became iconic documents of French cinematic culture, invested with a strong regional (meridional) flavour[1] – and established art film auteur Jacques Feyder (1885-1948). Feyder, who, although he made his films abroad, was nonetheless born in Belgium and worked with Belgian artists, notably screenwriter Charles Spaak (1903-1975) on the classic *Carnival in Flanders/ La Kermesse Héroïque* (1935).

An evaluation of modern Belgian directors and their films follows, with individual sections devoted to the country's most celebrated auteurs. Ahead of a whole section dedicated to women in Belgian cinema, this will be the place to cover the extraordinary career of Chantal Akerman, born in Brussels in 1950. While Brussels-born Agnès Varda (b. 1928), cannot really be considered a Belgian film-maker as she is closely associated with the French New Wave and Left Bank movement and has not filmed extensively in Belgium, Akerman is connected with her birthplace, Brussels, and is, in many ways, the very face of contemporary Belgian cinema. A later section of this volume is devoted exclusively to Akerman's life and work, with an introductory essay by co-editor Marcelline Block and reviews of several of Akerman's major films. Akerman's *Almayer's Folly/La folie Almayer* (2011), an adaptation of Joseph Conrad's eponymous first novel (1895), has been selected as our 'Film of the Year'. The careers of Jean-Pierre (b. 1951) and Luc Dardenne (b. 1954); André Delvaux, and Jaco Van Dormael (b. 1957) are also explored at length in this section. A discussion of 'Other

Belgian Auteurs,' a group of film-makers perhaps less internationally recognizable, yet of no lesser impact, follows suit: the directorial duo Dominique Abel (b. 1957) and Fiona Gordon (b. 1957); Jan Bucquoy (b. 1945); Gérard Corbiau (b. 1941); Dominique Deruddere (b. 1957); Harry Kümel (b. 1940); Joachim Lafosse (b. 1975); and Thierry Zéno (b. 1950). We present some of their most important films. Joachim Lafosse's *Our Children/À perdre la raison* (2012) is also featured as our 'Award of the Year'.

Although the vast majority of Belgian films struggled to impact the box office – at least until the 1990s, with the exceptions of the popular comedies of Edith Kiel, Jan Van Der Heyden, and Gaston Schoukens' popular comedies – several from three very different genres are exceptionally popular: *Home Sweet Home* (Benoît Lamy, 1973), *Daens* (Stijn Coninx, 1992), and *Memory of a Killer/De Zaak Alzheimer* (Erik Van Looy, 2003), which are reviewed in 'Box Office Successes', the following section.

Even more important than the films that have garnered high revenues at the domestic box office, some have acquired cult status. Two of the most important films produced in Belgium may have generated little profit, but stand today as inspirations for generations of new film-makers. Tellingly, these two films are deeply invested in – whether to celebrate or subvert – documentary aesthetics that convey the power of a (deceptively) 'raw' style to the viewer: *The Lank Flower Has Already Flown/Déjà s'envole la fleur maigre* (Paul Meyer, 1963), and *Man Bites Dog/C'est arrivé près de chez vous* (Rémy Belvaux, André Bonzel, Benoît Poelvoorde, 1992). 'Documentary and Beyond' section is thus dedicated to the important Belgian documentary tradition. In this section, along with reviews of *The Lank Flower* and *Man Bites Dog*, we include an essay by popular culture scholar Christophe Den Tandt about the TV program *Strip-Tease*, which aired on the International French channel for almost two decades, and whose influence upon Belgian cinema – including *Man Bites Dog* – cannot be stressed enough. Another classic Belgian documentary, *Death of a Sandwichman/Dood van een sandwichman* as well as other feature films by cineastes who began as documentarians – such as Benoît Mariage's *The Carriers are Waiting/Les Convoyeurs attendent* (1999) and Thomas De Thier's *Feathers in My Head/Des Plumes dans la tête* (2004) – are also reviewed here.

With Chantal Akerman's career at the fore, Belgium, like France, has seen the emergence of major women film directors, many of whom reach beyond the boundaries of documentary and make successful forays into the usually male-dominated world of fiction film-making, often with remarkably original and auspicious results. The 'Women in Belgian Cinema' section is devoted to Belgian female directors such as Marion Hänsel (b. 1949), along with numerous other emerging figures, such as Fien Troch (b. 1978). Alongside reviews of these directors, Belgian film scholar Muriel Andrin takes a look into the current state of female Belgian cinema on both sides of the linguistic border.

'Francophone Belgian Cinema since 1990' is dedicated to selected francophone films from the last decade of the twentieth century onward, all of which have been acclaimed at home and on the international market, including the Golden Globe winning *My Life in Pink/Ma vie en rose* (Alain Berliner, 1997). These films often feature French actors, showing the intimate link that many Belgian francophone productions have with their neighbour.

Although not as internationally known as its francophone counterpart, Flemish cinema is vibrant in popular comedies and genre films – often emulating American models with impressive results – as well as in its artsier iterations. 'Flanders,' the next section of this collection, is dedicated to the cinema of the Flemish region, comprising a thematic entry about contemporary Flemish cinema, followed by reviews of selected recent Flemish films – including the Oscar nominated *Bullhead/Rundskop* (2011),[2] which features the latest Belgian star, Matthias Schoenaerts – as well as socio-historical insight into exhibition and commercial infrastructures in Flanders, focusing in particular on the city of Antwerp. The links between Flanders and Brussels (the mostly-francophone city claimed

by Flanders as its capital) are also considered, through a specific case study by Belgian scholars Daniel Biltereyst, Kathleen Lotze, and Philippe Meers.

Belgium is known for sheltering political refugees who found it a land in which to prosper (the parents of Jeremi Szaniawski, co-editor of this volume, are among many others who have emigrated there). The tragic exiles, transits, and deportations of the unfortunate individuals fleeing the Holocaust are commemorated in 'Exiles and Transits', a section which features reviews of two films addressing these issues: *Brussels Transit/Bruxelles-Transit* (Samy Szlingerbaum, 1982) and *Looking for my Birthplace/À la recherche du lieu de ma naissance* (Boris Lehman, 1990). Hospitable to minorities, Belgium cradles a wealth of films exploring Jewish culture beyond the Shoah. For example, Micha Wald (b. 1974) who, as a child, acted in Samy Szlingerbaum's remarkable film, went on to become a director in his own right, earning critical acclaim for a short, *Alice and Me/Alice et Moi* (2004). He then directed the feature films *In the Arms of my Enemy/Voleurs de chevaux* (2007) and *Simon Konianski* (2009). While some cineastes, such as Belgium-born Ulu Grosbard (1929-2012), left their homeland for greener pastures – countries with more established film industries – in order to make their movies, it behooves us to recall that Belgium has also been the place where people of various nationalities have come to study, forming creative partnerships leading to collaborative works: German-born Sam Garbarski (b. 1948), teamed up with Iranian-born screenwriter Philippe Blasband (b. 1964), on a series of short films that explore multicultural entanglements as well as the bittersweet feature comedy *The Rashevski Tango/Le Tango des Rashevski* (2003). Belgium has also been the refuge for international and/or exiled figures, such as the Palestinian director Michel Khleifi (b. 1950), whose career is discussed at length in this section by Daniel Fairfax. 'Exiles and Transits' addresses national production in the full spectrum of its diversity; films reviewed herewith include those made in Belgium (or with Belgian funds) by Canadian director Philippe Falardeau (*Congorama*, 2006) and French couple Hélène Cattet and Bruno Forzani (*Amer*, 2009).

From these international figures that elected to make their home in Belgium, whether for a film or for a lifetime, we move to a series of critically acclaimed film-makers who have been honoured throughout their careers with prestigious festival awards, but have nevertheless received little attention from mainstream audiences. This is due, no doubt, to their rather radical formal choices. This section is entitled 'Alternative Figures In Belgian Cinema' for these reasons and also because the authors discussed herewith challenge the boundaries of medium and Genre: Olivier Smolders (b. 1956) with the short film form; film-making duo Jessica Hope Woodworth (b. 1971) and Peter Brosens (b. 1962) as well as Peter Krüger (b. 1964) with documentary as well as fiction. This group of film-makers embarks upon memorable journeys across the time-space continuum and explore the intersection of philosophy and spirituality via the medium of film.

In 'Animation,' we consider another important and critically acclaimed yet somewhat experimental category in Belgian cinema. This section of the book is dedicated to this genre, with Raoul Servais (b. 1928), its foremost figure, at the helm.

Following this varied overview of Belgian film and film-makers, the next section of the volume, 'Belgian Cinema and the Other Arts,' treats Belgian cinema as it intersects with literature and visual culture, since Belgium carries a strong tradition of cross-pollination between the fine arts: Nobel Laureate Maurice Maeterlinck (1892-1949), surrealist painter René Magritte, and bestselling author Georges Simenon (1903-1989) are among the luminaries examined in this group of essays.

Far from the historic prestige and fame of the names referenced above, the next section is entitled 'Belgian Cinema Confidential': while there is no real organized nor celebrated underground cinematic scene in Belgium, there certainly are many film-makers whose films literally exist 'underground', either lost or stored (but seldom shown) in the Royal Film Archive, and are hardly ever viewed in spite of their obvious artistic

merit. An interview essay hybrid is dedicated to the exemplary figure of this type of Belgian cinema, the intrepid film-maker and remarkable pedagogue Jean-Marie Buchet (b. 1938).

Chantal Akerman is again featured, this time, along with Boris Lehman (b. 1944), in the 'Interviews' section. As Akerman and Lehman are both auteurs and masters of a hybrid form of fiction and documentary as well as the 'genre' of autofiction, interviews – conducted respectively by Jean-Michel Vlaeminckx and Gawan Fagard – are the ideal medium through which they can reveal themselves.

However anecdotal, a collection about Belgian cinema for a global readership would be incomplete without a tribute to its most famous international figure, Jean-Claude Van Damme (b. 1960, Brussels) also known as JCVD. Once an international action star – nicknamed 'The Muscles from Brussels'– and now substance-abuser *par-devers-soi* comic figure and para-philosophical guru (his concept of the '*je suis aware*' remaining a classic to this day), JCVD's inchoate career and indisputable – even if dishevelled – charisma is recognized in the eponymous section devoted to him which contains a critical biographical essay about his life and work.

This volume's last section, 'On Location,' is dedicated to cinematic representations of Belgium, with a text treating Belgium onscreen as a 'non-space', and another one offering a counter-argument through cinematic portrayals of the preserved medieval city of Bruges, which had been forgotten or overlooked by the industrial age, and, therefore, remains preserved as a relic of the past. Invested in a discussion of the ghostly quality of the 'Venice of the North', this article also raises the question of the switch from 35mm film to digital at a time when Belgium's own political situation is comparable to this transition (King Albert II announced his abdication of the Belgian throne on July 21, 2013): from the fragile/tangible/beautiful format to the uncertainty of a new medium based upon numbers.

This collection closes with the 'Test Your Knowledge' quiz and a bibliography, filled with many references for further reading. While it is unavoidable that a book of this scope might miss some entries – including, but not limited to, André Cavens (1912-1971), Luc de Heusch (1927-2012), Jacques Brel (1929-1978) as film-maker and actor,[3] and Thierry Michel (b. 1952) – we hope that this volume will inspire readers to continue their own scholarly research into and enhance the larger study of the field of Belgian cinema.

Jeremi Szaniawski and Marcelline Block

Note
1. For further discussion of the regional elements of Marcel Pagnol's 'Marseilles Trilogy' films, see Marcelline Block, ed., *World Film Locations: Marseilles* (Bristol: Intellect, 2013).
2. As this volume was going to press, another Flemish film, Felix van Groeningen's *The Broken Circle Breakdown* (2013) was submitted by Belgium to the Academy of Motion Pictures Arts and Sciences for consideration for nomination for the Best Foreign Language Film Oscar.
3. For further discussion of Jacques Brel as film actor and director, please see Marcelline Block, "Jacques Brel (1929-1978): 'Le plus grand Belge'", in Michael Abecassis with Marcelline Block, eds., *French Cinema in Close-up: La vie d'un acteur pour moi* (Dublin: Phaeton, 2013).

Directory of World Cinema

Stanislas Merhar in *Almayer's Folly*. Artémis Productions, Liaison Cinématographique, Paradise Film.

FILM OF THE YEAR
ALMAYER'S FOLLY/ LA FOLIE ALMAYER

Studio/Distributor:
Shellac Distribution
Director:
Chantal Akerman
Producers:
Chantal Akerman
Partick Quinet
Screenwriter:
Chantal Akerman
Cinematographer:
Raymond Fromont
Music Producer:
Steve Dzialowski
Editor:
Claire Atherton
Duration:
127 minutes
Genre:
Fiction/drama
Cast:
Stanislas Merhar
Aurora Marion
Marc Barbé
Zac Andrianasolo
Year:
2011

Synopsis

Kaspar Almayer is a European fortune seeker whose business and dreams dwindle in a river trading post in a Southeast Asian jungle. His loveless marriage to the adopted daughter of the prosperous Captain Lingard and his failed journeys in search of a hidden treasure leave him with only one source of comfort, his 'mixed-blood' daughter, Nina. Convinced by Lingard of the benefits of a 'white' education for her, Almayer snatches Nina from her mother and sends her to a boarding school. Estranged by this education forced upon her, Nina escapes and returns home to the jungle and soon falling in love with Dain, a young man her father has enlisted to locate the mysterious treasure. While Nina emerges as the leading character, Almayer slowly sinks into his own folly, turning the film into a tale on the timeless legacy of colonialism, and its intertwined roots, greed and desire.

Critique

'Almayer's Folly' refers to the Conradian hero's madness, but also conjures up other resonating layers of meaning in its architectural acceptation of 'folie'/folly – a secluded building where one broods or celebrates. Conflicting etymologies tie this term to nature (originally a leaf cabin) and extravagance (outrageous spending). Akerman's film stands precisely at the intersection of these two origins since Almayer shelters his extravagant love for his daughter in a secluded trading post in the Malay forest. Like a *folie*, the film builds up along its own spatial and temporal swaying lines – or vines – that alienate Almayer, his daughter and all those who approach him: are we in the nineteenth century, in the 1950s, in Malaysia, in Cambodia? Akerman's signature sequence shots along with her non-linear treatment of the narrative provide a hypnotic rendition of Conrad's novel.

In a staggering opening sequence, a tracking shot follows a man entering a nightclub while a Dean Martin-wannabe lip-syncs 'Sway,' surrounded by swaying dancers, Nina among them. After he is stabbed onstage, she stares at the camera and starts singing Mozart's *Ave Verum Corpus*. Neither totally western nor Eastern, past or present, this a cappella song crystallizes the essence of Akerman's cinema: while bearing an organic relationship to the world, Nina does not belong to any specific place or time. Both victim and escapee from her father's *folie* (both his house and mental alienation), Nina personifies the resolute human desire for freedom, even in subservience. This first scene contains in itself the architecture of the whole film and its flashback portrayal of Almayer's ravaging folly. A cinematic symbiosis associates Almayer's malaise and *folie* with the wild Malay forest – incidentally, 'forêt *malaise*' in French, which further ties the environment and the uneasiness it yields. Similarly, Nina's tragic gaze through barred windows cinematically reflects her being treasured and victimized. In *Almayer's Folly*, treasures are elusive – Lingard's promised treasure and his daughter's love – and never materialize. Instead, nature and its material, palpable presence invade

the screen. 'Cut in the rough' of the Malay jungle, Akerman's film delves into a sensual exploration of a suffocating and majestic nature that permeates the characters' personae (i.e. the jungle of Almayer's mind). Natural and human bodies seem to merge, such as Lingard's floating deathbed or the sense of stagnation that shapes the film. Paradoxically, this osmosis with the environment invites a search of stolen, lost and regained time.

Almayer's Folly is inhabited by a constructive folly. While she focuses on Nina's rebellious search for her own identity, Akerman also beautifully portrays a father's insane pain at losing his daughter, a subject rarely explored. Whereas Almayer falls victim to his own caste, Nina becomes strong *because* she is an outcast. The opacity of the film's ending – what happens to Nina? Is she sinking in nightclub life or finding a new voice? – only adds to the film's powerful perspective on the legacy of colonialism. This is a demanding, intoxicating and mesmerizing trip into the heart of a telluric darkness, an epitome of Akerman's cinema.

Noëlle Rouxel-Cubberly

AWARD OF THE YEAR
OUR CHILDREN/ À PERDRE LA RAISON

Studio/Distributor:

Versus Production
Samsa Film
Les films du Worso/Benelux
Film Distributors
Filmcoopi Zürich
Les Films du Losange

Director:

Joachim Lafosse

Screenwriters:

Thomas Bidegain
Joachim Lafosse
Matthieu Reynaert

Cinematographer:

Jean-François Hensgens

Editor:

Sophie Vercruysse

Production Designer:

Anna Falguères

Musical Director:

Adriano Giardina

Duration:

111 minutes

Genre:

Historical fiction/true crime/family drama

Cast:

Niels Arestrup
Émilie Dequenne
Tahar Rahim

Year:

2012

Synopsis

Protagonists Murielle and Mounir, deeply in love, get married and live with Mounir's surrogate father, Dr. André Pinget, who had brought Mounir to Belgium from Morocco. Murielle, a schoolteacher, becomes pregnant four times in a row, and is soon overwhelmed with the responsibilities of motherhood. She furthermore feels smothered by Dr. Pinget's oppressive presence and controlling attitude toward her. Due to this stressful domestic situation, she can no longer cope with her teaching and must quit her job. The pressure of Dr. Pinget's permanent role in her life and his negative influence upon her husband, combined with her increasingly unstable emotional state, leads her to commit the unthinkable: the murder of her four children.

Critique

Joachim Lafosse's tale of multiple infanticides is reminiscent of a tragedy that occurred in the Brussels suburbs in 2007, when middle-aged homemaker Geneviève Lhermitte murdered her five children. In that notorious case, it was four daughters and a son, ages 4-14, before Lhermitte unsuccessfully attempted to kill herself. Parallels can be drawn between the Lhermitte infanticides and those in the fictitious film *Our Children*. Lhermitte, a former schoolteacher, and her husband, Bouchaïb Moqadem (born in Morocco), lived with Moqadem's Belgian sponsor/father figure, Michel Schaar, a doctor who had his medical office in their shared home. The similarities between *Our Children* and the Lhermitte case led Moqadem and Schaar to file a lawsuit against Lafosse, claiming violation of privacy and demanding to review his script, when the film's production was already underway (Lafosse refused). Although he admits that he was 'freely inspired' (Unifrance 2012) by the notorious Lhermitte infanticides that shook Belgium in 2007, Lafosse denies that *Our Children* seems to be a reenactment of this tragic event but rather, is 'purely the fruit of my subjectivity and my imagination' with which he has 'created a fictional work without the pretension of explaining everything, but we wanted to make people think and discover the roots of a tragedy… The film doesn't take away responsibility but it doesn't judge any of the characters either. It asks questions and seeks answers through the only medium that allows us to proceed in this

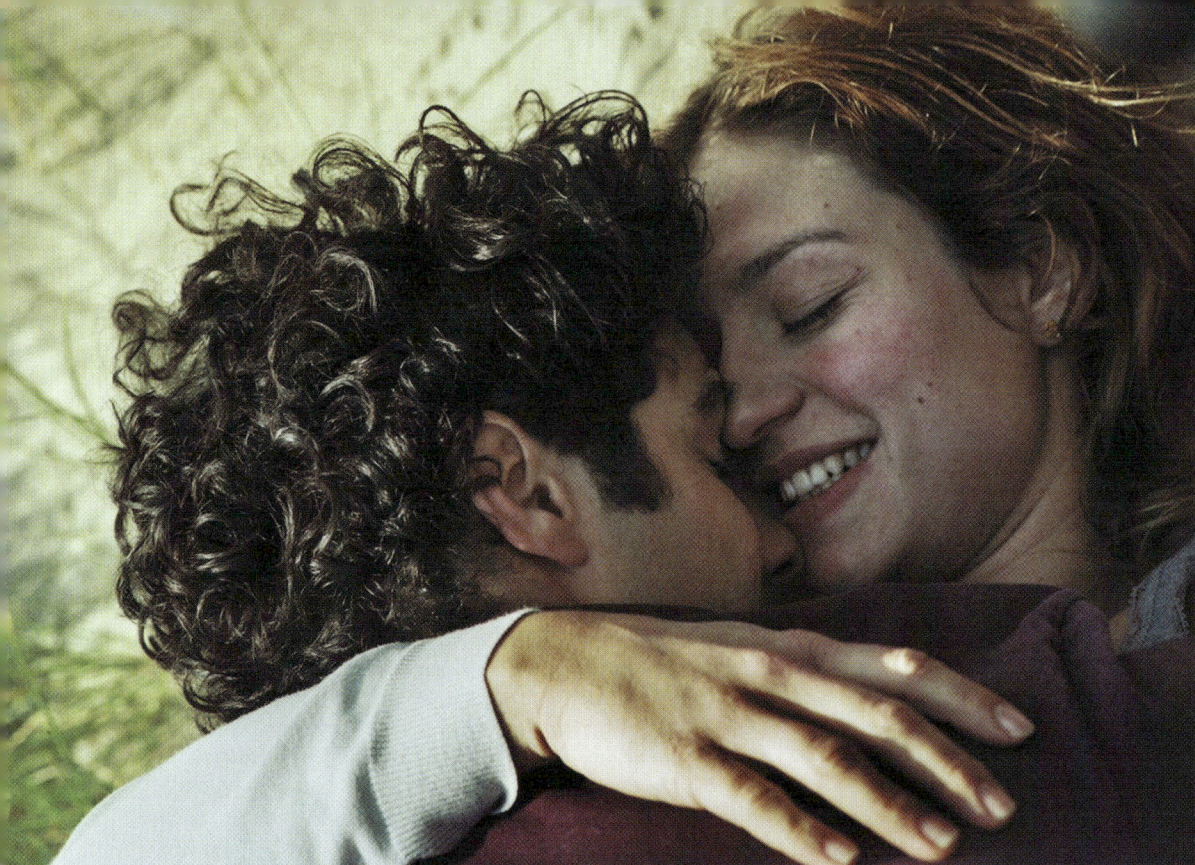

Tahar Rahim and Emilie Dequenne in *Our Children*.
Versus Production, Samsa Film, Les Films du Worso.

way: a fictional account' (Unifrance 2012). In creating his characters, Lafosse stated that he was inpsired by Alfred Hitchcock's *Shadow of a Doubt* (1943) and John Cassavetes' *A Woman Under the Influence* (1974).

Our Children's controversial narrative has nonetheless received much critical acclaim. Belgian-born Emilie Dequenne was given the Cannes' Film Festival Un Certain Regard Award for Best Actress for her interpretation of the infanticidal mother (previously, Dequenne had won the Best Actress Award at Cannes for her debut performance in the Dardenne brothers' 1999 *Rosetta*). *Our Children* was the Belgian entry for Best Foreign Language Film for the 85th Academy Awards. Although the film was not ultimately selected for nomination by the Academy, it triumphed at the 2013 Belgian Magritte Awards (the Belgian Oscars/Césars for the French-speaking community of Brussels-Wallonia), winning Best Film, Best Director, Best Actress, and Best Editing. It also won the 2012 André Cavens Award (from the Belgian Syndicate of Cinema Critics) for Best Belgian Film of the Year. In 2013, at the Palm Springs International Film Festival, Dequenne was awarded the FIPRESCI Prize for Best Actress for her performance in *Our Children*

as well as the Best Actress Award at the Saint Petersburg International Film Festival.

This film reunites actors Niels Arestrup and Tahar Rahim, who had previously been cast together in Jacques Audiard's critically acclaimed *A Prophet/Un prophète* (2009), for which each won a César: Arestrup for Best Supporting Actor and Rahim for Best Actor. In *Our Children*, they again portray a co-dependent relationship between the older Dr. Pinget and his protégé Mounir. Pinget, wielding power and control over the household, further alienates Murielle, who feels trapped in the claustrophobic environment where the triangular relationship between her husband, the doctor, and herself, negatively impacts her. The bond between the two men makes Murielle feel estranged from their intimacy as she is left to raise her and Mounir's four children. Pinget is involved in every aspect of the couple's life, taking control over everything, including their finances, since he is Mounir's employer and landlord (and he is also married to Mounir's sister Fatima in a sham marriage to grant her Belgian citizenship). Increasingly exhausted with multiple pregnancies in a short time, Murielle is abused by Mounir and despised by Pinget, which causes her fragile mental state to collapse.

Despite receiving praise, *Our Children* has polarized critics and viewers who find the subject matter horrifying, even more so because only five years separate the film from the actual Lhermitte murders, which impacted Belgian collective memory.

Of his reasons for making a film treating such appalling events, Lafosse, who often tackles complex subject matter about disturbing and tragic human relationships such as in his earlier *Private Property/Nue propriété* (2008) and *Private Lessons/Élève libre* (2010), remarked: 'I was in my car when I heard a dramatic report on the radio about a woman who had killed her five children. I immediately felt that this harked back to Greek tragedy and that the incident offered me the possibility to go deeper into what I spoke about in my previous films: excessive love and its consequences, debt, perverse bonds, dysfunctional families, the question of limits' (Unifrance, 2012). This interview with Lafosse brings to mind Albert Camus' *The Misunderstanding/Le malentendu* (1943). Camus was inspired to write this tragic play after a *fait divers* in a newspaper: the case of mistaken identity reported in a small Czechoslovakian town which led a mother and her adult daughter to murder a young man before recognizing that he was her own grown son, rather than a wealthy stranger whom they decided to murder for his money. This *fait divers* had impressed Camus so much that he wrote about it in two of his major works: not only in *Le malentendu* but also in his iconic novel *The Stranger/L'étranger* (1942). In *The Stranger*, a newspaper clipping of this *fait divers* in Czechoslovakia is read by the character Meursault, an antihero *par excellence*, while he is jailed, in French Algeria, after he had killed an Arab.

Remnants of the recent colonial past can be inferred in *Our Children*, as the white, Belgian, sixtysomething Dr. Pinget behaves as if Mounir, whom he had brought to Belgium, belongs to him and that Mounir 'owes' Pinget for his assistance in obtaining citizenship papers for his sister, as well as employment, lodging, and financial support. A parallel can be drawn between the paternalistic Pinget

and the European colons when Morocco was a French protectorate. Therefore, Pinget behaves as if he were the 'protector' of two individuals from Moracco, Mounir and Fatima. Furthermore, Pinget is under the impression that his protectorate extends to Murielle, whom he also dominates financially and psychologically, stifling her (although she is not Moroccan). He controls nearly every aspect of Murielle's life: he is her medical doctor, he robs her of her agency as a wife and mother; he furthermore interferes in her relationship with her psychotherapist, causing Murielle to cut off this treatment that she clearly needs; he alienates Murielle from sister Françoise (although he later arranges a sham marriage between Françoise and Mounir's brother Samir so that Samir can become a Belgian citizen); he forces Murielle to accept his dominion, demanding to live with the couple after buying a house in which they all reside, and in which his medical office is located. He employs Mounir as his office manager. Murielle's attempts at independence from Pinget are futile and immediately quashed, such as her desire to move her family to Morocco, which she imagines is a happier place to live because she had employed it when she visited. As 'parrain'/ 'godfather' of Murielle and Mounir's four children, Pinget functions as the head of this household, crushing any independence expressed by Murielle or Mounir. Not only does Lhermitte's case evoke infantacides in Greek mythology (such as Medea) but also in film, such as Fellini's *La dolce vita* (1961), in which the philosopher Steiner (Alain Cuny) murders his two young children before committing suicide for ideological reasons because he believes that this life is not worth living. *Our Children* also recalls numerous real-life examples similar to Geneviève Lhermitte: in 1994, Susan Smith drowned her two young sons in a South Carolina lake; in 2001, Texas housewife Andrea Yates drowned her five children in the bathtub, and Véronique Courjault of France, who between 1999 and 2003 killed three of her newborns, keeping two of their bodies in the freezer and burning the third.

Lafosse's interpretation of horrific events such as these is reflected through *Our Children*'s diegesis and sensitive treatment of the subject matter: the children's deaths are learned of early on in the film when Murielle, from her hospital bed, insists that they are to be buried in Morocco. But the manner in which the infant victims died is not shown onscreen, a decision based on classical theatre aesthetics, which informs Lafosse's larger philosophy of cinema: 'that's what the cinema is, in fact, an art of what happens off screen, an art of talking about things without showing them … I felt that there was no sense in filming the murders' (Unifrance, 2012). In this respect, *Our Children* is close to the model of Greek tragedy where violence is not shown onstage. This aesthetic choice is reminiscent of that taken by Karen Moncrieff, writer/director of the 2006 film *The Dead Girl*, who refused to depict the murder of the film's titular figure by a male serial killer from whom she had hitched a ride:

> Moncrieff, in writing and directing *The Dead Girl*, chose not to present the woman's murder for visual consumption, but rather, only the moments leading up to and the aftermath of her death…[Moncrieff] 'never wanted to see the moment' of [the murder]; despite the movie 'dealing with issues of violence against women,' Moncrieff does not want to portray 'gratuitous images of women being bashed,' nor 'show this woman being killed.' In this respect, the film's aesthetic follows Aristotelian theatrical conventions, which prescribe that violence not be shown to the spectator, but only be narrated, and take place offstage. (Block 2013a)

The offscreen violence in *Our Children* is narrated in the film's final scene, when Murielle calls the police and confesses her crime—also stating that she was planning to commit suicide but could not bring herself to do so (again bringing to mind Susan Smith, who stated that she was planning to kill herself along with her two infant sons, but did not).

In considering how to approach and represent *Our Children*'s subject matter, Lafosse searched for 'the right form to inspire emotion without resorting to sensationalism … We had to film in long takes, shot on a level with the characters and children' (Unifrance, 2012). Music – whether the baroque melody accompanying the early scene when the four children's coffins are loaded into a plane, or French singer Julien Clerc's 1982 *chanson* 'Femmes, je vous aime' ('Women, I love you'), filtered through Murielle's car radio – is crucial to the unfolding of the narrative. Music functions as an accompaniment 'each time a transgression occurred' (Unifrance, 2012). Clerc's song resonates with Murielle, as she feels unloved and abandoned while Clerc expresses love for and eulogizes women precisely for being, like her, fragile and difficult:

> Femmes…je vous aime / Women, I love you
> Femmes…je vous aime / Women, I love you
> Je n'en connais pas de faciles / I don't know any who are easy
> Je n'en connais que de fragiles / I only know fragile
> Et difficiles / And difficult ones
> Oui…difficiles / Yes…Difficult
>
> (lyrics by Jean-Loup Dabadie)

But Murielle, who identifies with such women, does not receive the reward of love that is, in Clerc's song, to be showered upon them; at the end of the song, she breaks down, sobbing over the wheel of her car after she has arrived home. Her husband, who abuses her, is certainly not singing her praises. *Our Children* contributes to contemporary Belgian cinema, bringing the country's recent tragic events to the forefront, interrogating the factors that triggered them, investigating how a society could better protect the lives of the most vulnerable human beings in order to prevent their victimization. With *Our Children*, Lafosse states that he does not 'illustrate nor document the incident, but takes possession of it with [his] subjectivity, [his] point of view as an artist' (Unifrance, 2012). In doing so, he has succeeded beyond all expectations.

Marcelline Block

SMALL COUNTRY, GREAT CINEMA?
ANATOMY OF BELGIAN CINEMA

If we study the links between methods of production and types of films, we find three distinct periods in the history of Belgian cinema. The first, from 1896-1965, was characterized by a lack of substantial, consistent film funding. Documentaries were made essentially with public funds (from ministries and the tourism commission) but also occasionally with support from the private sector. Some film-makers succeeded in transcending the notion of the 'commissioned film' and were able to innovate cinematographically by transforming their limited means into a pseudo-choice of *mise-en-scène* (what could be called an 'aesthetic of poverty'). Charles Dekeukeleire and Henri Storck were the first Belgian documentary film-makers to receive international recognition (Storck, above all, thanks to the politically-engaged film, *Poverty in Borinage/Misère au Borinage* that he made in 1933 with Joris Ivens – a film that was financed by Le Club de l'écran, which prefigured the Belgian Cinémathèque). André Cauvin is the first director to make films about art that are also feature-length films. He is the first who dared to show a canvas in close-up in a film.

Cauvin went on to become a pioneer in ethnographic cinema with films made in the Belgian Congo. Later, he was followed by film-makers such as Luc de Heusch, who was more mindful than Cauvin in associating a scientific rigour to his cinematic approaches. Several world histories of cinema (such as Georges Sadoul's) discuss the Belgian documentary school. However, most of these documentaries did not have a commercial distribution in theatres, and their only spectators were either the most determined cinephiles or the films' own backers. The marginalization of experimental cinema was even more manifest. Several Belgian directors excelled in the domain of avant-garde cinematography (Henri d'Ursel, Ernst Moerman), but remained unknown to the public at large. Self-financed, their films did not aim for profitability. The budget for a feature-length film could not ignore the realities of commercial distribution. Before 1965, they were made with private funds. The few films made during this period were divided into two categories: unpretentious regional dialect films (comedies or operettas) versus films with artistic ambition (especially after the 1950s). Gaston Schoukens and Jan Vanderheyden produced their own dialect-based comedies, which had popular appeal in their particular regions (Brussels, Antwerp), but encountered difficulty with distribution elsewhere. Although these films proved to be profitable, critics panned them.

Auteur films did not achieve enough commercial success to permit their directors to develop a filmography. Made on a shoestring budget, they were mostly uncompleted. In this period, only one film-maker, Paul Meyer, was able to establish himself artistically, with a feature film that oscillated between fiction and documentary: *The Lank Flower Has*

Already Flown/Déjà s'envole la fleur maigre (1963). Despite its critical and festival acclaim, this film was a complete commercial failure, and Meyer spent years repaying the debts he incurred by making it.

The second period of Belgian film history began in 1965, running just until the end of the 1980s. It was defined by the political will to support feature-length fiction films. The directors' and producers' desire to take charge of their own destinies (to find the most substantial means to make their movies) intersected with the evolution of Belgian institutions. However, one might wonder who was exploiting whom: the politicians or the 'artists'? The newly created film commissions were immediately divided between the francophone and the Flemish sections of the country: in 1965, on the Flemish side, and in 1967, on the francophone side. Culture and Education were the first sectors to be regionalized. 1965 was also the year when André Delvaux made *The Man Who Had His Hair Cut Short/L'Homme au crâne rasé/De Man die zijn haar kort liet knippen*, the first feature-length Belgian film that received true international recognition, without running into the production and distribution difficulties that Paul Meyer had experienced only a few years beforehand.

Production still from Frédéric Sojcher's *Hitler in Hollywood*, in Brussels' Galeries Royales Saint-Hubert. Picture from private collection, with kind permission by the author.

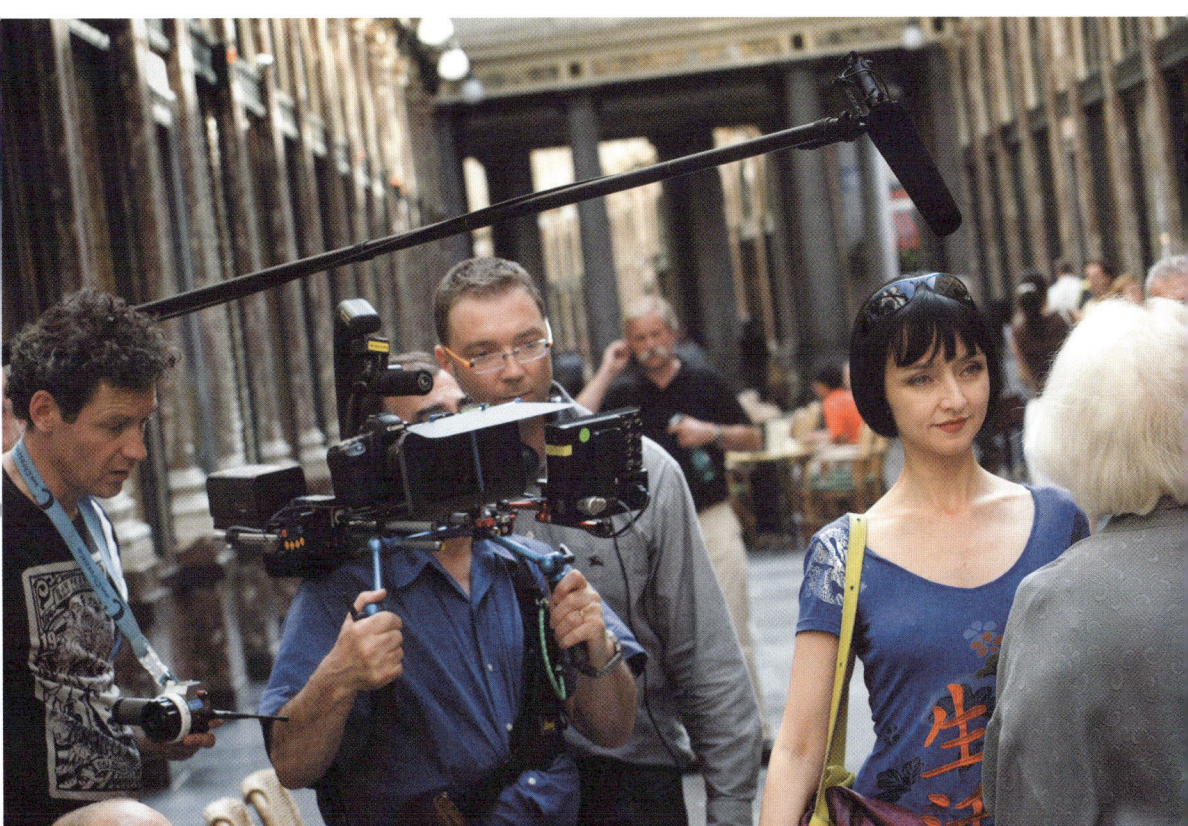

One underlying question was raised: does a 'small' country have the 'right' to its 'own' cinema? Beginning in 1963, in a colloquium he organized about Belgian cinema, Jean-Claude Batz put forth the hypothesis that the Belgian market was too small to allow Belgian productions to be profitable and therefore the public financing of films was a necessity. Batz was simultaneously correct and incorrect. He was correct since, other than American Hollywood cinema, no other cinema had succeeded in distributing its films abroad more than in its own territory. The natural market for films is national (or even regional). Yet Batz was also incorrect, since films made with small budgets (the regional films) were able to flourish. The question had to do, rather, with the 'type' of film implied by the size of the market for which it was intended.

Starting with the appearance of the selection committees devoted to financially supporting the production of feature-length films, Belgian cinema was divided into two distinct identities. On the Flemish side, a plethora of 'culturally engaged' films appeared. These were adaptations of popular mainstream Flemish novels, often anchored in a historic context and criticizing francophone 'dominance'. Roland Verhavert is the major figure of this type of film, but we can also name Robbe de Hert (*Whitey/De Witte van Sichem*, 1980) or Hugo Claus (*The Lion of Flanders/De leeuw van Vlaanderen*, 1984). Comedies (*Hector* by Stijn Coninx, 1987) and films openly inspired by the American aesthetic completed the picture (Patrick Le Bon's detective film, *Zaman*, 1983; Marc Didden's road movie *Istanbul*, 1985, with Brad Dourif, filmed in English; and the Charles Bukowski stories which were adapted by Dominique Deruddere with *Love is a Dog from Hell/Crazy Love* in 1987). These approaches had a commercial appeal and were popular with the Flemish public. Yet Flemish films were rarely, if at all, exported outside of Flanders.

On the francophone side, it was, rather, auteur cinema that dominated, with directors such as Chantal Akerman (*The Meetings of Anna/Les rendez-vous d'Anna*, 1978) and Jean-Jacques Andrien (*Le Grand paysage d'Alexis Droeven*, 1981). These films often received critical acclaim and were selected for prestigious international film festivals, but were largely ignored by the general viewing public. Thus emerged a politics of 'cultural showcase'. There were also film-makers who did not belong to any category, or who combined several tendencies, whose artistic path/journey/identity could not be reduced to being francophone or Flemish, 'auteurist' or Americanized. André Delvaux attempted to make auteur films that would more widely appeal to spectators (by casting stars such as Yves Montand in *One Night... a Train/Un Soir, un train*, 1968; Vittorio Gassman in *Benvenuta* in 1983 and Gian Maria Volonté in *The Abyss/L'Œuvre au noir* in 1988). Harry Kümel made fantasy films (*The Legend of Doom House/Malpertuis*, 1973, with Orson Welles). Documentary and experimental film-makers stayed active, but did not offer their films for cinematic exhibition. Rather, documentaries were mainly shown on television (only Thierry Michel succeeded in regularly showing his films in theatres). Experimental films were voluntarily placed in a marginalized position, 'outside of the laws of the market' (Boris Lehman and his autobiographical films; Roland Lethem and his surrealist provocations; Thierry Zéno who explored a schizophrenic universe with a man who makes love to a sow in *Wedding Trough/Vase de noces*, 1975).

The third period in the history of Belgian cinema is concomitant with the appearance of audio-visual European programmes and with the birth of a new wave of directors acclaimed by the Cannes festival. On the European side, Belgium, as a country, is a trendsetter on the cinematic map. Its propensity to develop co-productions appeared very early on, due to the country's own limited means of production and distribution. When the MEDIA programme and the EURIMAGES programme were established at the end of the 1980s by the European Union and the Council of Europe, Belgian producers were, naturally, the first beneficiaries. One of my hypotheses is that Belgian cinema can be considered/observed as a 'European laboratory'. The lack of interest by the

francophone public for Flemish films and Flemish spectators for francophone films is symptomatic of a Europe that is constructed more as a collection of nations (or even regions) rather than as a culturally-homogenous whole.

Francophone directors are the main beneficiaries of Cannes' aura: the Dardenne brothers, of course, but also Jaco Van Dormael – who received the Golden Camera in 1991 for *Toto the Hero/Toto le héros* – while the mockumentary *Man Bites Dog/C'est arrivé près de chez vous* (Rémy Belvaux, André Bonzel, and Benoît Poelvoorde), was selected for the International Critics' Week in 1992. If we were to consider the number of films produced per year and the number of films selected for Cannes, Belgian francophone cinema would top the list of world cinemas from 1990-2000. This fact is explained by cultural policies that allow a variety of film-makers to emerge. It is also explained by the artisanal quality of the productions (which permits individual cineastes' visions to flourish and also allows for the breakthrough performances of Belgian actors, most notably in the Dardenne brothers' films).

Several new elements have impacted the past ten years. The appearance of new forms of financing – regional funds, Wallimage funds, and tax shelters – has boosted the sector, increasing the number of productions. Philippe Reynaert, formerly a film critic, now presides over the Wallimage Regional Fund for Audiovisual Investment. Pierre Drouot, director of VAF (the Flemish film commission), favoured supporting as many commercial productions as auteur films, a decision which had the direct effect of the selection of Flemish films for Cannes (such as *The Misfortunates/De helaasheid der dingen*, Felix van Groeningen, 2009). Frédéric Delcor, the new general secretary of the Walloon Community in Brussels (responsible for Culture and Education) wishes there were more of an effort to promote and distribute francophone films, which still suffer from a lack of popular appeal. More and more francophone directors make a first, and then a second feature-length film… and if their films are not selected for Cannes, they find themselves discredited, in a paradoxically perverse process/effect. This is a merciless, unforgiving chopping block: among those who are increasingly called, few are chosen. There is stiff competition between Flemish and French films for international recognition. The increasing tendency toward a professionalization of cinematic productions can provide a structure/framework, but can also lead to the loss of artisanal charm. Belgian cinema is at a crossroads, like the country itself, whose institutional future is more than uncertain.

Frédéric Sojcher

Translated by Marcelline Block

A METHODOLOGY FOR BELGIAN CINEMA

How does one go about writing the history of a national cinema? By speaking about all the country's films? By focusing solely on the films that have received critical acclaim or that were screened at prestigious international festivals? By privileging films that were box office hits? I asked myself these questions while working on my doctoral thesis, a history of Belgian cinema from its origins to 1995 – in other words, one hundred years of cinema. The problems of methodology – to choose what corpus, what historical segmentations, what analytical rubrics – are at the core of a work of research conducted in a university setting. In perceiving that there was a large number of unrecognized, even unknown feature-length Belgian films, as they were not distributed commercially, and that films produced in Belgium had different characteristics depending on whether they were made with public or private financing, in Flanders or in the francophone part of the country, with or without foreign co-production… I thus implemented a multidisciplinary approach that takes numerous factors into account all at once, including economic, institutional (the political evolution of the country), aesthetic, and cultural considerations. Addressing a national cinema also allows us to raise questions that go beyond the scope of the study and reveal a sociological dimension to it.

 The question of sources is primordial. It was not always possible to see the films, as copies of certain films, mainly those made before 1940, seem to have disappeared. Other histories of Belgian cinema existed before I wrote 'mine'. The best known are Paul Davay's *Cinémas de Belgique* (1973) and Francis Bolen and Paul Vermeylen's *Histoire authentique, anecdotique, folklorique et critique du cinéma belge depuis ses lointaines origines* (1978). The one that influenced me the most is a collaborative work, *Une Encyclopédie des cinémas de Belgique* (edited by Guy Jungblut, Patrick Leboutte and Dominique Païni, 1990), which shows subjectivity in both the film-makers and films that the editors choose to feature. I think that it is impossible or very difficult to be 'objective' in establishing a history of cinema; but, rather, a study should highlight its analytical tools and the reasons for one's choices, selections, and prevalences. Thus, I always endeavoured to account for the contemporary critical reception the films received upon their release in order to eventually develop my own divergent analysis and explain my argumentation for it.

My work of inquiry into, and viewing of, Belgian films brought me to question certain commonly-accepted clichés of the country's cinema, such as the critical contempt for 'patois' films. Marcel Pagnol admired Gaston Schoukens, who gave him the idea to adapt two of his plays, *Marius* and *Fanny* to the screen; Pagnol subsequently made the film *César*, thus making his iconic *Marseille* trilogy for the big screen. Schoukens was deemed by most of the critics of his day as merely making 'filmed theatre' and, therefore, his cinematic production was of no critical interest or esteem. He moreover committed the 'crime' of mocking the Brussels accent, and of making Belgian people appear 'ridiculous' abroad, according to many journalists. It is necessary to have a 'critical distance' to analyse the films for what they are and not as a function of a cultural complex or of prejudices, whatever they may be. There is a real truculent, creative force at work in a number of 'patois' films that allows for their rehabilitation. I also made some surprising discoveries, as far as history is concerned, such as the specificity of the treatment reserved for Belgian cinema by the Nazi occupiers during World War II. The attitude of Henri Storck raises questions: in spite of being a leftist close to the communist party, he continued to make films in Belgium during the Nazi occupation. In his *Peasant symphony/Symphonie paysanne* (1944), Storck developed a contemplative aesthetic about peasants and their land (which we could characterize as Stalinist just as well as Pétainist). Nor does the film's commentary escape ideology: 'Wheat is the property of man, there is no wild wheat, where there is wheat, there is man.' André Cauvin had, in the same period, an opposing trajectory to that of Storck, since he participated in the Resistance and fled Belgium for London.

It is worth noting that several films of interest did not have a real commercial release that would have made both the public and critics alike aware of their existence. One example among others is *Les Arpents dorés* by Armand Rocour (1977). This film unfolds in the countryside near Liège and the story of a peasant corrupted by the city lights and their lure, which threatens his marriage. There is a Rohmerian aspect to this 'moral tale', which takes on the artificiality of the actor's performance and which disturbs through its Bressonian distancing stance.

The 'heroic' (even quixotic) quality of a number of producers and film-makers to make a film 'at all costs', without the means to do so, is a constant of Belgian cinema that must be underlined, even after the establishment of public aid for film-making. Today, Jean-Jacques Rousseau, who started to make films in the 1960s when he was about 20 years old, is the most emblematic figure of this kind of process. He defines himself as the 'Walloon Ed Wood' (or the 'Belgian Ed Wood'). His films are hallucinatory; they develop an oneiric and paranoid imaginary, reminiscent of *art brut*. They are accessible on demand online (the film-maker has created his own website, http://www.infojjr.be/, entitled 'Jean-Jacques Rousseau: Cineaste of the Absurd').

My dissertation about the economic and cultural history of Belgian cinema was successfully defended in 1996 at the Université de Paris 1 Panthéon – Sorbonne, with André Delvaux as president of my committee. It was awarded the Prize Filippo Sacchi for the best European doctoral dissertation about film, and was published as *La Kermesse héroïque du cinéma belge* (three volumes, Paris: L'Harmattan, 1999). I updated my approach to Belgian cinema in *Pratiques du cinéma* (Paris: Klincksieck, 2011), a book that attempts to identify current issues. In it, I show how much film-makers depend upon means that are accessible to them and the links that exist between a 'thinking' and a 'practice' of cinema.

Frédéric Sojcher

Translated by Marcelline Block

SMALL COUNTRY, BIG MEMORY?

'Small country, small minds' ('Petit pays, petit esprit'), King Leopold II of Belgium is rumoured to have quipped about his country and people.[1] In many ways, Belgians know exactly both how accurate and unfair such a description was. If none of its subsequent kings displayed the same Babylonian colonial and urban-planning ambition, and if large-scale enterprises are generally frowned upon by a nation that cultivates a certain down-to-earth-ness, Belgians have also inherited from this much-maligned sovereign a form of quixotic ambition, which can account for the nation's somewhat schizophrenic nature. After all, was this small country not the second most industrialized power in the world at the turn of the twentieth century? Did it not shine in the realms of literature (Maeterlinck), painting (Ensor), music (Adolphe Sax), architecture (Art Nouveau and Art Deco), and technology (Zénobe Gramme)? This wealthy, bourgeois country thus expressed its anarchic and self-conscious relationship to its absurd geopolitical condition (some would say its 'surrealist' identity). Even past its prime, in the second half of the twentieth century, Belgium owed it to itself to boast a plentiful cinematography as well. At some point, everyone wanted to make films there, from surrealist artists Marcel Broodthaers and Marcel Mariën to singer Jacques Brel, who made a jab at Belgian petit bourgeois values in his songs such as 'Les Bourgeois' and 'Je vous ai apporté des bonbons', while loving his birthplace and its people all the same.

However improbable, Belgium nevertheless became a country of cinema, regardless of the fact that it had no film industry to speak of. Moreover, by the late 1970s, modern Belgian cinema had emerged on the international scene, thanks primarily to the critical acclaim received by the films of André Delvaux and Chantal Akerman. At home, the national cinema had proven that it could be critically acclaimed and yet enjoy popular success, as Benoît Lamy's 1973 *Home Sweet Home* demonstrated. But there were many other names, although much less known internationally, who also partook of the national patrimony's richness. Within its borders, one of the first notable attempts at celebrating Belgian cinema in its diversity and depth was conducted by Adolphe Nysenholc, curator of the 'Week of Cinema in Belgium'/'Semaine du cinéma en Belgique', held during the celebration of the University of Brussels' 150th anniversary, from 20 to 26 February 1984. The conference was accompanied by a multitude of screenings[2], boasting 54 short films (of which twelve were animated) alongside ten features. Many of the shorts were films about art (including the works of the unsung cinematic and scientific hero, Luc de Heusch, 1927-2012) – through which Belgian cinema could celebrate its country's glorious artistic traditions. Many of the shorts were films about art – including the works of the unsung cinematic/scientific hero, Luc de Heusch (1927-2012) – through which Belgian cinema could celebrate its country's glorious artistic traditions. In the conference's catalogue, film historian and critic Hadelin Trinon identified three generations of Belgian cinema, pointing out the latter's richness and vitality, in spite of the absence of a film industry in the country. Even if some filmmakers – such as Henri Storck or Charles Dekeukeleire -- were able, thanks to their independent wealth, to pursue their filmmaking careers, all of them still remained 'beggars':

> One could be optimistic if money did not ruin hopes, if time did not lay a
> thick layer of dust on dossiers. Our film-makers have remained beggars.
> None of them makes an actual living from their artistic métier. Each project
> remains an adventure subject to chance, on the whims of a commission's
> decision, of the financial powers of a politician. And once the film is done,
> each film-maker must turn into a traveling salesman, running from a festival
> to another, from one distributor to another.[3]

However harsh Trinon's observations might sound, they were probably accurate. And yet, in spite of this pessimism, Belgian cinema grew: Delvaux, Akerman, and also Jean-Jacques Andrien as well as Harry Kümel had already met with international success. A few years later, several other Belgian film-makers would emerge on the international scene: Jaco van Dormael, Marion Hänsel, Stijn Coninx, Dominique Deruddere, Gérard Corbiau and the Dardenne Brothers, to name just the most recognizable figures. While the vast majority of film practitioners in Belgium must still resort to another source of income to insure their sustenance, the fact that not all of them had to enjoy the dubious pleasures of 'beggar-ship' was already a victory in its own right.

Concurrent with the flourishing of national cinema (often in complicated conditions of funding and co-production, as Frédéric Sojcher's dissertation *La Kermesse héroïque du cinéma belge* documents, interest in film studies in Belgium grew. Next to the two main film schools (the INSAS in Brussels and the IAD in Louvain-La-Neuve), founded in the sixties, one should not play down the importance of schools such as the RITS, the INRACI (both in Brussels), or important film studies departments at universities such as Antwerp, Ghent, Liège, and Brussels, among others. Last but not least, one should point out the phenomenal role of the Royal Film Archive (now known as 'Cinematek'), which boasts one of the largest collections of film prints in the world and, as a repository of film culture and history, has contributed in an invaluable and perhaps confidential way to the development of film culture in Belgium. All this fostered, in spite of the quasi-absence of film industry, a wealth of technicians, artists, critics, and scholars that have kept the boat of Belgian cinema vibrantly afloat for the past thirty years. So much so that Belgium might be the country to have produced the largest number of film professionals, relative to its size.

On 15 April, 2008, director Benoît Lamy was murdered at his house – killed by his lover following a drunken brawl between the two men. Shaken by the untimely death of his friend and neighbour, Richard Olivier, the author, among other pieces, of several memorable episodes of the *Strip Tease* series, decided to embark on a quest to collect interviews with 170 Belgian film-makers, past and present (the dead ones being presented through the intercession of 'porte-paroles' or 'porte-coeurs').[4] The work, called *Big Memory* (www.bigmemory.be) was, at the time of its inception, supposed to be a work-in-progress constantly evolving, already close to 40-hours long and expanding.

The format of each interview is identical: each film-maker (who must have at least made three short films in order to be taken into consideration) is filmed in one fixed shot, in a location of his or her choice, with the same question, asked by Olivier: 'what motivates you to make films?' From thirty minutes of capture, each portrait was edited down to thirteen minutes – incidentally, the traditional duration of an episode of *Strip Tease*.

That this quasi-entomological, and perhaps slightly morbid, project should have originated from Olivier is not surprising: the film-maker's best-known works often have

to do with mortuary statues and taxidermy (as his excellent episodes of the *Strip-Tease* TV series, 'Un amour de bronze' (1988) and 'J'aurai ta peau' (1993), testify). He was a neighbour and friend of Benoît Lamy, and recollects, in interviews, how the latter told him that 'If there is another world, that is where we will see each other again' ('S'il existe un autre monde, c'est là que l'on se reverra'),[5] on the last day they saw each other, shortly before Lamy's tragic and violent death.

If truth be told, Olivier has somewhat marred the nobility of his huge enterprise of mourning and its avowed promise of a 'never-ending' story by closing his work after four years, not seeming too keen on leaving the work-in-progress open (a book, and a DVD, came out as concluding the process, while each interview was broadcast daily on the national francophone public service), bringing it all back into the bosom of pragmatic film-making for (relative) profit and mercenary celebratory exploitation of the national patrimony. Besides, some major omissions here (Akerman and Dekeukeleire are absent, for example) seem ultimately less important than the fact that Flemish film-makers are glaringly under-represented, something caused, no doubt, by one of the major problems of Belgian culture, namely the lack of communication, linguistic but also cultural, between its two major entities.

However one might look at these shortcomings, the final result is as much a media coup as it is a memorial 'cinematic monument', reminding us that, if the political existence of Belgium has become precarious, its work of remembrance, of memory, is even more important, as here is a most fragile cinematic culture celebrating not only its own survival but its often paradoxical flourishing – Belgium being, indeed, the country with probably the highest rate of film-makers per square kilometre and used to working in difficult conditions – as many other European practitioners of films are learning now, with the economic recession and cuts in culture budgets. A troupe of beggars? Maybe. But seldom have beggars been so resiliently dashing.

Jeremi Szaniawski

Notes
1. Incorrectly condensed from a remark by Leopold II to Baron Vander Elst, in 1907, on the unwillingness of the Belgian Parliament to accept the Congo as a national colony: 'Je suis le souverain d'un petit pays et de petites gens. J'ai passé ma vie à vouloir leur faire du bien; ils m'ont traité de voleur, d'assassin!' ('I am the King of a small country, and of small people. I've spent my life wanting to do what's best for them. In exchange, they've called me a thief, an assassin!')
2. Leading to the publication of the volume 'Ombres et lumières, Études du cinema belge' in the celebrated *Revue de l'institut de Sociologie* of the ULB, in 1985 (vol. 3-4), including pieces from a wide range of disciplines, from academics (Hadelin Trinon, Claude Javeau), practitioners of film (André Delvaux, Boris Lehman, Thierry Zéno) and members of cultural institutions (Henry Ingberg).
3. Adolphe Nysenholc (ed.), *Semaine du cinéma en Belgique*, ULB 150 ans, catalogue (projection de 64 films en présences des réalisateurs), colloque interuniversitaire (27 communications et tables rondes) : du lundi 20.2.84 au dimanche 26.02.1984, Bruxelles, 1984, bibliographie p. 52.
4. Notable film critics and scholars such as Jacqueline Aubenas (for Henri Storck), Philippe Reynaert (for André Delvaux) and Henri Sonet (for André Cavens).
5. www.bigmemory.be

FILM CULTURE FOCUS
THE ROYAL BELGIAN FILM ARCHIVE

As for every other organization of its kind, the main purposes of the Royal Belgian Film Archive ('la Cinémathèque royale de Belgique' in French and 'Koninklijk Belgisch Filmarchief' in Dutch – and referred to here as 'the Cinémathèque') are the preservation, classification, and making available to the public and researchers alike the films that comprise its culturally-significant collection, as well as maintaining documentation accompanying it. It is distinguishable from other film archives, however, due to its international prestige, acquired over the years, and its prominence in the area of film archiving. Nothing seemed to prepare the Cinémathèque for such a fate. Belgium remains, for all intents and purposes, a small country, without a studio system, and where cinema does not enjoy a particularly privileged/popular status outside of some small, specific circles. And yet the Cinémathèque undeniably boasts an extremely rich collection, one of the largest in the world, and the model envisioned by its iconic curator, Jacques Ledoux (1921-1988), was surprisingly innovative, efficient, and precedent-setting.

The history of the Cinémathèque began in the 1930s, at a time when the first film archives appeared: in Stockholm (1933), Berlin (1934), Milan, London, New York (all 1935) and of course Paris, founded in 1936 by Henri Langlois. Three young Belgian intellectuals, André Thirifays, Henri Storck, and Pierre Vermeylen, who had previously organized a film-club ('The Screen Club'/'Le Club de l'Écran', created in 1931), decided to go beyond the simple act of screening films they deemed of high quality (often with very strong left leanings) and also took part in the preservation of the memory of cinema. They were greatly encouraged by Langlois, with whom they developed a close relationship. Their non-profit organization 'Cinémathèque de Belgique' was thus founded in Brussels on April 9, 1938.

In spite of the enthusiasm of its founders and the team they formed (including Dimitri Balachoff, Paul Davay and René Jauniaux), the Cinémathèque had difficult beginnings. Until 1944, its collection consisted of only three films (the other prints were borrowed from various sources) and it grew very slowly, amidst general indifference if not outright contempt from the political sphere: the Cinémathèque had to wait until 1951 to finally receive its first public subsidy. Until the end of the 1960s, its main activity was the screenings of art films at the Palais des Beaux Arts, under the rubric of 'The Arts Seminar Screen'/'Ecran du Séminaire des Arts' (which succeeded 'The Screen Club') and very often used prints graciously loaned by Langlois.

The true development of the Cinémathèque coincided with the arrival of an uncommon figure, Jacques Ledoux, who took its helm. Born in 1921 in Warsaw to a Jewish family, he immigrated to Belgium at a young age. There, he discovered the cinema and the tiny world of cinéphiles (including 'The Screen Club'). During World War II, he was arrested along with his parents, but managed to escape from a train headed to the death camps. He found refuge at the Abbey of Maredsous, where he remained hidden during the entire Nazi occupation. This is where he changed his name to Jacques Ledoux (his real name was never disclosed). In 1945, when still an engineering student, he volunteered his services to the Cinémathèque. Legend has it that he came to the

initial meeting with prints of *Nanook of the North* (Robert Flaherty, 1922) under his arm. Little by little, Ledoux became the key figure of this institution. Officially 'secretary to cultural affairs,' in 1958, he succeeded André Thirifays as lead curator, a position he held until his death in 1988.

The name Jacques Ledoux remains inseparable from that of the Cinémathèque, and in some respects, one can say that he incarnated it. He was a passionate man, with a passion for cinema above all, but it is also worth noting his related passion for memory, which he felt must be not only preserved at all costs, but also restored and transmitted. His tragic experience during World War II is no doubt related to this commitment. According to Ledoux's relatives, it was as though he literally embarked upon salvaging all of the films he could – irrespective of their nationality or their aesthetic value – as well as ensuring that their preservation be conducted properly and that they be screened to the largest audience possible. This was the source of his enthusiasm, ardour, curiosity, energy, and creativity, as well as his stubbornness, workaholism, and secretive or even paranoid side.

At the Liberation, the Cinémathèque enjoyed some unexpected opportunities, such as the confiscation of the property of Universum Film AG (UFA) – that is to say, the Cinémathèque received all the films seized by the Nazis during the Occupation, as well as those distributed by their propaganda services. But the decisive move, in the 1950s, was convincing distributors that it was in their own best interest to leave one copy of each of their films with the Cinémathèque (until then, distributors lived in fear that their films would be copied and distributed illegally, and preferred to destroy the prints of a film once it was no longer of use). Thanks to this free and deliberate deposit, the film collection of the Cinémathèque grew in a formidable manner through the years, finally becoming one of the world's richest.

However, all-out accumulation is not all. In Ledoux's vision, the quality of archiving was essential to the system. In this sense, he differed from Langlois, who gave full priority to viewing the treasures that he had accumulated, even at the cost of screening original prints and taking the risk of them deteriorating with each new showing. Ledoux was closer to another pioneer of film archives, Ernest Lindgren, in charge of the British Film Institute from 1935 to 1973, who preferred to invest in stocking rather than screening films, keeping future generations in mind, even if this meant forbidding screening original prints.

From very early on, Jacques Ledoux offered the Cinémathèque the technical means to preserve films in ideal conditions of temperature and humidity. Likewise, he saw that a department was created within the Cinémathèque to restore damaged prints. Finally, by making duplicate negatives and/or positives of the prints, he did not neglect preservation, either. He thus put in motion a practice of complete film conservation, based on reference material documenting the process and state-of-the-art lab equipment, coordinated by specialized technicians.

Another essential preoccupation of Ledoux was the diffusion of the collection (an activity that does not necessarily figure among the priorities of other film archives). Already, as head of 'The Arts Seminar Screen'/'L'Ecran du Séminaire des Arts', Ledoux had made an impression with his programming of classic and contemporary films as well as his ability to give to projections a ritual or chronological dimension. On occasions, prominent painters of the time (Paul Delvaux, René Magritte, Edgard Tytgat, Serge Creuz) collaborated by illustrating the programme leaflets and posters. The Cinémathèque was also a place where silent films were accompanied by the piano, in keeping with the old and glorious practice from pre-sound cinema. Among the anonymous piano players was a young man who would come to redefine Belgian cinema: André Delvaux. In order to create a location that was permanently accessible to the largest possible number of people, Ledoux founded, in 1962, the Museum of Cinema/Musée du Cinéma. At first, it featured one screening room with about a hundred

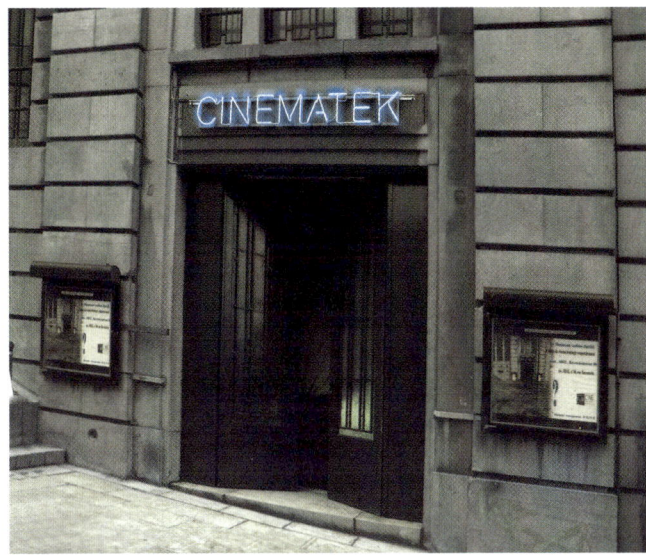

Main entrance to the Royal Belgian Film Archive, Brussels. Private collection.

seats; it was completed five years later with an exhibition space dedicated to the pre-history of cinema and, in 1982 opened a second, smaller screening room, dedicated exclusively to silent films. This museum became the showpiece of the Cinémathèque's collection.

The operation of the Museum follows a very precise pattern: for a negligible price, five films are offered each day (three sound films, two silent ones), year-round. Access to the Museum, the originality of the programming, and the quality of the projection had a significant influence on the development of Belgian cinema. It allowed students from film schools as well as researchers to discover authoritative films as well as documents and press articles about them. French cinema also benefited from this fount of information: in the 1960s, Brussels had become a destination of choice for young new wave film-makers looking for cinematic points of reference. Tired of Langlois' mercurial choices, they were touched by Ledoux's open-mindedness and by the personalized greetings he reserved for them.

This interest in cultivating new talent and expanding the Cinémathèque's horizons also took other forms. Ledoux had had the opportunity to organize four International Competitions of Experimental Film/Compétitions internationales du Film Expérimental, better known under the acronym EXPERMNTL, first held in Brussels in 1958 (during the World Expo), and then in Knokke (1963, 1967, 1974). In these competitions, the early films of Agnès Varda, Kenneth Anger, and Martin Scorsese were awarded prizes. The success of this experience compelled Ledoux to prolong, as of 1973, the competition, turning it into an annual event at the Film Museum. Called L'Âge d'Or, it aims at rewarding 'a film which, by its questioning of established values, reminds us of the poetic and revolutionary film of the same name by Luis Buñuel'. In conjunction, in 1977, Ledoux created, again at the Cinémathèque, another competition, Film Discoveries/Ciné-découvertes, with the goal of encouraging the diffusion of novel films of quality.

Finally, it must be noted that Ledoux – and by extension, the Cinémathèque – was distinguished at the global level by the influence he had in the International Federation of Film Archives (FIAF), of which he was the General Secretary from 1961-1978. He

became, according to Raymond Borde, its 'conscience, because he had a policy and because the means of achieving it would be a strict insistence on coherent objectivity.'

Today, more than twenty years after the death of Jacques Ledoux, the Royal Belgian Film Archive has had to adapt to new conditions while remaining true to its original mission and goals.

In the figurative storm of Belgian administration and politics, the Cinémathèque has acquired a unique status, that of a 'foundation of public utility'. A bicultural institute, it is subsidized (but for how much longer?) by the Federal Ministry of Scientific Policy and is addressed to both linguistic communities. A new name was given to it in 2009, in order to satisfy both the Flemish and the francophones: 'Cinematek'.

Gabrielle Claes succeeded Jacques Ledoux in 1988, and, in October 2011, retired. The position of head curator was given to Wouter Hessels, who acted as interim director and resigned shortly thereafter (on 1 December 2011) in favour of Nicola Mazzanti, who began his new position on 15 December 2011.

Between 2006 and 2009, the old Film Museum and its screening rooms were entirely rebuilt and renovated, returning to the model desired by Victor Horta, who devised the plans of the Jugendstil Palais des Beaux Arts which houses the Museum. The number of weekly screenings has slightly increased to 40 films (which are complemented by regular screenings of prints from the collection at the Flagey theatre), although fewer silent films are being shown. In remaining faithful to the original work, film stock is systematically preferred over digital transfer, but the prints shown are always the most damaged, keeping the best prints safe from scratches and other deterioration that might inevitably occur during screenings.

In 2011, the Cinémathèque's collection amounted to 143,318 copies of films, for a total of 62,213 titles – fiction films, documentaries, feature and short films – illustrating cinema from its inception to the present day, including extremely rare prints of old films. The collection increases by 2,000 prints per year on average. The most urgent challenge currently faced by the Cinémathèque is digitizing its entire collection. This operation is part of the evolution of preservation processes. In the 1950s, nitrate film stock was abandoned in favour of acetate film stock, which was much less flammable. Some decades later, film preservationists and curators came to the realization that acetate suffered from 'vinegar syndrome', a process of decay accompanied by a strong smell of vinegar – hence the name. The only solution to save a film, therefore, was to make a new print. There emerged, then, the apparently miraculous process of digitizing. However, the longevity of films preserved through this means still remains unknown and it is extremely expensive.

Since its creation, the Cinémathèque has never been pampered by public authorities. Its budgets were always slim, even parsimonious, and it owes its survival mostly to the resilience, resourcefulness and sense of management of its staff and administrators as well as the trust that was put into it by the local film industry. Today, when its financial needs are ceaselessly growing – in great part due to digitization costs – its budget tends to stall and dwindle. Will the Cinémathèque succeed in overcoming this difficult hurdle? Will its new team display the ability to adapt and invent as did its founders and pioneers? Only time will tell.

Serge Goriely

Translated by Marcelline Block and Jeremi Szaniawski

CARTE BLANCHE TO GABRIELLE CLAES: THE ROYAL BELGIAN FILM ARCHIVE

I spent 40 years at the Royal Film Archive. During those years, I performed numerous functions in the fields of documentation, publication, programming, diffusion and, finally, as Lead Curator. Of these 40 years, nearly twenty were spent under the direction of Jacques Ledoux, and twenty in his stead.

Let us begin with the beginning, with Jacques Ledoux. While he was not the founder of the Cinémathèque[1], he joined it very early on, at a young age, and indisputably became its historical lead curator for nearly 30 years. Ledoux truly created the Cinémathèque: in the manner of an architect, he devised its plans, erected it, maintained it throughout the years, considering its needs and its expansion. Like certain architects constructing their own homes, he invested in it as if it were to be 'inhabited'. Is this a metaphor? Barely. Ledoux was ubiquitous at the Cinémathèque. Everything there bore his stamp: the policy of the institution, the choice and evaluation of collaborators, and its strategic and operational decisions. Programming options, the acquisition of books, the assessment of technical equipment, administrative and budgetary appraisal, (harsh) supervision of human resources, aesthetic options:[2] nothing, absolutely *nothing* was left untouched by his mark. Was he a tyrannical pioneer? Let us rather call him an enlightened despot.

Under Ledoux, the Belgian Cinémathèque was clearly oriented toward its international component. Locally, Ledoux was accused of disdaining Belgian cinema, which is a false charge, as attested to by the Cinémathèque's huge collection of national fiction films and documentaries. That he might have neglected Belgium in favour of the potential international influence of the institution and worked as an active agent of the FIAF[3] is, however, unquestionable. His active role within the institution – for seventeen years, he was the Federation's general secretary – was very promptly forgotten.

Twenty-five years after his death, do *we* still remember Jacques Ledoux? To some old film archive curators[4], some film-makers who, when young, he encouraged and helped become famous[5], and to historians and theoreticians of the cinema whose research he facilitated[6], he left an indelible memory. But in the pantheon of film archives, what is Ledoux's place?

To succeed Ledoux-as-builder was the challenge that was proposed to me in 1989, one year after his death. I knew the Cinémathèque, having worked there for seventeen years, but without – far from it – having discovered all its mechanisms or fully comprehending its innermost functioning. Ultimately, it was Ledoux alone who guaranteed the indispensable transmission between the different pieces of the system: the collection of films was at its centre, fed by the deliberate deposits coming in mainly from the local industry: Belgian productions, of course, but mostly the very active network of film distributors, thanks to whom the international cinematic traditions are

largely represented in the Cinémathèque's collection. Preservation was guaranteed in climate-controlled storage rooms, according to norms adapted to the various stored materials (nitrate, acetate, colour). In a small restoration lab, transfers from flammable film stock onto new, safe materials were regularly conducted.

The film collection in turn nurtured an abundant and diverse programme: created in 1962 by Ledoux, the Musée du Cinéma featured, at his death, two screening rooms, showing five films each day, the smaller screening room reserved solely for silent films. This constituted the 'permanent exhibition' of the collections, accessible year-round. An inextinguishable well of knowledge, the library's rich collection (also open to researchers and students) served as a constant reference to the work of cataloguing on the one hand, and for the purposes of programming, on the other.

Last but not least, borne out of the elements of the 'Ledoux system', a unit of distribution was put into place at the end of the 1970s, whose catalogue proposed international films that had been neglected by local distributors. Thanks to the acquisition of the rights ad hoc as well as new copies, cinema classics – first arthouse, and then later commercial – were made accessible to other users.

Preservation, restoration, programming, and dissemination: such were the missions ensured by the Cinémathèque's small team, which, in 1989, had fewer than 30 members.

To understand the mechanism's gears, to guarantee its proper functioning and, when needed, to improve it, were my prime objectives, which I was only able to achieve thanks to the support and confidence placed in me by the principal people in charge of the department.[7] It was a mystery what films (and how many copies) we had, since the lists and inventories were held under lock and key, accessible only to the people in charge of the collection: the gradual technologizing of the latter, through the 1990s, favoured (or perhaps should I say forced) its opening. The doors to these venues, storage facilities, and labs hitherto inaccessible to anyone but the competent personnel were suddenly left ajar: when I walked through these doors for the first time (after twenty years!), freshly appointed as lead curator, I had the feeling of transgressing a forbidden, hallowed space.

As a result of the resolutely-internationalist policy of Ledoux, the Cinémathèque enjoyed a flattering reputation abroad (something I was to discover during my first FIAF congress in 1990) but remained almost unknown at home. During our first meeting, the appropriate Minister at the time[8] made this singular and salutary declaration: 'Madam, if I decided to close down the national Opera, my colleagues at the Government would be indignant; if I shut down the Cinémathèque, no one would care. And yet I am convinced that my colleagues the Ministers prefer, and by far, cinema to the opera.' Besides the few thousand cinephiles who rush to the Cinémathèque's gates (which boasted, it is true, a record attendance level of 90 per cent, that is to say, about 100,000 viewers per year), very few people in Belgium knew about the Cinémathèque. And its international reputation left those with political power hopelessly indifferent. While we were, in terms of legal status, 'independent'[9], we were still financially dependent upon government subsidies. The efforts at opening up and communicating aimed essentially to make known and to acknowledge the institution, to secure and maintain as solid a position as possible, and to lend it a place among Belgium's 'cultural jewels'. It is paradoxically thanks to one of those recurring financial crises that have plagued the history of the Cinémathèque that we were given the opportunity, in 2001, to measure the progress of its notoriety: Belgian film-makers, national press, local cinephiles, film students, international colleagues and, last but not least, leading figures in the world of film such as Martin Scorsese[10] and Catherine Deneuve[11] supported us in our opposition to the political decision that had intervened a few months earlier, which aimed to leave it solely up to the National Lottery to finance us.

This was a victorious but hardly glorious battle, upon reflection; a long way from the noble objectives that the Cinémathèque had set for itself, but revealing the overwhelming importance of the financial stakes at the heart of cultural institutions. Still today, the

Cinémathèque remains vulnerable in a complex and divided country that reserves only an infinitesimal part of its budget for culture, thereby expressing the 'passionate' interest that the government and the governors harbour for it.

The process thus involved opening onto the world, and computing the data. Formulated at the onset of the 1990s, these two main goals apparently served discrete strategies, but rapidly turned out to be intrinsically connected. Conceived at first as a tool of knowledge with internal use, digitizing the catalogues of the collections very quickly entailed a new dynamic through the increased interaction of departments and services (films and associated documents, preservation and restoration, collections and programming…). Most of all, this allowed for a new perspective on these collections and the revelation of its riches and treasures. Without hierarchized descriptions, the socio-historical significance of this corpus of non-fiction films, for instance, had remained hitherto unexplored. The desire to show more, and to show differently (today we would use the term 'to valorize') was borne out of this rediscovery which digitizing made possible.

The DVDs that the Cinémathèque began to issue, starting in 2002, were the first manifest results of this enterprise.[12] Conceived like a chronicle of cinema in Belgium, this series features around thirty titles so far, and addresses a double need: to make Belgian cinema classics more widely known, and to valorize the collections of the Cinémathèque. On the one hand, we find fiction films (by Henri Storck, Roland Verhavert, André Delvaux, Harry Kümel, among others) but also nonfiction, in a series of thematic DVDs: Sabena (Belgium's long-time airline), the 1958 World Expo, the Belgian Congo, and along with these, so many other major chapters in the history of Belgium as illustrated by filmed documents are found in our collections.

'To expose the cinema' thus became the guiding principle of the enterprise that mobilized the bulk of the Cinémathèque's strengths between 2005 and 2009: to transform the Museum into CINEMATEK. To keep the soul but to change everything else: the architecture, the exhibition of pre-cinematic technologies, the screening rooms, the projection cabins – in sum, everything, even the name of the leaflet (now a full-blown, bimonthly magazine) commenting on the programme. This set of radical changes – indeed, an unprecedented upheaval for the institution – shook some things up, while seducing a brand-new audience. Digital cinema made its appearance at CINEMATEK: a 2K projector is now used alongside the traditional 35- and 16mm projectors, as well as for the 'Moviola' and 'Remix' screens.[13] The collection of films is thus made accessible in a variety of ways: on the screens and on an even more intense schedule of 40 different weekly screenings. The Moviolas are dedicated almost entirely to Belgian non-fiction film, and can be browsed at will.

The collection, in the meantime, is no longer limited to film.[14] Cinematic production in Belgium, as elsewhere, now has recourse to digital technologies, but this also applies to exhibition side of things as Belgium is one of the first countries in Europe in which the majority of screening venues are digitally equipped. Now obsolete, the 35mm print is quickly making way for the DCP.

Today, the digital has invaded all sectors of the Cinémathèque: the library's inventories[15] are now available online, and a chunk of its huge collection of press clippings and of its iconographic collections is also digitized. In the domain of film, as we saw, knowledge of the collections and access to some of the prints have been greatly facilitated through this new technology. In order to do so, we had to acquire the necessary equipment and the expertise to use it: this is a new job that the Cinémathèque had to learn, without forgetting the old one. Because the preservation and the digitizing of some hundred years of cinema shot on film stock remains a necessity, it is quite a challenge, especially as budgets are skimpier than ever.[16]

This challenge has a backdrop of concern: a fear that history might repeat itself. Because cinema is not *simply*, but first and foremost, an industry. Is an industry that hardly

cared, during its first 100 years, about preserving film, likely to do so any more with its current digital products? In order to insure their mission of long-term preservation, the film archives learned to tame a material – film stock – hardly conceived for such purposes. We already know that the new technologies offer hardly any more guarantees in this respect. The fundamental question remains, much as it did 100 years ago: will an industry, hardly preoccupied by the question of preservation, place its trust – in order to ensure this task is completed – to institutions and film archives, of which cinema, and therefore the film industry, has always been the *raison d'être*? Time is running out.

Gabrielle Claes,
Lead Curator of the Royal Belgian Film Archive, 1989-2011

Translated by Jeremi Szaniawski

Notes
1. The Belgian Cinémathèque was founded in 1938 by Henri Storck (film director), Pierre Vermeylen (future politician) and André Thirifays (film critic). Jacques Ledoux joined the team right after WWII, and became the lead curator in 1960.
2. Corneille Hannoset was, for forty years – and in close collaboration with Jacques Ledoux – the interior architect and exclusive graphic designer of the Cinémathèque. The original Musée du cinéma was built by architect Constantin Brodzki, in collaboration with Hannoset, in 1962.
3. The International Federation of Film Archives (FIAF), founded in 1938 – only a few years after the appearance, in 1933, of the first film archives – has approximately 150 members today.
4. One can cite, among other names, those of Vladimir Opela (Narodni Filmovy Archiv, Prague), David Francis (BFI, London, and then the Library of Congress, Washington D.C.), Eric de Kuyper (Nederlands Filmmuseum, Amsterdam), or, still active to this day, Vladimir Dmitriev (Gosfilmfond, Moscow).
5. The organization, between 1949 and 1974, of five international film competitions of experimental cinema in the Belgian seaside resort of Knokke, earned Jacques Ledoux a long-standing international reputation in the cinematic avant-garde environment: Martin Scorsese, Roman Polanski, Agnès Varda, Michael Snow, Steven Dwoskin, Peter Kubelka saw their first films awarded there.
6. I would mention first and foremost David Bordwell, who is 'Jacques Ledoux Professor of Film Studies' at the University of Wisconsin-Madison. But let me also point out that François Truffaut had used the resources of the Cinémathèque in preparing his book of interviews with Alfred Hitchcock (1968).
7. Marianne Winderickx and Noël Desmet (in charge of the film collection and head of the laboratory, respectively) are intrinsically linked to the history of the Cinémathèque. After a career of more than 40 years there, both retired in 2010. Noël Desmet has earned an international reputation in the area of silent film restoration, especially tinted and toned prints, through his Desmetcolor process.
8. Louis Tobback, then a Minister of the Interior (Socialist Party), and in charge, within the Federal Belgian Government, of national cultural and scientific institutions, was fabled for being frank and outspoken. He still is.
9. The Royal Film Archive is a Foundation of Public Utility, managed by an administrative board. Its financing is currently in the hands of the Federal Belgian Government.
10. Crowned at Knokke (cf. point 5) in 1967 for his short film 'The Big Shave', Scorsese remained grateful to Ledoux. His commitment to the restoration and preservation of films need not be restated.

11. Catherine Deneuve was a UNESCO Goodwill Ambassador for the Safeguarding of Film Heritage. Sensitive to the difficulties of the Belgian Cinémathèque, she voiced her concern to Prime Minister Guy Verhofstadt. Her intervention caused a real sensation within the Government.
12. At the initiative of this enterprise, we find a memorable figure of Belgian cinematic life, Michel Apers. He had joined the ranks of the Cinémathèque in 1991, after an already long career as a film critic, film exhibitor and distributor. He worked closely on the edition of each of these DVDs until his death in 2004.
13. The Moviolas of the CINEMATEK are screens that visitors can access freely, offering several hundred films, mostly from the collection of non-fiction films, accessible through an interactive menu subdivided in various categories. As for the Remix, its 8 screens suspended from the ceilings of the museum offer, in a loop, countless fragments of films from the Cinémathèque's collection, orchestrated in the manner of an art installation.
14. After the BFI, the library of the Cinémathèque is the most important in Europe: in 2011, it featured over 50,000 books, 4,000 magazine titles, 1.5 million newspaper clippings, 1 million pictures and hundreds of thousands of film posters.
15. In order to finance its activities, the Cinémathèque had at its disposal, in 2011, a federal government subsidy of 3.3 million euros. Among its main expenses: managing a collection of over 140, 000 prints (and over 65,000 different titles), a restoration lab, a library (cf. note 14), three screening rooms, and a distribution unit. The personnel comprises fifty-five people in charge of the various activities.
16. The film stock support (exclusively nitrate until the 1950s, then acetate) decays in a manner inversely proportional to the quality of their preservation/stocking. As for the colour emulsion, it gradually fades until the total disappearance of its basic components. Let's recall that Martin Scorsese had questioned Kodak in the 1980s, denouncing the instability of their film prints. 'As of now, Eastmancolor will keep for 400 years,' was Kodak's reply. Since the company filed for bankruptcy last year, let us bet it won't be able to verify this claim.

DIRECTORS: THE PIONEERS

ALFRED MACHIN

Alfred Machin (1877-1929) was one of the major directors during the first two decades of European cinema. A pioneer at heart, he established himself, from his first collaborations with the Pathé studio onward, as the film-maker for new situations and technical innovations: he was the first 'image hunter' ('*chasseur d'images*') to travel to central Africa, from which he brought back the first sketches of what is now called ethnographic cinema, as well as a prototype of the telephoto lens. He also captured the first aerial visual shots for the French military, and was one of the first wartime camera operators. He was the first French director to integrate wild animals into his films and to create cinematic 'animal fiction'. Following commissions by Charles Pathé, he directed, under the banners of Hollandsche Film and Belge-Cinéma, the first fiction films of Dutch and Belgian cinema, of which he consequently became the founding figure. On the eve of World War I, he directed, in Belgium, the first major pacifist film, which prefigures aerial combat, a technology that would change warfare in the course of the twentieth century.

Eugène Alfred Jean-Baptiste Machin was born on 20 April 1877 in Westove, France. The fifth child of Maria Célina Sergeant and Jules Machin, a paper manufacturer, he rounded out a group of siblings that already comprised Julia, Fidéline, Eugénie and Auguste. Machin was only eight years old when his mother passed away, and he lost his father at the age of seventeen. The following year, he enrolled in the French army and served in Algeria from 1896 to 1900 in the second regiment of Spahis; the discovery of Africa by this young man from northern France left an indelible imprint on his future film-making career.

Early experience of photo retouching with a renowned photographer, Reutlinger, allowed Machin to start at Alexandre Paulin's weekly magazine *L'illustration* in 1902, at a pivotal time when the publication was opening up to the medium of photography. It was there that Machin honed his craft as a photo-journalist, bringing pictures of the Parisian daily news to the magazine's readership.

In 1906, the discovery of images brought from Africa by Schillinger and the vision of the first films shot in the colonies offered new horizons to Machin's career. These touristic postcards, whose *mise-en-scène* was meant to satisfy the audience's thirst for exoticism and to flatter the colonial spirit, disappointed Machin, as he yearned instead to give a truly authentic vision of Africa. His novel conception of reporting compelled Charles Pathé to seize a new opportunity to jump ahead of his competitors, by financing Machin's project.

In December 1907, Machin and Adam David, the explorer from Basel, left from Marseilles for Egypt, arriving in Karthum (Sudan) before going up the White Nile to Fachoda and subsequently re-orienting their itinerary toward the Valley of the Dinder. It was during this expedition that Machin conceived of the first telephoto-lens. Upon returning to Vincennes in August 1908, however, the final assessment of the expedition turned out to be catastrophic: the African climate had destroyed most of the film stock, leaving barely enough material to produce three short newsreels: *Hunting Hippopotamus on the Blue Nile/Chasse à l'hippopotame sur le Nil bleu*; *Crocodile Hunt/Chasse au crocodile*, and *Panther Hunt/Chasse à la panthère* (all 1908). The impact of these three films allowed Pathé to finance Machin's second African expedition (1909-1910), this time hiring a 19-year-old cameraman, Julien Doux. These two men would be the

Alfred Machin and his leopard, Mimir. Collection Cinematek.

first photo-journalists to bring back moving images from Central Africa. This expedition offered the material for three documentary series: *Voyage en Afrique* (ten reels), *Les grandes chasses en Afrique* (seven reels), *Voyage en Egypte* (four reels), all from 1910, as well as an 80-minute feature film, *Voyages et grandes chasses en Afrique* (1914), an audacious experiment for that time, which was met with acclaim in France as well as in the US, where it was released under the title *Sport and Travel in Central Africa* that same year.

Alfred Machin's African expeditions mark an important moment in the evolution of documentary film. Besides the unprecedented risks taken by the director, they reject the lure of exoticism or 'orientalism' in favour of authenticity, emotion, and didactic intentions, sketching out what would become ethnographic film. Machin also brought back one of the first stars of French cinema from his African journeys: Mimir the leopard (known as Saïda on the screen), who helped reinvigorate the spirit of his short comedies shot for Pathé and who became the unmistakable signature of Machin's films for many years.

Between the two expeditions, Machin shot five documentaries in the Netherlands and directed his first fiction film near Ghent, *The Mill/Le moulin maudit* (1909), which also happens to be the first fiction film in Belgian cinema. This melodrama exploits the first occurrence of a recurring theme at the heart of the director's fiction films, namely, the metaphorical and tragic correlation between the windmill and the unleashing of human passions. Refined lighting and compositions contrast with, but also underline, the rising power of a narrative marked by the suicide of a betrayed husband following a scene in which he attaches his unfaithful wife's lover to the blades of the mill, before her eyes.

In November 1910, Pathé and Machin collaborated on a commission from the French air force: in doing so, they offered cinema its first sixty metres of aerial views captured

Directors 39

on film. Pathé, which owned two subsidiary companies in Nice, Nizza and Comica, in charge of producing comedies, put Machin in charge of improving their quality. Machin convinced Pathé that Mimir could play a decisive role in the short films produced by these rejuvenated studios. During the winter of 1910-1911, Machin notably directed figures such as Maurice Schwartz in two reels of the 'Little Moritz' series, and Louis Boucot for five reels of the 'Babylas' series. The presence of Mimir revolutionized the worn-out chase formula, renovating it by adding a terrified crowd running away from the wild cat. The director's pet leopard also added a new thrill to the melodramas Machin directed for the parent company, *Dévouement d'un gosse* (1911) and *La fleur sanglante* (1912), and even to more prestigious films, shot for the 'Série d'Art Pathé Frères', such as *La grotte des supplices* (1912), which marked Machin's consecration as a legitimate film director. It is on the shoot of this latter film that he met the actress Germaine Lecuyer. The two married in 1914 and had three children together: Alfred (Charles Pathé's godson), Ginette, and Claude.

Machin's mission in Nice was short-lived: Pathé soon offered him the opportunity to shine in the virgin territories conceded to the Belge-Cinéma-Film, a subsidiary that Pathé had implanted in Brussels in 1908. Machin thus became responsible for cinematic production in the Netherlands (1911-1912) and Belgium (1912-1914). Returning to Volendam (in the Netherlands), the location of his first shoots, Machin made over a dozen films during thirteen or fourteen weeks there. These films, mainly melodramas, exploit backgrounds and natural exteriors all the while associating the dynamics of drama with the irascibility of the elements. *L'or qui brûle* (1912) was chosen by Pathé to inaugurate the Hollandsche Film series and was greeted with enthusiasm by the critics, particularly struck by the performance of Louis Bouwmeester (and that of his body-double, camera operator Paul Sablon), turned into a human torch on a boat.

Belge-Cinéma-Film set up camp in Brussels in 1912, at the Karreveld, where Machin was in charge of *mise-en-scène* and production, making no less than 21 films and thereby consecrating the birth of Belgian cinema: he showed respect for Belgium's national identity by the choice of his themes, the exploitation of landscapes, and the use of local artists (such as Deverre, Balthus, and Fernand Crommelynck) as well as dancers borrowed from various theatres in Brussels and the ballet of the National Opera House, La Monnaie. Machin also collaborated with two technicians from Paris, Raoul Morand (set designer) and Jacques Bizeuil (cameraman), to whom he added the services of two Belgians: Auguste Meuter (newsreel operator) and André Jacqumin (production assistant and set manager). A consummate and passionate animal trainer, Machin also installed a menagerie on the grounds of the Karreveld. There he directed, over the course of two years, three comedies, four short comic reels, seven dramas, four newsreels or documentaries and two episodes of the Napoleonic legend. It is however with three melodramas from this production company that he reached the fullest and most mature expression of his talent.

In *Black Diamond/Le diamant noir* (1913), the director enriched his love for travelling, animals, Africa, and the theme of abusive accusation around which his narrative develops. *La fille de Delft* (1914), initially entitled *La tulipe d'or*, attests to a perfect mastery of alternating between long shots of landscapes and tableau-shots that function as narrative sequences. Machin also exploits the resources of the background with expert skill, in order to suggest the off-screen space and manage the simultaneity of actions through a *mise-en-scène* in depth of field. He injects a spectacular impact in the love story of a young shepherdess, a dancer struck with blindness following an accident aboard a balloon: a pretext for combining aerial shots with footage shot in the studio, and to experiment with superimposed footage.

War Be Damned/Maudite soit la guerre (1914) can be considered Machin's masterpiece. This pacifist and premonitory melodrama develops a double narrative line between the armed conflict of two fictitious nations and the tragic story of a young woman's love for an enemy officer who, she later finds out, has killed her brother – his

friend – in combat. The film was released on 29 May 1914, two months before the general mobilization of France against Germany. Pathé, who had sensed the American public's interest in spectacular combat scenes, had also organized the release of the film in New York in early May under the title *War is Hell* (Eclectic Film). Following France's entry into war, he felt that the pacifist message carried by the film's title could hurt its commercial career: *Maudite soit la guerre* was withdrawn from the screens and re-appeared under the new title *To Die for One's Country/Mourir pour la patrie*.

For this film, Machin benefited from significant capital, including the collaboration of the Belgian military that provided him with infantry, weapons, automobiles and airplanes. The film made a strong impression on both sides of the Atlantic, not only with its footage of aerial fights and destruction of airships, but also by the signifying contrast of colours, opposing love and fight scenes. The use of split-screen heightened the spectators' attention in the management of various locations and times, and narrative lines were also conjured by evocations and scenes of reminiscences.

Machin's final production in Belgium, *Suprême sacrifice* (1914), seemed a minor achievement by comparison, and was only released in Paris in 1919, as the war prevented the director from completing his film on schedule. Starting in 1915, he received commissions from Pathé within the Section cinématographique des armées, the future Service photographique et cinématographique des armées (1917), on which he collaborated with three camera operators dispatched by Eclipse, Gaumont, and Eclair-Journal.

Machin's output during the war years is estimated to be around a hundred short films, each between four and fifteen minutes, shot from March 1915 to October 1917. When the subject lent itself to it, the director went beyond the simple capture of wartime footage to integrate pans, cutaway shots, and allegories.

In 1919, Pathé initiated the dismantling of its empire and offered Machin the chance to buy the equipment from its Nice studio. Machin seized the opportunity and completed his acquisition through purchasing the plot of land and buildings that Pathé was renting out to Nizza and Comica. Machin then founded his own production company, Films Alfred Machin, which he enriched with a menagerie, and associated himself with Henri Wulschleger, with whom he co-directed eight of eleven films produced by his company between 1920 and 1924, including the famous *Stupid... as men/Bêtes... comme les hommes* (which also translates to *Like animals... like men*), 1922. This film marks a zenith in the animal film genre, which defined the style of the studio located on the route de Turin. This was Machin's only film of the time to rival the new cinematic industry as well as the success of American comedies. Machin also enjoyed directing children alongside animals, such as the touching duo of his son Claude and Auguste the monkey in *L'énigme du mont Agel* (1924). The death of Auguste, the star of the Nice productions, dealt a blow to the creativity of his master. From that moment on, Machin's productivity declined, amounting to only four short- or medium-length films between 1925 and 1929. Ever pragmatic, Machin had compensated for financial difficulties by multiplying his sources of income, innovating in new commercial practices consisting of renting out his studio and his services to many film-makers who arrived to shoot on the Riviera (André Andréani, Léonce Perret, Germaine Dulac).

Following *Le cœur des gueux* (1925), *De la jungle à l'écran* (1928) and *Robinson Junior* (1929), Machin dreamt of a new expedition to Africa, with sound footage that would enable one to hear 'the wild beasts roar'. He found a sponsor in François Coty, the renowned perfume-maker, but he sadly never realized his project: Alfred Machin died suddenly at his worktable, on 16 June 1929.

Anne Gailly

Translated by Jeremi Szaniawski

HENRI STORCK

Henri Storck (1907–1999) is widely considered one of the indisputable founding figures of Belgian cinema. Already in the 1940s, film historians like Georges Sadoul, in his *Histoire du Cinéma Mondial* (1949: 450), mentioned Storck, along with Charles Dekeukeleire (1905-1971), as a leader of the strong Belgian documentary film tradition. Storck, who grew up in a petit-bourgeois milieu of shoemakers in the Flemish coastal city of Ostend, started his film career at the end of the 1920s. After watching Robert Flaherty's *Moana* (1926) at the Brussels Club du Cinéma in February 1927, Storck decided to run his own film club, specializing in international avant-garde movies, with the aim of 'making contact with cinema in its purest form.' Storck, who had been an amateur film-maker for some years, also started to make experimental movies of his own, starting in 1929 with *Images d'Ostende*, a 10-minute poetic evocation of his hometown. During that period, Storck also read André Breton's *Manifeste du Surréalisme*, joined the Brussels Surrealist Group where he met René Magritte, and became very active on the Left. In the following years, Storck became part of the international network of avant-garde cinema with Paris as its headquarters, where he met Léon Moussinac and Boris Kaufman. During the second international congress of independent cinema in Brussels (27 November–2 December 1930), he met many more film-makers, including Germaine Dulac, who invited him to work in Paris; there, he met Jean Vigo. Later, Storck worked with Jean Grémillon and was Vigo's assistant on *Zéro de Conduite* (1933), in which he also had an uncredited role as a priest.

Building on this experience, and after having made more short experimental pictures such as *Une Idylle à la Plage* (1931), a 23-minute 'erotic fantasy' (according to Ado Kyrou), Storck tried to develop a more professional career, which from the 1930s onwards consisted mainly of combining artistic film projects with the production of newsreels and (often shorter) documentaries commissioned by all kinds of public and private organizations. These included films he made for his hometown or other local administrations (*Vacances*, 1938), material for the Belgian department of Foreign Trade (*Coton*, 1935), or for the Belgian socialist party (*Le Patron est Mort*, 1938). Working in a country without a significant film industry, Storck realized he had to develop a wide scope of expertise apart from film-making, ranging from financing, producing and distributing to running his own production firm (Cinéma-Edition-Production, or CEP, founded in 1934), thereby acknowledging his dependence on his clients' demands. Throughout his life, Storck spent a considerable amount of energy lobbying and attempting to convince political, financial, and other powerful circles to invest into his work and, more generally, to support the fragile domestic film industry.

At the end of his career, Storck, who had made a few attempts to produce feature films (including the quite unsuccessful *The Smugglers' Banquet/Le Banquet des Fraudeurs*, 1952), left an impressive amount of some 70 non-fiction films on different kinds of topics, ranging from footage of political events to longer documentaries and art films. Storck's international reputation, though, was very much based on his one-time collaboration with Joris Ivens (1898-1989) on the openly communist *Misère au Borinage* (1933). Dealing with a long miners' strike and the poignant poverty among workers families in the Borinage region of Belgium in 1932, *Misère au Borinage* soon became a landmark in international documentary and political cinema. Nevertheless, one might question to what degree the film bears both men's signatures, and to this end, whether it is more the result of Ivens' critical stance than Storck's. Although he later made a

few other openly-leftist pictures like *Les Maisons de la Misère* (1937) and *Le Patron est mort* (1938, on the death of the socialist leader Emile Vandervelde), Storck was very much considered a figurehead not of a radical cinema but, rather, of a respected and technically well-made socially-engaged film.

After World War II, Storck succeeded in attaining prestige with his work at international film festivals, mostly with art films. These include an interesting series of creative portraits of Belgian writers and artists, such as the surrealist painter Paul Delvaux (*Le Monde de Paul Delvaux*, 1944), *Rubens* (1948) or the expressionist *Permeke* (1985, made with Patrick Conrad). These art films were deeply informed by Storck's own formative influences, which included writers and artists whom he personally met, such as James Ensor, Leon Spilliaert, and Constant Permeke. He also made dozens of ethnographic movies about local folklore, carnivals, and feasts.

Storck also became a figurehead in the reorganization of the Belgian film scene, where he was strongly involved in various professional organizations and where he had managing positions at the Royal Film Archive (which he co-founded in 1938), in film schools or in industry-related unions. By the 1960s Storck's international recognition, as well as his role in the development of the local film culture, had given him a nearly unassailable position in his homeland, resulting in a cascade of public awards and distinctions (e.g. a *honoris causa* doctorate of the Vrije Universiteit Brussel in 1978, and a royal distinction in 1979).

Misère au Borinage. Fonds Henri Storck, Collection Cinematek.

At one of these occasions, in 1995, when the French-language Free University of Brussels (Université Libre de Bruxelles) announced that the film-maker was to receive an honorary *honoris causa* degree, a public controversy broke out about Storck's attitude and activities during the Second World War. Old rumours about the film-maker's rather questionable attitude under German occupation were reinforced when, in 1999, film critic and director Frédéric Sojcher insinuated in his book on the history of Belgian cinema, *La Kermesse héroïque du cinéma belge* (part 1, p. 44), that Storck might not have been an active resistant, and indeed had been quite a clever opportunist during war time. Storck's filmography clearly indicated that he had been one of the few Belgian film-makers who was able to produce a series of movies under German rule, but it remains unclear under what conditions this had happened and to what degree the presumed leftist director had catered to, or even collaborated with, the Nazi regime.

In the French-speaking part of Belgium, especially within leftist cultural and intellectual circles where war collaboration is easily associated with Flemish nationalism, the Storck case came to symbolize the as-yet-unexplored ambiguous attitudes some of the most prestigious writers, artists and intellectuals had shown during German occupation (e.g. Hergé, Georges Simenon, Paul De Man). In 2006, the rumours were repeated by the Belgian French-language public broadcaster RTBF, and, one year later, SOMA/CEGES (the Belgian archive and research centre devoted to contemporary war and society) decided to investigate the Storck case. The result was *Henri Storck, le cinéma belge et l'Occupation* (2010), a book in which Bruno Benvindo closely reconstructs Storck's pre-war activities, thereby not only stressing the film-maker's pioneering role in the field of documentary and avant-garde film production but also underlining how Storck, as a film-maker and producer, tried to survive under difficult economic circumstances. The main part of the book carefully reconstructs Storck's initiatives and strategies in order to make movies during the wartime years, illustrating how the film-maker not only received permission to produce pictures under German control but also how, in 1943, he obtained a managerial position in the central film production unit of occupied Belgium. The book also meticulously described how the film-maker was involved as a lecturer in a film school that was openly considered to be a hotbed of extreme right-wing collaboration with the German regime. Even more painful is Benvindo's description of Storck's later denials and success at minimizing these positions, underlining his main conclusion about Storck's fundamentally opportunist stance during the war.

During World War II, Storck made a series of ethnographic documentaries, grouped under the title *Peasant Symphony/La Symphonie Paysanne/Boerensymfonie* (1942-44), which are often considered amongst the film-maker's finest work. *Peasant Symphony* describes in a visually marvellous manner the harmony of rural life throughout the four seasons. The question of to what degree this technically superb full-length ethnographic documentary indirectly supports the German occupier's view of an idyllic image of rural life remains open to interpretation. For Benvindo, though, it is clear that Storck had made an anti-modernist 'anti-*Borinage*' film, from which social and political involvement were removed altogether, at least on a manifest, discursive level.

Although Benvindo's book was not widely covered by the press, it clearly delivered a serious blow to Storck's image as a leading left-wing independent film-maker and as the founder of Belgian documentary and cinema in general. It remains to be seen to what extent the book will undermine Storck's central position in Belgian film history, where he is also considered to be a precursor of the internationally acclaimed, socially-oriented and realist cinema by film-makers such as the Dardenne brothers.

Daniel Biltereyst

CHARLES DEKEUKELEIRE

Charles Dekeukeleire (1905-1971), born in Ixelles, one of the boroughs ('communes') of Brussels, was a pioneer of experimental film and one of the founding figures of Belgian cinema alongside Alfred Machin (who was French) and Henri Storck, in whose eyes Dekeukeleire was a little-known precursor.[1] His father, the youngest child of a peasant family of thirteen children, had moved his way up the Brussels hierarchy from clerk to procurator. Young Charles grew up in a happy Flemish household but spoke French at school, as was the rule at the time.[2] Flemish by stock and sensibility but French by expression, Dekeukeleire perfectly embodied the notion of Belgian-ness (*belgitude*), making him an artist and intellectual figure with a foot in each culture.

At the age of four, and much like Ingmar Bergman, young Charles received a magic lantern, and his passion for the moving image would define his entire life from there on. Although he started out by working at a bank, Dekeukeleire's yearning for cinema proved stronger. After spending many hours in the film clubs of the Belgian capital in the 1920s, he became a film critic, influenced by the enthusiasm of early film theory written by Riciotto Canudo, Louis Delluc, Jean Epstein, Élie Faure, and Léon Moussinac. His first critical study, published in 1924, dealt with Epstein's *La Belle nivernaise*; the French film-maker and critic's theories of 'impressionism' and camera movements would exert a great influence upon Dekeukeleire's own cinema. He also admired and wrote about Claude Autant-Lara's short *Fait-divers* (1923), Lupu Pick's *La nuit de la St. Sylvestre* (with a script by Carl Mayer, 1924), *Ménilmontant* (Dmitri Kirsanoff, 1926), *Le fantôme du Moulin Rouge* (René Clair, 1925) as well as F.W. Murnau's *The Last Laugh* (1924), especially for its camera movements and Karl Freund's cinematography – its 'cinégraphie', to borrow Marcel L'Herbier's expression. Dekeukeleire's enthusiasm also extended to Ewald Dupont's *Baruch* (1923), for its elliptical style, and *Variété* (again, for Karl Freund's camera work, 1923). If he criticized Walter Ruttmann's attempt at 'pure cinema' (*Lichtspiel*, 1921-25), he adored *Berlin, Symphony of a City* (1927) and *Melody of the World* (1929). Through Ruttmann, and later Dziga Vertov, the aspiring Belgian film-maker experienced the influence of constructed documentary.

From a theoretical perspective, Dekeukeleire no doubt interrogated and probed the notion of autonomy and media specificity of cinema (cf. a talk he gave in Paris in 1930), echoing the writings of Jean Epstein, whom he admired: 'We stand before our camera with an absolutely virgin mind' (quoted in Dubois, *Revue belge du cinéma*, 1, 1982). Much like Maya Deren many years later, Dekeukeleire wanted to shoot his films outside of the studio space. Although he admired studio films, he wanted to go beyond what that system had to offer, wishing to produce a cinematic poetry with its own form, greater spontaneity, suppleness – a deeper cinema. An advocate of meditation, he tried to express the inner dream on the screen, not in order to invent a cinematic vocabulary but, rather, to use existing vocabulary in new ways.

Dekeukeleire lamented the inner poverty of the cinema of his time, caused by the noxious omnipotence of money, which stifled freedom of expression; as well as the co-opting of the avant-garde by commercial cinema. In his view, audiences had little access to the best films as distributors went for bankability, leaving cinema in the hands of people Dekeukeleire deemed ignorant. Consequently, good cinema could only be born in quasi-artisanal circumstances, as in the cases of *Vampyr* (Carl Theodor Dreyer, 1932) and *L'Âge d'Or* (Luis Buñuel, 1930), produced with money from angel investors.

Combat de Boxe.
Collection Cinematek.

The paradox was that a rebellion against this situation could not express itself through cinematic means. Cinema was a mirror of its times, so that a bad film reflected a world in a state of disarray. Rejecting theatrical and pseudo-realistic literary styles in film, Dekeukeleire wished for a realism that would be properly cinematic, finding its truth in the authenticity of the object, the scenery, and the light, but also in the actors' gestures, attitudes and behaviour.

Rather sensitive and intuitive than theoretical, Dekeukeleire aimed to go beyond traditional definitions and boundaries. Although he was interested in abstraction, he was unquestionably a humanist who regarded cinema as a modern language designed to establish a deeper connection between people. His ideal was one of *unanimism* in synchrony, and permanence in diachrony. By *unanimism*, he meant a principle that gathered diverse human activities, and he saw the cinema as the ideal technology with which to address and express this principle. This, however, did not mean leaving the past behind: Dekeukeleire was dearly attached to his homeland's traditions and, even in films exalting modern technology, he would show its link with folklore and the labour of the industrious, *bon vivant* Belgian folk, in 'a dance from life to the machines' (in Polet 1982: 40). His cinema, however enraptured by the new possibilities offered by the camera, would thus not be one of rupture, but one of continuity between man and his context, with the human figure always firmly at the centre.

An entirely self-sufficient ('I do everything myself: I buy the raw stock and when it leaves me, it is a film. I direct, photograph and develop the film all by myself')[3] and self-taught film-maker, Dekeukeleire started out by producing four experimental films independently. In 1927, he directed the energetic *Combat de Boxe*, made on a shoestring budget (a couple of ropes against the background of a white cloth were meant to represent the ring where two boxers fought, while a few extras, running in a line before the moving camera, faked an enthusiastic crowd). The film remains memorable for alternating positive and negative footage, and for its rapid editing. The latter may be explained by the fact that Dekeukeleire wanted cinema to translate a certain phenomenological truth of life, beyond mere stories and anecdotes: his interests were not so much in things themselves, but rather, in the movement of things.

One of the theoretical concepts most important for Dekeukeleire was the decomposition of the gaze. Already at play in *Combat de Boxe*, it became even more obvious in his *Impatience* (1928), a long visual poem with four recurrent motifs/characters: a motorcycle, a naked girl, a mountainous landscape, and abstract geometric motifs à la Hans Richter. In this uncompromising rhythmic film, movement is generated by the camerawork and editing, the subjects themselves moving very little, save for the pulse of the motorcycle engine. The title itself could refer to the motorcycle's impatience to be ridden through the landscape, or the girl's sexuality (at the end, a shot of a quivering leg might evoke birth). But, in truth, none such reading is very productive. The film is a true abstract experiment in doubled rhythm using referential motifs: representing actions that are already quick (boxing, motorcycle), Dekeukeleire does not oppose the filmic rhythm to referential rhythm but couples them instead, which is different from the contemporary practices of Richter or Fernand Léger, among others.

Impatience brought the initial period in Dekeukeleire's career to a close. Sensing himself at odds with the public and film exhibitors, he decided, in his next effort, to come closer to a traditional script while remaining committed to the 'serious plasticity and high rhythmic sense' that he sought (quoted in Flouquet, 'En dessinant Charles Dekeukeleire', *Aurore* (Paris, April 22, 1929)). *Histoire du détective T* (1929) was to be this film. It tells the story of a private eye hired by a woman to explain her husband's disappearances. In order to do so, the detective documents the husband's activities with a film camera. It is eventually revealed that the husband simply runs to the seaside to take a break from city life. Through its use of subjective camera and surrealist imagery à la Man Ray (although here surrealism returns to the bosom of reason in the end), the film investigates and exposes 'ennui' and narration of the quotidian. What makes it stand out is its peculiar use of narrative intertitles and its rather banal images, breaking the usual received expectations of cinematic narration: because he distrusted acting, Dekeukeleire suppressed it, which was one of the goals of his cinema.

Following a short documentary about the Belgian seaside town of Dixmude (1930), Dekeukeleire made the socially conscious *Witte Vlam/Flamme Blanche* (1930). Halfway between documentary and militant poem, this film depicts a demonstration repressed by the police. Access to Soviet films was limited in Belgium due to the French government's anti-Soviet measures, but between 1930 and 1933, Germany distributed more Russian films in Belgium, and their influence can be felt in this film. Furthermore, Dekeukeleire had covered the second congress of independent cinema (Brussels, December 1930), underlining the importance of the manifesto 'Statement on Sound' by Sergei Eisenstein, Vsevolod Pudovkin and Grigori Alexandrov. As far as Soviet cinema was concerned, he personally favoured the collective hero and lyrical vision of Eisenstein over Pudovkin's characters, but the fundamental influence on his own cinematic practice came from Dziga Vertov.

In the years that followed, Dekeukeleire gradually veered away from pure formal experiments and towards documentary, as much by necessity as by taste, a 'humanist' turn lamented by Kristin Thompson. The transition was hardly a radical one, however: Dekeukeleire must have had Vertov in mind when he made *Visions de Lourdes* (1932), one of his own favourite films. This clever denunciation of the merchandising of Lourdes, which Jacques Polet called 'a plastic poem,' (Polet 1982: 23) where the physical dissolves into the ecstatic, and matter into art by virtue of the film's framing and editing, clearly shows a continued influence of the avant-garde.

With his films receiving notice at film clubs in France, Dekeukeleire was hired in 1932 by Germaine Dulac as the correspondent to Société Gaumont in Belgium, but the appointment lasted only one year. He followed up with *Terres Brûlées* (1934), a visual diary documenting Captain Brondeel's expedition to the Congo, the first successful attempt to travel from Belgium to West Africa by truck (and which took almost four months). This was the director's first sound film, featuring memorable footage of

Watuzis jumping. This film gave Dekeukeleire his legitimacy, but also showed his progressive approach to the local populations of Africa, against the grain of the general patronizing colonialist mood that pervaded Belgian culture at the time (even if a late-1930s documentary, entitled *Black People Evolve/Les noirs évoluent*, certainly bears the hallmark of said patronizing attitude).

The thirties were a prolific period for the film-maker (with 19 films made between 1930 and 1939) that prompted a score of inspired documentaries, such as *La Laine*, *Symphonie Florale*, and *Signaux ouverts*, all made in 1936. These are beautiful poems that show the director's interest in the process and evolution of human and natural creation (wool production, flowers and locomotives, respectively). That same year, Dekeukeleire made his sole feature film, written by Herman Teirlinck (1879-1967), *Le Mauvais œil/The Evil Eye* (1936). It tells the story of a mysterious vagrant who seems to bring misery to a small town. It is later revealed that the unfortunate man lost his mind many years before, when the woman he loved drowned in the river. A tragic pastoral, using non-professional actors, this story of an impossible love was inspired by witchcraft tales told by Dekeukeleire's mother when he was a child. Shot in a particularly gorgeous area of southern Flanders, imbued with folklore and the striking physiognomies of the local peasants, the film was deemed overly theatrical and slow, and proved a commercial failure.

Returning to a cinema of more modest means and scale, Dekeukeleire, still inspired and attracted by the Flemish countryside of his ancestors, produced one of his masterpieces (and personal best-loved films). *Thèmes d'inspiration* (1937) establishes analogies between paintings of the Flemish and Dutch golden age with contemporary landscapes and the faces of Belgian people. The resemblance is nothing short of striking, commenting both on a sense of tradition and continuity as well as modern technology, through the cinematic apparatus.

This intense and prolific period in the director's career was brutally interrupted by World War II. Unlike Henri Storck, Dekeukeleire was reluctant to work under the German Occupation. Avoiding outright collaboration with the Nazis, his entire output from the war years amounted to five short films, done for Belgian charities, the Red Cross, and for banks. Retreating into the written medium, he wrote and published prolifically about the cinema, with sophisticated philosophical and humanist overtones, regarding the promises of the medium, but also calling for greater spiritual and physical understanding and communication between people.

Resuming his documentary activity after the war, Dekeukeleire directed, among other films, the excellent *Het Stichter* (1947), about King Leopold I, Belgium's first king (another one of the director's personal favourites) and *In het Land van Tijl Uylenspiegel* (1948) about western Flanders. Much as in the thirties, his documentaries, whether invested in history, technology, science, institutions, or treasures of Belgian culture or geography, remained centred around the human figure, but acquired, however discreetly, an institutional feel, most of them being clearly commissioned works.

In 1950, Dekeukeleire tried to set up an independent studio in Waterloo, with all the necessary infrastructures, but the enterprise proved short-lived. With cinema becoming an overly complicated enterprise financially, he worked in television, for both the francophone RTB and Flemish BRT networks, where he became one of the best-loved and endearing figures of the Belgian 'audio-visual landscape'. He also taught at the Brussels film school INRACI, making fewer films and shooting his last one in 1958. On 26 November 1962 he suffered a stroke, and spent the rest of his life in the Flemish countryside he so dearly loved, in Werchter (now the site of a famous rock/pop music festival), where he died on 1 June 1971.

Taken as a whole, Dekeukeleire's cinematic output (amounting to some 80 short films, documentaries, newsreels and one feature) is characterized by a form of lyrical poetry, stylish cinematography, and a uniquely personal sense of rhythm and editing, energetic but not aggressive. Moving from the daring experiments of the 1920s to the growing nostalgia of the later years, these films reflect upon a certain image of the Belgian spirit in the twentieth century. They combine the qualities of the work of an intrepid pioneer's proud flights with down-to-earth humanism. The oeuvre and the man proved quaint and robust, good-natured yet adventurous, nostalgic yet curious, passionate about the advances of the arts and sciences, and endlessly affectionate towards the homeland, now sadly bygone and surviving only in a co-opted, uprooted folkloric imagery.

From the perspective of world film history, Charles Dekeukeleire will be remembered mostly for the earlier part of his oeuvre, as a truly original voice of early experimental cinema. If these films can seem derivative of French impressionism, German expressionism and Soviet cinema, it can also be argued that their use of stylistic features (including subjective camera) and the director's later efforts in ethnography anticipate many subsequent trends, most importantly *cinéma vérité*. From a national perspective, it is in his steadfast resilience and passion to make films that Dekeukeleire best embodied the spirit of Belgian cinema: when obstacles such as limited means and other technical restrictions threatened the completion of his films, they were overcome by the director's typical resourcefulness and grounded determination, coupled with an unquestionable originality – 'with his feet on the ground, and his head in the stars.'[4]

Jeremi Szaniawski

Notes
1. This entry owes much to the lectures of Henri Sonet, whose classes I took in college, and who gave me the opportunity to see many of Dekeukeleire's early films on 35mm. Two other important scholarly resources I used were the issue of the *Revue belge du cinéma* (nr 1, Autumn 1982), with pieces by Henri Storck, Paul Davay, Jacques Polet and Philippe Dubois. In English, Kristin Thompson wrote a piece on Dekeukeleire's experimental films, '(Re)Discovering Charles Dekeukeleire,' published in 1981, and subsequently posted on David Bordwell's blog in 2009, when several of Dekeukeleire's films became available on the 'Avant-garde 1927-1937' DVD. Thompson offers a formalist close reading of *Impatience* and *Histoire du détective T*, as well as some considerations on *Combat de Boxe* and *Witte Vlam*.
2. He attended the Institut St. Boniface, which remains, to this day, one of the capital's leading schools.
3. A. F., 'Charles Dekeukeleire nous parle de ses débuts,' no source (June 4, 1940) In http://www.davidbordwell.net/essays/dekeukeleire.php#_edn4
4. 'Les pieds sur terre et la tête dans les étoiles/Met beide benen op de grond and zijn hoofd in de sterren.'

INTERMEDIATE FIGURES

JACQUES FEYDER

Belgian-born Jacques Feyder (1885-1948) is one of those film-makers who have been unjustly reduced to almost a footnote in film history. During the 1920s and the 1930s, Feyder was considered to be one of the great French film directors of his time. In fact, Feyder, who saw himself as 'a craftsman working in a very big industry called cinema' (Feyder and Rosay 1946: 11), occupied a unique position. Although he made a great number of costly and commercially successful films, many of them contained a sharp criticism of French social and political life. His aesthetically refined work also included experimentation with visual and narrative techniques coming from the avant-garde tradition. Feyder, who was very much part of artistic and literary circles, was also probably the only film-maker who succeeded in retaining a key position in the different film movements which made French cinema so vibrant during the Interwar period, from 'prestige' or 'quality' pictures to darker and more socially-conscious films announcing poetic realism.

Born Jacques Louis Léon Frederix in Brussels, Feyder started his career as a stage actor. Against the wishes of his French-speaking bourgeois family, who had hoped Jacques would pursue a military career, Feyder left for Paris in 1911, where he soon began acting in films. From 1912 onwards he played many roles in short movies, including pictures made by Georges Méliès, Louis Feuillade, and Gaston Ravel. He became Ravel's assistant, and by 1915 he co-directed his first film for Gaumont, *Feet and Hands*. In the following years, Feyder made some fifteen pictures for that company, mostly short comedies. In one of those pictures, *Têtes de Femmes, Femmes de Tête* (1916), we see the young actress Françoise Rosay, who would become Feyder's wife (they married in 1917) and life-long fellow traveller.

Feyder's career was briefly interrupted by his military service with the Belgian army but after World War I, he resumed his work as a film-maker. He first made another short movie for Gaumont, *La faute d'orthographe* (1919, about a job candidate for an insurance company who finds out that he made a spelling error and tries to correct it by sneaking back into the company offices), but this interesting movie, with a clear critical stance, turned out to be a bit too eccentric for the company. Working now as an independent film-maker and scriptwriter, and searching for more ambitious projects, Feyder mounted his first major production, *L'Atlantide* (1921), based on the novel by Pierre Benoît. The most expensive French movie at that time and one of the earliest films to depict French colonial presence in North Africa, *L'Atlantide* was filmed under difficult conditions on location in the Sahara desert. The movie was internationally acclaimed, particularly for its realism, and was Feyder's first box office and critical success.

In the following years, Feyder confirmed his position as a master of naturalism and cinematic inventiveness, with movies like *Crainquebille* (1922, released 1923), *Visages d'Enfants* (1923) and *Gribiche* (1926). He was praised for his ability to bring passionate and often poignant characters to life, such as the ageing greengrocer Jérôme in *Crainquebille*, who becomes a victim of class prejudice within the French judicial system. In this social critique, based on a novel by Anatole France, Feyder skilfully employed

a wide variety of techniques which were used in French impressionist cinema in order to express character subjectivity, like superimpositions, optical point-of-view shots and dream sequences. Feyder also started to work for Films Albatros, a medium-sized French production company with international ambitions, which was created after World War I by Russian immigrants. At Films Albatros, Feyder also started to work with the Russian-born art director Lazare Meerson, who would become a key figure in the development of the French poetic realist aesthetic during the 1930s. After *Gribiche*, a subtle movie about social mobility, Films Albatros asked Feyder to direct another film, *Carmen* (1926) with the popular actress and singer Raquel Meller. Although the production of this star-vehicle turned out to be difficult, mainly due to personal conflicts between Feyder and a recalcitrant Meller, the movie became a major international success. Sold to dozens of foreign markets, *Carmen* was Albatros' greatest hit and the movie reconfirmed Feyder as a director of international stature.

Feyder's reputation as a leading innovative film-maker peaked during the second half of the 1920s with *Thérèse Raquin* (1928) often considered his masterpiece. *Thérèse Raquin*, an adaptation of Zola's sombre bourgeois tragedy, was a German-French coproduction shot in Berlin. The movie, now lost, was another major critical success and, according to film director Jean Grémillon, an example of Feyder's 'fineness of analysis, his subtlety in depicting complex emotions'. In 1928 Feyder worked again for Films Albatros under the condition that he would have total creative freedom. The result was *The New Gentlemen/Les nouveaux messieurs* (1929), a highly controversial satire on the political ethos during the Third French Republic. As the film openly dealt with issues such as corruption and class differences in the political arena, the French censors banned it for 'insulting the dignity of the parliament and its ministers.' After being banned for four months, *Les nouveaux messieurs* finally opened in April 1929, though only after a long list of cuts had been made.

By the time the controversy around *Les nouveaux messieurs* was over, Feyder, who had become a French citizen in 1928, accepted an invitation from MGM and left for Hollywood. As with so many other European film-makers, Feyder's American experience, which lasted until 1933, was a very mixed one. Although he directed Greta Garbo's last silent movie, *The Kiss* (1930), and made some other films, including two minor Ramon Navarro pictures, his work mainly consisted of making foreign-language versions of MGM films, including a German version of Clarence Brown's *Anna Christie* (1930, again with Garbo). In his book *Le Cinéma, Notre Métier*, which he co-authored with Rosay, Feyder looked back at his Hollywood journey not with bitterness or resentment but with a characteristic lucidity. The Hollywood system needs 'some exotic ideas' from time to time, he wrote, and it needs to 'renew its spirit and its style without breaking the tradition.' But, Feyder concludes, at the end, 'the system nearly always fails' (p. 29).

Back in France, Feyder intensified his collaboration with his fellow countryman Charles Spaak, making some of his most successful works in quick succession, including *Le Grand Jeu* (1934), *Pensions Mimosas* (1935) and his classic *Carnival in Flanders/La Kermesse Héroïque* (1935). These three sound pictures, all with Spaak as a writer, Rosay as leading actress and Lazare Meerson as set designer, re-established Feyder's role as a major director. *Pension Mimosas*, a psychological drama set in a small hotel on the French Riviera, is often considered a forerunner to French poetic realism, a mode associated with a nostalgic and fatalistic view of life and a stylized form of realism. *Carnival in Flanders*, probably Feyder's best-known movie today, is an historical satirical (or even black) comedy, with an original script by Spaak and Feyder, about the Spanish occupation of Flanders in the early seventeenth century. As was the norm with German-French productions of the time, two versions of the Tobis productions film were made, with an alternative cast (except for Rosay, who appeared in both pictures). *Carnival in Flanders* (*Die Klugen Frauen*, 1936, in German) tells the story of the town of Boom,

where the local mayor and his board of aldermen fear the arrival of a Spanish duke with his army. Their strategy to fake the mayor's death in order to bring the fearsome occupiers to respect the townspeople's mourning is rejected by the mayor's more courageous wife (Rosay), who decides to develop a strategy of warm welcome and hospitality. Although the movie was a huge critical success and received various prizes at international festivals (including best director at the Venice Film Festival in 1936), it was also met in places with great uneasiness. Praised for its sumptuous sets, splendid costumes, the high quality of acting, and the many delightful references to works of the Flemish Old Masters (such as Brueghel), *Carnival in Flanders* was also criticized, especially in Belgium, where the unflattering portrayal of Flanders and its cowardly politicians led to public protests, riots, boycotts, and even diplomatic actions.

In the years prior to World War II, Feyder forged ahead with his international career, although he would never reach the same level of critical and audience success. He first made a British picture for Alexander Korda, *Knight without Armour* (1937), an historical drama about the Russian Revolution with Marlene Dietrich playing opposite Robert Donat, followed by *Les Gens du Voyage/Fahrendes Volk* (1938), another Tobis picture in two versions shot in Germany. In 1939 he directed another French movie, *La Loi du Nord*, a romantic adventure drama about an escaped prisoner, his secretary and two policemen in the Far North, starring the young Michèle Morgan. With the outbreak of the Second World War and the Nazi occupation, Feyder and his wife left France and found refuge in Switzerland, where the French-Belgian director was involved in teaching acting and film directing. Feyder was also caught up in several productions and he made one last movie, *Portrait of a Woman/Une Femme Disparaît* (1942), a rather disappointing star-vehicle for Rosay who had no less than four roles in it.

Feyder died in May 1948 in Prangins, in the canton of Vaud, Switzerland. His relatively early death and the fact that his career stopped before the end of the Second World War is one explanation for the fading interest in his work. Some of his films, including *Carnival in Flanders*, have also been criticized for lacking a dynamic editing style. Feyder's best films, however, are still worth viewing as great achievements of pictorial beauty and classical realism with a keen eye for details and the non-gratuitous inclusion of formal and narrative experiments. Many of his works are imbued with empathy for the common man and focus on obtaining a deeper psychological interpretation of the characters. Feyder, who had been a screenwriter for other directors, also knew how to attract great actors and other talents like Meerson as set designer or Henri Chomette and his better known brother, René Clair, as assistant directors. During a lecture he gave in 1965, Clair said that, to him, 'Feyder was a great inspiration for the generation that followed'.

Daniel Biltereyst

Carnival in Flanders

La Kermesse héroïque

Studio/Distributor:
Films Sonores Tobis
American Tobis Company
Filmsonor
L.C.J. Editions & Productions
Ciné Vog Films
Tamasa Film
BFI Video
Cecchi Gori Home Video
Hen's Tooth Video
Timeless Video

Director:
Jacques Feyder

Producer(s):
Pierre Guerlais (production manager)

Screenwriters:
Charles Spaak (short story)
Bernard Zimmer (dialogues)
Jacques Feyder
Robert A. Stemmle

Cinematographer:
Harry Stradling

Art Director:
Lazare Meerson

Composer:
Louis Beydts

Editor:
Jacques Brillouin

Duration:
110 minutes

Genre:
Comedy
Historical Drama
Romance

Cast:
Françoise Rosay
André Alerme
Jean Murat
Louis Jouvet
Lyne Clevers

Year:
1935

Synopsis

In 1616, the Flemish city of Boom, under Spanish rule, puts the finishing touches on its preparation for the annual fair, the *kermesse/carnival* (or *kermis* in Dutch). The Burgomaster and his aldermen are then apprised of the imminent arrival of Duke Pedro d'Olivarès and his troops. Convinced that the arrival of the Spaniards will lead to the worst possible atrocities, the Burgomaster concocts a plan to pass for dead, and therefore turn the *kermesse* into a funeral procession, so that the 'invader' can quickly go on his way. The Burgomaster's wife considers this situation absurd and decides, in agreement with the women of the town, to greet the Duke and his troops, who will take part in the festivities given in honour of the departed.

Critique

Jacques Feyder based *Carnival in Flanders/La Kermesse héroïque* on a short story by screenwriter Charles Spaak, who had worked on the script for Jean Renoir's *Grand Illusion/La Grande Illusion* (1937). According to an early sound cinema tradition, two versions of the film were made: one in French and the other in German, which was entitled *Die Klungen Frauen*. Each version went on to win, respectively, the Grand prix du cinéma français and the prize for best director at the Venice Biennale in 1936.

La Kermesse héroïque, like a fresco of the seven deadly sins, is a mise-en-abyme of several divisions, depicting, in both realist and grotesque terms, the turpitudes of the human soul and the cupidity of religion. The film is a 'heroic-comical farce,' and a tribute to the realistic frescoes of sixteenth century Flemish painters. One of the main characters, a painter named Jean Breughel whose talent is unpopular with the local administration, is nevertheless recognized by virtue of the Spaniards' good taste. Pictorial references (such as to Rubens and El Greco) are multiplied here, both through images and in the film's dialogue. Such references are physically incarnated throughout the film: from the mill to the fields as far as the eye can see, from the military parade to a meal in honour of the 'deceased.'

The director, depicting the daily life of seventeenth century society, mixes rural and urban pragmatism with the absurdity of the situation and the grotesque attitude of men, represented among other things by the comical width of their pantaloons. In order to demonstrate this stupidity attributed to the male gender, Feyder evokes, through the image, their subconscious negative interpretation of the Spaniards' arrival: a faux flash-forward, a simple product of their imagination, shows multiple atrocities that could be committed by the invader, including ransacking, pillage, rape, and murder.

Women are not spared, however. If Françoise Rosay as Cornelia, the Burgomaster's wife, demonstrates her virtue, her friends do not hesitate to use their charms with the Spanish soldiers, with material comfort and gain as their goal. Much like Aristophanes' Lysistrata, Cornelia demonstrates the abilities of women to manage a city through diplomacy and without the help of men. She takes control of

Directory of World Cinema

Production still from *Carnival in Flanders*, a film by Jacques Feyder.
The Kobal Collection.

54 Belgium

the situation from her balcony, gathering and haranguing the female crowd: 'Woman, since paradise, has always retained the superiority of armament.'

La Kermesse héroïque stands as a symbol for multiculturalism, although it opposes the ugliness, hypocrisy, and cowardice of Flemish men with the beauty and grandeur of the Spaniards as proudly represented by the Duke d'Olivarès. While the film depicts a social and cultural fragmentation and a divide between genders, it also delivers, in subtext, a universal message, represented by the budding love between Cornelia and the Duke, and also in the fraternity and friendship unifying the two peoples, who initially appear so different.

The film was very well received by francophone audiences in Belgium. However, particularly in Flanders, where Feyder's film acquires a strong political and historical reach, it was considered a metaphor, or even possibly a denunciation of the way the German invader was greeted by Flemish nationalists during World War I. But in spite of some unfavorable interpretations and reactions, the film's primary objective is not to bring a moralistic and conflict-fostering message to the screen. On the contrary, Feyder, a great traveler who lived in Belgium, France, America, and Switzerland, favors the universality of the message and the communion of two seemingly disparate cultures: he is unquestionably the spokesman of a united Belgian cinema with infinite and complex representations.

Aurélie Lachapelle

Translated by Marcelline Block and Jeremi Szaniawski

GASTON SCHOUKENS

Belgian film-maker Gaston Schoukens (1901-1961) might be best remembered today for his earnest and self-disparaging (or perhaps cynical) assertion: 'I don't sell art, I sell sausages' ('Je ne vends pas de l'art, je vends des saucisses'). It would be unfair, however, to relegate him to the undignified role of pork butcher of the seventh art. His cinema, entirely imbued with a Belgian *bon-enfant* spirit, might not have aimed to be studied in schools or anthologized in film archives decades after his death, but it was solid then as popular entertainment and has acquired an added quasi-ethnographic quality over the years, portraying a Belgium and its people that are practically gone today. In 2012, Schoukens' filmography was the subject of a nearly complete retrospective at the Royal Belgian Film Archive, one crowned with popular success, testifying to the nostalgic appeal of a not-so-distant and yet vanishing era.

At first a spontaneous craftsman, Schoukens gradually became a weathered maker of comedies (screen adaptations of popular theatrical successes, sometimes in the delightful *Brusseleir* dialect) and short documentaries, mostly about Belgian culture and Belgian life. In so doing, and much like his correspondents in Flanders, Edith Kiel and Jan Van der Heyden, Schoukens became the key transitional figure of Belgian cinema between the early experiments of Henri Storck and Charles Dekeukeleire, and the cinema of André Delvaux that would usher the national cinema into a new age of modernity and critical acclaim. Quite popular at home at the time of their release, some of Schoukens' films even found an audience as far as Paris.

When watching the films of Schoukens today (perhaps because they focus more on the ethnographic and the cultural patrimony of Belgium, his short films appear more interesting than his features), spectators are touched by their truculence and warmth, beyond the stilted, overly theatrical acting. While Schoukens' feature films might have felt rough-cut and indeed were shot with limited means, they were charming in their own way due to these limitations: films which exploit situations dear to the popular theatre of the time, with its songs and typical actors, and boasting an unabashed love for local folklore, as attested, for instance, in the display of *zwanze* – the typical Brussels' café-counter humour in local dialect. Through it, we feel the powerful love of Schoukens for his native city, its tradition and its old quarters. Here are the inescapably charming colours of a bygone era, when, to quote Jacques Brel, 'Brussels brusseled' ('le temps où Bruxelles brusselait').

Markedly regionalist in feel and expression, Schoukens shot documentaries about many Belgian cities. While Brussels retains the lion's share, many of these short films focus on specific manifestations of various other cities, such as the carnivals of Malmédy and Binche, each with its own regional flavour and peculiarities.

A projectionist at his father's cinema, and then a distributor (through his production and distribution company Lux film) and exhibitor himself, Schoukens started his film-making practise proper by making short documentaries. In 1928, he shot, with Paul Flon, one of the first films entirely dedicated to World War I (and partly in colour), *Les Croix de l'Yser*. He would not maintain the sombre tone of this silent debut in his subsequent work, however: starting in the mid-1930s and up until World War II, his films adopted a comedic tone, most starring the well-loved Gustave Libeau, such

as *En avant… la musique* (1935), *C'était le bon temps* (1936, the highest grossing film in Belgium in the 1930s, second only to Walt Disney's *Snow White and the Seven Dwarves* (1937)), *Gardons notre sourire* (1937), *Mon Père et mon papa* (1937) and the cult *Bossemans et Coppenolle* (1939), a transposition of the Romeo and Juliet story to the milieu of Brussels' football supporters, starring the iconic couple of Libeau and Marcel Roels, and based upon their popular play. With the outbreak of war, Schouken's 1939 *Those Who Watch Over/Ceux qui veillent*, commissioned by the Military General Staff, was meant to reassure the population during the Phoney War ('La Drôle de Guerre'), when many Belgian men were drafted and waiting at the frontline, while the title referred to professional soldiers who were given this name by the press of the day.

Many years later, in a series of films dedicated to the 1958 World Expo, we see the journeyman's agile recuperation of the same footage, modified by the use of a slightly ornate, and always gently-quizzical, voice-over. *Bruxelles, que tu es jolie* is a good example of this: shots of a city entirely defaced and rendered impracticable by the 'grands travaux' of the 1950s (tunnels, subway, new boulevards), are accompanied by a highly ironic voice-over about the scenic beauties of the capital. It is also during the World Expo that a fake late-medieval town, known as 'La Belgique joyeuse' was erected near the Palais des Expositions. Schoukens wasted no time in producing several documentaries based on footage of this curiosity, which also served as the setting for his final feature, yet another comedy, *Scandale à la Belgique joyeuse* (1959).

Among the director's last short films, let us point out the charming *La Corne d'or* (1960), which takes place in a small family-owned convenience store, and is composed entirely of shots of the actors' hands, as expressive and characterized as faces. Through these close-ups, we immediately identify the callous and grouchy father; the plump and loving mother; the jaded grandmother; and the nervous son. The latter has just had a child, with the young woman who used to work in the store, until the father fired her. Disgruntled at first, the patriarch eventually gives in and manifests his joy to a customer, raising his hands in the air. With its bright colours capturing the display of commodities in the small family store (the film opens notably on a customer debating what color toothbrush she should buy), the film unwittingly anticipates some of Jean-Luc Godard's experiments later that decade. And in spite of its maudlin message and slow pace, *La Corne d'or* boasts more creativity and artistry than many self-proclaimed cutting edge films made today.

The author of over forty films (combining shorts, documentaries and features), Gaston Schoukens died on April 10, 1961. His granddaughter, Sophie, also a film-maker, perpetuates the family tradition to this day, including her debut feature, *Marieke, Marieke* (2010), which she wrote, produced and directed.

Jeremi Szaniawski

MODERN BELGIAN DIRECTORS

ANDRÉ DELVAUX

André Delvaux (Héverlée, 1926 – Valencia, 2002) is not only the 'father of Belgian cinema', as so many scholars proclaim. He also represents the cultural touchstone of the whole nation and, moreover, never shied away from representing its tensions and divisions.

Born to a Flemish family, Delvaux quickly became bilingual and, as such, the representative of a unified Belgian culture. He graduated from the francophone University of Brussels and became a teacher of Germanic languages, adding English and German to his repertory. Passionate about cinema, he established a film-making workshop within his own classroom, introducing his students to the making of short films, such as *Nous étions treize* (1956), *Two Summer Days* (1959) and *Yves boit du lait* (1960).

Originally from a musical family, he also pursued studies at the Royal Brussels Conservatory and endowed some of his cinematic works with a musical dimension, a quality of his filmography that remains undeniable.

His path as a film-maker began with documentaries, for which he was commissioned by Belgian television: portraits of Federico Fellini (1960) and Jean Rouch (1962), and several news reports about Polish cinema, whose leading figure, Andrzej Wajda, was among his close friends.

André Delvaux's career, which really took its full dimension in the mid-1960s, developed in a culturally favourable context. Along with the newly instated policy of state financial sponsorship for films were added the foundation of francophone and Flemish film schools in 1959 and the creation of the film museum in 1962 by Jacques Ledoux. Delvaux was a co-founder, in 1962, of the most important Belgian film school, the INSAS, created according to the model of the acclaimed Polish film school of Łódź. The 1960s marked the rise of cinematic new waves in Europe and of an artistic modernity to which Delvaux was one of the leading contributors.

He was, above all, the Belgian ambassador of cinematic magical realism. This movement is characterized by an ineffable link between imagination and reality: the idea of a subtle gap vis-à-vis reality which allows the film-maker to enter a different world, and, more importantly, allows the viewer to enter into that other world in order to investigate the secrets of the human soul. Delvaux's first feature film, *The Man Who Had His Hair Cut Short/L'homme au crâne rasé/De man die zijn haar kort liet knippen* (1965), the adaptation of a novel by Johan Daisne, instills a permeability between dream and reality. It is the story of an obsession, of a love quest, of an unfulfilled fantasy, where the characters travel between two inseparable universes, which makes them only more phantom-like and untouchable as horror and beauty collide.

In his next three feature films – *One Night… a Train/Un soir, un train* (1968), *Appointment in Bray/Rendez-vous à Bray* (1971) and *Belle* (1973) – Delvaux favours a structuring of the mental image close to those found in the works of cinematic modernity. Male characters, all professors or intellectuals – much like Isak Borg in Ingmar

André Delvaux.
The Kobal Collection.

Bergman's *Wild Strawberries* (1957) – are pushed toward introspection, in search of a previously unknown truth. This ubiquitous figure of the professor can be interpreted as the allegory of the film-maker himself, who decided to present his observable experiences, all the while transforming them into a narrative with an ontological quality. His first films express an undermined masculine identity and a reflection about the characters' essence and latent desires.

An adaptation of another text by Johan Daisne, *One Night... a Train*, depicts, at first, a social reality and a conflict that is both internal and collective. As protagonist Mathias Vreeman, Yves Montand loses touch with reality. While the Flemish nationalist revolt is raging – leading to the expulsion of the francophones from Leuven University – he too suffers an identity breakdown, both linguistic and mental. He becomes a being who oscillates between his fantasies and an opaque quotidian universe. In this film, Delvaux denounces the linguistic and nationalistic extremes that are still – and perhaps even more than ever – rampant in Belgian society. The characters, as sublimated by Delvaux, want to escape this claustrophobic space through the imaginary, even at the cost of their mental sanity.

Following his series of magical realist films, Delvaux made two documentaries, placing his fiction feature pursuits on hold for a while. With *Met Dieric Bouts* (1975), dedicated to the work of the Flemish fifteenth-century painter, and *To Woody Allen, from Europe with love* (1980), Delvaux creates a *mise en abyme* of these artists' oeuvres with his own cinematic practice.

In *Woman in a Twilight Garden/Femme entre chien et loup/Een Vrouw tussen hond and wolf* (1979), Delvaux returned to feature fiction film-making in order to broach a subject that remains taboo even today, namely, the Flemish collaboration with the Nazis during World War II. Much as with *One Night… a Train*, he refuses the dichotomy that distinguishes between two types of peoples – the Latin and the German – since he himself embodied both as a unified representative entity of Belgian culture.

With *Benvenuta* (1983), an adaptation of the autobiographical book by Belgian novelist Suzanne Lilar, Delvaux gives full voice to his love of music and sets up the pattern of two worlds, alternating between the Ghent landscape where the young pianist Benvenuta (Fanny Ardant) wanders and her philandering in Italy. Informed by his musical sensitivity, *Benvenuta* constitutes a narrative 'for four hands', as it were, in which Delvaux turns our ability to listen into a striking aesthetic challenge. The original soundtrack (by composer Frédéric Devreese) serves the depiction of the characters as much as it evokes the most diverse atmospheres.

Delvaux's final opus, *The Abyss/L'Œuvre au noir* (1988), an adaptation of a novel of the same title by Marguerite Yourcenar, is a historic and metaphysical fresco, representing a deliquescent medieval world that denigrates scientific and philosophical discoveries. This film symbolizes the entirety of the director's *oeuvre*, recuperating its previous topics: protagonist Zénon's loss of identity, the introspection needed to understand the world in its physicality, and the consequent perversion of the human soul in a violent world on the verge of self-destruction. A final message is bestowed upon us: that of the eternal return of the same, of a world bound to be reborn from its ashes.

A great intellectual figure and musician, Delvaux references other cultural and artistic dimensions in his works: music in his fiction-documentary *Babel Opera ou la répétition de Don Juan de Wolfgang Amadeus Mozart* (1985); classical history in *Benvenuta* and its visit of the ruins of Pompeii; painting in *Belle* and the representation of a train station typical of the paintings of Paul Delvaux; and cinema itself with *Woman in a Twilight Garden*, the inspiration for which Delvaux claimed to have found in the solitary and damaged female characters from the films of Ingmar Bergman.

Throughout his career, André Delvaux has endeavoured to deliver a humanist and universal representation and message: man lives in a world in constant deliquescence, and exists only through his creative force and his ability to rebuild this world.

Dominique Nasta with Aurélie Lachapelle

Translated by Marcelline Block and Jeremi Szaniawski

The Man Who Had His Hair Cut Short

L'Homme au crâne rasé/
De man die zijn haar kort liet knippen

Studio/Distributor:

Belgische Radio en Televisie (BRT)
Ministère de l'Education nationale et de la culture/La Pagode Films
Trans World Attractions
Ciné Vog Films

Director:

André Delvaux

Producers:

Paul Louyet
Jos Op de Beeck

Synopsis

Govert Miereveld, a Law professor, falls in love with one of his students, Fran, but dares not declare his feelings to her. He meets her ten years later by chance, in a hotel. She confides in him that her feelings were mutual, but that she also loved many other men. She asks him to deliver her from her tragic existence and gives him a gun. We hear gunshots, but do not see her corpse. Years go by, and the lovesick man is in a mental institution, remembering his traumatic past experience and love. It is uncertain whether he ever killed or even met Fran. All might have happened in his mind, and in spite of the film's realism, there is no certainty that he ever committed a crime.

Critique

Commissioned by Belgian TV to glorify Flemish literature, André Delvaux's first feature was the fruit of his collaboration with Ghislain Cloquet, the man he brought back to his native Belgium from France to teach at the newly founded INSAS film school. Delvaux professed that Cloquet taught him 'everything' he knew about film-making: Cloquet himself had learned from his father-in-law, Jacques Becker, a disciple of Jean Renoir. Honouring the trans-national nature of this debut, Delvaux gave the lead role of Fran to Beata Tyszkiewicz, Andrzej Wajda's wife, the INSAS having been modelled on the prestigious Polish film school of Łódź.

Senne Rouffaer in *The Man Who Had His Hair Cut Short*.
The Kobal Collection.

Screenwriter:

André Delvaux
based on the novel by Johan Daisne
and Anna De Pagter

Cinematographers:

Ghislain Cloquet
Roland Delcour

Art Director:

Jean-Claude Maes

Composer:

Frédéric Devreese

Editors:

Suzanne Baron
R. Delferrière

Duration:

94 minutes

Genre:

Drama/psychological thriller

Cast:

Senne Rouffaer
Beata Tyszkiewicz
Hector Camerlynck.

Year:

1965

The Man Who Had His Hair Cut Short/L'Homme au crâne rasé/De man die zijn haar kort liet knippen, a variation around the themes found in Sternberg's *Blue Angel* (but in a much more enigmatic vein) enshrined Delvaux as the father of modern Belgian cinema and a master of magical realism. The screenplay is an adaptation of a novel by Johan Daisne, an important Flemish author of magical realism. In the book, it is clear from the onset that the hero is mentally ill and in an institution, where he writes his confession and tries to explain why he might have killed the woman he loved. Delvaux believed that in cinema, the viewer 'buys' the film's narrative if one can identify with the protagonist, but as a madman is bound to be the proverbial Other, spectators would reject him. Transposing the novelistic 'I' to the screen, Delvaux had to choose a lead character, always present, through whom we see, hear and understand the film's narrative as it unfolds. For this role, Delvaux chose an average, almost normal man who gradually becomes disturbed. Since we never leave his consciousness, we can never assess the objectivity of what has happened. Therein lies the doubt regarding everything that might have happened to him. The character's imagination is the sole reality we can ever access here, and Senne Rouffaer, in the role of the neurotic protagonist who might not have committed the crime he accuses himself of, is perfect in his self-contained and inscrutable hyper-neurosis. This is the ambiguity practised in European cinema's new waves: in *L'Avventura* (Michelangelo Antonioni, 1960), has the missing woman died? In *Last Year in Marienbad* (Alain Resnais, 1961), what really happened? And this doubt is of a constructed nature: the script indicates that Delvaux had planned to film Fran's body, which would have given a certain materiality to her death. In the finished film, once the death has been denoted on the soundtrack (by gunshots), the room is shown in a wide-angle shot, empty of her presence, and doubt remains, unadulterated.

While the film was received coldly by the Belgian press, it was hailed as a masterpiece by many international figures, including Jean-Luc Godard and Bernardo Bertolucci (at the Hyères and Pesaro festivals, respectively). Michel Capdenac called it 'perhaps the most important cinematic revelation of 1966, if not of the last ten years' (*Les Lettres Françaises*, 1966). A turning point in Belgian cinema, it was the first time that a Belgian film received international acclaim. At the Mannheim festival, it received the special prize 'for the depth of its thought and its remarkable commitment to life,' and received the Sutherland Trophy at the BFI for 'the most original and inventive film shown at the National Film Theatre,' thereby launching Delvaux's career on a global scale.

Adolphe Nysenholc

Translated by Marcelline Block and Jeremi Szaniawski

One Night... a Train

Un soir un train

Studio/Distributor:

Parc Film
Les Productions Fox Europa
Les Films du Siècle/20th Century Fox

Director:

André Delvaux

Producer:

Mag Bodard

Screenwriter:

André Delvaux
based on the story by Johan Daisne

Cinematographer:

Ghislain Cloquet

Art Director:

Claude Pignot

Composer:

Frédéric Devreese

Editor:

Suzanne Baron

Duration:

92 minutes

Genre :

Fantasy/drama/mystery

Cast:

Yves Montand
Anouk Aimée
François Beukelaers
Hector Camerlynck
Adriana Bogdan

Year:

1968

Synopsis

Mathias Vreeman, a professor at Leuven University, lives with his mistress Anne. Their relationship is marred by constant misunderstandings. One evening, they take the train to go to one of his conferences. When Mathias wakes up, Anne has vanished. Everyone is asleep in the other compartments. The train stops in the middle of the countryside and starts up again, without any reason. Mathias, left on the tracks with two other travellers, goes in search of his lover. The three men wander in a vast wintry and desolate landscape, a land of death. As the world surrounding him grows weirder and more disjointed, Mathias emerges from what appears to have been a coma-induced dream, following a train wreck in which he lost the woman he loved.

Critique

In spite of the international success of his debut feature, Delvaux was unable to secure subsidies in Belgium for his sophomore effort, *One Night... a Train/Un soir, un train*, in which the derailing train symbolizes Belgian society heading toward its doom, with the struggle to the death of its two linguistic communities. In order to bolster the film's chances of receiving financing, Anouk Aimée suggested that Delvaux cast Yves Montand as Mathias. The actor-singer took up the offer, against the grain of his usual leading-man roles. With Montand joining the cast, French producer Mag Bodard (who had already produced films made by Robert Bresson, Maurice Pialat and Jacques Demy at the time), managed to convince the European branch of 20th Century Fox to produce the film.[1]

The film, shot in Delvaux's hometown, Leuven, evokes the linguistic conflict that reached a breaking point there around that time, with the Flemish authorities chasing the francophones away and eventually building another university town elsewhere (Louvain-La-Neuve). The couple that is torn apart in the film thus finds an echo in the historic and sociological background of recent Belgian history. This is also the inner drama of Delvaux, who was born Flemish, but studied in French. He considered his bi-cultural background to be a riches, and thought that the country's culture suffered from this form of 'ethnic' purification. The film (another adaptation of a story by Johan Daisne, following *The Man Who Had His Hair Cut Short*) is a philosophical dialogue about the meaning of life between three friends aboard a train that derails. And just as a train does not stop dead in its tracks, life sinks slowly into death. It is in this duration, between two worlds, that the film is located. There was no female character in the original story, in which each character was on a quest of his own, exploring his personal ideals. Delvaux incarnates Mathias' own ideal in this missing woman, Anne. The search for her in the realm of shadows is figured by the journey in the flat land, a moor whose vacuity suggests Nordic representations of the Beyond. It can be read as a retelling of Orpheus in Flanders. Like the mythological character, Mathias fails to bring his own Eurydice from the land of the dead. The first part of the film, which depicts the everyday of Mathias and Anne, is an invention of the director, who deemed it necessary to ground this couple's crisis

into a mundane reality. In order to establish a connection between the two worlds (mundane/everyday versus the fantastical), he made this first section a mirror reflection of the second part of the film, following the train wreck. The final shot, where Mathias is shown with his face against the cheek of the dead Anna, her eyes closed, corresponds to the final shot of the first part of the film. The only difference in the images is that in the first part of the film, after Mathias makes love with her in the forest, her eyes are open, and she is alive.

As mentioned above, this film evokes Jean Cocteau's *Orphée* (1950), but without the allegory. In Delvaux, myths are lived *au naturel*. Magical realism, which imagines the possible existence of another world more real than the real world itself, naturally yields this Orphic quality. A fable about a journey unto Death that no one can escape, *One Night... a Train* is not unlike Bergman's *The Seventh Seal* (1957).

Adolphe Nysenholc

Translated by Marcelline Block and Jeremi Szaniawski

Note:
1. However, in May 1968, the anti-American protests in Europe because of the Vietnam War were so violent that all US companies (including Fox) decided to pull their films from European festivals. This impacted the fate of the film in several ways: its theatrical distribution was somewhat impaired (and it was hardly ever shown in America, officially for tax reasons, having been co-produced by an American company with European funds), nor did it earn any awards, unlike all of Delvaux's other films. Moreover, this is the only film by Delvaux that is not available on DVD, because the rights demanded by Fox were prohibitive.

Appointment in Bray

Rendez-vous à Bray

Studio/Distributor:
Ciné Mag Bodard
Parc Film, Office de Radiodiffusion Télévision Française (ORTF)
Studios Arthur Mathonet
Ciné Vog Films
Taurus Film /Parc Films
Boomerang Classic

Director:
André Delvaux

Producer:

Synopsis

The year is 1917. Not far from the front, pianist Julien Eschenbach receives a telegram from his friend, composer Jacques Nueil, inviting him to a meeting in Bray. There he is greeted by a mysterious woman, Elle. Julien waits the whole day for his comrade's arrival in vain. Jacques, a war pilot, is technically on leave. Before departing the villa in the morning, Julien spends the night with Elle, who seems to be Jacques' mistress as well. Did Jacques, in his absence, prepare a gallant rendezvous for the chaste Julien in order to initiate him into the ways of love, as he had tried before the outbreak of the war? Or maybe he never reached Bray, because his squadron was shot down in the air? However, a snippet from a local gazette, unreliable because of wartime disinformation, claims that no plane could take off that day because of heavy fog conditions...

Critique

'This is a rare film,' claimed its producer, Mag Bodard. Delvaux based his screenplay on *Le Roi Cophétua* (1970), a recently published short story by French author Julien Gracq. Delvaux, who admired

Anna Karina in *Appointment in Bray*. The Kobal Collection.

Mag Bodard
Screenwriter:
André Delvaux (uncredited) based on a story by Julien Gracq
Cinematographer:
Ghislain Cloquet
Art Director:
Claude Pignot
Composer:
Frédéric Devreese
Editor:
Nicole Berckmans
Duration:
90 minutes
Genre:
Drama/romance/historical fiction/war story
Cast:
Anna Karina
Mathieu Carrière
Roger Van Hool
Bulle Ogier
Year:
1971

the story and wanted to adapt it to the screen, met with Gracq, who gave him carte blanche to write the script, commending the Belgian director's talent and behavior (of Delvaux's on-set method, Julien Gracq later said that he directed by using a gentle tone, never raising his voice). Delvaux thus took many liberties with the original text, introducing numerous personal elements into the story. The hero, a journalist in the story, is transformed, in the film adaptation, into a pianist accompanying silent films, invoking Delvaux's own experience, when he worked at the Royal Film Archive. And while in the novella the relationship between the two protagonists is that of a vague and undeveloped camaraderie, in the film their friendship is based upon a series of strong oppositions: aristocrat/son of poor winemaker; composer/performer; Don Juan/Tristan; heroic soldier/non-combatant. While, in the short story, the character who tells his tale in the first person is a Frenchman, 'reformed' because of a battle injury, Delvaux turns Julien, living in hiding in Paris, into a citizen of a neutral country, Luxembourg. He is played by Mathieu Carrière, originally from Hamburg, and who thus assimilates two rival cultures, Latin and Germanic.

In the film, in order to pass the time as he waits for his friend, Julien reminisces about his pre-war existence with Jacques. This yields parallel editing with subtle segues and cues between past and present. Delvaux builds the film as if it were a musical rondo, composed of a verse and a refrain. A work of great perfection, Delvaux's own *Jules and Jim* (François Truffaut, 1962), *Appointment in Bray* is musical in every possible way – its heroes, structure, and of course in its soundtrack. Made by a Belgian director, it was awarded the prestigious Prix Louis Delluc, in 1971, for best French film of the year.

Adolphe Nysenholc

Translated by Marcelline Block and Jeremi Szaniawski

Belle

Studo/Distributor:

La Nouvelle Imagerie
Albina Productions S.a.r.l.
Ministère de la Culture de la
Republique Française

Director:

André Delvaux

Producers:

Jean-Claude Batz
Albina du Boisrouvray

Screenwriters:

André Delvaux
Monique Rysselinck

Cinematographers:

Ghislain Cloquet
Charles Van Damme

Art Director:

Claude Pignot

Composer:

Frédéric Devreese

Editors:

Emmanuelle Dupuis
Pierre Joassin

Duration:

93 minutes

Genre:

Psychological drama

Cast:

Jean-Luc Bideau
Adriana Bogdan
Danièle Delorme
Roger Coggio

Year:

1973

Synopsis

Mathieu Grégoire, a provincial poet, is married to Jeanne while having an affair in the Fagnes region with a woman he calls Belle. Belle seems to appear in nature as though by enchantment. The affair starts around the time when Mathieu's daughter, for whom he harbours incestuous thoughts, gets married, and he seems to compensate for this loss with his new love for Belle – who is also supposedly a character in his latest novel – and with whom he meets regularly in a cabin in the woods. The mysterious woman has a companion who comes and taunts them. The two lovers decide to kill the companion, and sink his body in a swamp. On the day of his daughter's wedding, Mathieu and Belle decide to flee together. Mathieu goes to the bank to withdraw a large amount of money, but when he comes back, Belle has vanished. He looks everywhere for the young woman, and upon returning to his car, finds that his money has been stolen. Dejected and abandoned, he leaves town and his family, retiring to live alone in the empty shack where he awaits Belle's return. One day, he thinks he sees the hand of a corpse under the ice of a pond. Did Belle really steal his money? Did she ever exist, other than in Mathieu's delusional poet's mind?

Critique

For the first time in his career, Delvaux made a film from an original screenplay, a logical development after having gradually taken more and more liberties with his previous cinematic adaptations of literary works. Conceived in Paris during the editing of *One Night… a Train/Un soir, un train* (1968), the idea for *Belle* was subsequently rejected by producer Mag Bodard. As Delvaux wanted to keep on working with her, he proposed the Julien Gracq adaptation that would become *Appointment in Bray/Rendez-vous à Bray* (1971). But having finished that film, Delvaux immediately returned to his idée fixe, creating his own production company, La Nouvelle Imagerie, with Jean-Claude Batz, in order to be able to shoot his own scripts.

Taking place in the Fagnes (the High Fens) and the town of Verviers, the film constantly shifts from one space to the other, in a movement recalling the alternation between reality and dream as they fluctuate between inner and outer life. The setting of the narrative is highly symbolic. The Fagnes and their humid, spongy moss-covered lands are a border-zone between Germany and Wallonia. This old, foresty area is filled with a myth-like atmosphere, and clods of earth there are called 'têtes-de-mort' ('skulls', or literally 'dead man's heads'). In Germanic mythology, hell is not a fiery underground realm but rather the murky waters of a swamp; in that respect, this no man's land represents the beyond. Much like Mathias in *Un soir, un train*, Mathieu descends into hell, and Belle is an infernal creature, a femme fatale. Once she vanishes, Mathieu is like Genjurô in *Ugetsu* (Kenji Mizoguchi, 1953) who, having lost Lady Wakasa, is uncertain whether his love for this divine Geisha was not indeed for a ghost.

With *Belle*, Delvaux closes his magical realism cycle, unable to go any further.

In *The Man Who Had His Hair Cut Short* (1966), one wondered if the murder of Fran ever really took place. In *Appointment in Bray* (1971),

one never found out whether or not Jacques schemed to trick his friend; in *Belle*, one does not question an action, but rather, the very existence of a character. Belle disappears much like she came, like one of Méliès's devils, vanishing in a single image. Was there a Belle anywhere else than in the imaginative spirit of the cursed poet of the Fens? Indeed there was, at least to a certain point – but Delvaux cut, in the editing room, the only image which could have proven her existence, in which we see her stealing Mathieu's money. If that shot had been retained, she would have been a seductive con-artist, a vulgar thief. Without this shot, her image becomes mythical. And thus the film works its ambiguous magic.

Adolphe Nysenholc

Translated by Marcelline Block and Jeremi Szaniawski

Woman in a Twilight Garden

Een Vrouw tussen Hond en Wolf/Femme entre chien et loup

Studio/Distributor:

La Nouvelle Imagerie Gaumont
Les Productions de la Guéville/Gaumont

Director:

André Delvaux

Screenwriters:

Ivo Michiels
André Delvaux

Cinematographer:

Charles Van Damme

Sound Designer:

Antoine Bonfanti

Composer:

Etienne Verschueren

Duration:

111 minutes

Genre:

Drama/war/romance/historical fiction

Cast:

Marie-Christine Barrault

Synopsis

The narrative begins on the eve of World War II in Antwerp, and ends there around 1950. The events are experienced by an ordinary woman, Lieve, torn between two enemies: her husband and her lover. Her husband sides with the occupying Nazi forces and goes to war on the Eastern front, leaving his wife without news. One night, a fleeing underground partisan knocks on her door, and the two become lovers. After the war, the husband, condemned for treason, is saved from death when Lieve asks her lover to intercede in his favour. When he comes out of prison, the husband is trapped in his own madness, spending most of his time justifying his actions to himself. When Lieve realizes that he took part in the Jewish genocide, she leaves him on the spot. We have just witnessed a slice of life, over fifteen years, framed by the changes of the seasons in the garden – a recurrent image, like a recurring motif, a refrain.

Critique

Following his cycle of four films that fully develop magical realism, Delvaux renews his art with *Woman in a Twilight Garden/Een Vrouw tussen Hond en Wolf/Femme entre chien et loup*, a committed realistic, antifascist period piece. He portrays warring ideologies, incarnated in beings of flesh and blood. This film was born during the resurgence of neo-Nazism and the affirmation of negationism in the West. 1979 was, indeed, the year when the Reichstag wanted to abolish the imprescribable nature of crimes against humanity. Delvaux questions the role of the church in rallying young idealists in Hitler's Germany to fight on the Eastern front against the Bolsheviks, but he also interrogates the motivations of certain members of the Resistance.

The director illustrates the heroine's belated awareness of the Holocaust, which prompts her, once informed by newsreels in which she sees the footage from Dachau screened at the Nuremberg tribunal, to finally free herself from her compromised husband. The film, built around this beautiful female figure, embraces a feminist agenda of sorts. Ultimately rejecting the two men, between whom she is torn (the original title carries both the meaning of twilight time and

Rutger Hauer
Roger Van Hool
Senne Rouffaer
Hector Camerlynck
Mathieu Carrière

Year:

1979

the metaphorical idea of a woman trapped 'between wolf and dog'), the woman experiences her own liberation. This theme was close to Delvaux's heart: the film pays homage to his wife, Denise, who participated in the underground in the same city (Antwerp) during World War Two, and who personally experienced several of the events depicted in the film.

Upon its release, the film fuelled debates in the media, provoking many controversies. Delvaux later on regretted overly placing the SS collaborator and the resistant on the same level, even if the latter had his own agenda and was a flawed character.

It is important to remember that Delvaux's earliest collaborators (Ghislain Cloquet for the image and Antoine Bonfanti for the sound) had shot Alain Resnais' *Night and Fog* (1955). Delvaux went with them in 1964 to shoot a series of documentaries in Poland, where Nazi Germany had established its extermination camps. This demonstrates the importance the Jewish experience always had for Delvaux. Fifteen years later, without his mentor Cloquet but mindful of his legacy, the tragic subject of the Holocaust resurfaced in his work. In her revolt, the wife of the ex-SS officer secures herself an escape from her problems – and by the same token, from the film as well.

In Valencia in 2002, during his final public speech (at the end of which he fell dead at the lectern), Delvaux said he felt remorse for having made formalist films which he felt did not sufficiently engage with the problems of the city, or even with the world. Here, the director forgot to mention *Woman in a Twilight Garden*, a film that for the first time raised issues of uncivil behaviour in Flanders and testified to its director's anger and disgust at crimes against humanity, crimes which had been conducted, moreover, at the heart of Delvaux's century and in his native country.

Adolphe Nysenholc

Translated by Marcelline Block and Jeremi Szaniawski

Benvenuta

Studio/Distributor:

Union Générale Cinématographique (UGC)
Europe 1
France 3 Cinéma (as FR3 Paris), La Nouvelle Imagerie
Opera Film Produzione (as Opera Films), Ministère de la Communauté Française de Belgique (support)/UCG
Artificial Eye

Director:

André Delvaux

Synopsis

In Milan, Ghent pianist Benvenuta meets a Neapolitan magistrate, Livio. She decides to take him as her lover. This Don Juan introduces her to passionate love before leaving her. She subsequently experiences her passion for him from afar, akin to a mystical love. When visiting the Villa of the Mysteries in Pompei – where, during antiquity, esoteric cults devoted to Dionysos and Orpheus held their meetings – she realizes that she underwent a similar type of initiation. This entire story, however, appears to merely be a fiction, framed by the discussions of two 'real life' characters, François and Jeanne, who may or may not have experienced Benvenuta's adventures.

Critique

This film is an adaptation of *La confession anonyme* (1960), a personal novel by Suzanne Lilar, a francophone writer from Ghent,

Producers:

Jean-Claude Batz
Renzo Rossellini

Screenwriter:

André Delvaux
based on Suzanne Lilar's novel

Cinematographer:

Charles Van Damme

Art Director:

Claude Pignot

Composer:

Frédéric Devreese

Editor:

Albert Jurgenson

Duration:

105 minutes

Genre:

Drama/romance

Cast:

Fanny Ardant
Vittorio Gassman
Mathieu Carrière
Françoise Fabian
Claire Wauthion
Philippe Geluck
Anne Chapuis

Year:

1983

whose book Delvaux literally devoured in one night. With *Woman in a Twilight Garden* (1979), Delvaux had already chosen a female protagonist. With *Benvenuta*, he continued on this path. These films are clearly linked to the advent of second-wave feminism. In many ways, *Benvenuta* is a feminine version of his *Appointment in Bray/Rendez-vous à Bray* (1971). It is constructed in much the same way, with a pianist protagonist and a parallel montage cutting between the two couples whose alternating stories form the film's narrative. Benvenuta/Livio, on the one hand, and François, the film-maker, and Jeanne, the novelist, on the other, correspond to Julien/Elle and Jacques and his momentary conquest, Odile, in the earlier film. But these four characters evolved in the same diegesis. In *Benvenuta*, two of the characters are imaginary heroes of a novel, about whom the two other characters – artists in the real world – talk (evoking *The French Lieutenant's Woman*, Karel Reisz, 1981). Real and imaginary are nevertheless interconnected and overlap once again, as the film begins in the present with François asking Jeanne about her autobiography, which he wants to adapt into a film. As the writer's past is evoked in her love with the one she calls Livio, sequences appear on the screen that are in fact imagined by François for his forthcoming film, so that in the end, when he is about to direct it, the film to be is the one that was unfolding in his screenwriter's head: past, present and future are just as enmeshed and relative here as are fiction and reality. We witness the genesis of the film, a bit like in Fellini's *8 ½* (1963). *Benvenuta*, an elegant and sophisticated narrative, was Delvaux's penultimate film, receiving a score of international awards, including the 1985 Efebo d'Oro prize at Agrigente for best literary adaptation of the year.

Adolphe Nysenholc

Translated by Marcelline Block and Jeremi Szaniawski

The Abyss

L'Œuvre au noir

Studio/Distributor:

Philippe Dussart
Films A2
La Nouvelle Imagerie
La Sept Cinéma/Union Générale Cinématographique (UGC)
Cecchi Gori Home Video

Director:

André Delvaux

Producers:

Jean-Claude Batz
Philippe Dussart

Synopsis

Zénon Ligre, a Renaissance humanist, returns to Bruges, the city of his childhood, under a pseudonym. Considered a heretic, a philosopher and a witch because of his activities as a scientist, his books are burned and he is wanted by the Inquisition. Gradually, he will be recognized, and eventually denounced, arrested, judged and sentenced to death. In order to escape the fire of the stake, he commits suicide in the Stoic manner, by slashing his veins. Why did he return to the place where he could most clearly be identified and easily captured? The viewer can surmise a few hypotheses, with no certainty.

Critique

This film is an adaptation of the eponymous novel by Marguerite Yourcenar, the distinguished Belgian-born French author and first woman elected to the Académie Française. Its genesis began with the 1981 Cannes film festival. Delvaux wrote to Marguerite

Screenwriter:

André Delvaux
based on Marguerite Yourcenar's novel

Cinematographers:

Charlie Van Damme
Walther van den Ende (cameraman)

Art Directors:

Claude Pignot
Françoise Hardy

Composer:

Frédéric Devreese

Editors:

Albert Jurgenson
Nadine Muse
Jean-Pierre Resnard

Duration:

110 minutes

Genre:

Historical drama

Cast:

Gian Maria Volonte
Philippe Léotard
Sami Frey
Jacques Lippe
Anna Karina
Jean Bouise
Marie-Christine Barrault
Mathieu Carrière
Senne Rouffaer
Marie-France Pisier

Year:

1988

Yourcenar that he had no intention of making an anticlerical film but that he wanted to depict the birth of a free man. The two met in 1986. Yourcenar, who received the screenplay, sent a telegram to Delvaux from Rabat, 24 February 1987, containing the following message: 'Très beau'.

The narrative is set during the wars of religion in the Netherlands. Delvaux, true to himself, does not deliver an epic, spectacular movie – for which he could no doubt not have found funding in Belgium – but rather focuses on the main character instead. The 400-some characters of the novel are reduced to about forty here, circling around Zénon. The narrative voice in the third person singular in Yourcenar's book is replaced, in the film, as per Delvaux's habit, by a more subjective perspective. We have the feeling of experiencing, from within, a consciousness moving through its time.

Films with a philosopher as the main character are very rare. In general, they are remakes of *Faust*, and the trap to avoid for the film-maker embarking upon such an undertaking is lapsing into didacticism. Delvaux thus made successive cuts in the four versions of his script in order to reach the essence of the story, evoking the alchemist he portrays in the film. He deleted most of the erudite words of the novel and invented images to render them concrete. Therefore, in order to show the scientific vocation of young Zénon, Delvaux does not mention that he studies Lucretius's *De Natura* with his tutor, canon Campanus; this detail would alienate the film's audience. Instead, he puts the child in a kitchen where his nanny prepares the food and makes him play with a chicken's leg from which the child pulls the tendon as though he were manipulating a puppet. This playful gesture, which visually represents his interest in science, is nowhere to be found in the novel; Delvaux re-invents the story in new images. His adaptation is an act of creation. Another example is when Zénon tries to flee: before returning, he crosses paths with children playing bocce ball with the heads of saints' statues. These young iconoclasts are doing with these idols what Zénon did with the ideas of his time, which he equally disrupts. Again, this scene is not in the book, which simply mentions that he walks past noisy children. We see here the creative expression of the film-maker who parades as the great image-maker, thus expressing his *weltanschauung*. If Yourcenar considers Zénon a pioneer of modern atheism, Delvaux's character is rather agnostic, which is concomitant with the magical realism that is present throughout his oeuvre, and which is founded upon doubt.

Made for 120 million Belgian francs (about three million dollars, ten times less than *The Name of the Rose*, dir. Jean-Jacques Annaud, 1986), this film's chiaroscuro universe is akin to a tribute to the German expressionism that Delvaux so revered, but also, through its story, forms a homage to the universes of Murnau's *Faust* (1926) and Dreyer's *Day of Wrath* (1943). At its 1988 Cannes film festival premiere, Delvaux's final feature was greeted by a four-minute standing ovation.

Adolphe Nysenholc

Translated by Marcelline Block and Jeremi Szaniawski

CHANTAL AKERMAN

Chantal Akerman was born in Brussels in 1950. Her Polish-Jewish immigrant parents relinquished religious observance after Chantal's grandfather passed away in 1968. The Holocaust – a recurring theme in Akerman's filmography – casts its dark shadow over her family, as it claimed many of her relatives, but fortunately her mother survived Auschwitz. According to Jonathan Rosenbaum, one 'obstacle to appreciating Akerman's films has to do with Akerman being a Belgian Jew – even though she has spent extended periods of her adult life and shot several of her films in both France and the U.S…because she is both Belgian and Jewish, Akerman has a stance that is essentially that of an outsider in an international context' (Rosenbaum 2011). Akerman speaks of her complex relationship to Judaism and the Old Testament prohibition against making graven images in a semi-autobiographical documentary, *Chantal Akerman par Chantal Akerman* (1997). *American Stories/Histoires d'Amérique: Food, Family, Philosophy* (1989), 'the first of Akerman's films explicitly devoted to the subject of Jewish experience' is 'an ambitious, unconventional avant-garde film about displaced Eastern European Jews trying to make a new life for themselves' (Bergstrom in Foster (ed) 2003: 95). In *From the East/D'Est* (1993), Akerman explores 'her parents' Eastern European Jewish imaginary' (Fowler in Foster (ed) 2003: 77), while 'often in connection with *News From Home* and *Meetings with Anna*, Akerman has talked about her identification with the wandering Jew' (Bergstrom in Foster (ed) 2003: 109).

Akerman was an aspiring writer, but after viewing Jean-Luc Godard's *Pierrot le fou* in 1965, when she was barely fifteen years old, she was struck by the muse of the Seventh Art. Three years later, she wrote, directed, and produced her first film, the Godard-influenced black-and-white short *Blow Up My Town/Saute ma ville* (1968), in which she cast herself as the solo protagonist, a female character with Chaplinesque gestures and a bob haircut reminiscent of Anna Karina.[1] Akerman's underlying interest in literature is evident in her later cinematic adaptations of Marcel Proust's 1923 *La Prisonnière* (the fifth volume of *A la recherche du temps perdu*) as *The Captive/La captive* (2000) and Joseph Conrad's first novel *Almayer's Folly* (1895) as *La Folie Almayer* (2011). Akerman compares the screenplay of her most celebrated film, *Jeanne Dielman, 23 Quai du Commerce, 1080 Bruxelles* (1975), which she wrote in a few weeks when she was 24 years old – the film was released when she was 25 – to a kind of Nouveau Roman and initially wrote her first feature film, *I, You, He, She/je, tu, il, elle* (1974), 'as a novel, not a film' (Akerman interview with Brenez 2011). According to Jean-Michel Rabaté, in his discussion of *The Captive*,

> Akerman's minimalism, anti-naturalism, stylized interactions, her Hitchcock-like insistence on voyeuristic exchanges and perverse innuendoes, along with her choice of a modern setting and relatively unknown actors (except for Sylvie Testud…), end up highlighting the very meaning of Proust's oeuvre in so far as at its very core there lurks an obsession with deviant sexuality … thus prolonging in an original manner Proust's own interrogations… (Rabaté in Block (ed) 2010: xii)

Akerman's films often rely upon documentary aesthetics marked by the use of long takes and the static camera, as in her first feature, *I, You, He, She*; in her most acclaimed film *Jeanne Dielman*, and in the New York City film *News from Home* (1977). Akerman's prolific filmography sweeps across diverse genres, including shorts (*Blow up my Town*; *The Room/La*

Chantal Akerman. Private collection.

Chambre, 1972; I'm Hungry, I'm Cold/J'ai faim, J'ai froid, 1984); silents (*The Room* and *Hotel Monterey*, both 1972); musicals (*The Eighties/Les années 80*, 1983; *Golden Eighties/Window Shopping*, 1986); more 'accessible' films (*Night and Day/Nuit et jour*, 1993; *A Couch in New York/Un divan à New York*, 1996 and *Tomorrow We Move/Demain on déménage*, 2004); documentaries (*The Eighties; On Tour with Pina/Un jour Pina m'a demandé*, 1983; *From the East/D'Est*, 1993; *Chantal Akerman par Chantal Akerman*, 1997; *Sud*, 1999; *From the Other Side/De l'autre côté*, 2002; *Là-bas*, 2006).

 Blow Up My Town contains, in kernel form, some of the major themes Akerman treated over the course of her career so far, namely, women engaged in domestic tasks and their occasionally tragic outcome. In *Blow Up My Town*, after the solo female protagonist has

finished her housework in an erratic, fashion, she bends over the oven, ignites a match, and provokes a gas explosion which presumably kills her. This scene, reminiscent of the explosive finale of *Pierrot le fou*, whose eponymous male protagonist blows himself up with a dynamite necklace – not without regret. But the solo protagonist of *Blow Up My Town* demonstrates no hesitation, but only a determination. *Jeanne Dielman*, made eight years after *Blow Up My Town*, returns to the thematic of female housework culminating in violence: Jeanne (Delphine Seyrig), a bourgeois widow raising her teenage son alone, is, unbeknownst to her son and neighbours, a self-employed sex worker. At the end of the film, she suddenly murders a male client after experiencing, unexpectedly, orgasm.

Throughout Akerman's oeuvre, focus is placed upon women protagonists' engagement with their surroundings, in particular their confining domestic spaces – 'most often it is a lone woman, and most strikingly the film-maker herself – as she cleans, eats, cooks, moves furniture, rocks under a blanket and writes' (Margulies 2006): *Blow Up My Town*'s kitchen; Julie's room in *I, You, He, She*; Jeanne Dielman's apartment in Brussels; *The Captive*'s elegant Parisian home where Ariane (Sylvie Testud), based on Marcel Proust's Albertine, is practically held prisoner by her possessive lover (the only way she is able to escape him is by drowning in the ocean); the duplex of *Tomorrow We Move*, whose clutter reflects the mother and daughter's inner sense of uprootedness and their inability to settle in one place – a legacy of the Holocaust; the studio in a Tel-Aviv high-rise, in *Là-bas*, where Akerman dwells. Akerman's exploration of 'the discomfort of bodies in rooms…would probably be my first choice… if I had to try to summarise the cinema of Chantal Akerman, thematically and formally, in a single phrase', states Jonathan Rosenbaum (2011). This leads to a critical reflection upon larger questions of marginalization, alienation, and deterritorialization bearing upon the female condition as women protagonists and characters attempt to navigate, resist and/or escape a patriarchal society. Mother-child are at the core of her films, in particular, *Jeanne Dielman*, *News from Home*, *The Meetings of Anna/Les rendez-vous d'Anna* (1978), *Tomorrow We Move*, and *Almayer's Folly*.

Akerman's films have been shown in art galleries and museums, where they have not only been screened, but were also resemantized as video installations, starting in 1995 with 'Bordering on Fiction: *D'Est*,' in which her documentary about the early days of post-Soviet Eastern Europe was reconfigured as a video installation. The installation 'Bordering on Fiction' (1995-1997) travelled throughout the US (the San Francisco Museum of Modern Art; the Walker Art Center in Minneapolis; the Jewish Museum in New York City) and Europe (Paris; Brussels; Germany, and Valencia). Among her installations, 'Chantal Akerman: Moving Through Time and Space', is her 2008 travelling exhibition originating at the Blaffer Gallery at the University of Houston before moving to the MIT List Visual Art Center, the Miami Art Museum and the Contemporary Art Museum in St. Louis, featuring five of Akerman's works from 1995 to 2007: *Là-Bas* and *South* screened in their original formats, with *D'Est* and *De l'autre côté* reconfigured as multichannel video installations, along with her commissioned installation *Femmes d'Anvers en novembre/Women from Antwerp in November* (2007). In 2011, Akerman's documentary *De l'autre côté*, about the US-Mexico border, was presented in the travelling exhibit 'Where Do We Migrate To?' (starting at the Centre for Art, Design and Visual Culture at the University of Maryland, Baltimore County, moving throughout the US to New York City, New Orleans, and El Paso, TX). In the spring of 2013, Akerman's *Maniac Shadows*, a multimedia installation, was screened at The Kitchen gallery/performance space in New York City (and also shown in Brussels). Exploring global nomadism and (mother-daughter relationships), *Maniac Shadows* features a video installation of images taken from/of Akerman's various places of residence around the world as well as a video recording of her live reading of her text *My Mother Laughs*, performed at The Kitchen on 11 April, 2013.

Along with these explorations of various foreign countries, Akerman had, from her earliest cinematic endeavors, featured Brussels as the background for some of her

narratives, after 'having blown up Brussels in her first short film, *Saute ma ville*' (Fowler in Foster (ed) 2003: 77). Although *Jeanne Dielman, 23 Quai do Commerce, 1080 Bruxelles* is set primarily within an apartment, Brussels is represented in the film's diegesis as well as embedded within its very title thus "situating' the beginnings of Akerman's cinema in Brussels' (Fowler in Foster 2003: 90). The name of the street of the Belgian capital where Jeanne lives and practises the world's oldest profession from within the confines of her bourgeois living quarters hints at the commercial relationships that Jeanne has with men. Her relationships to men are paid transactions, reflecting that her modus vivendi is grounded mainly on the commodification of her body: as her male clients leave her apartment, they pay her in cash, which she symbolically puts in a soup tureen. This is how she makes a living, supporting her son and herself. For Marsha Kinder, 'the full title of the film immediately tells us that Jeanne Dielman is defined and circumscribed by the space she occupies…the patterns of her life have been determined by the socio-economic structures of her society' (Kinder in Martin 1979: 43-44).

In *A Whole Night/Toute une nuit* (1982), romantic encounters between unnamed characters take place on a hot summer night in several Brussels locations. In this film, Akerman's objective 'was to film a Brussels that was not cold, as we often see it … a grey Belgium, but an overheated night in Brussels' (see Vlaeminckx interview of Akerman, this volume). For Catherine Fowler, in *A Whole Night*, 'Akerman's relation to Brussels is depicted overwhelmingly as one of ambivalence' and while the film 'formally and aesthetically refers to Belgian texts, thematically there seems to be…a distance between Akerman and her home city…Akerman casts her friends and family in a film which plays out a Belgian "magical" imaginary' (Fowler in Foster (ed) 2003: 87). The Belgian capital figures as an absent presence, a point of departure for exciting metropolises, 'the city to be escaped from if one is to escape the life of one's mother…as well as to be able to film' (Fowler in Foster (ed) 2003: 78) such as New York City in *News from Home*, Berlin and Paris in *The Meetings of Anna* or Paris in *I'm Hungry, I'm Cold*. In that short fiction film, two adolescent girls, who had left Brussels for the City of Light, discover, to their disappointment, that the bread does not taste the same in Paris as it does back home. According to Fowler, 'although it had been geographically left, Belgium was carried through Akerman's cinema, formally and thematically' (Fowler in Foster (ed) 2003: 89). Yet, 'while initially any links between Akerman and Belgium would seem to "place" Akerman, she resists the fixing which such an identity might imply through sustaining a sense of ambivalence to Belgium' (Fowler in Foster (ed) 2003: 91).

In 1971, the 20-year-old Akerman arrived in New York City, where her film-making journey truly began. At Anthology Film Archives on Manhattan's Lower East Side, she associated with avant-garde cineastes including Hollis Frampton, Jonas Mekas, and Michael Snow, whose work influenced hers. At the premiere of Snow's *La Région centrale*, she realized that even 'without a story, you could still experience something emotional and palpable. You don't need a [complex] story…[to] create suspense' (Akerman 2009). *Jeanne Dielman* hails from this concept.

During her New York stay, Akerman made several experimental films, including the silents *The Room* and *Hotel Monterey*, which illustrate her preoccupations with exploring the passage of time onscreen and the female character's relationship to the space in which she evolves. In the ten-minute *The Room*, Akerman lies in bed while the camera circulates continuously around that small room, filming her as it passes by. *Hotel Monterey* is a lengthier silent film that explores the eponymous welfare hotel – no longer in existence – on Manhattan's Upper West Side, filming it over the course of one day with a static camera and tracking shots of its lobby, elevator, hallways, and residents. This series of haunting tableaux are often likened by critics to Edward Hopper's melancholy portrayals of human alienation: with this early film, 'already Akerman is expressing an interest in the transient nature of modern urban life, with an emphatic eye towards spaces that underscore the discord of mobility – hotels, train stations – and the people who move between these spaces' (Foster 2003: 1). Yet in a 1977 interview in *Camera*

Obscura, Akerman described *Hotel Monterey* as 'an erotic film. I felt that way – *la jouissance du voir*' (cited in Martin 1979: 37).

Back in Belgium after New York City, Akerman made her first feature, the experimental black and white *I, You, He, She*, which explores female subjecthood through foregrounding her own sexuality and nudity. In it, Akerman plays the protagonist Julie, who, in the film's first section, is in self-imposed confinement to a room where she eats sugar from a bag, reads/writes letters, rearranges the furniture: 'enclosed in the bedroom, the heroine of *I, You, He, She* links involutive refuge-and infantile postures in a mode which is that of waiting, counting the days: a ceremony of anorexia' (Deleuze 2005: 196). She leaves the room, and, in the next two episodes of the film, experiences sexual encounters, first with a male truck driver (Niels Arestrup) from whom she has hitched a ride and then with her former female lover (Claire Wauthion), 'in a sequence that has attracted a great deal of attention from feminist critics' since 'the camera records the action in a scientific manner, the scene has often been noted for its self-conscious display of dehumanisation and lack of visual pleasure…the camera positioning is specifically meant to de-aestheticise the onscreen lovemaking, by making us aware of our offscreen voyeurism' (Foster 2003: 1-2). Same-sex desire and relationships are recurring motifs of Akerman's films, such as in *The Meetings of Anna*, *Portrait of a Young Girl at the end of the 1960s in Brussels/Portrait d'une jeune fille de la fin des années 60 à Bruxelles* (1994), *The Captive*, and *Tomorrow We Move*, illustrating Rabaté's claim that 'with Akerman, we are haunted by questions about love, jealousy, dehiscence between other-sex and same-sex patterns … the impossibility of love, the paradoxes of desire and the ambivalence of gender' (Rabaté in Block (ed) 2010: xii).

Following *I, You, He, She*, Akerman made *Jeanne Dielman*, the film that placed her on the map as a 25-year-old auteur: during its more than three-hour duration, the film foregrounds the everyday activities of the titular protagonist as she goes about her daily routine in an approximation of real time over a period of three days. This groundbreaking aesthetic choice foregrounded 'images between images' that are normally excluded from the big screen. *Jeanne Dielman* is acclaimed as the *urtext* of feminist film-making in terms of both content and form, which were considered groundbreaking. *Jeanne Dielman* opposes patriarchal traditions of filming the woman character for male viewing pleasure/visual consumption, such as by fragmenting the female body in close-up. By using medium shots rather than close-ups as well as long takes with a static camera, *Jeanne Dielman's* minimalist aesthetic denies patriarchal traditions of fetishizing, fragmenting, and objectifying the female body for the male gaze. Akerman stated in a 1977 interview with *Camera Obscura* that, 'I do think [*Jeanne Dielman*] is a feminist film because I give space to things which were never, almost never, shown in that way, like the daily gestures of a woman' (cited in Martin 1979: 24). Akerman later states, 'I won't say I'm a feminist film-maker … I'm not making women's films, I'm making Chantal Akerman's films', (Martin 1979: 24) This stance is espoused by Maryse Condé, who claims, 'I write neither in French nor in Creole. I write in Maryse Condé' (Condé 2013).

News from Home (1977), which follows *Jeanne Dielman*, provides a *cinéma vérité* documentation of New York City, set to Akerman's monotonous voice-over as she reads the letters her mother wrote to her from 'home' in Belgium. The film becomes an autobiographical account of Akerman's formative experiences as a struggling young female film-maker and, thus, forms a meditation upon the condition of the female artist/creator, another *leitmotif* of Akerman's filmography including *The Meetings of Anna* and *Tomorrow We Move*, which, along with *News from Home*, explore home and its dislocations for female characters. Moreover, 'exile is a recurring theme in her work. Major examples would include *News from Home*, *Les rendez-vous d'Anna*, *Toute une nuit*, *L'homme à la valise* (*The Man with the Suitcase*, 1983), *Golden Eighties*, *Histoires d'Amérique*, *D'est*, *A Couch in New York*, and *De l'autre côté*' (Rosenbaum 2011).

Tomorrow We Move centres upon the chaotic and unstable domestic arrangements of

widowed Catherine (Aurore Clément) and her adult daughter Charlotte (Sylvie Testud). Catherine's moves – first to, and then from Charlotte's Parisian duplex – bookend the film. Catherine's sense of displacement stems from the legacy of the Holocaust, in which Catherine's mother perished, during which Catherine was born and rescued as a child, and to whose 'third generation' of survivors Charlotte belongs. Catherine's new, larger country home is yet another site of female fugue and escape, as its previous female inhabitant ran away, leaving behind a husband and young child, who now reside in a small apartment. When Charlotte states 'I feel at home nowhere', she echoes Virginia Woolf's claim that 'as a woman, I have no country. As a woman I want no country. As a woman my country is the whole world' (Woolf, *Three Guineas* 1938: 109), a notion nearly universally applicable to Akerman's transient female protagonists, whose nomadism is an intrinsic quality impossible to transcend/resolve, whether they are traversing the boundaries of countries and cities as in *News from Home*, *The Meetings of Anna*, and *I'm Hungry, I'm Cold*, or whether they remain fixed within one location/interior setting as in *Blow Up My Town* and *Jeanne Dielman*. Deleuze draws a parallel between Woolf and Akerman, stating that in Akerman's films, 'in the same place or in space, a woman's body achieves a strange nomadism which makes it cross ages, situations, and places (this was Virginia Woolf's secret in literature). The states of the body secrete the slow ceremony which joins together the corresponding attitudes, and develop a female gest which overcomes the history of men and the crisis of the world' (Deleuze 2005: 196).

In her four documentaries made in the late 1990s and early 2000s, Akerman examines 'the commonplaces of exile, emigration, diaspora, and nomadism' (Allen in Block (ed) 2010: 270), as well as 'states of exilic displacement and linguistic discontinuity' (Block 2010: xlvii). These films, made in various locations throughout the globe marked by political strife, produce haunting ruminations about and meditations upon identity, belonging, culture, and the ever-present legacies of historical events and conflicts. Akerman treats early post-Soviet Eastern Europe in *D'Est* (1993); a recent example of racially-motivated violence and murder in the Southern United States in *Sud* (1999); Mexican immigrants attempting to cross the border into the United States in *From the Other Side/De l'autre côté* (2002), and Jewish exile/diaspora in the present-day Tel-Aviv of *Là-bas* (2006).

Presented herewith are reviews of exemplary Akerman films: her first, the short *Blow Up My Town*; her first feature-length narrative, *I, You, He, She*; her second and most acclaimed, *Jeanne Dielman*, and the semi-autobiographical *The Meetings of Anna*, all of which, through formal experimentation and innovation, explore female psyches and women's sexuality; *News from Home*'s homage to the gritty New York City in the 1970s; the 'irrepressible gaiety' (Deleuze 2005: 196) of the Brussels-set *A Whole Night*; the group of four documentaries, each filmed in a different part of the world – *D'Est*; *Sud*; *From the Other Side*; *Là-bas* – that form an 'exilic cinema ... representative of a postmodern homelessness' (Allen in Block (ed) 2010: 273), as does the comedic *Tomorrow We Move*, in which the female protagonists, in their quest for 'home' and belonging, oscillate between different residences in and outside of Paris; and literary adaptations *The Captive* (from Proust) and *Almayer's Folly* (from Conrad), which is selected as our Film of the Year.

Marcelline Block

Note
1. Akerman often makes an appearance in her films; according to Margulies, 'Akerman's presence in her films answers a deep personal need' (2006). Among others, some of her most memorable roles are Julie, the protagonist in her first feature film, *I, You, He, She/je tu il elle* (1974). In *Jeanne Dielman, 23 Quai du Commerce, 1080 Bruxelles* (1975), Akerman is the voice of an unseen character, an insecure housewife/neighbour who rings Jeanne's bell and monologues about mundane tasks such as grocery shopping and other domestic tasks, while remaining behind the door.

Blow Up My Town

Saute Ma Ville

Studio/Distributor:
Criterion Collection
Director:
Chantal Akerman
Producer:
Chantal Akerman
Screenwriter:
Chantal Akerman
Cinematographer:
René Fruchter
Editor:
Geneviève Luciani
Duration:
13 minutes
Genre:
Short
Cast:
Chantal Akerman
Year:
1968

Synopsis

In her studio located in a modern high-rise building, a young woman goes about domestic chores: mopping the floor, washing the dishes, cooking and then eating spaghetti, drinking wine, polishing her shoes, then dancing in front of the mirror, all activities performed with frenzy. She is preparing to commit suicide, evidenced by her sealing the front door with duct tape and igniting the gas, which blows up with a loud bang.

Critique

Chantal Akerman wrote, directed, produced, and starred in her first film, the short black-and-white *Blow Up My Town/Saute ma ville*, when she was barely 18 years old. This brings to mind Mozart, who, at that same age, composed his Symphony 25 in G minor/K.183 (1773), a 'stylistic prototype of the later K. 550 [Symphony 40 in G Minor, 1788],' (Laux n.d.). Similarly, *Blow Up My Town* is a precursor of Akerman's chef d'oeuvre, *Jeanne Dielman, 23 Quai du Commerce, 1080 Bruxelles* (1975). It also contains the major themes explored in Akerman's career as a director, spanning four decades: female protagonists engaging with their surrounding space(s), particularly oppressive and confining domestic environments; kitchen chores; and death, be it by suicide as in *Blow Up My Town*, *The Captive/La captive* (2000), and *Là-bas* (2006), or the post-coital murder of a john committed by Jeanne Dielman in Akerman's eponymous film, most acclaimed by critics. Of her debut film *Blow Up My Town*, Akerman stated, 'the first movie I made was my own… but I achieved what I wanted in that project, so it gave me confidence. I know a lot of young people who want to begin with a big feature and big actors. I didn't do it that way; I built my confidence little by little, step by step, film by film' (Akerman in Martin 1979: 29).

Akerman was inspired to make movies after viewing Jean-Luc Godard's *Pierrot le fou* (1965) at age fifteen (when she was an aspiring writer). *Blow Up My Town* has a strong Godardian element: not only is Akerman's dark, bobbed hairstyle reminiscent of Anna Karina's, Godard's muse/wife – the star of *Pierrot*, *Vivre sa vie*, *La Chinoise*, and other films of his – but also, *Blow Up My Town*'s explosive finale evokes how Ferdinand/Pierrot (Jean-Paul Belmondo) commits suicide in the final scene by blowing himself up with dynamite wrapped around his neck (after having shot and killed his former lover, played by Karina). Whereas Ferdinand/Pierrot changes his mind at the eleventh hour and tries to rid himself of the explosives in a desperate, unsuccessful attempt to escape death, Akerman's unnamed protagonist does not seem to have any regret about her decision to end her life. Couched within her off-kilter, jerky, Chaplinesque gestures are deliberate acts that prepare herself for her imminent suicide, such as, early on in the film, when she carefully seals shut the edges of her apartment door with duct tape, so that the gas from her oven will not escape and therefore prevent her from accomplishing her goal. The film's last moment depicts her leaning over the stove: she turns on the gas, which explodes loudly a few times, startling the viewer, as the screen fades to black. *Blow Up My*

Town 'announces literally with a bang Akerman's entry into artistic adulthood' (Margulies 2006). *Blow Up My Town* expresses a certain preoccupation with the tragi-comedy of life, depicted through the protagonist's frantic attempt at straightening up the kitchen, pots and pans clanging, and her last meal, devoured solo: spaghetti, a youthful favourite and a staple of Chaplin's films such as *The Gold Rush* (1925) and *City Lights* (1931), with pasta dripping out of her mouth in a grotesque resemantization of the final meal of a condemned person. These gestures of feeding or feasting recur in other Akerman feature films, although played out on a different scale: in *Jeanne Dielman*, the eponymous female protagonist (Delphine Seyrig) appears tidy and orderly as she breads a veal cutlet and mixes the ingredients for a meatloaf with graceful hands and elegant gestures in her kitchen, decorated with delft porcelain dishes – painted with tiny blue flowers – that she places on her cabinet shelves, after she has towel-dried them. She wears a peignoir, also of bleu de delft colours (which exemplifies a Dutch, Vermeer-esque aesthetic).

Blow Up My Town's notion of female housework culminating in violence and murder is also explored, albeit on larger scale in *Jeanne Dielman*. Parallels can be drawn between these two films (eight years apart): Both foreground domestic rituals, a ceremony of routine performed by a female in her kitchen, after which the woman goes on to commit a suicide or murder. The young protagonist of *Blow Up My Town* self-immolates, simultaneously destroying herself and her studio. Whereas Jeanne Dielman murders her third john a day after having an orgasm with her second client, which has shattered her habitual self-control, according to an Akerman interview (Akerman 2009). After killing him, Jeanne sits at her kitchen table, seemingly waiting, perhaps in shock, over the violence that just occurred to – and through – her. A line of flight can thus be traced from the suicide in *Blow Up My Town* to the murder in *Jeanne Dielman*. Although these two kitchens are very different, both films end with death: suicide and murder are not usually expected to occur at the end of a woman's day's work in her kitchen/home. In Janet Bergstrom's estimation, the final scene of *Blow Up My Town*, in which 'the girl sets fire to a letter she has propped on the stove (we never see what it says), turns on the gas and leans over the stove, awaiting the explosion that blows up not only "her city", but also, first of all, herself' is linked to the opening of *Jeanne Dielman*: 'before the opening credits, we can hear the loud sound of a jet of gas, a sound we hear later every time Jeanne turns on the kitchen stove' (Bergstrom in Foster 2003: 104).

Yet the two films differ, in terms of form and content. In an interview with Nicole Brenez, Akerman describes *Blow Up My Town* as 'the opposite of *Jeanne Dielman*' (Akerman interview with Brenez 2011). While *Blow Up My Town* literally hums – with its extradiegetic music of Akerman who 'sings' (la-la-la) with the intrusiveness of a troubled child vying for attention, especially as she becomes louder and more persistent' (Bergstrom in Foster 2003: 103) – and bursts with a manic energy until its final, explosive frame, the slow and controlled pacing of *Jeanne Dielman*, at over three hours, with extended sequences filmed with a static camera, allows for a gradual build up of the tension that comes with the unravelling of Jeanne's strict household routine, itself depicted in near-real time for a period of three days.

When Jeanne meticulously polishes her son's shoes, the spectator is reminded of *Blow Up My Town* in which the frenzied protagonist polishes her own shoes while she is still wearing them – smearing black polish all the way from the tips of her shoes to her bare calves and knees (including her white socks) 'until she has also brushed her legs and stained the floor around it black' and thus 'the same gesture seems to produce at once disarray and tidiness. For a while, it is enthralling to try to sort out one from the other' (Margulies 2006). Polishing shoes in a Chaplinesque manner, which began as a mad gesture in *Blow Up My Town* – the depiction of an erratic moment – is transformed into precise gesture in *Jeanne Dielman*, when performed by the complex homemaker/widow/mother/prostitute Jeanne.

Blow Up My Town inaugurates what Stanley Cavell calls Akerman's 'new discovery of the violence of the ordinary' (Cavell 2005: 259), to which she would return and examine, on a much bigger scale, less than ten years later, in *Jeanne Dielman*, a film which, like *Blow up my Town*, foregrounds domestic ritual performed by a female protagonist and ending in violence.

Marcelline Block

I You He She

Je tu il elle

Studio/Distributor:

French Ministry of Foreign Affairs
Paradise Films

Director:

Chantal Akerman

Producer:

Chantal Akerman

Cinematographers:

Bénédicte Delesalle
Renelde Dupont
Charlotte Szlovak

Art Director:

Michel Fradier

Synopsis

This black-and-white work in three episodes begins with twenty-something Julie (the eponymous 'Je', or 'I', played by Akerman, who also wrote and directed the film) alone in a small room, as a first-person voice narrates her activities, sometimes anticipating them, sometimes explaining them *a posteriori*. In the same room, for weeks, she writes letters and sprinkles them with sugar. She undresses often, revealing a beautiful young body, and inviting the looks of passersby. Out of sugar, she leaves the house and hitchhikes with a trucker about ten years her senior ('Il', or 'him' in English, played by Niels Arestrup). Listening to radio programmes from around the world, they travel together in his rig, pausing at restaurants along his trucking route. He tells her about his family and sex life, and they grow close. Then, Julie visits a young woman her own age ('Elle'), with whom she dines. In a powerful, raw ending, the two embrace.

Critique

I, You, He, She/Je, tu, il, elle evokes sensuality through stirring play with light, nudity, and languorous long takes. Its frank portrayal of female sexuality remains potent yet unspectacular. Through a free and frequent display of Akerman's own body, the viewer is implicated in a kind of barely-conscious voyeuristic complicity, amplified by the fact that Akerman elects to expose herself twice, as auteur and actor, and yet is simultaneously orchestrating that process, down to the angle of each individual shot. Made directly before *Jeanne Dielman, 23 Quai du commerce, 1080 Bruxelles*, the film which put Akerman on the map, and which, likewise, deals with female sexuality, *I, You, He, She* is an example of an experimental film director making a fictional narrative that functions in both camps. Unlike some of Akerman's films which

Niels Arestrup and Chantal Akerman in
I, You, He, She. The Kobal Collection.

Sound:

Marc Lobet
Alain Pierre

Editors:

Luc Fréché
Geneviève Luciani

Duration:

90 minutes

Genre:

Drama/erotic/art

Cast:

Chantal Akerman
Niels Arestrup
Claire Wauthion

Year:

1974

contain continuous dialogue or voice-over, *I, You, He, She* is largely devoid of the narrative fabric that holds those other films together.

I, You, He, She has often been considered in the context of feminism, which was emerging as a major force in film theory and film-making at the time. As Laura Mulvey was breaking new ground on gendered spectatorship in the cinema and the power relations embedded and performed therein, Akerman was making films about the particularities of women being in the world and their bodies as gazed-at objects ('to-be-looked-at-ness'). Yet, Akerman herself has often been reluctant to align her films with specific ideologies and movements, instead emphasizing the work on its own. Just as she refuses to allow her films to play in gay and lesbian film festivals for fear of 'ghettoizing' them, Akerman does not identify as a feminist film-maker.

Although some have viewed this policy as a rebuke, one might argue that the Akerman of *I, You, He, She* was in many ways a post-feminist film-maker *avant la lettre*. *The film* insists not only on women's bodies as object of the camera's and spectator's gazes, but on the

fundamental multivalence of the power relationships at work in this process, going so far as to illustrate that women are not only objects of the male gaze, but that women, too, may spectate under its aegis. Just as Akerman organizes the *mise-en-scène* as screenwriter and director, she also submits her own nude body to it – and to the audience's gaze – as an actor. Akerman insists on this complex process of self-representation, but does not define it in ideological terms, wary of allowing her work's reception to be defined by the very feminist movement which often claimed it as an avatar. Although her cinema is clearly about women – their worldviews, sexuality, thoughts, and desires – it does not seek to exempt them from the greater whole of experience, but nevertheless insists on their presence therein.

Much like Julie, whose initial isolation gives way to ever-more intimate human contact, *I, You, He, She* begins closed-off, clamped down, and terse, but ends with an irruptive expression of sensuality that holds nothing back. It is through the journey between these two poles that Akerman – a film-maker who composes her art through the studied application of restraint and excess – shows her mastery.

Jonathan Robbins

Jeanne Dielman 23 Quai du Commerce 1080 Bruxelles

Studio/Distributor:

Ministère de la Culture de la Communauté française de Belgique/Carlotta Films
New Yorker Films
Janus Films
Criterion Collection

Director:

Chantal Akerman

Screenwriter:

Chantal Akerman

Cinematographer:

Babette Mangolte

Art Director:

Philippe Graff

Editor:

Patricia Canino

Duration:

201 minutes

Synopsis

A bourgeois widow, Jeanne Dielman, who lives with her adolescent son Sylvain in Brussels, secretly earns her living as a prostitute. She services one male client a day at home while Sylvain is at school. In this film, for three days (Tuesday-Thursday), Jeanne goes about her daily homemaking routine: cleaning, cooking, shopping, and even babysitting an infant boy for her neighbour. Everything appears routine, until on the second day, Jeanne's well-organized routine starts to unravel.

Critique

Jeanne Dielman placed Chantal Akerman on the cinematic map as a 25-year-old auteur with worldwide attention to her artistic influence. Groundbreaking in both content and form, *Jeanne Dielman* has been acclaimed as one of the most significant films of the twentieth century as well as the *urtext* of feminist film-making (although Akerman rejects labels and categorizations, including that of feminist). During its more-than-three-hour duration, *Jeanne Dielman* foregrounds the everyday domestic tasks of its titular protagonist, a widow raising her adolescent son, while performing the daily chores of a mother/homemaker in what appears to be real time. This revolutionary aesthetic choice foregrounds the 'images between images' that are usually not shown on the big screen and yet form the core of the protagonist's existence, like the generations of housewives and stay-at-home mothers whose very 'invisibility,' as they perform domestic rituals, inspired Akerman to make a film showcasing the realities of their life's work.

Jeanne Dielman became a turning point in film-making because representing 'women's work' in what feels like real-time was an

Genre:

Drama

Cast:

Delphine Seyrig
Jan Decorte
Yves Bical
Jacques Doniol-Valcroze
Henri Storck
Chantal Akerman (voice)

Year:

1975

unusual subject matter. The film was 'shocking, less because it depicted the apparently senseless murder of a customer by an occasional prostitute than because the audience had to follow the process of boiling water or peeling potatoes in real time' (Rabaté in Block (ed) 2010: xi) (this traditionally-female activity of peeling potatoes is resemantized as a male activity in Claire Denis' *Good Work/Beau Travail* (1999) when a group of male legionnaires prepares a meal together, thus inverting an established gendered division of labour). *Jeanne Dielman*'s aesthetic choices and formal elements include 'long, low-angles, static shots associated with ''objective realism''' (Allen 2010: 258), no extradiegetic music nor reverse shots and monologues in favour of dialogue. By using the static camera in extended silent sequences which do not follow Jeanne but, rather, allow her to move back and forth under its apparatus while performing her activities, Akerman refuses to employ traditional, patriarchal conventions of filming/framing women by fetishizing/fragmenting their bodies (such as through close-ups, reverse shots, or slow motion).

Appearing at the height of Second Wave Feminism in 1975 – along with several major feminist texts such as Hélène Cixous's 'The Laugh of the Medusa', Laura Mulvey's 'Visual Pleasure and Narrative Cinema' as well as Marguerite Duras' film *India Song* – *Jeanne Dielman* made a lasting contribution to female/feminist film-making practice and theory. As noted by Rabaté, 'just when Mulvey was denouncing the domination of the male gaze in Hollywood films depicting women as subjects of desire and subjugation, a female director [Akerman] was turning the tables (kitchen tables, no doubt) on the male setup of voyeurism and dominance' (2010: xi). Akerman's cinematic technique can be understood as representing the female as a subject in her own right.

Jeanne Dielman is considered the *urtext* of feminist film-making in terms of both content and form, which were – and remain – revolutionary, as was its primarily female crew, including cinematographer Babette Mangolte, although, in Akerman's words, 'I wasn't out to provoke in any way ... I wanted to show [that] we could do it' (Akerman 2009). With *Jeanne*, Akerman performs 'a pivotal role in the unfolding of film-making [as she] has constructed new means of presenting the world' and inaugurates 'a new discovery of the violence of the ordinary' (Cavell 2005: 259). In his discussion of *Jeanne Dielman*, Stanley Cavell describes Akerman's approach to her subject matter, in particular the long takes with the static camera, as no less than 'prophetic'. He compares her to Beckett, Chekhov, Emerson, Nietzsche, and Rousseau (Cavell 2005: 259-60).

Despite *Jeanne Dielman*'s impact upon female/feminist film-making and film theory, Akerman does not align herself nor does she identify with any school of thought nor ideological movement and rejects classification, including the label of feminism: she is 'a good example of that generation of feminist film-makers who did not follow in the paths of their male elders, but also refused to paint themselves in the corner of 'experimental' or 'avant-gardist' cinema' (Rabaté 2010: xi).

Of *Jeanne Dielman*, Akerman stated that the subject matter was inspired by her observations of the day to day lives of her female relatives around whom she grew up: 'I made this film to give all these actions that are typically devalued a life on film. If we saw

Delphine Seirig as *Jeanne Dielman*. [Ministère de la Culture Française de Belgique, Paradise Films, Unité Trois.]

someone making beds … we wouldn't really see that person, just like men are blind to their wives doing dishes' (Akerman 2009), foregrounding traditional women's labour within the home and confronting the viewer with it. Central to the film's narrative over the course of its more than three hours are Jeanne's seemingly-tireless array of domestic tasks, performed in sequence. This routine includes polishing her son's shoes, folding clothes, preparing meals as well as running errands, grocery shopping, and babysitting a neighbour's infant. 'Starting with *Jeanne Dielman*, Akerman wants to show 'gestures in their fullness''' (Deleuze 2005: 196).

Jeanne holds on to her domestic routine, since 'knowing [at] every moment of every day what she must do … brings a sort of peace and keeps anxiety at bay' (Akerman 2009). On the second day, her routine unravels; in an interview, Akerman states that it is because she experiences pleasure for the first time with a client, and this disturbs her a great deal: as a result, her potatoes are burned, she forgets to cover the soup tureen, and she has to start cooking dinner all over again. Unexpected pleasure 'destroys the rhythm and rituals of her life', those 'rituals which keep her together' (Akerman 2009). As Jeanne's domestic routine comes undone throughout the third day, culminating in her murdering her client, the film shows 'how tenuous Jeanne Dielman's control over her life was… suggesting something like a feminist *Waiting for Godot,* with the difference that the final twist turned to sudden horror' (Rabaté 2010: xi): the murder, followed by a final scene of Jeanne sitting at her kitchen table: 'the almost unendurable long take of the woman sitting at a table for several

minutes after the murder (doing absolutely nothing) discourages audience identification, even as it builds tension' (Foster 2003: 2).

Therefore, *Jeanne Dielman*'s narrative is at the antipodes of the Cinderella fairytale narrative. In Perrault's tale and in Disney cartoon version, Cinderella performed all of her housework duties fastidiously and cheerfully. At the end of the patriarchal tale, the good little houseworker, as a reward, marries the prince, a narrative which reflects how patriarchy rewards a girl whom it deems worthy – a 'good girl' according to patriarchal dictates – and recognizes her for her efficient service in a male-dominated system. Yet *Jeanne Dielman* subverts the patriarchal ideal of valorizing women's housework since, despite Jeanne's constant service to the men in her life – her son, her neighbour's baby boy, and of course, her male clients – she refuses to submit or to succumb to patriarchal dictates for women. She chooses instead to remain independent and, as head of her household, raise her son alone. Unexpectedly, she seizes a pair of scissors from her vanity and slits the throat of her third day's male client in a scene that functions as the absolute antithesis to the patriarchal fairytale's conclusion: there will be no happily ever after for Akerman's Jeanne nor for Jeanne d'Arc (the comparison between these two Jeannes is made by Austrian film-maker Daniel Hoesl in his 2013 film *Soldier Jane/Soldate Jeannette* (Titze 2013)).

Jeanne Dielman's content and form subvert accepted mythologies about female submission and enslavement to their housework as well as patriarchal conventions of film-making in representing women for the male gaze/scopophilia, and thus 'develops a female gest which overcomes the history of men and the crisis of the world' (Deleuze 2005: 196).

Marcelline Block

News from Home

Studio/Distributor:

Institut National de l'Audiovisuel (INA)
Paradise Films
Unité Trois
ZDF/Carlott Films
Eclipse from the Criterion Collection
World Artists

Director:

Chantal Akerman

Producer:

Alain Dahan

Screenwriter:

Chantal Akerman

Synopsis

Set in New York City in the 1970s where Chantal Akerman was starting out as a young film-maker, the camera roams around the city, filming its streets and pedestrians in long, often static takes, while Akerman herself, in voice-over, reads letters from her mother back 'home' in Brussels. Her mother's letters are filled with news about relatives and friends – their engagement parties, break-ups, vacations, her parents' business, her father's health. In her letters, Akerman's mother asks about Akerman's life in the US. She wishes to understand why her daughter left Brussels for New York without saying goodbye. Akerman's mother longs to know when her daughter will return home to Brussels.

Critique

Chantal Akerman made several films in New York City in the 1970s, including the two silents *The Room/La chambre* and *Hotel Monterey* (both 1972), the unfinished *Hanging Out Yonkers* (1973) and *News from Home* (filmed in 1976). *News from Home* depicts the gritty New York City of that period where Akerman, in her early twenties,

Cinematographers:
Jim Asbell
Babette Mangolte

Sound:
Dominique Dalmasso

Editor:
Francine Sandberg

Duration:
85 minutes

Genre:
Drama/documentary

Cast:
Chantal Akerman (voice-over)

Year:
1977

lived, associating with Anthology Film Archives' avant-garde film-makers including Hollis Frampton, Jonas Mekas, and Michael Snow. In Manhattan, Akerman made films while working odd jobs such as waitressing to support herself and her film-making. Akerman describes *News from Home* as her 'relationship to New York' (Akerman in Martin 1979: 29).

News from Home evokes the New York City as depicted in classic films from the 70s, particularly Martin Scorsese's *Mean Streets* (1973) and *Taxi Driver* (1976). Prefiguring Godfrey Reggio's *Koyaanisqatsi: Life Out of Balance* (1982) as a meditation upon the human body engaging with its surroundings and the anomie produced by living in contemporary urban settings, *News from Home* provides a *cinéma vérité* documentation of the cityscape: downtown urban canyons, the subway system and buses, businesses more eerie than bustling, pedestrians walking by. Set to Chantal Akerman's monotonous voice-over as she reads her mother's letters, the film is also an autobiographical rendering of Chantal's formative experiences as a film-maker struggling financially yet blossoming artistically, while in a foreign country – a potentially-dangerous environment.

In inaugurating a psychogeographical poetics of New York City through exploring the metropolis' streetscape, *News from Home* invokes the 'rhetoric of walking' – unique to New York City in the US, since most US cities are made for driving rather than walking – as discussed by Michel de Certeau in his iconic essay, 'Walking in the City' (1980), which seeks to

> locate the practices that are foreign to the 'geometrical' or 'geographical' space of visual, panoptic, or theoretical constructions. These practices of space refer to a specific form of *operations* ('ways of operating'), to 'another spatiality' (an 'anthropological', poetic and mythic experience of space), and to an *opaque* and *blind* mobility characteristic of the bustling city. A *migrational*, or metaphorical, city thus slips into the clear text of the planned and readable city. (Certeau 1999: 128)

News from Home's nonlinear unfolding articulates a search for meaning and belonging amidst the long, often static takes of passers-by, streetscapes, and subway cars, culminating with the powerful New York City skyline featuring the formerly standing Twin Towers (1973), which were, at that time, recently erected (merely three years before the film was shot). The doomed Twin Towers were destroyed in a terrorist attack on 9/11/2001; their destruction occurred approximately a quarter of a century after *News from Home* was filmed, rendering this film not only a historical monument, but also almost a relic. Proudly profiled on the New York horizon, the Twin Towers represented the power, ingenuity, and achievement of the human mind at its greatest. In Akerman, the towers are present, vibrant, nearly alive as they were, and as they will remain nostalgically in memory. For de Certeau, the World Trade Center was 'the most monumental figure of Western urban development' (1999: 128). From the mobile vantage point of the Staten Island ferry, where the camera captures these skyscrapers as they slowly recede and then fade in

the distance, viewers re-experience a wide array of feelings for these pictures-as-relics/memorials of the recent past, preserved/eternalized onscreen by Akerman.

In *News From Home*'s representation of what de Certeau calls a metaphorical/migrational New York – 'la ville tentaculaire', to cite Akerman's compatriot, celebrated nineteenth/twentieth century francophone Belgian poet Emile Verhaeren (1855-1916) – Akerman takes on the role of the European visitor/outsider to the United States, recording impressions/observations/reflections about the new world, almost following in the footsteps of Alexis de Tocqueville's *Democracy in America* (1835-1840). *News From Home* also recalls Michel Butor's travelogue *Mobile* (1962) about his discovery of the United States. *News From Home* emblematizes the Baudelairean/Benjaminian flâneur, whose perambulations in the city have no fixed starting point but proceed from an ethic of walking with no destination in sight, whose purposelessness engages with the cityscape. In *News from Home*, as anonymous people cross in and out of the frame, they function as what de Certeau calls 'ordinary practitioners of the city' (1999: 128):

> They walk – an elementary form of this experience of the city; they are walkers, *Wandersmänner*, whose bodies follow the thicks and thins of an urban 'text' they write...The networks of these moving, intersecting writings compose a manifold story that has neither author nor spectator, shaped out of fragments of trajectories and alterations of spaces...The operation of walking, wandering, or 'window shopping', that is, the activity of passers-by, is transformed into points that draw a totalizing and reversible line on the map. (de Certeau 1999: 128-131)

Here, it behooves us to recall that *Window Shopping/Golden Eighties* (1986) is the title of Akerman's musical film, set inside a Parisian shopping centre – for de Certeau, 'window shopping' is an integral aspect of the 'the activity of passers-by': '*News from Home* embraces de Certeau's metaphor: the subject here dwells in the city spaces as she dwells in "the house of language"...the notion of embodiment, both in the human body and in the spaces of the city, is imbued with creativity: one gives shape to space by walking through it' (Barker in Foster (ed) 2003: 47).[1]

Akerman's flat voice is heard throughout the film as she monotonously and dispassionately reads her mother's letters from Belgium, the film's titular 'home'. Yet what is the meaning of 'home' for Akerman, and where is her 'home'? Is it Brussels, which she had precipitously left as a young adult, without any warning? Is 'home' New York City where, like countless immigrants, she had come, seeking refuge, inspiration, aspiration, with a heart filled with dreams and a camera loaded with film? Sadly, neither of these places can fill the role of 'home': 'her mother is, in a sense, "homeless" in the Brussels family home after the departure of her daughter; Akerman is "homeless" in Manhattan' (Barker in Foster (ed) 2003: 44). The footloose mother cannot anchor herself and is given to pangs of anguish gripping her as she endlessly seeks to recover her precious offspring, Chantal.

Thus, *News From Home*, in exploring the human search for belonging, 'bridges the geographical situation of "home" and its philosophical

theorisation by interrogating the Heideggerian (im)possibility of home…whether that "home" could only exist in its mythic forms and representations' (Block 2012), exemplifies the Lukacsian 'experience of modernity [as] compared to transcendental homelessness' (Boym 2011: 32) and Rousseau's concept of the state of nature as 'a State that no longer exists, which perhaps had never existed, which probably will never exist, and of which it is nonetheless necessary to have the right concept' (Rousseau 1964:123, trans. mine) applied here to Akerman's state of anomie, rootlessness, estrangement, nomadism, and exile. Novalis claims that 'philosophy is really homesickness, the wish to be at home everywhere' (Schuster 2011: 34). Akerman's homesickness here is diffuse; she does not really seek a return to Brussels, as she, a wandering author, belongs everywhere and, could state, as did her beloved Charlie Chaplin, that she is 'a citizen of the world'.

News From Home forms a haunting meditation upon the human quest for belonging as well as the search for and meaning of home in all its discontents/dislocations, particularly for female characters, to which Akerman returns throughout her filmography, such as in her fiction films *The Meetings of Anna/Les rendez-vous d'Anna* (1978), *A Couch in New York/Un divan à New York* (1996), and *Tomorrow We Move/Demain on déménage* (2004) as well as in her documentaries *From the East/D'Est* (1993), *Sud* (1999), *From the Other Side/De l'autre côté* (2002), and *Là-bas* (2006), which foreground these concepts on a global scale. Throughout the above films, she expresses a muted pang of anguish that is also experienced by the rootless, the uprooted, homeless, vagabond, estranged, foreign, displaced, exilic, stateless, unattached, floating, wandering, unbourgeois, expatriated, and nomadic individuals.

Marcelline Block

Note
1. For further discussion of de Certeau and *News From Home*, see Jennifer Barker in Gwendolyn Foster, ed (2003), especially pp. 41-42, 46-47, 50-51, 53.

The Meetings of Anna

Les Rendez-vous d'Anna

Studio/Distributor:
Criterion Collection
Director:
Chantal Akerman
Producers:
Alain Dahan
Maya Faber-Jansen

Synopsis

Anna Silver, a single, successful film-maker, is in Germany to present one of her films. She invites Heinrich, a handsome blond German man, to her hotel room. Smitten with her, Heinrich invites her to his daughter's birthday party, where he relates his version of German history and expresses his desire to see her again. Anna, however, remains cold and aloof. In the train station, she meets an old family friend from Poland, a Jewish woman who survived the concentration camps and who prefers the German language to French, although neither is her native tongue. On the train home, Anna talks with a dark, intriguing German stranger. In Brussels, she meets her mother, and the two spend the night in a hotel, talking intimately. Arriving in Paris, Anna meets her ex-lover Daniel. Returning to her apartment, she listens to her phone messages.

Cinematographer:

Jean Penzer

Art Director:

Andre Fonteyne

Editors:

Pierre Louis Lecoeur
Catherine Spanu

Duration:

127 minutes

Genre:

Drama

Cast:

Aurore Clément
Helmut Griem
Magali Noël
Hanns Zischler
Jean-Pierre Cassel
Lea Massari

Year:

1978

Critique

In each of Anna's meetings, she is alone in a different way and plays various roles. Her meetings are as much encounters with her other selves as with other people.

Chantal Akerman's films are often most potent in their elisions and silences. What Heinrich skips over in his heartfelt discourse on the history of Germany – World War II – is the most powerful non-presence at work in Anna's existence, not to mention its governing role in her relation to him. The contents of this elision are in many ways the contents of Anna's narrative, of European Jews – a group to which Anna is both a member and an outsider. Akerman's decision to have Anna dye her hair blond (all the people she is closest to have dark hair) exteriorizes the outsider status she feels within herself. Struggling in the shadow of the Holocaust, on the very soil on which it happened – its trains, its languages, the people who lived through it but yet did not – Anna's meetings are populated with strangers she will never really know. And she is aware of this.

In The Meetings of Anna, Akerman touches on some of the twentieth-century's most compelling narratives: those regarding the Shoah, gender relations, and sexuality. Akerman's insight, that we create the world we know from details, much as cinema does, is explored with depth, wit, and room for play that make the film more gripping than its narrative and formal structures would suggest. The Meetings of Anna captures something ineffable about life that rings true, even though the film never really articulates its insights, nor does it claim them as its own. Rather, it arranges ellipses and silences, as if these were the purest style for illuminating the normally unseen real world from which the film itself draws its verisimilitude and force.

In one fascinating scene, Akerman challenges the viewer with a whiff of sex between Anna and her mother. Such provocation challenges the norms and codes with which we parse the cinema, which are put in relief by the film's slight but powerful paradigm shifts; in this case, Anna recounts a sexual experience to her mother, as the two lie together in the dark, naked. Akerman's is a cinema in great part about women, about women in the world, about patiently focusing on women as primary subjects. The tension accompanying Anna's intimate revelations to her mother, as their arms touch in the dark, is palpable. It reveals a sphere of womanly life – camaraderie, emotional closeness underrepresented in cinema. The image of Anna in bed with her mother recalls the first time we see Anna in bed: with Heinrich. There she was naked, with full breasts and hips, a sexual entity. Here, she is another woman's child. Her multiple identities can be seen as at once a blessing and a handicap. Anna is in perennial exile from Belgianness, Europeanness, Judaism, and from her own womanhood. Her sexuality extends to both men and women, and not to any one person in particular. She can be described as a free, happy, independent and fulfilled woman, yet the defamiliarizing aesthetics of the film (rigorously composed of long takes) also present her as estranged, aloof and lonely. In the film's final scene, when she listens to the messages left on her answering machine, many themes dear to Akerman, absence, transience and memory at the fore, are effectively thematized.

Jonathan Robbins

A Whole Night

Toute une nuit

Studio/Distributor:

Ministère de la Culture de la Communauté française de Belgique

Director:

Chantal Akerman

Assistant Directors:

Liria Begeja
Ignacio Carranza
Jean Philippe Laroche
Pierre de Heusch

Producers:

Paradise Films
Avidia Films

Associate Producers:

Gerick Films
Lyric Films
Partner's Production
Centre Bruxellois de l'Audiovisuel
Film International
Ciné 360

Cinematographers:

Caroline Champetier
François Hernandez
Mathieu Schiffman

Sound:

Ricardo Castro
Miguel Rejas
Henri Morelle
Daniel Deshays

Editors:

Luc Barnier
Veronique Auricoste

Duration:

87 minutes

Year:

1982

Synopsis

A summer night in Brussels, from dusk til dawn. People meet and part ways.

Critique

A Whole Night/Toute une nuit begins with a low, suspenseful thrum of string instruments. This sound accompanies the title credits and fades abruptly with the film's first shot: a view of Brussels, its Gothic city hall tower distinct in the gathering dusk. Gino Lorenzi's syrupy pop song, 'L'amore perdonerà' immediately replaces this single note, but the disquiet it has introduced to the film does not disappear. The feeling is transfused into each of the dozens of vignettes on the subject of love that comprise *A Whole Night*. Taken together, they form a condition rather than a narrative: the condition of desire, as constant as it is insatiable. Love affairs and lovers are not the end points of this desire but, rather, two of many nodes to which it can attach.

Over and over again, couples pace, embrace, and part. Some press hard against each other, dancing. Their awkward and hungry displays of affection illustrate the paradox of romance: its conception can take place in the public sphere, but its consummation belongs in private. Two of these dance scenes are shot in long takes in deserted cafés. Jukeboxes seem to provide the music, but many times Akerman chooses not to distinguish the diegetic from extra-diegetic. Lorenzi's song continually recurs on the film's soundtrack, fading in and out of various scenes rather than starting and ending. This melody and others fuse with one another associatively as if the film were a radio, changing frequencies at random.

A Whole Night does not dwell long enough on any pair to define them individually for the viewing audience. We never learn the backgrounds of these love affairs or the names of those involved; couples represent a dynamic rather than an established relationship. Strangers or intimates, requited or unrequited lovers, they climb into bed with one another or leave their beds to wander through the summer night. The viewing audience wanders as well, traversing the city from centre to periphery and back again. The tender, casual documentation of Brussels – its tulip glasses of Belgian beer, worn café interiors, and *art nouveau* ornament – suggests that the city is yet another beloved to discover and abandon.

After an hour, the tempo of these *rendez-vous* slackens. The urgent embraces of the first two-thirds of the film now give way to insomnia, loneliness, and oppressive calm. Akerman finishes off this balmy night of desiring with a thunderstorm. 'I hope it's going to rain', a woman in her nightgown says to her lover, as they stand in a dark apartment. 'It'll be better afterward'. They do not hug, but rather turn away from one another to watch the downpour from separate windows. The storm offers relief from the intensity of the night's interactions but, after dawn breaks, desire resumes. One couple checks out of a hotel, rushing to another destination. Another slow dance takes place, this time in a hallway, until it is interrupted by a mysterious phone call. The din of un-locatable car traffic crescendoes. When the woman who has answered the phone hangs up, she rolls into the arms of her reclining lover.

Unlike most feature films, *A Whole Night* does not allow its viewers to identify in a conventional manner with its fictional world. Instead, the film is a conduit, like the countless corridors and stairwells and other *lieux de passage* its inhabitants move through. The places, the plights and the manifold kinds of touch Akerman shows us are merely pretenses; the film's true aim is to arouse our own emotional memory of desiring and being desired in these same kinds of situations. In this way, Akerman makes us aware of the limit of cinematic illusion: all films lure us in by promising an embodied experience they do not actually provide. Her film reveals its own production of desire and explores desire in its narrative at the same time.

Jennifer Stob

From the East

D'Est

Studio/Distributor:

Icarus Films
le Centre de l'Audio-Visuel à Bruxelles (C.B.A.)
RTBF (Carré Noir)
le Gouvernement de la Communauté Française de Belgique
la Loterie Nationale

Director:

Chantal Akerman

Producers:

Lieurac Productions
Paradise Films
La Radio Télévision Portugaise

Cinematographers:

Raymond Fromont
Bernard Delville

Sound:

Pierre Mertens
Thomas Gauder
Didier Pecheur

Editors:

Claire Atherton
Agnès Bruckert

Duration:

107 minutes

Genre:

Documentary

Synopsis

A series of shots (mostly extensive, lateral tracking shots) reveal the everyday life of a town in immediate post-Soviet Eastern Europe.

Critique

Akerman has written that *D'Est* (which translates as 'From the East') was motivated by her desire to record a journey across countries of the former Eastern bloc, 'while there's still time.' Her un-narrated, non-narrative film essay documents the psychogeography of Poland, Russia, and the former East Germany. She approached the East as an intimate stranger; as a Belgian born to Polish-Jewish immigrant parents, she has an ancestral kinship with the East that must always remain indirect. *D'Est* makes use of this personal distance in its subtle historical and social observation. It captures the expectancy, poetry, and lingering numbness pervading the lives of those who experienced Communism's dissolution day by day. Three types of long takes compose the film, shifting the audience between public and private atmospheres: fixed long takes constellated by traffic and people; fixed shots of home interiors with *tableaux vivants* of those who live there; and traveling shots which flank or circle vast indoor and outdoor spaces.

The opening shot of *D'Est* is more pattern than picture: we see horizontal bands of varying thicknesses and colours – black, bottle green, grey, brown, and yellow. This is the first of several odd and interesting combinations of colour and line in the film. These sorts of patterns in signage, wallpaper, and clothing are outmoded in a way that immediately identifies them as 'from the East' to Western capitalist viewers. As we focus on this image, a car speeds past in a rush of sound, and the pattern is disrupted. In fact, the shot is of a three-tiered highway overpass. The dull roar of unseen vehicles, the harsh glow of neon lights at the top of the frame and a white lane demarcation below help solve the puzzle and re-establish depth to the initial abstract image.

After a minute, the film cuts to another static long take, radically different in subject matter. This shot depicts the interior of a café or restaurant. Beyond its brightly painted windowsill lies a country road, and beyond that, lush green landscape. Together, the two shots reveal the formal logic of the film: our entry into its space and time is both

solicited and discouraged. We must content ourselves with surface, with contemplation at the window provided for us by these moving images of foreign lands. If we are patient, however, flashes of comprehension and emotional depth will appear to us like the cars which helped us perceive a two-dimensional image in three dimensions. All of Akerman's shots coax us, by diagonal roads or far-off background detail, into the liminal post-Communist culture on our screen.

Akerman and her crew shot footage for *D'Est* over two years, in summer, autumn and winter. In its passage through the seasons, its frequent focus on mass portraiture, its spatial distance and emotional proximity, the film is not unlike the seasonal cycle of paintings fellow Lowlander Pieter Bruegel the Elder painted in the mid-sixteenth century. Just as in Bruegel's six panels, Akerman's film portrays harvesters and sledding children, deformed beggars and dark figures trudging home across snowy fields. Yet the director also takes us dancing in cavernous ex-Soviet dance halls and paces us through unending railway-station waiting rooms filled with huddled travellers. She shows us the melancholy beauty of city lights in the darkness. She gives us music and voices, untranslated and unattributed. The greatest gift of the film, however, is the hundreds of faces it offers. Bemused, suspicious or impassive, they return the address of the slow moving or still camera. Without speaking, these faces at kiosks, bus stops, concerts, and markets ask the same question film spectators are asking of them: Where are you from? Where are you going?

After its European television broadcast and its warm reception at film festivals worldwide, *D'Est* was shown in 'Bordering on Fiction: Chantal Akerman's *D'Est*,' a 1995 exhibition at the Walker Art Centre in Minneapolis, Minnesota. Projected in its entirety in one room, fragmented over eight separate monitors in another and accompanied by readings that Akerman recorded, the film was reborn as installation, speaking to Akerman's talent at flaunting generic boundaries and her status as a full-fledged contemporary international artist.

Jennifer Stob

Sud

Studio/Distributor:

Intermedio
AMIP
Paradise Films
Chemah I.S.
La Sept Arte
Carré Noir – RTBF Liège
INA

Director:

Chantal Akerman

Cinematographer:

Raymond Fromont

Year:

1993

Synopsis

Chantal Akerman investigates the American Deep South through the story of a lynching and grisly murder of an African-American man that took place in Texas in 1998.

Critique

In its title and its structure, *Sud* ('South') continues the essayistic project that Akerman had begun with *From the East/D'Est* (1993). This time, she sought to concurrently map the geographical region of the American southeast and the emotional aftermath of a racially motivated murder in that region. The project had its origins in Akerman's love of southern American fiction. This literary – and undoubtedly also romantic, white, and European – approach to an exotic race and locale was soon abandoned, however. Akerman found the subject she wanted to film when she learned of a late

Sound:
Thierry de Halleux
Editor:
Claire Atherton
Duration:
70 minutes
Genre:
Documentary
Year:
1999

twentieth-century lynching that had taken place in Jasper, Texas. On 7 June 1998, an African-American man named James Byrd Jr. was beaten, chained to a truck, and dragged to his death by three men who were white supremacists and/or sympathizers of the movement. Byrd's decapitated head and pieces of his body were found strewn along three miles of country road. In focusing *Sud* on the death of one individual and its resonance, Akerman returned to straightforward documentary in many of the film's sequences. A thirteen-minute sequence of a memorial service for Byrd in a Baptist church, for example, focuses primarily on relaying what took place rather than explicitly framing, aestheticizing, or questioning the event. Ultimately, however, Akerman's documentary style is resolutely partial and unresolved. What interests her is not the criminal case in all its details, the psychological make-up of the perpetrators and victim, or the consequences of the crime for their extended families but, rather, the trauma's actual and historical reverberation within a community of black southern Americans.

Sud foregrounds speech acts instead of incorporating them, untranslated, into a complex texture of indigenous sound as *D'Est* had done. Akerman records several southerners (unnamed until the film's closing credits) who were directly or indirectly affected by the hate crime. She employs these locals to guide the viewer's historicized and politicized reading of the film. The reactions of passersby in her numerous, long tracking shots are also less ambivalent in comparison to those in *D'Est*: some men, women and children wave warmly at the camera while others yell at the camera crew in irritation. In this manner, viewers are forced to confront their own comfort or discomfort in gazing upon these documented subjects.

The film opens with a long shot of the Greater First Baptist Church, its freshly-mown lawn stretching into the foreground. The combination of intense sunlight and the recording medium of video flattens and intensifies the green of rural summertime in this and other outdoor shots in the film. The camera takes us into town, and then into a poorer neighbourhood whose street is lined with small, dilapidated houses. In a rocking chair on her porch, surrounded by her children, Cora Jones explains, 'When the Civil Rights movement came into the county, that made a whole big difference … We live in these houses now. They may not be much, but they're ours.' The account of Byrd's lynching that follows is thus contextualized within the region's overarching struggle against racial prejudice. Interviewee John Craig, who has studied the evolution of the white supremacist movement, reminds viewers toward the end of the film that this battle must continue.

The interviews in *Sud* constitute a solemn counterpoint to a series of alluring pastoral shots in the film: puppies playing in the tall grass, a flock of white egrets gathered on a riverbank, and countless trees covered in Spanish moss which stand like sentinels, dead or alive. In the south, Akerman suggests, natural beauty and societal tragedy are deeply intertwined. We see this in a desolate shot moving through the town's commercial strip in the dusk and in the numerous tracking shots that wind through verdant but poverty-stricken districts. We hear it in the film's diegetic music: the fusion of personal expression and religion found in gospel and blues is shown to be an important source of both solace and resistance for this community. *Sud* ends

with a haunting tracking shot that moves continuously outward from the film frame instead of across it. With it, Akerman follows the same asphalt road on which Byrd was killed. Ever receding and yet seemingly never-ending, the path memorializes the history of the violent murder and the perseverance necessary to transcend it.

Jennifer Stob

The Captive

La Captive

Studio/Distributor:
Gemini Films
Arte France Cinéma
Paradise Films

Director:
Chantal Akerman

Producer:
Paulo Branco

Screenwriters:
Chantal Akerman
Eric De Kuyper; inspired by *La Prisonnière* by Marcel Proust

Cinematographer:
Sabine Lancelin

Production Designer:
Christian Marti

Editor:
Claire Atherton

Costumes:
Nathalie de Roscoät

Duration:
113 minutes

Genre:
Drama

Cast:
Stanislas Merhar
Sylvie Testud
Olivia Bonamy
Liliane Rovere
François Bertin
Aurore Clément

Year:
2000

Synopsis

Simon lives with his grandmother in her sprawling old apartment, which is also shared by Simon's lover Ariane, whom Simon suspects of leading a secret love life with someone else. A fleeting moment in an amateur vacation movie causes him to suspect Andrée, a beautiful woman who spends a lot of time with Ariane away from his apartment. Simon's weak constitution prevents him from getting around much. This is an ironic development since, initially, Simon had wanted Ariane to spend time with Andrée, relying on Andrée to keep his girlfriend occupied and to reassure him of her fidelity by reporting on her whereabouts. Increasingly convinced that they are having a lesbian relationship, he starts preventing Ariane from leaving the apartment, and then follows her in his car whenever she manages to go out. His anxiety becomes obsessive, and he seems equally unable to break up with her, or to return to their previous life together. Attempting to do the latter, he drives her to a seaside hotel where the narrative ends tragically.

Critique

The Captive/La Captive is inspired by *La Prisonnière*, the fifth of Marcel Proust's thirteen-volume novel *À la recherche du temps perdu* (1913-1927). Translated into English first as *Remembrance of Things Past* and then as *In Search of Lost Time*, it is a key work of modernist literature that has proven difficult for film-makers to adapt. Harold Pinter's impressionistic distillation was published in 1978 as *The Proust Screenplay* but has never reached the screen. *Il Quartetto Basileus* (1983), an Italian film by Fabio Carpi, restricts its focus to musical and homosexual angles. Volker Schlöndorff's *Swann in Love/Un Amour de Swann* (1984), starring Jeremy Irons and Ornella Muti, is an elegant but chilly version of early portions of the novel, while *Marcel Proust's Time Regained/Le Temps retrouvé, d'après l'œuvre de Marcel Proust* (1999), directed by Raoul Ruiz and starring Catherine Deneuve and John Malkovich, does not capture the last volume's majesty despite some enchanting moments.

Like previous Proust adapters, Akerman condenses the action and trims the cast of characters but, unlike most of her predecessors, she modernizes the narrative. The apartment building where Simon and Ariane live was probably around when Proust started writing the novel in 1909, but the outdoor scenes show Paris at the turn of the twenty-first century – not the twentieth – and Simon and Ariane drive snappy cars, not horseless carriages.

Akerman also makes thought-provoking changes to the characters' names. The novel's narrator/protagonist is traditionally referred to as

Marcel; calling him Simon – which, like 'Marcel', contains two syllables with an 'm' and a sibilant – is a way of suggesting that the character on the screen is similar but not identical to his prototype in Proust's text. Akerman may also be implying that, as a lesbian film-maker, she is both similar to and different from the gay novelist whose work she is adapting. As for the captive or *prisonnière* of the title, named Albertine in the novel – possibly named after Albert (the author's real-life chauffeur and companion) – Akerman calls her Ariane. Is she named after the mythological Ariadne who helped Theseus in the labyrinth? Film critic Bérénice Reynaud cleverly notes that Ariane is a partial anagram for Akerman, containing five of its seven letters, and she further observes that the name Simon preserves the Jewish identity of the novel's narrator while also alluding to Simonet, which is Albertine's family name.

These details are far from trivial, since they point to the multiple layers of selfhood – conscious and unconscious, psychological and biological, public and private, secret and overt – that coexist within every human being's heart and soul. The concept of the secret self underlies the entire film, which Akerman has likened to Stanley Kubrick's mysterious melodrama *Eyes Wide Shut* (1999), another dark tale centring on a man's realization that he can never truly know what his lover's mind contains.

The Captive is one of many Akerman films (including her 1975 masterpiece *Jeanne Dielman, 23 Quai du Commerce, 1080 Bruxelles*) set largely in an apartment or similarly circumscribed place. Here she is able to alternate the sometimes comfortable, sometimes suffocating moods of Simon's flat with angular Paris cityscapes and finally the expanses of the sea, through which a modern-day analogue of Charon's chthonic boat carries a tragic burden to shore in one of the most impressive and expressive shots Akerman has ever created. *La Captive* is paradoxical in many respects: sober yet dreamy, active yet introspective, realistic yet stylized, lucid yet hypnotic. And it is never less than spellbinding – in its images, its rhythms, and its fiercely intelligent vision of what Proust's melancholy captive can mean to us today.

David Sterritt

From the Other Side

De L'autre côté

Studio/Distributor:
Icarus Films
Director:
Chantal Akerman
Producers:
AMIP

Synopsis

An investigation of the fates of illegal migrants from Mexico on the Arizona border, seen from both the perspective and the American government's surveillance apparatuses, as well as the relationship of the local inhabitants of the border region to people not much unlike them, but whom they nevertheless refer to as scum and trash.

Critique

From the Other Side/De l'autre côté can be thought of as the third in a quartet of Akerman's essay films that are united by the themes of place and displacement. If the previous films in this grouping – *D'Est* (1993) and *Sud* (1999) – were made in the experimental genres of collective portraiture and individual elegy, respectively, *From*

Paradise Films
Chemah I.S.
Arte France
Carré Noir – RTBF Liège

Cinematographers:

Chantal Akerman
Raymond Fromont and Robert Fenz

Sound:

Pierre Mertens

Editor:

Claire Atherton

Duration:

100 minutes

Genre:

Documentary

Year:

2002

the Other Side belongs in that of manufactured landscape. The landscape in question is the United States-Mexico border, which is over 3,000 kilometres in length. For the first hour of the film, Akerman concentrates on individual Mexicans' stories of their experiences with illegal immigration in the border region of Sonora, Mexico. She shoots her interviewees in medium-long shot, seated or standing, often at the threshold between two rooms or between indoors and outdoors. In their statements, they repeatedly use the phrase 'the other side'/'al otro lado'. For viewers, this seems to confirm that the 'other side' of the film's title is in fact the United States: near, desired, and forbidden.

However, the meaning of this 'other side' shifts in the last 40 minutes of the film, which are shot in the border region of Arizona, in the US. A long and masterful tracking shot documenting the congested traffic leaving Mexico and the utter lack of traffic entering the country signals this transition. In the US, most of the interviewees are American. Although their experiences differ drastically from those of the Mexicans interviewed, they speak of the border, and the dangerous, illegal immigration it does not prevent, in the same general terms: fear, loss, and tribulation. The social, linguistic, economic, and physical divides that motivate the passages of testimony in *From the Other Side* is rendered formally in static long takes or travelling shots of border-town streets and southwestern landscape. The vast skies and arid ground are split by the horizon as well as by border fencing erected in wood, concrete, steel, and wire.

Much as in Akerman's *Sud*, narrative is more explicit in *From the Other Side* than it was in *D'Est*. It is relayed through an interlocking series of direct parallels and contrasts. Early on in the film, Delfina Maruri Miranda wipes her eyes silently. She is an elderly woman in poor health. She has paused in the telling of her son's life and premature death. He died while attempting to cross the border into the US to earn money that would have supported his family and his village. His story resonates directly with that of interviewee José Sanchez, who Akerman's crew met and helped during another failed border crossing – this time, thankfully, without fatalities. Sanchez becomes an impromptu spokesperson for the group of seven illegal immigrants with whom he was travelling. They flank him at a long dinner table covered in brightly coloured Mexican tablecloths. He frames their plight in the language of the Lord's Prayer: 'If the US refuses to give illegals a chance and doesn't appreciate the value of their manpower, then God forgive us, them and us … I ask God to protect us, all of us, and forgive our trespasses.'

When the film moves to the US, Akerman sets these earlier scenes in provocative contrast to American stances on illegal immigration. She films a uniformed minister presiding over a funeral ceremony for a fallen American border-patrol agent. This man also sets the issue of border control into a Christian context, but the message is one of antagonism, not of clemency: 'How long will my enemy triumph over me? ... My enemy will say I have overcome him, and my foes will rejoice when I fall', he says, reciting from the Bible's Psalm 13. The film depicts the 'daily war' he has spoken of in archival aerial footage of a ghostly line of border-crossers, as well as eerie night scenes of the Sonoran desert. In these shots, the territory illegal 'aliens' must traverse is transformed into a lunar landscape.

From the Other Side ends with Akerman's own voice. She recounts the tale of a Mexican woman who has repeatedly disappeared from odd jobs and rented rooms. Faced with the impossibility of reconstructing the journey of this undocumented immigrant, Akerman suggests we must make do with the faint traces she and others have left – with our fragmented memories of them, with their mirage. Like *D'Est*, *From the Other Side* had an afterlife as a multi-channel video installation, which premiered at the 2002 Documenta in Kassel, Germany.

Jennifer Stob

Tomorrow We Move

Demain on déménage

Studio:
Gemini Films
Radio Télévision Belge Francophone (RTBF)
Arte France Cinéma films

Director:
Chantal Akerman

Producer:
Paul Branco

Screenwriters:
Chantal Akerman
Eric de Kuyper

Cinematographer:
Sabine Lancelin

Art Director:
Regine Constant

Editor:
Claire Atherton

Duration:
106 minutes

Genre:
Comedy

Cast:
Sylvie Testud
Aurore Clément
Jean-Pierre Marielle
Lucas Belvaux
Elsa Zylberstein
Natacha Régnier

Synopsis

Catherine Weinstein, a sweet, lively, and romantic piano teacher, widowed after 41 years of marriage, moves into a duplex apartment in Paris' Ménilmontant district with her adult daughter Charlotte, who is her only child, a writer. Charlotte is struggling to complete a commissioned erotic/pornographic novel. Catherine and Charlotte decide to move, together, to a nicer residence. Their duplex is put up for sale. Prospective buyers include an unnamed pregnant woman and a real estate agent named Samuel Popernick. Charlotte ends up finishing the erotic/pornographic novel with the help of a housewife/aspiring author named Michèle. Mr. Popernick and Catherine together move into a house near Paris, while Charlotte remains in the duplex with the pregnant woman, and they will raise the baby together.

Critique

Central to the bittersweet comedy *Tomorrow We Move* are Chantal Akerman's signature themes, often mediated by music: women's life experiences and engagement with their domestic environments as well as mother-daughter relationships. This film is a meditation upon the condition of the female author/artist, Charlotte (Testud), who functions as Akerman's onscreen surrogate: Akerman initially wanted to be a writer, but decided to make films after viewing *Pierrot le fou* (Jean-Luc Godard, 1965), when she was fifteen. Charlotte, in attempting to complete her commission (which is an erotic/pornographic text), scribbles vulgar terminology for genitalia and fragments of overheard conversations in a black notebook. She comes to realize that, to write, one needs peace – a room of her own – away from the chaotic clutter of their duplex environment. After Catherine (Clément) moves in with her daughter in the duplex, they decide to sell it. Prospective buyers parading into their living space interrupt Charlotte's writing and Catherine's piano lessons. Yet these interruptions, which, at times, border on the absurd – sometimes set to the diegetic music of Brahms' Hungarian Dance no. 5 – provide Charlotte with fodder for thought, and allows her to fulfill her assignment duties as she scrutinizes the apartment-hunters' interactions and squabbles. These interruptions bring to mind Diderot's posthumously published (anti)novel *Jacques le fataliste* (1796) in which the narrative thread is constantly broken.

Year:
2004

In searching for a space where she can develop and blossom as an author, Charlotte emblematizes Virginia Woolf's claim that, in order to write, a woman needs 'a room of her own'. Charlotte finds a kindred spirit in elegant Michèle (Zylberstein), a bourgeois housewife looking for a place to go in the afternoons to escape her 'adorable' husband, children, and maid. Michèle seeks time away from her family to enjoy solitude. Charlotte and Michèle rent a studio together, where Charlotte writes in the morning, and which Michèle occupies after 2 pm. This exclusively female space allows for a fruitful collaboration to ensue, as Michèle, who longs to be a writer and poet, takes it upon herself to rewrite Charlotte's pornographic text.

Tomorrow We Move features women rebelling against roles imposed upon them by patriarchal society, another staple of Akerman's filmography, as exemplified in the following situations: the story of a young mother, Sophie, who abandoned her husband and child; the unnamed pregnant woman (Regnier), about to give birth, who claims that she never wanted children and would rather live with Charlotte and Catherine than with her husband. In a burlesque episode, she gives birth to her baby in their apartment, behind a curtain and away from the spectator's gaze, magically, within a few seconds. As Mr. Popernick and Catherine hold the newborn, he initially calls the infant Simon, but as she is a girl, immediately renames her Simone, recalling twentieth century French philosophers Simone de Beauvoir and Simone Weil as well as former French Minister of Health Simone Veil.[1] Chantal Akerman's male protagonist in her film *The Captive/La Captive* (2000) is named Simon, although in Marcel Proust's *La Prisonnière*, upon which this film is based, the titular 'prisoner' is the female character Albertine Simonet. The name Simon(e) originates from the Hebrew Simeon/Shimon (meaning 'the one who hears'), underscoring Chantal Akerman's Jewish roots which reverberate throughout her cinematic universe.

The Holocaust's legacy, particularly the atrocities in Poland in which Catherine and Mr. Popernick's families perished, shapes these characters in opposing ways: whereas Catherine found joy in her close-knit family (a closeness that can perhaps be interpreted as a form of co-dependency), Mr. Popernick never dared to have children, as he feared he would inflict his personal trauma upon them. Catherine and Charlotte share a poignant moment when they read the 1924 diary, written in Polish, of Catherine's own mother Tosca/Tosha (this scene was inspired by a true experience in Akerman's life: along with her mother, Nathalia/Nelly Akerman, while sitting at a kitchen table, the two had read the diary, written in Polish, of Nelly's mother, Holocaust victim Sidonie Erenberg—an event which, captured on digital video, formed part of Akerman's 2004 installation *To Walk Next to One's Shoelaces Inside an Empty Fridge/Marcher à côté de ses lacets dans un frigidaire vide*, shown in Paris and New York). In that journal – which recalls Charlotte's eternal writer's notebook – Tosca wrote about the condition of womanhood: in her opinion, women are meant to suffer in silence and be stifled in their artistic ambitions/endeavours. Tosca's journal's dual function as notebook and sketchbook is a reminder that her innermost thoughts, as well as her drawings, will never be seen nor exhibited; indeed, Tosca's journal was accidentally discovered in a closet by one of the prospective apartment buyers. It becomes evident that Tosca had passed down

her artistic gifts to Catherine, who became a music teacher, and to her granddaughter Charlotte, who is a writer.

In discussing Tosca's diary, Catherine reminds Charlotte that their lives are 'miracles'. This forms an intertextual reference to Akerman's most acclaimed film, *Jeanne Dielman, 23 Quai du Commerce, 1080 Bruxelles* (1975), in which Jeanne's sister Fernande stated that meeting her husband and moving with him to Canada was a 'miracle' in the aftermath of the Holocaust and World War II in Europe. In *Tomorrow We Move*, Catherine, despite great suffering and loss, considers herself blessed with the love of a husband (now deceased) and daughter. Catherine radiates hope and optimism: encouraging Charlotte to pursue her calling as a novelist; helping Popernick to play piano in public; cooking chicken for friends and visitors – the chicken dish that her late husband had enjoyed so much during his lifetime. Catherine is an archetypal mother, whose enduring cheer and polished appearance belies a steely resolve to overcome tragedies. Her very existence is nothing short of a miracle.

Catherine's zest for life is expressed in her excitement at wearing beautiful clothes, in gong out to exciting places, sipping champagne – all the paraphernalia/clichés of the good life. Her passionate love for her husband contrasts with the romantically unattached Charlotte, whose boyish figure and demeanour widely differs from Catherine's interest in fasion and style. Charlotte sports thick eyeglasses and, according to Akerman herself, is 'Chaplinesque' – which is already inscribed in the first name Charlotte, which is the feminine for Charles. As far as Charlotte is concerned, her lack of male companionship is due to her preoccupation with writing, which takes all her time and energy. Among those seeking to buy the duplex, the Delacres, a couple, who had arrived together, split up; the husband, played by Lucas Belvaux – a renowned Belgian filmmaker/actor – subsequently returns alone, and faults Charlotte as 'too sensitive and too pure' to undertake the writing of a pornographic novel. Although Charlotte had seen risqué films, without the help of the more mature Michèle, she could have not imparted her readers with a novel of this order. The audience notices this after the reading of the first draft of her novel, which provokes unending laughter among her interlocutors. Charlotte is praised for her great comic talent, but this was not what she was after. At the end of the film, Charlotte writes a text of her own, entitled *A Day in the Country/Une journée à la campagne* – a title reminiscent of Jean Renoir's film *A Day in the Country/Une partie de campagne* (1936) as well as of Bertrand Tavernier's film *A Sunday in the Country/Un dimanche à la campagne* (1983) – based upon the outing she and her mother took to the house outside of Paris in which Catherine and Popernick will reside together.

Tomorrow We Move is infused with themes already explored in Chantal Akerman's previous films. Charlotte spilling water on the floor to mop and later running up the stairs to her studio while carrying a bouquet of flowers are both intertextual references to almost identical scenes in Akerman's first film, *Blow up my Town/Saute ma ville* (1968). *Tomorrow We Move*'s widowed Catherine can be seen as a kind of counterpoint to another widowed mother character in Akerman: the eponymous protagonist of *Jeanne Dielman*. Yet Jeanne displays indifference toward her late husband, whereas Catherine, in her season of widowhood, remains passionately devoted to the

memory of her husband, reminiscing about their conjugal bliss. Jeanne keeps her home spotless; Catherine lives in perpetual chaotic disorder. Catherine giggles and dances around when performing household chores, à la Cinderella, while Jeanne meticulously carries out her domestic duties. Furthermore, in *Tomorrow We Move*, the dialogues between Charlotte and Catherine bring to mind those of Anna (Clément) and her mother (Lea Massari) in Akerman's *The Meetings of Anna/Les rendez-vous d'Anna* (1978). In this instance of cross-pollination between Akerman's films *The Meetings of Anna* and *Tomorrow We Move* – separated by an interval of nearly thirty years – the mother-daughter relationship is inverted through the appearance of the actor Clément: in the earlier film, Clément portrays the titular Anna, a young female artist, a daughter making her way in the world of film-making. But in *Tomorrow We Move*, Clément portrays the mother of a young female artist, a writer (played by Sylvie Testud). Therefore, Clément is at both ends of the mother-daughter relationship – first as a daughter, and then as a mother.

Sylvie Testud, in the leading role of Charlotte in *Tomorrow We Move*, reminds the spectator of her previous starring performance as Ariane in Akerman's *The Captive*, a film adapted from Proust's *The Prisoner/La prisonnière*. There is also a Proustian undercurrent throughout *Tomorrow We Move*, since it foregrounds Proust's hallmark, the involuntary memory retrieved through olfactory sensations. The odour of insect fumigation, in an empty apartment for rent, instantly transports Mr. Popernick and Catherine to their native Poland, a flood of memories of near-extermination haunting them both. Exterminations of insects and of humans intersect through breathing in the foul odour of an empty Parisian apartment. Moreover, nostalgic tears brought about by Catherine's roasted chicken function as the film's *leitmotif*. The chicken's aroma and taste of thyme evoke the iconic Proustian aroma of the madeleine dipped in tea. The enduring presence of the roast chicken in *Tomorrow We Move* recalls yet another episode from *Combray*, the first volume of Proust's *In Search of Lost Time/A la recherche du temps perdu*, where the family cook Françoise slaughters a chicken, much to the horror/fascination of the narrator-as-young-boy, witnessing this disturbing killing, a quasi-primal scene (yet at the next meal, he relishes the delicious taste of the cooked bird). Alluding to Proust through olfactory/gustative sensations, *Tomorrow We Move* precedes Akerman's *Almayer's Folly/La Folie Almayer* (2011), in which she follows in the tradition of adapting a greatly acclaimed author – this time, Joseph Conrad.

Marcelline Block

Note
1. And uncannily, a late female professor of French literature, also a Holocaust survivor (born in Romania) and near namesake of the film-maker: Simone Ackerman.

Là-bas

Studio/Distributor:
Intermedio

Director:
Chantal Akerman

Producers:
AMIP
Paradise Films
Chemah I.S.
Le Fresnoy

Cinematographers:
Chantal Akerman
Robert Fenz

Sound:
Thierry de Halleux

Editor:
Claire Atherton

Duration:
78 minutes

Genre:
Documentary

Year:
2006

Synopsis

Chantal Akerman reflects on a variety of themes during her stay in Israel, mostly filming from the recesses of her apartment.

Critique

Là-bas ('Over There') concludes Akerman's series of films made between 1993 and 2006, based on the themes of place/displacement, physical/emotional space. While *From the East/D'Est* (1993), *Sud* (1999), *From the Other Side/De l'autre côté* (2003) and *Là-bas* (2006) are frequently grouped together as a foursome of essay films, a pairing of two and two seems more appropriate: *D'Est* with *Sud* and *De l'autre côté* with *Là-bas*. *D'Est* and *Sud* examine a socio-historical event of the recent past, showing the traces it has left upon the lives of local inhabitants. In them, a major transition has taken place, and the films' subjects must find a way to remember and rebuild. *De l'autre côté* and *Là-bas* are about the presence of containment and isolation in the everyday; the subjects in these films must themselves become transitory in order to cope with chronic problems or unmoving obstacles.

Là-bas takes place in Tel Aviv, Israel, but the film is never directly about Israel or its culture. Nor is it directly about Akerman herself; viewers catch only a fleeting glimpse of her, and her rough and sensuous smoker's voice is heard intermittently in voice-over. In one voice-over, Akerman gives a wry description of her project: 'I stay here in the apartment, and I eat what my landlord has left, and I read very complicated books about the Jews. I take notes, I reread them, I try to understand. Sometimes I understand. Or I get a whiff of something, something that is already there inside of me, but [that] I can't express'. At the beginning of the film, she juxtaposes her aunt's suicide with that of Israeli author Amos Oz's mother, the former in Brussels and the latter in Tel Aviv. 'Was it for both of them a sort of exile, wherever they were?' she asks. These diaristic soliloquies and the partitioned images that accompany them evoke the difficult negotiation of exile and return that Akerman and others touched by the Jewish diaspora must undertake.

Là-bas is comprised almost entirely of static long shots. Most of these are of the high-rise apartment buildings directly opposite Akerman's own vacation apartment, seen through the rattan window blinds. Twice, we see footage shot outdoors at the seashore. The first sequence is a welcome release from the confines of the apartment but, by the second sequence, this watery expanse overwhelms the senses, triggering a desire to return to the familiar, dark living room. In the last four minutes of film, the camera pans and zooms rapidly across the open sky. The montage provokes anxiety and a dizzying feeling of disorientation, the same emotional states that Akerman has been describing.

At first, it seems that Akerman is spying on her neighbourhood. The subject matter, the fixity of the camera, the medium of digital video and its generic deep focus immediately calls to mind surveillance footage. The film's ambient noise, however, complicates this interpretation. Sounds of street traffic and hollering children

mingle liberally with sounds coming from the unseen interior of the apartment, like the click of a gas burner on the stovetop, footfalls, objects moved around on a counter or table, or the tapping of computer keys. There is a profound ambivalence between what can and cannot be seen. The gaze of Akerman's camera is not omniscient and impassive but rather unseeingly subjective in nature. This, too, she supposes, is linked to Belgium and her past, as she spent much of her childhood gazing out the window at children she was not allowed to play with. 'Now I'm in the habit of looking out the window', she says. 'I look and I get all up inside myself.'

If, amidst these dark meditations on personal prisons, *Là-bas* also affirms life, this affirmation is found in Akerman's devotion to creative work, in many senses a direct result of and an antidote to her non-belonging. The man with a balcony and a rooftop garden directly opposite Akerman's window embodies this devotion, suggesting that Akerman's work as a Belgian Jew reconciling herself with Israel is, in many senses, collective work. The man tends restlessly to his potted plants, watering, inspecting and repositioning them as a contemporary Candide would, cultivating his garden. Akerman does the same, learning through her film-making to 'put down roots in space'.

Jennifer Stob

JACO VAN DORMAEL

Born in Brussels to a francophone mother and Flemish father, Jaco Van Dormael spent his childhood in post-war Germany. Alternately a clown, a theatre stage director for children and a world-renowned author of short films, Van Dormael's films bring together a Hollywood-like screenwriting savoir-faire with an auteurist approach that he defends as a trademark of Belgian cinema, shifting between a documentary/realist vein and a somewhat Magrittian surrealism. A director of music videos (including 'Ladyboy' for the French band Indochine, 2007), commercials (such as Spa Reine mineral water, 2010) and an occasional theatre director (*Est-ce qu'on ne pourrait pas s'aimer un peu?* 2011), he expresses the themes of a pluralistic art.

As a favourite student of André Delvaux at the Brussels film school INSAS (Institut National Supérieur des Arts du Spectacle et des techniques de diffusion), and having taken the seminars of screenwriting 'guru' Frank Daniel who taught him the art of creating characters with complex motivations, Van Dormael was praised and awarded as early as his senior year project, *Maedeli-la-Brèche* (1979), which received the Honorary Foreign Film Award at the 1980 Student Academy Awards sponsored by the Academy of Motion Picture Arts and Sciences. In this film – a sort of post-war *Forbidden Games/Jeux interdits* (Réné Clément, 1952) – are found, in embryonic form, the thematic and stylistic essences of his future cinema: the superiority of the imaginary to the real world, the magic of nature operating more effectively than the derisory opulence of the city world, and child's play installing a Rimbaldian identity crisis where 'I' incessantly turns into 'someone else' (recalling Rimbaud's iconic statement, 'I is someone else'/'Je est un autre'). This alterity is launched not only on the level of children but also touches upon the universe of the developmentally disabled, with whom Van Dormael shares an affinity, as demonstrated in a variety of his projects: several short documentaries (*Stadium/Stade*, 1981, about the first Special Olympics) and semi-fictional works including *L'Imitateur* (1982), an attempt to investigate the 'normal' world as discussed by two mentally-challenged people, in a plea for the recognition and integration of difference. Alongside documentaries about neighbourly relationships (*The Neighbours/Les Voisins*, 1981) and socially-marginalized teenagers (*Emergency Exit/Sortie de Secours*, 1983) the film-maker worked tirelessly on his feature project, whose themes were inaugurated in his early short *E pericoloso sporgersi* (1984), a meditation upon the meaning of identity as orchestrated by the oneiric visions of a child, but this film's aesthetics are very controlled and the postmodern citations combine the magical worlds of Georges Méliès as fantasies of the unconscious with the disruptive editing of Alain Resnais' cinema.

When his *chef d'oeuvre Toto the Hero/Toto le Héros* (1991) finally appeared, Van Dormael's talent was quickly recognized beyond the borders of Belgium: this film received the Caméra d'or at Cannes, the César for best foreign film, the Best European film in Berlin, a wide European distribution thanks to the MEDIA programme, and its remake rights were bought by the Americans. With *Toto*, Van Dormael wrote and directed a film that is intriguing due to the complexity of its processes but which also manages to appeal to a wide audience, offering what David Bordwell has called a 'lightweight modernism'. Much like Orson Welles' *Citizen Kane*, in *Toto*, young Thomas, switched at birth during a fire in his nursery, is directed by the film-maker-creator who ingeniously finds him a destiny, a death, and a rebirth by virtue of the voice-over. *Toto the Hero* plays on this discrepancy between sound and image: indeed, Thomas's voice-over, repeating ceaselessly that he has no attachment to life, to the point of being nobody, is opposed to a deflagration of images demonstrating the upheavals that punctuate life,

Jaco Van Dormael on the set of *Mr. Nobody*.
The Kobal Collection.

every step of the way… unless these fantastic events are mere fiction, pure daydream. Indeed, the art of Jaco Van Dormael resides in this desire to create ambivalent cinematic figures, where truth is not distinguished from falseness, where the real and the imaginary fit together in order to form an ultimate 'reality', in this case, Thomas's – whose every thought directs each moment of existence. This great metaphor of life blithely combines visual supports (elaborate chromatism, Super 8 footage, TV screens where we see simulacra of film noir) and aural (the jubilant use of Charles Trenet's song 'Boum'). It culminates in a Russian nesting doll structure, where Thomas (Michel Bouquet) is the sum of several parts: half old man, half child, at the crossroads of all possible realities. Among these, there is the uplifting complicity with his Down syndrome brother, Célestin, who, we learn – in an obligatory nod to surrealist heritage – was 'born in a washing machine, which explains why he is different'.

Van Dormael thus reconnects with the topic of nonstandard people, already dealt with in his short films (and also in his one-minute film for the 1995 collective project *Lumière et Co*, revealing a long kiss between two people with Down syndrome) in his second feature, *The Eighth Day/Le Huitième jour* (1996), a contemporary tale about the virtues of friendship between Georges, a young man with Down syndrome, and Harry, a dynamic corporate executive in full crisis. In this European *Rain Man* (Barry Levinson, 1988), the parable aspect ('On the eighth day, God made Georges') manages to erase the stereotypes of a predictable everyday life through the use of the fantastic, such as in the oneiric parentheses in which Georges sees his missing mother in the arms of a pseudo Luis Mariano (played by Laszlo Harmati) or in the shape of a singing mouse. An ode to nature, *The Eighth Day* reveals our world in its simplest joys, where each naturalistic detail becomes a source of wonder. Whether in *Toto the Hero* or in this second film, truth is revealed only through a human being considered 'different', who is in total osmosis with the macrocosm that surrounds him. Van Dormael blends two poetics: nature depicted by a palette of bright colours and a Belgian magical realism. His first two features show an existence with many pluralities, and pose a conundrum: are we capable, as mere mortals, of truly understanding the greatness of the universe that surrounds us? Less complex and more uneven than *Toto*, *The Eighth Day* nevertheless met with great public success: its two leading actors, Pascal Duquenne (as Georges) and Daniel Auteuil (as Harry), shared the prize for best actor at Cannes (the first time in history that this occurred), where critics were divided, some reproaching the film for its strong dose of manicheism.

Thirteen years separate *The Eighth Day* from *Mr. Nobody* (2009, although the project goes back to at least as early as 2001), Van Dormael's third foray into feature film-making. This is the story of Nemo Nobody (Jared Leto), a character whose name has a homonymic etymology (nemo in Latin means 'nobody'), destined to choose, upon his parents' divorce, between the way of his father or that of his mother. The film recounts the multiple lives of the main character through the device of Nemo's ageing personality, with a failing memory, as he is the last mortal man alive in 2092 in a world where eternity and lack of self-knowledge have become the laws of a futuristic generation, almost anesthesized by this decadent immortality. Nemo decides to live the entirety of the lives that are offered to him according to an exponential logic. Much as in *Toto the Hero*, Van Dormael structures the fragmented narrative according to the principle of Russian nesting dolls. Based on the butterfly-effect theory, *Mr. Nobody* allows its main character to travel through an imaginary reality, through an intrinsic temporality that defies space and time. Reminiscent of the ontological dynamic of Stanley Kubrick's *2001, A Space Odyssey* (1968), Man, both ephemeral and evolutive, is at the centre of a Vandormaelian cinematic reflection. Moving across the spatio-temporal paradigm, he experiences its multiple effects. The representation of Nemo as an old man, locked in an aseptic room of the future, seems taken straight out of Kubrick's film, which also imagined a character literally aspirated by space and progressively altered by time, before being reborn under a new shape. At the heart of these ontological constructs and these modernist representations of parallel worlds, Man cannot dominate the infinite Universe.

As in *Toto the Hero*, *Mr. Nobody* tells a multiplicity of love stories, none of which are really lived. Van Dormael creates a cinema of duality, of multiplitcy: he fashions a polyphonic and meta-filmic world where the characters confront their anxieties and their desires through a game of binary connections and a mirror structure. This type of perception allows the viewer to integrate the mental universe of the characters and to follow their psychological journey. While *The Eighth Day* favoured a dyad and is less complex in the final analysis in its cinematic representation – but no less extravagant – *Toto the Hero* and *Mr. Nobody* privilege a dual confrontation of one and the same character. One is freed from his imaginary double identity, Toto, the secret agent, and Thomas, swapped at birth. The other one is discharged from his other lives and keeps

only one, or maybe none: 'I'm Mister Nobody, a man who doesn't exist'. By following the example of *Citizen Kane*, *Mr. Nobody* attempts to reconstruct, through various layers of past lives, a man's one life. The dehumanized characters Charles Foster Kane and Nemo Nobody gradually lose their physiological consistencies. Apprehended by the dialogical way of reminiscence, they are freed from their tortuous pasts. In order to represent this progressive evolution from the destruction to the liberation of the characters, the cinema of Van Dormael uses the principle of synesthesia in an original and pertinent manner. Much like Andrei Tarkovsky, Van Dormael develops a universe where nature, symbolized by the four elements, is omniscient, both destructive and cathartic.

In spite of its imposing cast and budget (the largest in Belgian cinema history), *Mr. Nobody* was, once again, consecrated on the altar of the popular audience as the work of a lifetime of the director. However, critics remained ambivalent about the film, and it did not meet with the commercial success it deserved.

Jaco Van Dormael uses the dual elements of Belgian heritage – surrealism and magical realism – in order to create these three works of multiple references – literary, pictorial, musical, and cinematic – and thereby proposes an overtly philosophical reflection. As genuine Magrittian elaborations, the works of this Belgian postmodern artist capture the real in order to better deliver its invisible side. Surrealist images, with iterative motifs, depict the thought of an arborescent world. *Toto the Hero*, *The Eighth Day* and *Mr. Nobody* set René Magritte's cloudy frescoes in movement, but also the trains and mysterious feminine figures of Paul Delvaux. Van Dormael extends his vision of a unique oneiric and dual cinematic universe through his current collaboration with his partner, the dancer and choreographer Michèle Anne de Mey, in a conceptual contemporary dance performance. This show, entitled 'Kiss and Cry' where all the colours of Vandormaelian cinema blossom, was presented for the first time in Brussels, in November 2011.

Dominique Nasta with Aurélie Lachapelle

Translated by Marcelline Block and Jeremi Szaniawski

Toto the Hero

Toto le héros

Studio:
Iblis Films/Metropolis Filmproduction/Canal +

Director:
Jaco Van Dormael

Producers:
Dany Geys
Luciano Gloor

Screenwriters:
Jaco Van Dormael with Didier De Neck
Pascal Lonhay and Laurette Vankeerberghen

Cinematographer:
Walther van den Ende

Production Design:
Huber Pouille

Composer:
Pierre van Dormael

Editor:
Susana Rossberg

Duration:
91 minutes

Genre:
Drama

Cast:
Michel Bouquet
Jo De Backer
Mireille Perrier
Gisela Uhlen

Year:
1991

Synopsis

Thomas Van Hazebrouck, an old man living in a retirement home, reflects on his life and fantasizes about killing his childhood neighbour, Alfred Kant, with whom he imagines he was switched at birth. Thomas is shown at various stages of his life. As a child, he envies Alfred and requests to trade lives with him, only to be punched and mocked. Thomas and his sister begin to develop romantic and sexual feelings for each other, which are strengthened when their father disappears while on an errand for Alfred's father, but cause tension when his sister develops feelings for Alfred. As a middle-aged man, Thomas, lonely and unfulfilled, becomes obsessed with a woman he believes may be his sister. As an old man, Thomas learns that Alfred's business has collapsed, bringing financial ruin to many. He steals a gun, escapes from the retirement home and searches for Alfred, intending to murder him before anyone else can.

Critique

Toto the Hero/Toto le héros is one of the most renowned Belgian films of its time, and its status is well deserved: it is a startlingly original film, and remains so more than twenty years after its release. It presents something that is far rarer in film than in literature: a work seen entirely from the point of view of an unreliable narrator. What is more, it combines its already unreliable narrative with sequences of pure fantasy, and yet it is never confusing and always coherent. Much of this is due to the intricacy of its editing, which moves the film back and forth from one plot strand – and one stage in the narrator's life – to another, and back, without making the leaps seeming jarring or forced.

Throughout, the viewer is unsure if what he or she is seeing represents the truth. Even the climax of the film may not be 'real'. It is presented as if it is the culmination of Thomas's story but, just like the beginning of his story, it may take place only in his mind. There are subtle indicators, in even the most ostensibly factual scenes, that everything we witness is a refraction, rather than a reflection, of Thomas's life. We are shown Thomas's birth, but it is clear he remembers it – and so it is unclear if what we are seeing is his birth as it happened, or simply a fantasy he has concocted around it. The suburb in which he passes his childhood is too pristine – its grass and paint too bright and even the items in its grocery shop too perfectly arranged – to be real, and so, even though the events that play out against their backdrop seem reasonable, we doubt they happened quite as they are being shown to us.

Throughout, the sense that we are absorbing impressions of events, rather than events themselves, is unshakeable. Consequently, the film's plot becomes secondary. What matters is not Thomas's story, but the insight into Thomas that his story gives us. *Toto the Hero* is a character study in which every event, and every character, is illustrative chiefly of the man relating them.

Our perceptions of him, and our expectations of the film, change rapidly. We begin by believing that he was switched at birth but, once the incredible circumstances of that birth are revealed, doubts arise. Soon, we question not whether he was switched at birth but why he

chooses to believe he was. When he develops sexual feelings for his sister, it suggests he may have adopted the idea to free him from the guilt caused by his incestuous longing, but we are never given enough evidence to make conclusions about the issue and, even if we were, we would not know it was reliable.

Ultimately, the aim of *Toto the Hero* is not to present conclusions about Thomas but simply to create a picture of its main character from fragments of his own mind and memory. Few films have ever achieved such an esoteric aim in such an amusing and accessible manner.

Scott Jordan Harris

The Eighth Day

Le Huitième Jour

Studio/Distributor:

Canal+ Centre for Film and Audiovisual Arts of the French Community of Belgium
Centre National de la Cinématographie (CNC)
D.A. Films
Eurimages
Homemade Films
Pan Européenne Production
Polygram Filmed Entertainment
RTL-TVi
TF1 Films Production
Working Title Films

Director:

Jaco Van Dormael

Producer:

Philippe Godeau

Screenwriter:

Jaco Van Dormael

Cinematographer:

Walther van den Ende

Art Director:

Hubert Pouille (Production Designer)

Composer:

Pierre van Dormael

Editors:

Aurore Moutier
Susana Rossberg

Synopsis

Overworked sales executive Harry may project success in his professional life but his private life is in pieces, his wife having left him and taken their two children away from the city life to live by the sea. When at his lowest ebb Harry encounters Georges, a young man with Down Syndrome, who has run away from his care facility and set off in search of his mother. Despite, or perhaps because of his disability, Georges is able to appreciate the simple things in life: the feel of grass, the warm breath of a cow, the sight of a ladybird in flight, the spiritual rewards of hugging a tree. In helping Georges to come to terms with his mother's death, Harry comes to view the world through his new companion's eyes, allowing him to slow down, acknowledge that which is truly important to him and put his priorities in order.

Critique

The Eighth Day/Le Huitième Jour has been routinely and somewhat simplistically filed away by critics in the same category as the likes of *Rain Man* (Barry Levinson, 1988) and *Forrest Gump* (Robert Zemeckis, 1994), ploughing as it does the 'disabled individual battling adversity to succeed by virtue of their goodness, transforming the lives of the cynical, world-weary souls that they touch in the process' furrow. While the film unquestionably resorts to politically-correct orthodoxy in its use of Down Syndrome as a means to render the character of Georges ineluctably 'pure', two factors help to elevate it out of the syrup of sentiment in which those two American films wallow. First, the casting of Pascal Duquenne, a young actor with Down Syndrome, lends an undeniable immediacy to the performance which those of Dustin Hoffman and Tom Hanks can only hope to strive towards. Duquenne's presence, and that of the other care-home patients, also played by people with real disabilities, challenges the space that audiences might automatically place between themselves and the predicament of the characters they are watching. Casting of this nature carries risks, and there are moments in the film which are prone to accusations of exploitation. But Duquenne's performance is so palpably honest and surprisingly multi-layered that only the most ardent of naysayers would have one believe that this was anything less than a commanding and thoughtful piece of acting. Daniel Auteuil has a tough task competing with Duquenne for audience empathy but manages to bring depth to

the rather stock character of Harry. Duquenne and Auteuil deservedly shared the award for Best Actor at the 1996 Cannes Film Festival.

Next, the film possesses a surprising visual inventiveness reminiscent of the work of Jean-Pierre Jeunet. Van Dormael employs some audacious camerawork augmented by discreet but effective CGI to attempt to capture Georges' worldview. In addition, the director/writer populated Georges' journey with two other fellow travellers: the spirit of his departed mother (Isabelle Sadoyan) and the embodiment of his favourite Mariachi singer Luis Mariano (Laszlo Harmati) whose soothing, calming influences help Georges in times of trouble. We also see the results of Georges' reconfiguring of the term 'Mongoloid', switching it from a derogatory label into one of romantic heroism by envisaging himself as a mighty Mongol warrior in full costume. Splashes of colour abound in an otherwise murky world: at one point Harry takes the fireworks planned for a product launch and uses them as a birthday display to win back the heart of his eldest daughter. Throughout the film, Van Dormael uses the repeated visual metaphor of a ladybird in flight to neatly capture Georges' free spirit. Its appearance as a moving spot of colour during one of Harry's dull, grey, business meetings acts as a catalyst to reunite the pair. As if to acknowledge and deflect the potential for his subject matter to slip into sickly sweetness, Van Dormael makes Georges fatally allergic to chocolate, which lends a tragic bittersweetness to the final moments of the film.

Jez Conolly

Mr. Nobody

Studio/Distributor:

Pan Européenne Production (production)
Virtual Films
Christal Films
Pathé
Integral Films
Lago Film
Toto & Co Films
ARD Degeto Film France 2 Cinéma
France 3 Cinéma (co-production)
SCOPE Invest
Groupe Un
Caviar Films (associate producer) Belga Films
Programme MEDIA de la Communauté Européenne
RTL-TVi
Région Wallone
Société de Développement des

Duration:

116 minutes

Genre:

Comedy/drama

Cast:

Daniel Auteuil
Pascal Duquenne
Miou-Miou
Isabelle Sadoyan

Year:

1996

Synopsis

The year is 2092. 118-year-old Nemo Nobody is the oldest man in a world where science has conquered the aging process and even death. He reminisces about his past on his deathbed, recounting his life to a psychiatrist and a reporter. He mentions his parents' divorce, as well as his three loves: Anna, Elise and Jean. It appears that Nemo is living in a variety of worlds, each story inflected by choices he made, or did not make, during his life. The journalist tries to figure out which of the narratives is Nemo's real life story, until it appears that they are all but a figment of a 9-year-old child's imagination, refusing to make a choice between his divorced parents.

Critique

A drama about childhood trauma (the film bears vague intimations of incest, but mostly it is about the parents' divorce) under the guise of a science-fiction film, *Mr. Nobody*'s non-linear narrative is heavily influenced by a variety of scientific and philosophical theories, such as the Big Bang, the Big Crunch, Zugzwang, string theory, argyle patterns, entropy, innate versus inbred fears and behaviours. Many of these ideas were already at play in Van Dormael's masterpiece *Toto the Hero/Toto le Héros* (1991), for which *Mr. Nobody* serves as a big-budget remake. At an expense of nearly 40 million euros, it is and probably will long remain, the most expensive Belgian production,

Mr. Nobody.
The Kobal Collection.

Entreprises Culturelles (SODEC)
Téléfilm Canada
France 2 (FR2)
France 3
Le Tax Shelter du Gouvernement Fédéral de Belgique
Poisson Rouge Pictures (participation)
Canal+
Fortis Film Fund
CinéCinéma
Climax Films
eutsche Filmförderfonds (DFFF)
Medienboard Berlin-Brandenburg (in association with)
/Belga Films (2010) (Belgium) (theatrical)

shot in 2007 over 120 days in Belgium, Germany, and Canada, in English and featuring an international star cast led by Jared Leto, Sarah Polley, Diane Kruger, and Rhys Ifans.

The film's means are at once too much and not enough to sustain its ambitions. *Toto the Hero* and its modest budget told a very similar story better, perhaps *because* of the productions' limitations, which prompted a formidable creativity in the film's *mise-en-scène*, editing and its poetically-quaint special effects. Here, while Van Dormael's talent as a virtuoso director remains clear in places, the means at his disposal are gigantic yet still insufficient to match the technique of many Hollywood blockbusters, with the CGI special effects, for instance, feeling often a bit under-developed. But the film's problems reside not so much in its technical limitations as in its hybrid nature between experimental cinema and mass entertainment, and its ultimately muddled script. Constructed like a tree, various possibilities and 'butterfly effects' branching out into an ever-wider array of choices, the film clearly gets lost and many of its narratives are never fully developed – even in the director's cut. It is a paradox that a film about chance and choices should be so overwrought and overdetermined – and not always in the best way, as the mish-mash of derivative material

Director:
Jaco van Dormael

Producer:
Philippe Godeau

Screenwriter:
Jaco Van Dormael

Cinematographer:
Christophe Beaucarne

Art Director:
Stéphane Taillasson

Composer:
Pierre van Dormael

Editors:
Susan Shipton
Matyas Veress

Duration:
157 minutes (Director's cut)

Genre:
Science-fiction/philosophical tale/drama/love story

Cast:
Jared Leto
Diane Kruger
Sarah Polley
Lin Danh Pham
Rhys Ifans

Year:
2009

from the world of commercials, Hollywood films and installation art coalesce in an endearing, but non-compelling whole.

One wonders, if the three female characters seem to be posited on an even foot early on in the film (when three girls are seen sitting on a bench), why it is that Anna, played by Kruger, would become Nemo's final choice – at the precise moment when he dies and the expansion of the universe is suddenly inverted. The colour scheme of the film, associating Polley's chronically-depressed character with the colour blue, the Asian Lin Danh Pham with the colour yellow (meant to evoke fullness and material success), and Anna with red, the colour of passion and love, seems to solve this question. But this resolution seems facile and superficial, and contradicts the complexity of the various theories with which the film tries to grope and to unravel.

What is clear and compelling is the intolerable choice asked of the child, namely to choose between the father and the mother as they split up. Sadly, while the film definitely emphasizes the crucial dimension of this moment, it fails to elaborate on the many dramatic potentials of such a Cornelian dilemma. As long as the child does not make a choice, all possible lives remain open to him. Ultimately, the old and dying Nemo acknowledges neither choice, but a third scenario – that of escapism and fantasy. The film's strange, happy ending, with entropy suddenly inverted and all things going backward, speaks more to a negatively-regressive journey into imaginary nothingness than a truly-enchanting utopian drive back into the Lacanian 'Real'. But movement and time might be only an illusion, as the white pre-natal world matches the white aseptic future, and secret desires for a world where no one should die become one where people neither live nor die.

In the end, it is not the musings of the oldest man on earth to which we have been privy but, rather, to a hurt child's powerful inner cosmos and infinite imagination, blessed or cursed as the angel of Oblivion forgot to wipe his memory clean. Unsurprisingly, even Van Dormael's intellect and artistic skills were no match for such a formidable challenge. If this undermines the film, it makes the film-maker, so often associated with innocence and eternal childhood, only more relatable.

Jeremi Szaniawski

THE DARDENNE BROTHERS
Jean-Pierre and Luc Dardenne

The Dardenne Brothers (Jean-Pierre, b. Engis, 1951, and Luc, b. Awirs, 1954) profess a preference for 'filming with a thick rather than a fine brush'. Their cinematic production has three distinct phases: first, a phase of documentary memory as mirror of great social crises that the workers' movement underwent in their native Wallonia (examples include their documentary videos such as *Le chant du rossignol*, 1978, *Lorsque le bateau de Léon M. descendit la Meuse*, 1979, and *Regarde Jonathan*, 1983); second, a phase of fictional exercises portraying a collective experience which privilege lyricism and theatricality (the short film with surrealist undertones *Il court, Il court le monde*, 1987, and their two first 'features', *Falsch*, 1986, and *Je pense à vous*, 1992); and the third, current moment, which earned them international recognition, at the centre of which is their cinematic approach to an ordinary protagonist 'resisting' a crumbling society (*The Promise/La Promesse*, 1996; *Rosetta*, 1999; *The Son/Le fils*, 2002; *The Child/L'Enfant*, 2005; *Lorna's Silence/Le Silence de Lorna*, 2008; and *The Kid with a Bike/Le Gamin au vélo*, 2011). The common denominator of this declension in three 'tenses' is the film-makers' perennial desire to institute a Lévinasian 'ethics of optics': to learn to see again and to re-create connections with a viewership whose cinephilia is often reduced to easily-identifiable fictional stereotypes.

Born and raised in a working-class city of Wallonia bordering the river Meuse, and witnessing, from their childhood on, a collectivity gradually forced to relinquish its revolutionary ideals and descending into idleness, Luc (who received his degree in philosophy) and Jean-Pierre (who was trained as an actor), founded, with the assistance of the Ministry of Culture, the 'Dérives' production workshop in 1975. With 'Dérives', the Dardennes took as their thematic keystone the analysis of European resistance movements. Equipped with a shooting unit (the 'Portapack'), the use of which was a first in Belgium, the Dardennes embarked upon directing video documentaries in the form of testimonies: interviews set against the backdrop of a montage of archival material, punctuated by musical inerludes and lyrical voice-overs. *Le Chant du rossignol*, a collective chronicle of working-class clandestine activities from 1930 to 1960, is no longer available, but *Lorsque le bateau de Léon M descendit la Meuse* and *Pour que la guerre s'achève les murs devraient s'écrouler* (1981) as well as the documentary *Regarde Jonathan*, dedicated to proletarian playwright Jean Louvet, all constitute a vast aesthetic laboratory that anticipates the film-makers' subsequent evolution. We detect here an affiliation with the great masters of the Belgian documentary tradition, such as Henri Storck and Paul Meyer, but what is most striking is the pedagogical element underlying the film's various sequences (for example, an intertile claims 'first way to start the film' in *Pour que la guerre s'achève...*) and the peerless mobility of the camera: each ritual gesture of worker Léon M as he builds his boat becomes an existential metaphor, much as the waves of the Meuse are doubled by an unadorned lyricism, comparable to Michelangelo Antonioni's first documentaries. To this, the 'power of speech' is added, a discourse of memory theorized by Jean Louvet in *Regarde Jonathan*, often finding its justification in the poignant archival footage that prevaricates the temporality of the narrative, recalling the 'Eisenstein montage'. Under the influence of their

spiritual father, the militant writer Armand Gatti (b. 1924), the Dardenne Brothers become aware of the necessity for a mixing between a purely documentary and fictional approach, the latter being trickier but already present in their desire to refine the scripts of their testimonial-films. Therefore, *R... ne répond plus* (1981), a documentary about free radios in Europe, marks an explosion of pre-existing structures by favouring the recourse to parable through the metaphor of radiophonic chaos. *Leçons d'une université volante* (1982), a series of short films about Polish immigrants in Belgium from the 1930s to the 1980s, is presented as a series of testimonies, and ends up appearing to be a history of Polish exile, resorting to a poetics of repetition to carry its point across.

After their documentary project about philosopher Ernst Bloch (1885-1977) failed to materialize, the Dardennes' full-blowm entrance into the realm of fiction cinema occurred through the adaptation of an unfinished play by René Kalisky, *Falsch* (1986), the story of a scattered bourgeois Berlin Jewish family that gathers together at the moment of the death of its last survivor (Bruno Crémer). The filmic discourse is articulated again around the work of memory magnified by theatrical speech, with the family serving as a metaphor for the Holocaust. A stylistic break with

Luc and Jean-Pierre Dardenne, The Kobal Collection.

documentary production is nevertheless very strongly emphasized, as the plot unfolds in a deserted airport and constantly blurs temporal parameters, the elaborate mise-en-scène favouring a Brechtian distancing effect ('verfremdungseffekt') and the acting combining pathos and tragi-comedy. Undeterred by the commercial failure of their fictional debut, for which they took full responsibility, the Dardenne brothers went forth with their next effort, *Il court, il court, le monde* (1988), a small exercise in fiction film-making that serves as an acerbic critique of the forced mediatization of society, in a surrealistic vein close to slapstick. After years of investigating the steel industry crisis in Wallonia, under the impulse of the documentary tradition initiated by Henri Storck, the Dardennes turned their attention toward the story of a couple drifting in a space disinherited by history in *Je pense à vous* (1992). This important international production was co-written by Jean Gruault, who worked as a screenwriter for Roberto Rossellini, François Truffaut, and Alain Resnais. In this film, Fabrice (Robin Renucci), the son of Italian immigrants whose life takes a dramatic turn after he is fired, and Céline (Fabienne Babe, a good mother and a beautiful seductress) love and tear each other apart against a background of chromatically-complex shots interspersed with overbearingly-lyrical music, while an unexpected turn of fate will reunite them during an ancestral celebration. This melodrama-in-spite-of-itself was poorly received by Belgian critics, with low viewer turnout and poor distribution in Europe, and, moreover, was partly rejected by the Dardennes themselves.

Four years following *Je pense à vous*, the Dardennes initiated with *The Promise* (1996) a saga whose creative equation restores eternity and universality to human misery and despair. Much like their ulterior protagonists, Roger (Olivier Gourmet), a trafficker who remorselessly exploits illegal immigrants in the Liège area and his morally conflicted son Igor (Jérémie Renier) are no longer documentary or realistic fictional characters but, rather, promptly acquire symbolic status. The powerful *mise-en-scène* feeds off of their gestures, their hesitations and their imperfection, in order to start a work of 'sensory' montage, closer to Bresson than Rossellini, to whom some referred by calling the film 'Belgium Year Zero'. This was the Dardenne brothers' first international success in Europe, as well as in the USA, where the arthouse circuit considered the film a revelation. Indeed, the world of illegal workers in *The Promise* looks like a Tower of Babel, and the love-hate relationship between father and son is reminiscent of Dostoevsky. The informed audience recognized, in the long shot showing the young black mother running away with Igor, the correspondence with the Biblical flight into Egypt. But what radically changes compared to their preceding films is the emotional anchoring of the audience in the conscience of imperfect beings whose 'being-there'/'dasein' literally bursts through the screen.

It is this radicality of cinematic anchoring within a marginalized character – a young woman ready to do everything to get her job back – that earned Luc and Jean-Pierre Dardenne the first Belgian Palme d'Or (for a feature film) with *Rosetta*. The film's success took on a socio-political dimension, leading to the creation in Belgium of the 'plan Rosetta',[1] while critics hailed it as the birth of the 'character-

film'. Much like young Igor in *The Promise*, Rosetta (Emilie Dequenne, who received the Best Actress Award at Cannes) acquires the status of a universally recognizable symbol thanks to a mobile, hand-held camera, which follows her everywhere and records the psycho-physiological states of her fierce battle, without any ellipsis. This identificatory mechanism does not imply a moral contamination, however: reminiscent of Pasolini's first films as well as Kieslowski's *Decalogue*, Rosetta is often framed from the back when she hesitates about which expression or attitude to display when confronted with adversity, awkwardly playing the game of seduction and turning in the only person who shows her affection. Her behaviour, close to hysteria, does not exclude moments of intense lyricism, recalling the Dardennes' first documentaries, where poetry was born when least expected, such as on the edge of sinister zones and exhausted landscapes.

The Son concludes the trilogy of 'individual time' by renewing the 'character-film'. Contrary to what its title deliberately falsely indicates, the film does not deal with the son but, rather, with the intolerable confrontation between Francis (Morgan Marinne), who murdered the titular son, and the son's father Olivier, a carpenter, played by Olivier Gourmet (the unworthy father in *The Promise*, employer of *Rosetta*, and recipient of the Best Actor Award at Cannes for *The Son*). Olivier, the carpenter, takes the viewer into a philosophical and moral thriller of quasi-evangelical simplicity, shaking once again our visual habits: filmed with the smallest camera on the market (the A Minima), which literally sticks to his skin, the lonesome father will track down the younger Francis in order to decipher the enigma of a stupid gesture of tragic consequences. There is no ellipsis nor any music to assist the viewer, who feels a malaise quite comparable to the one felt in some scenes in *Rosetta*. True to their cinematic ethics, the Dardennes chose a positive ending, of cathartic virtues: forgiveness, suggested by the complicity of manual work whose minutiae is only matched by the ability to confess to the unspeakable.

The Dardennes then created another trilogy, of the de-radicalization of their style in order not to confine themselves to one method. With *The Child* (2005), they present a suspense movie depicting the quasi-Christological redemption of Bruno (Jérémie Renier), an irresponsible Accattone-like figure from Seraing, whom Sonia (Déborah François) abandons after he has sold their newborn Jimmy. From the most drastic use of handheld camera for *The Son*, where they pushed their stylistic possibilities to the limits, the Dardennes return, with *The Child*, to a camera that places several characters on an even footing. The cinematography opens the frame to the gestures of a couple that it follows and to those of the wrongdoer who accomplishes his misdeed. The gesture suffices in itself: Bruno's refusal to take the child in his arms shows, rather than symbolizes, his refusal to take his place in society as a responsible father. It is through the superiority of ethics above social considerations that the film-makers achieve the originality of the film, their second Palme d'Or – earned within a window of six years and over only three films. The retention of pathos in no way precludes tears at the end of the film: in the Dardennes' cinema, emotion is not a goal but, rather, an implacable collateral damage.

For the 60th anniversary of the Cannes festival, the Dardennes took part in the short film omnibus *To Each his own Cinema/Chacun son cinéma* (2007) by making the short film *Darkness/Dans l'obscurité*. A young woman in a theatre reaches out for a handkerchief to wipe the tears on her face prompted by the spectacle she is beholding. Her hand meets that of a thief. With this acousmatic *mise-en-abyme* of cinema, the Dardennes offer an outline of Lévinas's ethics that is entirely their own: her gesture toward the thief reprises, over an intertextual background, all the complexity of an ethics that they relentlessly explore. Through the features of Emilie Dequenne moved to tears by Bresson's *Au hasard Balthazar*, the Dardennes revive the Godardian power of Anna Karina's face watching Dreyer's *Passion of Joan of Arc* in *My Life to Live/Vivre sa vie*.

Lorna's Silence (2008) foregrounds protagonist Lorna (Arta Dobroshi), an Albanian immigrant to Belgium, who is pulled into a vicious cycle of sham weddings orchestrated by the gangster Fabio (Fabrizio Rongione): she tries in vain to save Claudy (Jérémie Renier), the drug-addicted man she married in order to obtain EU citizenship, which she will subsequently bestow upon her next husband, the Russian (Anton Yakovlev), after Claudy's death. *Lorna's Silence* is the film of rupture: it marks the passage from 16 to 35mm, including some occurrences of fixed shots taking a step back from the characters, announcing thereby a progressive passage from an accompanying camera to an observing one. The Dardennes here propose a film that is definitely more narrative, dealing with a more mysterious character than their usual protagonists. The extremely complex script proposes a revolutionary treatment of a marginal action, marking the refusal of classical narration of genre cinema by treating the centre of a traditional plot through an ellipsis. This film, about the inhumanity of illegal networks, received the prize for best script at Cannes. *Lorna's Silence* ends on the template of the fairy tale, imposing a space of belief as last bastion of an ethic violated by greed and murder.

The latest Dardenne film, *The Kid with a Bike* (2011) shows the adoption of Cyril (Thomas Doret) by Samantha (Cécile de France) after his abandonment by an irresponsible young father (Jérémie Renier). Both a film of action that does not preoccupy itself with any preliminary narrative justification and lyrical exploration of human suffering, *The Kid with a Bike* concludes the trilogy of de-radicalization through recourse to a classical cinematic grammar. It takes even further the options already explored in *Lorna's Silence*: observing camera, long fixed shots, brutal narrative ellipses, resorting to shot-reaction-shot and even extra-diegetic music (a theme by Beethoven). The film nevertheless remains eminently 'Dardennian', proposing a self-reflexive opening sequence *in medias res* strongly reminiscent of *Rosetta*. These evolutions do not affect the fidelity of the brothers to their original ethics, as demonstrated by the film being awarded the Grand Jury Prize at Cannes (a prize shared with Nuri Bilge Ceylan's *Once Upon a Time in Anatolia*).

The Dardenne Brothers, now inscribed within the elite pantheon of double-Palmes d'Or winners, enjoy a substantial success with the critics. But their impact goes beyond the festival circuit. Indeed, the

'Dardenne method' inspires and feeds many current movements, whether young Italian cinema, the new generation of German cinema (the Berlin School) or Romanian 'minimalist' cinema. This considerable influence goes hand in hand with the constant desire to share the work with the largest possible number through regular teaching, and through aiding experienced or young film-makers, through their Dérives workshop and their production company Les Films du Fleuve. In reality, as in their cinema, the Dardennes demonstrate a great humanity, a great humility, and an infinite generosity.

Dominique Nasta with Mathieu Pereira e Iglesias

Translated by Marcelline Block and Jeremi Szaniawski

Note
1. The Rosetta plan, initiated by Minister Laurette Onkelinx, facilitates the insertion of young people on the job market by offering a six-month professional experience following their graduation from school. The plan was subsequently enlarged, offering recruitment to all young job seekers.

The Promise

La Promesse

Studio/Distributor:

Les Films du Fleuve
Touza Productions & Touza Films
Samsa Film
RTBF/New Yorker Films

Directors:

Luc and Jean-Pierre Dardenne

Producers:

Hassen Daldoul
Luc Dardenne
Claude Waringo

Screenwriters:

Luc and Jean-Pierre Dardenne
Leon Michaux
Alphonse Badolo

Cinematographer:

Alain Marcoen

Production Designer:

Igor Gabriel

Editor:

Marie-Hélène Dozo

Costumes:

Monic Parelle

Music:

Jean-Marie Billy
Denis M'Punga

Duration:

90 minutes

Genre:

Drama

Cast:

Jérémie Renier
Olivier Gourmet
Assita Ouédraogo
Rasmane Ouédraogo

Year:

1996

Synopsis

Fifteen-year-old Igor has an apprenticeship with an automobile mechanic, who is angry when the boy's father, Roger, arrives early to take him out of work. Roger drives at high speed behind a truck loaded with new cars which prove to be hiding illegal immigrants on their way to illicit housing and employment provided by Roger, who oversees the busy operation with Igor's help. Among the new arrivals is Assita, who has come from Burkina Faso to join her husband Amidou, bringing their newborn baby. The undocumented workers flee when inspectors make a surprise visit, and Amidou falls off outdoor scaffolding. Mortally injured, he begs Igor to look after his wife and child, and Igor promises that he will. Roger covers up the accident, secretly buries Amidou, and forbids Igor to tell Assita her husband is dead, instead saying he ran away because of gambling debts. Feeling bound by his promise, however, Igor sabotages Roger's plans to fly Assita back to Africa or take her to Germany and sell her as a prostitute. Soon he finds himself on the run with Assita, caught between his father's demands and the obligation to fulfill his pledge.

Critique

Although the Dardenne brothers produced and directed a number of shorts, documentaries, and dramatic features in the twenty years before *The Promise/La Promesse*, this 1996 masterpiece launched the major phase of their career when critical raves at Cannes propelled it to international distribution and acclaim. Compared with most of the films that followed it, *The Promise* is less single-minded (obsessive, some would say) in organizing every aspect of camerawork and montage around the actions and behaviours of one protagonist – a pattern that peaks in later works such as *The Son/Le Fils* (2002) and, especially, *Rosetta* (1999), both of which earned Cannes best-acting prizes for their leads. Two main characters have roughly equal status in *The Promise*, although Igor has more screen time than Roger, and certainly has more existentially-daunting problems to confront.

Igor is also among the psychologically richest characters in the Dardenne filmography. To some degree, this is a function of his age. He is in his middle teens, a time when a youngster's personality is fully formed in some respects yet still ambiguous and amorphous in others, susceptible to impressions that may last for years to come. Igor's complexity also stems from the peculiar household in which he lives, works, and learns about the conundrums of human nature as best he can. While he is fully aware of his complicity in a criminal enterprise, he clearly loves and respects the single father who is raising him; and when crises of conscience arrive, forces of good and evil wage a war within his mind that is rendered all but visible on his expressive, often unhappy face. When he defies Roger in order to help Assita, is he driven primarily by the pangs of a healthy conscience, or is it more a matter of adolescent rebellion against parental authority? Or are both in play? Or is the motivating force some other, deeply unconscious factor that neither he, nor we, nor the film-makers can ever claim to understand?

Roger, meanwhile, is complicated in other ways. Is he fundamentally a responsible adult who takes care of business and nurtures his growing son? Or an irrepressible rogue who does not mean any real harm? Or is he a dissolute criminal with callousness and nastiness to spare? As in many a Dardenne Brothers film, the answers to such questions are never spelled out. Inklings, intimations, hints, and tantalizing clues are woven into the fabric of the film, and every moviegoer is entitled and encouraged to interpret them, perhaps coming to different conclusions with every viewing.

As usual, the Dardennes filmed *The Promise* on locations in Seraing, a largely industrial Walloon city in eastern Belgium; and, as always, they put the cinematic stress on showing, not telling. The settings are modest, the dialogue is spare, and the handheld camera races to keep up with characters perpetually on the go. Yet the film's virtuoso technique does not in any way divert attention from the moral issues at its core – issues relating not only to Igor and Roger as individuals but to the society that fails to stop the abuse of immigrants and tolerates the vicious racism that causes Assita to be demeaned and mortified by strangers when she finds herself on the street without shelter or protection. The personal and the political are intimately linked in the Dardennes' films, and *The Promise* stands with their most moving and revealing works. Moreover, as the movie that introduced the brothers as world-class auteurs, it holds a place of unique importance in the annals of Belgian cinema.

David Sterritt

Rosetta

Studio/Distributor:
Les Films du Fleuve
Directors:
Luc and Jean-Pierre Dardenne
Producers:
Luc and Jean-Pierre Dardenne
Laurent Pétin
Michèle Pétin
Screenwriters:
Luc and Jean-Pierre Dardenne
Cinematographer:
Alain Marcoen
Art Director:
Igor Gabriel
Editor:
Marie-Hélène Dozo
Duration:
95 minutes

Synopsis

Rosetta, a 17-year-old girl, lives in a trailer park with her alcoholic mother, going from job to job. One day she meets Riquet, who works at a waffle cart in town. With seduction as his goal, he tries to help her. Finding out about his workplace thieving, Rosetta denounces him to his boss, who fires Riquet and gives his job to the young woman. Gripped by remorse and stalked by the angry young man, she decides to end her life by opening a gas canister in her trailer, where her drunken mother is sleeping. However, the canister runs out of gas and the suicide attempt fails. As Rosetta goes out to get another canister, the young man circles furiously around her on his bike.

Critique

A follow-up to the critical success of *The Promise/La Promesse* (1996), *Rosetta* was an unexpected triumph at the 1999 Cannes festival (only slightly overshadowed by a drunken Sophie Marceau's rambling speech), where it took the Golden Palm as well as the Best Actress award for newcomer Belgian actress Emilie Dequenne, who was fifteen at the time of the filming. With each of their subsequent features, the Dardenne Brothers have consistently taken prizes in various categories at the prestigious festival.

Refining techniques already seen in *The Promise*, the film-

Genre:
Drama

Cast:
Emilie Dequenne
Fabrizio Rongione
Olivier Gourmet
Anne Yernaux

Year:
1999

makers intensify an aesthetic approach based on nervous handheld camerawork, emphasizing a documentary feel – at least on the surface – while telling a story with profound philosophical implications, in a film that was painstakingly conceived, scripted and rehearsed. The influence of Italian neorealism, Paul Meyer, Maurice Pialat, John Cassavetes, and, most evidently, Robert Bresson (*Mouchette* in particular) are evident in this story of a young, socially-marginalized woman's struggle to lead a normal life – complete with a job, a home, and a boyfriend. The Dardennes, however, are no mere epigones of great masters from the past, but have devised their own unique idiom.

Even more than in their previous feature, the camerawork, which relentlessly stays with the protagonist but often seems tardy in following her, is in perfect accord with the jerky awkwardness that pervades the film, especially in the scene where Riquet plays some music and tries to engage in a dance with Rosetta in his sordid apartment. It is here that the dialectical tension of the film is laid out, with contrasting movements pitted against one another: passive versus agitated bodies, anger against joy or class solidarity against

Emilie Dequenne in *Rosetta*.
The Kobal Collection.

callous self-interest. As in Bresson's work, no force prevails over the other, and so the movement of the film is one of a spiral: downward, then momentarily upward, and back down again, a viciously indecisive circle. Rosetta's stubborn persistence, against all odds, is perhaps her most admirable quality. She is the story, and this is why the camera so closely adheres to her. The viewer, constantly following Rosetta, and constantly being shrugged off by her, is denied empathy with her character, and is invited instead to partake in a sort of 'moral trance', to use Luc Dardenne's words, which refuses moral judgment but does not preclude the work of reflection.

Because of its investment in social themes (on a formal level the film might evoke the Dogme 95 but, thematically, it is much closer to British social cinema) and the squalid underclass milieu in which their films are set, the Dardennes' cinema has quickly been qualified as 'realist'. There is no denying that this is partly true, if only by virtue of the locations themselves, but claims to an 'authenticity of the quotidian' are weakened by the obvious melodramatic aspects which recur in the film-makers' oeuvre, in which the social dimension is much less important than the metaphorical aspect. Hence the many symbolic objects taken from everyday life: Rosetta's bottle and boots, almost war-time implements; her blow-drier meant to soothe her painful menstrual cramps, calming her belly as much as her existential rebellion and anger; the bog into which she and Riquet fall; or his manic circling around her on his motorcycle while she carries the gas canister with which she intends to commit suicide.

In the end, the film remains undecided, open-ended, much like Rosetta's struggle with and for life. Blinded, throughout the film, by the fight she has been leading, she might come to *see* at its conclusion, having escaped death, which is suggested, in absentia, by the film's remarkable refusal of a reaction shot. *Rosetta* develops an aesthetic approach toward philosophical dilemmas that the film-makers would perfect further in their masterpiece, *The Son/Le Fils* (2002).

Jeremi Szaniawski

The Son

Le Fils

Studio/Distributor:
Les Films du Fleuve
Archipel 35
RTBF/Diaphana Distribution
New Yorker Films

Directors:
Jean-Pierre and Luc Dardenne

Producers:
Jean-Pierre and Luc Dardenne
Denys Freyd

Synopsis

Olivier runs a carpentry shop in a training and rehabilitation centre, helped by apprentices chosen from the institution's current crop of adolescent boys. He seems uncertain about accepting a 16-year-old named Francis who has just arrived, but decides to go ahead and include the boy in his group. Olivier's ex-wife Magali drops by to share the news that she is pregnant; a little later Olivier visits Magali in turn, telling her that Francis has applied to his programme and falsely saying he rejected the boy. Magali expresses shock that he even considered accepting Francis, who (we now learn) caused their young son's death a few years earlier. Back at work, Olivier keeps a sharp eye on Francis, trailing him when he leaves the centre. Magali trails Olivier as well, catching him with Francis and fainting when he admits who the boy is. Olivier takes Francis on a car trip to a lumberyard, strengthening his bond with the teenager, who asks

Screenwriters:
Jean-Pierre and Luc Dardenne
Cinematographer:
Alain Marcoen
Production Designer:
Igor Gabriel
Editor:
Marie-Hélène Dozo
Costumes:
Monic Parelle
Duration:
103 minutes
Genre:
Drama
Cast:
Olivier Gourmet
Morgan Marinne
Isabella Soupart
Year:
2002

Olivier to become his guardian. A little later Olivier abruptly reveals to Francis that he is the father of the murdered child, prompting Francis to run away in a panic. Olivier catches him and calms his fears, whereupon Francis returns to work alongside him.

Critique

The chief hallmarks of the Dardenne brothers' visual style are proximity and mobility: the camera stays close to the central character of a scene, who is usually the central character of the film, and it moves as the character moves, sometimes with surprising speed and agility. These traits are especially prominent in *The Son/Le Fils*, charging the edgy, suspenseful drama of an edgy, conflicted man with extra measures of hard-driving energy. The film-makers' achievement is all the more impressive in a film that must communicate a good deal of psychological and sociological nuance pertaining to the main character, develop two secondary characters into fully-rounded personalities, and convey pivotal backstory information while maintaining the present-tense urgency produced by the camerawork. It is a minor miracle to accomplish all this within the parameters of the Dardenne technique, which privileges sustained intimacy with the lead actor over details of *mise-en-scène*. The style occasionally comes close to sacrificing spatial clarity for the sake of visual immediacy –

Olivier Gourmet and Morgan Marinne in *The Son*. The Kobal Collection.

certain settings and locations are tricky to sort out, particularly near the beginning – but by and large the film-makers reach their goals with remarkable success.

The film's moral clarity is never in doubt, and here the title provides an early clue. *The Son* may refer to the child of Olivier and Magali, who died four years ago and never appears on the screen; or to Francis, who becomes Olivier's apprentice and surrogate child; or to any of the youngsters Olivier takes into his workplace and trains in the skills and responsibilities of a useful trade. But the title is most productively taken as a reference to all three, since they occupy adjacent points on Olivier's ethical topography.

Magali is aghast when Olivier tells her that Francis is out of jail and has been in the training centre, even though Olivier quickly adds the falsehood that a transfer has removed the boy from the area. How could he think for one second, Magali wants to know, of helping and mentoring the killer who took their child's life? Olivier's decision to do just that seems impulsive at first but, in fact, he has been doing something similar for years by working at a trade school that regularly opens its doors to difficult and troubled kids. When his relationship with Francis breaches the wall of teacher-pupil detachment, the reason has less to do with sentiment than with his curiosity as to whether the boy has owned up to his crime or simply pushed it out of consciousness; finding this out is his hidden agenda when he takes Francis on a weekend trip to the lumberyard, and it is safe to assume that he does not make a private commitment to an ongoing connection until Francis ends his stalling, tells what he did – not having any idea that Olivier has ever heard of the case – and describes it sufficiently to indicate that it remains vividly present in his memory. The final rapprochement between the two is as logically determined as the dimensions and distances Olivier so meticulously measures in his work, and it is emotionally gratifying for spectators despite the understatement of the concluding scene. This understatement recognizes the open-endedness of the story's moral dilemmas in a manner consistent with the film's Christian overtones, manifested by the imagery of the carpenter father, his forgiveness of the murderer of his son, and the title itself. These elements are in line with the Dardennes' own politics, as they were brought up in a Roman Catholic household but have preferred to not be viewed as Christian film-makers, downplaying the implications of this lineage while also acknowledging the powerful influence of Robert Bresson's films, to which they were introduced in school by a priest.

The Son was a finalist for the Palme d'Or at Cannes in 2002, and Gourmet won the best-actor award. Marcoen's cinematography is equally impressive, staying mere inches away from the protagonist in most instances, then pulling back for more inclusive views at strategic moments, as when the dawning friendship of Olivier and Francis is affirmed by their co-presence within the same relatively wide shot. This is bravura film-making by any standard.

David Sterritt

The Child

L'Enfant

Studio/Distributor:

Les Films du Fleuve
Archipel 35/Sony Pictures Classics

Directors:

Jean-Pierre and Luc Dardenne

Producers:

Jean-Pierre and Luc Dardenne
Denis Freyd

Screenwriters:

Jean-Pierre and Luc Dardenne

Cinematographer:

Alain Marcoen

Production Designer:

Igor Gabriel

Editor:

Marie-Hélène Dozo

Duration:

95 minutes

Genre:

Drama

Cast:

Jérémie Renier
Déborah François
Jérémie Segard
Fabrizio Rongione
Olivier Gourmet

Year:

2005

Synopsis

Bruno and Sonia are barely into adulthood – he is twenty, she is eighteen – and they still behave like adolescents, living a catch-as-catch-can existence with nothing to support them but Sonia's welfare money and Bruno's small-time crimes. As frequently happens with unstable couples, the woman bears more burdens than the man, including responsibility for the wellbeing of Jimmy, their newborn baby. One day soon after Jimmy's birth, Bruno agrees to look after him while Sonia collects her benefit payment; but seeing an opportunity for profit, he abruptly sells the infant to an illicit adoption ring. Sonia collapses from shock when she learns what Bruno has done, alarming him so much that he contacts the baby merchant and asks to buy Jimmy back. The merchant consents to the deal but demands a dauntingly high price. Bruno believes that honest work is only for losers, so he has no legitimate way to raise the cash. His solution is to get together with Steve, his 14-year-old partner in crime, and embark on a string of petty larcenies. The plan immediately goes wrong, putting the police on Bruno's trail and making his future look bleaker than ever.

Critique

The Child/L'Enfant started forming in the minds of Jean-Pierre and Luc Dardenne when they were shooting their previous picture, *The Son/Le Fils* (2002), on location in Seraing, the urban setting for many of their films. They frequently saw a young woman in the area who pushed a baby carriage with a strangely aggressive attitude that piqued their curiosity about what was on her mind. At first they planned a story about a woman seeking a father for her child but, as the screenplay developed, their interest shifted to the baby's father, whose conviction that everything has a price leads him to betray his girlfriend by selling their infant son. They shot the film in sequence, using about forty different babies (and a prosthetic one for potentially-dangerous scenes) to play the 9-day-old title character, always taking care to make the infant's hands visible so spectators will have the sense of watching a living, breathing child – a factor that contributes directly to the film's effectiveness.

The Child emerged as one of the Dardenne brothers' most emotionally complex films, slipping ingeniously among at least three genres as the story unfolds. It functions as a psychological drama by portraying a conflicted and obtuse man whose inchoate opposition to the work ethic is matched by a limited intellect and a stubborn, self-centred personality. The movie also works as a suspense story, steadily escalating the tension as Bruno tries to renege on his deal with the black-marketeers, thus finding himself at the mercy of violent thugs, and winds up running from the law with little chance of success. Moreover, the film is in many ways a pitch-black comedy, thanks to Bruno's inexhaustible talent for making bad decisions, failing to think more than a few minutes into the future, and embracing the preposterous notion that he and a teenage street kid (a good accomplice, because Belgium does not prosecute minors for

Déborah François and Jérémie Renier in *The Child*. The Kobal Collection.

such crimes) can somehow steal enough mobile phones and snatch enough purses to buy him out of a dilemma he brought entirely upon himself. Although the comic aspects of *The Child* have received little attention from critics, they are central to the film's meaning. When we watch Bruno tussle playfully with Sonia in a park, or totally bungle a theft, or wrestle with a tangled wire that has snared his getaway motorbike, it is clear that the 'child' of the title refers not only to baby Jimmy but to his painfully immature father as well.

As always in the Dardenne brothers' films, the camera stays close to the protagonist, capturing every nuance of Bruno's gestures and facial expressions, which are sometimes revealing, sometimes opaque, and sometimes as enigmatic as the inner life of a character who is both banal enough to live by petty crime and bizarre enough to sell his own child. Yet the cinematography is not as unyieldingly fixated on one character as in such other Dardenne pictures as *Rosetta* (1999) and *The Son*, and the slightly-widened visual field heightens the emphasis on relationships between the characters and their environment – a city permeated with unemployment, poverty, and the kind of improvised, anything-goes lifestyle that Bruno has fashioned for himself. Far from seeing him as evil, the Dardennes present him as person who is not a great deal worse than the poorly functioning society around him.

The Child was the Dardennes' sixth dramatic feature. It promptly became one of their most honoured films, earning them a second Palme d'Or at the Cannes festival (the first was for *Rosetta* in 1999) amongst many other accolades. All were richly deserved, since this ranks with their most thoughtful and engrossing pictures.

David Sterritt

Lorna's Silence

Le Silence de Lorna

Studio/Distributor:
Les Films du Fleuve

Directors:
Luc and Jean-Pierre Dardenne

Producers:
Luc and Jean-Pierre Dardenne
Denis Freyd

Screenwriters:
Luc and Jean-Pierre Dardenne

Cinematographer:
Alain Marcoen

Art Director:
Igor Gabriel

Editor:
Marie-Hélène Dozo

Duration:
105 minutes

Genre :
Drama

Cast:
Arta Dobroshi
Jérémie Renier
Fabrizio Rongione
Alban Ukaj
Morgan Marinne
Olivier Gourmet

Year:
2008

Synopsis

Lorna, an Albanian living in Liège, has entered into a marriage of convenience with a Belgian drug addict, Claudy, in order to acquire EU citizenship. They live together, but sleep in separate rooms, as Lorna prepares to open a snack-bar with her boyfriend Sokol. Fabio, who is in the charge of the scam, however, has another plan in mind, in which Lorna is to allow Claudy to overdose, and then marry a Russian mafioso, himself seeking EU-status. To forestall this, Lorna attempts to attain a fast-track divorce by claiming domestic violence, and even harms herself to prove the allegation. At the same time, affection between the married couple blossoms. The day after they make love, however, Fabio engineers Claudy's death. Lorna discovers that she is pregnant, and insists on keeping Claudy's child, even when told that she was merely subject to a phantom pregnancy. Having ruined Fabio's scheme, she is taken into a car by one of his henchmen – ostensibly to be returned to her home in Albania. It becomes clear, however, that a more ominous fate awaits Lorna, and she escapes into a nearby forest.

Critique

Critics have grumbled at various inaccuracies in the Dardennes' treatment of characters caught within the vagaries of EU immigration policy, but the redemptive nature of *Lorna's Silence/Le Silence de Lorna*'s final scene should have underscored that documentary realism is remote from the film-makers' aesthetic concerns. We do not, however, have to share the Dardennes' theology to admire their poetry. Reaching a Cocteauian transcendence at its climax, this poetry has its core in the screen presence of Arta Dobroshi, the Kosovar actress playing Lorna. We can hardly do justice to her interpretation of the role by terming it a performance; rather, it is an embodiment, an incarnation, a transfiguration. Like Falconetti's Joan of Arc, Dobroshi's Lorna radiates her suffering out towards the spectator over the course of this sparing yet intense film.

The Dardennes' elliptical filming style is foregrounded from the very first scene, with its echoes of the opening of Robert Bresson's *Money/L'Argent* (1983). An anonymous pair of hands passes banknotes over a counter. Belatedly, the camera pans up to their owner: a young woman speaking heavily-accented French, wearing high-waisted red trousers, with alabaster skin, raven-hair and two small moles on her left cheek. Lorna *is* the film: not a single scene passes without her incandescent presence, as the camera tirelessly

pursues her in the same way it did for the central characters of *Rosetta* (1999) and *The Child/L'Enfant* (2005).

In comparison to these earlier films, however, *Lorna's Silence* contains a complex, intricate storyline which irrepressibly pushes forth towards its conclusion at a heady pace. At its centre lies the enigmatic transformation in Lorna's attitude towards Claudy. Throughout the first half of the film, she is cold and indifferent in her mercenary relations with the recovering drug addict. Their sham marriage is merely a business deal, their cohabitation a nuisance she must put up with until his inevitable overdose, at which point she can embark on a new transaction, in order to fulfil her dream of opening a snack-bar with Sokol.

But Claudy's childlike dependency on her as he attempts to kick his habit soon pierces through Lorna's unflappable aloofness. Her growing compassion towards Claudy initially leads her to claim domestic violence against him, thus leading to a fast-track divorce that could stave off the need for Claudy's death. No sooner is the divorce granted, however, than she strips naked in front of Claudy and makes love to him in the living room of their apartment. This moment ranks as one of the most inscrutable scenes in the Dardennes' œuvre, and it is from this point onwards that the film progressively departs from any standard notion of believable narrative, and towards a more unconventional, even fairytale-like world. Fabio, as omniscient as a network of surveillance cameras, increasingly assumes the role of dark lord of this domain: first ensuring that Claudy overdoses as planned, and then becoming ever harsher towards Lorna herself, after losing patience with her prevarications.

Indeed, the spectator is hurled into a Buñuelian epistemological uncertainty when Lorna, having previously had a pregnancy confirmed, is told by a nurse that she was never pregnant in the first place. With Lorna herself refusing to accept this, we simply do not know what to believe – was the baby merely a psychosomatic reaction, or has Fabio's malevolent power extended its reaches into the state hospital system?

Our sympathies nonetheless lie unambiguously with the film's dogged protagonist, whose tenacity is undeterred by the setbacks she suffers. With Claudy dead, the loan for the snack-bar cancelled, and an irate Sokol, having found out about the infidelity, agreeing with Fabio's plan to dispatch her back to Albania, Lorna still resists. As Spirou (Marinne), Heurtebise to Fabio's Angel of Death, drives her through the backwoods of Belgium, a sinister foreboding pervades the car, until Lorna, having used the pretense of a need to urinate to escape from Spirou's grip, returns and strikes him over the head with a rock.

The trancelike final scene, with Lorna fleeing through the woods before resolving to spend the night in an abandoned shack, constitutes the highpoint of the film's mysterious quality. This is underlined with a rare use, by the Dardennes, of non-diegetic music, as strains of Beethoven's Piano Sonata No. 32 in C Minor accompany Lorna's soothing words to her belly: 'I won't let you die. Never. I let your father die. You will live.' Even those who would ordinarily bristle at such an overtly Christian-themed conclusion will be swept away, at this point, by the raw emotional power in Dobroshi's rendition of the indomitable Lorna.

Daniel Fairfax

The Kid with a Bike

Le gamin au vélo

Studio/Distributor:
Diaphana Distribution

Directors:
Luc and Jean-Pierre Dardenne

Producers:
Luc and Jean-Pierre Dardenne
Denis Freyd

Screenwriters:
Luc and Jean-Pierre Dardenne

Cinematographer:
Alain Marcoen

Editor:
Marie-Hélène Dozo

Duration:
87 minutes

Cast:
Thomas Doret
Cécile de France
Jérémie Renier
Fabrizio Rongione
Olivier Gourmet

Year:
2011

Synopsis

Cyril, an 11-year-old boy living in a foster home in the Seraing region, persists in seeking out the father who has abandoned him. Tracking down an old address found through an advertisement selling a bicycle, Cyril encounters Samantha, a hairdresser working on the ground floor of the tower block, while trying to flee the foster home workers pursuing him. Samantha abruptly determines to adopt Cyril, a decision that will throw her own relationships into chaos as she struggles to cope with Cyril's violent mood swings. The tension leads Cyril to fraternize with a gang of adolescents, whose leader, Wes, himself 'adopts' Cyril and engages him in a series of delinquent crimes culminating in the bungled robbery of a nearby news-stand. The newsagent's son, seeking retribution, tracks Cyril down to the gang's woodland lair, and seems to strike him dead with a stone thrown at the head.

Critique

Devotees of the Dardenne brothers' work will find *The Kid with a Bike/Le Gamin au vélo* at the same time both familiar territory and a departure from their previous work. Familiar, because it continues their politico-aesthetic approach of filming socially marginalized figures in Seraing, an economically-depressed, post-industrial town in francophone Belgium. Familiar, too, will be the prominent role of children in the film, a score of faces taken from the Dardennes' previous films, many who have since become established actors (Renier, Gourmet, Rongione), and the tight handheld camerawork

Thomas Doret and Cécile de France in *The Kid with a Bike*. The Kobal Collection.

dominating its visual style. But the film constitutes a departure nonetheless. For the first time, the directing duo, more generally known for a bleak, austere aesthetic matching their Walloon surroundings, not only eschew filming in the grey winter months but also elect to give a major role in their film to a star actress, Cécile de France. As such, *The Kid with a Bike* is their brightest film, illuminated by the binary radiance of the summer sun and de France's charisma.

Cyril has been placed in the care of a foster centre but, unable to accept the finality of his abandonment, persistently flees its confines in search of his aloof father. With resolute ingenuity, the child uses the ad his father placed selling his bicycle to track down his old residence, and it is here that he encounters Samantha. Why Samantha makes the decision to assume responsibility for the boy, a challenge she is evidently unprepared for, is left unexplained – even when she is asked, she can only stammer a reply of, 'Well... I don't know.' But when the shiftless father, having been located by Samantha, slams the door on his own child, we can only share her gut sympathy and nurturing urges for Cyril.

Although ensconced within a newfound domestic environment, with even his bicycle returned to him thanks to Samantha's generosity, temptation still lurks in wait for Cyril, as he makes the acquaintance of a band of local delinquents who occupy a wooden shack in a forest on the outskirts of the town. Their leader, Wes, takes Cyril under his wing, and seeks to involve him in the violent robbery of a local newsagent.

While its title will inevitably invoke Italian neo-realist cinema, *The Kid with a Bike* is impregnated with a consciously fairytale-like structure, which the Dardennes emphasize with the use of non-diegetic music. The Christian-Humanist philosophical framework for their films is, however, no less present. Whereas *The Son/Le fils* (2002) closed in forgiveness of a father for his son's murderer, *The Child/L'enfant* (2005) was marked by a culminating penitent sacrifice, and *Lorna's Silence/Le silence de Lorna* (2008) by the motif of hope in rebirth, here it is the theme of resurrection which defines the film's conclusion.

Characters are on occasion filmed 'at the back of the neck', in the manner made famous by the Dardennes' earlier work, but to nowhere near the same degree of tenacity as in *Rosetta* (1999), for instance, and the divergence from their earlier claustrophobic practice not only allows de France to shine through her peroxide perm, fake tan, and denim outfits, but also throws light onto the concentration of violence in the diminutive Doret's performance. Just as, throughout the film, Cyril turns from relative calm to explosions of rage within seconds, so too will the spectator be catapulted from one emotion to another in this film-meteorite, whose restless kinetics are the nexus between the film's form and its content.

Daniel Fairfax

OTHER BELGIAN AUTEURS

Although Chantal Akerman, André Delvaux, Jaco Van Dormael and the Dardenne Brothers are indisputably the most famous names of modern Belgian cinema, both at home and on the global stage, Belgium is rife with other noteworthy cineastes that have also made an impact on the international festival circuit scene. This short (and hardly exhaustive) list thus includes those who have shone then and now with at least two remarkable features.

Harry Kümel (b. 1940), an Antwerp native who has become a master of a very personal type of fantastic cinema, oscillating between the captiously oneiric and the baroque, has delighted amateurs of vampire stories with his *Daughters of Darkness/Les Lèvres rouges* (1971), one of the classic examples of that sub-genre, the lesbian vampire film (with Delphine Seyrig as its lead Sapphic temptress, little wonder). Although his reputation in the 1970s ranked him at the top of Belgian cinema's names at home and abroad, working with actors of the ilk of Seyrig and Orson Welles, Kümel lost popularity throughout the 1980s and 1990s, moving into semi-retirement and teaching film students instead. In this predicament (but certainly not in the subject matter of his films), his career trajectory evokes that of Jean-Jacques Andrien (b. 1944), another Belgian director initially headed for fame and glory, but whose star-studded productions ended up faltering, and who should be mentioned here, if only in passing.

Thierry Zéno (b. 1950) must have been blessed by the 'Satanic muses' while in the cradle. Perhaps the single most original auteur in Belgian cinema, Zéno has made a series of ethnographic documentaries dealing with notions such as alienation and death, of which *Of the Dead/Des Morts* (1979) remains the most notable. Zéno began his career with a unique feature, *Wedding Trough/Vase de Noces* (1974), where his interest in the transgression of boundaries, mixed with uncompromising formal rigour, allows scintillating and painstaking artistic talent to shine through, renewing the idiom of Belgian surrealism in the process (Zéno is also the curator of the Félicien Rops museum in Namur, his hometown). A telling anecdote of the author's dedication to his work: after completing the shoot of this electrifying debut, Zéno went back to school, enrolling in the department of Sinology at the university, spending most of his free time, in the manner of a Medieval monk, numbering each of the frames of the raw footage to his film, which would otherwise have proven impossible to edit – a process that took him years.

Gérard Corbiau's (b. 1941) interest in baroque and classical music has led him, in association with producer Dominique Janne, to make a series of films dealing with this subject matter, earning him Oscar nominations for *The Music Teacher/Le maître de musique* (1988) and *Farinelli, Il Castrato* (1994). While these films are hardly cinematic masterpieces (one can detect Corbiau's television background through his fairly academic and unimaginative visual style), their cultural significance and their role in promoting classical music in film is unquestionable.

Jan Bucquoy (1945) is a minor film-maker, perhaps, but he embodies a type of Belgian irreverence and absurd humour (Bucqoy, also a writer and graphic-

novel artist, made an album illustrating the pornographic adventures of Belgian's most famous fictional character, Tintin) that must be mentioned in a volume such as this one. Surrounding himself with a scene of provocateurs from Brussels, his cinema attempts to redefine a humour of bad taste and disenchantment which, taken from the right angle, can be both thought-provoking and even refreshing. Among the massive ensemble casts featured in his films, one should point out Noël Godin (b. 1945), a curious intellectual figure and film critic-cum-agent provocateur who, under the nickname le Gloupier, has made one of his trademarks the notorious 'entartage' – throwing cream pies in the face of public figures – accompanied by his war cry of 'Gloup! Gloup!'. But Godin's anti-bourgeois stance must be assessed in a critical light: after all, however anti-bourgeois, he married into a wealthy family (albeit surrealist): Marcel Broodthaers's daughter is his wife – another typical Belgian paradox.

Trained in classic circus arts, Dominique Abel (b. 1957) and Fiona Gordon (b. 1957, Australia), the professed heirs to a charming tradition that stems from silent comedy and up to Jacques Tati, have created a series of personal and unique films (also with accomplice Bruno Romy) which boast an enchanting and quaint poetry of the pantomime. Their films have never failed to seduce critics and audiences alike, but unfortunately their real-life business ventures have been less enchanting. L'Arenberg, the theatre the duo managed in downtown Brussels, was a staple of arthouse cinema, which each summer presented one of the city's most exciting repertory festivals, ingeniously called 'Ecran Total' (literally 'total screen', but which also translates as 'sun block', playing upon the context of darkness during the summer season). Yet unfortunately, in 2011, this theatre had to close down on account of heavy debts, re-opening as a more traditional commercial cinema, with digital projection rather than the old cinema's 35mm systems, marking the death of an important cinephilic tradition.

Dominique Deruddere (b. 1957) is one of the most successful names of Flemish cinema, whose precociousness (he was making professional short films in his teens, although his first feature, Crazy Love, did not come out until 1987, when he was thirty) and intelligence earned him an Oscar nomination for Everybody's Famous!/Iedereen Beroemd! (2000). This film is a fascinating case study of Flanders' relationship to American cinema and to the region's own powerful sense of nationalism. While a blueprint of an American kidnapping and ransom/fairytale rise to stardom narrative, Deruddere's film is also filled with a very Flemish frankness and crude sense of humour, careful to deconstruct the clichés of American glamour in its every(wo)man protagonists. Everybody's Famous! also presents Dutch as the nation's language through the film's central pop song, 'Lucky Manuelo', which cleverly encompasses the spirit of the whole film and, by extension, of the film-maker himself: pragmatic, smart, filled with wit and whimsy, and with an irony which never entirely sacrifices the power of raw emotion.

Closing this short panorama of important Belgian auteurs, Joachim Lafosse (b. 1975) is unquestionably one of the most talented voices to have emerged from Belgian cinema in the 2000s. Lafosse's perverse yet moralizing tales – including Private Property/Nue proprieté (2006) and Private Lessons/Elève Libre (2008) – are endorsed by an impressive mastery of film-making and actors' direction. His cohesive corpus of introspective, heavily psychoanalysed films, consistently centred around dysfunctional familial nexuses, destine him to become the most important

name of francophone Belgian cinema in the future. Lafosse has also been cultivating a sensitive, penetrating, seductive, and at times disingenuous, persona, which can only contribute to his image as an artist, especially in the eyes of French critics. His latest feature, *Our Children/À perdre la raison* (2012), based on horrific events that occurred near Brussels in 2007, was Belgium's submission to the 2013 Academy Awards and is our choice for 'Award of the Year' as, among its many other honours and accolades, it swept the 2013 Magritte Awards (the Belgian version of the Césars/Oscars for francophone Belgium), winning Best Movie, Best Director, Best Actress, and Best Editing.

Jeremi Szaniawski

HARRY KÜMEL

Malpertuis

Studio/Distributor:
Artémis Productions
Les Productions Artistes Associés

Director:
Harry Kümel

Producers:
Paul Laffargue
Pierre Levie

Screenwriters:
Jean Ferry
Jean Ray (from his novel)

Cinematographer:
Gerry Fisher

Art Director:
Pierre Cadiou de Condé

Composer:
Georges Delerue

Editor:
Richard Marden

Duration:
125 minutes

Genre:
Fantasy

Cast:
Orson Welles
Susan Hampshire
Michel Bouquet
Mathieu Carrière
Jean-Pierre Cassel
Walter Rilla
Sylvie Vartan

Year:
1971

Synopsis

Yann, a young sailor, disembarks on shore leave to visit his family's old house, only to be assaulted and kidnapped by a suspicious man employed by his uncle, Cassavius. He awakens in Malpertuis, a mansion inhabited by a panoply of bizarre characters. Cassavius explains to Yann that he has brought him to Malpertuis to make him his heir. Cassavius dies, but not before announcing to the denizens of Malpertuis that they will only receive an inheritance if they remain on the estate's premises. Yann attempts to flee, but the inhabitants of Malpertuis prevent his escape. Their prohibition, the resident Abbé explains, is owed to the fact that they are really gods: if he leaves, no one will believe in them any longer, and they will cease to exist. Euryale confirms that the denizens of Malpertuis are Greek gods, rescued from oblivion by Cassavius. The scene then shifts to contemporary Belgium. Here, Yann resides in a psychiatric hospital, writing the story that we have just seen. He is collected from the hospital by his wife but, as he arrives home, we realize that he has in fact returned to Malpertuis, where his double – the Yann of the fiction – waits to meet him.

Critique

Malpertuis, Harry Kümel's second fiction feature (after 1969's *Monsieur Hawarden*), seems on paper to be a perfect prestige film, and was selected as Belgium's entry at Cannes in 1971. Its art film ambitions, however, stand alongside a firm foundation in pulpy genre fiction: based on the eponymous novel by Jean Ray, Belgian author of detective stories and tales of the fantastic, *Malpertuis* melds a sophisticated surrealist visual sensibility with a rambling, vague, and often absurd narrative.

Kümel allows finely-crafted images to take clear precedence over narrative, and fills out the flimsy storyline with ample references to Belgian art: a Magritte painting serves as the backdrop for the credit sequence, set design and iconography are clearly influenced by surrealist/magical realist Paul Delvaux, while several homages to Bruegel and other Flemish painters appear in scenes depicting the kitchen and servants' quarters. The manifold citations of Belgian art determine both the content of the film and its style. Whereas Ray's narrative deals mainly with Cassavius's rescue of the Greek gods, here the patriarch seems to set into motion an allegory about art. Before the divine identity of Malpertuis's inhabitants is revealed, a servant recounts to Yann Cassavius's joy in creating living creatures, several of whose disembodied hands show up, later on, in a mouse trap. Cassavius, then, allegorizes the artist, and his actions suggest that the artist takes over from the Gods, domesticating them. This function, however, is treated with ambivalence: Malpertuis is clearly characterized as a place of evil. The art and culture held within its walls are not vital but sequestered, a sign of gothic decadence and decay. Coupled with the Belgian art iconography, this characterization of art suggests a national-cultural

Susan Hampshire and Mathieu Carrière in the ruins of the Villers-la-Ville Abbey, in *Malpertuis*. Harry Kümel.

reading, in which art is not a patrimony to be cherished but a force that binds one to death and decay, to provincialism and isolation. The modern-day epilogue, meanwhile, rather heavy-handedly invites a psychoanalytic reading in which myth and creation are suppressed, not by their own decadence and decay but by modern secularism and technology. This repression, of course, only leads to periodic bouts of madness, and we, like Yann, cannot truly escape from Malpertuis: if the Gods menace us, it is because we do not, like Cassavius, give them a home but seek to evict them from their lodging within our souls.

Both the thematic paradoxes and the formal limitations of *Malpertuis* are embodied in the person of Orson Welles, who seems to have stepped out of *Chimes at Midnight* still looking like Falstaff. Rather than serving as a dramatic character or developing the plot, Welles spends the entirety of his screen time simply sitting in bed. It is his presence rather than his dialogue, or even his character, that matters to the film. On the one hand, he serves as guarantor of its level of prestige but, on the other, carries an extra-textual connotation as a patriarch and master creator. The early death of this creator doubles the film's lack of direction, yet the role he plays within it – one that does not unfold in time, dramatically, but simply stands static, looming – is continued by the sets and tableaux that Kümel deploys. This is a film of icons and statues, of stasis and repetition, imprisoned, like its characters, by its own inability to create movement or energy. *Malpertuis* is a cinematic charnel house, a mausoleum full of *cadavres exquis*.

Michael Cramer

Daughters of Darkness

Les lèvres rouges

Studio/Distributor:
Ciné Vog Films (Belgium)/
Showking Films (Belgium)/
Maya Films (France)/Roxy Film (Germany)

Director:
Harry Kümel

Producers:
Paul Collet
Henry Lange

Screenwriters:
Pierre Drouot
Harry Kümel
and Jean Ferry

Cinematographer:
Eduard van der Enden

Set Designer:
Françoise Hardy

Sound:
Jacques Eippers

Music:
François de Roubaix

Editors:
Denis Bonan
August Verschueren

Duration:
100 minutes

Genre:
Drama/horror

Cast:
Delphine Seyrig
John Karlen
Danielle Ouimet
Andrea Rau

Year:
1971

Synopsis

Newlyweds Stefan and Valerie travel from Switzerland to Belgium by train. Although they plan to return to Stefan's home in England, they stop in Ostend. They are the sole guests in a palatial seaside hotel, until Countess Elizabeth Bathory and her 'secretary' Ilona arrive. Stefan and Valerie read reports of nearby murders, and then witness the police taking away a fresh corpse during a visit to Bruges. Upon their return to Ostend, they are followed by a policeman who suspects that Ilona and the Countess are not only behind the murders but are also a pair of vampires. The Countess pursues Valerie, while sending Ilona to seduce Stefan. The two women catch Stefan and Ilona in a post-coital scuffle that results in the accidental death of the latter. Distraught, Valerie allows the Countess to drink her blood. The two murder Stefan and flee, but the sunrise causes them to crash their car. The Countess is impaled on a tree branch, while Valerie survives. The final scene reveals her seducing a young couple, just as the Countess seduced her and Stefan.

Critique

Perhaps the most understated and elegant of the many lesbian vampire films made in Europe in the 1970s, Harry Kümel's *Daughters of Darkness/Les lèvres rouges* privileges character and subtle eroticism over sensationalized sex and violence. Slowly but deliberately paced, the film focuses on the gradual seduction of both Stefan and Valerie by the diabolical Countess. As with most of the films in the lesbian vampire cycle, such as Vicente Aranda's *The Blood Spattered Bride* (Spain, 1972) and José Ramon Larraz's *Vampyres* (UK, 1975), *Daughters of Darkness* relies on two main intertexts, Joseph Sheridan Le Fanu's 1872 tale *Carmilla* (also the main source for Carl Dreyer's 1932 *Vampyr*, which features a considerably-less seductive female vampire) and the legend of sixteenth-century Hungarian Countess Erzsébet (Elizabeth) Bathory, who supposedly killed hundreds of young women and bathed in their blood.

Despite its gothic sources, Kümel's film relies on a decidedly-modern iconography: the hotel in which most of the action takes place is a clear analogue to the one in Alain Resnais's *Last Year at Marienbad* (1961), and the play with empty, labyrinthine spaces owes much to both that film and Resnais's earlier documentary *Toute la mémoire du monde* (1956). Seyrig's presence underscores the importance of Resnais's work to *Daughters of Darkness*, although here she takes on the role of the male characters in *Marienbad* and *Hiroshima, mon amour* (1959), relentlessly pursuing and seducing a confused and anguished young woman. In ironic contrast to the rather lifeless and unappealing young couple, Seyrig's undead countess is the vivacious centre around which the film turns, performing with a gloss and sophistication that matches Kümel's immaculately-dressed and majestically-filmed set.

Despite the generic and tonal distance between the two films, *Daughters of Darkness* is in many ways the double of Kümel's *Malpertuis*, released in the same year. Both films are preoccupied with sexual anxiety and death but, more importantly, both use a single edifice as an allegorical representation of Belgium itself. Whereas the cursed estate of *Malpertuis* functions as both a dead museum and a

provincial prison, the Ostend hotel of *Daughters of Darkness* situates Belgium as a trans-European crossroads, home to none and therefore the site of the most unspeakable evils. Belgium here figures not as the source of a stifling cultural patrimony but, rather, as a marginal, transitional space, in which pan-European perverts (the death-obsessed and sexually-ambiguous Englishman Stefan, the repressed Swiss lesbian Valerie, and the murderous Hungarian Countess) meet to play out their diabolical ménage-à-trois. As in *Malpertuis*, desire and drive move in repetitious circles, never reaching their goals, instead ossifying into both monumental immobility (the statues in *Malpertuis* and the neoclassical hotel of *Daughters of Darkness*) and bloodless lifelessness, thereby revealing their inextricable kinship with death.

Michael Cramer

THIERRY ZÉNO

Wedding Trough

Vase de noces

Studio/Distributor:
Zeno Films
Director:
Thierry Zéno
Producer:
Thierry Zéno
Screenwriters:
Dominique Garny
John Kupferschmidt
Thierry Zéno
Cinematographer:
Thierry Zéno
Music:
Perotinus
Monteverdi
Alain Pierre
Editor:
Thierry Zéno
Duration:
79 minutes

Synopsis

A man removes a dove from a small enclosure and fumblingly places a doll's head over the bird's own head; it quickly falls off and, after doing the same with a second dove, he releases both from an upstairs window of his large farmhouse. An extreme long shot down a corridor then shows the farmer kneeling behind a pig, and a tight close-up shows his fingers caressing the animal's nipples. Soon afterward he has (soft-core) sex with the pig, entering her from behind. Later he slices a vegetable, beheads a chicken, and places the head, the chicken's feathers, and the vegetable into a jar, one of many he keeps in a glass-walled solarium. Eventually the sow gives birth to three piglets; he cares for them, plays with them, and then kills them. Afterward he finds that the mother pig has died as well; retrieving her carcass from the sump where it lies, he buries it and crawls into the grave with her. He then goes home, places the piglet carcasses in jars, makes noisome tea and gruel from feces and other detritus, and eats and drinks copious amounts. Finally he climbs a ladder and hangs himself. The last image shows his body ascending into the sky.

Critique

Belgium's film culture is famously experimental, but this superlatively strange melodrama may hold the record for visual extremes and thematic derring-do. The film's lone character, a farmer who does not speak and is never named, is associated with animals, earth and abjection throughout the story. His activities include cooking and eating, slaughtering fowl, defecating into a tub, using his pig to pull a plough, and making love to the sow while she eats from the ground, not seeming very interested in the farmer's amorous attentions.

The man is also connected with the sky, however, and perhaps with

Genre:
Melodrama/Cinema of Excess
Cast:
Dominique Garny
Year:
1975

the transcendent. After playing with his doves in the first scene, he allows them to fly away and one of them perches high on a cupola, next to an even higher weathervane. Later he kills his baby pigs by hanging them in the open air and, at the end of the film, he climbs a ladder to hang himself. The sky motif reaches its pinnacle in the final shot, when the farmer's body appears to be transported to the heavens – or assumed into Heaven – for reasons we must gather from the preceding episodes.

A plausible way to interpret the farmer's trajectory from barnyard earth to heavenly heights is to regard him as a lord of misrule, reigning over an anarchic kingdom of animals with a guilelessness and ingenuousness equal to their own, and therefore free of culpability for what worldly people see as immorality and sin. The transgressions of taste that make *Wedding Trough/Vase de Noces* beyond the pale for most moviegoers arise from an unrestricted and intensive focus on the lower body, and the resulting visual excessiveness has the effect of inverting, subverting, and perverting the norms of decency maintained in polite society, even in an age as uncensored and freewheeling as ours is alleged to be. *Wedding Trough* is what cultural theorist Mikhail Bakhtin would call a radically carnivalesque film, conjoining elements of life that are ordinarily held apart – birth and death, food and shit, animal sex and sex with animals – in order to perceive their qualities and fathom their mysteries in unfamiliar ways.

The view of the farmer as a holy fool is confirmed by the games he plays during the film, as when he fiddles with dolls' heads and engages the sow in a sort of blind man's buff. He also plays with the

Dominique Garny in *Wedding Trough*.
The Kobal Collection.

piglets and knits tiny garments for them to wear, and, in a prolonged shot worthy of the Disney studio, he gives them bowls of milk, sits at the table to share the repast, and needs to interrupt his own drinking with amusing frequency because the impolite little creatures keep absentmindedly wandering away. If one sees the farmer as a holy fool, his ascension to the heavens is an appropriate outcome for his life.

The strongest evidence against the holy-fool hypothesis is the killing of the piglets, a seemingly unmotivated act that may be the cause of the mother pig's death as well, if one thinks of her off-screen demise as a possible suicide. Whether or not he brought about her passing, the farmer immediately repents, or at least decides that life is no longer worth living, thus reaffirming his holiness, or his foolishness, or both. *Wedding Trough* is a holy fool of a movie, strenuously serious in some respects, yet ludic enough to serve up a visual pun on Luis Buñuel's classic *Un Chien Andalou* (1929), the begetter of many a disobedient film since. The Andalusian dog should be proud to have the beloved pig among its descendants.

David Sterritt

Of the Dead

Des Morts

Studio/Distributor:

Zeno Films
Les Films du Losange/
Woodhaven Entertainment

Directors:

Jean-Pol Ferbus
Dominique Garny
Thierry Zéno

Screenwriters:

Jean-Pol Ferbus
Dominique Garny
Thierry Zéno

Cinematographers:

Thierry Zéno
Terry Stegner

Music:

Alain Pierre

Editors:

Thierry Zéno
Roland Grillon

Duration:

101 minutes

Synopsis

This documentary shows contrasting approaches to dying, death, and disposal of cadavers in cultures around the world: Belgians participate in a Christian funeral service.[1] Mourners in Thailand perform lengthy ceremonies before burying the deceased. Indians prepare a corpse on the bank of the Ganges River and then cremate it nearby. Mexican physicians perform surgery on a man with serious knife wounds sustained during the Day of the Dead festivities. In the United States, patients with muscular dystrophy speak of their impending deaths; a widow describes a videotape her late husband made when he was dying of cancer; people grieve over their dead dog at a pet cemetery; and a mortician demonstrates some of the methods used to prepare a body for burial. In one sequence, a pilot talks about the money he earns by spreading remains over San Francisco Bay from his plane; another episode gives close-up views of a cremation; still another visits a cryogenics company that freezes corpses for a price. Some of the rituals depicted in the film treat death as a sad but natural occurrence while others seem motivated by commerce and the modern tendency to sanitize mortality and keep its realities at a distance.

Critique

Fans of subversive cinema frequently place *Of the Dead/Des Morts* into the 'mondo' or 'shockumentary' genre. But viewers in the market for lurid thrills are likely to find it rather tame, since the film is a legitimate documentary about death and dying, albeit a flawed one that too often editorializes its subject through the selection and juxtaposition of material.

Shot in *cinéma-vérité* style without narration, the film jumps from place to place at will, returning to some situations repeatedly while

Genre:

Documentary

Year:

1979

devoting more limited amounts of time to others. The structure seems almost random at first, but eventually takes on a certain logic dictated by the attitudes of the film-makers toward their material. Thus, the first sequence shows an American mortician cleaning the fingernails of a body being prepared for burial. This is immediately contrasted with a funeral in Thailand, where ceremonies go on for many days, during which the corpse is allowed to begin the process of decay in a natural fashion. When the Thai funeral reaches the interment stage, the coffin proves too small for the body it is meant to hold, so the attendants tilt the corpse and slide it in at an angle – a simple expedient carried out in a practical, unsentimental spirit that provides further contrast with the fussiness of Western mortuary procedures.

Like other juxtapositions in the film, this one carries the implicit message that Eastern cultures may have more natural, less technologically mediated and, consequently, healthier approaches to mortality than so-called advanced cultures. The film also contains occasional sardonic touches that reveal cultural biases on the directors' part. The mortician is shown awkwardly leaving an interview to take a telephone call, for example, and when a paralysed man in a wheelchair speaks of his growing immobility, the frame momentarily freezes, punctuating the scene with a visual joke in very questionable taste.

Other portions of the film, such as those dealing with the burning of cadavers, are more objective. Different points of view about cremation are briefly articulated by patients whose bodies have been wasted by the muscular dystrophy that will inevitably kill them: one man says that burning a human body seems wasteful, while another says that the body relates to the soul in the same way that a tin can relates to the beans it contains, arguing that in both cases the container can be summarily discarded when no longer needed. The film supplements these verbal statements with shots filmed in a crematory oven, giving close-up views of a body being consumed by fire, and with outdoor cremations in other parts of the world, where scientific efficiency has not intruded on traditional practices. Other segments show images of embalmed and mummified bodies that were jolting when the film was new in 1979, but seem quite mild now that exhibitions by anatomist Gunther von Hagens have normalized the viewing of preserved cadavers in the flesh.

The cultural meanings in *Of the Dead* are also affected by the near-impossibility of filming the *act* of dying in the modern world. In an apparent effort to fill this gap, the directors present a piece of archival film from the Philippines showing the execution of a man captured by guerilla fighters; it is momentarily jolting, but the absence of context deprives it of more lasting value.[2] Rarely does *Of the Dead* approach the insightfulness and emotional power of such superior documentaries as Frederick Wiseman's *Near Death* (1989) and Michael Roemer's *Dying* (1998). Imperfect though it is, however, *Of the Dead* applies useful techniques of ethnographic cinema to a subject left untouched by all but a handful of nonfiction film-makers.

David Sterritt

Notes
1. This sequence was shot during the Toussaint holiday, the 'all hallow's day' held on November 1st. A far cry from Halloween's festivities, this is a rather mournful holiday, in line with the typically grey and damp weather to be usually found in Belgium around that time.
2. This sequence was removed from subsequent versions of the film, most likely by keeping the televisual audience in mind.

GÉRARD CORBIAU

The Music Teacher

Le Maître de musique

Studio/Distributor:

Radio Télévision Belge Francophone (RTBF)
K2 SA/ Orion Classics
Orion Home Video
France Télévision Distribution
Gativideo
Jaguar Vídeo
Umbrella Entertainment

Director:

Gérard Corbiau

Producers:

Alexandre Pletser
Dominique Janne
Jacqueline Pierreux

Screenwriters:

Andrée Corbiau
Christian Watton
Gérard Corbiau
Luc Jabon

Cinematographer:

Walther van den Ende

Art Director:

Zouc Lanc

Editor:

Denise Vindevogel

Synopsis

In the early twentieth century, Joachim, a renowned bass-baritone, announces his retirement from the stage during his final opera performance. He decides to dedicate himself to teaching singing and welcomes a first student, the bright Sophie. Soon, Joachim becomes demanding, pushing Sophie to the purest form of perfection. In the meantime, he meets a vagrant, Jean, whose voice impresses him. Joachim takes Jean under his wing and gives him the opportunity to become an opera singer. Between conflicts and amorous relationships, Joachim gradually withdraws and leaves centre stage to his students whom he sends to Prince Scotti, his greatest rival, whose voice broke during an epic competition. This rivalry resurfaces when Jean stands up to one of Scotti's protégés during a singing contest.

Critique

Following five years of seeking funding and re-writing the script, Gérard Corbiau's project was finally accepted for production. *The Music Teacher* was primarily sponsored by the RTBF (Belgian Francophone Radio and Television), where the director had worked for many years. The crew was composed mostly of the network's technicians.

In this film, music is privileged over image, a constant throughout Corbiau's œuvre, in which he creates parallels between voice and life. The final representation of Joachim is, much like a swansong, a baleful symbol. The opera star nevertheless attempts, through his teaching, to reinvent himself. Under his tutelage, his students, are transformed into majestic songbirds once they become professional singers. They grow in stature, while the voice of their master can fade away forever.

The Music Teacher was shot in a solitary and closed landscape, the La Hulpe castle,[1] denoting the isolation of the various characters. Their destinies exist only as a function of their voices, which lock them into a peculiar artistic construct. Sophie and Jean are no longer in control of themselves: art dominates, shapes, and unites them. As a consequence of this emphasis on the voice, the narrative of the

Duration:

100 minutes

Genre:

Romance/drama/period drama/musical

Cast:

José van Dam
Anne Roussel
Philippe Volter
Sylvie Fennec
Patrick Bauchau

Year:

1988

film itself is classic, its *mise-en-scène* formally unremarkable, giving full attention to music and song that transforms each shot in this lyrical and complex oeuvre. The final scene, the apotheosis, perfects the film: two opera singers in Venetian masks, with their crystalline tonalities and their anonymous costumes, bewitch the viewer.

Corbiau favours the period piece/costume drama genre, underscoring the originality of extraordinary characters, which is far removed from everyday life. For the director, the cinema must foster dreams, must go beyond any realistic or naturalistic reference: in the film's DVD commentary, he stated that 'films must be more beautiful than life'.

The Music Teacher, which was nominated for the Best Foreign Language Academy Award, is a mainstream film (unlike most Belgian cinema, which is typically innovative and/or avant-garde), authentic in its musical narration, which offers a harmonious *potpourri* of Mozart, Schubert, Schumann. The director combines a classical narrative universe and a captivating musical dimension. Authentic frescoes for music lovers, filled with history, his films usher sublimity and novelty to an admiring audience. However, critics reproached him for his occasional thematic esotericism, his lack of originality in the *mise-en-scène* and the quasi-televisual elements of the film-making. Corbiau preserves, it is true, a form of cinematic traditionalism. But it is thanks to this conformism and this academic filmic construction that he was able to reach a wide audience and receive yet another Hollywood acknowledgment with his subsequent feature, *Farinelli*. With the *Music Teacher*, Gérard Corbiau accessed an international audience, won acclaim and engendered another cinematic projection of Belgian-ness, an artistic oeuvre without borders which attempts to demonstrate that cinema is, through the portrayal of song and music, a factory of dreams.

Aurélie Lachapelle

Translated by Marcelline Block and Jeremi Szaniawski

Note

1. Located in the Brabant Wallon province, not far from Brussels, La Hulpe is one of the prettiest small towns in Belgium, boasting breathtaking parks built in the English fashion. The castle and park in which the film was shot were the residence of chemical baron, Ernest Solvay, built at the turn of the century.

Farinelli, Il Castrato

Studio/Distributor:

Stéphan Films (primary production company)

Director:

Gérard Corbiau

Synopsis

The story follows Carlo Broschi's rapid rise to fame as 'Farinelli' – a stage name based on a family sobriquet – one of eighteenth-century Europe's most famous singers. Farinelli was a fine example of a *castrato*, a male singer possessing a voice at the top end of the vocal range caused by the removal of the testicles prior to puberty. Performing the songs of his brother Riccardo, he eventually sings his way into the court of King Philip V of Spain, where he spends many

Producers:
Vera Belmont
Linda Gutenberg
Dominique Janne
Stéphane Thenoz

Screenwriters:
Marcel Beaulieu
Andrée Corbiau
Gérard Corbiau

Cinematographer:
Walther van den Ende

Art Director:
Gianni Quaranta

Music Director:
Christophe Rousette

Editor:
Joelle Hache

Duration:
96 minutes

Genre:

years performing the same four songs each night to relieve the king's melancholy. Along the way, during a period of residency in London, his talents spark a bitter feud between Riccardo and the composer George Frideric Handel, who tries to separate the brothers and lure Farinelli to perform his songs in his rival Covent Garden opera house.

Critique

Much like its central character's critical reception, *Farinelli* was lauded around Europe upon its release in 1994, and subsequently rewarded by the continent's cultural cognoscenti, receiving César Awards (production design and sound) and crossing over successfully to the US to win the Golden Globe Award for Best Foreign Film as well as an Academy Award nomination for Best Foreign Language Film. It also shares a good deal of theatrical artifice associated with its subject matter; the expedient flamboyance on display through the film's art direction and costumes is arguably employed to distract the viewer away from the numerous liberties taken with historical fact. Much of what we see is dramatic confection, as real as the painted cloud backdrop visible behind Farinelli during his opera house performances. Thus, behind the sumptuous decoration lies not just inaccuracy but an impoverished, underdeveloped story and several missed opportunities.

Stefano Dionisi as *Farinelli*.
The Kobal Collection.

Biography/drama/musical

Cast:
Stefano Dionisi
Enrico Lo Verso
Jeroen Krabbe
Elsa Zylberstein
Caroline Cellier
Omero Antonutti

Year:
1994

That being said, there is a legitimate place for poetic licence in such a production, especially when unequivocal historical proof of accuracy is not available. There are very few recordings known to exist of real *castrati* upon which to base the voice that is heard in the film. In order to reproduce the three and a half octave range, director Corbiau recorded two separate singers, the American male countertenor Derek Lee Ragin and the Polish female soprano Ewa Malas Godlewska, and fused them together electronically. The result is quite arresting – being the film's performative centrepiece, it needs to be – but is let down by frequently poor synching with Dionisi's lip movements, a *faux pas* that undermines the film's attempts to be convincing and serves only to draw attention to, perhaps become emblematic of, the film's overall weaknesses.

The casting of Dionisi, a wiry, angular Italian actor, in the central role was likely driven by the desire to present Farinelli as the possessor of contemporary sexual charisma for the film's audience. However, this tendency towards formal modern masculinity conflicts with what is known of the actual demeanour and asexual allure of *castrati*, which would have made interesting telling. That said, Dionisi excels in the scenes of rivalry that he shares with Jeroen Krabbe as Handel. Krabbe in fact gives the film's best performance, which, while commendable, places the focus of interest too much on Handel and draws attention away from Farinelli, thereby further weakening the viewer's connection with the main protagonist.

Overall, given the potential for historical exploration, celebrity mystique and intriguing peculiarity, and despite the over-the-top set dressing, the most remarkable impression the film leaves is how sedate and ordinary the life of Farinelli, as presented, was. He is simply not interesting enough to demand one's attention. The film shares much of the critical failure ascribed to many other period pieces: beautiful to look at but lacking in depth and substance. As such it is ultimately little more than the overblown surface detail, the parade of a stage peacock that lacks sufficiently rewarding exploration of its bizarre subject matter.

Jez Conolly

JAN BUCQUOY

The Sex Life of the Belgians

La Vie sexuelle des Belges 1950-1978

Studio/Distributor:

Transatlantic Films/ Meteor Film Productions
Prime Films S.L.
Atlas Film Verleih
Metro Tartan Distribution Ltd.
Finnkino
CTV International
First Run Features
Filmes Lusomundo
Øst Für Paradis
Allstar Film
Icelandic Film
Monaco International
Regina Films
Willmar Andersson AB
Boomerang Pictures
Hrvatska Radiotelevizija (HRT)
Poltel International
RTV Slovenija
SBS Television

Director:

Jan Bucquoy

Producers:

Jan Bucquoy
Francis de Smet

Screenwriter:

Jan Bucquoy

Cinematographer:

Michel Baudour

Art Directors:

Nathalie André
Nicole Lenoir

Composer:

Francis de Smet

Editor:

Matyas Veress

Synopsis

Jan Bucquoy tells the story of his life, from birth until the age of 28. The central theme of the film is his sexual and sentimental initiation and, to a lesser extent, his artistic and intellectual realizations. Following a binge, he imagines his conception, tells Eddy about the discovery of his sexuality, the failure of his first love (for Christine, a classmate) and the circumstances of his first romantic conquest of Mia during a village dance. As an adult, he leaves the Flemish countryside and moves to Brussels. Greta, a bar owner, initiates him into the ways of the Kama Sutra, and his friend Esther, to revolutionary theories. In college, his political commitment leads him to meet Thérèse, whom he marries. She gives him two children but he breaks up with her after three years together. His confidence with women grows, his adventures multiply, all equally inconsequential. Jan remains marginal and decides to dedicate himself to his vocation as a serious novelist (which does not prevent him from writing pornographic fiction for a living).

Critique

The Sex Life of the Belgians/La Vie sexuelle des Belges 1950-1978 marks the beginnings of Jan Bucquoy as a film-maker, and is the first installment of his autobiographical trilogy, followed by *Camping Cosmos* (1996) and *La Fermeture de l'Usine Renault à Vilvoorde* (1998). Produced without government subsidy, the film enjoyed an undeniably popular and critical success both within and outside of Belgium. It was awarded the 1994 prize for best Belgian film, granted by the Union de la Critique Cinématographique. While Dutch would have been the natural choice for the film by virtue of its characters, locale, and situations, the only language used here is French.

A quintessentially personal effort, the film was written, produced and directed by Bucquoy. But whereas others would operate a *mise-à-distance* (through pseudonyms, avatars, a more discreet presence), Bucquoy has no scruples in placing his most intimate experiences directly on the screen. Everything is there to signify that this is Bucquoy's life – and not someone else's – that we are watching. The voice-over as self-commentary and the frequent addresses of his characters to the camera (breaking the fourth wall), reinforce this pose. If he does not play his own part, Bucquoy interprets – a significant choice! – a Dadaist poet. It comes as no surprise that the initial title of the film was *The Sex Life of Jan Bucquoy/La vie sexuelle de Jan Bucquoy*.

The direction is on par with the title that was eventually chosen, as Bucquoy avoids the pitfalls of narcissism/solipsism and manages to universalize his discourse by painting a portrait of an ordinary Belgian man in the throes of his own psyche, but also in the contradictions and limitations of the world in which he evolves: a narrow-minded Flanders and then Brussels in the 1960s, preaching revolution, female liberation and liberalization of morals.

The Sex Life of the Belgians.
The Kobal Collection.

Duration:

85 minutes

Genre:

Comedy
Romance
Coming of age

Cast:

Jean-Henri Compère
Noé Francq
Isabelle Legros
Sophie Schneider
Jacques Druaux

Year:

1994

In spite of its subject matter, the film remains relatively modest. Sex is reported rather than shown, suggested rather than used in order to shock. Conversely, one will remember the satirical take on the Flemish petit-bourgeois spirit (perfectly incarnated by the mean and greedy mother) or the iconoclastic charge against all signs that send one back to the official Belgium or that pretends to a form of grandeur. The royal family, the church, the national folklore are all ridiculed. Likewise, Bucquoy does not hesitate to cast anarchist figure Noël Godin as writer Pierre Mertens and cut him in between shots of cows. Some scenes, featuring incongruous associations, tend toward surrealism: such as the episode of the first orgasm, where Bucquoy is masturbated by Eddy in a trailer among sand dunes, while watching Laurel and Hardy. Another such quasi-surrealist touch is the character of Aunt Martha, 'very beautiful but who only listened to her whims,' and who never wore underwear, except on the day she hanged herself.

The episodes have few causal links between them, and compose a story that can seem disjointed. However, a general emotion emerges, that of disenchantment. Bucquoy claims to love all women, and yet all his relationships fail. As to revolutionary ideals, they seem to partake in a conventional discourse that he himself does not take seriously. This yields a disillusioned and derisory vision for a life chronicle, which ironically ends the way it started: with an ode dedicated to his mother's breasts.

Serge Goriely

Translated by Marcelline Block and Jeremi Szaniawski

Camping Cosmos

La vie sexuelle des belges nr 2

Studio/Distributor:

Transatlantic Films
Vlaamse Film Commissie/
Brussels Avenue
Polygram
Allstar Film Boomerang
Cinerives
De Smet Films Metrocine
Mongrel Media
RTV Slovenija
Telewizja Polska (TVP)
Willmar Andersson AB

Director:

Jan Bucquoy

Producers:

Jan Bucquoy
Françoise Hoste
Francis de Smet
Johan J. Vincent

Screenwriter:

Jan Bucquoy

Cinematographer:

Michel Baudour

Art Directors:

Nathalie André
Nicole Lenoir

Editor:

Matyas Veress

Music supervisor:

Francis de Smet

Duration:

88 minutes

Genre:

Surrealist
Farce
Sex comedy
Comedy of manners

Cast:

Jean-Henri Compère

Synopsis

In the second installment of the *La vie sexuelle des belges* cycle, we find protagonist Jan Bucquoy, now an animator at the North seaside Cosmos campsite ('Camping Cosmos'), desperately trying to bring culture to the Belgian people. He is soon joined by Eve, his adolescent daughter, for whom he never cared very much. Between boxing matches and aborted performances of *Mother Courage*, between a *fritkot* (Belgian fries stand) and hula hoop sessions on the beach, a group of colourful characters abounds, all in search of themselves. They meet, kill each other, throw cream pies at one another, part ways, sing, read Sartre or *Tintin au Congo*, eat fries, vomit while having orgasms, collect panties and express their reverence for cyclist Eddy Merckx.

Critique

It is not by chance that the Grand Prix at the 1996 Lille trashy film festival was awarded to *Camping Cosmos*. Jan Bucquoy, the eternal iconoclast, seems to deliberately disseminate upsetting themes: sexual perversion, terrorism, murder, adultery, Tintin, artistic subsidies, the Aristocracy, literature, advertisements, and the like. Nothing seems to escape his bad taste. And yet, this schoolboy humour is a veneer covering despair: stricken by the mediocrity surrounding him, Bucquoy advocates for an exaltation of desire that flies in the face of a gloomy, capitalist society.

Furthermore, a wonderful *mise-en-abyme* is offered here: much like his character who finally reconciles art and popular culture by having large-breasted porn actress Lolo Ferrari (sublimated by the film-maker's tenderness) brandish surrealist authors' quotes between the rounds of a boxing match, Bucquoy manages to offer a film that is both intellectual and lighthearted, so that, for a moment, a popular Belgian hit song could almost rhyme and resonate with Antonio Gramsci's theses.

Besides, the film unveils a a well-kept secret: if we Belgians enjoy laughing at ourselves, we are often ashamed of trying to define our identity beyond a few worn clichés (beer, surrealism and chocolate). Jan Bucquoy does however, subtly, offer here a cornerstone to a collective identity-building: *belgitude* is present everywhere, and it is not by chance that the action of the film takes place in 1986, the year when Sandra Kim won the Eurovision contest with her song *J'aime j'aime la vie*, while the *petits belges* reached the semi-finals of the soccer World Cup in Mexico. Popular songs (*La P'tite Gayole*), literature (Marcel Mariën), a cast that is as impressive as it is bewildering (with a special mention to singer Arno as a gay coast guard), regional accents, sports glories (Eddy Merckx), depictions of national mores and paid vacations spent at the Belgian seaside, gastronomy (the *real* recipe for the oil for Belgian fries at last revealed!) and, of course, our legendary sense of self-derision: this film is a magnificent love song to the *plat pays* ('flat country') once exalted by Jacques Brel.

The question of identity is not reduced to the country alone: much as in *La vie sexuelle des belges* (1994) and for the last time in the eponymous fresco, Jean-Louis Compère incarnates Jan Bucquoy, while the director himself takes on the part of Cibulski, a terrorist who teaches the formula of nitroglycerin to the children of the campsite,

Fanny Hanciaux
Lolo Ferrari
Jean-Paul Dermont
Noël Godin
Arno
Jan Decleir

Year:
1996

and, therefore, to the film's audience. The cast evokes a hall of mirrors where some play their own fictionalized roles (a system Bucquoy will later explore more deeply, as in *Christmas Vacation/Les vacances de Noël*, 2004), while other Belgian celebrities are used in jubilant *contre-emplois* (Noël Godin, the anarchist and infamous 'entarteur' is hilarious here, as he plays a clumsy and pontificating cinematic version of famous writer and lawyer Pierre Mertens). Characters are in search of themselves, and the distribution takes us into a grinning *kermesse* (carnival) that evokes the paintings of James Ensor.

Camping Cosmos is a sensitive film, and an ontological one, too, for those who take the road less travelled with Jan Bucquoy as guide, stubbornly leading to a life that is both free and… Belgian.

Clotilde Delcommune

Translated by Marcelline Block and Jeremi Szaniawski

DOMINIQUE ABEL AND FIONA GORDON

The Iceberg

L'iceberg

Studio:
Courage Mon Amour
Radio Telèvision Belge Francophone (R.T.B.F.)

Distributor:
First Run Features U.S. (DVD)

Directors:
Dominique Abel
Fiona Gordon
Bruno Romy

Producers:
Dominque Abel
Fiona Gordon

Screenwriters:
Dominique Abel
Fiona Gordon
Bruno Romy

Cinematographer:
Sébastien Koeppel

Synopsis

Fiona is the manager of a fast food restaurant. Her life with husband Julien and their two children is bland and perfunctory. When she accidentally locks herself in the restaurant's deep freeze overnight, her family is oblivious to her absence. In a series of accidental incidents, Fiona finds herself in a coastal town, where she sees René, a deaf-mute sailor. Fiona vies for his attention in the hopes he will take her to an iceberg – a strange attraction she seems to have developed while in the deep freeze – aboard his small sailboat aptly named *Le titanique*. When Julien finally realizes that Fiona is missing, he locates her just as she sails away with René. One struggle after another ensues between Julien and René, resulting in both men falling overboard as Fiona sets sail in search of her iceberg.

Critique

The Iceberg/L'iceberg is a quirky Belgian comedy from the directorial trio of Fiona Gordon, Bruno Romy, and Dominique Abel, all of whom have a background in circus performance and professional clowning. Such abilities are ever present in *The Iceberg*, which consists mostly of slapstick skits, physical humour, and is almost entirely without dialogue. The plot is fairly simple: an unacknowledged and underappreciated suburban wife seeks to escape her tedious existence after being locked in a restaurant freezer overnight and realizing that her family did not miss her.

The night spent in the deep freeze seems to have triggered an attraction between Fiona and ice. When she returns to work the next

Art Director:

Laura Couderc

Composer:

Jacques Luley

Editor:

Sandrine Deegen

Duration:

84 minutes

Genre:

Comedy

Cast:

Lucy Tulugarjuk
Fiona Gordon
Dominique Abel
Philippe Martz
Thérèse Fichet

Year:

2005

day she spends time in the freezer, sitting and lying on the icy boxes until suddenly rising, as if ashamed, when a colleague happens upon her. On one sleepless night, Fiona goes to her own fridge at home, appearing to climb into the small freezer compartment in order to satiate an icy craving, which is amusing in itself. It is only when the camera angle changes that we realize Fiona was modelling an iceberg from the ice crystals on the freezer walls. It is classically Chaplinesque, and reminiscent of the scene in Chaplin's *The Immigrant* (1917), where the little tramp is bent over the railings of a boat, apparently vomiting from seasickness, until it is revealed he is actually struggling with a fish on a line. Numerous touches of such humour are found throughout *The Iceberg*: for example, as Fiona is crying on the bed, her words are muffled by the bed sheets, and when Julien tries to console her, he is unsuccessful. Only when Julien renders his own speech unintelligible does Fiona acknowledge him, the subtle implication being that spousal intelligibility is a coded language that is unintelligible to the world at large.

Through a series of unlikely events – hiding in a freezer truck, being caught by immigration officials in a throng of illegal immigrants, and then herded on to a coach for senior citizens – Fiona finds herself at a seaside resort. Here, she meets René (Philippe Martz), a deaf-mute sailor; they fall rapidly in love. Soon after, however, Julien abandons his children in search of Fiona. He succeeds at first and takes her home, but Fiona immediately runs back to the resort in time to prevent a grief-stricken René from committing suicide. From this point on, Julien's efforts to win back Fiona repeatedly fail in typically slapstick fashion, until both René and Julien fall overboard as Fiona sails on, alone.

In terms of its storyline, *The Iceberg* is similar to such works as Germaine Dulac's experimental *L'invitation au voyage* (1927), in which a neglected housewife seeks escape from a banal marriage by meeting a sailor in the hopes of long sea voyages to exotic lands. It might even be compared to Silvio Soldini's *Bread and Tulips/Pane e tulipani* (2000), in which a stultified housewife, again through happenstance, takes the opportunity to leave her husband and children and start a new life in Venice. Yet, where *L'iceberg* differs – and differs greatly from traditional narratives – is that it becomes a celebration of gesture, utilizing the human body as a diegetic instrument by means of athleticism and the orchestration of posture and movement – in other words, a gesticulatory cinema, as further demonstrated in Gordon, Romy, and Abel's subsequent film, *Rumba* (2008). But, if the poetics of the body are the tip of *The Iceberg*, what lies beneath its surface is a critique of modern society, its mechanized existence, automatic routines and dreariness of life where even fast food is prepared on an assembly line and where the instinct to explore is all but extinct. Buffoonery stands in sharp contrast to the rigid and perfunctory nature of modern life. What Gordon, Romy, and Abel are able to achieve with their particular brand of clowning is to capture the physicality of Chaplin, the aesthetic of Jacques Tati, and at the same time, the absurdity of Samuel Beckett.

Zachariah Rush

Rumba

Studio/Distributor:

MK2 Diffusion
Filmoption International

Directors:

Dominique Abel, Fiona Gordon, Bruno Romy

Producers:

Dominique Abel, Claire Dornoy
Fiona Gordon

Screenwriters:

Dominique Abel, Fiona Gordon
Bruno Romy

Cinematographer:

Claire Childeric

Art Director:

Laura Couderc (set dresser)

Editor:

Sandrine Deegen

Duration:

77 minutes

Genre:

Comedy

Cast:

Dominique Abel
Fiona Gordon
Bruno Romy
Philippe Martz

Year:

2008

Synopsis

Fiona and Dom, a happy couple, are teachers in a rural elementary school. They share a passion for Latin dancing and unfalteringly high spirits. The course of their lives and relationship is altered by a car crash that occurs when they avoid running over Gérard, a depressive man who consistently fails to commit suicide. The accident leaves Fiona with one leg, Dom with unreliable short-term memory, and Gérard with a guilty conscious for the catastrophe he has caused. The post-accident part of the narrative shows how all three characters adjust to their new life circumstances while remaining committed to their identities prior to the accident.

Critique

The Abel-Gordon-Romy directorial trio debuted with their critically acclaimed film *Iceberg/L'Iceberg* (2005). Their follow-up, *Rumba*, is in the same style and has a nearly identical cast. With their stage acting and burlesque theatre background, Abel and Gordon bring to the big screen a revival of the silent comedy and pay homage to their self-proclaimed heroes: Charlie Chaplin, Buster Keaton, Jacques Tati. *Rumba* is a near-silent comedy that uses slapstick and pantomime to narrate, with few words and many physical gestures, the story of a couple that is reunited after a series of adventures that occur in a surreal setting. Through its mix of slapstick and deadpan comedy, *Rumba* adopts a nostalgic aura as part of its artistic identity. In addition to this retro feel, *Rumba* stands as an eccentric and much-needed experimental presence in the current comedy landscape. It demonstrates the pliability of the comedy genre along with that of its protagonists, Fiona and Dom, whom Gordon describes as a burlesque duo. Gordon's statement here helps temper spectatorial expectation about protagonists Fiona and Dom, since gags and physical comedy are privileged over character development or emotional depth.

Rumba is a comedy that offers copious moments of humour while also inviting the audience to contemplate how elements of verbal expression, tragedy, and sentimentalism are distilled into comedy material. The story is linear and the characters – as well as their emotions – are flattened out like Dom's impaired memory or Fiona and Dom's horizontal dance on the gymnasium floor. Fiona and Dom's facial expressions transform from neutral to highly spirited. This emotional minimalism makes laughter possible in a plot that is otherwise saturated with darkness: amnesia, leg amputation, a house set on fire, job loss, attempted suicide. When Dom tries to make an omelette for dinner, due to his impaired memory, he keeps adding three eggs and one pinch of salt. The result is a shockingly salty and enormous dish. A feast of bright and vibrant colours along with perfectly beautiful photographic frames undercut the plot's darkness. The three episodes of rumba music and dance are the only outlets hinting at an emotional undercurrent: starting on a cheerful note (Fiona and Dom's suave and goofy dance in the gymnasium), transitioning to a dramatic one (the dance of Fiona and Dom's shadows) and ending in a melancholy mood (the dance on the sea).

Along with the suggestion of emotional depth, these episodes make visually explicit how no longer being able to dance is a major loss for Fiona and Dom's post-accident emotional configuration. *Rumba* manages never to compromise its serious undertones, while still remaining visually delightful and compellingly comedic.

Oana Chivoiu

The Fairy
La Fée

Studio/Distributor:

MK2 Productions
Courage Mon Amour
France 3 Cinéma (co-production)
France Télévision (participation)
Canal+ (participation)
CinéCinéma (participation)
BeTV (participation)
BNP Paribas Fortis Film Fund (in association with)
Cinémage 5 (in association with)
Cinémage 4 Développement (in association with)
Région Haute-Normandie (support)
Le Tax Shelter du Gouvernement Fédéral de Belgique (support)
Centre National de la Cinématographie (CNC) (in partnership with)

Distributors:

Kino Lorber (2011) (USA) (theatrical) (subtitled)
MK2 Diffusion (2011) (France) (theatrical)
Pandastorm Pictures (2011) (Germany) (theatrical)
Njutafilms (2012) (Sweden) (all media)

Directors:

Dominique Abel
Fiona Gordon
Bruno Romy

Producers:

Elise Bisson

Synopsis

In a cheap hotel in Le Havre, the receptionist Dom makes the acquaintance of an elfin woman, Fiona, who, when checking in, claims to be a fairy, and promises to grant Dom three wishes. His desire for a scooter and unlimited petrol is fulfilled the next morning, and the two fall rapturously in love. Fiona, however, is on the run from a local psychiatric hospital, and is joined in her attempts to evade the local authorities by African refugees intent on reaching England. Having been captured and returned to her psychiatric ward, Fiona is rescued by Dom, and gives birth to his child with improbable rapidity. With the aid of an English tourist, the short-sighted owner of a local bar and a women's rugby team, Fiona and Dom help the refugees clandestinely leave for England but, in doing so, are involved in a mountainside high-speed car chase.

Critique

The Fairy is a cinematic curiosity in all regards, the least of which is its triplicate directorial signature. With a long collaboration in theatrical comedy stretching back to their studies in Paris in the early 1980s, Dominique Abel, Fiona Gordon (a Canadian born in Australia) and Bruno Romy team up for their third feature, which, after *L'Iceberg* (2005) and *Rumba* (2008), continues their rejuvenation of the slapstick film, at the same time as nodding back to pioneers of the genre such as Buster Keaton and Jacques Tati.

In spite of the film's Belgian provenance, the setting is – as with Aki Kaurismäki's *Le Havre* (which, like *The Fairy*, premiered at Cannes in 2011) – the French port city Le Havre. Dom (Abel), working at the reception desk of a run-down one-star hotel in the city's old quarter, has his attempts to eat a sandwich in front of the television repeatedly stifled in an opening scene which constitutes one of the film's best set pieces. First an English tourist (played by Philippe Martz) attempts to sneak a small dog into the hotel room he has just booked through phrasebook-French, and then a barefooted fairy named Fiona (Gordon) enters, promising to grant Dom three wishes. This gangly, not particularly imaginative porter can only muster the desire for a motor scooter and an endless supply of petrol. Fiona fulfils his wishes – but it becomes clear to everyone bar the obliviously enamored Dom that, rather than a fairy, she is actually a recently escaped patient from the town's psychiatric hospital.

From this point on, the film focuses on the duo's adventures – their repeated escapes from the hospital's wardens, security guards at the

Marina Festré
Charles Gillibert
Marin Karmitz
Nathanaël Karmitz
Valérie Rouy

Screenwriters:

Dominique Abel
Fiona Gordon
and Bruno Romy

Art Director:

Michel Denis (visual effects producers)

Composer:

Frédéric Meert (sound)

Editor:

Paul Englebert (post production coordinator)

Duration:

93 minutes

Cast:

Dominique Abel
Fiona Gordon
Philippe Martz
Bruno Romy
Vladimir Zongo

Year:

2011

department store from which Fiona shoplifted the dress and shoes for her first date with Dom, and, late in the film, immigration authorities. On the way, they attempt to aid two African refugees stow away in a ferry bound for England, have repeated run-ins with the visually-impaired owner (played by Romy) of the bar L'amour flou and its most steadfast patrons (the all-conquering, karaoke-loving Le Havre women's rugby team), and consummate their whirlwind romance in a scene of underwater love, which results in a plot turn giving new meaning to the term 'sudden pregnancy'.

Indeed, the appearance of Dom and Fiona's baby deep into the film gives rise to one of *The Fairy*'s comic centrepieces, involving a mountainside car-chase and, as with similar numbers in *L'Iceberg* and *Rumba*, a prodigious use of green-screen effects, the obviousness of which will go some way to calming our nerves at the perils the infant is subjected to.

Like Kaurismäki, the directing team uses Le Havre as a setting to fuse a trenchant political statement on the fate of immigrants in 'Fortress Europe' with a whimsical, light-hearted comedy. But whereas the Finnish director continues with his trademark droll, understated humour based on terminally laconic main characters, Abel, Gordon and Romy take a more anarcho-absurdist route. They feature heavy doses of physical comedy, at which the two corporeally elastic leads are particularly adept, and a storyline whose twists and turns leave our more commonplace notions of narrative logic by the wayside. At turns mischievous, outlandish and moving, *The Fairy* is a film for those who persist in believing that a kilogram of feathers really does weigh less than a kilogram of lead.

Daniel Fairfax

DOMINIQUE DERUDDERE

Love Is a Dog from Hell

Crazy Love

Studio/Distributor:

Multimedia/Cineplex-Odeon Films

Director:

Dominique Deruddere

Producers:

Erwin Provoost

Synopsis

Based on stories by Charles Bukowski, this portmanteau film tells three stories about one protagonist at different stages of life. In the first chapter, Harry Voss is 12 years old and eager for an introduction to sex, as a voyeur if not a participant; his older friend Stan is happy to help, arranging for him to snoop around in a woman's bedroom while she sleeps. Harry is finishing high school in the second chapter, and while he has become an appealing and intelligent young man, his love life is stymied by the horrible acne covering his face; he finds a novel way to mitigate the problem and attend a dance, but the solution is short-lived and his discontents return. The third chapter portrays Harry a few years later, when disillusionment with life has made him a recklessly hard drinker; stumbling away from a bar one evening, he and a friend see an unlocked hearse parked at a curb and

Alain Keytsman

Screenwriters:

Marc Didden
Dominique Deruddere;
based upon works by Charles Bukowski

Cinematographer:

Willy Stassen

Production Designers:

Hubert Pouille
Erik Van Belleghem

Composer:

Raymond Van Het Groenewoud

Editors:

Ludo Troch
Guido Henderickx

Cast:

Josse De Pauw
Geert Hunaerts
Michaël Pas
Gène Bervoets
Amid Chakir
François Beukelaers

Duration:

87 minutes

Genre:

Drama

Year:

1987

impulsively steal the corpse of a beautiful young woman, with whom Harry falls desperately and hopelessly in love.

Critique

Dominique Deruddere's debut feature has little in common with Charles Bukowski's poetry collection *Love Is a Dog from Hell* beyond its title and a general view of life as an inescapably-raw, frequently-obscene spectacle in which unhappiness is the baseline and frustrated desire is the norm. Rather than poems, the movie takes its source material from some of Bukowski's stories, using one protagonist to link three separate tales in a manner that reflects the fleeting, fragmentary nature of human experience as Bukowski sees it. Excellent acting and nuanced cinematography work with the economical Flemish screenplay, written by Deruddere and Marc Didden, to create a film that is paradoxically as restrained and understated as Bukowski's writing is outspoken and blunt.

The first chapter introduces Harry Voss as a 12-year-old who imagines grown-up life to be as richly romantic as a melodramatic movie, such as the epic about an imprisoned princess and a courageous prince that he sees in a local theatre. Eager to mature, he tries to uncover the secrets of adulthood by watching frogs mate, gazing at a necking couple, plying his mother with questions about her past, and briefly spying on his parents as they make love. He also spends time with his older friend Stan, who shows him a picture of a naked woman, arranges his first kiss at an amusement park, and instructs him in masturbation. In the most boisterous scene, Harry and Stan sneak into a woman's house to watch her body as she sleeps, but she wakes up and screams for help. In the end, Harry is left with his movie photo, his loneliness, and his unanswered questions.

Harry is 19 in the film's second part, suffering with acne so severe that his dermatologist can only give him feeble remedies and advises him to wait the affliction out. So he hides from his schoolmates as much as possible, stays away from graduation, and writes poems to Liza, the girl of his dreams, instead of asking her for dates. Even a promiscuous woman procured by a friend refuses to have sex with him after getting a look at his blemished face. In a moment of unexpected boldness, he wraps his face in toilet paper, goes to the gala graduation ball, and gets Liza to dance with him for a few exquisite minutes. Then, as at the close of the previous chapter, he returns to solitude.

The third section, based on a well-known Bukowski story called 'The Copulating Mermaid of Venice, California,' portrays Harry at 33, when he is isolated from society by alcohol and misery. He is irresponsible enough to join a friend in stealing a young woman's corpse, and romantic enough – now in a perverse, self-defeating way – to fall in love with the cadaver, knowing that with this ultimate transgression his life is slamming into an existential dead end. Against all odds, Deruddere makes this shocking, abrasive tale seem gentle, tender, and compassionate.

Influences on Deruddere sometimes show in obvious ways; when Harry steals a display photo of the leading lady after seeing the romantic movie, for instance, he resembles Antoine Doinel,

the preteen hero of François Truffaut's classic *The 400 Blows/Les Quatre-cent coups* (1959), and the sight of Harry and the awakened woman screaming into each other's faces is right out of Steven Spielberg's *ET: The Extra-Terrestrial* (1982). This notwithstanding, however, Deruddere's achievement is remarkable, especially since Bukowski's fiction is usually hard to translate into film: Marco Ferreri's *Tales of Ordinary Madness* (1981) lapses into sentimentality; Barbet Schroeder's *Barfly* (1987) never quite finds its footing; Bent Hamer's *Factotum* (2005) has little lasting impact. Avoiding these pitfalls, *Love Is a Dog from Hell* is the most resourceful and moving of them all.

David Sterritt

Everybody's Famous!

Iedereen beroemd!

Studio:
Canal+
Eurimages
Flanders Film Fund,

Distributor:
Miramax Films US (DVD)

Director:
Dominique Deruddere

Producers:
Dominique Deruddere
Loret Meus

Screenwriter:
Dominique Deruddere

Cinematographer:
Willy Stassen

Art Director:
Hubert Pouille

Composer:
Raymond van het Groenewoud

Editor:
Nico Leunen
Ludo troch

Duration:
91 minutes

Genre:
Comedy/social satire

Synopsis

Factory worker Jean wanted to become a songwriter in his youth but his dream never materialized. He now vicariously seeks fame through his thankless and moody teenage daughter Marva, whom he pushes into local talent shows where her terrible performances are often cut short by the organizers. One day, Jean's car breaks down. He leaves to call for assistance, but when he returns, a female cyclist is tinkering with his engine. After she removes her helmet Jean realizes the young woman is Debbie, Belgium's most famous pop star. Seeing an opportunity to make millions, he drugs Debbie and kidnaps her. But Jean wants something other than money – he wants a chance at fame for Marva, with a song he has written for her entitled 'Lucky Manuelo'. Little does he know that Debbie's diabolical manager, Michael, has unexpected plans for father and daughter.

Critique

Everybody's Famous!/Iedereen Beroemd! begins, even as the credits roll, with a photograph of Marva, a real-life Flemish pop star from the 1960s/1970s. As the camera angles down we see an infant in its crib, also named Marva, who, like a baby about to be baptized, is ordained by her father (De Pauw, who performed multiples roles in Deruddere's 1987 *Crazy Love/Love is a Dog from Hell*) for a particular course in life. The tone of this film is set, quickly becoming farcical, as in Deruddere's later *The Wedding Party/Die Bluthochzeit* (2005), when a disagreement over shrimp escalates into warfare. In its investigation of the desire to achieve fame, *Everybody's Famous!* brings home its critique of the entertainment industry and the 'dream factory'.

Marked by Deruddere's dark satirical humour, *Everybody's Famous!* adroitly blends a kidnapping and ransom narrative straight out of Hollywood with a frankness of tone characteristic of Flemish cinema, with the two being reunited by a certain pragmatism common to both cultures. In this flawed fairytale mixed with pointed social critique, the director portrays media moguls as shallow and manipulative, whose *raison d'être* is securing TV ratings, preying easily on the multitude whose will to fame and obsession with celebrity drive them to do almost anything for stardom. As characters, Jean and his fellow factory

Eva Van Der Gucht in *Everybody's Famous!*.
The Kobal Collection.

Cast:

Josse De Pauw
Eva Van Der Gucht
Werner De Smedt
Thekla Reuten
Victor Löw

Year:

2000

worker Willy (De Smedt) are two-dimensional at best and, in this satire, Deruddere adequately conveys a sense of emptiness. No one is lacking more in substance than pop star Debbie (which, it might be said, accurately reflects many such entertainers). Her appearance in the film can only be likened to a prop, like Yorick's skull, or the bone the apes throw in *2001: A Space Odyssey* (Stanley Kubrick, 1968) – yet without their level of meaning. Debbie's insignificance is exemplified in her exhibiting signs of the Stockholm syndrome, absconding to Australia with Willy. The two are not seen again until the film's final moments.

The divide at the centre of *Everybody's Famous!* is between those possessing fame and fortune, but still longing for all that they sacrificed to achieve them, versus those who, like Jean and Marva, live in working-class obscurity and lack everything valued by the entertainment industry, yet desperately desire their idols' notoriety. In a society conducive to the proliferation of reality shows and where every major TV network carries 'talent' shows entered by tens of thousands of hopefuls pursuing their quest for fame, Deruddere's film mocks, by means of outlandishness and even nonsense, the obsession with the modern phenomenon of celebrity and the ridiculous lengths that some will go to fulfil Warhol's prophecy and achieve their fifteen minutes of fame.

Zachariah Rush

JOACHIM LAFOSSE

Private Property

Nue propriété

Studio/Distributor:

Tarantula
MACT Productions
Radio Télévision Belge
Francophone (RTBF)

Director:

Joachim Lafosse

Producers:

Joseph Rouschop
and Martine de Clermont-Tonnerre
Eddy Géradon-Luyckx
Donato Rotunno
Arlette Zylberberg

Screenwriters:

Joachim Lafosse
François Pirot

Cinematographer:

Hichame Alaouie

Art Director:

Anna Falguères

Editor:

Sophie Vercruysse

Duration:

95 minutes

Genre:

Family drama

Cast:

Isabelle Huppert
Jérémie Renier
Yannick Renier
Kris Cuppens
Patrick Descamps

Year:

2006

Synopsis

Pascale lives with her two grown-up twin sons, Thierry and François, in a nice, if barren, house of the Belgian Brabant Wallon province. Without the financial support of her ex-husband, Luc, Pascale could not afford this lifestyle. She decides to sell the house in order to start a bed and breakfast in the south of France with her Flemish lover, Jan. When her sons learn the news, they react in different ways: Thierry violently opposes his mother's plans, while the gentler François, content to remain a handyman and unwilling to antagonize her, considers working in the 'family business'. As the tension escalates, Jan loses interest in Pascale, who moves out with her friend Gerda, but the long-repressed familial resentment has reached a point of no return and a carelessly angry gesture on Thierry's part leads to tragedy.

Critique

An impressively mature work about coming to terms with the loss of youth and innocence, and the repercussions of growing up in an emotionally-unstable environment, Joachim Lafosse's *Private Property* (capturing at once a very concrete legal concept as well as evoking the deceptively raw, naked quality of the film's emotions – this poetic flavour of the French title, *Nue propriété*, is lost in its English translation) is taut and uncompromising. This is clearly expressed in its formal rigour: the film features hardly any reaction shots or camera movements, opting instead for a fixed *mise-en-scène* which expresses much about the unspoken drama unfolding before our eyes: the subtly stilted, contrived quality of this absence of camera movement clearly unveils the deadlocks and parapraxes of narcissism and denial. With the image's fixity bearing so heavily on the film, the notions of frame and coterminous limits, is foregrounded. Aptly so, as the film itself is dedicated 'to our limits' (or 'boundaries'), and illustrates a prison-like existence, from which each character attempts to break free in a different way.

In this truncated and too-close-for-comfort family, certain principles of libertarianism and modern ethics seem to have turned sour: the borderline mother displays her withered naked and lackadaisically-sexualized body to her grown-up sons, while they playfully mime coitus in front of her and take liberties in calling her names. Yet the film is not really about the failure of the sexual revolution or Western liberal post-1968 morals. At least it is not only about that, as the real drama has been buried, repressed, and will eventually explode to the face of its protagonists. What is at stake is another byproduct of late capitalism and vacuous individualism: a ubiquitous sense of entitlement coupled with a complete lack of empathy and genuine responsibility. This transpires everywhere: in the lack of involvement, other than financial, on the part of Luc, the normal, reasonable upper-middle class and middle-aged father who has started a new life with a younger woman; or in the overt but spineless doting on the part of Pascale which has led to the lack of social maturity of her sons. Here one feels the fruits of

Yannick and Jérémie Renier, Isabelle Huppert, and Kris Cuppens in *Private Property*. The Kobal Collection.

Joachim Lafosse's long psychoanalysis, capturing perfectly, now from a cold, clinical distance, the pitfalls of blindness and contrived intimacy bathing in a cesspool of amorality. The drama of the sons, prisoners of this domestic, loveless hell, is that they are inescapably connected to the home, the hearth, left behind by the father and bestowed upon them. The place they should flee in order to grow remains attached to the joys and memories of childhood, however unwholesome.

The film opens on a clear image of narcissism: Huppert, looking at herself in the mirror, calls François to comment upon her new babydoll nightgown she just purchased on sale, while Thierry makes a disparaging comment, jocularly calling her a cheap whore. The excessive influx of narcissistic impulse and its lack of feedback leads, in psychoanalytical theory, to melancholia, and certainly the visuals and landscape of the film are of a melancholic nature, grey, muddy, devoid of the beauty that the Brabant Wallon genuinely possesses (the film was shot in the lovely and quintessentially-bourgeois towns of Wavre, Jodoigne, Grez-Doiceau, and Chaumont-Gistoux). All this symbolism is perfectly embedded in the film's realistic frame, as in the scene where François' motorbike gets stuck in mud following Pascale's announcement of her desire to sell the house. The mud here allegorizes the dirty feeling weighing on the protagonists' clothes and bodies as they try to get the bike to start again. Later, the two brothers are seen bathing together, in a retreat away from the unpalatable symbolic (the mud) into a pre-sexualized realm of male intimacy, a clear indicator of an attempt to return to the safe recess of the imaginary, the bathtub evoking the mother's womb where the two twins once were.

The final scene of the film, equally memorable, is a tracking shot driving away from the deserted house, by now probably sold, after everything that happened. The dynamic nature of the shot might promise change and hope but, in its being turned backward, toward

the past, it only adds to the already-established melancholia, the strictures of regret and nostalgia. For Lafosse, no doubt, the film was an exorcism. But it is uncertain whether his characters can ever mend the pieces of their broken past, as the image of the father and mother picking up broken glass on the floor in silence, near the end, seems to failingly promise. *Private Property* offers a brilliant, if gloomy and indiscreet picture of banal and deliquescent human relations: the questionable charm of the petite bourgeoisie.

Jeremi Szaniawski

Private Lessons
Élève libre

Studio/Distributor:

Versus Production
MACT Productions
Inver Invest
Radio Télévision Belge
Francophone (RTBF)
Ryva
Eurimages
Canal+
CinéCinéma
Haut et Court
Le Tax Shelter du
Gouvernement Fédéral de
Belgique/ PRO-FUN media
Filmverleih
Haut et Court
EDKO Film
Optimale
Twin Pics

Director:

Joachim Lafosse

Producers:

Jacques-Henri Bronckart
Olivier Bronckart
Martine de Clermont-Tonnerre
Arlette Zylberberg
Hélène Coker
Caroline Thirion
Eric Van Zuylen

Screenwriters:

Joachim Lafosse
François Pirot

Cinematographer:

Hichame Alaouie

Synopsis

Sixteen-year-old Jonas, a resident of Brabant Wallon, is training to become a tennis champion. He wants to become a professional – but only vaguely so. He is failing all his classes at school. His divorced parents agree that he should pass his GED examination to receive his high school diploma, rather than remain enrolled in classes. A friend of Jonas's mother, Pierre, along with Didier and Nathalie, a couple that appears to be close and supportive, offer to help Jonas with private lessons. Math and French classes follow in quick succession, until Jonas's learning progressively turns into a personal and sexual initiation.

Critique

Imagine a live frog that is thrown into a pot of water and cooked without realizing it, first in tepid, then boiling water. When does the warm water stop being comfortable and start to burn? From what moment does a relationship of apprenticeship turn into one of domination? How does a pedagogical relationship encourage autonomy and independence while also establish the ability to recognize to step back from it when things go too far? Joachim Lafosse's *Private Lessons/Élève libre* blurs boundaries in order to subtly ask these questions, recalling Rousseau's claim in his *Discourse on the Origin of Inequality* that the absence of education is the only thing worse than education itself.

Lafosse's film is a work of ambiguous elegance, supported until the very end by a tenacious and subtle *mise-en-scène*, akin to a spider's web. The direction of the actors is precise, but the script's extreme rigour still permits occasional departures from an overly strict vision. The director allows us to experience Jonas's entrapment and the sad passions of the adults surrounding him. We witness the original gesture that establishes trust, followed by the education, the abuse, the lost sensuality, the unspeakable interests and the violence of a relationship. The meal scenes with Didier, Nathalie, Pierre and Jonas are akin to psychological violations, all the more disturbing as they assume the perspective of an initiation into sexual emancipation done in good faith. Within this framework, the director hides nothing.

Lafosse puts into delicate balance the on- and offscreen space, refusing both facile avoidance and conveniently suggested violence. No music here, no constructed sounds. Nevertheless, the displayed

Art Directors:

Anna Falguères
Gaspard Berlier
Maria Gabriel Martins Mateus

Editor:

Sophie Vercruysse

Duration:

105 minutes

Genre:

Drama/coming of age

Cast:

Jonas Bloquet
Jonathan Zaccaï
Claire Bodson
Yannick Renier
Anne Coesens
Johan Leysen

Year:

2008

restraint of the *mise-en-scène* remains a way of exploring darker, more disturbing topics. *Private Lessons* imposes neither a spectacle nor emotional blackmail, but its apparent sobriety reminds one of the rhetorical device of the young attorney who begins his argument by stating: 'I shall go straight to the heart of the matter, using no artifice.'

This is because the delicacy of the analysis displayed by the film-maker does not mask the Jansenist element that Lafosse has imposed upon his cinema from its inception: violence is borne out of the decay of morals in those who are supposed to inculcate them. Lafosse's ethical position is weighty, even overwhelming. *Private Lessons* denounces Jonas' abandonment by his parents and the failure of a society whose belief in freedom often leaves individuals utterly shattered. There is no salvation for these perverse adults who draw pleasure from playing with their victim, even if said victim is fully consenting, as his success on the exam is at stake.

Lafosse does not hesitate to make a repressed pederast out of Pierre and two drifting beings out of the apparently loving couple who, in the end, cannot find each other or themselves, as if the marginality of their sexual practices inevitably leads to shame and withdrawal into the self. Disturbing by the quietude of its *mise-en-scène*, purified to the point of dryness, *Private Lessons* offers a moralizing tale where a wholesome sexuality cannot be separated from feelings of love.

Lafosse is nevertheless a better moralist than philosopher, in the sense that the moralist denounces and criticizes the mores of his times, while the philosopher interrogates, in this context, the foundations of truth, good and evil. Lafosse's film does not only remind us that education is a struggle where one never knows what will emerge: whether it be the saint's halo or the leg of a hellish goat. The film therefore also shows how manipulation feeds upon the seduction of the master, the apparent frankness of speech and the simulacrum of egalitarian dialogue. In the end, Lafosse never sacrifices the indeterminacy of his characters on the altar of his moral demonstration. The actors of this story are neither solely guided by their compulsions nor shaped by their environment; nor are they sovereignly accountable for their deeds. They are vulnerable, influenced yet autonomous. Jonas is not solely a victim but also a student who believes that he is making his own choices. Pierre retains his share of sincerity, unwittingly crossing the boundary between the libertarian choice of values and the loss of all markers and moral standards.

Lafosse's insinuating camera does not show a pervert and his prey. It depicts, from a distance, an alienated society composed of lonely people who lack the ability to comprehend the distinction between the self and the other. *Private Lessons* allows us, the viewers, to believe that it is our role to judge Jonas by the yardstick of one's own morality, but the words that open the film – the same that opened Lafosse's earlier film *Private Property/Nue Propriété* (2006) – are its true dedication: 'to our boundaries'.

John Pitseys

Translated by Marcelline Block and Jeremi Szaniawski

BOX OFFICE SUCCESSES

Home Sweet Home

(and the legacy of Benoît Lamy, 1945-2008)

Studio/Distributor:

Lamy Films
Pierre Films
Reggane Films/Compagnie Française de Distribution Cinématographique (CFDC)
Melimedias

Director:

Benoît Lamy

Producers:

Jacqueline Pierreux
Jacques Perrin

Screenwriters:

Benoît Lamy
Rudolph Pauli

Cinematographer:

Michel Baudour

Composers:

Walter Heynen
Wannes van de Velde

Editor:

Guido Henderickx

Duration:

91 minutes

Genre:

Comedy/drama

Cast:

Claude Jade
Jacques Perrin
Ann Petersen
Marcel Josz
Jacques Lippe

Synopsis

In a Brussels retirement home, residents are subjected to the authoritarian and infantilizing regime of a narrow-minded director, in spite of social worker Jacques' attempts to alleviate their plight. The arrival of Yvonne, a bold resident, awakens consciences. Led by Jules, the most determined of them all, the old-timers manifest their discontent, but the director refuses to listen to their demands. Instead, she fires Jacques and tightens regulations. This proves to be too much for Jules, who leaves the home. The other pensioners follow suit and together they roam around town, determined to no longer take orders from anyone. Their fugue is short-lived, except for Jules and two other home residents who take advantage of this opportunity to go on a trip around the Mediterranean. Wanted by the police, they are repatriated and committed to a mental institution. Hearing the news, the other pensioners rebel once again. The police intervene, leading to the death of one of the elderly rebels. Following the ensuing scandal, the director resigns from her post. Jacques takes her place, instituting a fair regime crowned by the wedding of Jules and Yvonne.

Critique

Between popular songs at the bar, hunger strikes against chocolate mousse and Tunisian belly dancing, when elderly people fight boredom we are a far cry from conventionality and conformism. Yet in spite of this colourful programme, it was not easy for Benoît Lamy to put *Home Sweet Home* together: in 1973, few film production companies existed in Belgium, and the topic, although eminently in the spirit of 1968, scared investors, as the elderly were not deemed 'sexy' enough to attract audiences. Eventually, French actor and producer Jacques Perrin, on whose films Lamy had worked as an assistant, secured and contributed the funds needed in order to realize a French-Belgian co-production with the young Jacqueline Pierreux who, at the time, had only produced one short film. This was an auspicious move: *Home Sweet Home* turned out to be a rousing popular success. In Belgium alone, it stayed at the top of the box office for eight months and reached 130,000 viewers. Distributed in many countries, including the US – a first in Belgian feature film history – it garnered no less than fourteen awards in various festivals, including a special prize at the Moscow film festival in 1973. In France, the film was released a year later under the title *Jules' Party/La Fête à Jules*.

The late Lamy used to introduce this film as a tribute to his grandfather, who had similarly fled his home one day (and was eventually found in the Dutch city of Maastricht). Confronted with

Year:
1973

changing demographics, the subject of the well-being of the elderly was at the time largely repressed in public discussion. Bolstered by the ideals of May 68, Lamy applied those principles of achieving happiness here and now, as well as of a certain pleasant, sugarcoated anarchy, to this segment of the population. On this basis alone, one could consider *Home Sweet Home* a 'social' film. It could be said that the film's mission is to denounce a blatant defect in society: the situation of elderly pensioners who are the victims of blind and incompetent institutions. Both the screenplay and elements of *mise-en-scène* seem at times to lead us in this direction. Does the fate of the elderly not echo the sufferings of all the victims of repressive societies? Is their insurrectional enterprise not exemplary? Does the camera not capture them in the heat of the moment? Do we not have the feeling of watching a documentary, or even militant cinema?

However, if its dimension of social critique is indisputable, at the film's heart is its ability to entertain its viewers about a grave subject. This type of comedy is to be found in the film's gallery of colourful characters who are sometimes ridiculous and at other times touching, as well as in the comical or even absurd situations that confront them. Most of all, it is contained in its magnificent premise: to make heroes of a group of senior citizens from a modest social class – in other words, putative clowns. The film thereby universalizes their struggle for freedom, presenting it as essential and pathetic, tender and pitiful, glorious and meaningless, remarkable in its ability to bypass quaintness and folklore. The film is thus filled with a light, tender yet vibrant humour, and surprises its viewers by making them wish they could befriend Jules and his acolytes, who demonstrate inventiveness, rebelliousness, and humanity.

'Humanity' is the key word of this film, around which its story, actors and emotions are centred. The casting is surprising, to say the least: on the one hand, some heavyweights of French cinema (Claude Jade, at the time François Truffaut's muse, had also starred in Hitchcock's *Topaz*, 1969) and Belgian theatre (a masterful Marcel Josz as Jules, who spearheads the old people's revolution). On the other hand, we find a number of amateurs speaking with typical *brusseleir* accents that Lamy found in the bars of the Marolles (Brussels' popular borough) and selected for their distinctive physiognomies. Between handheld-camera aesthetics (very innovative for a feature fiction film of the time), multiple group scenes following the small troupe in its perambulations, and the use of close-ups to emphasize the characters' distinctive appearances, one feels the director's love for his actors.

The music also emphasizes this humane and popular aspect. Far from preconceived notions that would require old age to be accompanied by piano and other melancholy tunes, we hear the *Brabançonne* (Belgium's national anthem), played on hunting horns and brass instruments, creating a flamboyant atmosphere where people raise their pints of beer and sing heartily Antwerp's popular singer Wannes Van de Velde's *Ik wil deze nacht in de straten verdwalen* ('I want to lose myself on the streets tonight').

Unfortunately, and no doubt because this is a feature debut, the film has the flaws of its qualities: Lamy seems too often preoccupied

with what emanates from his actors to care about the rest, often to the detriment of the image and the editing. If close-ups on this sympathetic troupe of nice old people serve the tale well, they also sometimes have a gratuitous, documentary aspect. The film would probably have gained from greater attention paid to aestheticism, and its many drawn-out passages could have been taken care of at the editing stage. Finally, the director often seems to be led by his actors, and, considering that many are amateurs, this is not always successful. Despite these flaws, the great strength of this much beloved and innovative film lies in its message: 'We must fight from now on all our abdications of responsibility and all impostors' (Henry Chapier, *Combat*).

In spite of his efforts, Benoît Lamy was never able to repeat the success of *Home sweet home*. None of his three other feature films, *Ham from the Ardennes/Jambon d'Ardennes* (1977), *Life is Rosy/La Vie est belle* (co-directed with Congolese director Mweze N'gangura, 1987) and *Wild Games/Combat de fauves* (1997), had the power or grace of his debut. However, he succeeded in paving the way for a cinema situated midway between documentary and fiction, between live capture and reconstruction of the real, using both professionals and amateurs and often giving way to a bittersweet comedy. Lamy also influenced many an aspiring film-maker, through his presence as a well-loved teacher at the film school IAD (Louvain-La-Neuve), until his untimely and tragic death. Yet Benoît Lamy's legacy, and the model he set forth with *Home Sweet Home*, lives on.

Clotilde Delcommune and Serge Goriely

Translated by Marcelline Block and Jeremi Szaniawski

Daens

Studio/Distributor:

Favourite Films
Films Dérives/Universal Pictures Benelux

Director:

Stijn Coninx

Producers:

Dirk Impens
Jean-Luc Ormières
Maria Peters
Hans Pos
Dave Schram
Frank Jansen
Daphni Gadellaa

Screenwriters:

François Chevallier
Stijn Coninx

Synopsis

At the end of the nineteenth century, in the town of Alost where his father is a printer, Adolf Daens, a priest sympathetic to socialist ideals, fights for the working classes, who are forced to toil in wretched conditions. At that time, there is a tremendous boom in industrialization and by taking on the plight of the destitute, Father Daens is confronted by the very conservative clergy, as well as by the world of employers and factory owners who would rather see the workers remain subservient and obedient. Daens will be the witness, and then the leader of the upheaval that marked the birth of social reforms in the industrial era.

Critique

At the beginning of the 1980s, director Robbe de Hert, freshly out of his militant phase, hoped to adapt Louis-Paul Boon's masterly book *Pieter Daens* (1971). After attempts to secure funding proved unsuccessful, he mentioned his idea to producer Dirk Impens. The latter found financing, but on the condition that the film focused on Abbot Adolf Daens, Pieter Daens's brother. Stijn Coninx was

based on the novel by Louis Paul Boon
Addy Weijers

Cinematographer:

Walther van den Ende

Art Director:

Ewa Skoczkowska

Composer:

Dirk Brossé

Editor:

Ludo Troch

Duration:

138 minutes

Genre:

History/drama/biopic

Cast:

Jan Decleir
Gérard Desarthe
Antje de Boeck
Michael Pas
Karel Baetens
Johan Leysen

Year:

1992

eventually chosen as the film's director. The film premiered in 1993 and, in spite of some criticism, it enjoyed significant success in Belgium. Moreover, it was nominated for an Oscar for best foreign film and earned an award at the Venice film festival.

Adolf Daens (1839-1907), an important Belgian figure of class struggle, was a brilliant mind from a common background. This priest was capable of teaching Latin to the sons of factory owners, and yet was wholly dedicated to the cause of the poor. A fervent Catholic who knew how to reconcile his political interests – he eventually became a member of parliament – with those of the church, which cast a sceptical eye on his actions, Father Daens was the perfect subject for the realization of a historic and social fresco of global proportions, in the style of a Flemish *Germinal*. *Daens* combines virtually documentary sequences about the working and living conditions of most workers with narrative sequences centred on the protagonist and his struggle.

The film's screenwriters ensured that *Daens* featured the essence of Boon's novel: namely, the description of an atmosphere and a period where the social and political divisions were very strong. And in order to best render this environment, it was indispensable to find sites that best evoked the nineteenth century. The film was thus shot in Poland, one of the only remaining countries in the late 1990s where wool was still being spun traditionally in the style of the late nineteenth century. The Polish locations were magnified by the cinematography of Walther van den Ende, who, with his Flemish-painting-inspired chiaroscuros, achieves an ideal reconstruction of a Belgium from another time.

Although written at the time of the fall of the Berlin Wall and the events in Romania following the death of Nicolae Ceaucescu, *Daens* is not really an ideological film. It is rather a strong film about solidarity, about becoming aware that one is not alone and that social progress will exist only once tyranny ends. *Daens* is the story of a singular man, of a specific town, but also of a universal and still-relevant struggle. The screenwriters understood this and the duel between Daens and his reactionary opponent Charles Woeste, interpreted by two excellent actors, Belgian Jan Decleir and French Gérard Desarthe, focuses upon all the fights, defeats, hopes and reversals of fortunes experienced by a subjugated group of people who nonetheless aspire to be treated as human beings and achieve better living and working conditions. The film's credit sequence is impressive in this respect: around the main actors, no less than four thousand extras were gathered. All the while avoiding the clichés of melodrama, Coninx adds a love story to the film, endowing it with a romantic, epic dimension.

Nicolas Thys

Translated by Marcelline Block and Jeremi Szaniawski

The Memory of a Killer

De zaak Alzheimer

Studio / Distributor:

MMG Film & Television Production

Director:

Erik Van Looy

Producers:

Erwin Porvoost
Hilde de Laere

Screenwriters:

Carl Joos
Erik Van Looy (from the novel by Jef Geeraerts)

Cinematographer:

Danny Elsen

Art Decoration:

Johan Van Esche

Composer:

Stephen Warbeck

Editors:

Yoohan Leyssens
Philipe Raveot

Duration:

123 minutes

Genre:

Crime thriller

Cast:

Jan Decleir
Koen Van Bouw
Werner de Smedt
Vic De Wachte

Year:

2003

Synopsis

Angelo Ledda, an aging, retired hit man suffering from Alzheimer's disease, travels from France to his hometown of Antwerp to carry out what could be his last contract killing. He kills the first of his targets, the head of town planning, after retrieving some evidence from his safe. But when Ledda realizes his second target is a 12-year-old girl, he refuses to kill her. Learning from the television news that she has been killed by someone else, and discovering that the evidence in his possession implicates a high-profile minister in both murder and a child prostitution ring, he resolves to kill those involved, who in turn resolve to kill him. He alternately taunts and assists two police officers who are trying to solve both the murder he committed and that of the young girl, and seeks their help when the worsening effects of his Alzheimer's prevent him from completing his mission.

Critique

The Memory of a Killer/De zaak Alzheimer succeeds largely because of the performances of Jan Decleir as the contract killer Angelo Ledda and Koen Van Bouw as Detective Chief Inspector Vincke, who pursues him. Decleir's task is the more difficult: he is required to present a cohesive portrayal of a man marked by jarring contrasts. Ledda is both a dispassionate professional murderer and yet empathetic enough to avenge the victims of those whose crimes he deems worse than his own; he can be frail and helpless when attacked by the worst symptoms of Alzheimer's, but is also fit and powerful enough to disarm and murder men much younger than he.

Furthermore, he is fearless within the horrifying world of organized crime but terrified when left alone with his disintegrating mind. That Decleir's performance manages to encapsulate all of this is proof of both his physical skill and his total understanding of the role. Van Bouw, in contrast, has only to present an honest policeman who wants to see all criminals, regardless of their social standing, brought to justice, but does so with an earnestness and intensity that adds depth to a character that could easily be shallow.

Because the two lead actors present such compelling portrayals of their characters, the audience is able to overlook the lack of originality that could otherwise have damaged the film. The stories of a retired outlaw embarking upon one last job; of a hit man who turns against those who employed him and hunts them as they hunt him; and of a policeman who sympathizes with the killer he pursues and is made uncomfortable by the similarities he sees between them are all well-known to film audiences and, as such, are no longer inherently fascinating. What makes them work in *The Memory of a Killer* is the conviction with which they are executed, particularly by the director, the editors Yoohan Leyssens and Philipe Raveot, who keep the pace of the film brisk and even, and, of course, by the lead actors.

Where the film fails is in the way the secondary characters are both written and acted. Vincke's deputy, for example, comes too close to cliché when he exclaims 'Sometimes you have to break the rules!' and Vic De Wachter, as an all-action officer from another, competing

Jan Decleir in *The Memory of a Killer*.
The Kobal Collection.

department who dislikes the 'intellectual' Vincke, is indistinguishable from the many other actors who have played similar roles in similar films.

The Memory of a Killer is not a particularly original film and it will not become a classic, but it is made with far more care and intelligence than a summary of its plots perhaps suggests. The best test of a thriller is whether or not it is thrilling, and Van Looy's film passes that test well. It is also an excellent example of a type of plot, and a style of film, more obviously associated with Hollywood being appropriated – and handled with aplomb – by a European film-maker.

Scott Jordan Harris

DOCUMENTARY AND BEYOND

Strip Tease: Documentary Realism as (Post)modernist Art

In 2000, alerted by news of famine in North Korea, a group of Belgian political dignitaries set out on a trip to the world's most notorious surviving Stalinist dictatorship. As the title of the short TV documentary chronicling their visit aptly puts it, these visitors qualify as a 'top-level delegation' (Dutilleul, 'Une délégation'; my translation): the group includes representatives of all major political parties from either side of Belgium's linguistic border. Predictably, the documentary depicts their tug-of-war with Korean officials eager to limit their sightseeing to propaganda showcases – giant statues of Kim Il-Sung, eerily-quiet multi-lane avenues encased in Babylonian skyscrapers, primary schools spewing out robot-like worshippers of the Dear Leader, deserted state-run stores, patriotic shows with flawless group choreography, and technology museums advertising nails and screws as marvels of proletarian engineering. Given the dearth of information about North Korea in the West, the film footage is undoubtedly newsworthy. Yet viewers cannot help but wonder whether the documentary's actual topic, rather than North Korean Stalinism, might not be the behaviour of the Belgian delegates themselves. Instead of acting as dignified spokespersons for Western European democracy, they come off as a band of rowdy tourists on a low-cost mini-trip, bound by a complicity that clashes with their ostensible political differences. Worse still, a delegate of the French-speaking Belgian Socialist Party confesses to his covert admiration for North Korean education. In this, the documentary's title fulfils its promise: the target is indeed the delegation itself. Symptomatically, within days of the film's broadcast, the Parti Socialiste gave in to public uproar and stripped its North-Korea-admirer official of all political duties.

'Une délégation de très haut niveau' (2000), directed by Philippe Dutilleul, is one of the most memorable documentary shorts produced in the framework of Marco Lamensch's and Jean Libon's documentary TV show *Strip Tease*. Programmed on French-speaking Belgian public television (RTBF) since the mid-1980s as well as on the regional channel of French public television (FR3) since the mid-1990s, *Strip Tease* became a popular and critical success, celebrated for coining a new idiom for the representation of everyday life in Belgium and France. On Belgian TV, *Strip Tease* was given the prime-time slot following the evening's newscast. Each episode begins with a credit sequence displaying the show's signature graphics against a goofy-sounding theme tune by the experimental marching band Combo Belge. Standard episodes are composed of four films of approximately thirteen minutes, each graced with untranslatable pun-based titles disclosing little about their actual contents. Special issues

Un amour de bronze. Private collection Richard Olivier, with kind permission by the author.

feature longer segments – Dutilleul's North Korean report is close to fifty minutes. A few feature-length documentaries – Yves Hinant's *The Cop, The Judge, and the Assassin/Le flic, la juge et l'assassin* (2008) – were shot as *Strip Tease* spin-offs. Over the decades, more than five hundred documentary short films were thus produced, making the show an ideal venue for the creativity of both junior and established Belgian and French TV directors and producers: Jean Libon and Marco Lamensch themselves, Manu Bonmariage, André François, Benoît Mariage, Philippe Cornet, Richard Olivier, René-Philippe Dawant among many others (Devanne 2011). The show's popularity even in its early years may be gauged by the fact that Rémy Belvaux, André Donzel and Benoît Poelvoorde's pseudo-documentary thriller *Man Bites Dog/C'est arrivé près de chez vous* (1990) – a breakthrough hit for French-speaking Belgian film – was initially conceived as a *Strip Tease* pastiche.

In recent decades, the term surrealism has been invoked in order to characterize most aspects of Belgian culture. *Strip Tease*, with its foraging into offbeat aspects of everyday life, deserves some credit for the construction of this national stereotype. Yet, while James Ensor and René Magritte may act as distant landmarks for the TV programme, its direct field of aesthetic intervention lies, rather, with the metamorphosis of documentary realism at the turn of the twenty-first century. RTBF's 1970s' current-affairs shows such as *À Suivre* privileged solid documentary fare focused on controversial topics – the Vietnam War, Latin American dictatorships, the Baader-Meinhof group. Such programmes exposed the network to perennial accusations of left-wing propaganda. Symptomatically, in an interview with Laurent Devanne, Marco Lamensch reveals that *Strip Tease* marked a move away from this tradition. Political disagreement was not the main incentive for change; more important was the awareness that the previous ventures were epistemologically and aesthetically unmanageable. Classic documentaries provide an abstract, monological mapping of social life: they boast a voice of cognitive authority relying on interviews of expert witnesses, and shape their contents according to predefined political and sociological categories. Lest any ambiguity creep into their narrative, their directors painstakingly 'past[e]' explicit voice-over comments 'onto the pictures' (Lamensch, in Devanne 2011). The shortcomings of this format were clearly brought home to Lamensch and Libon when they were entrusted by *À suivre* to cover the socio-political situation of Turkey. A suitably comprehensive report could evidently not be made within the appointed one-month term and on the basis of the generalist knowledge of political journalists. This unwieldy assignment revealed by contrast the need for a documentary format that would strive to produce 'an impressionistic mapping' of 'things [the film-makers] did know' (Lamensch, in Devanne 2011). Thus, instead of merely 'illustrat[ing]' a pre-conceived blueprint of given topics, *Strip Tease* was created in order to allow directors to 'film self-evidently compelling things.' (ibid.). This goal, intriguingly, required that documentary film-making be brought 'closer to the language of fiction' (ibid.) seeks the greatest immediacy in its approach to reality, and cultivates the capacity to capture social relations instead of discrete social facts (ibid.).

The ideal of narrative immanence advocated by Lamensch is illustrated in *Strip Tease* shorts such as Yves Hinant's 'Tiens ta droite (1995) and 'Tiens toi droite' (2000), as well as in Manu Bonmariage's 'Gustavine et Khalifa' (1986) and Olivier Lamour's 'Passe ton bac d'abord' (1994). Hinant's two films investigate the extreme right in Belgium, yet eschew historical contextualizing or interviews of political actors. Instead, they immerse viewers into the daily life of a foot soldier of a Walloon neo-Nazi party – a semi-literate juvenile delinquent. We are shown how this disreputable figure spurns the humanistic advice of his considerate juvenile-corrections educators. In moments of comic relief, we see him haplessly practising for the motorcycle driving test that would give legal certification to his chosen lifestyle as a virile motorcyclist (a true rebel without

a clue, he is content to ride without a licence in the meantime). Five years later, he is shown coming to terms with parenthood. While his hopes had been set on a boy – he candidly tells his pregnant partner that 'girls are shit' – he evidently grows fond of his baby daughter, yet makes sure she never wears anything remotely resembling feminine attire. Likewise, Bonmariage's 'Gustavine et Khalifa' and Lamour's 'Passe ton bac d'abord' make no references to sociological abstractions as they tackle the issues of multicultural coexistence and cultural marginalization, respectively. The former maps the everyday world of an elderly couple composed of a Muslim husband and his Belgian Catholic wife, focusing on the daily compromises each had to make over the decades. The latter, under the semblance of a school-exam cliffhanger, suggests that, for the son of a farmer's family in provincial northern France, obtaining the otherwise banal baccalauréat ('bac') diploma still represents a social breakthrough.

Depending on the nature of individual films and the mode of reception to which they are subjected, *Strip Tease* can be shown to appropriate techniques anchored in several moments of twentieth-century art. Its indebtedness to previous artistic experimentation is noticeable in its handling of ambiguity. Lamensch's ambition to let situations express themselves 'self-evidently,' with only minimal interventions of an interviewer's voice, harks back to the critique of narrative omniscience that developed in the field of fiction from the mid-nineteenth to the early twentieth century – from Stendhal to Henry James. English critic Percy Lubbock coined the term 'showing' (as opposed to 'telling') in order to designate the non-monological technique of modern writing allowing a narrative situation to 'tell its own story' (Lubbock 1921: 156); structuralist theoretician Gérard Genette uses 'internal' and 'external focalization' for the same purposes (Genette 1998: 206; my translation). This technique implies a non-judgmental attitude about narrative content and therefore generates ambiguity. In his comments, Lamensch seems to favour a closed form of narrative polysemy: the suspension of judgment is oriented toward the revelation of an essence – capturing 'life as it unfolds' (Lamensch in Devanne 2011). In this reading, *Strip Tease* qualifies as a documentary offshoot of the brand of modernist realism informing the works of Ernest Hemingway or Albert Camus in literature, or the French New Wave and Robert Altman in film. Similarly, the hope to bequeath to sociologists of the future 'a kaleidoscopic portrait of society' (Lamensch, in Devanne 2011) suggests that *Strip Tease* documentaries and the various interpretations they elicit might be re-totalized within a broader synthesis – in the same way as the multiple narratives of John Dos Passos's *USA* trilogy add up to the composite picture of a single country.

A few *Strip Tease* shorts appear, however, to support more radical forms of ambiguity. It appears that Michel Stameschkine's 'Brise larmes' (1986) and Emmanuel Riche's 'Conversations' (1991) leave their documentary topics undefined. The former records the sentimental musings – and predictable frustrations – of elderly people spending the end of their lives at a Belgian seaside resort. It is mostly composed of conversations framed by voice-over comments delivered by the central protagonist, an old lady in a wheelchair (her condition, however, is only revealed a the end, rendering her romantic and nostalgic musings from earlier on in the film all the more poignant). A modest climax of action occurs when the film's protagonists take a trip to Sluis, a Dutch border town famous for its sex shops mainly catering to Belgian customers. 'Conversations,' as its title suggests, is a pure collage of aimless chatter: three elderly ladies in a Brussels café ramble about health problems and the complexities of Brussels public transportation. Lamensch pertinently describes the protagonists of 'Conversations' as 'Beckett's and Ionesco's daughters' (Lamensch, in Devanne 2011): in the absence of an ostensible sociological agenda, documentary TV joins the theatre of the absurd or, in Gilles Deleuze's terminology, the aesthetic of the 'time-image' (Deleuze 2005: 37). Designating the contemplative form that developed after Italian neo-realism, the 'time-image,' in his logic, makes possible

a 'direct presentation of time' (ibid: 37); it is the antithesis of the 'movement image' (ibid: 35), which exhausts itself in the display of purposive action. Without entering into the intricacies of the French philosopher's comments on cinema, it is fair to note that *Strip Tease*, as it broadcasts action-depleted documentaries yielding little determinate meaning, links up with a modernistic tradition of contemplative art of which Deleuze offers a compelling account. This aspect of *Strip Tease*'s cinematography is most noticeable in its recourse to what Deleuze calls 'sound conversation' (ibid: 222) – the foregrounding of language disconnected from action. In this respect, *Strip Tease*, more than other manifestations of realism in Belgium – such as Jean-Pierre and Luc Dardenne's films – offers a window of empowerment for Belgian French. By broadcasting slow-paced documentary segments with minimal narratological framing, *Strip Tease* lets the non-standard idioms of its protagonists unfold free of normative constraints. The show's shooting process, which requires the film crew's prolonged immersion into the subjects' daily lives, is decisive in this respect: in the absence of an interviewer's questions, subjects do not feel compelled to censor their mode of expression.

Furthermore, the ambiguity of *Strip Tease*'s sociological reporting confers to the films a degree of playfulness emblematic of postmodernist aesthetics. *Strip Tease* shorts might indeed be called performative meta-documentaries: they challenge viewers to take part in the construction of sociological meaning. The first stake of the game is in some cases the literal identification of the filmed situation itself – an arduous task, given the use of enigmatic titles and external focalization. Viewers of Richard Olivier's 'Un amour de bronze' (1988) will predictably need a few minutes before realizing that they are watching a family so dedicated to the memory of deceased pop idol Claude François that they have commissioned a life-size bronze statue of their beloved singer. We catch these characters in medias res, when the prized object is being delivered. An inauguration ceremony follows, organized for fellow Claude François devotees. The second moment of the game concerns sociological interpretation. Most viewers are, of course, cognizant of the conventions of the documentary genre, particularly its striving for serious social content. In this case, they are left wondering which sociological purpose is being served by the film's unusual anecdote: is it a critical exposure of alienating fandom, or a benevolent portrayal of people who find meaning in their life through unconventional channels? Or is the focus merely the surrealistic, Deleuzian sound conversation? Even films that sketch out an answer to their own interpretation game leave its outcome open. Philippe Cornet's 'Classe touriste' (2002) follows an Algerian-born secondary school student on the brink of educational failure. The young man's worried mother attributes his destructive behaviour to the absence of the father. Yet the film is too impressionistic to corroborate this hypothesis: the guessing game remains unresolved.

Another, arguably crueller aspect of *Strip Tease*'s playfulness works at the expense of documentary subjects themselves. Lulled into confidence by the film crew's long-term presence, they end up revealing aspects of their behaviour they might later regret. 'Une délégation de très haut niveau' illustrates this dynamic, as do André François's 'Monsieur le Bourgmestre' (1992), which tangentially exposes the Brussels mayor's excessive fondness for alcoholic beverages, and Peter Boeckx's 'Patient un jour, patient toujours' (2000), where a dubious plastic surgeon is given free rein to show to the camera that he treats his patients like butcher's meat.

Over the decades, *Strip Tease* has found its niche within an ever-more diversified landscape of film and TV documentaries. Classic, monological nonfiction documentaries still abound – Davis Guggenheim's *An Inconvenient Truth* (2006); Erwin Wagenhofer's *Let's Make Money* (2009) – and arguably play an important part in environmental awareness and the critique of global capitalism. On the other hand, the late twentieth century has witnessed the development of the so-called new documentary aesthetic: performative investigations by Michael Moore, Errol Morris, and Morgan Spurlock. Yet

this new mode of film-making is still wedded to narratological omniscience: regardless of the brilliant montage and the authors' recourse to investigative methods characterized by meta-discursive theatricality, new documentaries entertain little ambiguity about their political agenda. This confirms that *Strip Tease*'s cultural effectiveness and specificity are rooted in the show's very sociological indeterminacy. The point can best be made by contrasting *Strip Tease* with yet another variety of nonfiction present on European TV channels, namely, hyper-redundant Discovery-Channel-type films, often focused on outdoor activities or hazardous professions, such as *Ice Road Truckers* and *Deadliest Catch: Crab Fishing in Alaska*. In the latter works, extreme narrative redundancy is keyed to the rhythm of commercial breaks: the documentary payload is rehashed after every interruption, anticipating maximum distraction on the part of the audience. Ironically, *Strip Tease*'s thirteen-minute shorts might fit the material constraints of this commercial format. Yet it is doubtful whether profit-minded networks would find the show's narrative ambiguity acceptable. It is clear in this perspective that *Strip Tease*'s contemplative scanning of everydayness acts as a strategy of resistance: it indicates a refusal of the commercially-determined mediatization of reality. Symptomatically, many *Strip Tease* shorts are concerned with the impact of the dominant media. Peter Boeckx's 'BRT dehors… VTM d'abord' (1992) highlights the hold recently-created Flemish commercial networks exert on their audience: it chronicles the misadventures of a family desperate to attend the live recording of a popular music show. Ironically, they realize that the event is far more enjoyable on TV. Conversely, Benoît Mariage's 'Radio Chevauchoir' (1989) offers a tongue-in-cheek portrayal of a grassroots media venture defying any commercial imperative: a radio station run by farmers, featuring local advertising and live accordion music. Such films underscore the hopes their authors invest in the resilience of local life: they depict everydayness as a space that, by its very inscrutability or by the residual freedom of those who inhabit it, eschews the logic of mediatic reification.

Christophe Den Tandt

The Lank Flower Has Already Flown

Déjà s'envole la fleur maigre

Studio/Distributor:

Les Films de l'Eglantine/Cinéma Public Films
Libra Film

Director:

Paul Meyer

Producers:

Paul Meyer
Maurice Taszman

Screenwriter:

Paul Meyer

Cinematographer:

Freddy Rents

Composer:

Arsène Souffriau

Editors:

Roland De Salency
Paul Meyer
Rose Tuytschaver

Duration:

85 minutes

Cast:

Brighella
Giuseppe Cerqua
Luigi Favotto
Marie-Louisa Franco
Mela Franco

Year:

1963

Synopsis

This film depicts life in a Borinage coalmine (in the Hainaut province), affected by brutal unemployment at the end of the 1950s. This triad (coal mine, Borinage, unemployment) serves as the dominant structure of Paul Meyer's masterpiece, showing the decrepitude of the Walloon mining industry and its influence upon the uncertain fate of hundreds of locals and European immigrants. This is the story of Domenico, of the fate of the Sanna family, of social realism and hardships but also of the insouciance of youth. It is a tale of profound disillusionment, of a gaping chasm that grows, little by little, under the feet of these workers whose sole goal is to provide for their loved ones.

Critique

The film was commissioned by Belgian television producers, who wanted a document about the everyday life of miners in the Borinage region. Influenced by neorealist Italian cinema, Paul Meyer decided to mix some elements of fiction into his documentary. Loosely interpreting the narrative demands of his producers, he built a unique œuvre, which transcends simple reportage or documentary. Meyer created a cinematic text by hybridizing two distinct tendencies: a realism that constantly intersects with a more extravagant approach.

The title, *Déjà s'envole la fleur maigre*, is a verse from Italian poet and Nobel Laureate Salvatore Quasimodo. This poem, illustrated by song and quoted during the opening credits, symbolizes the wait for a flight toward a better tomorrow: 'From the branches, already the lank flower flies away/And I await the patience of its irrevocable flight.'

The cast is composed of non-professionals. They are real-life Belgian, French, Ukrainian, Algerian, Greek, and Polish workers from the towns of Flénu, Mons and Jemappes who lay bare their daily experience. However, as opposed to Henri Storck's *Misère au Borinage* (1933), Paul Meyer avoids sentimentalism or pity. He turns these lives into a bucolic and synesthetic poetry.

Little by little, nature reclaims this industrial landscape left fallow. The disfiguration of mechanized spaces is contrasted with the bucolic aspect of several sequences in which birdsong and children's cries intermingle. This nuance allows for the creation of a balance between social reality and a flight toward the imaginary, represented by the use of the voiceover.

Domenico is the voice of this contrast: is he a worker, physically real, or the isotope of the film? He is the reflection of the collective unconscious, he is the lank flower that takes its flight – but is the latter irrevocable? Indeed, many mock this apparently careless decision, but Domenico wants his share of the dream: his freedom and his return to his family's side.

The film's aesthetic is free of any contingency, putting forward notions of multiculturalism and solidarity. The rhythmic din of the clogs of the 'Gilles' (the traditional folkloric figures of the Binche carnival who symbolize the rebirth of spring)[1] blend together with an Italian popular song in order to demonstrate this richness and diversity.

Paul Meyer's film is an ode to freedom, itself represented by childhood: this journey through the Borinage gives the viewer a glimpse into the playful reality of children who reclaim the abandoned industrial landscape as their playground. Idleness, stereotypically associated with unemployed workers, is not represented directly but through the carefree children as they joyfully run around the dumps, or by adolescents as they indulge in the joys of first love. The workers gradually detach themselves from their yokes but aspire to abandon this social prison once and for all. This realist and sociological dimension still lives today in the cinema of the Dardenne brothers, who overtly acknowledge Meyer's influence. The latter does not stop at the fatalistic aspect of social reality constructed through the use of static shots. Instead, he pushes toward a form of documentary poetry wherein the characters, whom the camera follows, perambulate through unexpected panoramas of an abandoned industrial landscape, rendered almost ferric.

Aurélie Lachapelle

Translated by Marcelline Block and Jeremi Szaniawski

Note
1. The Gilles figures are fixtures of the Binche carnival, an age old and extremely important tradition in this region of Belgium. On the day of the carnival, men dress as Gilles, wearing masks and clogs filled with straw. These surrealist and anonymous characters are supposed to scare the winter away by the noise made by their clogs on the paved roads of Binche, thereby announcing the spring. According to the legend, the Gilles are a representation of Native Americans that Charles V allegedly brought to his sister, Mary of Hungary, who resided in Binche. The burlap that they don is meant to symbolize the dark skin of the Native Americans, while the ostrich feathers represent their attributes. However, the real sources of the Binche Carnival and its Gilles remains highly hypothetical.

Death of a Sandwichman

Dood van een sandwichman

Studio/Distributor:

Iskra
Arcueil

Directors:

Robbe De Hert
Guido Henderickx

Synopsis

Crowned in 1970 as world champion of road cycling, Jean-Pierre Monséré (1948-1971) was one of Belgium's most popular sports figures when, in March 1971 at the age of 22, he was struck and killed by a publicity car during a local race. His death provoked a strong reaction and his funeral became a national demonstration. Behind his hearse, *Death of a Sandwichman*'s film-makers interview supporters, politicians, and sponsors as well as a sports journalist. Little by little, an indictment of the commercialization of sports emerges, along with a stark denunciation of social hypocrisy. The ending is deliberately shocking: footage of vultures and hyenas tearing at the carcass of a zebra is set to the homily of the Bishop of Bruges, an audio-visual association that caused a scandal.

Producer:
Fugitive Cinéma

Screenwriters:
Robbe De Hert
Jan-Emile Daele
Frans Huybrechts

Cinematographers:
Guido Van Rooy
Paul De Fru
Dennis Van Huffel

Duration:
33 minutes

Year:
1971-1972

Genre:
Documentary short

Critique

In 1964, 22-year-old Robbe de Hert won two prizes at the Belgian film festival. In 1968, he founded Fugitive Cinéma with Patrick le Bon and Guido Hendericks, an independent production company that aimed, among its other goals, to change the tone and mentality of informative reporting broadcast on television. The trio launched a series entitled 'Off television.' Their first report, 'SOS Fonske' (1968) dealt with a man whose insurance company went bankrupt and whose goods were all sold. *Death of a Sandwichman* is the second installment in this series. The film places on trial the world of sports, and denounces the precarious and dangerous working conditions of cyclists, in spite of the ephemeral glory they attain. During the period at which the film was made, the popular sport of cycling was sacred in Belgium, and no negative aspect had yet been revealed. Nevertheless, journalist Jan Emiel Daele self-published a book filled with shocking revelations. When Jean-Pierre Monséré was killed in the accident, the film-makers and the writer seized the opportunity to attack an exploitative system. Boosted by the fact that this adored star was a publicity tool used by the business world, the film-makers hired a Flemish television crew and began to shoot. Standing right next to well-known sports journalists, they interviewed numerous parties who were involved, and who, believing that they were dealing with national television, did not dare take French leave.

The shoot was conducted in three stages. During the funeral, a large crew shot and recorded a wealth of material. Following this, a few additional interviews were filmed during one evening in order to avoid any collusion among the political parties. A cyclist and friend of the departed as well as the boss of his main sponsor were the two main interviewees. Questions were asked in a straightforward manner. The third shoot consisted of a discussion between Jan Emiel Daele and Piet Thys, a notorious sports journalist who had previously criticized the world of sports. This interview became the key element of the film. A 'voice of truth' of sorts, Piet Thys punctuates the reportage with precise commentary and philosophical citations. The film-makers also inserted a few documents showing Monséré, pictures of his athletic triumphs or silent Super-8 family footage where we see him as a smiling and handsome young man.

Although aestheticism is not at the heart of the authors' militant preoccupations, the image is treated with care. The camera does not only record, it demonstrates and denounces. The film opens with a series of short shots where wreaths with commercial streamers immediately announce the film's premise, namely, how cyclists are manipulated/mistreated by sponsors with the media's complicity. A lateral tracking shot subsequently presents a crowd in mourning, while the soundtrack prominently features a funeral march, the musical leitmotif of the film. We hear the funeral oration of the bishop. Then, a sudden cut at the level of sound and image plunges us into the hustle and bustle outside of the church, which seems incongruous with the respectful silence and contemplation expected in such circumstances. Organized by themes and points of view that respond to one another, the editing orients our perception of the content, not without biting wit. This Belgian caustic humour would be

found again in the *Strip Tease* television documentaries.

Flemish television refused to broadcast this film until it obtained an award at a festival and was shown successfully by other networks, including on francophone television. A deliberate lampoon, if this film remains relevant more than forty years after it was made, it is not only because it constitutes a sociological and ethnographic document about a specific moment in Belgian history, but also because it goes beyond its subject, namely cycling. With biting irony, this film constitutes a provocative attack against the commercial exploitation of human beings within an often de-humanizing system, as well as the hypocrisy that surrounds it all.

Anita Jans

Translated by Marcelline Block and Jeremi Szaniawski

Man Bites Dog

C'est arrivé près de chez vous

Studio/Distributor:
Les Artistes Anonymes

Director:
Rémy Belvaux
André Bonzel
Benoît Poelvoorde

Producers:
Rémy Belvaux
André Bonzel
Benoît Poelvoorde

Screenwriters:
Rémy Belvaux
Benoît Poelvoorde
André Bonzel
Vincent Tavier

Cinematographer:
André Bonzel

Composers:
Jean-Marc Chenut
Laurence Dufrene
Philippe Malempré

Editors:
Rémy Belvaux
Eric Dardill

Duration:
95 minutes

Synopsis

A documentary film crew follows Ben, a charismatic and voluble serial killer. As the film-makers come to know Ben's normal side, his friends and family, they also become gradually involved in his horrible crimes. In an abandoned house and an old factory, Ben kills several gangsters. Forced to wear a neck brace following a boxing accident, he fails in an attempt to kill again, is identified and put in jail. The crew helps him escape, but it is too late – his family has been murdered by the mob. In the film's conclusion, Ben, along with the entire crew, is shot in the old building where he had stashed his money.

Critique

Few films are more deserving of the appellation 'cult film' than *Man Bites Dog/C'est arrivé près de chez vous*, which went on to become the sensation of the 1992 Cannes film festival, taking home three minor prizes. A brilliant 'mockumentary', this senior film school project, midway between *Strip-Tease*'s fly-on-the-wall aesthetics and the excesses of *Henry, Portrait of a Serial Killer* (1986), *Man Bites Dog* makes abundant use of a very dark humour both in its over-the-top murder scenes and its memorable dialogues – which a whole generation of Belgian youth has come to know by heart. Shot on a shoestring budget and on 16mm black-and-white filmstock (additional scenes were subsequently shot for commercial release), and making deft use of the resources offered by subjective camerawork, *Man Bites Dog* transcends the paucity of its budget and highlights the complicity between audience and subject in fiction films and reality TV.

The film invites us to partake in the everyday life of its infamous protagonist, in Benoît Poelvoorde's life-defining performance as an endearing psychopath (a graduate of an art school, he did not originally dedicate himself to acting). In spite of his ugliness, he endows his character with the candid charm of a child, bringing much appeal to the film. A larger-than-life figure, emotionally detached

Promotion still from *Man Bites Dog* featuring the film-makers. From left to right: André Bonzel, Benoît Poelvoorde and Rémy Belvaux. Roxie Releasing.

Cast:

Benoît Poelvoorde
Rémy Belvaux
Jacqueline Poelvoorde-Pappaert
Jenny Drye
Malou Madou
Valérie Parent

Year:

1992

from his murders yet deeply connected to the viewer by virtue of his magnetism, Ben is a poet: in some ways he regards what he does not only as an eternal game, but also as an art, and revels in cinematic references, from Michèle Morgan and Jean Gabin to Philippe Noiret. Ben is indiscriminate in his discrimination: midgets, homosexuals, black people, old people, children, pregnant women, postmen and even close friends – all are good enough to become his next potential victim, or the grist for his comedic mill. His odious character fulfills a buffoon function: he proffers racial or sexist slurs and we enjoy it and laugh at it by means of distancing mechanisms. Carrying on this modus operandi, Poelvoorde became one of the audience's favourite comedic characters in subsequent years.

The mix of the film's deadpan tone and its outrageous contents (and the fact that many actors, including Poelvoorde's family, had no clue as to what they were involved in) makes the whole film absurdly funny. Ben makes a living off his victims' money, but also kills for the fun of it: he relishes the opportunity of an original, creative crime, such as killing an old woman with cardiovascular problems by yelling at her – a means to save a bullet. Ben feels no remorse whatsoever, except when a family of 'innocent people', murdered, yields no money. 'Such things should not happen,' he says, in all seriousness.

Beyond the dialogues, the dark humour, and the characters' apparent levity, one clearly sees the reflection on voyeurism, the

manipulation of the image and the complacency of the crew in intervening into the reality they film. Ben's violence becomes more and more random and motiveless (he even shoots an acquaintance in front of his friends during a birthday meal), his criminal frenzy motivated and matched by the crew's insatiable desire to film *more*, both fuelling each other's insanity.

The film strikes most in its questioning of political correctness and how far we are willing to laugh at it all. At first mere observers, the crew begins to get more and more involved in the murders. For most viewers, the breaking point in this gradual participation of the crew in the subject of their film happens in the 'night watch' scene on New Year's Eve, where the inebriated crew members, hitherto merely accomplices of Ben, barge into an apartment and rape a woman while Ben holds the husband at gunpoint. The following morning, the camera dispassionately records the bloody aftermath: the woman, who might have been pregnant, lies eviscerated on the table, while her husband's naked corpse is slumped on the kitchen counter, shot in the head. This scene, which pushes voyeurism to its very limits (and was edited out in several national releases of the film due to censorship concerns), also marks the beginning of the end for Ben, his subsequent decline accompanied by less and less laughter, and more and more reflective pause in the audience. The greatness of the film lies in its ability to balance out dark and cynical comedy with a profound statement on the stakes of cinema and voyeurism. It also highlights and literalizes the intimate connection between cinema and death: during filming, two crew members are shot, their deaths later referred to as 'occupational hazards' by the director. And when they are called upon to help Ben, in his failed attempt to kill a postman, the film-makers stand back, resuming their non-participative stance, this refusal to kill paradoxically leading to the undoing of their subject – and themselves.

The film in many ways brilliantly anticipated and riffed on what would become some of the most morally questionable aspects of present-day reality TV. It also weighed heavily on its makers, with Poelvoorde's real-life proclivity toward excess and violent outbursts very similar to that of his character, and Belvaux's dark genius leading to his self-destruction. In 2007, the director, who never truly recovered from his masterpiece, committed suicide under murky circumstances, after Poelvoorde, at that time France's best-paid actor, refused to help him financially. The actor, who by then had destroyed his wife Coralie's health by emotional abuse and a score of infidelities, descended into an ever-deeper spiral of drug, alcohol and dangerous erratic behaviour (including smashing his car through a wall while drunk-driving, and running away), immersing himself more and more in solitude. Reality had become as sordid as the fiction that led to fame – minus the fun.

Great works of art do sometimes come with their accursed share, and *Man Bites Dog* – one of the best films of the 1990s – is no exception.

Jeremi Szaniawski

The Carriers are Waiting

Les Convoyeurs attendent

Studio/Distributor:

K-Star
K2 SA
Radio Télévision Belge Francophone (RTBF)
CAB Productions
Canal+
Centre National de la Cinématographie (CNC)
Eurimages
L'Office Federal de la Culture
Télévision Suisse-Romande (TSR)/Filmcoopi Zürich
Kuzui Enterprises
Mars Distribution
Samuel Goldwyn Films

Director:

Benoît Mariage

Producers:

Dominique Janne
Jean-Louis Porchet
Arlette Zylberberg

Screenwriters:

Emmanuelle Bada
Benoît Mariage
Jean-Luc Seigle

Cinematographer:

Philippe Guilbert

Art Director:

Chris Cornil

Composers:

Stéphane Huguenin
Yves Sanna

Editor:

Philippe Bourgueil

Duration:

94 minutes

Genre:

Family romance/drama/comedy

Cast:

Synopsis

On the eve of the new millennium, Luise is still in primary school. She is a shy girl living in a slightly forlorn and depressed post-industrial Walloon village. Along with a group of children, she has a friend, a slightly simple-minded pigeon-fancier who is always ready to help other people. Luise's family is composed of Madeline, her withdrawn, unemployed mother, ready to defend her children but without much conviction; Michel, her disillusioned and lackadaisical brother who sees life pass him by; and Roger, her father, a photographer for a local newspaper, *L'Espoir* ('Hope'). Roger dreams of getting out of the shackles in which he became entangled, but his ambition is only matched by his lack of willpower and it is Michel who will have the honour of beating the world record of door opening in order to offer a small car to the family. But nothing goes according to plan…

Critique

Melancholy and funny, *The Carriers are Waiting/Les Convoyeurs attendent* is a film of tragic burlesque which is reminiscent at times of Aki Kaurismäki's cinema as well as a raw realism that compares it with the cinema of the Dardenne Brothers. It possesses the freedom and formal strength of the former, and the interest in focusing on marginal individuals and a delinquent society of the latter. However, the film goes far beyond these references and finds its own path, one of redemption and possible happiness. Completely unique, it proposes the universe of children's films because the gaze it poses on the world is that of a child – in this case, Luise.

Magical and down to earth, dreamy and realistic, naïve but violent, Benoît Mariage's film is situated within this undefined in-between of the child – the silent little girl who watches it all without understanding. She has seen too much but cannot yet interpret what she sees, only to lay her feelings on a world that still goes beyond her comprehension. Luise's father brings his daughter to sordid scenes as part of his work, and, far from the flat reality of adults, she seems only to distinguish impressions. She is the real photographer, and her mental pictures compose the film, which by and large is made of still shots, a succession of family portraits.

Everything about *Les Convoyeurs attendent* is in the same vein, flirting with drama and comedy, with seriousness and improbability. For instance, one image of Luise, happy and demonstrative, shows her clinging to her new sister-in-law in order to congratulate her upon her wedding, which is in reality only a hastily arranged marriage of convenience with a coma-stricken Michel, in his hospital room. Luise reacts instinctively, without asking herself any questions. And by the same token, the *mise-en-scène* confronts us, in a few long shots, with the truth of the situation, sordid as can be.

With the same intensity, and within one image, real and magic manage to coexist. They take the form of a mysterious door which appears in the middle of a garden, a recurring symbol in fantasy and fairy-tales, but also a reference to Belgian surrealism: a passage to another world to which a concrete reality is brought, that of the

Benoît Poelvoorde
Bouli Lanners
Morgane Simon
Philippe Grand'Henry
Philippe Nahon

Year:

1999

contest which will lead to the film's central drama. It is the madness and hubris of the father that are symbolized here, and where love relationships will be knotted, imperceptibly, as well.

In the face of this mad world, quite incomprehensible when one is not even ten years old, the black and white of the film's cinematography comes in full effect. It destabilizes the real to bring it another dimension as well as a smooth, stylized beauty, however much ugliness is to be found at its zenith. A post-industrial landscape, practically abandoned, factory chimneys like smoking mastodons, the ubiquitous greyness, the flat country of *terrils* (slag heaps): all is blended in a disquieting photogenic harmony. It is the world of a child that does not have enough experience to bring his own colours and who sees what expands in front of him with a different eye. And it is this return to childhood – albeit through aging eyes – that the director successfully conveys.

Nicolas Thys

Translated by Marcelline Block and Jeremi Szaniawski

Feathers in My Head

Des plumes dans la tête

Studio/Distribution:

Magellan Production
JBA Production/JBA Distribution

Director:

Thomas De Thier

Producers:

Jacques Bidou
Marianne Dumoulin
Nicolas Meyer

Writer:

Thomas De Thier

Composer:

Sylvain Chauveau

Cinematographer:

Virginie Saint-Martin

Editing:

Marie-Hélène Dozo

Art Direction:

Wouter Zoon

Synopsis

In the small Walloon town of Genappe, the peaceful everyday life of a couple is shattered when their young son Arthur tragically drowns. While the father, Jean-Pierre, grows cynical and reticent, the mother, Blanche, retreats into a delusional state bordering on madness, persuaded that her son is still very much alive. As the couple drifts apart, the mother meets a strange and dreamy teenager, François, with whom she has a liberating and short-lived affair, which will help her be reborn to life and escape her fantasy existence. Having emerged from her trauma – yet without forgetting Arthur – Blanche, and life, can go on.

Critique

The starting point of *Feathers in My Head/Des plumes dans la tête*'s genesis is not so much the story as its setting: a sugar factory's settling tank where migratory birds stop by on their trip south, attracted by the beets and canes rejected by the factory and decomposing into mud, making it a favourite spot for ornithologists in search of a good bird-watching spot. This accent put on the location – and quiet, immobile observation – is inescapable: the film perspires with an aqueous and contemplative quality, the strong haptic nature of the rusty waters and vegetation on the banks of the tank relegating its narrative to the background. De Thier, primarily a documentary film-maker, evokes Andrei Tarkovsky as a model for his debut feature, and the final scene, in which a mechanical ride on which Arthur used to play animates itself in a deserted store, can be read as a mild, timid, and Belgian rendition of the electrifying miracle that closes Tarkovsky's *Stalker* (1979). It is thus in its evocation of nature, of mud, of grey skies and of water pipes that we find the film's soul,

Cast:

Sophie Museur
Alexis Den Doncker
Francis Renaud
Ulysse De Swaef
Bouli Lanners

Year:

2004

and not in the tragic story of mourning, which is aptly meant to be taken in a sweet rather than bitter and detached, muted manner. As De Thier put it himself: 'I did not lose a child – but I lost childhood.' Contemplation in nature seems to be suggested as remedy to this loss, and the tranquil, discreet score by Sylvain Chauveau plays along this peaceful philosophical stance. But do the birds – figured in the film's opening and metonymically in the title – ever take their proud flight, here?

Feathers in My Head has everything going for it, save perhaps a certain *je ne sais quoi* of madness or genius that would have allowed it to escape a somewhat sterile academicism, which turns all its strengths into weaknesses: the careful compositions and refusal of the superfluous, the insistence on symbols, and overly signifying acting can either enhance or kill all emotion and mar the aesthetic experience. If the feathers of cinematic art are weighed down by these elements, the film still boasts at least two remarkable features: first, the memorably rich and dynamic images, in spite of an otherwise completely immobile and frontal camera work, courtesy of a careful story-boarding by the director, to which cinematographer Virginie Saint-Martin added a sensual, rich quality, especially in the use of the dynamic perspectival vectors provided by the pipes adjacent to the settling tank. The other unforgettable feature of the film is the solar presence of newcomer Alexis Den Doncker as François, a uniquely humble, generous, sensitive and talented young man. Even covered in mud, or grimacing as he masturbates in the wet grass, he brings to his character the miraculous quality that he embodies: that of a secular angel, touched by an unlikely grace.

Jeremi Szaniawski

Marion Hänsel.
The Kobal Collection.

WOMEN DIRECTORS IN BELGIAN CINEMA

The last ten years of Belgian fiction cinema have seen the rise of several young women directors, both on the Flemish and the francophone sides of the country. As already-established directors continue to make films regularly (Chantal Akerman, Marion Hänsel), new names have started to show up: Vanja d'Alcantara (*Beyond the Steppes*, 2010), Martine Doyen (*Komma*, 2005), Bénédicte Liénard (*A Piece of the Sky/Une part de ciel*, 2001), Inès Rabadan (*Belhorizon*, 2005), Sophie Schoukens (*Marieke Marieke*, 2011), Caroline Strubbe (*Lost Persons Area*, 2009), Patrice Toye (*Rosie*, 1998, *Nowhere Man/(N)iemand*, 2008), Fien Troch (*Someone Else's Happiness/Een ander zijn geluk*, 2005; *Unspoken*, 2008; and *Kid*, 2012), and Dorothée Van Den Berghe (*Meisje*, 2002; *My Queen Karo*, 2009), in addition to French/Swiss Ursula Meier (*Home*, 2008) and Uruguayan/Belgian Beatriz Flores Silva (*Masangeles*, 2009), who both studied cinema in Belgium. Nonfiction has long provided a site of development for female film-makers. Though, in comparison to documentary film-making, fiction film-making still remains a masculine bastion, for more than forty years now the artistic work for women directors has progressively found a legitimate place in the Belgian production landscape.

In previous decades, most women directors have expressed themselves through short film and more financially manageable forms; few of them had the opportunity to actually direct feature films. Since her first short film *Blow up My Town/Saute ma ville* (1968) and especially the groundbreaking *Jeanne Dielman, 23 Quai du commerce, 1080 Bruxelles* (1975), which depicts the everyday life of an isolated housewife who lives with her son in a claustrophobic apartment and regularly prostitutes herself, Chantal Akerman has provided the leading source of inspiration for female Belgian film-makers. Playing with the borders between fiction and documentary traditions, Akerman simultaneously dealt with questions about the female body, sexuality and identity. This radical thematic and aesthetic stance belongs to the first wave of the feminist-film era and represents a strong reaction against patriarchal filmic language, which the director deconstructed in a form of counter-cinema.

This first emblematic example paved the way for other film-makers in the 1980s, even though, as opposed to the documentary tradition in which women directors blossomed, few have managed to direct a feature fiction film. In the 1980s and 1990s, some succeeded without being able to repeat the experience, or doing it scarcely, and by conveying hybrid forms like Mary Jimenez (*21:12 piano bar*, 1981) or Lili Rademakers (*Menuet*, 1982). At the beginning of the 1990s, the situation was basically unchanged, with female directors being few and far between: Anne-Marie Etienne (*Impasse de la vignette*, 1990), Marie Mandy (*Pardon Cupidon*, 1992) – who then turned to documentary forms – and Franciska Lambrechts (*If There is Realism, There Has To Be Possibilism Too/Als werkelijkheidszin bestaat moet mogelijkheidszin ook bestaan*, 1995) provide the most notable examples. Then there is Marion Hänsel, who provides one of the rare exceptions to the rule: from *The Bed/Le lit* in 1978 to her most recent, *Océan Noir* (2011), Hänsel has never stopped producing and directing films.

During the last two decades, the number of women film-makers directing feature fiction films has increased, despite the fact that isolated initiatives are still predominant and no collective effort was ever organized to specifically support female fiction film-making. Among the new policies that did in fact benefit female fiction film-makers were the new financing policy of the Flemish VAF (Vlaams Audiovisueel Fonds) in 2002, which encouraged and supported new talents like Patrice Toye, Fien Troch, and Dorothée Van Den Berghe. However, the situation remains unbalanced. Undertaken by Nadine Plateau and Linda Van Tulden for the Women Film Festival 'Elles tournent/Ze draaien' in 2009, an insightful study about the place of women in Belgian cinema has shown that, in Flanders, 21 per cent of the projects that have been submitted for public funding come from women directors, while that number, in the French Community, is 24 per cent (for fiction, documentary and animation films). In a broader perspective, this means that scarcely

9 per cent of the public funding for cinema in Flanders and 19 per cent in the French Community is given to women directors. Even though the number of female students constantly grows in film schools on both sides of the country, the picture gets even worse when one considers fiction film-making, since women directors mainly ask for money for nonfiction films. Unsupported by public funds, some have to turn to alternative financing. For instance, Nicole Palo (*Get born*, 2008) and Sumeya Kotken (*Sens interdits*, 2008) have turned to micro-budget productions in order to bring their projects to life.

Often isolated or lacking official collective structures to support them, women directors tend to show what is hidden, say what is hushed. Nowadays, the necessity to deconstruct stereotypes and to offer new forms of filmic language is no longer a priority for contemporary women directors. These strategies have been assimilated into a more traditional form of storytelling and film-making. If it is very difficult to otherwise define a coherent landscape of 'women cinema' in Belgium, with each director presenting a very specific filmic aesthetic and point of view, they all seem to reiterate the recurring themes of Belgian cinema: the question of boundaries or borders, of exile, a specific preoccupation for landscapes, a constant redefinition of realism. More significantly still, they testify to a relentless quest for identity. Bringing forth social, national or sexual questions, identity constitutes the basic narrative ground of their filmic narrations. What is essential is the suffering of the subject, which can be read in faces and bodies, in voices and stories, in the always-redefined border between real and imaginary.

Many of the main characters in this cinema remain female (from young girls to mature women) and narratives often tell of their harsh and painful physical and mental experiences: *Rosie*, in which an adolescent is living between reality and the projection of her fruitful imagination, but also *Meisje*, *My Queen Karo*, and *Beyond the Steppes* (in which a young Polish woman, deported in a *sovkhoz* of Central Asia, tries to save her sick baby); or, in a minor mode, *Marieke Marieke*, which portrays a contemporary 20-year-old girl who tries to define her own life and sleeps with older men. Going beyond the former feminist argument of focusing only on feminine characters, the concern broadens to groups or family portraits (*Belhorizon*, *Home*, *Lost Persons Area*), as well as couples (*Unspoken*) and even male characters (*Komma*).

On a thematic level, women directors take an interest in the way the characters communicate with the exterior world. Alternative forms (silence, poetic or artistic expression) replace a too-explicit patriarchal language. Since basic information is not transmitted through traditional modes, directors focus on the representation of bodies. Bodies articulate time through the rhythm of sensations lived by the characters. Indeed, many directors shape their films according to an aesthetic of the senses: a synaesthetic cinema insisting on multiple close-ups of skin, hands, gestures, etc. One especially remarkable example occurs within *Komma's* opening sequence where a man wakes up in a morgue without knowing why he ended up there and then decides to start a new life. Martine Doyen's camera is so close to the body that we first discover the character as a series of fragmented and abstracted close-ups of skin. Bodies, often reflecting a mental state or identity, are also often locked into restricted and restraining spaces from which they try to escape. In *Home*, an entire family is first cut away from the rest of the world by a driveway, before it literally locks itself up inside the isolated house, cementing all the exits. In *Lost Persons Area* and *Beyond the Steppes*, infinite and rough landscapes create the narrative tension but also mirror the character's quests.

This attention brought to bodies leads to new aesthetic forms, somehow resisting classical representations and narrative efficiency. Even if classical cinema is still present (like in Hilde Van Mieghem's drama *Love belongs to Everyone/Dennis van Rita* (2006) or her romantic comedy *Madly in Love/Smoorverliefde* (2010)), contemporary women directors seem to indulge in more minimalist stories. Through the expression of the

senses and an intense focus on streams of miniature gestures, they seem to petrify characters in a frozen movement even though they are still slowly moving forward in a very subtle way. This new conception of bodies also brings a new way of considering temporality. The result is a new aesthetic proposition: not the rejection of existing forms but a balance created between a mainstream conception and the insertion of 'breathing spaces' or suspended time. The representation of time remains at the centre of their aesthetic questioning; even if they will not indulge in Akerman's radicalism, they nonetheless slow down the pace of the narrative. It is the time of waiting and longing, a temporality of transitional states, a parenthesis showing the construction of a new identity: the metamorphoses from childhood to adolescence, from adolescence to adulthood.

Dorothée van den Berghe's *My Queen Karo* depicts an idealistic and barely adult couple who leave Belgium in 1974 to live 'freely' in a squat in Amsterdam, taking their 14-year-old daughter Karo (Anna Franziska Jaeger) with them. Mainly left by herself in this new environment, the teenager has to learn to cope with the absence of limits and restrictions, but also with the disillusionment of her parents. Van den Berghe mainly films the world at Karo's height, proposing an initiation from the all-powerful world of childhood into the more frustrating world of adolescence. Its pace and editing follows both the chronological unfolding of the parents' Amsterdam experiment and of Karo's transformation. Just as in *Meisje* (2002), the director's previous film, albeit in a less obviously sexualized way, the feminine character struggles with the psychological and physical changes of her age, fleeing away from herself by staying constantly on the move. Ironically, however, she seems to dream of being frozen in order to escape – such as when she puts her pet hedgehog in the freezer in order to wake it up later, when times will be better.

Unspoken is another film, whose plot also corresponds to the idea of characters being stuck in an undefined temporality. With their daughter Lisa having disappeared four years before the beginning of the film, a middle-aged couple tries to find ways of coping with the experience. While dealing with a crack in their apartment's ceiling, Grace (Emmanuelle Devos) takes care of their friend's daughter and follows strangers she thinks might be her grown-up daughter. Lucas (Bruno Todeschini), on the other hand, barely goes on with his job as an accountant, is confronted with the death of a dog he hits, and avoids his father's illness. Nothing is clearly defined and miniature gestures pile up as a series of microscopic attempts to reach their longed-for goal (though they will not find Lisa, they do ultimately find each other again.) Fien Troch's close-ups act like self-sufficient territories, taking the film away from a realist treatment of the couple's impossibility to communicate their grief.

In this new perspective on the world, filmic characteristics are sometimes reshaped, making pre-existing categories such as fiction/nonfiction, universal/auto-biographical, original/adaptation, obsolete. In these cases, boundaries collapse, engendering shocks as well as amalgams, without ever falling into confusion. In *A Piece of the Sky/Une part du ciel* (2002), Bénédicte Liénard plays on both fiction (fictional narration and characters) and documentary elements (amateur actors or actresses, documentary style and emphasis on gestures, real-time conventions).

Very recent projects by women directors confirm the new vitality of Belgian cinematic production: Akerman's *La Folie Almayer* (2011), Bénédicte Liénard and Mary Jimenez's *Le chant des hommes* (2012), Patrice Toye's *Little Black Spiders* (2012), and newcomers Fleur Boonman's *Portable Life* (2010), Kadija Leclere's *Le Sac de farine* (2012), and Géraldine Doigon's *De leur vivant* (2011). Yet one should not forget that feature fiction films are only one aspect of Belgian film production; if the presence of women is still restricted in that specific area, their work in documentary, animation, and more experimental and shorter forms related to contemporary art is far more significant and constantly growing.

Muriel Andrin

Dust

Studio/Distributor:

Daska Films
Flach Film
France 3 Cinéma
Man's Films
Ministerie van de Vlaamse Gemeenschap
Ministère de la Communauté Française de Belgique/20th Century Fox
Kino International

Director:

Marion Hänsel

Producers:

Jean Daskalidès
Jacques Dubrulle
Marion Hänsel
Jean-François Lepetit
Michèle Tronçon

Screenwriter:

Marion Hänsel
based on JM Coetzee's novel *In the Heart of the Country*

Cinematographer:

Walther van den Ende

Art Director:

Pierre-Louis Thévenet

Composer:

Martin St. Pierre

Editor:

Susana Rossberg

Duration:

88 minutes

Genre:

Drama

Cast:

Jane Birkin
Trevor Howard
John Matshikiza
Nadine Uwampa
Tom Vrebus

Year:

1985

Synopsis

Magda, a rigid middle-aged virgin who lives with her indifferent father and his young black mistress on an isolated South African farm, is torn between contradictory desires and needs, confusing reality and fantasy.

Critique

With her first feature-length film, *The Bed/Le lit* (1982), director, producer and screenwriter Marion Hänsel began engaging in the practice of adapting international novels that conveyed universal themes such as the difficulty to communicate as well as the experience of mental and/or physical suffering. When she discovered South African Nobel Laureate JM Coetzee's *In the Heart of the Country* (1977), she became fascinated by the author's writing, which describes, in a long monologue, the thoughts and confusion of a suffering woman. While reading the novel, Hänsel immediately thought it possible to express not only Magda's story but also Coetzee's style through the language of film. She then contacted the author, who gave her his permission to adapt his book for the screen. Yet rather than allow Coetzee to adapt his own work, Hänsel took it upon herself to do so.

Lacking the appropriate authorization to spend Belgian (both francophone and Flemish) public money on a set in South Africa, the film was shot in the similar landscape of a Spanish desert, frozen in time: Almería in Andalusia. The first crucial elements of Hänsel's adaptation are indeed the choice of the appropriate landscape and the embodiment of the characters that live in them. South Africa's endlessly dry and almost silent country echoes the psychological and physical identities of Magda (Jane Birkin) and her father (Trevor Howard). Like many of Hänsel's characters, Magda is a mistreated body, a locked personality; she is stuck in a grandiose no-man's land, which is both a place of exile and an in-between space where the elements play an essential role. The South African desert is a mirror for human emotions in which the characters are lost. Even though they are based on a classical *mise-en-scène*, aesthetic choices support the rhetoric of universal pain, allowing the spectator to have access to the characters' mental images that break the flow of time and disrupt the vast and oppressive expanses of the landscape.

Another aspect of the adaptation process was to find the right chromatic texture of the film: in each film, Hänsel chooses a specific and essential colour palate that bathes and shapes it, giving it its tone (here, yellow and blood red), a visual autonomy that replaces the original literary style. Elements are added to this tonality to produce variations or counterpoints (like Magda's rough-textured little black dress).

Helping to shape the characters, just like bodies or actions, sounds also play a highly significant role in the narrative. They open space, freeing it and leading the way to mental images, for better or worse (images of happiness in Magda's mother's dress, of anxiety when she imagines cutting her wrists on the window glass). They embody the young woman's inner troubles and descent into madness – such as when the high-pitched noise made by the cicadas reaches a crescendo, triggering the slippage between reality and fantasy.

Trevor Howard and Jane Birkin in *Dust*. The Kobal Collection.

The treatment of sound was essential: in this film, where characters are silent, where emotions cannot be put into words, the use of isolated sounds creates a real universe. Hänsel and sound technician Henri Morelle listened to a great number of natural sounds – selecting some to work on, deform, and amplify, such as crickets, tiny bells, the howling of the wind – looking for a thread connecting these sounds together as well as linking them to the film's music (composed by Martin Saint-Pierre, in order to correspond to the sounds of wind), forming a delicate, coherent and organic whole. Just as with the film's visual chromatic tone, sounds work in harmony with the music and with Magda's voice-over. Indeed, since Magda cannot communicate with others through everyday conversation, in order to express her repressed thoughts and desires Hänsel decided to create a voice-over based on Coetzee's original text. Magda's voice guides us into the labyrinth of her thoughts and feelings.

Even though it is based on a South African story and is one of Hänsel's most internationally acclaimed films (it won the Silver Lion in Venice in 1985), *Dust* is somehow emblematic of Belgian cinema in its representation of blurred boundaries, but also of a need to escape, a schizophrenic identity and an extreme difficulty in communication.

Muriel Andrin

Komma

Studio/Distributor:

OF2B Productions
La Parti Productions
Moviestream
Radio Télévision Belge Francophone (RTBF)
Programme MEDIA de la Communauté Européenne
Centre National de la Cinématographie (CNC)
Angoa-Agicoa
Procirep
Région Poitou-Charentes/ Pierre Grise Distribution
Rézo Films
Bavaria Film International

Director:

Martine Doyen

Producers:

Isabelle Filleul de Brohy
Philippe Kauffmann
Guillaume Malandrin
Jean-Luc Ormières
Vincent Tavier

Screenwriters:

Martine Doyen
Valérie Lemaître

Cinematographer:

Hugues Poulain

Art Director:

Valérie Grall

Composer:

Jeff Mercelis

Editors:

Martine Doyen
Matyas Veress

Duration:

101 minutes

Genre:

Psychological drama/romance/fantasy

Cast:

Arno
Valérie Lemaître
Edith Scob

Synopsis

Peter de Witte wakes up in the morgue following an alcohol-induced coma and heart attack. For no apparent reason, he decides to assume the identity of a dead man, Lars Erickson, and imagines a new life, creating a new personality for himself. On this imaginary road, he meets Lucie, a depressive artist who, following the shock of the harsh reception of her recent exhibit, has lost her memory. Together, they escape into a universe of their own.

Critique

Komma is Martine Doyen's feature debut, following a few short films. The director favours certain themes dear to Belgian cinema as well as specific to contemporary female film-makers: the quest for identity, the relationship with corporeality and temporality, psychological enclosure, the tenuous link between reality and the imaginary, and the importance of landscape. Doyen establishes a physical connection between the two main characters. Genuinely wandering souls, they each awake, in turn, in a halo of regenerative light. An incisive camera then scrutinizes their slightest movements and comes close to their bodies, while hypnotic music embraces the duo.

The double identity of these characters is connected to light and cathartic waters, and, conversely, to destructive fire and darkness. Peter and Lucie seek the light in vain, from the aseptic swimming pool to the whiteness of snowy mountains. However, the austerity of their pasts and the usurping of another identity send them back to their baleful condition: inner death. The swimming pool, in this sense, is a place of contrast, purifying for Peter and an outlet for Lucie, during a spectacular scene in which fire and water, elements of artistic creation, struggle under the bewildered eyes of the viewer.

The duality of the landscapes, between urban Brussels and the Bavarian countryside, reinforces the mental schism in the characters' minds and their flight into a new world. Bavaria is thus turned into a white paradise where these liminal beings regain a form of vitality. The landscape instills a form of ritualization, notably through the recurrence of aquatic elements, and inscribes itself in a suspended temporality and an infinite spatiality.

Komma attempts to reconcile these beings with life through the imaginary, referring to the literary genre of the fairytale. Lucie is both a symbol of Cinderella's flight and Sleeping Beauty's eternal dream. Obsessed by this ideal representation of an immutable slumber, she pricks her finger and tirelessly takes photographs of her gesture in order to better find this soothing universe and fly away, in dreams, from the unbearable reality. Peter, a modern metaphor of Prince Charming, takes her to the deep end of this unreal world. Bavaria, after all, is where Sleeping Beauty's castle is located. But it is finally she who will wake him up, by revealing his double personality; she reanimates the dark side of the character that recovers his real identity.

Here, corporeality governs the notion of temporality. The metamorphosis and awakening of the body, coming out of its milky pupa, create a suspended temporal regime leading to a form of

François Négret
Year:
2006

identity abstraction. The bodies, in the course of their regenerative process, attempt to flee from physical enclosure. For both protagonists, identity recreation symbolizes the flight toward psychological freedom.

Komma has a great synaesthetic power, the spectator playing a reflective role, experiencing within his or her own corporeality each sonic and visual representation. The recurrent use of close-ups and sound masks allows for entry into the unconscious and imaginary realm of the characters.

At the end of the film, an actor reveals this shredding of identity, creating a parallel between the story of the Bavarian king and that of Peter de Witte:

> He abandoned the kingdom of his imagination in order to plunge into the reality of existence. After having lived in his dreams, he began to put them into practice. His new kingdom was night and he lost his footing there.

The duality of the main character is reinforced by the versatile and exuberant quality of his interpreter, Brussels pop star Arno, who is a popular phenomenon in Belgium, particularly in Flanders. Arno brings his second-degree humour to the film, and thus a relativism toward this tragedy of identity.

Komma features elements of Belgian magical realism. A true metaphor for the fragmentary soul, the film combines fantasy with representational realism. With this first feature film, Martine Doyen inscribes herself in the vein of auteur cinema and develops a contrasted aesthetics in the service of this chaotic narrative universe.

Aurélie Lachapelle

Translated by Marcelline Block and Jeremi Szaniawski

Unspoken

Studio/Distributor:

Motel Films
Versus Production/ Cinéart
Twin Pics

Director:

Fien Troch

Producers:

Jeroen Beker
Antonino Lombardo
Frans van Gestel

Screenwriter:

Fien Troch

Cinematographer:

Frank van den Eeden

Synopsis

Grace and Lucas are a couple drifting apart, five years after the disappearance of their teenage daughter, Lisa. Each attempts to fill the void in their own lives: Grace hides from her pain as best as possible, while Lucas, a tax controller, looks for his daughter wherever he can. This schizophrenia of the couple has pulled them apart and ends in a total absence of communication, placing the essence of their pain in what remains unspoken.

Critique

Unspoken's narrative strategy is to silence the principal problem of its characters, as its title announces. This translates to a script that avoids verbalizing the problem of Lisa's disappearance as much as possible, a lack that is expressed in lengthy periods of silence. Indeed, this is mostly a film of and about silence, or favouring forceful, anecdotal entreaties. This silence is underscored by two elements of cinematic grammar: shots that inscribe themselves in a lengthy duration and a

Composer:
Peter Van Laerhoven
Editor:
Ludo Troch
Duration:
97 minutes
Genre:
Drama
Cast:
Déborah Amsens
Emmanuelle Devos
Chloé Henry
Bruno Todeschini
Year:
2008

majority of close and extreme-close ups, most notably on the faces of Grace and Lucas, where one can read all that the sparse dialogues disseminate. Silence, conjugated in cinematic grammar, becomes a screenwriting element in its own right, and the place where the characters express their emotions.

This absence of communication that corrupts the couple, is symptomatic of the characters' solitude, also treated through cinematic form. Close-ups are used quasi-systematically here, preventing the characters from co-existing within the same frame and prompting the consistent and coterminous logic of shot-reverse-shots. Director Fien Troch also uses a shallow depth of field, which seems to make the characters stick out from the background surrounding them. This signifies the exile of the characters from a certain reality, as though they are retreating from the world, thereby marking a flight from a reality that hurt them. The depth of field thereby immediately diagnoses a problem. Space is, from the very start, considered a threat to these characters: whether it is the crack in the ceiling that Grace cannot patch up, or the cupboard that collapses on a neighbour. Even when the characters are within the same frame, the depth of field separates them, as in the scene where Grace is separated from Benjamin (whom we suppose is Lisa's ex-boyfriend) through shallow depth of field. This radical use of visual grammar is viscerally effective. The film also boasts a dark, disquieting cinematography, which ushers it into the possibility of typically Belgian magical realism. It is indeed in the zones of shadow that Grace and Lucas see their daughter appear. This form of magical realism is also attached to the urban space represented, again, through a shallow depth of field.

This use of magical realism introduces Lisa's presence through apparition-images and sonic manifestations (the phone which rings more and more frequently). Lisa's absence is also represented by many symbols throughout the film: indeed, the panther poster on the door of her room allows an iconoclastic transfer later on, when Lucas picks up the dead dog in order to bury it, or when he watches panthers in a zoo. The transfer is also performed through his search for Lisa in the lower depths, going so far as seeking a substitute for his daughter in a prostitute. The symbolic presence of Lisa extends to the space of the apartment. In fact, the crack in the ceiling that Grace desperately tries to cover up obviously symbolizes the inability of the couple to be cured from the void left by their daughter's disappearance and the impossibility of making her survive in any way other than in the symbolic realm.

As far as the temporality of the film is concerned, it is organized around a series of rituals. To the already-mentioned phone whose ringing paces the film, one can add the sequences where Grace waits for her daughter at the station, which inscribe her quotidian routine into a cycle that prevents her from moving on: by repeating the same gestures – waiting at the station, repairing the ceiling – Grace is imprisoned in time much in the same way that she is locked inside the space of the apartment.

Mathieu Pereira e Iglesias

Translated by Marcelline Block and Jeremi Szaniawski

FRANCOPHONE BELGIAN CINEMA SINCE 1990

My Life in Pink

Ma vie en rose

Studio/Distributor:
Haut et Court

Director:
Alain Berliner

Producer:
Carole Scotta

Screenwriters:
Alain Berliner
Chris Vander Stappen

Cinematographer:
Yves Cape

Art Direction:
Véronique Melery

Composer:
Dominique Dalcan
Zazie

Editor:
Sandrine Deegen

Duration:
89 minutes

Genre:
Drama

Cast:
Michèle Laroque
Jean-Philippe Écoffey
Hélène Vincent
Georges Du Fresne

Year:
1997

Synopsis

The Fabre family – mother Hanna, father Pierre and their four children – are new to the neighbourhood. Seemingly a 'normal' family, they have a small secret which happens to go public in front of the neighbours at a welcome party: their youngest son, 7-year-old Ludo, likes to dress up as a girl. Passed off initially as a joke, Ludo's behaviour takes a more serious turn when he announces his intention to become a girl and marry Jérôme, a boy in his class who happens to be the son of Ludo's father's boss. Ludo's parents decide to take Ludo to a psychologist, who, it is hoped, will be able to help Ludo to be a more conventional little boy. But, as Ludo persists in his efforts to be a girl, consequences begin to arise both for the family and for the community as a whole. Will Ludo ever manage to be happy?

Critique

My Life in Pink/Ma vie en rose, directed by Belgian film-maker Alain Berliner, but shot in France with financing from both countries as well as from the United Kingdom, fits into a tradition of exceptional Belgian films that deal with the messiness of childhood, such as *Crazy Love* (Dominique Deruddere, 1987) and *Toto the Hero/Toto le héros* (Jaco Van Dormael, 1991). In each of these films a strain of blissful fantasy is mixed in with the harsh realities of the world. *My Life in Pink*, while ostensibly a 'light' film, nevertheless offers an acute portrayal of the unintentional cruelty of human beings, and how this stems in many ways from the limitations of conformism.

The film rests on a remarkable performance by Georges Du Fresne as Ludo. Du Fresne has a wide-eyed, accepting face, which, in its ability to take the indignities inflicted upon it from adults and other children, situates him in a European cinematic lineage of figures who endure suffering, from Falconetti in *The Passion of Joan of Arc/La Passion de Jeanne d'Arc* (Carl Theodor Dreyer, 1928) to a host of Robert Bresson's protagonists. Furthermore, Du Fresne's is a performance of true gender ambiguity which pushes the film towards a committed transgenderism. The film's socio-political effectiveness rests on the things we see that most of the people surrounding Ludo do not: that there is nothing malicious in this 7-year-old's efforts to be a girl, nothing calculating or deliberately destructive. The film's somewhat schematic design is tempered by the ways in which the story keeps a constant balance between fable-like simplicity and the complexities of the adult world in which Ludo must fight for recognition.

Indeed, *My Life in Pink* is just as much a study in adult stress as in children's instincts. Pierre's tensions at work arise not just from Ludo's fondness for Jérôme but also from Pierre's efforts to impress his boss at a time of lay-offs; while Hanna turns on Ludo partly because of his non-conformism but also because of her own frustrations – especially when she sees her own mother's blanket acceptance of the child. In moments such as these, the film subtly shows how life works differently for grown-ups and for children: while the adults are battered by the emotions they experience throughout the course of the film, Ludo gently persists in following his desire, in the restorative

way in which children pick themselves up and carry on.

But how much can Ludo take? It is heartbreaking to see how his spirit is slowly being stifled. And so, while in narrative terms the family ends up in a better place, literally, than the one in which they started, the abiding impression is that although Ludo's troubles may have temporarily abated, there is no guarantee whatsoever that they will not be replaced by others. Thus, the rapturous, liberating pink of the film is, in the final shot, held in dichotomy with the clear sky above suburbia – blue in both colour and mood.

Edward Lamberti

An Affair of Love

Une liaison pornographique

Studio/Distributor:

ARP Sélection
Artémis Productions
Canal+
Centre du Cinéma et de l'Audiovisuel de la Communauté Française de Belgique
Eurimages
Fama Film AG
Fonds National de Soutien à la Production Audiovisuelle du Luxembourg
Les Productions Lazennec
Radio Télévision Belge Francophone (RTBF)
Samsa Film
Schweizer Fernsehen (FS)
Wallons/ ARP Sélection
Alcine Terran
Fama Film AG
Fine Line Features
Scotia International Filmverleih
United King Films
Alliance Atlantis Communications
Líder Films
Momentum Pictures
New Line Home Video
Umbrella Entertainment

Director:

Frédéric Fonteyne

Synopsis

A woman, a man, a sexual fantasy. We will never know their names, or the nature of the obscure object of their mutual desire. The two meet at a bar, go to a hotel and begin a fiery liaison that will last several months, during which they will reveal nothing about their respective existences. But little by little, other links are forged, feelings arise, and the film-maker deciphers the full mechanics of a nascent relationship. This is a peculiar couple, no doubt, first formed through sex, not knowing what it has in common; a couple that does not know what it wants, and whose desire becomes multiple… until the inevitable break-up.

Critique

One remembers the description of Cinemascope that Jean-Luc Godard put in Fritz Lang's mouth in *Contempt*/*Le mépris* (1963): 'this is not made for people but for snakes and funerals'. *An Affair of Love* (a peculiar if apt translation of the French's deceptive 'Liaison Pornographique') is shot in this format, which strikes the viewer from the very onset of the film: an out-of-focus credit sequence that spreads out, dilates time and empties bodies and space of their material substance.

But, beyond a joke about Adam and Eve and a man who dies before his wife commits suicide, both offscreen, the snake and the funeral are not shown here. Yet they are present, discreet, metaphorically lurking in the shadows. The snake represents those feelings that creep where they do not belong, viciously taking the protagonists by surprise. The funeral is the foretold death of the relationship of these two lovers, from the film's very beginning, by this enigmatic aspect ratio, which decomposes rather than composes the image and is therefore in perfect harmony with a narration that tends toward the impossibility of accepting the other one's love.

Cinemascope, often used to show the vast expanses of the world, is used here to film the opposite: two narrow and enclosed spaces, corridors, rooms, a bed and a bathtub, or urban and blurry spaces, further shortened by a total absence of depth of field. The wide format is specifically used to show poorly framed faces and bodies, which are cut up and fragmented, and often in shot-reaction-shot, in order

Nathalie Baye and Sergi Lopez in *An Affair of Love*. The Kobal Collection.

Producers:
Patrick Quinet
Rolf Schmid
Claude Waringo

Screenwriter:
Philippe Blasband

Cinematographer:
Virginie Saint-Martin

Art Director:
Véronique Sacrez

Composers:
André Dziezuk
Marc Mergen
Jeannot Sanavia

Editor:
Chantal Hymans

Duration:
80 minutes

Genre:
Drama/romance

Cast:
Nathalie Baye
Sergi Lopez
Jacques Viala

Year:
1999

to insist further upon the impossible union of souls and bodies. It is impossible because the fulfillment of a fantasy – namely, the dream of a perfect relationship – prevents them from reaching and enjoying these moments when reality hits them.

As a matter of fact, everything in this 'pornographic liaison' is a lie and the *mise-en-scène* tends toward the revelation of this intrinsic deception. The narrative, although presented like a documentary, is pure fiction: his lie and her lie about their encounter, their time spent together, their relationship. Lying to themselves from the moment when speech comes into their union excludes any possibility of their remaining together. There is also the lie of the original French title: if these two human beings are indeed 'liaised' – connected, linked – nothing here is pornographic since sexuality is never represented, except perhaps through a surreptitious image of a breast or a bare chest. The whole film is founded upon lies: how could the voice-over find these two individuals who know nothing about one another, not even their names or addresses, in order to conduct an interview with them?

Here again, we return to Jean-Luc Godard: if 'cinema is truth 24 times a second,' as is formulated in *The Little Soldier/Le Petit soldat* (1963), this pornographic relationship of a film is the exact opposite, the negative epitome of this definition. Without containing a sliver of truth, it reveals through its *mise-en-scène*, 24 times a second, the lie that constitutes the film.

Nicolas Thys

Translated by Marcelline Block and Jeremi Szaniawski

Hop

Studio/Distributor:

Film Movement

Director:

Dominique Standaert

Producers:

Dominique Standaert
Michel Houdmont
Thierry De Coster

Screenwriter:

Dominique Standaert

Cinematographer:

Raymond Fromont

Art Director:

Yvan Bruyère

Composer:

Vincent D'Hondt

Editor:

Arnout Deurinck

Duration:

104 minutes

Genre:

Drama/comedy

Cast:

Justin Kalomba Mbuyi
Jan Decleir
Antje De Boeck
Ansou Diedhou
Alexandra Vandernoot

Year:

2002

Synopsis

Dieudonné and his young son Justin are illegal immigrants from Burundi living in Brussels. Their relatively quiet lives change when they are about to watch their favourite Congolese player, Emile M'Penza, in a major soccer game. As usual, Justin taps into his neighbour's cable television line. When their neighbour discovers the reason for his poor cable reception, he calls the police, thus exposing Dieudonné and Justin as undocumented. The two run away, but Dieudonné is caught, interrogated, and deported – to Congo. What follows is Justin's plot to reunite with his father while sheltered and aided by Frans and Gerda, who sympathize with the plight of illegal immigrants. Justin's confrontation with Belgian authorities plays out on the cultural level as Justin employs the wisdom of the trickster figure in African folktales to compel Belgian authorities to reverse his father's deportation.

Critique

Hop is Dominique Standaert's debut feature film and the first Belgian feature film shot entirely digitally. With humour, attention to detail, and surreal inflections, *Hop* fictionalizes the true story of two illegal Nigerian immigrants in Belgium, a father and son separated by the former's deportation. It also crafts an uncanny conclusion that fashions a morally- and aesthetically-reparative gesture aimed at restoring power to the marginalized. From a vantage point of utter marginality – that of an illegal African immigrant child contemplating the possibility of orphanhood – Justin is nonetheless invested with narrative control. He holds the narrative impetus that puts the story in motion and, more importantly, is in charge of plotting the return of his father to his country of choice. Standaert explains his interest in storytelling, which is central to the film: '*Hop* treats childhood and the life of immigrants in Europe in a magical way … I don't like to show things that everyone already knows' (http://www.filmmovement.com). Storytelling is crucial in light of the postcolonial history of Belgium and Burundi that Standaert invokes in *Hop*. The film opens with Justin lecturing his all-white classmates on the secret of hop used by the Pygmies to tame African elephants or to trick a more powerful adversary to surrender. The hop is a trickster's tale that is adopted as the narrative template of the film.

The aesthetic choice of filming in black and white could not create a better resonance with the state of racial and geo-political segregation that haunts the West European metropolis. As Standaert explains, it is a way of contemplating contrast, especially in the close-ups of faces, and of giving up claims of realist representation. In this whimsical universe, the characters are solidly constructed and remain grounded in a reality that is pliable and allows itself to be manipulated by their vision.

Standaert's surreal fictionalization of reality is far from a facile solution that diffuses the drama into fairytale magic. On the contrary, it maintains a salutary proportion of tragic imminence, suspense, and comic resolution. It is no coincidence that the presence of dynamite accompanies all the critical moments that bring Justin closer to his father (although the dynamite only explodes once, destroying the

Turkish toilet in Frans's backyard). In other circumstances, dynamite functions as a hop that genuinely propels Belgian authorities to carry out Justin's plan. The suspense is the hop that Standaert skillfully reserves for the audience, fully immersing it in the story. The film's narrative and visual sophistication makes Hop a fulfilling cinematic experience.

Oana Chivoiu

When the Sea Rises

Quand la mer monte...

Studio:

Ognon Pictures
Stromboli Films
Radio Télévision Belge Franco Phone (RTBF)

Distributor:

New Yorker Films U.S. (DVD)

Directors:

Yolande Moreau
Gilles Porte

Producers:

Humbert Balsan
Catherine Burniaux

Screenwriters:

Yolande Moreau
Gilles Porte

Cinematographer:

Gilles Porte

Art Directors:

Serge Berkenbaum
Jackie Delavoye
Marc-Philippe Guerig
Alice Retorre

Composer:

Philippe Rouèche

Editors:

Muriel Douvry
Eric Renault

Duration:

88 minutes

Genre:

Drama

Synopsis

Irène, a performance artist on tour with her one-woman show, loosely improvises her act each night, inviting male members of the audience to perform as her 'chicken', while she relates her hideous crimes. When her car breaks down, Dries, a passing motorcyclist, assists her. Out of gratitude, Irène offers him a ticket to her performance that night, where she chooses him, despite his reluctance, to be her 'chicken'. Their relationship turns into a passionate affair as Dries follows Irène to her shows, where she obligingly chooses him to be 'chicken' before each new audience. Enamoured of Irène, Dries tells his foster parents that she is his wife – although she is married to another man – prompting her to select another 'chicken,' thus infuriating Dries. After a violent argument, the two split. Sometime later, Irène is performing in Lille when she encounters Dries. They talk briefly, both recognizing that the beginnings of a romance are often more important than its conclusion.

Critique

When the Sea Rises/Quand la mer monte… was Yolande Moreau's screenwriting and directorial debut. Her character, Irène, is a performance artist whose one-woman show, 'Dirty matters of sex and crime'/'Sale affaire, du sexe et du crime,' is actually the same title of Moreau's real life performance piece with which she toured in the 1980s. Irène's onstage persona is that of a demented murderous clown with a long nose reminiscent of the ultra-violent Alex (Malcolm McDowell) in *A Clockwork Orange* (Stanley Kubrick, 1971), in which Italian opera music prominently features. Notable throughout *When the Sea Rises…* is the recurrent use of Verdi's opera *La traviata*, to which Irène sings along while driving from one border town to another. 'La traviata' translates to 'fallen woman,' referring to a woman who has lost her way and goes astray. Irène, in a sense, becomes a *traviata*: although she dutifully calls her husband and son nightly from her hotel rooms, she goes astray after meeting Dries. Their friendship quickly turns sexual. It is not long before she pictures Dries as a knight on horseback – although he resembles Don Quixote more than Sir Lancelot – and is even arrested with him for sleeping naked on sand dunes. Irène, however, realizes that if she is to avoid following the path of Verdi's Violetta, she must end her relationship with Dries.

The interplay between the stage and real life is elegantly interwoven throughout the film. In trying to end things with Dries, Irène tells her audience that what matters is the start of a great

Cast:

Yolande Moreau
Wim Willaert
Olivier Gourmet
Jackie Berroyer
Philippe Duquesne

Year:

2004

romance, not how it ends, and further tells the crowd: 'When the holiday is over we throw out the tree.' Dries does not fully understand the metaphor until Irène spells it out to him that their relationship must end. Like a petulant child, Dries plants himself on Irène's chair (the only prop in her show) at the roadside – as if to introduce theatre to the outside world – before smashing it in anger.

The metatheatrical aspect is important here, but it never takes over the warmth between the central characters in a poignant depiction of the life of these constant drifters. Above all, *When the Sea Rises…* is a love letter to the real-life community that nurtured Moreau's talent in the early 1980s, years before she found success and acclaim as an actor and writer/director. Moreau beautifully conveys, through the rural franco-Belgian countryside, the sense of emptiness and loneliness Irène feels as a lone performer, continually on the road, staying in one hotel after another. Even the electricity pylons she passes by stand like lonely skeletal figures, linked to each other by only the smallest strand, and yet remaining perpetually separated; they aptly represent Irène who, much in the same way, is connected to and yet removed from her family, both geographically and emotionally.

Zachariah Rush

Eldorado

Studio/Distributor:

Programme MEDIA de la Communauté Européenne
Radio Télévision Belge Francophone (RTBF)/
Filmmuseum Distributie

Director:

Bouli Lanners

Producers:

Jacques-Henri Bronckart

Screenwriter:

Bouli Lanners

Cinematographer:

Jean-Paul de Zaetijd

Art Director:

Paul Rouschop

Composer:

Renaud Mayeur

Editor:

Ewin Ryckaert

Duration:

81 minutes

Synopsis

Eldorado tells the story of two drifters: Yvan, who buys old American cars and sells them in Belgium, and Didier, a drug addict. One day, as he comes home with the '79 Chevrolet he just purchased, Yvan finds Didier, who has broken into his house, hiding under his bed. Yvan does not call the police and, instead, ends up agreeing to give Didier a ride home, near the French border. On the road to Didier's parents' house, the two encounter a strange psychic, as well as a nudist called 'Alain Delon'. Didier's return home turns out to hardly be a happy reunion, and so Yvan agrees to give him a ride back to the city. On the way, a dog comes crashing down onto the roof of their car. As they look for a solution to put the animal out of its misery, Didier asks for money for heroin, which he says he will use to give the dog a painless death. Yvan reluctantly accepts to give Didier money for the drug. He never sees the young man again, and buries the dog himself at dusk, by the side of the road.

Critique

With *Eldorado*, Bouli Lanners attempts to recreate an American formula – the buddy/road movie – in a most unlikely locale, Belgium, one of Europe's smallest and most-densely-populated countries. Through the magic of cinema, the director manages to expand the borders of Belgium into vast expanses of land and forest, offering an anecdotal yet new definition of the cinematic frontier. This metaphorical landscape populated with strange characters clearly combines the narrative situations of Wim Wenders or Aki Kaurismäki's

Cast:

Bouli Lanners
Fabrice Adde
Philippe Nahon
Françoise Chichéry
Stefan Liberski

Year:

2008

Euro-road movies (think of *Kings of the Road,* 1976, and *Take Care of Your Scarf, Tatiana,* 1994), alternating quirky humour with a keen sense for nostalgia. The first aspect is nowhere more obvious (and somewhat grating) than in the appearance of the nudist camper 'Alain Delon', and the second is captured in a beautiful scene in which Yvan tries to convince Didier of the charms of bathing in a mountain river (and where Lanners's sensitivity as a self-taught painter shines through). These elements combined produce a bittersweet story of lost opportunities, where Lanners clearly wants to turn everything into something bigger than it actually is: a place of enjoyment of childhood into Eldorado, and Belgium into America. But the director also shows that all these attempts fail miserably in the end, as no one finds their Promised Land of Plenty, and even the injured dog is not given the benefit of a painless death…

As the final scenes take place in a rather grey and depressed urban environment, it appears that the film tries to be both fairytale and social portrait, with a pointed critique of the declassified status, but also resigned and cowardly attitude of some people, here epitomized in the character of Didier, the irresponsible and amorphous drug addict. This poetry with social sensitivity sounds better on paper than it does on the screen, however. The scenes, taken individually, display technical savoir-faire, but Lanners never quite finds his stride overall. His attempts to produce a truly original and personal product through the addition of a typically-Belgian surrealist (or absurdist) feel, poised between a manifest destiny (the ending of the film is foretold by the ominous psychic played by French character-actor Philippe Nahon) and a profound sense of lack of goal and purpose to these characters' lives, ends up never satisfying or fulfilling one's wait.

Bouli Lanners is no Samuel Beckett, and his picaresque film certainly lacks the strength of a real philosophical tale, much as it could have used a more refined screenplay. A protracted short rather than a real feature story, the film nevertheless features sufficient interesting elements to sustain viewing, and confirms another forcibly-original voice among the somewhat colourful and dissonant chorus of Belgian cinema.

Jeremi Szaniawski

FLANDERS

CONTEMPORARY FLEMISH CINEMA

In 1964, the Belgian government created a selection committee for Flemish film culture, allowing Flemish films to be publicly funded. The first films produced on those new terms were *Y mañana?* (Emile Degelin) and *The Man Who Had His Hair Cut Short/De Man die zijn haar kort liet knippen* (André Delvaux), both 1965, with the latter co-financed by the Ministry of National Education and the public broadcaster BRT. That political decision immediately led to a shift in scope for Flemish cinema.

Flanders maintained small but consistent film production from the 1930s onward; most of these were vernacular comedies by Jan Vanderheyden, Edith Kiel and Jef Bruyninckx. In 1955, the trio of Roland Verhavert, Ivo Michiels, and Rik Kuypers made, with private funds, Flanders' first arthouse movie, *Seagulls die in the Harbour/Meeuwen sterven in de haven*, which competed in Cannes the next year. But it was only a decade later with the establishment of public funding that Flemish cinema enjoyed a real boost. At this later moment, Roland Verhavert's career got a second and now definitive, start. Other names to emerge at the end of the 1960s and the beginning of the 1970s were Harry Kümel, Hugo Claus (an all-around artist, though first and foremost known as a writer) and Robbe de Hert, the most famous face of Fugitive Cinema, the leftist cinema collective from Antwerp. Adaptations of famous Flemish novels dominated film production during those years. A few of them (*De Witte van Sichem*, De Hert, 1980, and *Mira*, 1971, ironically directed by Dutchman Fons Rademaekers) are still in the top fifteen most popular Flemish films of all time.

Already in the 1970s a few directors tried to replace the *heimat* cinema with more contemporary subjects: Guido Henderickx with *Burned Bridges/Verbrande brug* (1975) and *De proefkonijnen* (1979); and Patrick Conrad with *Slachtvee* (1979). However, Marc Didden's *Brussels by Night* (1983) is generally considered the caesura and the start of a modest Flemish 'new wave'. Apart from Didden, the main name is Dominique Deruddere, whose debut *Crazy Love/Love is a Dog from Hell* (1987) was highly praised. He went on to make films in France, Germany and the USA (the Francis Ford Coppola-produced, Faye Dunaway-starring, *Wait until Spring, Bandini*, 1989) and received an Oscar nomination for *Everybody's Famous!/Iedereen beroemd!* (2000).

Parallel with this 'new wave', Flanders saw a surge in popular comedies, mainly those centred around famous television entertainers like Urbanus and the duo Gaston and Leo. Until 2008, the Urbanus-starring *Hector* (1987) and *Koko Flanel* (1990) were, respectively, number two and number one on the all-time Belgian box office chart. Both were directed by Stijn Coninx, who in 1993 made *Daens*, the social drama that landed Flanders, under the Belgian flag, its first nomination for an Academy Award for Best Foreign Language Film. The phenomena of television stars cashing in on their popularity continued into the 1990s (Jacques Vermeire, Chris Van den Durpel), but came to a halt around 2000.

A second new wave of Flemish directors emerged in a more significant way at the beginning of the twenty-first century, creating an interesting mix of commercial successes (thrillers *The Memory of a Killer/De zaak Alzheimer* (2003) and *Loft* (2008), both by Erik Van Looy; *Dossier K* (2009) by Jan Verheyen; the romantic comedy *Aanrijding in Moscou* (2006) by Christophe Van Rompaey; and the 'dramedy' *The Misfortunates/De helaasheid der dingen* (2009) by Felix Van Groeningen) and

Matthias Schoenaerts in *Bullhead*. Savage Film.

respected auteur films by directors such as Fien Troch, Koen Mortier, Dorothée Van den Berghe, Geoffrey Enthoven, Gust Van den Berghe, and Michaël R Roskam, whose *Bullhead/Rundskop* (2011) received an Academy Award nomination for Best Foreign Language Film.

Distancing themselves from cinematographic adaptations and classical *mise-en-scène*, some films opened the path to production, narrative or aesthetic changes – among them, *Any Way the Wind Blows* (2003, directed by Tom Barman, the mainstay of popular Antwerp rock band dEUS). This network narrative revolves around a series of unconnected characters that will eventually meet at a party. The interest of the film lies in its accurate and personal cartography of Antwerp, in the loose trajectories of its characters, and in a cultural dynamic based on close connections to music and contemporary art. Cutting away from formal rigidity and classical storytelling, Barman's ode to his hometown brought new aesthetic challenges to Flemish cinema.

More classical in form, Frank Van Passel's *Manneken Pis* (1995) and Patrice Toye's *Rosie* (1998) created personal and subjective worlds, lingering on detailed portraits of marginalized characters. Both films are important offshoots of the 1980's new wave and harbingers of the second Flemish new wave of the twenty-first century.

Yet, more than these scattered examples, new guidelines and financial decisions changed the face of Flemish film production and helped with the development of this aesthetically highly diversified second new wave. Changes in the Belgian financial and cultural landscape allowed this new generation to emerge. Taking over the former Filmfonds Vlaanderen, the VAF (Vlaams Audiovisueel Fonds) helped develop a new kind of cinema even if some traces of aesthetic changes were already visible at the end of the 1990s.

The new policy of the VAF was created in September 2002 and launched at the beginning of 2003. Selection committees determine financial support for screenwriting, production, as well as promotion. The VAF spends a yearly budget of between 15 and 17 million euros, 55 per cent of which covers fiction films. The rest is shared between documentaries, experimental films, high-quality television drama and animation, allowing more or less ten features to be filmed each year. A broad scope policy is part of VAF's dynamics, since it supports both commercial *and* auteur films. The support is also highly significant in terms of diversified promotion networks (including a website, different books, both on this second new wave and isolated directors, and a publicity periodical called 'Flanders Image'). Far from focusing only on recently-confirmed talents, the VAF also encourages the younger generation through its Wild Card series, which for instance allowed the discovery of the highly talented Gust Van den Berghe, director of *Little Baby Jesus of Flandr* (2010) and *Blue Bird* (2011), an adaptation, set in Togo, of Maurice Maeterlinck's play *L'oiseau bleu*. Both films were selected for the Quinzaine des réalisateurs ('Directors' Fortnight') at the Cannes Film Festival.

Another important factor was the creation, in early 2003, of the tax shelter on a national level in Belgium. It aimed at stimulating companies to invest in the Belgian film industry. Every company that pays corporate taxes in Belgium can benefit from this tax measure. Thanks to the tax shelter, it became easier to finance films or to make them with a bigger budget.

Television plays yet another essential role in contemporary Flemish cinema. The public Flemish Broadcast Organization (BRT, later BRTN, and VRT since 1998) has a long tradition of co-producing feature films. In the twenty-first century, commercial television stations joined in, with VTM, a channel of the VMMa (the Vlaamse Media Maatschappij), together with the VAF, launching *Faits Divers* in 2003. *Faits Divers* consists of a series of seven unconnected films based on a true story or on a story that could have happened. Each film had a production budget of 375,000 euros, split two ways between vtm and the VAF. Four of them were eventually released commercially before being shown on television. In 2006, *Faits Divers 2* followed; for the sequel, four films were made with a budget of 500,000 euros each.

The smaller Flemish commercial broadcaster VT4 (part of European media conglomerate ProSiebenSat.1 Media AG until 2011) also contributed, on a smaller scale, to the Flemish film industry: in 2008 it launched its new crime series *Vermist*. It did not do so with a pilot, as would be customary, but rather with a feature film by the same name.

In the twenty-first century, children's films have been thriving in Flanders, almost exclusively thanks to the highly successful entertainment company Studio 100. Always looking for cross-medial synergies, their exclusively privately-funded feature films are strands in a bigger story, alongside television series, amusement parks and musical bands. Between 1999 and 2012 they produced 25 feature films based on children's television series (*Kabouter Plop*, *Mega Mindy*, *Piet Piraat*), young adult's television series (*Het huis van Anubis*) and a musical act (K3).

These various elements allowed a highly diversified cinematographic landscape of both commercial and arthouse films to develop. Classical genres are revisited by Hollywood-like productions, based on well-drafted screenplays, with thrillers like Van Looy's *Loft* (2008) and Verheyen's *Dossier K* (2009), comedies such as *Madly in Love/Smoorverliefd* (Hilde Van Mieghem, 2010) and *Zot van A* (Jan Verheyen, 2010) and even Pieter Van Hees's horror film *Left Bank/Linkeroever* (2008). Simultaneously, some 'auteurs' emerged, escaping pre-established categories and proposing new and very personal universes, with Koen Mortier (*Ex-drummer*, 2007; and *22 mei*, 2010) as the prime example.

In the niche of gay and lesbian film festivals, director Bavo Defurne has never failed to draw attention to his compelling postmodern short films, filled with unabashed queer sensuality and a pointed love of cinema. Among his works, one can highlight the 1950s locker room aesthetics of *Particularly Now, in Spring* (1996), the gay martyrdom of St Sebastian in the silent peplum *Saint* (1997) or the Jean-Paul Gaultier commercial-inspired *Matroos* (1998), with its imagery of muscular sailors. In 2011, Defurne released his first feature, the underwhelming but visually exquisite *North Sea Texas/Nordzee Texas*.

Flemish cinema also follows new artistic trends that blur the confused borders between cinema and contemporary art. Though artist Johan Grimonprez started his career in galleries, his films (like *Dial H-I-S-T-O-R-Y*, 1997; and *Double Take*, 2009, where the artist combines Hitchcock impersonations with historical footage) were also projected at festivals and in cinemas. Another example is Nicolas Provost who first anchored his artistic practice in world-famous short films (*Papillon d'amour*, 2003; *Plot Point*, 2007; *Stardust*, 2010) presented at international festivals (Sundance, Berlin, Venice). Nonetheless, his first feature film *The Invader* (2011) was not financed by the VAF, but by its francophone Belgian counterparts.

Directors are the most important but not the only element that shapes this refreshed landscape. Interesting networks can be traced through technicians or actors that work on very different films. This new generation has its emblematic faces. Even though very different, *Left Bank*, *Pulsar* (Alex Stockman, 2010), and *Bullhead* share one main element: actor Matthias Schoenaerts. Another prominent actor of this new wave is Koen De Graeve, who appears in such diverse films as *The Misfortunates*, *Loft* and *Smoorverliefd*.

Whereas the first new wave in Flemish cinema witnessed only sporadic box office success, the second one carved out, in just a few years, a strong reputation amongst cinemagoers. In 2004, only two Flemish films passed, and only barely, the 100,000 visitors mark. By comparison, in 2010 six feature films surpassed the same number. In fact, over the same six-year period, the market share of Flemish films in Belgium increased, according to the 2010 annual report of the VAF, from 4.8 to 10.25 per cent, reflecting the financial health and dynamic quality of Flanders during this period.

Muriel Andrin and Christoph Verbiest

Any Way the Wind Blows

Studio/Distributor:
Corridor/Cinéart

Director:
Tom Barman

Producers:
Kaat Camerlynck
Alex Stockman

Screenwriter:
Tom Barman

Cinematographer:
Renaat Lambeerts

Art Director:
Johan Van Essche

Composer:
Tom Barman

Editor:
Els Voorspoels

Duration:
127 minutes

Genre:
Comedy/ensemble/drama

Cast:
Frank Vercruyssen
Diane De Belder
Eric Kloeck
Natali Broods
Matthias Schoenaerts
Dirk Roofthooft
Jonas Boel

Year:
2003

Synopsis

On an early summer Friday in Antwerp, the sun is shining and desire takes hold of people's bodies. A handful of characters go about their daily lives before attending a *soirée* at Nathalie's. Walter – the party's DJ and Nathalie's boyfriend – is unjustly fired from his work as a movie theatre projectionist. Lara, the mother of Walter's daughter, sustains a naïve and casual worldview. Nathalie cancels her appointments to talk to her brother Chouki about the death of their father, an immunologist. Chouki steals a virus from his father's office that he intends to use on himself in order to turn his death into performance art. Firmin, a contemporary art gallerist, oversees the installation of his forthcoming exhibit and fancies himself a new Andy Warhol. Paul Garcin, an aging French teacher and unsuccessful writer, is bored with the bourgeois monotony of his family life. A burlesque duo, nostalgic for the 1980s, clandestinely hangs posters around town. All the while, a mysterious character, The Windman, walks through the narrative and seems to experience the suffering of the world as he causes a gust of wind in his wake. In the end, all characters' paths intersect, and ultimately they are reunited for an evening of carousing.

Critique

As demonstrated by its synopsis, *Any Way the Wind Blows* is a choral film. Its various characters are presented one after another following the opening credits, and their stories are narrated alternately. As they roam the city, they unwittingly cross each other's paths. It is not so much the story that constitutes the fabric of the film, but rather the puzzling and often comical richness of the dialogue in these everyday exchanges, where incommunicability and self-centeredness are often primary motifs. The film's off-kilter atmosphere is emphasized by its secondary characters: two policemen go from door to door as a device to raise questions about art. Originally a character in drawings the director made in his youth, the Windman moves through the events as the breath of fate, and injects an air of poetry into the film.

Tom Barman, the singer and lead member of the rock band dEUS, whose international success interrupted his film studies, takes advantage of his debut feature to pay homage to Antwerp, the city where he was born and which saw him grow up. He specifically depicts Antwerp's trendy artistic crowd in a moving portrait that is equally musical and cinematic. He paints this portrait in light touches, and makes the city a character in its own right. Unsurprisingly, music is ubiquitous here: Herbie Hancock, Puccini, Archie Shepp, Queens of the Stone Age, Bach, Charles Mingus, and many others work smoothly together. Some passages of the film could qualify as mere music videos, but the broader point is primarily to represent how music can correspond to a moment in one's life.

An interview with Wim Delvoye, a contemporary Belgian artist, punctuates the film, which also features contemporary dance, an important element of Flanders' culture. In the film's finale, all the characters perform a dance and The Windman always dances more

than he walks, evoking a dEUS music video censored by MTV on the charge of epileptic motion.

The framing, choice of focal lengths, and camera movements, that lend the film its fluidity, are executed masterfully by cinematographer Renaat Lambeerts, Barman's longstanding collaborator on music videos. Without Lambeerts, *Any Way the Wind Blows* would not reach such a degree of visual accomplishment. This kaleidoscopic film treats us to an accumulation of small off-kilter events much as real life does, alternating the banal with the extraordinary. Tom Barman skillfully captures this nonchalant atmosphere of an urban summer afternoon leading to an evening in which all characters let go and paint the town red, as a necessary exorcism from their – and our – daily routines.

Anita Jans

Translated by Marcelline Block and Jeremi Szaniawski

Ben X

Studio:
MMG Film
Director:
Nic Balthazar
Producer:
Peter Bouckaert
Screenwriter:
Nic Balthazar (adapted from his novel *Nothing Was All He Said*)
Cinematographer:
Lou Berghmans
Production Designer:
Kurt Loyens
Composer:
Praga Khan
Editor:
Philip Ravoet
Duration:
93 minutes
Genre:
Drama
Cast:
Greg Timmermans
Laura Verlinden
Marijke Pinoy

Synopsis

Ben, a troubled and socially-maladjusted teenager with Asperger's Syndrome, is relentlessly bullied at school and uses the online role-playing game *ArchLord* as an escape from his intolerable and incomprehensible life. While playing, he befriends a girl he knows only by her in-game name, 'Scarlite'. After a bully is chastised by a teacher for tormenting Ben in class, various classmates turn on Ben and force him onto a desk, pulling down his pants and filming his distress, before uploading the footage to the internet. A few days later, Scarlite leaves Ben a message on his mobile phone saying she will be at his local train station the next morning. That evening, two bullies take Ben to a park, beat him and force him to swallow drugs. In the morning, Ben makes it to the train station, but once there cannot bring himself to talk to Scarlite and resolves to commit suicide by throwing himself under a train.

Critique

The most striking aspect of *Ben X* is that, while it is the directorial debut of a writer working from a screenplay he adapted from his own novel, it is characterized not, as might be expected, by verbal over-explicitness, but rather by visual invention. The film often presents the world as its main character sees it, and the effects of his autism are represented by rapid editing, freeze frames, changes in colour scheme, and extreme close-ups of incidental details on which Ben has become momentarily transfixed. Reality is interspersed with short scenes of fantasy (as when, for example, we see Ben kissing the girl he is actually too shy to approach) and is mixed with images from the computer game *ArchLord* that reflect Ben's thoughts and actions. We are also frequently shown direct-to-camera interviews from Ben's teachers, family and classmates that, it is later revealed, are segments from a television news item about him.

Laura Verlinden and Greg Timmermans in *Ben X*. The Kobal Collection.

Year:

2007

As a consequence of this varied and frenetic style, *Ben X* is at times a challenging and even abrasive film to watch. This fits well with its unsettling subject: an autistic boy who feels he is 'being bullied to death'. Part of the reason the film is so unsettling is that significant portions of it are presented as an obvious challenge to the viewer. The direct-to-camera interviews, which begin early in the film and are used to intensify the sense of approaching tragedy, all dwell upon how intervention is key in bullying cases and how our natural instinct when witnessing the victimization of the weak is often to do nothing. This makes *Ben X* into a modern equivalent of the social problem film: it is a drama and a character study, but not one from which it is possible to feel distance. Instead, it is always the moral of the story, rather than the story itself, that Balthazar is most keen to communicate. This does not mean, however, that his plotting feels perfunctory. We know from the first scenes that something awful will occur towards the end of the film, but we do not know what it will be or to whom it will happen. At times, it seems Ben may erupt in rage and take revenge upon his tormenters; at other times he seems sure to kill himself. Even when the questions around whether tragedy will occur are apparently resolved, another mystery arises from them, making the viewer uncertain of what he or she has seen. Major revelations occur until the film's final moments and so, although *Ben X*'s message is obvious throughout, the events used to illustrate it are frequently surprising.

This is an arresting and unusual film. Its visual flair and unpredictable plot allow it to avoid the dullness and lack of depth that could easily come with such an earnest examination of an issue like teenage bullying and, consequently, few films that aim to address an unpleasant social problem do so with the power or panache of *Ben X*.

Scott Jordan Harris

Ex Drummer

Production Company:
CCCP

Director:
Koen Mortier

Producers:
Eurydice Gysel
Koen Mortier

Screenwriter:
Koen Mortier

Cinematographer:
Glynn Speeckaert

Art Director:
Geert Paredis

Composer:
Various

Editor:
Manu Van Hove

Duration:
101 minutes

Genre:
Comedy/drama

Cast:
Dries Van Hegen
Norman Baert
Gunter Lamoot
Sam Louwyck

Year:
2007

Synopsis

In the coastal city of Ostend, the famous writer Dries Van Hegen is visited by three disabled punk rock musicians, Koen, Jan and Ivan. They want Dries to become the drummer in their band, to which he agrees, despite his inability to play the drums. The three musicians lead chaotic, squalid lives filled with violence and crime. The band, which Dries christens The Feminists, plans to cover Devo's 'Mongoloid' and play live only once. Dries – sophisticated yet cruelly cynical and exploitative – plans to use his glimpse into the lives of the troubled band members as inspiration for his writing.

As the band rehearses for a 'rock rally' concert, Dries causes numerous arguments between the friends and their loved ones, inflaming an already tense atmosphere. After The Feminists perform, Machiavellian Dries quits the band, hatching a destructive plan with the unstable Koen that will have horrific consequences for all but the erstwhile drummer.

Critique

Bursting forth from the screen from its first frame to the last, Koen Mortier's adaptation of the popular (but critically-derided) Flemish writer Herman Brusselman's 1994 novel *Ex Drummer* is a divisive, defiantly politically incorrect visual and aural assault on the senses and sensibilities of the viewer. After struggling to obtain funding for his long-cherished debut feature, Mortier, previously a director of commercials and short films, was eventually able to bring Brusselman's nihilistic, scatological and darkly comedic text to the big screen. Channelling the furious energy, outré themes, and censor-baiting material of films such as *A Clockwork Orange* (Stanley Kubrick, 1971), *Brothers of the Head* (Keith Fulton, Louis Pepe, 2005), *Man Bites Dog/C'est arrivé près de chez vous* (Rémy Belvaux, André Bonzel, Benoît Poelvoorde, 1992), and *Trainspotting* (Danny Boyle, 1996), *Ex Drummer* is a tour de force of outrageous dialogue, graphic sex and violence and unsettling, unforgettable imagery. Politically-correct representations of, and attitudes toward, disability, gender, class, race, religion, nationalism, sexuality, exploitation and fame are ridiculed, demolished and challenged in a whirlwind of discordant guitars, bodily fluids, and extreme violence.

There is no sanctuary in *Ex Drummer* for the faint of heart, and certainly no space for a sentimentalized view of disability or mental illness. The loose plot sees celebrated but morally-bankrupt writer Dries Van Hegen (played by himself) enter a world of filth, rampant misogyny and chaos as he recounts in faux-documentary style (partly in flashback, sometimes breaking the fourth wall and at other times in voice-over), his destabilizing effect on the already-unbalanced group. Koen (Norman Baert), a lisping, sexually depraved and violent singer, Jan (Gunter Lamoot), a homosexual with a frozen arm and the deaf, wife-beating Ivan (Sam Louwyck) are the trio of 'handicapped losers', a grotesque and alienating version of the Three Stooges, hoping to use Dries' fame to further their limited musical ambitions. Dries becomes the fly in the already dirty ointment throughout *Ex*

Drummer, turning the tables on the trio's idea to suit his ulterior motive, symbolizing a cold, dismissive bourgeois culture that has no time for or empathy with the underclass. Mortier's visualization of Brusselman's bleak view of humanity takes on a suitably punk/downtrodden aesthetic – blood-stained, grime-ridden, dilapidated and ugly – in keeping with the source material's inhospitable environments and taboo-breaking themes.

Except for Dries' modern, minimalist abode, *Ex Drummer* takes place in squalid interior settings in gloomy industrialized locations, all of which are enveloped in fog, rain, and overcast skies. The coruscating, high-tempo soundtrack mirrors the fevered, restless camerawork, often off-kilter framing and frantic editing, creating a disorienting, nauseous feeling to match the eyebrow-raising dialogue and imagery onscreen. Mortier combines *vérité* depictions of the economically deprived, emotionally-scarred lifestyles of Dries' fellow band members with scenes of truly nightmarish, surrealistic fantasy. Peopled exclusively by unsympathetic characters, with Dries as the blackened heart of the film, *Ex Drummer* deteriorates into a climactic, savage outburst of violence recalling the denouement of Martin Scorsese's *Taxi Driver* (1976). To add fuel to the already controversial fire, Mortier implicates the viewer in the onscreen obscenities by breaking the fourth wall, using POV shots and offering no escape from the sense of voyeurism evoked throughout.

As likely to offend as it is to entertain, *Ex Drummer* is a provocative, anti-mainstream film that defies simple genre categorization due to its blending of arthouse stylistic tropes with underground subcultures and uncomfortable themes. It showcases Mortier's talent for adapting difficult material, eye for kinetic visual imagery, and left-of-centre humour that matches his offbeat directorial style. Love it or hate it, *Ex Drummer* is an unforgettable viewing experience, and certain scenes will be seared into the spectator's brain like a particularly unpleasant photograph.

Neil Mitchell

The Misfortunates

De Helaasheid der dingen

Studio/Distributor:

Favourite Films NV
IDTV Film/ Evokative Films
IFA
MK2 Diffusion
NeoClassics Films
Polyfilm Verleih
Wild Bunch Benelux

Synopsis

Novelist Gunther Strobbe narrates his youth, of which he is literally a survivor. At thirteen, he lived at his grandmother's home with his father and three uncles. A pietà figure with a heart bigger than her retirement pension, the old woman takes in those four filial failures. The models with whom Gunther grows up are thus his alcoholic father (the local postman who stops at each bar on his way to distribute the mail) and three unemployed men, one of whom regularly ends up in jail. Each family has its codes and, at the Strobbes, the rules are dictated by alcohol. A manly man knows how to drink and knows his repertory of ribald songs. Ostracized by virtue of his socially marginal background, Gunther cannot connect with the world. He lives torn between his sense of belonging to this dysfunctional family and by the certainty that breaking away from it is necessary for his survival. His only remaining option: boarding school. There he discovers his passion for

Johan Heldenbergh in *The Misfortunates*.
The Kobal Collection.

Against Gravity
Bir Film
Camino Filmverleih
Lumière Home Entertainment
Transeuropa Video Entertainment (TVE)

Director:

Felix Van Groeningen

Producers:

Jeroen Beker
Dirk Impens
Frans van Gestal

Screenwriters:

Christophe Dirickx
Felix Van Groeningen (based on a novel by Dimitri Verhulst)

Cinematographer:

Ruben Impens

Art Director:

Kurt Rigolle

Composer:

Jef Neve

Editor:

Nico Leunen

Duration:

108 minutes

Genre:

Comedy/drama/coming of age

writing and how people his own age interact with each other. In spite of adversity, fate is realized: Gunther will become a writer.

Critique

The Misfortunates is Felix Van Groeningen's third feature film and is based upon a semi-autobiographic novel by the Flemish writer Dimitri Verhulst (b. 1972). The film's protagonist is a novelist who narrates his past and sends the manuscript of his tale to a publisher. In this narrative unfolding, we witness the genesis of the novel that the film adapts. Born in 1977, Felix Vangroeningen graduated from the KASK, the Art academy in Ghent, and at age 25 directed his first feature, *Steve + Sky* (aka *Beats of Love*, 2004), a sort of Belgian *True Romance*. We find in *The Misfortunates* the same quasi-documentary aesthetics and raw tone. But, most importantly, we register the vivid lust for life of the characters (especially, in both films, in Johan Heldenbergh's remarkable and rugged performances, as a prison inmate in *Steve + Sky* and as the alcoholic father, here). *The Misfortunates* is not a pamphlet à la Jan Bucquoy, as one of the film's posters, showing the four Strobbe brothers naked on their bikes, could suggest. It is rather a sensitive portrait of provincial Flanders from thirty years ago, poised between the local bar, cycling, and boarding school.

The camera work is mobile and close to the actors, wavering according to the situation like a character trying to find his own place in this socio-psychological mess. Far from being lurid, however, the film is dynamic, combining lush images with documentary-style filming. The finesse here resides in the treatment of decadence and perdition, and some scenes evoke Fredrick Wiseman's *Public Housing* (1997), notably when the boy takes care of his drunken father, completely in thrall to his addiction. The film addresses rural Belgian folklore in a fictitious village that resembles so many others. The score by pianist Jef Neve brings a carnivalesque aspect to the episodes of binges or naked cycling (a local

Cast:

Kenneth Vanbaeden
Valentijn Dhaenens
Koen De Graeve
Wouter Hendrickx
Johan Heldenbergh
Bert Haelvoet

Year:

2009

tradition), exemplified in the contest for who can drink the most beers. This competition is held in the public square and won easily and in popular jubilation by one of the Strobbe uncles while, alone at the bar, it is Gunther's father who beats all the drinking records. After all, pints of beer and gin are part of the national patrimony.

Many situations are objectively awful, such as the gullibility of the uncles, the squabbles and fights, the ubiquitous scatology, and the alcohol that the children are forced to drink as a hazing rite. But through their comedic treatment and the film-maker's tender gaze, we can only note a lack of education and witness this tragic group of people who simply do not know any better. Speaking of the less fortunate, the film constitutes a welcome jab at decency, clichés, well-meaning precepts, and self-righteous ideals. But there is no didacticism or excessive pathos, here; rather, the film is dynamic, the scenes move forward and in spite of the horror of some of its situations, it is humour that gets the upper hand, as a mechanism of survival. The closing scene, in which Gunther teaches his child to ride a bike, offers a window of optimism upon this story of a family afflicted by its social deprivations. The unwanted child throws himself gleefully into a cornfield on the side of the road. In order to grow, one needs to fall and learn to get up.

Anita Jans

Translated by Marcelline Block and Jeremi Szaniawski

Bullhead

Rundskop

Studio/Distributor:

Savage Film
Eyeworks Film & TV Drama
Waterland Film & TV/Celluloid Dreams
Kinepolis Film Distribution (KFD)
Ad Vitam Distribution
Drafthouse Films
Just Film Distribution
Film1
Just Bridge Entertainment
Njutafilms

Director:

Michael R. Roskam

Producers:

Bart Van Langendonck
Wilant Boekelman
Peter Bouckaert
Alexander Djeranian
Koji Nelissen

Synopsis

Jacky Vanmarsenille comes from a family of cattle farmers and feeders from the South Limburg region. He is 33, stubborn, taciturn, muscular and sweaty, like the bovines that get injected with growth hormones and antibiotics. Through his collaboration with a corrupt veterinarian, Jacky made his own place in the world of the hormone mafia. Under heavy, cold Flemish skies and in an atmosphere of lukewarm beer, Jacky's small business follows its quiet course. He is about to seal an exclusive deal with the most powerful hormone trafficker of West Flanders when the assassination of a federal agent prompts the infiltration of a double agent, Diederick. What neither the police nor the traffickers know is that Diederick is a childhood friend of Jacky, the kind one would rather forget: Jacky has his secrets, which have the acrid taste of a mutilated childhood and tragically-aborted romance.

Critique

A rural thriller and a fleshed-out portrait of a pathetic, traumatized man, *Bullhead*'s ambitions are clear: it epitomizes an uninhibited Flemish cinema which mixes genres, unashamed of its roots and surveying wider horizons (the film was Belgium's Oscar nominee in 2012 for best foreign film). As Jacky, Matthias Schoenaert imposes with finesse and gravitas the monstrous silhouette that he has forged for the needs of this film: one shudders at the sight of the empty and shameful eyes of this Bullhead ('rundskop'), his back bowing under the yoke of a mass

Patrick Quinet
Jan van der Zanden

Screenwriter:

Michael R Roskam

Cinematographer:

Nicolas Karakatsanis

Art Director:

Walter Brugmans

Composer:

Raf Keunen

Editor:

Alain Dessauvage

Duration:

124 minutes

Genre:

Crime/drama

Cast:

Matthias Schoenaerts
Jeroen Perceval
Jeanne Dandoy
Barbara Sarafian
Kris Cuppens
Ludmilla Klejniak

Year:

2011

of muscles, tense like a barricade. Roskam films his castrated beast thick and strong, evoking the sweat of crime in backrooms, the smell of loam, plastic boots, and cold BMW seat leather.

To be sure, Bullhead is at times clumsy in its attempts at emulating the style of mainstream entertainment. Schoenaerts' memorable performance meets with an uneven cast, and the description of hormone mafia, worthy of a Hugo Claus novel, is sometimes marred by brutal psychological and cultural shortcuts, such as Erico Salamone and Philippe Grand'Henry providing the Flemish audience with the stereotype of Walloon mechanics: stupid, lazy and corrupt. In general, the film overly emphasizes the actors' regional accents, both Flemish and Walloon – here the typical Liège province accent – to the point of becoming unnatural to the native's ear. Masquerading as a faux thriller infused with rural psychology, in its weaker moments the film ends up resembling the block of swollen flesh inflated with hormones that lends it its title. The coherence of tone that Roskam manages to instill in places is not enough to dissipate the feeling of a somewhat scattered jigsaw puzzle. *Bullhead* is somewhere between an organic portrait, a barely-touched-upon romance, an American-style thriller, and a sketch of a Flanders stuck between the paintings of Constant Permeke and the impersonal architecture of a modern-day Flemish convention centre.

Perhaps this hybridity is the key to the film. *Bullhead* does not tell a criminal story, nor is it even a tale about destiny. It is a cruel and ambitious dialogue between its author and the self-image of the political and social community of which he is a part, with its unsavoury mix of separatism and nationalism. Roskam's *Bullhead* proposes a portrait à la Dorian Gray of today's Flanders: pink and doped, marked in its flesh by its silent shames. The way Roskam films his country exhumes its contradictions and disruptions, whether in the depiction of the urban tempo of rural Flanders, where classical motifs of the Dutch-speaking countryside and Anglo-American visual grammar co-exist, or the m*ise-en-scène* of the linguistic patchwork that is Belgium. For that matter, Roskam does not seem to care much for official Belgium, nor for a Flanders that has the taste of animal oil and dough. His characters do not understand each other anymore, do not recognize each other and refuse to talk, favouring violence instead. 'What is left of what we are? What are we allowed to become?' the film seems to ask. Exuding the surface arrogance and the garish angst of the protagonist as well as the film-maker himself, *Bullhead* offers itself to the viewer as a fine object, glossy yet rough, ensconced in a thick armour of savoir-faire. But it also proposes an anxious tale about a man who, one fateful day, was deprived of his childhood and had to dramatically alter his identity and future, like a mutilated angel putting on the skins of a monster. He is a golem of flesh in the service of his masters, an ogre so that he might not be the child anymore, a pathetic Bluebeard. *Bullhead* tells the story of a destroyed identity, and of the impossibility of expressing the original and resulting trauma. In so doing, the film resonates with the many doubts of its time.

John Pitseys

Translated by Marcelline Block and Jeremi Szaniawski

ANTWERP, AND THE CINEMAS OF TYCOON GEORGES HEYLEN

Since the early twentieth century, Belgium has had a high cinema density and attendance. Even when compared with larger nations such as France, Germany, and Italy, the numbers of cinemas and cinema attendance in Belgium were (relatively) higher (Browning and Sorrel 1952: 133-70). For almost a century, the medium-sized port city of Antwerp in the north of Flanders played a leading role in film distribution and exhibition, along with the Belgian capital of Brussels. Cinema life was most vibrant in the Station Quarter at the heart of the city, around Antwerp's Central Station and on both sides of the famous Avenue De Keyserlei. It was here that the first permanent cinema of Antwerp – Cinema Krüger – opened in 1907 and where most of Antwerp's cinemas – including its most beautiful ones – were located. The cinematic history of Antwerp and its Station Quarter is inseparably linked to Georges Heylen (1912-1995) and his Rex cinema group, because it dominated Antwerp's cinematic and cultural life for decades.

In line with the recently emerging *new cinema history* approach, our focus here lies in the economic and sociocultural contexts of exhibition and reception, moving away from film production and the study of film texts. We link Antwerp's institutional cinema history (with a focus on the Station Quarter) with cinemagoers' memories of a period stretching from the late 1940s until the mid 1990s. This time frame covers the existence of Heylen's cinema empire from its early days until its bankruptcy in 1993. At the same time, this period witnessed radical changes in the cinema world on a national and global level. Just as in many other countries, the heyday of cinemagoing in Belgium was in the late 1940s and early 1950s. After a dramatic decline in cinema attendance caused by, among other things, the arrival of television into the home, increased wealth and changed recreational patterns, a massive closing down of cinemas occurred from the 1960s onwards. In the 1970s, large multiplexes and small niche cinemas replaced legendary picture palaces and neighbourhood cinemas. In the 1980s home video posed a new threat for cinemas. For Antwerp in particular, the 1990s witnessed the replacement of an 'old' cinema culture with a 'new' multiplex experience.

Rise and expansion of the Rex group

Georges Heylen began his cinema career as shareholder of the prestigious Rex cinema during World War II. After a disastrous Allied bombing of the Rex in 1944, which also killed the Rex's owner (Heylen's father-in-law), Heylen rebuilt the cinema. The reopening of the Rex in 1947 marked the beginning of the career of one of Belgium's most successful cinema entrepreneurs. After World War II, Antwerp's cinema market was highly fragmented and dominated by small-scale exhibitors, most of them owning only one or two cinemas. In 1952, Heylen had three cinemas to his name. Gradually he took over one cinema after another until by the late 1960s he had acquired a quasi-monopoly in the Station Quarter (the only cinemas operating independently from him there were pornographic cinemas). As Antwerp's liveliest quarter with the best shops, cafés, bars, and restaurants, the Station Quarter attracted visitors from all over Antwerp and beyond. It was the perfect place to spend a night out, combining dinner with a visit to the cinema and/or a dance hall.

In addition to his cinemas in the Station Quarter, Heylen also exploited (and/or programmed) a considerable number of cinemas in adjacent neighbourhoods and districts, such as Stuivenberg, Borgerhout, Kiel and Berchem. They were all single-

People lining up in front of a theatre owned by Georges Heylen, Antwerp, late 1940s. Private collection.

screen and their seating capacities ranged from 200 to 2000. Yet it was not only the size of his cinemas that offered an experience for everyone; the film programming was equally diverse. Heylen's cinemas included prestigious premieres, screenings of the latest attractions, and other distinct programming (e.g. French dramas or German family entertainment) where films would run for weeks or even months. His neighbourhood cinemas screened a broad spectrum of older films, which would only run for a week and for a lower admission price. By offering such a broad range of cinemas and by securing certain privileges from contracted distributors, Heylen was able to block a film from screening in competing cinemas for periods that could last up to a year.

Besides the films themselves and the exquisite viewing experiences his picture palaces provided, Heylen was also known as the organizer of impressive publicity stunts and for bringing national and international film stars to Antwerp to promote their films.

Troubled times for a local tycoon

Great publicity and better service at Heylen's cinemas, together with his work ethic and networking abilities paid off in higher revenues and earned him the trust of – and better treatment by – film distributors and producers. Heylen received better films for more favourable rental conditions than his competitors. On the one hand, Heylen's powerful bargaining position with regard to distributors and producers affected his relationships with other local players on Antwerp's cinema market. Due

to a lack of access to quality films, many of Heylen's competitors were either forced to get by with the leftovers (films Heylen did not have under contract) or even resign and close down their cinemas. As an alternative, they could let Heylen take care of programming their cinemas (for agreed percentages). This meant that in addition to the general post-war changes occurring worldwide, that would contribute to the ongoing recession in the cinema industry, Heylen's powerful position was an additional cause for the disappearance of many cinemas in Antwerp (especially outside the city centre) from the 1960s onwards.

On the other hand, Heylen's growing power on the lucrative Antwerp market also implied increased influence on negotiations with distributors. This, of course, clashed with their interests. Growing friction between Heylen and the major American distributors about publicity budgets and rental conditions, for instance, led to a now legendary distribution conflict in the late 1960s/early 1970s. Encouraged by the Motion Picture Export Association of America, the Hollywood players enacted a complete distribution lockout for all of Heylen's cinemas (including the cinemas of his 'competitors', for which Heylen did the programming). However, instead of giving in to their demands, and in order to fill the sudden gap of films for his cinemas, Heylen looked for films from smaller, predominantly Belgian and French distributors. In addition, he officially launched his own distribution company, Excelsior, which would grow quickly and become one of Belgium's top distributors in the 1980s (Magiels and De Hert 2004: 69).

The conflict not only affected the programming in Heylen's cinemas, but turned the whole of Antwerp's cinema landscape upside down: whereas big box office hits would usually premiere in (Heylen's) prestigious cinema palaces in the Station Quarter, they now premiered in smaller neighbourhood cinemas located outside of Antwerp's inner city. Eight of them had united to form the Associated Independent Cinemas of Antwerp and Agglomeration/Verenigde Onafhankelijke Cinemas te Antwerpen en Agglomeratie (VOCA), a rather informal and short-lived organization. At first sight, the VOCA provided an outlet for Hollywood distributors for their films within Antwerp's historically lucrative market. However, the Hollywood companies quickly realized that films playing at the VOCA would never make the amount of money they would in Heylen's cinemas. In the meantime, with the help of Hollywood producers, the successful Dutch cinema entrepreneur Piet Meerburg opened the cinema triplex Calypso in 1973 (right across from Heylen's flagship cinema Rex) in an attempt to break Heylen's quasi-monopoly in the Station Quarter.

Eventually, the conflict came to an end. New distribution agreements were made and Heylen actually came out of the conflict a winner. Nevertheless, the lockout and the founding of the VOCA had revealed a weak point in Antwerp's cinema culture. In addition to creating dramatic economic imbalances within Antwerp's cinema landscape, Heylen's dominance also led to scrutiny of its aesthetic shortcomings. Heylen was often accused of being interested in only platitudinous commercial entertainment, and of depriving Antwerp's residents of the 'better' or arthouse films – a situation that was laconically summarized in a newspaper heading: 'Antwerp Cinema City calls for development aid' (Nelissen 1970). As a consequence of this dissatisfaction, in the 1970s Antwerp saw the birth of film festivals and film clubs as platforms for the screening of non-commercial films. Based on the principle of offering Antwerp's residents non-commercial films on a regular basis, the Monty and Cartoon's arthouse cinemas were opened (in 1976 and in 1978, respectively) in Antwerp's historic centre. Operating independently from Heylen, Cartoon's (equipped with three screens) turned out to be a huge success. Nevertheless, these clubs never posed an actual threat to Heylen's empire because of the different types of films they offered.

Fall of the Rex-empire

The early 1970s also saw the birth of the first multiplexes in Belgium. They were built by the Claeys and Bert families, who would later found the Kinepolis group, Belgium's most powerful cinema chain today. Although by the late 1980s Kinepolis had opened multiplexes in six cities in Flanders and Wallonia, it did not enter the Antwerp cinema market until 1993. In the course of the 1980s, Heylen was forced to react to this trend towards multiplexes. The topography of Antwerp's cinema landscape changed for the better: former single-screen picture palaces were split up and/or made way for smaller film clubs and art-house theatres (for instance, Metro, with originally 1600 seats, became Metro 1 and 2).

Part of the downfall of his empire was also due to the ongoing decline of the Station Quarter from the 1980s onwards. In the late 1980s and early 1990s, what had once been the gem of Antwerp became famous for its crime rates, drug trafficking, and dilapidated buildings. Not only the cinema landscape but also the city had changed. Heylen's biggest challenge, however, was how much his audience had changed. While the tycoon kept spoiling his cinema patrons with red carpets, thick curtains and ushers accompanying them to their seats, the new generation of cinemagoers clearly had a different notion of the cinema experience. They were not likely to choose from a restricted number of films in different (by then) rundown cinemas scattered across the Station Quarter and watch them under poor conditions (no air-conditioning, antiquated sound and image technologies) when they were able to get a much better experience elsewhere. New means of transportation and greater disposable income meant also that people were less bound to their own neighbourhoods and more inclined to travel greater distances for leisure time activities: Europe's first megaplex, Kinepolis in Brussels (25 screens, opened in 1988), was less than half an hour away.

Investments in existing cinemas and staff could not stop Heylen's decline. His cinemas generated too little cash flow to remain profitable. The misfortune in the cinema industry that had haunted so many of his competitors since the 1960s had caught up with him, and he had to start closing one cinema after the other. In the end, he could not even sell tickets fast enough to pay all his creditors, from film producers and distributors to the local suppliers of electricity and ice cream. Still it came as a surprise to the public and his employees when Heylen declared bankruptcy on 3 September 1993. For Antwerp, it meant that its once-flourishing cinema landscape had diminished from nine cinemas to one (Calypso) in the Station Quarter (excluding porno cinemas). Only one month after the bankruptcy, the Kinepolis group would open a new multiplex, Metropolis, in northern Antwerp.

Georges Heylen died in 1995. Two years later, Gaumont opened a new cinema multiplex (seventeen screens) at the very spot where Rex and Metro had been located for almost half a century, and later sold it to UGC. These drastic developments made the number of cinemas in Antwerp's Station Quarter fall to only a fraction of what it once was, while, surprisingly, bringing the total number of screens in Antwerp back to that of its glorious heyday in the 1950s.

The Antwerp cinema culture has been clearly marked by the Rex group and its head, Georges Heylen. For Antwerp cinemagoers, his cinemas are enshrined as significant sites of social and cultural memory. His peculiar approach to the exhibition business left its imprint on the cultural and recreational life of Antwerp. We can assume Heylen was a unique figure as a local cinema tycoon, but further comparative research needs to show if similar cases existed across Europe in the twentieth century.

Philippe Meers and Kathleen Lotze

CINEMA CULTURE IN FLANDERS AND BRUSSELS IN THE TWENTIETH CENTURY: FROM THE PICTURE PALACE TO THE MULTIPLEX

Flanders is the northern region of the federal state of Belgium, with Brussels as its (mostly French-speaking) capital. In this concise overview based on a large-scale film historical research project, we sketch the cinema culture of Flanders and Brussels as it has developed over the last century. A general history of structures, places, and industry is complemented with the bottom-up stories of cinemagoing as experienced by generations of spectators. This combination allows for a more complex view on cinema cultures and links up with what Richard Maltby has called 'new cinema history' (Maltby, Biltereyst and Meers 2011, *Explorations in New Cinema History: Approaches and Case Studies*), a movement that calls for multidisciplinary empirical research on cinema cultures.

The tension between urban and rural areas is one of the main characteristics of the Flemish cinema landscape, with a surprising role for the more rural areas. We will illustrate that there is a clear trend towards the spread of cinemas to smaller towns and villages from the 1920s on, together with a steady, high number of cinemas in the main cities, with almost total coverage by the end of the 1950s. From the 1960s on there is a gradual downward movement until the 1980s, where we see an almost complete disappearance of village and small-town cinemas, with multiplexes dominating in the large cities ever since. Another feature is that local entrepreneurs play an important role in the development of the exhibition sector in larger cities. In Antwerp, Georges Heylen and his Rex group developed into the major player on the scene, dominating local cinema exhibition for the larger part of the second half of the twentieth century. In Ghent, Jean Lummersheim had an important part in the exhibition scene from the 1930s up to the 1980s with the Sofexim-Cinex group. A third feature is the way in which film attracted increasing attention from ideologically and/or politically inspired groups. Key players were, in socio-political terms, the different 'pillars' of Flemish society. From the mid-nineteenth century onwards, various politico-ideological groups organized the different stages in citizens' lives within the same 'pillar' of institutions. The main protagonists in this 'pillarized' society were of a Catholic, Socialist, Liberal, and Flemish-nationalist signature, each forming a distinct 'pillar.' Film exhibition soon became a key feature in the strategy to influence the population. 'Pillarized' film exhibition took on many forms: commercial cinema owners were often linked to – and influenced by – a Catholic or Socialist pressure group; pillarized societies regularly rented out spaces for ideologically-inspired film showings; priests organized their own cinema in town, proclaiming 'good cinema'; and Socialists organized proletarian shows in the local people's house. Many municipalities knew competing 'pillars' on their film-exhibition platform, not to mention the various active 'pillarized' film clubs. Therefore, we could state that, throughout its history, Belgian and in particular Flemish film exhibition culture proved a unique case because of its diversity.

From ambulatory cinema to the picture palace

Cinema was first introduced in December 1895. In fact, Belgium was the first country outside of France where the Lumières showed their *cinématographe* projections. The latter, initially considered a scientific curiosity, was first exploited for commercial reasons by people working in the broader field of fairground attraction and variety shows. Similar to what happened in the USA and countries like France and Germany, film theatres appeared in Belgian cities between 1905 and 1907. The first fixed Belgian film theatre, Théâtre du Cinématographe, opened in December 1904 in Brussels. It closely resembled American nickelodeons or German *Ladenkinos*. Another widely-popular form of film exploitation, not only in Brussels, Antwerp and other major cities, but also in minor towns in rural areas, was the *café-ciné*. Many pub and bar owners opened cinemas as a sideline.

After World War I, filmgoing became the most popular leisure form, not only in urban but also in rural areas, where even in small towns one or more cinemas could be found. Of the 776 movie theatres in Belgium in 1920, 426 were located in Flanders. A key trajectory in this first golden age of cinema was that the number of cinemas reached a peak around 1925, followed by a strong decline towards the end of the decade. Besides the overall economic crisis, this decline was due to the increasing taxation on cinemas and the additional financial burden of the introduction of sound films.

Complementing the commercial interests of film in the region, political pillars in Belgian and Flemish society took a particular interest in film exhibition. Various locals chapters of the Socialist party and other leftist organizations and parties started organizing picture shows in people's homes, Catholic priests screened what the church labelled 'good cinema' in parish churches on Sundays, and the liberal pillar also tried to incorporate a slice of the new cake into their daily provision of entertainment.

In the next decade, the number of film theatres grew steadily. In this period, many cinemas started, reopened or were heavily modernized. The cinema pool became more diversified, with a system of different runs and the arrival of theatres that specialized in current events (mainly part of the international Cinéac circuit). Both Ghent and Antwerp gained two film palaces (Rex and Capitole in both Antwerp and Ghent) and one newsreel cinema (Cinéac in Antwerp and Actual in Ghent).

Postwar cinema culture: from heydays to crisis

After World War II we see rapid growth in the establishment of movie theatres all over Flanders. The period between 1945 and 1960 can be considered the heyday of Belgian movie theatres in general. The growth of the cinema in Flanders was, however, largely due to new cinemas opening in smaller villages and towns. In these decades, cinema was no longer an urban phenomenon, but fully permeated everyday life in all areas of Flanders, whether metropolitan, urban, or rural.

In the post-World War II period until the pivotal years of 1957-1958, cinema seemed to be able to maintain its role as the leading form of popular entertainment, with the continued opening of many new huge cinemas, often built in a modernist architectural style. In Flanders and Brussels, we witness an inverse relationship between the growing numbers of cinemas and the quickly declining numbers in film admissions. This situation led to a crisis at the end of the 1950s. The nearly doubling in numbers of the cinemas (from 560 in 1946 to 984 in 1957 in Flanders and Brussels) contrasted with the halving of cinema attendance (from 147 million in 1945 to 79.56 million in 1960 in

Belgium). Among the various reasons for the post-war drop in cinema attendance were, besides television (introduced in 1953), the availability of new forms of entertainment, leisure activities, and transportation, as well as socio-demographic trends in the 1950s (such as the baby boom leading to an absolute historical peak of the number of births in 1961) and, later on, changes in the urbanization structure and the role of the city. The turning point, 1957-1958, marked a continuous downfall in the number of movie theatres. In ten years, Flanders lost 541 cinemas. Theatres in Flanders and Brussels lost over 34 million visitors in the 1960s. It is also important to note the gradual implosion of the pillarization system from the 1960s onwards. In many rural areas, cinemas or theatres with regular film exhibition were often linked to Catholic film actions, which started declining in the 1960s.

During the 1960s, there were two distinct waves of decline in the numbers of movie theatres in Flanders and Brussels. In 1962, the agreement between Belgian cinema owners and the public television broadcaster concerning the restriction of one televised film per week was annulled; the next year, there were 98 fewer movie theatres in Flanders, and within a year there was a 15 per cent drop in admissions. A similar event took place in 1967 with the stricter regulation on taxation that finally drove many more small cinemas into closing their doors. In the 1970s and 1980s, the former film palaces in city centres, such as those in Brussels and Antwerp, were transformed into multi-screen cinemas with varied offerings directed at adolescents. This resulted in a continuing decline in the number of movie theatres as well as cinema attendance in Flanders and Brussels.

Revival towards the new millennium

In the 1990s, tendencies of decline and crisis were curbed: for the first time, the number of cinema screens started to increase. These shifts were mirrored in the rate of cinema attendance, which increased for the first time since World War II. A major player in this process was a smaller local exhibitor, Albert Bert, who was inspired by the multiplex phenomenon of the USA and UK. In 1981, Bert had already built a twelve-screen multiplex in Gent (Decascoop), followed in 1989 by the bigger gamble of building a 25-screen complex in Brussels (Kinepolis). Bert's concept was rather new for the continent, and it consisted in offering a wide choice (of mostly American movies) aimed at teenagers or young adolescents on the outskirts of a major city. These shopping mall-inspired multiplexes also had the advantage of offering wide transportation- and car-parking facilities. The gradual introduction of similar multiplexes in other Belgian cities made Bert and his Kinepolis Group (a merger with cinemas belonging to the Claeys family) into a dominant and even quasi-monopolist player in most Belgian cities. From the 1990s onwards, the Belgian market leader, which also established film production and distribution activities in Belgium (Kinepolis Film Distribution/KFD), developed an international strategy and became a major European film exhibitor. The group now owns 23 cinema complexes in Belgium, France, Portugal, Spain, and Switzerland.

Urban and rural cinemagoing as social experiences

To complement the history of film exhibition structures and places, we need to look into the social experience of cinemagoing, in urban as well as in rural areas. As in most other modern Western societies, going to the movies was a

habit, a weekly routine and an important part of the fabric of daily life. For many decades, cinema-going was an out-of-the-home event as well as an extension of home life, a social event and, for many, the only available form of leisure. Cinema as leisure activity had obtained the status of a cheap and popular mass-entertainment medium that appealed to a wide and heterogeneous audience. Cinema-going was also a collective and social experience. Cinema-goers frequented specific cinemas because they felt 'at home' there.

When describing urban film culture in Flanders' larger cities like Antwerp and Ghent as experienced by the average cinema-goer, it is important to note that different cinemas were linked to different social groups, which were clearly more of a determining factor in the choice of movie theatre than the actual film that was playing. First of all, there is the distinction between movie palaces in the centre and neighbourhood cinemas, sometimes called 'flea pits'. Movie palaces are considered luxurious, beautiful, and comfortable. These cinemas were as much an object of consumption as the films they showed. What they lacked in atmosphere and familiarity they made up for with comfort, star-packed movies, and status. The neighbourhood theatres were spread across different districts of large cities that mainly housed poorer blue-collar workers, and were only visited by the people actually living near them. A community spirit was still very much alive in the different districts of the city and people considered neighbourhood theatres as 'their' theatres. And in Antwerp, as in Ghent, audiences of the neighbourhood cinemas were met with prejudice and often described as being 'uncivilized, loud and vulgar' by people living in the city or only frequenting the central cinemas.

A main aspect of movie theatres in small towns and villages was the lack of choice. Many only had one or two movie theatres, which played one film a week and were often only open a few days a week for business. Most villagers saw only one film a week. Their lower attendance frequency did not mean that cinema was less important for them. Leisure activities for the entire family were limited. Everybody used to dress up in their finest clothes to go to the cinema. In the movie theatres in the villages, the community sense was also alive. Seats were numbered and many villagers had a particular seat where they sat every week. Finally, it is in these rural areas that the impact of pillarized cinema culture was most palpable.

In this discussion of cinema culture in Flanders and Brussels we have highlighted some of the major tendencies and changes in the film exhibition scene in the twentieth century, such as the rise of cinemas in rural and urban environments, the boom in cinema-going, the decay and closure of many provincial and neighbourhood cinemas, and the rise of multiplexes, all of which was complemented by our consideration of the lived experience of cinemagoing. Regardless of location, going to the movies was an accepted way to pass the time and an inalienable part of everyday life outside work. Recently, it has become more than ever an urban phenomenon. Over the last century, geographical distribution and variety made way for economic and geographical concentration of screens and cinemas. After the first decade of the twenty-first century, cinema is clearly not dead. Contemporary cinema culture, with its new constellations and expressions, continues to finds its place in people's everyday lives and imaginaries.

Philippe Meers and Daniel Biltereyst

EXILES AND TRANSITS

Brussels Transit

Bruxelles-Transit

Director:
Samy Szlingerbaum
Producer:
Marilyn Watelet
Screenwriter:
Samy Szlingerbaum
Cinematographer:
Michel Houssiau
Art Director:
Ariel Potasznik
Editor:
Eva Houdova
Duration:
80 minutes
Genre:
Personal history/documentary/docu-drama
Cast:
Boris Lehman
Hélène Lapiower
Micha Wald
Year:
1980

Synopsis

Speaking in Yiddish in voiceover, the director's mother recounts her painful memories of her exilic train voyage taken with her husband and child immediately after World War II. Survivors of the Shoah, the family were fleeing their native Poland, where they had lost everything, and reached Belgium after several nights of travel. They thought they were awaiting transit for Costa Rica there, but, like many other refugees in their situation, they ended up staying in Belgium. Scenes of everyday life in the new host country follow, in Brussels' Midi station neighbourhood, where their train had arrived, showing the poverty of these immigrants, and their struggle to be reborn with a new dignity.

Critique

Samy Szlingerbaum (1950-1986) studied in Israel, New York and Paris. Yiddish cinema, which had yielded a masterpiece such as *Der Dibuk* (1937) before World War II, had failed to be revived after 1945, in spite of efforts by directors such as Jules Dassin. *Brussels Transit/Bruxelles-Transit* is one of the only films made in this 'genre'. Szlingerbaum, who had been a boom operator on Chantal Akerman's *Le 15/8* (1973), had recorded his mother's story, revealing her genuine talent for popular storytelling. The director decided to fictionalize but also historicize it by setting this moving soundtrack to images.

The film opens on a still shot at night, with the lights reflected on the station's rails, almost imperceptibly stirred by the movement of the locomotive. This evening is the night of the Shoah, from which one must escape, but from which so few did. The whole film is bathed in this poetic expressivity. Since the old Midi station had been destroyed by the time of the shoot, the film-maker elected to film the arrival of the small family on the contemporary train platform. Brussels of the immediate post-war period was thus not reconstituted. It would have been impossible to find a large enough budget for these purposes for a debut feature film in Belgium. Following earlier prestigious examples of film-makers such as Marguerite Duras, Szlingerbaum shows the city as it is, while his mother's story evokes the past. This anachronism creates a distance: the past is dead, and life is a form of perpetual exile.

Szlingerbaum shows his mother, his father, and his younger brother (all played by young actors) in a series of sequences where moments of humour, or even drollery, emerge from this existence lived in melancholy. It is a film of nostalgia, the primary meaning of which is 'the illness of the return': one's soul suffers because there is no return, ever. 'Yiddishland' has been destroyed. The mother speaks a particular Yiddish dialect of which she might be the only speaker left. With her passing, all will vanish. The film, however, redeems her; the son gives life to his mother. In more than one way, *Brussels Transit* is a unique film (which deservedly earned awards at the Rotterdam and Berlin film festivals) made by a sensitive film-maker who died too young, too soon.

Adolphe Nysenholc

Translated by Marcelline Block and Jeremi Szaniawski

Looking for my Birthplace

À la recherche du lieu de ma naissance

Studio/Distributor:

Amidon Paterson Film
Dovfilm

Director:

Boris Lehman

Producers:

Boris Lehman (Dovfilm (Brussels)
Amidon-Paterson film (Genève)
CBA
LA SEPT

Screenwriter:

Boris Lehman

Cinematographers:

Patrice Cologne
Aldo Mugnier
Antoine-Marie Meert

Editor:

Daniel de Valck

Duration:

75 minutes

Genre :

Documentary/autofiction/poetic diary

Cast:

Freddy Buache
Hélène Lapiower
Gaston Pillet
Jacques Roman
Alain Blum
Simon Bohler
Paulette Cyngiser
Lionel El Kaïm
Tito Fiero

Year:

1990

Synopsis

At the age of 44, Belgian film-maker Boris Lehman decided to travel to his birthplace of Lausanne, Switzerland, in search of his origins. Born in 1944 to Polish-Jewish parents who managed to flee to the neutral zone of Switzerland before the onset of World War II, Lehman only lived in Lausanne for the first year of his childhood before moving to Belgium at the end of the war.

Critique

It is exactly the tragic absence of memories from this first decisive year of his life that pushes Lehman unwillingly towards a cinematic reconstruction of his unknown origins. Filled with doubt and fear, his journey starts at the hospital named 'Sources' where he was supposedly born. In effect, administrative evidence of his birth can be found. But what about memory? Are there people who can witness the short stay of the young Lehman family in Lausanne? Do the stones of the city remember the light steps of little Boris on the waterfront walkway? What exactly happened in Switzerland during that final year of the war? What does it mean to trace one's own roots, and what does one expect to find at the end? Is there another origin to life than the birth-giving water of Lake Léman, which appears recurrently in the film and happens to bear the same name as the protagonist and film-maker himself?

The absence of precise historical evidence to answer these questions leads Boris Lehman to an associative collage of elements of a puzzle that cannot be possibly completed. The search for remaining family members ends up as a never-ending list of erratically spelled names in the phone directory, which can correspondingly be found on doorbell tags throughout Lausanne or on the tombs of Jewish cemeteries. But Lehman himself, who acts as an invisible, offscreen guide, stays a complete stranger to this city, defined by its neutrality and lack of history. Instead, the author starts to mingle documentary images of the city with clumsily staged reenactments of his family's own history, interwoven with documentary footage. A young girl is asked to play the role of his pregnant mother with a pillow under her clothes. In the hospital, Lehman films the birth of a young boy. Eventually we see another woman playing his mother, this time walking with the little Boris through the park. We also witness a Jewish circumcision ceremony and a marriage. Does the staging of memory, both documentary and fictitious, help Lehman overcome his obsession with the unknowable past? The soft and melancholic voice of the author himself sounds like a deep sigh, regretting the irreversibility of time.

Through associations, Boris Lehman intersects his own nostalgic essay about memory and loss with the recent history of Switzerland. Footage of the Swiss army, ready to defend neutrality, and reports from the *ciné-journal* of the forties, stress the sense of historicity. Images of childbirth are visually associated with war footage showing soldiers rescuing people from a hole in the ground. At the film's end, Lehman shifts to a five-minute sequence that could stand on its own

as a poetic parable. A bearded hermit leaves his cave in uptown Lausanne and walks backwards, all the way down the steps through the city till he reaches the waterfront. Halfway on this retrogressive Calvary he is joined by a child, confidently holding his hand. At the origin of life is not Lehman's physical birthplace – which seems to have ignored his existence – but rather, the universal element of water, reconnecting countries and continents. The thick fog above Lake Léman foreshadows the eternal renaissance of life.

Gawan Fagard

Congorama

Studio/Distributor:

micro_scope
Tarantula/Benelux Film Distribution
Christal Films
UGC PH
Dutch FilmWorks (DFW)
Laptv

Director:

Philippe Falardeau

Producers:

Luc Déry
Frédéric Joudiau
Kim McCraw
Joseph Rouschop
Emmanuel Ryz
Eric Tavitian
Sylvie Trudelle
Arlette Zylberberg

Screenwriter:

Philippe Falardeau

Cinematographer:

André Turpin

Art Director:

Jean Babin

Composer:

Jarby McCoy

Editor:

Frédérique Broos

Duration:

105 minutes

Genre:

Comedy/drama

Synopsis

Michel's mid-life crisis is compounded by the news that he is adopted, which marks the beginning of a journey that takes him from Belgium to Canada in search of his biological parents and also for a new market willing to capitalize upon his not-so-successful work as inventor. The quest does not bring Michel face to face with his biological parents but is life-changing in other ways that involve a car accident, diamonds, his long-lost father, a moral dilemma, and fame. This colourful mix of adventures creates a series of subplots that illuminate Michel's cross-cultural quest and life.

Critique

Congorama's plot is akin to a puzzle in which every piece eventually finds its place and completes the big picture by means of nearly implausible situations, multiple perspectives, and narrative juxtapositions. Nothing is left out or goes into the wrong spot in Falardeau's self-conscious, comically inflected drama. This perfect economy might seem contrived and rigid but is, in fact, a platform for playfulness and absurdity, trademarks of Falardeau's style. The film was highly acclaimed at its Cannes premiere.

Olivier Gourmet, known for his intense dramatic performances in Jean-Pierre and Luc Dardenne's films, steps into Michel's comic role with ease. Through his construction of protagonist Michel, writer-director Falardeau expresses his fascination for an economy of deficit. Michel is an underachiever, not so self-conscious, and not as self-righteous as his wife; he is less than what is expected from him or what he wants to be. *Congorama*'s narrative economy seems to eschew fullness in favor of incompleteness, although a form of incompleteness that is almost fully realized. Michel is a quasi-perfect hero because of what he lacks. As soon as he acquires an unexpected reputation for what he claims to be his patents, he is overwhelmed by the surplus and finds himself on the brink of collapse. The surplus is literalized as the diamond that enters his eye during the car accident he experiences in his quest for his biological parents. This close attention paid to the distribution of value and power makes the structure and functions of *Congorama* comparable to that of a fairytale.

From its cross-cultural vantage point (the film is a Canadian-Belgian-French co-production), *Congorama* reflects upon cultural

Cast:

Olivier Gourmet
Paul Ahmarani
Jean-Pierre Cassel
Claudia Tagbo
Gabriel Arcand

Year:

2007

encounters and identities, stories of cross-cultural migration (such as those of Michel and his Congolese wife), as well as Canadian diamonds versus Congolese diamonds. Michel's search for his birth parents is complicated by the fact that, before locating them, he has to understand a new culture. Falardeau balances the melodramatic potential of this episode with humour when he introduces Michel's first and literal taste of Canada: the sandwiches and the coffee that are obviously bad. Moreover, Canadian cuisine cannot hold a candle to Belgian frites, which remain the best and are, as we find out later, a source of patriotic pride. The subject of frites makes another comic appearance when Michel is invited to speak at a television show about his invention and proudly announces that Belgians can do more than make French fries. Falardeau's irony targets the nationalistic pride that Michel proliferates on television and for which he is applauded. He strikes a graceful balance of the nearly comic and the nearly serious, which is indeed the measure of things in *Congorama*. As the director explains: 'There's humour in the film, but it's not a comedy. There's drama and even a bit of melodrama, but it's playful.'

Oana Chivoiu

Amer

Studio/Distributor:

Anonymes Films
Tobina Films
Canal+

Directors:

Hélène Cattet and Bruno Forzani

Producers:

Eve Commenge
François Cognard

Screenwriters:

Hélène Cattet
Bruno Forzani

Cinematographer:

Manu Dacosse

Art Director:

Alina Santos

Composers:

Ennio Morricone
Stelvio Cipriani
Bruno Nicolai

Editor:

Bernard Beets

Synopsis

Amer tells the story of Ana, through three separate stages in her life, in her beautiful Riviera mansion. As a child, she witnesses her parents making love on the night her grandfather died, and is stalked by Graziella, their mysterious maid. In her early adolescence, Ana becomes aware of her budding sexuality: while shopping with her mother, she walks away and is confronted by a mob of leather-donning bikers. As an adult, Ana returns to the now-derelict mansion, and is confronted by a mysterious figure who seeks to destroy her. In the end, the evil force turns out to be none other than Ana's own dark side. On the morgue's slab, the dead woman's beautiful body seems about to come back to life.

Critique

As seen in the film's synopsis, each of the moments in Ana's life is investigated through the prism of her anxieties, growing more and more dangerous as eroticism and death become inextricably linked. While these three stages are clearly the centre-pieces of the film (and feature three different actresses, Cassandra Forêt, Charlotte Eugène Guibeaud and Marie Bos, all perfectly cast), *Amer* actually consists of seven distinct but coherent segments (including the opening credits), with shorter transitions addressing the changes in Ana's body: distortions evoking the passage from childhood to adolescence; a curious photographic stop-motion on hairy body parts commingling with Ana's flesh, evocative of the sexual act, and before the final fragment of the film, where Ana's aestheticized corpse reconciles Eros and Thanatos most seductively, becoming a beautiful metaphor of cinema's ability to animate 'dead life' as well as for the serial, repetitive nature of genre films.

Amer. The Kobal Collection.

Duration:

90 minutes

Cast:

Cassandra Forêt
Charlotte Eugène Guibeaud
Marie Bos
Bianca Maria D'Amato
Harry Cleven
Jean-Michel Vovk

Year:

2009

Paying homage primarily to the flamboyant universes of exploitation cinema of the 1960s and 1970s, one criticism of *Amer* is that it is merely a series of slick short films strung together, ultimately shallow and boring. Upon subsequent viewings, however, the film reveals its great cohesion, and the care with which the atypical script was put together strikes the viewer like a bright ray of Riviera sunshine. It took the film-makers over a year and a half of back-and-forth rewriting before they achieved this degree of sophistication, which can at first pass for a simplistic story.

The film is almost free of dialogue, but is filled with a densely textured and beautiful sound mix including gloriously re-mastered musical themes by Ennio Morricone, Bruno Nicolai, and Stelvio Cipriani – the latter used to fantastic effect in several key scenes. In its revisiting of *giallo* aesthetics (the film overtly quotes, among others, Mario Bava, Dario Argento, Lucio Fulci and Sergio Martino), *Amer* takes the genre's use of close-ups to a different level altogether – the majority of the film's 900 shots are close-ups. Camera movements also evoke Japanese B movies of the 1970s and, in blending these references, the film is akin to the cinema of Quentin Tarantino, with which it shares a kindred spirit of unabashed fandom for 'base' genres, choreographic chic and lush cinematography. Much like Tarantino's latest installments (one thinks of *Kill Bill*, *Death Proof* and *Inglourious Basterds*), *Amer* also works through the female character – powerful, beautiful, and deadly. Cattet brings a strong female subjectivity to the project, the film-makers quoting Claire Denis as another source of inspiration. Feminine and masculine, the film marries the brazen forcefulness of a roaring racing car's engine to the delicate texture of an eyeball and soft footsteps of a little girl on her parents' ominous seaside villa's wooden floors. Like all great exercises in genre cinema, *Amer* bypasses the boundaries that it set out to pay

homage to and becomes something bigger and stronger altogether, transcending its low budget in the process.

The title of the film gives away its affect and psychoanalytical implications: 'amer' means bitter in French, and this is the feeling that one is supposed to be left at the film's finale ('la mort a un goût amer' – 'death has a bitter taste,' claims the film's website). *Amer* also evokes the French words 'mère' (mother) and 'mer' (sea), and so Jung and Freud engage in a merry dance here. More subtly, *Amer*'s title could be envisaged as a truncated version of 'America', and in many ways most of the Italian and Japanese exploitation cinema of the time was trying to emulate the success of American movies, while adding original elements of their own.

Eliciting a bitter aftertaste in the viewer's mouth, the film produces a sheer physical and synaesthetic effect. Forzani and Cattet mixed the sound for us to feel inside the brain of the character, inviting us to let go of our traditional apprehension of films, investigating it through the five senses rather than the mind. As a result, we are left with a strong somatic and almost addictive response. While Dario Argento's most successful films and memorable imagery probably owed a lot to LSD (and the influence of Daria Nicolodi), *Amer* offers a positive counterpart to it. A genuine and potent 'good trip.'

With its Riviera setting and mostly French production team and cast, one can wonder what is actually Belgian about *Amer*. Aside from slight hints at the surrealist school, of which Magritte's country was a stronghold, the film can be envisaged as Belgian because of its unique, original and insular quality. There is little chance the film's example will be emulated, and, so, like many other successes of the country's troubled and heroically penniless cinematography, *Amer* is destined to remain a prototype of sensuous glory, one of the finest and most gorgeous horror films (and beyond) ever made. From the bitter seas of genre cinema came a gem! *Un bijou amer.*

Jeremi Szaniawski

MICHEL KHLEIFI AND THE POETICS OF RESISTANCE

An old man, affectionately referred to as Abu-Zaid, wanders through the ruins of Ma'loul village, and is overjoyed to take in the whiff of olive leaves on the surrounding trees, the odour immediately evoking his youth. The camera cuts to a pile of stones around a plaque dedicated to the memory of Aron Sojcher, who died, it tells us, in Auschwitz in 1944.

A middle-aged couple performs a hesitant dance around each other in a darkened Jerusalem hotel room, speaking words of love in poeticized classical Arabic. In a hospital bed in the same city, a young man who has not eaten food in seven months, after being shot in the stomach by Israeli troops, remains defiant in his call, in Palestinian dialect, for a free, independent state for his people, and exuberant when he adds, 'And why not a socialist one when we get there?'

A horse, having bolted from its stable, ends up in a minefield, but is brought out of peril by the gentle cooing of an elderly farmer, given directions to avoid the landmines by the IDF soldiers stationed in the district. That night, a newlywed couple struggles to consummate their marriage – the bride's saturnine, moonlit beauty not enough to overcome her groom's abashed impotence.

In these scenes there is fiction, and there is documentary, but in Michel Khleifi's poetry of images it makes no sense to differentiate between the two. A slice of documentary footage can have the narrative power of fiction, just as a nominally fictional segment can have the force of reality traditionally assigned to documentary. Khleifi's entire œuvre is marked by the co-presence of both documentary and fictional aspects, and in his best films the two mingle and blend in a ceaseless montage, giving rise to some of the most visually-powerful sequences in contemporary cinema, providing the Palestinian nation with a unique and persistent voice of struggle.

Khleifi shot to prominence in 1987 with the appearance in Cannes of *Wedding in Galilee*, widely (and inaccurately) touted as the first Palestinian feature film. Since the film's crowning at the festival with the International Critics' Prize, Khleifi has been viewed as 'nearly synonymous' with Palestinian cinema (Abu-Manneh 2006: 58), but in many ways it is one of Khleifi's weaker works, with a plot that rarely strays from narrative convention. The *Mukhtar* (elder) of an Arab village under Israeli control seeks an exemption from the IDF-imposed curfew for the wedding of his son Adel. Initially denied by the military commander presiding over the area, the elder eventually strikes a deal: the curfew can be lifted if the commander is made the guest of honour at the festivities. The village erupts over this agreement, but the elder imposes his decision with the argument: 'Would we ever want to stop anyone sharing our joy? Even our enemies?' Undeterred, however, the village's young men plot to use the opportunity for an attack on the commander, declaring 'There is no celebration without dignity, and no dignity under the army's heel.' Their frustrated attempts to carry out the attack are accompanied by Adel's inability to perform his marital duties. With the entire village awaiting the result of their wedding night, his bride loses her patience and, in order to 'protect the dignity of everyone', takes her own virginity, with the resultant bloodied sheet proffered to Adel's mother for the rest of the village to witness.

The documentary aspect of this 'modern tragedy' is more attenuated than elsewhere in Khleifi's work, and yet, even here, he claims to have 'wanted to erase the boundaries between fiction and reality'. Not only were the characters played by non-professionals, but, beyond this, Khleifi set himself the task of showing 'the overpowering immanence

of Palestinian society and the way it is anchored in vertical reality, in the historical and cultural reality of this land' (Khleifi 2006: 52). Indeed, six months after the film's premiere, with the village bursting into protest against an arbitrary arrest in its dénouement, the Palestinian nation itself erupted in the first Intifada.

For formal innovation, and for a more concerted explosion of the fiction/documentary divide, we have to look at Khleifi's more unheralded films, such as his first major work, *Fertile Memories* (1980). As Khleifi's brother George maintains, '*Fertile Memories* wages war on the Israeli story via discursive, not violent means. This struggle takes place … by suspending the dominant narrative and halting it' (Gertz and Khleifi 2008: 79). The film follows the lives of two Palestinian women, divided by age, social status and moral standpoints but with a common experience of occupation, dispossession, and injustice. The elder of the two, Romia Farah, a widow from Yefya, hews to the side of tradition. Devoutly religious, her employment in an Israeli swimsuit factory is a double affront to her conservative views. She reproaches her widowed daughter for re-marrying, and preserves local customs through traditional food preparation and farmwork. At the same time, she stubbornly refuses to sell her plot of land to Israeli settlers, in spite of the fact that it has already been expropriated, and maintains this intransigent stance even against the advice of the rest of her family. Romia's story is juxtaposed with that of Sahar Khalifa, a young woman who is employed at Ramallah's university while striving to become a writer. With a daughter studying paediatrics in Leningrad, Sahar is divorced, but her feminist views lead her to challenge conservative stigmas attached to this status. The pinnacle of the film comes when Romia, taken to her land for the first time since the Nakba, radiates when she is finally able to feel her soil beneath her feet. For Edward Said, this point of contact 'illuminates the screen like an epiphany', and the scene is 'one of the keystones of Palestinian cinema' (Said 2006: 5). Just as important to the film, however, are the drawn-out scenes of everyday reality for women in Palestine – no matter which side of the Green Line they live on – as they struggle with the irrepressible grind of household chores.

Khleifi followed *Fertile Memories* with *Ma'loul Celebrates its Destruction* in 1984, a 30-minute short which traces its origins to footage taken for the first film but not integrated into its final edit. In 1948, the entire population of the eponymous village was expelled to Nazareth by Jewish forces, its buildings razed and the confiscated land used for a kibbutz. Since then, every year, on the date celebrated in Israel as its Independence Day, Ma'loulees revisit their destroyed village to commemorate the *Nakba* ('catastrophe'). The affecting views of elderly inhabitants cautiously inspecting their paradise lost are juxtaposed with scenes of an Arab teacher struggling to impart the region's history to schoolchildren, archival footage of the 1982 war in Lebanon, and silent, slow-motion images of an imagined village life, whose golden hues and joyous farmers harvesting wheat could have come straight out of a Boris Barnet film.

In its use of montage to glide between contrasting discursive orders, *Ma'loul* is surpassed in Khleifi's work only by *Canticle of the Stones* (1990), made in the wake of *Wedding in Galilee*'s international success. While the former film augured the upcoming Intifada, *Canticle* was made during the most intense period of resistance, and bears the traumatic scars of the brutal repression that ensued. Moreover, its radical formal structure has led to it being seen as 'Khleifi's least understood and most experimental film to date' (Abu-Manneh 2006: 66). A Palestinian couple, both in their mid-40s, are reunited in Jerusalem after spending twenty years apart. Although we never find out their names, it is progressively revealed that they were separated when the man was imprisoned by the Israelis, and the woman fled to the United States. She has returned to research 'the myth of sacrifice', while he works for a relief organization and is trying to write a novel. Their reunion, which takes place in the solitude of hotel rooms, restaurants and apartment rooftops, is periodically interrupted by the clamorous reality of the Intifada: children shot

by Israeli soldiers are interviewed in hospitals; young men are forced by IDF soldiers to paint over graffiti on walls; a family stands amassed on top of the rubble that was their home. But the indomitable defiance of the Palestinian people amidst this indignity is equally present on screen: printing presses are shown reeling off resistance posters and newspapers; exuberant street gatherings burst into view; an enraged young woman, witnessing her house being levelled by Israeli bulldozers, declares: 'They think that by destroying our houses they will make us stop throwing stones. On the contrary. Even if every Palestinian dies, the stones will throw themselves.' *Canticle* ends ambiguously, with the couple shown in a silhouetted embrace. But Khleifi, by, in his own words, 'juxtaposing elements of the real with a fictional love story at the heart of the painful and tormenting violence of Intifada', was genuinely able to achieve 'a filmic act aimed against the perception of the other as something abstract' (Khleifi, cited in Abu-Manneh 2006: 66).

Tale of the Three Jewels (1995) shifts the setting from Jerusalem to the Gaza Strip. Notable for being the first film made in this region, it was shot in the days following the Hebron massacre. Whereas defiance against Israeli rule was still viable in the earlier work, in this post-Oslo Accords film the only possibilities for an escape from occupation take the form of childhood dreams and innocent delusions. *Three Jewels* follows the young Yusef, who, with his father in prison and his older brother a militant in hiding, lives alone with his mother. Befriending a young gypsy girl, Aida, whose family are outcasts even within Gazan society, Yusef schemes to escape with her to South America, eventually stowing away in a container of oranges in order to be smuggled out of the country. But a strike at the orchard coincides with his plan, and, being told in a dream that God created three borders for the world – time, space and flesh – and that whoever tried to break free of these constraints was doomed, Yusef decides to emerge from the container. The film's climax is ethereally oneiric, and Yusef's fate is left uncertain in the mind of the spectator. This ambiguity, however, is countered in the last shot of the film – a Gaza beach viewed from behind barbed wire – which leaves no doubt as to the lot of his compatriots.

In 2003 Khleifi's 4½-hour documentary *Route 181: Fragments of a Journey in Palestine-Israel* charted his and Israeli co-director Eyal Sivan's two-month journey along the borders outlined in Resolution 181, the original partition plan for Palestine adopted by the UN in 1947. The film gained notoriety when, in March 2004, the *Festival du Cinéma du Réel* in Paris cancelled a screening of it, with a statement signed by the Ministry of Culture giving the preposterous pretext that 'the film's underlying hostility to the existence of Israel may be of a nature to encourage [anti-Semitic] acts'.[1] In spite of declarations of support from a wide number of figures, including Jean-Luc Godard and Étienne Balibar, the furor has had repercussions for the careers of both film-makers. Fortunately, Khleifi has since completed another feature film, 2009's *Zindeeq*.

Zindeeq depicts an exiled film-maker – played by real-life director Mohammed Bakri, whose *Jenin, Jenin* (2003) has also suffered censorship – returning to Nazareth to record testimonies from victims of the Nakba. With clear autobiographical overtones, the film continues the themes that have prevailed throughout Khleifi's career. Khleifi is indeed a 'radical anti-colonial humanist' who sees the need to 'de-colonise cultural action from the domination of political and ideological discourse', and poses himself the questions: 'How can we create a culture that could retain within itself its own originality and specificity, while still being universal? How can we create a cinema, which could carry the Palestinian human experience, vertically (historically) and horizontally (on the basis of people's daily reality)?' (Khleifi 2003: 48). But just as doggedly as he opposes Israeli occupation, Khleifi also unflinchingly reveals the contradictions within Palestinian society – his films persistently take the standpoint of women, children and the elderly, and he is frequently critical of religious conservatism and intolerance – and seeks to diversify the image of

Palestine beyond the media cliché of the young militant male hurling rocks at tanks. In Khleifi's poetics of resistance, the universal thematics of time, space and memory assume prominence in his work over more concrete political issues – or rather, they *become* concrete political issues. In September 2012, an article in the leading francophone Belgian newspaper *Le Soir* indicated that Michel Khleifi had, in the director's own words, been tacitly blacklisted by distributors.[2]

But where does Belgium come into all this? In 1970, at the age of twenty, Khleifi left his native Nazareth and settled in Brussels, and has lived there, in exile, ever since. His film education in the mid-1970s took place in the Belgian capital's INSAS (the Institut National Supérieur des Arts du Spectacle, where he now teaches), and his first work came in the form of documentaries on Palestine made for Belgian television between 1977 and 1980. Only one of his films, 1993's *L'Ordre du jour*, takes Belgian reality for its subject matter, but the 'irrational rejection' of the film in Europe remains a 'painful memory' for Khleifi, and he has not repeated the gesture of filming in his adopted country (Khleifi 2006: 56). And yet, the cinema and culture of Belgium and the rest of the French-speaking world impregnate all his films: *Fertile Memories* recalls Akerman's *Jeanne Dielman*, *Canticle* invokes Resnais/Duras' *Hiroshima mon amour*, and its male lead's prospective novel has the Proustian title 'In Search of Time Destroyed'. Khleifi readily avows the influence film-makers such as Godard, Rouch, and Marker have had on his œuvre, and France and Belgium have traditionally been both co-producers of his films and – for better or worse – the sites where they have first been publicly and critically received. Indeed, Belgium often makes subterranean appearances in Khleifi's work: the stone plaque in Ma'loul dedicated to Aron Sojcher, for instance, notes that, before being deported to Auschwitz, he resided in Brussels. While Belgium itself currently seems to be witnessing its own destruction, perhaps it will be film-makers-in-exile such as Khleifi, infusing its cultural environment with works from a broad diversity of backgrounds and perspectives, who will provide the fragmented country with a future national identity.

Daniel Fairfax

Notes
1. http://electronicintifada.net/content/film-route-181-censored-french-culture-ministry/5017.
2. http://www.lesoir.be/94362/article/culture/cinema/2012-10-05/michel-khleifi-sur-liste-noire

ALTERNATIVE FIGURES IN BELGIAN CINEMA

Peter Brosens and Jessica Hope Woodworth.
Private collection.

OLIVIER SMOLDERS: A FILM-MAKER OF AMBIVALENCE

Using the short form as a genre in its own right, Olivier Smolders likes to explore various taboo subjects in his films through a personal stylistic continuity as well as a thought-out and masterful *mise-en-scène*. Among his preferred themes are death, sexual pleasure, sensuality, perversion, cannibalism, matricide and mental illness. Women, female bodies and, more generally, the human body are also at the core of this director's oeuvre. In his latest short, *A Small Anatomy of the Image/Petite anatomie de l'image* (2009), he goes so far as to symmetrically arrange wax figures of skinned human beings as presented at the Specola wax museum in Florence. Born in 1956 in the Belgian Congo's capital city of Léopoldville (now Kinshasa), Smolders was considered one of the most promising Belgian film-makers of his generation. After graduating from the Brussels film school INSAS (Institut National Supérieur des Arts du Spectacle et des Techniques de Diffusion) in film-making (for film and radio-television), Smolders became a screenwriter, director, and producer, founding the production company Les films du Scarabée. Very quickly, his short films were selected for numerous national and international festivals and received many awards at the Brussels, Namur, Clermont-Ferrand and Aix-en-Provence short-film festivals. Informed by his cinematic practice, Smolders began to teach in Belgium, both at the INSAS and at the University of Liège.

Displaying a quasi-systematic stylistic rigour (minimalism, over-framing, fixed camera, voice-over, frontality of the gaze, black and white, composed and researched body movements) characterized by the hybrid aspect of most of his films – which neither fully resemble fiction nor documentary forms – his cinematic œuvre attempts to observe and analyse human nature at its darkest and most disturbing, thus testifying to a double articulation ruling over content as well as form. At times, his short films boast a disconnect between the sobriety of the images and the violence of speech, while in others, image and text are fully united. As such, *Novena/Neuvaine* (1984) is a remarkable example in the director's filmography: it evokes the retreat of a writer into the boarding school where he spent his adolescence, and where he is now on a quest for his vanished imaginary. In this film, the director manages, on the one hand, to oppose the serenity of purified images with the aggression and violence of some words and, on the other hand, to associate text *stricto sensu* ('rather than a white sheet of paper, a black film') and form (a black background to the screen). This perfect union between form and content is found in several of his other films, such as in *Rapture/Ravissement* (1991), which explicitly cites fragments from the writings of Saint Teresa of Ávila while innocent young girls and pious ladies pass in front of the screen, the rhythm of succession of shots and the content of the voice-over in perfect harmony. Moreover, as in *Neuvaine*, the textual insert 'We see nothing, hear nothing' is projected against a long dark background. In *The Amateur/L'amateur* (1997), a man praises the nudity of the female sexual organ. Slow camera movements and tight framing showcase the sensuality of feminine bodies filmed by the protagonist. In the polysemically titled *Point de fuite* (which

can mean 'vanishing point' as well as 'no way out,' 1987), adapted from a short story by Marcel Mariën and expressing the malaise of the teaching profession, the subject of the lesson given by the female teacher on perspective, and her position in the classroom and vis-à-vis her students, are fully equated with the problematic raised by Smolders: namely, the question of the observer and the observed. Conversely, in *Adoration* (1987), inspired by the 1981 Issei Sagawa case (when the eponymous Japanese student shot a young Dutch woman in the neck before having sex with her corpse, then skinned her and ate parts of her body), the savagery and barbarity of the subject matter are filmed in black and white with an extreme sobriety and distance. In much the same way, the perversion of the words spoken are held in contrast to the fixity of the camera, the minimalism and the moderation and immobility of the characters in *Philosophy in the Bedroom/La philosophie dans le boudoir* (1991), in which the writings of the Marquis de Sade serve the purpose of illustrating a dialogue between the ghost of the writer and innocent young women. In *Lonely/Seuls* (1989), the sober and rigorous cinematography dissembles the depth and seriousness of the chosen subject, namely the difficult reality of children placed in psychiatric institutions. In *The Art of Loving/L'art d'aimer* (1985), a man recounts, with a neutral, distant tone, how he managed to murder his own mother. Through its rigorous *mise-en-scène*, the images acquire a great power of evocation. Lastly, in *Death in Vignole/Mort à Vignole* (1998), an atypical work within Smolders' corpus, the director shows a succession of images taken from family footage of a holiday in Venice to evoke the loss of a child. Exterior shots, long camera movements and the essential role of music in this film give the impression of a much more personal and accessible work, which is the best loved and most awarded of his films.

The double dichotomy which characterizes Smolders' short films is also illustrated in his sole feature film, *Dark Night/Nuit noire* (2005), which the director took many years to complete, and in which a series of elements are opposed but also associated with each other – black and white, snow and night, blood and milk, Europe and Africa – consequently reflecting some territorial preoccupations that are specific to Belgian cinema. As opposed to his short films, *Nuit noire*, which follows the night fantasies of an entomologist, did not meet with the anticipated success. The duration of the film's theme does not seem to correspond to the duration of the film itself, which consequently seems much less efficient. It is not surprising, thus, that Smolders elected to return to the short form for his next two films, *A Small Anatomy of the Image* and *A Journey Around my Room/Voyage autour de ma chambre* (2008), which evoke a graphic and imaginary space reflecting Smolders' vision on the multiple known spaces of his own body, allowing him, therefore, to resist the typical narrative requirements of feature films.

It is important to point out the importance of literature in the cinema of Olivier Smolders. Having earned a degree in Romance philology, he is the author of a variety of books. It appears that the recurring use of the voice-over, of explicit and implicit literary citations, textual inserts, the use of poetic and lyrical tones, the refinement and the accuracy of the words used give a prominent place to literature and poetry in the director's films, which seem to use cinema, as it were, as a means of continuing his literary pursuit. Finally, along with the unambiguous brutality of some actions (including the slaughtering of the pig in *Neuvaine*, the murder of the young student in *Adoration*, and the final sequence of *Thoughts and Visions of a Severed Head/Pensées et visions d'une tête coupée* (1991), which tells of an imagined artist based on the life and works of Belgian painter and sculptor Antoine Wiertz), the question of the gaze and voyeurism is ubiquitous in Smolders' cinema. Through the choice of subjects – slow, composed, sustained and intrusive camera movements, and the recurrence of looks into the camera – Smolders' films ask the question about

the exchange between voyeur and exhibitionist, sometimes turning the viewer into observer-observed.

Géraldine Cierzniewski

Translated by Marcelline Block and Jeremi Szaniawski

PETER BROSENS & JESSICA HOPE WOODWORTH

Over the last two decades, the film-maker Peter Brosens (b. Leuven, 1962) and his American partner Jessica Hope Woodworth (b. Washington, 1971) have played an important role in Belgian and international auteur cinema, at first in the creative documentary genre in the 1990s, and eventually in fiction film. Having had their own respective careers in documentary film-making, they wrote, produced and co-directed two acclaimed feature films in collaboration, *Khadak* (2006) and *Altiplano* (2009); founded their own independent production company, Bo-films, in Belgium; and now act as inseparable creative partners, promoted internationally as 'Brosens & Woodworth'.

Peter Brosens was born to parents who were researchers at the University of Leuven, where he later studied anthropology. During his studies, he not only developed a strong interest in visual aspects within his own field of study, but also in the practice of film-making itself, which led to the production of two short films in 1991, co-authored with his friend and colleague Peter Krüger: *Why Did Angels Lose their Faces?* and *Le Piège, d'après Luigi Pirandello*. Shortly thereafter, Brosens travelled to Ecuador, equipped with a small video camera, where he shot the 10-minute anthropological documentary *The Path of Time/El Camino del Tiempo* (1992). Far beyond the conventions of visual anthropological research, this short film is a subtle dialogue between the film-maker and a group of native musicians who do not know how to deal with the presence of the camera. During a short stay at the Manchester School for Visual Anthropology, Brosens learned traditional documentary techniques, which only confirmed his desire to break through the seemingly realistic film image and include imaginary and poetic elements in the documentary genre.

Brosens went on looking for the right place and time to make his cinematic imaginations come true, and finally found fertile ground in Mongolia. Between 1993 and 1999, he produced and co-directed the internationally-acclaimed *Mongolia Trilogy*, a series of three creative documentaries which tell the story of the rapidly-changing culture of Mongolia, undergoing a process of capitalization and sedentarization while preserving elements of shamanism and folk tradition. *City of the Steppes* (1993) was shot on video when Peter Brosens and his friend Odo Halflants were sent to Mongolia to do field research for a company interested in investing in renewable energy. It draws an intimate portrait of the capital city Ulan Bator, which is inhabited by people that lived for centuries as nomads in the steppes before being housed in the Soviet buildings of Mongolia's desolate capital. *City of the Steppes* was awarded the *Prix Joris Ivens* at *Cinéma du Réel* in Paris and was Brosens's breakthrough as a documentary film-maker.

Thanks to this first accomplishment, he was able to build an extremely complex co-production structure in order to finance the second part of the trilogy, *State of*

Dogs (1998). This creative documentary, which was also shot in Mongolia and co-directed by the locally-renowned Mongolian television journalist Dorjkhandyn Turmunkh, tells the story of the soul of a dead street dog called Baasar that ventures through Ulan Bator. Mongolian spirituality recounts that the soul of a dog is destined to be reincarnated as a man. However, since the number of stray dogs in Ulan Bator is increasing dramatically and causing massive hygiene problems, local authorities are forced to shoot the dogs and thus disturb the traditional mythology, leaving thousands of lost souls of dogs straying through the believer's imagination. The profound melancholy and misery of the violently modernized Mongols is thus pictured through the eyes of Baasar's tramping soul, reframing everyday reality in a mythological perspective by cinematic means. With enormous respect, Brosens recorded the remaining traditions and rituals, the music and poetry of traditional Mongolian culture, along with the abrasive reality of daily life. Since he was able to shoot with a fully equipped, professional 35mm camera, it is in *State of Dogs* that Brosens' extremely careful photographic talent reveals itself entirely. Clearly trained by his love of fiction authors like Tarkovsky, Paradzhanov, Antonioni, and Pasolini, this documentary discloses the sublime in nature, relies on careful composition and reveals a rich vocabulary of long takes. Not surprisingly, the documentary was awarded many prizes, including the prestigious Grand Prix at the *Visions du Réel* film festival in Nyon (Switzerland).

The third part of the trilogy, *Poets of Mongolia* (1999), was produced and shot shortly after the release of *State of Dogs*. Peter Brosens and his co-directors Peter Krüger and Sakhya Byamba decided to shoot the film in a completely free way, with a small video camera and some loose production notes. The need to go back to Mongolia came from a phenomenon Brosens had encountered on his previous journeys through the country, without being able to capture it on film: in the heavily industrialized contexts of Mongolia's new emerging coal mining industry, traditional oral culture continues to exist. The project was thus as simple as it was urgent: capturing the storytellers on camera and in so doing, honouring one of the last enclaves of nomadic culture, poetry and music in eastern Asia. *Poets of Mongolia* was awarded the Mongolian State Award for Best Documentary.

In the same year, Peter Brosens became involved in the work of the young American documentarian Jessica Woodworth, who became his partner and co-director. After finishing a degree in literature at Princeton University and an MA in documentary film at Stanford, she wrote and directed the short documentary *Urga Song* (1999), a lyrical cine-poem about the artistic community in Ulan Bator. Not surprisingly, it is in Mongolia that Woodworth and Brosens met and started their intense collaboration. That same year, Brosens produced Woodworth's *The Virgin Diaries* (1999) for IntiFilms, the company he founded in 1991 together with Peter Krüger. *The Virgin Diaries* is a radically investigative documentary about Fatiha, a young Muslim woman who is involved in a loveless marriage. Both the film-maker and the guide research Moroccan family law reforms, and journey through Morocco asking questions about virginity, sex, and religion. They cross the country, from touristic beachside resorts to Saharan camel markets, Islamic schools and doctor's offices. When Fatiha really falls in love, the investigations start to become very concrete and oppressive, causing dramatic frictions between concepts of duty and tradition on the one hand and feelings of love and desire on the other. *The Virgin Diaries* was a complex co-production of Western European and American public television channels, and caused a huge controversy due to its delicate subject matter. However, the documentary was widely acclaimed, most importantly in educational contexts.

For their subsequent project, Brosens and Woodworth decided to shift their focus to fiction. It was not only the ever-more restrictive format of the television documentary in which they had to conform to the 52-minute standard that prompted their decision. One could already feel a sense for the composed, cinematic image from the very onset of both Brosens' and Woodworth's work. Moreover, their epic and poetic documentary style called to break free in the open zone of fiction. Therefore, they decided to turn the initial

research they did for a documentary project about ex-Soviet pilots in Mongolia into a screenplay, which eventually became their feature film *Khadak* (2006). With *Khadak*, which tells the psychedelic story of a nomad shepherd boy named Bagi, destined to become a shaman while capitalist industry and lifestyle is rapidly invading Mongolia, Brosens and Woodworth did not make any efforts to compromise their very own film aesthetic. Disregarding the major tendencies in commercial fiction film today – characterised by a strong emphasis on the narrative and a very fast-paced editing technique – they developed a singular cinematic language, based on strong and careful photography, long takes and sequences, and extremely revelatory aspects of magical realism in sound as well as in image editing. As such, *Khadak* attempts to take the viewer on a monumental visual journey investigating the inner state of devastation undergone by Mongolian culture. Bagi's heightened sensory perceptions, epileptic seizures, apocalyptic visions and out-of-body experiences constitute the basic material for the storyline, as much as the documentary reality of Mongolia (as we already know from the *Mongolia Trilogy*).

The political and economic backdrop is no less dramatic and real, featuring the shift of Bagi's family from nomadic shepherd life to sedentary life in the ex-communist ghost cities. As the flock is starving *en masse* due to a plague intentionally caused by the mining industry, the Mongolian nomads are forced to accept jobs in the surrounding coalmines and reorganize their lives in small concrete apartments instead of their yurts. We are told how the lead characters organize themselves in raids against the freight trains transporting coal away from the facility. However, seen through the eyes of Bagi and his soulmate Zolzaya, the film does not focus that much on social tragedy but, rather, tries to dig deeper into the intimate experiences of sorrow and melancholy caused by the loss of spiritual meaning in a politicized world in which one has to fight for one's rights. The vast landscape of Mongolia, wounded by open pitmines and industrial plants, embodies this notion of loss physically and aesthetically in the medium of cinema. Brosens and Woodworth indeed believe that the natural environment of man in cinema has as much to say about the inner state of a character than the subtle features of a face in a close-up image. Hence the ever-recurring aesthetic of tiny silhouettes placed in extreme contrast to the large, surrounding landscape. Their cinema does not seek to establish an identificatory relationship between the viewer and the main characters but, rather, attempts to be a transcendent experience in itself. Rather than acting as denunciative journalists reporting the atrocities of rapid industrialization and disenchantment with nature, the film-makers engage themselves in the radical restoration of the experience of the sacred through the mere materiality of film. Reportedly, at the Mongolian premiere of *Khadak*, a community of shamans explicitly expressed their enthusiasm for the way Brosens and Woodworth translated their rituals and visions to the screen. Is cinema able to take over the age-old functions of ritual and metaphysical experience? Brosens and Woodworth seem to believe so.

Upon its release in 2006, *Khadak* was awarded the Golden Lion of the Future at the Venice Film Festival and received many prizes and special mentions all over the world. Three years later, Brosens and Woodworth presented a second feature-length drama to the public, this time in the prestigious framework of La Semaine de la Critique at the Cannes Film Festival: *Altiplano* (2009). Again, Brosens and Woodworth sought to integrate themselves into the daily life of a small community, this time located in the highlands of Peru. In this remote region they discovered a similar ethnographical situation to Mongolia's: after Spanish colonization, the native Quechua community adopted a mixture of their ancestral, nature-over a based spirituality and Catholic doctrine. Since the late twentieth century, however, the region has been entirely devastated through the discovery of extremely lucrative gold mines in the central Andes region. Along with dismal economic prospects, the health of the people has been affected due to a massive mercury spill in 2000, which killed over a thousand locals.

With this dramatic event in mind, Brosens and Woodworth wrote a screenplay which, again, goes far beyond socially engaged storytelling and reaches into the spiritual experience of the village residents, who have to deal daily with loss and death. This time, the film-makers seemed even more determined to transform daily life and existing rituals into an overwhelmingly-visual cinema. In the very emotional and extroverted context of Latin America (in contrast with the reserved and intimate nature of the Mongols) they even seem to embrace the theatrical aspect of their film-making, staging radically-symmetrical tableaux and camera movements which may recall Sergej Paradzhanov's films. However, the visual basis of *Altiplano* was found almost exclusively in historical photographs made by the local people themselves. Many of the exact framings and compositions of these pictures were brought to life through the camera, resulting in the often majestic and photographic imagery of the film. Again, Brosens and Woodworth succeeded in breaking through the borders of anthropological field research, sublimating the imagery of the local community into a radically staged and aestheticized epic drama.

A forthcoming project, whose rumoured working title is *The Fifth Season*, brings the film-makers to Belgium, most notably to the immediate surroundings of their home, not far from Dinant. Located in a small agrarian village in the beautiful Condroz region and set in a near future, *The Fifth Season* intends to investigate apocalyptic notions of the natural environment in relation to the local communities of Belgium.

Peter Brosens and Jessica Woodworth are tirelessly building their sublime cinematic oeuvre. Invariably based on a profound interest in the human being as part of a community, but more importantly, as a tiny creature in the vastness of nature, they seem to strive for a sense of spirituality through film. Yet their attempt seems not so much to be the representation of faith on film but, rather, the development of a cinema language as a revelatory means in its own right. Cinematic visions and ideas, according to Brosens and Woodworth, are the products of subtle intuition and free imagination, unbound by personal interest. In the creative process of collaborative film-making, the notion of authorship does not play a role anymore. Making a film thus becomes an act of pure worship to the metaphysical experience of cinema itself.

Gawan Fagard

PETER KRÜGER

Peter Krüger (b. 1970) is one of the contemporary Belgian film-makers who in the early 1990s started to write, direct and produce all of his films himself, in a small collaborative framework. While still completing his degree in philosophy at the Catholic University of Leuven in 1993, with a thesis on the aesthetic life in the work of Danish philosopher Søren Kierkegaard, Krüger founded the production company IntiFilms together with director Peter Brosens. They had co-directed two short films, *Why did Angels Lose their Faces?* and *Le Piège, d'après Luigi Pirandello* (both 1991). In these early works, Krüger already expresses a strong sense for the poetic image, echoing his interest in Kierkegaard's cultural critique of aesthetic versus religious life in search for existential meaning. In Kierkegaard, Krüger discovers an idea which will be decisive for his own film-making: Western tradition seems to have thrown away both religion and spirituality too easily in the course of the nineteenth and twentieth centuries, before even considering what society loses in doing so. In precisely the same fashion as Kierkegaard's philosophy, Krüger's cinema attempts to revisit and investigate religious life in the context of modernity. Moreover, as Krüger decided to start film-making as a profession without attending film school, his film training happened entirely in the Cinémathèque, where he absorbed films by Antonioni, Tarkovsky, Bergman, and Paradzhanov – all auteurs who can be understood in the context of the same quest for existential meaning through the medium of cinema.

In 1997, Krüger set up a complex co-production for a creative documentary called *Nazareth*, focusing on three villages throughout the world (Nazareth in Belgium, in Ghana, and in Palestine), which not only share names but also an intense Christian tradition. Both as an anthropologist and as an aesthete, Krüger observes three different ways of experiencing faith at the point where reason and positivist science have failed, focusing respectively on faith as consolation, faith as healing, and faith as acceptance.

Two years later, having co-produced the second part of Peter Brosens' *Mongolia Trilogy* (*State of Dogs*, 1998), Krüger agreed to co-direct the third part of the trilogy, *Poets of Mongolia* (1999). With this production, both film-makers decided to go back to the basics of documentary film-making: with a small crew, a handheld video camera, and only very loose production notes, they travelled through Mongolia in search of remains of the ancient oral culture among local workers in the post-Soviet mining industry. Again, Krüger and Brosens seem to be interested in unmasking a seemingly modern and industrial society as a far more complex structure, in which ancestral spiritual and shamanic practices continue to exist, unchanged.

The same cultural complexity is reflected in the short documentary the film-makers produced together for ARTE, *The Eclipse of Saint-Gilles* (2001). This time, they venture through their own neighbourhood of Saint-Gilles in Belgium which houses one of Brussels' liveliest and culturally mixed communities. Krüger and Brosens confront the viewer with an astonishing cultural and spiritual reality, ranging from popular folklore through intimate home rituals and confessions.

In 2004, Peter Krüger presented his first short fiction film, *The Strange Man*, in which he adopted a completely different visual and narrative style. Having trained himself in the genre of documentary, he now focused on the psychological involvement of written, fictional characters. *The Strange Man* portrays the growing alienation between two elderly people (starring Josse De Pauw and Catherine ten Bruggencate) who lived together in the same house for many years. The film, entirely shot as a *huis-clos*, was followed by *The Last Sigh* (2007), a documentary based on nearly the same idea,

however set this time in real life. Krüger was able to follow the last days in the life of an old couple, presenting a respectful portrait of man facing death.

During the 2000s, Krüger's activities as a co-producer of creative documentaries all over the world became increasingly a part of his professional activity. Krüger co-produced *Not All the World Does Is Good for a Mennonite* (Lut Vandekeybus, 1998), *Ikones/Boudauin I* (Manu Riche, 2002), *The Virgin Diaries* (Jessica Woodworth, 2002), and the acclaimed *Episode 3: Enjoy Poverty* (Renzo Martens, 2009), among others. In so doing, he played a key role in the development of this new cinematic genre within the context of the Flemish community in Belgium during the late twentieth and early twenty-first centuries, both in terms of funding and in terms of alternative distribution strategies. All the while, he managed to develop two major projects of his own: *Antwerp Central* (2011) and *N* (currently in production). In both 90-minute cinema documentaries, Krüger develops a marriage between, on the one hand, a documentary setup and subject, and on the other, the seemingly perfect integration of fictional elements.

Antwerp Central brings together the monumental architecture, the history and the current function of the central railway station in Antwerp with W.G. Sebald's novel *Austerlitz*, a book that partly plays in the very same setting. The main character (played by Johan Leysen) coincides with the first-person narrator in *Austerlitz* and guides the spectator through the mysterious realm of the passing of time, calculated by the majestic clocks, and through the magical-realistic images of memory and evanescence that appear within the architectural space. *Antwerp Central* was awarded the Grand Prix at the Festival International du Film sur l'Art in Montréal in 2011 and attracted wide international attention.

In his next feature film, *N* (preceded by a play he wrote and directed for the stage in 2006), Peter Krüger deals with an even more extreme notion of magical realism in documentary film-making. Guided by the restless spirit of the historical figure Raymond Borremans, Peter Krüger travelled through Côte d'Ivoire in search for remains of Borremans' unfinished encyclopedia of western Africa (Borremans died before finishing the alphabet and got stuck at the letter N). Herewith, *N* can be perceived as a key moment in Krüger's career as a film-maker, where various aspects of his oeuvre come together, such as anthropology, colonialism, the aesthetics of the uncanny and the existential and most importantly of all, the friction of the scientific and the spiritual within our contemporary perception of the world.

Gawan Fagard

Altiplano

Studio/Distributor:

Ma.Ja.De Filmproduktion
Bo Films
Entre Chien et Loup
Eurimages
Lemming Film/ Contact Film
Cinematheek
First Run Features
Imagine Films Distribution
Meridiana Films
AmaFilms
Cineworx
Farbfilm-Verleih

Directors:

Peter Brosens and Jessica Hope Woodworth

Producers:

Peter Brosens
Mercedes de la Cadena
Joost de Vries
Heino Deckert
Diana Elbaum
Leontine Petit
Daniel Rô
Martin Schlüter
Jessica Hope Woodworth

Screenwriters:

Peter Brosens and Jessica Hope Woodworth

Cinematographer:

Francisco Gózon

Art Directors:

Anne Fournier
Guillermo Iza

Composer:

Michel Schöping

Editor:

Nico Leunen

Duration:

109 minutes

Genre:

Drama/war

Cast:

Magaly Solier
Jasmin Tabatabai

Synopsis

Altiplano tells the story of a spiritual affinity between two young women, Saturnina, a Peruvian girl in the small village of Turubamba who is about to get married, and Grace, a Muslim photographer who is suffering from depression after a violent incident in the Iraq War. Grace's Belgian husband, Max, an eye surgeon in the highlands of Peru, falls victim to violent riots by the local residents who, angered by lethal mercury spills in the nearby mines, have turned against their Western doctors. After Saturnina's fiancé Ignacio dies of mercury poisoning, she becomes an activist, leading the community to protest against the mining industry. With the courage of despair, she decides to sacrifice her own life in an ultimate act of protest. This dramatic gesture gives meaning to Grace's life, while Saturnina's community goes on remembering her as a local saint and hero.

Critique

With this feature film, directors Peter Brosens and Jessica Woodworth succeed in reflecting upon extremely complex global power relations in a subtle way, not only in economic but also, and most strikingly, in metaphorical and spiritual terms. The historic event of the fatal mercury spill in Choropampa in 2000, which caused the deaths of more than a thousand villagers, forms the dramatic backdrop for a broader and more intimate story about love, death, and resurrection. The story begins in a beautifully staged mass in the village church after which the community parades a colourful statue of the Virgin through the streets. A young girl reaching for a glimmering liquid substance – which turns out to be mercury spilled by the passing mining trucks – causes the statue to fall and break into pieces. It is upon this metaphor of lost spiritual coherence that the whole story is founded. A blind sculptor is called to restore the statue, holding the whole community in an anxious waiting period, during which Saturnina's wedding is postponed. Little by little, Brosens and Woodworth's camera captures the signs of the nearby gold mine, introducing alarming images of oversized trucks crossing the sacred landscapes of the central Andes. It is through the same landscape that Ignacio, Saturnina's fiancé, climbs the mountain in search for holy water with which their marriage can be blessed. However, Ignacio will never return from this journey.

The story is paralleled by Grace's depression after having won the World Press Photo award for a photo she took during the Iraq War, when she was forced by an Iraqi soldier to photograph the execution of her local guide and friend. While Grace is at the gothic abbey in Aulne, Belgium (near Charleroi) – whose ruins take on a symbolic meaning – she makes the decision to quit photography altogether.

In Saturnina's powerful suicide scene, Brosens and Woodworth deploy all their visual and metaphysical qualities at once. In one dramatic movement, the scene evolves from a desperate suicide letter taped on video, through the drinking of mercury, to the tumbling down of the walls of her house. Amidst the sublime landscape that is revealed behind these walls, Saturnina miraculously returns as the Virgin herself. She is wearing a long white dress amidst hundreds of masked ancestors

Olivier Gourmet
Edgar Quispe
Year:
2009

standing like monoliths in the landscape, inviting her to join the world of the dead. Even though Grace arrives in the village only after Saturnina's suicide, both souls converge due to the sorrow and pain they feel for their dead lovers. Saturnina becomes a local Saint, worshipped through the newly restored statue of the Virgin. The last movement of the film, filled with melancholy – Saturnina's name is derived from the planet Saturn, often associated with melancholy in Renaissance astrology – is underscored by exalting choir music, creating a breathtaking atmosphere of spiritual liberation. Brosens and Woodworth's answer to the contemporary, socio-political, and human drama pictured in *Altiplano* is formulated through a transformative use of images, inviting the spectator to participate in an almost sublime cinematic experience.

Gawan Fagard

Antwerp Central

Antwerpen Centraal

Studio/Distributor:
Sophimages/Sophimages
Director:
Peter Krüger
Producer:
Jan Roekens
Cinematographer:
Rimvydas Leipus
Composer:
Walter Hus
Editors:
Nico Leunen
Els Voorspoels
Duration:
93 minutes
Genre:
Documentary
Cast:
Thessa Krüger
Johan Leysen
Year:
2011

Synopsis

The documentary *Antwerp Central* invites the spectator to a voyage in time through three centuries of the history of the eponymous Belgian railway station, as seen through the eyes of a lonesome traveller who arrived there.

Critique

Instead of shooting a standard, chronologically-structured documentary, director Peter Krüger decided to transform the monumental turn-of-the-century architecture of the Antwerp Central Station into an overwhelming and mysterious backdrop for the mental journey of an anonymous writer, played by the acclaimed actor Johan Leysen. Loosely based on W.G. Sebald's novel *Austerlitz* (2001), the writer-narrator arrives in Antwerp by train, and sets out on a melancholic peregrination through the collective as well as private memories related to this landmark of industrial positivism and its complex intertwining with Belgian history. Krüger develops a moving and carefully structured work, illustrated with archival footage of Belgium's colonial history (the construction of the station during the reign of King Leopold II at the turn of the twentieth century) alongside documentation of contemporary events (the station's renovation as well as its radical modernization, with the construction of a high-speed train tunnel). Moreover, Krüger adds a poetic-metaphysical layer of associative, fictional elements, translating Sebald's reveries into surprisingly expressive images, carefully photographed by the Lithuanian cinematographer Rimvydas Leipus.

Peter Krüger makes use of Sebald's ingenious writing technique in which associative elements of reality and fiction are intermingled and superimposed. For example, the observant, fluorescent eyes of the owl that flutters around in the station are reminiscent of Sebald's description of the nocturama in the Antwerp zoo, and thus gives Krüger immediate cause to investigate the connotations of both the Central Station and the adjacent zoological gardens as monuments of nineteenth-century cultural thought, characterized by colonial

exoticism. Archival footage of the megalomaniac King Leopold II, who initiated both projects, is ironically confronted with beautiful images of a majestic lion, appearing after the closing of the station at midnight and gadding around in nocturnal light as if it were the king's ghost himself. Guiding the camera into the dazzling heights of the dome of the station's central hall, Krüger zooms in on the symbolic ornaments reflecting the spirit of progress and the accumulation of capital and national glory. The whole atmosphere breathes the decay of nineteenth- and twentieth-century ideologies imprinted in the stone and steel of the building.

And then there is the aspect of time; time going by as a light breeze of air, underscored by the subtle soundtrack of Walter Hus, leaving a vague sense of melancholy in the enormous space of the station. But the motif of time is also present through clocks and schedules, moving people around like puppets. On the very same spot where, in a cathedral, one expects to find a statue of God's son, one can now see the enormous clock, regulating and structuring the activities beneath. The rationalization of time appears as one of the key elements of nineteenth-century industrialization, especially visible in respect to the railways, which necessitated the definitive synchronization of time schedules throughout Europe. However, by means of cinema, Krüger is able to re-establish a sense of poetic time, subtly inserted as a question mark to history.

As we stumble upon our narrator in the Café Royal, we witness some fragments of a conversation with a Congolese historian about Antwerp's role in Belgian colonial politics. We are also reminded that the station played an important role in the deportation of Jews during the Second World War. Later, we follow an architecture scholar who shows us old plans and pictures of the station in the city archives. In a series of old black-and-white photographs, an ever-recurring little girl (played by Krüger's own daughter Thessa) comes to life and plays around on the blue stone floor, marking a hopeful continuation of generations.

With this documentary marked by an aesthetic of magical realism, Krüger succeeds again in picturing, in an incredibly beautiful way, his pessimistic and nostalgic worldview. Through the eyes of the lonely traveller, he seems to suggest how the continuous drive of men to build and transform their physical environment is paralleled by a far more invisible, intangible experience of nostalgia and evanescence. Every history of urban development can also be perceived as a history of loss and decay. *Antwerp Central* thus embodies a critical perspective on the ideologies of progress and technological positivism, while remaining without a doubt the most beautiful and honourable portrait of one of Europe's most impressive railway cathedrals still in use today.

Gawan Fagard

ANIMATION

RAOUL SERVAIS : PIONEER AND EXPERIMENTALIST OF ANIMATION CINEMA

A leading figure of animation cinema in Belgium and also renowned throughout the world, Raoul Servais was born in 1928 in Ostende. *Havenlichten* (1960), Servais first animation film, in which a street lamp thrown into a trash dump ends up finding its place by replacing an old, sleepy lighthouse, was awarded with the main animation prize at the Antwerp festival, thus announcing a promising career. Most of Servais' subsequent films earned prizes at prestigious festivals, crowned by a Palme d'Or at the 1979 Cannes film festival for his short film *Harpya*.

Illustrator, graphic artist, and a painter above all, Servais created illustrations and drawings for political newspapers and collaborated with René Magritte in 1953 on the creation of the frescoes at the Ostende casino (among other projects). Passionate about art, he enrolled in the Ghent Royal Academy of Fine Arts (KASK – Koninklijke Academie van Schone Kunsten) in 1945, in the applied arts section, and became a professor there in 1960. His vocation as a teacher and his interest in animated cinema pushed him to create a department within this school, which is now named after him. In 1963, the first European school of animation cinema was created, making Servais a true pioneer of this genre. Before acting as assistant to the Belgian director Henri Storck on the film *Trésor d'Ostende* (1955), he shot, around 1952, a documentary about the works of his friend the painter Maurice Boel, as well as made experimental 8mm films, such as *Parallèle*, which aimed at establishing a correspondence between the parallel lines surrounding him, and *The Sand Runner/De Zandloper*, portraying people on Ostende beach. Essentially known for his animation films to which he dedicated most of his time in the 1960s, Servais nevertheless also directed live-action films. *Omleiding November* (1963), in which a man gets lost in a maze while trying to put a wreath of flowers on his old car, is one such example. The combination of live footage and animated images allowed him, in the late 1970s, to achieve the creation of the process that bears his name, 'Servaisgraphie', a technique consisting of embedding live footage into animated backgrounds. Although originally inspired by the works of Pat Sullivan, Otto Messmer, Walt Disney, the Fleischer brothers and Paul Grimault, Servais rapidly drifted away from the canon of traditional cartoon animation and attempted to draw closer to the visual arts. The pictorial and materialist aspect of his backgrounds, his

taste for angular contours, broken lines, and accelerated perspectives attest to this. His œuvre as a whole also resembles an excursion throughout the twentieth century. *Nachtvlinders* (1998), an explicit homage to Paul Delvaux, seems to be the most striking example of this tendency. Other indicators would be the character and backgrounds of *Pégasus* (1973) – in which an old unemployed blacksmith cannot find his place in a modern society founded upon technology – explicitly drawing upon expressionist paintings. *Chromophobia* (1965) implicitly references the works of Picasso. Although Servais, often financed both through the French and Flemish communities, worked in an autonomous and artisanal way as far as the making of his short films are concerned, two of them were indeed commissions. *Chromophobia*, which recounts the story of a world invaded by a grey multitude aiming at establishing the domination of the black-grey-white, was commissioned by the Belgian Education Ministry. *Het Lied van Halewyn* (1976), a television episode adapting a medieval song, was commissioned by a Roman production company, La Corona Cinematografica.

Servais was profoundly marked by the events of World War II, and his films reflect a committed stance, testifying to a complexity that is both formal and symbolic. The subject and the script determine the visual and sonic treatment of his films. The œuvre of the film-maker is characterized thus not only by a formal investigation but also by a thematic research. In *Havenlichten*, he uses light as a dramatic and narrative element, and in *Chromophobia*, colour is conceived as a signifying actor. In *Sirène* (1968), in which a sailor falls in love with a mermaid, colours literally translate a true dichotomy between the two universes: red serves the purpose of illustrating dramatic sequences, while blue highlights romantic and oneiric scenes. Furthermore, the sinuous style of the drawings has a poetic purpose in this ode to freedom. Lastly, in *Opération X-70* (1971), in which experiments are conducted involving a new gas, which plunges its subjects into a lethargic and soporific state, the cold and documentary tone of the film aims at translating a lurid universe marked by the Vietnam War. Servais' oeuvre offers a pointed critique of totalitarian political regimes in which religion, justice, capitalism, consumer society, militarism or even language are manipulated. Although producing films with widely diverse styles and techniques, his highly personal and emotional cinema offers a plastic and pictorial vision which demonstrates a deep humanistic commitment, as well as philosophical and aesthetic research. In *Pégasus*, the film-maker does not shy away from denouncing the ills of modernity and the technological era; *To Speak or Not to Speak* (1970) opposes the incoherence of the words of an interviewed man on the street about the political situation to the thought-out opinion formulated by a marginal character. The irritation provoked by the repetition of the sentences, whose rhythm and tempo increases to the point where words become incomprehensible, is in perfect harmony with Servais' idea of language as a reified consumer good. However, with *Harpya*, which tells the dark story of a man, Mister Oscar, who rescues a harpy, and *Nachtvlinders*, which takes the spectator on a walk through a train-station waiting room, the film-maker seems to drift from this ideologically-committed stance, privileging form instead. It is also important to note the constant evolution resulting from a refusal, on the part of the author, to repeat himself – a defining characteristic of Servais' œuvre. In constant renewal, his work has never ceased to evolve, from the 1960s to the 2000s and beyond, particularly as regards the techniques used for his drawings: while his first animation shorts strongly resemble drawings and traditional illustrations, Servais has ceaselessly perfected his style and visual universe, as 'Servaisgraphie' attests. Beyond the invention of this process and the founding of the first European school of animation cinema, he is recognized and admired for his talent, his creativity, the seriousness of his work, the thought-out and careful *mise-en-scène* of his films, the

themes they broach and the constant renewal which characterizes his oeuvre as a whole, rendering him the Belgian animation artist par excellence. Finally, let us point out that he waited many years before completing his only feature film, the highly anticipated *Taxandria* (1994), which tells the story of a state from which the notion of time has been banished. The film was very poorly received by critics. The result of Servais' collaboration with Frank Daniel, among others, on the script, *Taxandria* appears as a less personal work, located mid-way between auteur and entertainment cinema. Much less efficient and committed than the film-maker's short films, *Taxandria*, through the use of a technique invented fifteen years earlier, seemed a bit dated by the time of its release. Of this film, Servais himself stated, 'It is not an animation film'. It is thus not surprising that in his subsequent films, he returned to the short form, the place of real artistic freedom.

Géraldine Cierzniewski

Translated by Marcelline Block and Jeremi Szaniawski

Harpya

Studio / Distributor:
Absolon Films

Director:
Raoul Servais

Screenwriter:
Raoul Servais

Cinematographers:
Raoul Servais (animation)
Walter Smets

Composer:
Lucien Goethals

Duration:
9 minutes

Genre:
Animated short

Cast:
Will Spoor
Fran Waller Zeper
Sjoert Schwibethus

Year:
1979

Synopsis

Walking in a town square at night, a moustachioed man hears sounds of distress and sees a man strangling a woman in a fountain. He runs up behind the man and knocks him unconscious, and sees that what he thought was a woman is in fact a harpy: a large bird with a bald head, pale skin and a woman's breasts. Pitying the creature, he takes it home to care for it. He discovers it has an insatiable appetite; when he sits to eat his dinner, it flies down to the table and devours the food. Soon, it eats all his food and, when he tries to leave the house, it eats his legs. One night, walking on his hands, he sneaks out to buy some French fries but, as he eats them, the harpy appears. He snaps, and starts to strangle it. A soldier witnesses the assault, and runs over to the harpy's rescue.

Critique

Raoul Servais's renowned short is one of the best in Belgian cinema. The control the director displays of both his style and subject elevate *Harpya* into the highest class of short films: those that do not seem like apprentice pieces, or advertisements for the skills of a film-maker hoping to earn backing for a feature film but, instead, are fully realized, self-contained works which exemplify the potential for potency and succinctness inherent in the short film form.

Much of *Harpya*'s impact comes from its visual scheme, which Servais created by mixing live action and animation in a complex process involving 35mm front projection onto black velvet backgrounds, the retroreflective material Scotchlite and a multiplane camera. The technique causes the primary figures in any shot (the man, his parrot, the harpy, the dinner table) to appear brightly lit, while the areas around them (the walls, floor, streets, etc.) appear in near-darkness. Objects in the foreground seem to be lit by bright moonlight and yet this light does not spill onto the objects around them. The effect is unsettling. No film has ever looked quite like *Harpya*, and it is because of this that several of its oddest images – the harpy, the legless man eating atop a stone pedestal, the man putting on three hats, one on top of the other – prove as unforgettable as the images that fill Luis Buñuel's famed surrealist short *Un Chien Andalou* (1929).

Harpya's aural scheme is almost equally alarming. Without dialogue, it is composed of creaking floorboards, echoing steps, and bird shrieks. These are the sounds of children's nightmares and, by recalling bad dreams, the film's soundtrack instantly connects with subconscious fears. Its plot plays upon them. The scenario of a beautiful, apparently vulnerable female arousing the protective instincts of a man, only to manipulate and eventually devour him, is a primary male fear and consequently a staple of film narratives. (Indeed, in some genres, *film noir* or the modern American 'erotic thriller', for example, it has been so overused it has become a cliché.) In *Harpya*, though, its presentation is so unusual that it shocks, intrigues, and appals, and the plot becomes a key component of the film's uncanny atmosphere.

The film is simply too strange, and too charged with surrealism, to support a single reading. For male viewers, it may inflame fears about the danger of committing to a settled relationship with a woman (the harpy, who is supposedly being cared for by the man, soon controls him and rations his appetites; when defied, the harpy gnaws off his legs in a startling representation of castration). It can also be read as demonstration of the terrifying potential for any person, regardless of gender, to have their individuality diminished by another, stronger, personality and, as such, can been seen as a warning against committing to any kind co-dependence or, indeed, to any kind of intimacy. Ultimately, *Harpya* is so effective because its implications are as unnerving as its images.

Scott Jordan Harris

Taxandria

Studio/Distributor:

Iblis Films
Bibo Filmproduktion GmbH
Les Productions Dussart
Praxino Pictures
Mafilm
Belgische Radio en Televisie (BRTN)
Radio Télévision Belge Francophone (RTBF)
Hessischer Rundfunk (HR)
Nederlandse Omroepstichting (NOS)
Canal+
FilmNet
Club d'Investissement Média
Eurimages
Ministerie van de Vlaamse Gemeenschap
Ministère de la Communauté Française de Belgique
Centre National de la Cinématographie (CNC)
Berliner Filmförderung
ASLK-CGER Bank
Nationale Loterij van België
Loterie Nationale de Belgique/
Video Search of Miami

Director:

Raoul Servais

Producers:

Heinz Bibo

Synopsis

In order to prepare for his exams, a 10-year-old prince and his tutor are sent by the king himself to a deserted palace located along the seaside. The child befriends the lighthouse keeper, Karol, who also happens to be the keeper of the gates to Taxandria, the kingdom of eternal present, an immense and magnificent city. But this imaginary land is subject to a totalitarian regime from which the image is banned. Cameras are forbidden and any human representation is prohibited. However, two adolescents who refuse this tyranny defy the established order, get ahold of a camera obscura, and run away. By their side, the prince will discover love and freedom.

Critique

Belgian critics did not care much for *Taxandria* upon its release, but it received a much more favourable international critical response when fans of fantasy saw in it a poetic object, mysterious and childish. Perhaps the reason for the film's cold reception is that, after fifteen years of absence, Belgium expected more from Raoul Servais, its most important animation film-maker. As a matter of fact, *Taxandria* should have been quite different. After writing a synopsis as early as 1983, Servais proposed a storyboard of a film in which we recognize his limitless admiration for the oeuvre of Paul Delvaux (oneiric representations, immense and spectral cities, forlorn characters), and for Belgian surrealism in general.

But directing an animated feature film is costly, especially when the latter implies new technologies, 'Servaisgraphie,' whose foundations were laid with his *Harpya* (1979) but which had never really been experimented with. Since there exists no production company for animated features in Belgium, Servais proposed his film to Pierre Drouot and his company Iblis Films, which was used to supporting unconventional film-making ideas. But as the project moved on, the producers showed some reticence – first and foremost towards the references to Delvaux, whose imagery was not universally accepted among those involved in the project. The producers then

Bertrand Dussart
Dany Geys
Jacqueline Pierreux
René Solleveld
Dominique Standaert
Dénes Szekeres
Tharsicius Vanhuysse
Pros Verbruggen

Screenwriters:

Frank Daniel
Raoul Servais
Alain Robbe-Grillet

Cinematographers:

Gilberto Azevedo
Walther van den Ende

Art Director:

Suzanne Maes

Composer:

Kim Bullard

Editor:

Chantal Hymans

Duration:

82 minutes

Genre:

Animated fantasy/adventure

Cast:

Armin Mueller-Stahl
Elliott Spiers
Katja Studt
Richard Kattan
Julien Schoenaerts

Year:

1994

called François Schuiten, a comic-book graphic artist, famous for his collaboration with Benoit Peeters on *Les Cités obscures*. Servais proved enthusiastic, and the contribution of Schuiten, whose universe is composed of utopian and monumental imaginary cities, would prove decisive for the final result.

Over the years, the film was re-written several times, first by Frank Daniel, then by Alain Robbe-Grillet, but their influence did a disservice to the poetic style of Servais and modified, once more, the initial project. Besides, the era of CGI was arriving and, with it, new techniques of efficient digital implementation. The producers grew more and more reluctant about the total integration of Servaisgraphie, which they judged obsolete, preferring live capture with special effects, and limiting the use of the film-maker's technique to the décor of the town in which the boy walks.

Even if Servais himself was satisfied neither with the final product, nor with the film's mixed reception in view of the expectations its long gestation had generated, *Taxandria* is far from a failure. Beautiful and naïve, it is exemplary of the encounter between comic strip and animated cinema, where we find Servais's critical mind vis-à-vis society and totalitarianism. At the very least, the film constitutes an undeniable plastic and formal laboratory.

It is difficult not to see in *Taxandria* one of those hybrid films, whose cities, with their poetic and frenzied atmospheres, borne out of the mind of the film-maker, are conceived as animation and wind up in the realm of live capture. Servais is, in this respect, one of the precursors of the slick works following in his wake. For instance *The City of Lost Children/La Cité des enfants perdus* by Jean-Pierre Jeunet and Marc Caro (1995), the Gothic City of Tim Burton's *Batman*, some of David Lynch's creations, the later films of Jan Švankmajer, the realist experiences of the Quay brothers or Michel Gondry's *Science of Sleep* (2006), all first cut their teeth in the plastic arts and stop motion before building imposing cities or gloomy countries at the intersections of surrealism, dreamscapes, and, quite often, a child's worst nightmares.

Nicolas Thys

Translated by Marcelline Block and Jeremi Szaniawski

A Greek Tragedy

Een griekse tragedie

Studio / Distributor:

Cinété

Director:

Nicole Van Goethem

Synopsis

Three living caryatids (statues of women used as structural supports in ancient Greek architecture) stand atop stone pedestals holding up a triangular portion of a constantly crumbling temple. They are asleep. A falling piece of stone causes the first woman to wake up. She wakes the woman next to her and together they wake the third woman. The wind blows part of the first woman's dress from between her legs, exposing her. The second woman uses her foot to reposition it. An umbrella blows into the third woman, knocking her to the ground. The second woman catches a piece of debris to save the third woman, who groggily climbs back on her pedestal. Beneath

Producers:
Willem Thijssen
Linda Van Tulden

Screenwriter:
Nicole Van Goethem

Composers:
Jan Boonen
Luc Redig
Rudi Renson

Editor:
Chris Verbiest

Duration:
7 minutes

Genre:
Animated short

Year:
1985

them, someone walks past wielding a pickaxe, which snags the dress of the first woman and pulls her and the second woman from their pedestals. Only the third woman remains, holding up a single, broken, stone block, until she decides to join the two other caryatids in freedom, music and dance, leaving the rubble of the temple behind.

Critique

Nicole Van Goethem's hand-drawn debut is one of Belgium's best known animated films, largely because it won the 1986 Academy Award for Best Animated Short and thereafter earned a level of worldwide attention it would have otherwise been unlikely to receive. Unfortunately for its reputation, in winning the award, it beat John Lasseter's *Luxo Jr.* (1986), the first computer-animated film from Pixar Studios, and thus one of the most significant shorts of its era. Because of this, at least in the English-speaking world, *A Greek Tragedy* is often remembered chiefly, if not solely, as an undeserving Oscar-winner, and its name has almost become synonymous with the idea of the critical incompetence of The Academy of Motion Picture Arts and Science. While *Luxo Jr.* is certainly the superior film – it is more inventive, more amusing and far more influential – it is ultimately meaningless to judge a film through those over which it was given prizes, and *A Greek Tragedy* is overdue discussion that makes no mention of Pixar or the Academy Awards.

The film is characterized by its simplicity of style and content. The backgrounds, which change tone as the sun moves across the sky during the single day the film depicts, resemble carefully-composed watercolour paintings and the comically simple figures of the main characters recall those in Picha's *Tarzoon: Shame of the Jungle/Tarzoon, la honte de la jungle* (1975), on which Van Goethem worked as a background animator a decade earlier. Consequently, the story, which is similarly light and direct, completely fits the style in which it is told.

The film's comic mood is set from its first moments. After the opening credits, a quote, attributed to Lord Byron, appears onscreen: 'Quod non fecerunt Scoti fecerunt Cariatidi'. This is supposedly a sequel to Byron's famous attack on the (Scottish) Earl of Elgin's removal of sculptures from the Parthenon, 'Quod non fecerunt Gothi, hoc fecerunt Scoti' ('What the Goths could not destroy, the Scots did'), and translates as 'What the Scots could not destroy, the Caryatids did'. It is the only verbal joke in the film, which has no dialogue. *A Greek Tragedy* plays like a silent comedy with sound effects, with each comic situation building towards a larger one and finally to a joyous climax.

The film flows from a basic idea – that the sculptures of women used in ancient Greek temples are actually alive – and advances it logically without overstretching it. The caryatids' task, holding up a portion of a building, most of which has already collapsed, seems futile at the start of the film and becomes more so as its plot progresses, with the women finally beginning to question their previously-unswerving devotion to their occupation. In their Sisyphean function there is perhaps a metaphor or even an allegory

but, if there is, it is an obscure one and, indeed, such added depth would unbalance a film that displays such unashamed shallowness throughout. *A Greek Tragedy* has no great ambition: it aims to be a charming and unchallenging short animation, a task at which it succeeds entirely.

Scott Jordan Harris

Kirikou and the Sorceress

Kirikou et la sorcière

Studio:
Les Armateurs
Odec Kid Cartoons
Monipoly Productions

Director:
Michel Ocelot

Producer:
Didier Brunner

Screenwriter:
Michel Ocelot

Art Department:
Michel Ocelot

Production Design:
Anne-Lise Koehler
Thierry Million

Composer:
Youssou N'Dour

Editor:
Dominique Lefever

Duration:
74 minutes

Genre:
Animated drama

Cast:
Doudou Gueye Thiaw, Maimouna N'Diaye, Awa Sene Sarr
Robert Liensol

Year:
1998

Synopsis

In a West African village, apparently during the colonial period, a boy so precocious he talks to his mother from inside the womb is born and names himself Kirikou. Hearing that a sorceress has enslaved his village and eaten its young men, he decides to accompany his uncle to confront her. Kirikou steals a hat and hides inside it, leading the sorceress to believe the hat is magic and to prevent her from killing his uncle. The sorceress attempts to capture the village's children, first by luring them into an enchanted boat and then up an enchanted tree, but Kirikou twice saves them. He discovers the monster that has been drinking the village's water, causing a terrible drought, and bursts it with a fire poker. He is told that, to learn how to defeat the sorceress, he must make a hazardous journey to consult with his grandfather, a powerful sage, and so sets off to find him.

Critique

Judged by the frequency with which it is achieved, one of the most difficult feats in modern film-making is for a great and widely popular animated feature to be made outside of the United States or Japan. Though not as popular in the English-speaking world as it deserves to be, Michel Ocelot's *Kirikou and the Sorceress/Kirikou et la sorcière*, produced in part with Belgian funds, is just such an achievement. It displays some of the features (a story based, at least in part, on old and fantastical tales; a sing-along theme song; and meticulous hand-drawn animation) that characterize the great animated features of Disney but marries them with a sensibility (most obvious in the villagers' constant but empathically non-sexual nudity, which has hampered the film's distribution and certification in some countries) that is far removed from them. Consequently, to the English-language viewer, it feels both fresh and familiar.

The film's use of perspective is particularly noteworthy in an age in which many mainstream animated films are shot in digital 3D. The opening sequence, in which the 'camera' moves through a landscape populated by trees, bushes and huts, displays a command of perspective, and creates an illusion of depth, which is noticeably more convincing than that achieved by the makers of many of those aforementioned 3D features. *Kirikou* is also characterized, however, by the flatness of many of its images. Indeed, many of the film's most striking sequences employ silhouettes, the use of which is a consistent feature of Ocelot's oeuvre and draws unavoidable comparisons with the work of Lotte Reiniger. This delicate command of perspective has

one key result: it draws attention to itself. Whereas most animated movies settle upon a depth of field, a two-dimensional approximation of a three-dimensional environment, and stay with it throughout their running time, *Kirikou*'s occasional shifts in perspective remind the viewer of its director's voice and, as such, they function in similar, though far subtler, ways as camera zooms or quick edits do in live-action films.

To those accustomed to the animated films of Disney, Pixar, and Studio Ghibli, the shallow two-dimensional images that predominate in the film feel almost artificially flattened and, unlike the images in most of the aforementioned studios' works, they recall not those of other films but rather the illustrations in a children's storybook. Furthermore, the way the film is composed of short, self-contained stories, loosely linked by the larger tale of Kirikou's battle with the sorceress, recalls the structure of a children's adventure story, and each episode feels like a self-contained chapter.

It is brave, then, that a film so tied to childhood memory, and so carefully designed to capture and hold the interest of children, opts for a conclusion that will challenge, and perhaps confuse, younger viewers and appears to tell them that although the child Kirikou is superior in wits and accomplishment to the adults around him, it is still better for him be an adult than a child. Such courage, though, is characteristic of the film. *Kirikou and the Sorceress* is a bold, accomplished work and deserves to be celebrated as such.

Scott Jordan Harris

A Town Called Panic

Panique au village

Studio/Distributor:

La Parti Productions
Made in Productions
Mélusine Productions
Beast Productions
Canal+ Horizons
Canal+
Centre National du Cinéma et de l'Audiovisuel de la Communauté française de Belgique
Fonds National de Soutien à la Production Audiovisuelle du Luxembourg
Gébéka Films
Le Tax Shelter du

Synopsis

A Town Called Panic follows the zany adventures of three plastic toys – Cowboy, Indian, and Horse – who happen to be housemates. It is Horse's birthday, and the other two decide to surprise him by building a barbeque. The plan backfires when an accidental error results in the delivery of 50 million bricks to the characters' rural community. The rest of the film depicts a nonsensical, slapstick-driven joyride featuring a giant penguin robot and mischievous, flipper-sporting sea creatures, all of whom seem to have conspired to keep Horse from making his music lesson appointment with Madame Longray, his alluring equine love interest.

Critique

Jan Švankmajer has said that animation enables him 'to give magical powers to things'. To quote him, 'Suddenly, everyday contact with things which people are used to acquires a new dimension and in this way casts a doubt over reality. In other words, I use animation as a means of subversion' (Wells 2002: 11).

In their joint directorial effort, the stop-motion feature *A Town Called Panic* (2009) – a spinoff of the eponymous 2003 television series broadcast by Canal+ – animators Stéphane Aubier and Vincent Patar engage the medium's inherent phantasmagoric qualities to

A Town Called Panic. The Kobal Collection.

Gouvernement Fédéral de Belgique
Les Films du Grognon
Made in PM
Radio Télévision Belge Francophone (RTBF)
Région Wallone
Vlaams Audiovisueel Fonds
Wallimage/Cinéart
Gébéka Films
Nutopia
Angel Films
Frenetic Films
Zeitgeist Films

Directors:

Stéphane Aubier
Vincent Patar

Producers:

Xavier Diskeuve
Philippe Kauffmann
Guillaume Malandrin

conjure up a charmingly-chaotic vision of lost childhood out of several nondescript plastic toys and offer a nostalgic look at the simple, organic magic of pre-digital cinema. While playfully subverting tropes of the western (Horse is more sophisticated and intelligent than the bumbling duo of Cowboy and Indian), *A Town Called Panic* also incorporates elements of romance, detective story, and monster flick, mixing them up in a stylistic mélange which lovingly pokes fun at cinematic convention. The courtship scene between Horse and his equine love interest, her long mane blowing in the wind, is worthy of classical Hollywood – if only Hollywood could take itself less seriously.

Respecting the norm is never a priority for a movie so strongly rooted in the purest, most spontaneous expression of human imagination – child's play (with toys!). In fact, throughout, the film-makers remain consistent in their unapologetic lack of concern for the basic representational rules of perspective, proportion, and relative size. This results in delightful gags based on purely visual play, as for instance when a character drinks from a cup he could comfortably fit in, or consumes a meal which his stomach could never accommodate. Paradoxically, such detours from conventional cinematic realism arise from the directors' awareness of and adherence to the material reality of the objects used. If Horse's toothpaste is as large as he is (to obvious comical effect), it is simply because the horse toy itself is,

Adriana Piasek-Wanski
Stéphane Roelants
Vincent Tavier
Arlette Zylberberg

Screenwriters:

Stéphane Aubier
Vincent Patar

Cinematographer:

Jan Vandenbussche

Art Department:

Geoffrey Druard
Jean-Philippe Dugand
Laurence Gavroy
Andre Odwa, Christine Polis
Laurent Talbot
Manu Talbot, Pierre Wilock

Composers:

Dionysos
French Cowboy

Editor:

Anne-Laure Guégan

Duration:

75 minutes

Genre:

Animation/fantasy/adventure/comedy/family

Cast:

Stéphane Aubier
Jeanne Balibar
Nicolas Buysse
Véronique Dumont
Bruce Ellison
Christine Grulois
Frédéric Jannin
Benoît Poelvoorde

Year:

2009

indeed, the size of a tube of toothpaste. Certainly, this overt disregard for artificially-imposed verisimilitude is also at the core of the film's unorthodox and unpredictable architecture, which constantly challenges and destabilizes the viewer's perception of space. For instance, the prison, a seemingly tiny hut, appears to enclose infinite space and the inside of Horse's house is surprisingly roomy, creating the illusion of an alternate dimension hidden behind its façade.

If space – to recall Švankmajer – 'acquires a new dimension' in this film, so does movement. Norman McLaren has famously defined animation as 'the art of movements that are drawn' (Furniss 2007: 5). *A Town Called Panic* draws movement by foregrounding its limitations. Once again refusing to cheat the spectator by overcoming the physical parameters of its 'actors,' the film animates the movement of plastic toys still anchored to their bases (i.e. with immobile legs). The resulting jerky wobble may belong with Monty Python's 'Ministry of Silly Walks,' but it consciously uses estrangement in order to draw attention to the distinct way in which the stop-motion method creates movement. In that sense, this movie is a self-reflexive look at the animator's art, a celebration of the marriage of movement and stasis that is animation.

A delightfully original prototype, *A Town Called Panic* is also self-reflexive in the way it affirms its Belgian-ness: through its soundtrack, as many famous actors of the francophone scene voice the characters with inescapably regional accents. In so doing, the film allegorizes the communitarian patchwork of Belgian culture, showing how nonsense and humour may be its best remedies. But it also illustrates how it is the endless supply of goods that causes Belgium's cataclysmic stirs but perhaps also fosters its unity. In this sense, *A Town Called Panic* is far more political than may first strike the eye, and its politics are rather pessimistic, its main affect being that of nostalgia: nostalgia for a bygone childhood, as well as for a bygone Belgian era. Finally, *A Town Called Panic* expresses nostalgia for a marginalized art form. It is the expression of a longing for the simplicity embodied by simple plastic toys and papier-mâché decors, for a long-lost ideal of creativity left to roam free, unburdened by technological crutches. It is this creativity – at once free-spirited and rebellious – that permeates Stéphane Aubier and Vincent Patar's work, itself a rare gem of the organic, honest animation that is all but dead in today's digitally-enhanced world.

Mihaela Mihailova

Ernst Moerman's
Monsieur Fantômas
Films Hagen-Tronje.

BELGIAN CINEMA AND THE OTHER ARTS

MAURICE MAETERLINCK AND CINEMA

While Maurice Maeterlinck (1862-1949) is a writer of global fame, his relationship with cinema – or rather, the relationship between his works and cinema – remains relatively unknown. Born in 1862 in Ghent to an upper-class French and Flemish speaking family, the young Maeterlinck chose to pursue literature after first having studied law. Immersing himself in Symbolism, he participated in avant-garde artistic and literary circles in Brussels and Paris. Experimenting with diverse literary genres – such as short stories, novels, poetry, and theatrical works – Maeterlinck was 'discovered' by Octave Mirbeau, who compared him to Shakespeare. Maeterlinck soon became the leader of the Symbolist movement: he delivered his 'first theatre' – and certainly his *chef-d'oeuvre* – *Pelléas et Melisande* in 1893. Settling in France, he continued his literary trajectory, writing *Sister Béatrice/Soeur Béatrice* (1901), among other dramatic works during this transitional period, followed by his 'second theatre' and other major plays such as *Monna Vanna* (1902) and *The Blue Bird/L'Oiseau bleu* (1908). The Swedish Academy awarded him the Nobel Prize for Literature in 1911. In less than thirty years, Maeterlinck rose from quasi-anonymity to worldwide consecration. He became – and remains, to this day – the only Belgian writer to receive the Nobel Prize, the highest literary distinction.

Before 1905, the seventh art was in its earliest stages, far from enjoying its current legitimacy. Viewed as a mere 'carnival show', cinematic productions did not receive much credit amongst members of the educated public. Early forays into film – such as *The Assassination of the Duke de Guise/La Mort du duc de Guise* (Charles le Bargy and André Calmettes, 1908), made by the Société Film d'Art production company, contributed to the cultural elevation of film and the 'encounter between writers and the seventh art'. Around 1910, within this context, the first links developed between Maeterlinck and film. Maeterlinck's entry into this new domain coincides with that of other contemporary writers including Gabriele d'Annunzio, Rudyard Kipling, and Gerhart Hauptmann. At the same time, let us not forget that this new involvement was part of a broader strategy of dissemination: like other internationally renowned writers, Maeterlinck intended to have his dramatic works distributed worldwide, not only through their theatrical representations but also by translation; musical adaptation (for example, Claude Debussy's 1902 opera of *Pelléas et Mélisande*); and, finally, by recording live performances and screen adaptation(s).

Maeterlinck's relationship to cinema was most intense from 1910-1925. During this period, Maeterlinck maintained a steady

and sustained attention toward cinema, along with several other activities. The first indication of this interest is the recording, by Gaumont's cinematographers, of Maeterlinck's play *The Blue Bird* while it was performed in London at the Royal Haymarket Theatre in 1910. Between 1910 and 1918, dozens of projects were conceived, but only several were realized. Around 1913, Maeterlinck signed a contract with the AG-Union Produktion Company, concerning at least the film adaptations of *Monna Vanna* and *The Blue Bird*, but this Berlin firm ceded the rights to other producers. From 1914-1915, the Turin company SA Ambrosio produced the film version of *Monna Vanna*, directed by Mario Caserini. This was the first major cinematic adaptation of Maeterlinck, but the movie, distributed in a chaotic manner, did not achieve much success. During World War I, the French company Eclair also began adapting *The Blue Bird*, but then renounced the project. Yet Eclair made two less-expensive Maeterlinck projects in 1916: the adaptations of *Pelléas and Mélisande* and *Macbeth* (from Maeterlinck's translation), both directed by Gustave Labruyère and filmed at the Benedictine Abbey of St. Wandrille, the author's own residence. Finally, Adolph Zucker's Famous Players-Lasky/Paramount re-bought the rights to *The Blue Bird* from Éclair and produced the film, directed by Maurice Tourneur (1918).

Tourneur, a French expatriate living in the United States, was considered one of the best directors of this epoch, after DW Griffith, Thomas H. Ince, and Cecil B. DeMille. Trained in illustration and decoration, a man of the theatre and then of the cinema, Tourneur was known for his plastic sense of the image. Aided by cinematographer John van den Broek and set designer Ben Carré, he directed a sumptuous adaptation of Maeterlinck's work. The stylization of certain sequences was perhaps inspired by the great British stage director Edward Gordon Craig. There is a strong contrast between the scenes that are treated in a realistic manner and those that present a composition of lines and of forms that are delicately lighted. This research into lighting shows the degree of the director's formal exigency, and situates the film, on the whole, on the creative side. Screened in a large cinema in New York City, The Rivoli, *The Blue Bird* was, however, a commercial failure. Yet, today, that fact does not prevent the film from being listed by the National Film Preservation Foundation, nor from being counted among the classic American films of the 1910s.

In 1920, Maeterlinck travelled for a period of five months to the United States, where he took an important step in film: with Samuel Goldwyn and Goldwyn Pictures, he signed a two-year contract, giving Goldwyn the cinematographic rights to his works as well as of future screenplays and scripts that he would write. During his stay, he likely worked on several projects in the Goldwyn studios at Culver City, California, but none of them were realized. That same year, concrete plans were made concerning *Joyzelle* and *Sister Béatrice* (in the United States, with Alla Nazimova). Yet none of these plans came to fruition, no more than the three American propositions, in 1922-1923, concerning *Monna Vanna*. Ultimately, a new adaptation of *Monna Vanna* was made in Germany in 1922 by Richard Eichberg. In France, Jacques de Baroncelli directed the 1923 *Legend of Sister Beatrix* without, however, laying claim to Maeterlinck's *Sister Béatrice*.

Before, during, and after the Great War, Maeterlinck's interest in cinema was obvious. But the dispute that arose between him and Samuel Goldwyn – Maeterlinck reproached the American producer for not having used any of his scripts – undoubtedly affected his pursuit of other film projects. After 1925, his interest understandably diminished. A few words in his correspondence or at a lecture suggest that he had distanced himself from the cinema or that he had even renounced it altogether. In 1929, he however let the British theatre actor John Martin-Harvey adapt *The Burgomaster of Stilmonde/Le Bourgmestre de Stilmonde*

(1918), written at the end of World War I and which Maeterlinck himself considered a 'propaganda play'. In 1939, 20th Century Fox re-purchased the rights to *The Blue Bird* from Paramount and produced a second adaptation, this time with sound and in colour.

This new adaptation of *The Blue Bird* must be understood in its function as a star vehicle for Shirley Temple. Although she had once been considered among the most highly regarded actresses of 20th Century Fox – much more so than the studio's older stars – Shirley Temple's career was now in decline. As a young adolescent, she was no longer the right age for the roles that had been traditionally assigned to her. Through *The Blue Bird*'s protagonist Mytyl, producer Darryl F Zanuck saw a possibility of prolonging Temple's longevity as an actress. The script was thus remodelled to fit the star. Therefore, while in the original play Mytyl was the foil for her brother Tyltyl, in the film, the rapport between the two was inverted: Mytyl became the main character and the number of her lines was largely increased. In addition, the character of Mytyl is linked to other characters played by Temple in previous film productions. For example, in *The Blue Bird*'s scene of the meeting with the grandparents, a sequence sung and danced by Temple does not exist in Maeterlinck's text. This sequence harkens back to Temple's singing and dancing in *Heidi* (Allan Dwan, 1937) and *The Little Princess* (Walter Lang, 1939). This second film adaptation of *The Blue Bird*, made in a rather conventional manner by Walter Lang, was distributed in 1940 but did not achieve the success of another celebrated film of the same period, *The Wizard of Oz* (Victor Fleming, 1939), starring Judy Garland.

In 1939, Maeterlinck moved to Portugal, and then exiled himself to the United States, where he remained for the duration of World War II. He tried to reconnect with the film community but had no success. Returning to France in 1947, he died two years later, at the age of 87. After his death, a third adaptation was made of *The Blue Bird*, this time directed by George Cukor (1976), a US/USSR co-production, which was exceptional for the Cold War era. This film is infrequently cited in histories of cinema, because the aging Cukor was unable to successfully direct his renowned cast, including Elizabeth Taylor, Jane Fonda, and Ava Gardner. It is also worth noting several television adaptations of Maeterlinck's works, notably *Het mirakel van St. Antonius* (Belgian Dutch-speaking television, 1977) from *The Miracle of Saint Antony/Le Miracle de saint Antoine* (1904) and a 1980 Japanese cartoon inspired by *The Blue Bird*.

Maurice Maeterlinck had taken a genuine interest in cinema, albeit during a relatively short period. His cinematic fortune is not comparable to his literary one, but it is not certain that it has fully ended yet. On the one hand, there are numerous recordings of the opera *Pelléas et Mélisande* by Debussy – notably the one produced in 1999 at the Glyndebourne Opera Festival in England – while on the other hand, Gust Van Den Berghe presents, in the form of a tale unfolding in Africa, a contemporary fourth film adaptation of *The Blue Bird* (Belgium, 2011).

Christian Janssens

Translated by Marcelline Block

BELGIAN SURREALIST CINEMA

Surrealism was an avant-garde movement of high modernism that valorized the base, the pagan and the 'primitive,' the amorphous and the transgressive, the irrational and the physical as primary themes and practices in cultural production. These values were positioned in direct opposition to the elevated, the Christian and the civilized, the orderly and the progressive, the scientific and the abstract – the normative values that dominated conventional high modernist life. Numerous artists, authors and intellectuals joined – and left – the Surrealist movement over the course of the 1920s and 1930s. Despite their differing degrees of involvement, all affiliates of Surrealism were united in a fundamental commitment to the subversive and even revolutionary potential of drives and desires liberated from the unconscious mind and fused with conscious experience. Sigmund Freud had established the basic principles of psychoanalysis in order to apply them strategically in the treatment of his patients' psychopathologies. The Surrealists, on the other hand, adapted the principles of psychoanalysis to artistic creation, making collages, paintings, poems, and films inspired by dreams, transference, and random chance. They provocatively suggested that madness could provide a promising model for radically new and free social identities and, eventually, whole societies. As Surrealism's founder, André Breton, wrote in the movement's 1924 manifesto: 'The imagination is perhaps on the point of reasserting itself, of reclaiming its rights.'

Surrealism was firmly rooted in francophone culture and predominantly male, despite the decisive participation of a number of women as both independent creators and creative collaborators. The pinnacle of Surrealist creativity occurred in the late 1920s, when tracts, poems, artworks and films proliferated in resonance with the movement and seemed to constitute a brief but remarkable united front of avant-gardist output. In France, Surrealism is often characterized as a two-headed monster: one head is that of André Breton, who wanted the Surrealists to join forces with the Communist party and who was later denounced by disaffected members who regarded him as a hypocritical pope administering cloying Surrealist sacraments and unjustified excommunications. The other head is that of Georges Bataille, whose engagement with base materialism was shocking even by Surrealist standards. Bataille's literature dismissed the ideals of the marvellous and the beautifully convulsive – which clung stubbornly to much Surrealist production – and instead explored the limits of bodily disgust.

In contrast to France-based Surrealism, Surrealism in Belgium lacked a head altogether. Two loose clusters of Surrealists formed there, one in Brussels and one in the Hainaut province. Both profited creatively from their lack of a charismatic leader and their distance from French Surrealism proper. Their exchange of ideas was facilitated by museum and gallery exhibitions and a number of publications (Œsophage, the *Bulletin international du Surréalisme*, *Mauvais temps* and others). If a singular figure looms large in Belgian surrealism, it is undoubtedly artist René Magritte, who became famous for his enigmatic – and enigmatically titled – paintings after the Second World War. Magritte did not contribute significantly to the theory of the Belgian movement. However, his particular version of the Surrealist aesthetic was incredibly influential, and can be helpful for understanding the representational logic of many Belgian surrealist artworks and those inspired by Belgian surrealism in later decades.

Magritte's paintings seamlessly integrate a troubling and transgressive element into a composition that follows all the customary representational rules of naturalism and figuration. For example, in Magritte's 1934 painting *The Rape/Le Viol*, the face of a

woman is replaced by an entire female body, breasts serving as eyes and pubic area as a mouth. This systematic and repeated use of the *insolite* – the unexpected that startles us from within the routine – is common in much of Belgian surrealism. Simultaneously droller and more cerebral than the French surrealist aesthetic, it often depends on textual supplements and strongly guided associative readings of images. It is particularly evident in three films that Belgian film-makers made in the period between 1927 and 1937, strongly influenced by Belgian surrealism: Henri d'Ursel's *La Perle* (1927), Henri Storck's *For Your Beautiful Eyes/Pour vos beaux yeux* (1929) and Ernst Moerman's *Monsieur Fantômas* (1937).

Of these three film-makers, Henri d'Ursel and Ernst Moerman were most closely aligned with Surrealism as an avant-garde movement. Both men produced only one film during their lifetimes. Ursel lived in Paris for a significant period of time, absorbing the confluences of Parisian-based Dadaism and Surrealism. *La Perle*, which prominently features a pearl necklace as a fetishistic stand-in for libidinal attraction, seems to anticipate the mysterious pickled starfish around which the obscure (and obscured) narrative of Man Ray's *L'Étoile de mer* (1928) revolves. *La Perle* tells the elliptical story of a young man who intends to buy a strand of pearls for Lulu, his girlfriend. She waits drowsily and contentedly for him in a far-off garden. He ends up snatching a necklace from the hosiery of an alluring shopgirl, who then hitches a ride on his bicycle handlebars. When he accidentally breaks the necklace, she slips one pearl from the strand back into her stocking. A violent scene follows; then, in one of the film's most gorgeous and disturbing shots, he retrieves the pearl from her open lips. Her unconscious face, which fills the frame horizontally, is both mask and landscape at the same time. The next section of narrative pays loving homage to Louis Feuillade's silent film serial, *Les Vampires* (1915-1916): the shopgirl is resurrected as one of Irma Vep's female band of cat burglars. Meeting this black-clad thief in the hotel hallway and quickly recognizing her, the young man is smitten. They spend the night together, but the strand of pearls she had stolen is stolen once again by a ghostly female somnambulist, who ultimately drapes it around Lulu's neck. The film ends by repeating its original tragedy, and viewers are left to ponder the beautiful cinematography of Marc Bujard and the macabre eroticism of these pearl-obsessed encounters at the same time.

Like Ursel, Moerman also benefited from close contacts and friendships with Surrealists in France; cinephiles familiar with Dada associate René Clair and Surrealist Luis Buñuel might playfully consider *Monsieur Fantômas* as the conceptual hybrid of the former's *Entr'acte* (1924) and the latter's *L'Âge d'or* (1930). Moerman declares his allegiance to Belgian surrealism by billing his film as surrealist on its title card and by including a vignette dedicated to Magritte's *The Rape*. In it, Moerman himself makes a cameo as the painter, putting the finishing touches on the famous canvas. Like *La Perle*, *Monsieur Fantômas* is an unambiguous tribute to Louis Feuillade, the silent film-maker whose ingenious, addictive serials captured the imaginations of film-goers in the 1910s and the Surrealistically-inclined thereafter. Moerman uses the formulaic structure of Feuillade's *Fantômas* serial (1913-1914) as an improvisational base. Fantômas is transformed from dashing criminal into love-crazed and farcical murderer. He brings his lover Elvire (dressed in an outrageous cone bra, cone crown, veils and swimsuit bottom) back to his home – a stand-alone door and threshold propped on the beach. Using a giant key to break down the unnecessary door, a group of detectives find the lifeless body of Elvire and put Fantômas on trial. Moerman's film features a number of wickedly funny scenes skewering the Catholic church in a parallel to Monsieur Fantômas' seaside antics – clergymen file out of public urinals and nuns and priests square-dance.

Henri Storck's film-making was more sustained and wide-ranging than Ursel's and Moerman's; he sampled widely from film history in order to create his unique and politically engaged film aesthetic, becoming one of Belgium's most respected and influential documentary film-makers. Storck was intimately involved in the institutional life

of cinema from an early age, supporting and in turn drawing support from local ciné-club culture. He co-founded the Cinémathèque Royale de Belgique with Andre Thirifays and Pierre Vermeylen in 1938, an archive that proved instrumental in securing a past as well as a future for film culture in Belgium. Storck's *Pour vos beaux yeux* is an unusual mediation on the human eye as the initiator and the receptor of desire. Sight was the sense that Surrealism most prized and most distrusted, and Storck's film is a fitting illustration of this paradox. A display case full of gleaming metal scissors and other sharp instruments is juxtaposed with a close-up of rows of glass eyes. They are neatly arranged inside a box that resembles those containing liqueur-filled chocolates. A young man who had found a similar prosthetic eye in the gravel of a public park tries to mail it unsuccessfully to the Orient. When the postal service refuses to accept his package, he places the eye on a black column pedestal, springs onto the pedestal, and sits upon it.

Any overview of Belgian surrealism in cinema would be incomplete without a consideration of the important effect the movement had on experimental film-making after World War II. Marcel Mariën and Marcel Broodthaers are two artists who worked directly within the heritage of Belgian surrealism from the late 1950s onwards. Although Mariën had engaged with prominent Belgian surrealists Paul Nougé, Louis Scutenaire and René Magritte in 1937 and had participated in a Surrealist art exhibition in London, his most significant contribution to the movement did not come until 1954, when he began the international journal, *Les Lèvres nues*. *Les Lèvres nues* nourished a revival of avant-garde thought and creation in France and Belgium for second-generation Surrealists as well as the International Lettrists and later, the Situationists. Mariën penned a series of articles for his journal that advocated a cinematic montage of discrepant sound and recycled images. Mariën pointed to newsreels as an excellent model for this kind of hybrid film: in them, events were put together regardless of time, setting, context, or content. Mariën's call for a cinema of selective and subversive re-use is a call for *détournement*, one that anticipated and then resonated with *Les Lèvres nues* contributor Guy Debord's detailed theorization of the term. Like Debord, Mariën put his cinematic theory into practice with his subsequent film-making: Mariën completed *L'Imitation du Cinéma* in 1959. Its inspired editing allowed numerous instances of advertorial and religious appropriation. The film's climax is a series of astonishingly creative metonyms for sexual acts.

Marcel Broodthaers' surrealist-influenced films were less socially perverse but no less creative. Throughout his career as an installation artist and film-maker, Broodthaers was interested in cinema as moving images as well as an abstract concept. One of his most important early films, *Le Corbeau et le Renard* (1967) exemplifies this interest. With it, Broodthaers created an alternative viewing environment as well as an alternative non-narrative film: the film consists of photographic images, objects, and poetry text projected onto a special screen printed with a fragment of the titular La Fontaine fable. Spectators are treated to an illegible and complex layering of meaning – a filmic experience with its formal roots in Surrealism's automatic writing and its philosophy in postmodern conceptual art. In *Le Corbeau et le Renard*, wrote Broodthaers, 'cinema is used as a procedure, like photography in photographic painting'. The unexpected within the expected that characterizes Belgian Surrealism's legacy in film-making is turned into illusory words and images on top of material ones.

Jennifer Stob

GEORGES SIMENON AND CINEMA

Georges Simenon (1903-1989) is the Belgian author whose work is most frequently adapted to cinema, with 61 adaptations to the big screen and dozens of others for television. Simenon's works have been selected by producers and directors for adaptation during an exceptionally long period of time, from the 1930s until the present. Reviewing the cinematic adaptations of his works between 1932 and today provides an opportunity to traverse the history of cinema, at least since the days of the sound film.

Born in 1903 in Liège, the great Walloon metropolis, Georges Simenon left school at an early age and became a journalist. A young man on a mission, he settled in Paris at age 19, immersed himself in writing popular novels. He wrote approximately two hundred works of fiction under seventeen different pseudonyms. When the publishing house Fayard suggested that he create a detective character, Simenon invented Chief Inspector Maigret and produced a series of detective novels. Ten Maigret detective novels were published in 1931 alone, making him a phenomenon whose bestsellers attracted film circles. However, a limited number of producers and directors who were not yet well known were first interested in Maigret. In 1932, two film adaptations of his books were released: *Night at the Crossroads/La Nuit du carrefour* (Jean Renoir) and *The Yellow Dog/Le Chien jaune* (Jean Tarride). The latter director is, of course, not nearly as well known as the former. However, *Night at the Crossroads* is not a 'major' Renoir; rather, it is situated in the context of the master's training days, at the time that he was exploring possibilities of sound, image, and narrative. With *Night at the Crossroads*, Renoir worked with photography, chiaroscuro and, from this perspective it remains a remarkable film to this day.

In these two early film adaptations, Simenon intervened in matters of the script, editing, and dialogue. With the third cinematic adaptation of a Maigret novel, *La tête d'un homme*, Simenon went even further, controlling the entire project and assuming the role of director. But, in a few months, he saw his hopes dissipate and gave in to the production company, Vandal and Delac, which released the film in 1933, directed by Julien Duvivier. From this experience, Simenon felt the disappointment of not having been recognized as the film's auteur. After 1932, he distanced himself from cinema, especially as he was preoccupied with other concerns. In effect, during this period, he abandoned the detective novel, left Fayard and entered into the domain of 'serious literature', with a prestigious editor, Gallimard. Subsequently, his attitude toward cinema evolved. In a letter to Gaston Gallimard, he revealed his strategy: 'I would now like to request from cinema the monetary equivalent of what I received from the publication of my serial novels.' But producers showed little interest, it seemed, and the occasional projects did not come to fruition. For eight years, no further screen adaptations of his works were released.

While the 1930s were an important period for French cinema, Simenon was not part of it. Rather, it was under the Occupation that his relationship with cinema resumed. The Continental, the production company of the French Right under German rule, became the leader in the market. Its political aim was to promote a commercial, profitable entertainment cinema, and to produce French films for the French while avoiding the use of aggressive propaganda. Ultimately, its goal was to establish German cultural influence in occupied Europe. Between 1941 and 1944, the Continental found the tools of its policy in the works of Simenon. Other producers followed suit. In sum, nine adaptations

were made: three *Maigret*, along with six novels or short stories. Simenon was the most adapted author of the Occupation, ahead of Honoré de Balzac or Pierre Véry. Among these films, only *Le Voyageur de la Toussaint* (1943), adapted by Marcel Aymé from Simenon's novel and directed by a young Louis Daquin, has remained famous. Jean Desailly made his first onscreen appearance here, in the role of Gilles Mauvoisin, a shy heir confronted with the machinations of provincial notables.

The immediate post-war period was eventful for Georges Simenon. On the one hand, he left France for the United States – where he would reside for ten years – and on the other hand, he separated himself from Gaston Gallimard in favour of Sven Nielsen, a publisher who was less prestigious but upon whom he had greater control. In terms of cinema, the pace of adaptations diminished: four films were made between 1945 and 1951. Only three of them merit mention. In *Panic/Panique* (1946), adapted by Charles Spaak from Simenon's *Mr. Hire's Engagement/Les Fiançailles de M. Hire* and directed by Julien Duvivier, a superb Michel Simon played the role of an ordinary man misunderstood and persecuted by his neighbours. *La Marie du port* (1950), directed by Marcel Carné, saw the first appearance of that other major Simenonian actor, Jean Gabin. Gabin also acted, opposite Danielle Darrieux, in *The Truth about Bébé Donge/La vérité sur Bébé Donge* (1952), one of Henri Decoin's finest films.

In the 1950s, French cinema fared well economically: restructured and supported by the government, the sector enjoyed international renown via the newly created Cannes Festival.

The French cinema 'Tradition of Quality' – a term used equally by its detractors and its supporters – which dominated the era, privileged two genres: psychological drama (preferably adapted from a work of literature) and the detective film. Having returned from the United States in 1955 and living in Switzerland, Simenon was in tune with the times. At the rate of four or five books a year, he published psychological novels and Maigret books. Producers and directors found his stories solid, his characters strong – elements that adaptors and screenwriters could bring to an international star. Between 1952 and 1965, sixteen Simenon adaptations were filmed by a dozen directors, including Claude Autant-Lara, Jean Delannoy, Gilles Grangier, Denys de la Patellière and Henri Verneuil. This success is also due to the presence of Jean Gabin. At that time, Gabin was undergoing a difficult professional period. No longer the young, mythic figure of the 1930s, he could no longer play working-class characters destined for a tragic ending. Gabin was therefore seeking a new persona, such as a more mature bourgeois personality in the throes of a mid-life crisis. He plays the role of the confused lawyer André Gobillat in *Love is my Profession/En cas de Malheur* (Claude Autant-Lara, 1958); the ruined baron Jerome Antoine in *The Baron of the Locks/Le Baron de l'écluse* (Jean Delannoy, 1960), and the disillusioned politician in *The President/Le Président* (Henri Verneuil, 1961). Not only was Jean Gabin a recurring figure in Simenon adaptations, but so were screenwriter Michel Audiard and producer Jean-Paul Guibert. This link between Simenon, Gabin, Audiard, and Guibert is especially visible in two adaptations directed by Jean Delannoy: *Inspector Maigret/Maigret tend un piège* (1957) and *Maigret and the St. Fiacre Case/Maigret et l'Affaire Saint-Fiacre* (1959). These two films emblematize the French 'Tradition of Quality': studio craftsmanship, technical virtuosity for camera frames and movements, dialogues and roles tailored for great actors and actresses. In the first film, Gabin/Maigret faces Jean Desailly, a weak man, who, dominated by his mother, becomes a serial killer. In the latter film, the inspector investigates the death of the Countess of Saint-Fiacre (Valentine Tessier). In the two scripts, the plot is similar, but the narrative strategies differ. While the novels are based on mysterious figures – whom the reader and protagonist discover simultaneously – the screenplays have more characters, and, notably, more figures of suspense. These differences mean that the aforementioned films relate less to the original source material and more to the cinematic genre of the detective film.

To the sixteen adaptations made in France, it is important to add five American adaptations, including *The Bottom of the Bottle* (Henry Hathaway, 1955). In the 1950s, Simenon reached the peak of his art as a writer. During those years, he was most popular in cinematic circles.

The decline of the French 'Tradition of Quality' could have been fatal to Simenon. Aside from Jean-Pierre Melville (*Magnet of Doom/L'aîné des Ferchaux*, 1962), producers and directors of the New Wave paid little attention to Simenon. After the failure of *Three Rooms in Manhattan/Trois chambres à Manhattan* (Marcel Carné, 1965), seven years went by before Pierre Granier-Deferre made *The Cat/Le Chat* (1971), *The Widow Couderc/La Veuve Couderc* (1971), *The Train/Le Train* (1971) and *The North Star/L'Etoile du Nord* (1982). In *The Cat*, we find Gabin for the last time alone with Simone Signoret as they are sequestered behind the closed doors of their home scheduled for impending demolition. The choice taken by Granier-Deferre is understanable in the sense that he is rather close to a commercial cinema, and is, on the whole, heir to the 'Saturday Night Cinema' of the 1950s. More surprising is the selection of Simenon by the directors linked, whether loosely or not, to 'auteurist cinema'. Bertrand Tavernier made *The Clockmaker of St. Paul/L'Horloger de Saint-Paul* (1973); Claude Chabrol, *The Hatter's Ghost/Les Fantômes du chapelier* (1981) and *Betty* (1992); Patrice Leconte, *Mr Hire/Monsieur Hire* (a 1988 remake of *Panic*), and Cédric Kahn, *Red Lights/Feux rouges* (2003). The acting is always of very high quality, whether by Philippe Noiret, Jean Rochefort, Michel Serrault, Charles Aznavour, Marie Trintignant, Stéphane Audran, Michel Blanc, Sandrine Bonnaire, Jean-Pierre Darroussin or Carole Bouquet. This selection is linked to the literary consecration of Simenon. He is no longer the author of popular works of fiction and detective novels of the 1930s. Since 1989, the year of his death – and after writing approximately two hundred other novels under his own name – he has become a universal literary figure, from whose *oeuvre* film auteurs draw inspiration and take what pleases them, while renowned actors find in it memorable characters.

Spanning 85 years, the selection of Simenon by film producers and directors is neither consistent, nor uniform, but is rather closely linked to fluctuations in the history of cinema. It is because French cinema moved from 'poetic realism' to 'neoclassicism' – which focused on particular genres (detective film, timeless psychological drama) – that the years of the Occupation and the 1950s constitute the height of Simenonian adaptation *par excellence*.

Christian Janssens

Translated by Marcelline Block

GHISLAIN CLOQUET

Ghislain Cloquet was one of the key contributors to the aesthetic and technical renewal associated with the French New Wave. He was a cameraman and director of photography for cinema and television, and also dedicated himself to teaching his craft in France and Belgium. His talent and expertise are recognized in Europe and the United States: they earned him a place in the American Society of Cinematographers and led him to the presidency of the 'Prise de vue' section of the Commission Supérieure Technique de l'Image et du Son (France).

Pierre Ghislain Cloquet was born on 18 April, 1924 in Antwerp, Belgium. He is the eldest of the three children born to Belgian architect Paul Cloquet and his French wife Anne-Marie Lafollye. Cloquet adopted his mother's nationality when his parents moved to France in 1940. He graduated from the Ecole Technique de Photographie et de Cinématographie (ETPC, France) in 1944, joined the French resistance during the German occupation, and eventually left the French army in 1946 to study at the Institut des Hautes Etudes Cinématographiques (IDHEC, France). He later seized the opportunity to work with prestigious cinematographers – including Louis Page and Edmond Séchan – but remained confined to the role of assistant. His decisive career breakthrough came as a result of the revalidation of the short film format, a development for which he is credited by memorable figures of the French New Wave, such as Alain Resnais, Chris Marker, Agnès Varda, Jean-Luc Godard, Claude Lelouch, and Pierre Kast, who gave Cloquet his first opportunity to work as a cinematographer on a feature film (*Girl in His Pocket/Un amour de poche*, 1957). Cloquet's already sophisticated use of photography was sought after by Jacques Becker for the production of *Le trou* (1959), in which the dramatic use of lighting was internationally acclaimed by critics.

Cloquet's contribution to the feature-film format revolutionized existing practices: indeed, his mastery of the so-called 'light-weight' techniques of the short film allowed him to liberate the shooting process from studio constraints while preserving framing precision. He also introduced the now-widespread practice of hanging technical equipment in order to clear the set and enlarge the field of action.

The value of Cloquet's contributions, however, goes beyond his pragmatic handling of technical constraints. Though gifted with an undeniable conceptual intelligence and artistic talent, these skills were always attuned to the director's universe and intuitions. Indeed, his collaborations demonstrate a deliberate stylistic modesty underpinned by a remarkable ability to serve directors with different, if not conflicting, demands. This has given rise, for instance, to the transcendental plastic imposed by Robert Bresson's demanding direction (*Au hasard Balthazar*, 1966). It has also facilitated the powerful expressivity he lent to the 'magical realism' of Belgian director André Delvaux – whether suggesting the ambiguity between dream and reality though monochrome (*The Man Who Had His Hair Cut Short/L'homme au crâne rasé*, 1966) or evoking the masters of French and Flemish painting through colour (*One Night... a Train/Un soir, un train*, 1968; *Appointment in Bray/Rendez-vous à Bray*, 1971). One could also mention the pop art flare of *The Young Girls of Rochefort/Demoiselles de Rochefort* (Jacques Demy, 1967) or the eloquent black and white *Nathalie Granger* (Marguerite Duras, 1972) both of which bear witness to Cloquet's sincere attachment to the intrinsic value of chromatism(s) and his ability to master the semantic palette of photography.

Cloquet has also collaborated with TV productions and, among others, worked with Maurice Cazeneuve (*L'exécution*, 1960), André Delvaux (*Double-vue*, 1963), and even Maurice Béjart (*Le danseur*, 1968). In addition, he worked as a lecturer (1954-1962) and director of studies (1974-1981) at the Institut des Hautes Etudes Cinématographiques (IDHEC, France); and at the request of André Delvaux, he taught two months each year at the Institut National des Arts et du Spectacle (INSAS, Belgium) between 1962 (the year the school opened) and 1974, the year when he started giving occasional classes at the University of Mexico.

In a matter of years, Cloquet emerged as one of the best cinematographers of his generation and captured the attention of American viewers. Seduced by Cloquet's modern use of black and white in *The Fire Within/Le feu follet* (Louis Malle, 1963), Arthur Penn sought his collaboration for *Mickey One* (1965). Likewise, Woody Allen was impressed by his contribution to *Faustine ou le bel été* (Nina Companeez, 1971) and requested his services for the production of *Love and Death* (1975). With *Four Friends* (1981), Penn remains the last director to enjoy the prestigious signature of Cloquet, the only Belgian-born person to having been inducted into the very selective American Society of Cinematographers (ASC since 1977).

Called to the rescue for the production of *Tess* (1979) by Roman Polanski, Cloquet masterfully continued the work of Geoffrey Unsworth, who passed away in the early stages of filming. This tour de force is undoubtedly one of his masterworks. It earned Cloquet one César (France, 1980) and an Oscar (Best Cinematography, 1981) that he shared with Unsworth, who was posthumously honoured. Cloquet and Unsworth also received top honours from the British Academy of Film and Television Arts, and from film critics' associations in Los Angeles and New York (1980).

Ghislain Cloquet died on November 2, 1981 in Montainville, France. His premature death ruined the prospect of a new collaboration with Polanski (*Pirates/Les pirates*, 1982).

Anne Gailly

Translated by Edward Lybeer

ANDRÉ DELVAUX, A POET AND PHILOSOPHER OF CINEMA

> ' *L'épanchement du songe dans la vie réelle*' / '*The outpouring of dreams into real life*' (Nerval)

André Delvaux was born in the town of Heverlée, not far from Leuven, on 21 March 1926, into a Flemish Catholic family. His life's journey was nothing short of exemplary. After studying in a francophone high school, he received his BA in Germanic philology from the University of Brussels. As a high school teacher, he also played the piano to accompany silent films shown at the Royal Film Archive, while creating an experimental film class in his school, similar to Stanley Reed at the British Film Institute. *Forges* (1956), Delvaux's first documentary, won a prize at the Antwerp Belgian Film festival. In 1959, he married Denise Debbaut, who, as an executive secretary at the Royal Film Archive and subsequently in charge of programming for Flemish television (BRT), remained, for the next thirty years, a faithful and constant collaborator. When she died, on 3 November 1994, Delvaux, devastated by grief, told me that it was as if the story of his film *One Night... a Train/Un Soir, un Train* (1968), had caught up with him.

Even though international recognition of his films only kept growing, Delvaux refused to shoot outside of Belgium: 'One can't shoot just anything anywhere; I want to stay in my country,' he declared, after turning down an offer to make a film in Japan. 'I want to make films that have a direct connection to me. If you go see one of my films, take it as a love letter to Belgium and to the men and women who live there.'[1]

As president of the Royal Film Archive, Delvaux used his last legs to defend the institution, at a time when its financial fate was in jeopardy. He died in Valencia, in October 2002, just as he was finishing a speech, full of self-criticism, in which he regretted not having sufficiently taken a position in public life.

Film-makers are philosophers: they have a vision of things and of the world. A founder of two schools, both literal and metaphorical, Delvaux was a cinematic poet and philosopher. In many ways, he recreated Plato's allegory of the cave: our perception of things would only be of fleeting shadows. Each of us would be like protagonist Julien Eschenbach when he is in the darkened theatre in *Appointment in Bray/Rendez-vous à Bray* (1971). We remember that in this scene, he is the pianist accompanying an episode of the *Fantômas* series, a fugacious reflection of the Belle Époque. Having returned from the closed post office, standing alone in a park in twilight, Julien associates this pre-war souvenir with 'Elle' (Anna Karina), the strange heroine, who evolves before his eyes with a lamp, from one window to another, silhouetted like a Chinese shadow puppet, like a witch in the corridors of the Fougeraie Castle.

Delvaux's films stand thus, as it were, as distorted projections of another world. Mathias (Yves Montand), who drifts through the Northern plains in *One Night... a Train*, reaches an inn in a village whose language he does not understand, as it is, indeed, in the land of the dead.

In Delvaux, the enigma of existence cannot be resolved. In *The Man Who Cut His Hair Short/De man die zijn haar kort liet knippen* (1966), Govert (Senne Rouffaer) does not know whether Fran (Beata Tyszkiewicz), his beloved, is still alive. 'All is true', exclaims Grégoire (Jean-Luc Bideau) in *Belle* (1973), when all was probably false. Each character, each anti-hero, lives as though in check. Govert considers himself a failure. Mathias realizes too late that he loved Anne (Anouk Aimée). Delvaux's entire œuvre is traversed by this guilt

Gian Maria Volonte in *The Abyss*.
The Kobal Collection.

complex: it begins with a lawyer (who cut his hair short) who believes that he has killed his beloved – while she might very well still be alive – and ends with *The Abyss/L'Œuvre au noir* (1988), set in the sixteenth century, with the heresy trial of a dissident scientist, Zénon (Gian Maria Volonté), whose return to his native Bruges could only lead to his execution by the local authorities. Tellingly, Delvaux closed his career with the portrait of a rebel, a Renaissance humanist.

Delvaux's imaginary is located between the fantasy of his favourite film, F.W. Murnau's *Nosferatu* (1922), and the absurd universe of Franz Kafka. The illustrious vampire has become the inner demon, the characters' tendency to self-destruct, inflicting punishment upon themselves for an obscure fault they might – or might not – have committed.

Nurtured by the various cultures of his continent, Europe, of which he knew all the major languages, Delvaux became a master of literary adaptation to the screen. Practising a cinema of inwardness, Delvaux is haunted by the *indecidability* of the real. Everything has a hidden side. Fran, 'beauty made flesh', says that her image is deceitful. In the wake of modern cinema, Delvaux partakes, in an original way and with open-ended works, in the cinema of doubt. He follows his heroes, who are wrongly accused men, in search of their innocence, through an initiatory journey. Sensitive to the uncanny nature of beings and objects, he became a point of reference for magical realism in cinema. This aesthetic current, at first literary and pictorial, was born at the confluence of New Objectivity (Der Neue Sachlichkeit), documentary, and Marxist inspiration, and an expressionism tainted with Freudianism.

Cinema is, above all, a convergence of all the arts. And Delvaux did practise this *écran total*. He adapted novels, represented musicians, and referenced the world of painting. But it is philosophy that holds the first place in his oeuvre. *One Night… a Train* was already inspired by a 1953 short story, *De trein der traagheid*, written by Johan Daisne (the

pseudonym of Herman Thiery), which was also a philosophical tale. Twenty years later, Delvaux depicted, in *The Abyss* a thinker who, in order to affirm his freedom of thought and conscience, inflicts a stoical death onto himself, faithful to the Classical Zeno, the founder of the Stoic school. Why did this medieval Zénon, a bastard son from Flanders, return to a land where he knew death awaited him? Perhaps to find something of his mother, perhaps to rest in his native land, or perhaps to find the final answer to his life-long quest for truth and knowledge, his dignity in death radiating in the darkness of obscurantism?

These open, unresolved conclusions are the expressions of a philosophical attitude. Delvaux, who was rather agnostic, believed that we know nothing of the world, that we are deceived by our senses. We have seen *Belle*, and we cannot tell whether she was a vision of the hallucinated poet, madly in love with her, or a woman of flesh and blood. We are led astray in our judgments by our imagination. Yet Zénon, much like Delvaux, dies at the end. But what is death, and what is life? In the final scene of *The Abyss*, Zénon falls asleep and into death, in a mirror image of Govert awakening, in Delvaux's debut feature *The Man Who Had His Hair Cut Short*, in a close-up, bookending this humanist film-maker's entire œuvre. Where was the border between life and death? Dreams are so real, and life, perhaps, is just a dream.

Adolphe Nysenholc

Translated and edited by Jeremi Szaniawski

Note

1. In Adolphe Nysenholc, *André Delvaux ou le réalisme magique*, Collection 7ᵉ Art, Editions du Cerf, Paris, 2006, 35 (this combines two declarations: interview in *Revue belge du cinéma*, oct 1977 and conversation with the author, in *Ombres et lumières. Etudes du cinéma belge*, in *Revue de l'Institut de Sociologie*, 3-4, ULB, 1985, 373).

BELGIAN CINEMA CONFIDENTIAL

Simona. Private collection Patrick Longchamps, with kind permission by the author.

In Belgium, perhaps more than anywhere else in the world, there exists an inordinate number of film-makers who remain unknown outside of the film production world, or whose notoriety has more to do with their peculiar modes of production (for example, Jean-Jacques Rousseau's curious and idiosyncratic films). This section investigates several such 'confidential' figures.

THE CINEMA OF JEAN-MARIE BUCHET: A TUNNEL-FUNNEL AESTHETIC

There are, around us, many people who, at one point or another, have made a short film about which no one has heard. The case of a film-maker who has dedicated his entire life to cinema, producing over twenty short films and two features in the process, and of whom you have probably never heard and whose films you will never see, is rarer still. Such is the case of anti-conformist extraordinaire Jean-Marie Buchet (b. 1938).[1] To many, he was better known as a well-loved teacher than for his filmography. At the University of Brussels (between 1988 and 2003), his dour but generous demeanour and rigorous, constructive feedback helped bolster the screenwriting technique of many an aspiring film-maker.

A published film critic, librarian, and author of short stories and a novella (*Mémoires de Moi-Chant Premier*), Buchet appears as an authentic 'Jack of all trades' of Belgian film: freshly graduated from the La Cambre school (architecture and decorative arts), where he focused on cinematography as a member of the first class of experimental cinema (1957-1961), he started out as a sound designer on documentary films and as an assistant to cinematographer Willy Kurant. He subsequently worked in television as an editor, assistant director, cinematographer, and screenwriter, as well as as boom operator and producer.

Still very much active well into his seventies, not only as a film-maker but also in the world of film commissions and film restoration through the Cinematek, Buchet epitomizes the practice of many Belgian film-makers seeking outside sources of income to sustain their film-making passion. Heroically and resiliently making films with next to no money throughout his life, Buchet has built a respectable filmography, by any standard. His output amounts to two feature films, *La Fugue de Suzanne* (1974) and *Mireille and the Others/Mireille dans la vie des autres* (1979) and 22 shorts (and counting) of all genres (animation, documentary, live action), each of which is rife with the very personal mix of deadpan humour and existential ambiguity that makes him such an idiosyncratic figure. If Buchet's features have rarely, if ever, been seen since their original release in spite of their rather positive critical reception (and whose rare prints are carefully stored in the vaults of the Royal Film Archive), a selection of these films is available through a self-produced double DVD.

The ideology pervading this cinema reflected the environment in which Buchet evolved: cinephilia, Jack Kerouac (but without the use of drugs), *Mad Magazine*, anti-Cold war and anti-money positions, developing a DIY ethos at all levels. Generally penniless, Buchet made most of his first films on reversible 16mm film stock. As a young man, saving money on food in order to go to the movies,

he was nearly expelled from La Cambre School, which did not grant any money for senior film projects. Buchet found a loophole in the school's rules by arguing that he had shot most of his colleagues' films, then presented an animation film scratched with a pin onto the film stock itself, called *Deux choses* (1957, re-released with a soundtrack in 1974). 'There was no script, and I didn't even cut out the stuff that I thought was bad. But with some boogie-woogie as my soundtrack, it sort of did the trick. As far as the influence goes, I guess you could say Malcolm MacLaren, whom I admired a lot at the time (and still do)'.

Buchet's first film on 35mm, *Je t'aime* (1961), shows two men in a car, vying for a woman hitchhiker whom they pick up. 'It was made in completely crazy conditions. I even forgot to shoot the final shot that would have clearly identified the woman at the end. The film sort of worked on the big screen, but on TV, it is cruelly lacking'. The film is strongly reminiscent of Godard's *Breathless/À bout de souffle* (1960):

> At the La Cambre school, the news that we were receiving from the shoot of *Breathless* made us smile. All his technical 'inventions' and 'audaciousness,' we had used them a long time ago already. We had even done much worse. It is therefore more to the tradition of the early years at La Cambre that my film *Je t'aime* should be related, but the kinship to *Breathless* is undeniable, nonetheless.

Spirit of the times? Anxiety of influence? We'll take the author's word for it.

An influence that Buchet readily acknowledges is Michelangelo Antonioni. Of his *Que peut-on bien faire chez soi le dimanche après-midi quand on n'a pas la télévision?* (1964), a film in which a couple goes about their daily routine of reading Foucault and *Le Monde*, Buchet states:

> I had high expectations for Antonioni, I was passionate about *Le Amiche* (1955). *Il Grido* (1957) had disappointed me, but when I saw *L'Avventura* (1960), I was flabbergasted: it was exactly the type of film I wanted to make when I was sixteen. Antonioni, it seemed to me, was lapsing back into childhood. I thus made this film against *L'Avventura*, in order to prove to myself that what *Le Amiche* announced was possible. I know it sounds horribly arrogant, said like this. But the truth is that it was done in all humility. Just to console myself from a cinephilic sorrow. As for Foucault and *Le Monde*, it was pure coincidence – they were the cameraman's readings at the time.

A strong anarchic sentiment seeps through most of Buchet's films. Likewise, the people he employed for his films were often mentally unstable or had connections with revolutionary movements: Julien Parent, a friend of Buchet and the lead actor of *La Journée de Monsieur Chose* (1963), was expelled from the INSAS (first promotion of directors) after six months because he did not seem 'serious' enough, in spite of his allegedly amazing talent. Parent only made one short film (which Buchet 'produced'), and wrote a few short stories, which writer Jacques Sternberg[2] admired a great deal. Of Parent, Buchet comments that 'he lived for a while in the US, with his wife, who was a sculptress, growing unbearable, and dangerous. He must be dead now. Some people say he committed suicide'.

Much more innocuous but also colourful is Louis Langlet, nicknamed Lacaille, a friend of Buchet who stars in his *Hommage à Dom Helder Camara* (1970) in which a man, filmed in medium shot, sitting at a table, eats from a huge plate of mashed potatoes until he no longer can take another mouthful:

Viviane Annaert and Julien Parent with Jean-Marie Buchet on
the set of *La Journée de Monsieur Chose*. Private collection
Jean-Marie Buchet, with kind permission by the author.

It was not a film, but an exercise in view of my first feature, *La Fugue de Suzanne* (1974). Neither I nor Lacaille were certain that he could pull it off in front of the camera. So we shot this. Those desperate gazes that Lacaille is throwing at the camera were destined to me. He is a friend. He had his hour of fame in Brussels as a member of the *provo* movement[3], he's been a bookstore keeper, an extra in films, spent some time in prison, was a model for publicity photographs and is now spending quiet days as a happy retiree.

This film, much as all the others, suffers from an obvious lack of funding. Yet it made some money nevertheless:

At the time, I was in charge of a (very poorly organized) company distributing alternative cinema. A Dutch festival organizer demanded that I present a 'new' film. Since I was extremely broke, I put a credit sequence to the reel and blew into a flute (I am not a musician at all) for the soundtrack. Since I got credited as composer on this film, and it did receive a relatively wide distribution, this became the first of my films that actually brought me a little bit of money.

The spirit of Leftist anarchism that pervades Buchet's cinema must however not be associated with orthodox Leftist cinema, so popular at the time. *Potemkin 3* (1974), for instance, is more parody than homage. Although it does recreate scenes from the Eisenstein classic *Battleship Potemkin* (1925), the resemblance is tenuous at best, with the staircase of a Brussels home meant to evoke the Odessa steps, and a pond with swans, the furious waters of the Black Sea:

It was an experiment. And to try it, I needed a very famous silent film. At the time, they were rather few and far between. *Battleship Potemkin* was also one of my big cinephilic disappointments (it was practically considered the greatest film ever made at the time). Besides, I was part of a study group (mostly INSAS graduates), who had studied the place of *Potemkin* in political movements (whence the use of the Horst Wessel *Lied* over the credits). The orthography of the titles, if I remember correctly, comes from the Russian sub-titled copy that I had at my disposal. An amusing detail: I was curious enough to verify the Russian text of the Lenin quote which ends the film. It was falsified. Lenin wrote that whatever it was 'moved to the revolutionary stage', and in the film, it says: 'to the people'. Or something like that. As for my Marxist tendency, I suppose it can be qualified as communism in the vein of Paul Mattick[4], and even that would be a bit of an overstatement.

The second part of Buchet's career saw him delegating the production of his films to others. This helped improve their production value, and also took the burden of paperwork off his shoulders:

The production conditions were completely different. During the shoot of *La Fugue de Suzanne*, I realized that being one's own producer sometime had drastic consequences. Since then, I've tried to get my films produced by other people. First and foremost, I am allergic to bookkeeping and all things administrative.

Such help probably facilitated the production of Buchet's other feature, *Mireille dans la vie des autres* (1979), now in the vaults of the Royal Film Archive.

While still extremely peculiar in narrative terms, the short films Buchet made in the 1980s and 1990s are formally more traditional, alternating between the cinematic rendition of a joke (*Dupont-Durand*, 1989, taking place in a mini-market, and where a shopkeeper mistakes a hygiene inspector for a late customer; or *Saddam Hussein is Alive and Well and He Lives in Brussels*, 2004, in which Bouli Lanners plays the role of Saddam Hussein who has planted his weapon of mass destruction – George W Bush – inside the White House). The joke falls somewhat flat, partly because of a casting mishap. On *Dupont-Durand*, 'Kinepolis, Warner Brothers and a few others made a bit of money on this film. I was able to pay the actors and technicians, pay back the money I had borrowed. But this adventure was not possible again under the new legislature'.

Another film of the period, *Horrible* (2000, on the set of which he met his current producer, Patrice Bauduinet), functions as a self-contained film, even though it was meant to be another short sequence from another feature Buchet never had, in his own words, the courage to write.

Une fameuse journée/Een rare dag (2003) is a linguistic curiosity. In a small country town in Belgium, on a beautiful summer day, a score of characters look for a house. Two versions of the film were shot, one in French, one in Dutch, with the same French-speaking actors reciting phonetically their lines in Dutch. The film seems to make an indirect political statement, through its bi-lingualism and its use of the Belgian flag's colour pattern: black, yellow, and red. Yet, according to Buchet, 'I hadn't noticed the Belgian chromatism. I did not have any political intention, it was completely involuntary, but I think it's very well that it be this way. I thought I would please the VAF (Flemish Audiovisual Fund) by making a version of the film in Dutch. They were furious.'

Buchet's latest two shorts, *Fantaisie sur la Fin du Monde* (2008) and *Après-midi* (2012), boast similar minimalistic structures: a couple going about some daily mundane activity, inside or outside a house. In the former, the couple watching tv disappears in a dark room, thick syrupy blood emerging from under the door and spilling into the house; in the latter film, the couple is relaxing in the garden, interrupted by a series of phone calls. The woman is fed up with resting and goes inside to place some phone calls. 'It's evanescent in terms of plot, but it works, I think,' Buchet laconically sums up.

When watching these short films, one is tempted to discard them at first, both for their very impoverished means of production, as well as for their apparent lack of seriousness. Yet behind this appearance lies the inescapable mark of an artist, definitely building a body of work with a philosophical message and purpose. Much as the man himself appears, in spite of his old age, as a mischievous, sometimes unkempt child, Jean-Marie Buchet is very capable of a most elegant and sophisticated prose when circumstances require. Is this a camouflage method? Under the outward appearance of a lack of seriousness or carelessness, Buchet has managed to capture, through his interrupted actions, his strange rhythms, false leads and overly open endings, the plentiful void and absurdity of modern life. He has done so specifically through the farcical prism of Belgian culture, both quixotic and always at a distance from itself. What compels one to see his body of work as a unified, coherent whole has certainly to do with the fact that the author has mastered an oddly shaped form, both aesthetic and philosophical. I propose to refer to this as a 'tunnel-funnel' cinema, one of apparent abyssal emptiness, where nothing or practically nothing happens, or where the actions carried out by the characters make very little sense in terms of traditional diegesis or rules of causality. But perhaps this emptiness, as we decide to penetrate the tunnel in question, becomes, indeed, a fullness, and the overt open-endedness of these

short films compels one to see it all widening from the tunnel onto the funnel, onto a confusing, uncertain, and certainly greater set of questions and interrogations. But these can as well be traded for a refusal to address it all, leaving only a sense of discomfort, which is certainly sought out by the film-maker, who is as eager to discuss anecdotes of his shoots as he is reluctant, in his half-surly, half-bantering mode, to give a clear explanation to it all:

> Surely all these films give the impression that I am making fun of the whole world. I accept this criticism, and will only oppose two remarks: First of all, I only make one film out of every third project. The other ones are either turned down by producers, or don't find any financing. It gives an incorrect picture, if one wants to have a global vision of what it is I am trying to do.
>
> Secondly, it is true that I am irked by the inflationist tendency of contemporary cinema, as much on the budgetary as on the screenwriting level. So I go against the grain. Habitually, I try to tell or suggest as much as possible with the minimum of means. If my endings are too open, it's because I prefer that the viewers draw their own conclusions, even and especially if they are unacceptable for the average automobilist-telespectator.

Jeremi Szaniawski, with Jean-Marie Buchet

Notes
1. All quotes taken from the author's email correspondence with the film-maker, conducted in July 2011. Jean-Marie Buchet informs us that several titles of this filmography touch upon material that is akin to the worst joke of cinema, even by Belgian standards.
2. Sternberg (17 April, 1923, Antwerp, Belgium – 11 October, 2006, Paris) was a French-language writer of science fiction and fantasy.
3. Started in Amsterdam, a hippie-like movement of people who were fed up with Dutch society, including libertarian anarchists, who distributed free white bikes to protest against the use of cars. The movement had some echoes in Belgium, especially in Flanders. Lacaille blocked the clock at the Hôtel de Ville in Brussels. Later, Lacaille was accused of complicity in a hold-up that went wrong, having sold the weapon of the crime—a gun—to a collector. He spent a few months in prison in Namur, which is the rather unproductive way in which this troublemaker paid his debt to society.
4. Paul Mattick Sr. (13 March 1904-7 February 1981) was a Marxist political writer and social revolutionary, whose thought can be placed within the council communist and left communist traditions, criticizing the Soviet Union for being merely a form of modified capitalism. Early on in his life, he was a member of the Spartakist movement in Berlin, before becoming an established intellectual figure, teaching in America and Western Europe. The titles of his last books are evocative: *Anti-Bolshevik Communism* and *Marxism - Last Refuge of the Bourgeoisie*?

Simona

Histoire de l'œil

Director:

Patrick Longchamps

Producers:

Bruno Dreossi
Roland Perault

Screenwriters:

Patrick Longchamps
based on the book by Georges Bataille

Cinematographers:

Luigi Bernardini
Michel Houssiau
Angelo Lannutti

Art Director:

Pasquale Grossi

Composer:

Fiorenzo Carpi

Editor:

Panos Papakyriakopoulos

Duration:

91/81 minutes

Cast:

Laura Antonelli
Patrick Magee
Raf Vallone
Maurizio Degli Esposti
Margot Margaret

Year:

1974

Synopsis

A young man, Georges, meets the beautiful Simone in a Northern seaside town. She instructs him in the ways of sexuality and risqué erotic practices. One day while driving their car, Georges and Simone nearly run over Marcelle, a naïve young woman who has lived sheltered from the outside world in her father's castle, ever since her mother died. A triangular affair develops between Simone, Marcelle and Georges, causing much turmoil in the local community. With Marcelle's freedom increasingly limited by her strange uncle – who still harbours fantasies about Marcelle's dead mother, whom she resembles – and her father's morbid drive for taxidermy reaching threatening heights, tragedy seems close at hand. In an attempt to set her free from the castle, Georges is killed by the mad father, and Marcelle and her uncle shortly share the same fate. Simone moves south to forget the events of that summer.

Critique

An adaptation of Georges Bataille's eponymous 1929 story, made with exclusively private funds by a 28-year-old director, *Simona/Histoire de l'œil* is truly one of those projects that could only have seen the light of day in Belgium at a very specific moment in time – one of welfare and prosperity, in a climate of liberalism and mild censorship policies. Shot in Belgium (in the beach resort town of Knokke, the ruins of the Seneffe castle) and in Spain, the film opened in Italy under the title *Simona*, where it was promptly seized and banned. It was subsequently re-released in a heavily-censored version and made good money, but was never shown anywhere else theatrically.[1]

The script is quite tame compared to the original story, eschewing some of its most classic scenes, but retains displaced references to the irreverent behaviour of Simone, the seduction of the young priest, Marcelle (played by Longchamps' wife Margaret) peeing inside the cupboard, as well as the bullfight. Quite creative visually (to say that form takes over substance, here, would be an understatement), the film however lacks the stylistic audacity of Bataille's prose, or, more importantly, his sublime, ardent, vertiginous affect and paroxystic sexual imagery. Longchamps claimed to have wanted 'Dionysian ecstasy, a visual conception in the style of Magritte and Delvaux and an eroticism in the tradition of the surrealists.' And, indeed, if the film at first evokes the impressionist French cinema of the time of Bataille's story, it gradually and unmistakably embraces the eerie and static compositions of Delvaux, in an atmosphere of abandoned castles, cold seaside towns, greenish mists and twilight. However, these references, while clearly recognizable, short-circuit each other, finding themselves closer to the imagery of another baroque stylist of Belgian cinema, Harry Kümel, than to the sun-drenched landscapes of Southern France and Spain of Bataille's story. As a result, two surrealisms awkwardly co-exist and never combine harmoniously.

A bigger problem than Longchamps' failure to emulate the story's universe is the static and disjointed script. The film seems committed

to a sense of narrative progression, but none of the characters receive any development, save perhaps the uncle (absent from the source text) who caused Marcelle's mother's death many years before. But even he remains too vague and his presence random, and the feeble attempts by an elegant voice-over to bring the pieces together feel forced and even counter-productive, working against the dream-like, nonsensical quality the film could have otherwise acquired by virtue of its non-sequiturs. All this leaves the viewer wondering why he would even care, especially since many scenes were cut out or feel a bit inconclusive and incomplete. When they are developed, however, the film shows a vibrant creativity, which definitely enshrines Longchamps as a stylist in the vein of Fellini. Indeed, the film-maker confessed to having spent a couple days on the shoot of ROMA (1972), learning more in the process than he had in film school, which he dropped out of after a few months. One of the film's most memorable setpieces – the dance and orgy in the old castle with statues coming to life – is a wonderful and original combination of Cocteau and Fellini's Satyricon. The other scene that will linger in the viewer's memory has similar implications vis-à-vis inanimate objects: immediately following Marcelle's death, the father's stuffed menagerie suddenly comes to life and runs out of the castle, by virtue of a simple freeze-frame trick.

Instead of celebrating death as an endpoint and its corollary *jouissance*, continued in the minds of survivors and the reader, Longchamps inverts Bataille's terms and mourns death and violence: the film ends with Simone reflecting upon the tragic episodes and crying at a *corrida*, while the bull is pathetically slaughtered – instead of Bataille's memorable scene of the animal killing the torero. In Longchamps' own words, this scene also showed the depressing victory of culture over nature, the latter being associated with ebullience and freedom. The whole film is meant to speak to this central conflict. Apparently, church officials, to whom the film was screened in the Vatican, called it 'very Catholic.' Perhaps this, in the end, proves to be Longchamps' most subversive gesture of all: to have brought Bataille back, as it were, into the bosom of Christian morality, which the writer so ardently repressed, but could never truly escape.

Jeremi Szaniawski

Note
1. The film did come out on DVD under the title *Passion* (2009), a pan and scanned transfer of the poor print, a copy of which bootleggers could find in its original aspect ratio.

Vivement ce soir

Studio/Distributor:
Parallax Films
Director:
Patrick Van Antwerpen
Producer:
Georges Baeyens
Screenwriter:
Patrick Van Antwerpen
Cinematographer:
Michael Sander
Art Director:
Ariel Potasznik
Editor:
Daniel De Valck
Duration:
80 minutes
Genre:
Comedy/drama
Cast:
Robert Lemaire
Jean-Marie Degesves
Raymond Pradel
Monique Cools
Claude Tillier
Marco Badot
Gérald Dederen
Jean-Marie Buchet
Bernard Boccara
Geneviève Knoops
Mohamed EL Yacoubi
etc.
Year:
1984

Synopsis

In a supermarket in the outskirts of a big city, the workday is about to start. The management is a bit nervous, awaiting the visit of a Soviet commercial delegation set to arrive that evening. In the meantime, the members of the reassortment department have decided to take advantage of this official visit and treat themselves to a banquet at their employer's expense. Indifferent to these concerns, clients start to arrive. And the shop turns into a large theatre, on the stage of which a comedy of a hundred and one scenes unfolds.

Critique

In spite of a very decent run on the festival circuit, as well as a nomination for a César for Best French Language Film in 1986, *Vivement ce soir* has not, to this day, interested film distributors or TV networks and, consequently, its circulation has remained strictly limited. It is true that, while it is hardly a difficult film, its vision remains somewhat puzzling, and that in spite of the fact that it is one of the films that best expresses the realities of its country of origin, it does so through fantasy and, as such, is not very representative of Belgian cinema as a whole.

From the outset, there is a clear desire for realism on the part of the film's director, Patrick Van Antwerpen: 'The supermarket – the place as such – is the subject of this film. There is no main character; it is the place itself that fills out this role'.[1] But as is so often the case in Van Antwerpen's films, we quickly realize that, while not deceitful, this assertion is only made to hide an infinitely more complex reality, and it is difficult to know in what way he is aware of it himself. Elsewhere, he states that, 'the film recounts the unfolding of a day in a supermarket on the outskirts of Brussels. The story of that day … constitutes the general drama of the film.'[2] It seems as though he has no other intention, *a priori*, but to shoot some sort of reconstructed documentary. Moreover, the screenwriting itself had been preceded by a long period of observation of the actual location, the supermarket. Most of the events that constitute the film's narrative fabric are directly taken from notes written during that period.

However, one could make the claim that this 'day' is not picked at random. Rather, it is marked by two significant events: a few members of the staff steal the necessary goods to treat themselves to a nice little feast, and the management is about to welcome an important foreign delegation. The director could reply, and rightfully so, that these events have but the most marginal influence upon how the film unfolds. This is unquestionable, but… The film opens with the arrival of Gérard, the organizer of the banquet, and ends with his departure. The section of the plot involving the arrival of the delegation is only there to give relief to the personnel's shenanigans. Behind his desire for objectivity hides, thus, the basis for a classical narrative. What is less classical, however, and which is probably what disconcerted professional distributors, is how this story is developed.

The main appeal of Van Antwerpen's approach is that, as opposed to the classical one, he seeks primarily to describe the multiplicity of

interferences that affect the behaviour of the characters whose story he tells. His hero does not separate himself from the masses but, rather, remains integrated within it. He is in solidarity with his social environment and his actions are embedded within the abundance of activities that surround him. Characters, location and actions are barely formally distinguishable from each other and thus become an evanescent whole, so much so that, on the one hand, all that is shown seems familiar and trivial. Even when an incident leads to a comical conclusion, it is brought with such respect of logic that it seems inevitable. On the other hand, nothing seems normal but, rather, everything appears to harbour some secret intention and purpose. Hence the euphoric malaise brought about by watching the film: we are at the same time plunged into sordid banality and a poetry of the everyday which, far from being mutually detrimental, reinforce each other and plunge the spectator into a vertiginous delirium.

Jean-Marie Buchet

Translated by Marcelline Block and Jeremi Szaniawski

Note
1. Patrick Van Antwerpen. 'Note d'intention précédant le scénario *Un supermarché.*'
2. Quoted by Boris Lehman (ed) *Yellow Now*, 1992.

INTERVIEWS

CHANTAL'S KAMMERSPIELFILM

Chantal Akerman granted us an interview. It is available at cinergie.be (Webzine n°169 - March 2012), in both video and written format. It took place at the very location where *Blow Up My Town/Saute ma ville*, her first film, was made in 1968. Since then, the director has offered us an evolution of what the Germans, in the 1920s, called the Kammerspielfilm (the chamber drama, in the style of Ernst Lubitsch). In 2012, Akerman's *Almayer's Folly/La Folie Almayer* was released in theatres in Belgium and in France. After Akerman's beautiful *The Captive/La Captive* (2000), we find time lost and time regained.

Q.: One of Tarkovsky's statements makes me think of your approach: 'I think that the motivation of someone who goes to the movies is a search for time, for lost time, for neglected time and for recovered time.'

Chantal Akerman: I hope that when people go to see one of my films, they feel time as an experience that they can live out themselves. In general, when we are happy, we say that we don't feel time passing. Time is really all we have in life. When someone goes to see one of my films, it is an experience of time that passes and which can be perceived.

Q.: You probably chose to adapt *Almayer's Folly*, a novel by Joseph Conrad, because his novels offer us a superimposed time, as if we went from one draft to another. Your film, after a long flashback, functions in a fragmented manner, and even, dare we say it, as a type of choreography…

C.A.: Yes, I like choreography. It's true that my shots are often filmed starting with the body in space, in a sort of choreography. Cinema is a kind of space that exists before us: the screen shows us time unfolding. In this space, we can put bodies, but nature or other things can also move in a dramatic and choreographic manner. Moreover, choreography is part of drama, and vice versa.

Q.: A little bit like the musical, a very American genre?

C.A.: I don't know why, but I love musicals! It's true that, first of all, in them, we are outside of realism, or rather, the unpleasant aspects of reality that confront us day after day. Musicals do not try to imitate the real, even if sometimes they are closer to reality than we think. Just because one film is a history of coal mining does not mean that we are necessarily in the real. A musical, with the added joy that it often gives us, touches upon stronger points, even if it appears further removed from us personally.

Q.: You practice two genres, fiction and documentary. For you, is there a difference between fiction and documentary film?

C.A.: I am totally against the division of these two genres. A documentary is always a fiction film and a great fiction film very often has something from the documentary within it, if only through the actor. For example *The Misfits* is also a documentary about Marilyn Monroe undergoing a depression. And when I say that a fiction film is also a documentary, it is because as soon as we sense the actor breathing, we are already in a documentary.

Q.: In your films, the body speaks more than speech or dialogue…

C.A.: The body speaks, yes, but it is not necessary to go to extremes to see this. By this, I want to say that we could very well have a text read by two actors standing and facing the camera. To simply have them stand still, delivering a 'straight' text into the camera could have as much impact as if we had made them dance a ballet. There is no rule. All of a sudden, it exists or it doesn't. All of a sudden, we say no or yes, and the shot is there. [*Smiles*] It is often about the mystery.

Q.: The film about Pina Bausch that you made in the 1980s is a marvel, precisely because it's more than a documentary.

C.A.: With a documentary, the film is in some respects reinvented at the editing level, because when I begin shooting, I have an idea of the subject, but I don't know where it is going to take me. Today, before making a documentary, we are asked to submit a dossier with a scenario, as if it were a fiction, as if we already knew the final point we were going to make, the idea we had to prove! When I want to make a documentary, whether it's about the people who try to cross into the United States via the Mexican border (*From the Other Side/De l'autre côté*, 2002), or about Eastern Europe (*From the East/D'Est*, 1993), I start without preconceived ideas, and that is my greatest strength. I try to just be like a sponge… how shall I put it, to be in a state of hearing and seeing everything around me, floating, as it were, even if [*smile*] the resulting films themselves are not drifting. When we have something to prove, what do we begin with? The idea that Americans are horrible, and that Mexicans are poor? That is not what I am researching when I want to make a documentary. I will look for something else. For what? I don't know. When I went to film Pina Bausch and the dancers, I arrived on location the first day, and they were all sitting on the floor in the green room. They asked me, 'what are you going to do?' and I said, 'I have no idea'. They said, 'wow, finally, someone who will be open to whatever happens', and this proved to be my strength.

Q: *A Whole Night/Toute une nuit* was filmed in Brussels, at night. How did this idea originate?

C.A.: Actually, very stupidly, as do all ideas. Often, I take notes in notebooks, about very small situations, one note per page, and all of a sudden, in looking at them, I said to myself, 'these are fragments'. Someone proposed that I make a film, and I replied that I would like to make a film in Brussels. I took these fragments, and it's from there that we began to work.

The idea was to film a Brussels that was not cold, as we often see it…a grey Belgium, but an overheated night in Brussels.

It's true that of the majority of people who acted in this film, unfortunately, many are dead. It was before the AIDS years, some of them went through that and are no longer with us – Hélène, and Pierre who was Samy's boyfriend. It is really a film about people that I knew, except for the Flemish actors who I met at that moment. But other than them, yes, a good sixty per cent of the film crew and cast are made up of my friends.[1] I would very much like to make a film with the people who are still with us today.

Q.: Federico Fellini said: 'Ford is the unconscious of cinema'. In the early days of cinema, we still had the power of starting out, of the beginning of this new medium.

C.A.: It is said that Ford was rather rightwing when he made a film about early communism better than anyone! I just re-watched *The Grapes of Wrath*, and it's absolutely magnificent, everything about this film is magnificent. I know that he adapted it from a book by John Steinbeck, but was not obliged to make it, and yet he chose to do so all the same. I don't know if he is cinema's unconscious, but in any case, this speaks exactly about what is happening today, about this 'oh, you don't want to work anymore, well that's fine, we'll just get someone else who is less expensive than you', etc., etc. Ford had such a great eye for people and for décor, well, no…for space, rather. Between people and space, there is an extremely accurate, just relationship. Well, I don't know all of his films, I just happened to re-watch this one most recently, but I would like to know more about his life.

Q: Ford often filmed in Monument Valley to avoid the opinions of Hollywood studio producers…

C.A.: It is said that Ford filmed the American West the best, but I think that if he had been Belgian, he would have filmed Brussels the best. He had a relationship to space and to the horse in that space, or to man in that space, which is splendid. Bertrand Tavernier told me that when he saw my film *The Meetings of Anna/Les rendez-vous d'Anna* (1978), he said to himself that it was filmed like John Ford. At the time I knew nothing of John Ford, and I wondered what he meant. All I knew is that there were horses and John Wayne. I said to myself, 'since Tavernier knows American cinema by heart, he must know what he is talking about'.

Q: After the Second World War, Ford defended Joseph Mankiewicz, president of the Director's Guild of America, from Cecil B. De Mille and the Mccarthyites, who were in favour of the Black List.[2]

C.A.: The American notion of the Right and the Left is a notion that is much more complex than ours. When I made the film *From the Other Side/De l'autre côté*, I met a sheriff who was a Mormon and at the same time a constitutionalist. Observation balloons were being used to monitor immigrants, to see who had jumped across the US/Mexico border. He told me, 'this balloon is infringing upon my right to view the sky, I have the right to see the sky without a balloon in the way, it's in my Constitution'. Thus he couldn't care less about the immigrants he arrested, but somewhere else he was against that surveillance mechanism. As you can see, it's complex, but there, we are moving away from cinema.

Q: You have a burlesque quality when you are in front of the camera – there is, in you, a sense of the 'Chaplinesque'.

C.A.: Yes, throughout my whole body. When I was filming *Tomorrow we Move/ Demain on déménage* (2004) in Brussels, with Sylvie Testud, I realized that I should have played the role of Charlotte myself. Every time I move, something falls. Today, I am being careful in front of you, but, normally, the glass on this table would have been knocked over by now. Sylvie, who was really very good, made the glass fall, but in the way that an actress would. In fact, it should have been a film closer to *Blow up my Town/Saute ma ville*, in which I make the chaos happen. I actually showed her this first film of mine, which was no doubt a mistake on my part. Suddenly, she tried to imitate me, but she couldn't. What I do, I do despite myself, and yet I'm not a burlesque actress as in Chaplin's cinema, where everything is studied, where everything is of tremendous elegance and grace. On the contrary, I am in the brusqueness, I am not aware that my hands are moving. I stand up, and the glass of wine spills on the person next to me, there is nothing to do, it's like that. In *Tomorrow we Move*, I should have done things like I do them normally. You see, it's like Godard when he is in Anne-Marie Miéville's films. He is Godard, he doesn't have to act – he just is. If I had been Charlotte in the film, I would not have needed to act, and I think that the film would have been better. And Aurore could have been my sister, well, in the end, my sister or my mother, who cares, what was needed was a person who is, rather than does, burlesque. Well, we all make mistakes.

Q: …Well, it's complicated.

C.A.: Yes and no. Stanislas Merhar, at the end of *Almayer's Folly*, is not acting the fool, he is not playing the man losing himself; he really is losing his mind. He is not in the midst of doing something about which everyone says, 'my god, it's so well done'. Not at all – he is in that state of mind.

Q: This last shot of *Almayer's Folly* succeeds, because it is true, Stanislas Merhar is real, in fact…

C.A.: Often, when you see films where someone is in a state of losing himself, where he goes crazy, those are the things about which we say, 'oh, he acted so well'. Here, we do not say this. I am sure that if this had been said, the film would have been a failure. Stanislas was a being-there, living in the present.

Q: The shot that precedes this scene is also incredible. I have seen the film three times, and I keep asking myself about it. How did you take a panoramic shot followed by a tracking shot with the boat that doesn't move?

C.A.: Purely by chance. Well, that is how it was anticipated. After the first take, I said to myself, 'everything happened exactly the way it should have'. Then, [assistant camerawoman] Anne-Françoise Bersou, who was the focus puller, said, 'Chantal, there is a hair in the gate'. I replied: 'no, I am not redoing the shot', and she insisted, 'Chantal, there is a hair in the gate', which means that the shot is perhaps scratched and unusable. I said, 'Listen, Bersou' – because we call her Bersou – 'every time, I mean every time, that they say there is a hair in the gate, I never see it'. She replied, 'well, this time, we see it'. We ended up redoing the shot, and the boat wasn't as well situated as it had been in the first shot. Thankfully, the hair in the gate wasn't visible, and we could use the first take after all. It's crazy – it was good without even having to tell the boat 'stop here and there'. *Poof*, it landed right there by itself, just where we needed it to be.

Q: The just shot, as Godard said. You don't have just a shot, but the just shot.

C.A.: We had very good luck.

Q: Aurora Marion plays the role of Nina. Did she sing the Mozart aria herself?

C.A.: Yes, she sings it herself. She worked with composer Marc Hérouet. For *Almayer's Folly*, there were two leading roles: there was Almayer – who I knew would be played by Stanislas – and the young girl Nina, but I didn't have anyone yet for the role. Where to find a young mixed-race actress and singer in Belgium? Gerda Diddens, my casting director, had Aurora Marion in mind. I went to see Aurora. As soon as the young girl started to read the text, I said to her, 'no, no, no, you read it to me very, very simply, the simplest possible: I am not white,' and she said to me, 'I am not white.' I replied, 'that's good.' Aurora is the daughter of Estelle Marion, who dances in my film *The Eighties/Les Années 80*, filmed in 1983. When I made *Golden Eighties* right afterwards (1986), the producer didn't want me to use her again since we couldn't bring in any Belgians, pay their hotel fares, etc. It was a whole drama. Well, in any case, she acts in *The Eighties*, she dances for a moment in a hallway: a tall woman who is wearing a white costume. That's Aurora's mother, it's a great story…

Q: There is a network of impromptu links between two generations…

C.A.: It is not the first time that this has happened. When we made *Portrait of a Young Girl in the Late 60s in Brussels/Portrait d'une jeune fille de la fin des années 60 à Bruxelles* (1994), a girl had been chosen for the leading role: her name was Circé. We held auditions, I cast her, and then she said to me, 'you know, I am Roland Lethem's daughter,'[3] and I said, 'No way!' I love it when things like that happen [*smiles*].

Q: Explain cinematographer Raymond Fromont's camera work to us, the movement from darkness to light in the Asian night.

C.A.: With Raymond, for the shots in the forest, we did 'day for night', that is to say, the night scenes were filmed during the day. We didn't do this for the shots in the city. For the chase sequence during Nina's childhood, when she and her mother flee into the water, there are perhaps five or six shots that were 'day for night,' but otherwise the rest was really shot at night, with virtually no equipment.

Q.: The more we see the film, the more we appreciate it.

C.A.: It's undoubtedly because it's a film where the story can be forgotten. When the story can be forgotten, then cinema can be enjoyed.

Q.: Let's go back to the unconscious about which Federico Fellini spoke. It's the emotion in the early days of cinema, before the Second World War broke out. We don't have the same faith in the world that we could have had before this catastrophe.

C.A.: That's why it's necessary to find images that go beyond those that are sophisticated and artfully contrived, the 'visual' as Serge Daney would have called it. I try to obtain with the camera, and during the theatrical projection, a sort of face-to-face, as if something tranquil and still is facing us. It's hard to explain…

Q.: Gilles Deleuze has written a very nice page about your cinema in *The Time-Image* (*Cinéma 2*, 2002: 255-256).

C.A.: Yes. I think that there isn't a more modern philosopher in France than Deleuze. Everything he says goes, maybe Foucault for certain things, but otherwise, it's Deleuze. Well, unfortunately, I don't read philosophy every day.

Q.: Deleuze has the reputation of being complicated…

C.A.: But it's not complicated. Well, let's say that it's perhaps more complicated than the last little detective novel, but not if you're a little more focused… Evidently, when he starts giving you courses on Spinoza and if you haven't read Spinoza, clearly that's something else. But his *Abécédaire* is extraordinary. Personally, I discovered Deleuze in reading his *Kafka, Toward a Minor Literature/Kafka, pour une littérature mineure* and then I understood everything about myself, since I was doing everything that he described, that is to say, that minor literature is a minor language… I said to myself, 'he's describing me'!

Interview conducted by Jean Michel Vlaeminckx [4]

Translated by Marcelline Block and Jeremi Szaniawski.

Notes
1. Gabrielle Claes, the long-standing curator of the Royal Film Archive and a collaborator to this volume, also acts in the film.
2. Samuel Fuller attended this dramatic meeting. He speaks about it in *Un troisième visage*, trans. Hélène Zylberait, preface by Martin Scorsese (Paris: Allia, 2011), pp. 329-330.
3. Belgian film-maker, b. 1942. He is the author of the cult *Bande de cons!* (1970), a provocative film in which he insults the audience for 80 minutes.
4. Transcribed by Marie Pynthe from the video recording for the web video on Cinergie.be. Camera: Lucie Laffineure and Marie Pynthe, editing: Arnaud Crespeigne.

'AS LONG AS THERE IS ANOTHER FILM TO MAKE, LIFE NEVER ENDS': AN INTERVIEW WITH BORIS LEHMAN

For the past fifty years, Brussels-based film-maker Boris Lehman (b. Lausanne, 1944) has become one of the key figures of the independent cinema circuit, not only in Belgium but also in francophone regions throughout the world (most importantly France, Switzerland and Canada). Both a prolific public figure in Brussels' popular neighbourhood of Ixelles and an imperturbable film chronicler in constant search for cinematic authenticity, Boris Lehman self-produced over 400 movies, shorts, documentaries, autobiographical essays, and experimental video works on a wide range of subjects. Shifting throughout the years from rather ethnographically-oriented documentary film-making to the poeticized staging of his own life, Lehman can be considered one of the pioneers of the vanguard film diary genre which emerged in the sixties all over the world, together with Jonas Mekas, David Perlov, and many others. Moreover, his roots as a Polish Jew, born in exile in Switzerland during the Second World War, provide the constant historical as well as biographical background for his oeuvre, resonating in the melancholic and sometimes mystical tone of many of his later films. Boris Lehman was honoured at a retrospective at the Centre Pompidou in Paris in 2003 and his work is widely covered in mostly Belgian and French cinephile media. Tirelessly, he continues his daily shooting and editing activities on 16mm film as well as on digital video. He agreed to an interview at his favorite café on Place Flagey in Ixelles, the operating base for most of his activities.

Q: You started to make films before entering INSAS (the Brussels film school) in 1962. What was your first contact with cinema, and when did it really become your language of communication with the world?

Boris Lehman: I started as an amateur when I was still in high school. A friend's father owned a small rolex 16mm camera. We made a few films on the weekend, just like the Lumière brothers did. Instead of making holiday movies or family movies, we filmed short improvised stories.

In high school, I studied with André Delvaux, who gave a film class. That was something new here in Belgium. I also trained myself by attending screenings at the cinéclub: Eisenstein, Dreyer, Renoir, Buster Keaton... This was still before the Brussels cinémathèque was created in 1962 [sic]. INSAS, the first film school in Belgium, opened in 1962, the year I started to study there. By the way, I had a lot of other experiences too. I studied piano and drawing. And I also did some film journalism – a bit like the critics of *Cahiers du Cinéma*. I went to see films at the festivals, interviewed film-makers and wrote about it all. At a certain point, the idea of making films myself came to me.

Q: Then you worked in the Club Antonin Artaud as a social worker. Film was used as a therapeutic means of expression for the mentally ill. The result, among others, was your *Ne pas stagner* (1973), and then, later, *Magnum Begynasium Bruxellensis* (1978).

BL: Yes, that's after I graduated from INSAS. I had another experience with patients in a psychiatric centre. I am not trained in psychiatry, but I collaborated as an animator. It was a very positive and interesting experience. We used the cinema as a means of therapy, with people who do not want to be film-makers but who feel the need to express themselves through means other than words. In the late sixties, things were changing rapidly – in psychiatry as well. There was feminism, anarchy, and psychiatry was moving away from the police treatment of patients with what was called 'anti-psychiatry', a movement that came mainly from England and Italy, and was to be found a little bit in France with Félix Guattari, and which eventually came to Belgium as well. At that time, it was very avant-garde, in a way.

Eventually, I ended up working with Henri Storck, a pioneer of documentary film-making in Belgium. That's when I started making documentary films myself. I made only one commissioned production, though; all other films were produced on my own initiative.

Q: In that respect, you occupy a very unique position in Belgium's cinematic landscape. Your autonomy and self-sufficiency have allowed you to develop an extremely subjective aesthetic vision within the medium of documentary film-making.

BL: It came gradually, yes. I indeed tried to make poetic and personal documentaries, without any voice-over.

Q: Increasingly, you appeared in front of the camera, rather than behind it.

BL: That came later, yes, in the early eighties. I started making autobiographical work. That's how people know me best.

Q: How do you feel about the difference between being behind the camera and being in front of the camera?

BL: I'm both, indeed. At first, with *Album 1* (1974), which was shot in Super 8, it was more of a game. It was not a big deal yet. But then with *Babel* (1983-91), shot on film, it was very difficult. It became my life on film. Even though it was not really a documentary about myself, but rather staged fragments of my life. I am interested in following life as if it were a movie, but at the same time, my life became a movie. The documentary became fiction. I call this autobiographical fiction, instead of documentary. But it's always difficult to tell the difference. People often place me in the documentary genre, because I shoot with the means and form of documentary. Moreover, there are no actors, because I ask people to play their own role. They are my friends. These are people I met. If I shoot a scene in the post office, it would be the post office worker who plays his own role.

Q: In this respect, I would indeed not describe you as a documentary film-maker nor as a storyteller, but rather as a chronicler. You're documenting everything that happens around you in a deliberately subjective way, without making a clear distinction between reality and fiction.

BL: Yes, you could say that. This is a good term for me … However, 'chronicler' is somewhat too close to 'journalist'.

Q: An encyclopedist?

BL: Yes. Indeed, an encyclopedist. I always want to film, so to speak. Even if I know that it is impossible to film everything. It never ends – and it's true that my film-making has no end, really. It's like a newspaper. I shoot something every day. Throughout the years it grows and it becomes an oeuvre – like that of Jonas Mekas, who is a great example for me, even if he does not work in the same cinematic style. But it's the same idea: to create a chronicle of time, as you say. It's throughout time that the film makes itself. I always shoot over very long periods of time. Most of the productions today are made on a limited time schedule: preparation, filming and editing, and then the film is done. In my work, time moves slowly, and I often cut material together ranging over five or ten years of shooting. Right now, I'm editing a film from images I collected over the course of ten years. That doesn't mean that there are necessarily hundreds of hours of footage, but the material is spread over the years. There is a bit of everything: a funeral, a friend moving out, my girlfriend breaking up with me … in short: the screenplay of life. But obviously, some things are recorded on film, while others aren't.

Q: Exactly. That's what becomes the most crucial thing: how to select. What is being filmed, what isn't? What do you keep, and what is cut during the editing process?

BL: Yes. It's a little left to chance, depending on circumstances. You cannot have a camera with you at all times. Some people do – now with modern technology it's easy. Anyway, over time I end up building something, because I have my own vision, and because I choose to shoot at times and places that are important to me. In the end, you always need some organization in order to make a movie. You have to put up a tripod, install the sound, frame the image...Even if it's a poor man's cinema, you must still prepare the filming carefully.

Q: What step in the creative process is most intense and important to you? Is it the writing, filming, editing? Or perhaps it is the screening of your film, since you often try to be present at the screening?

BL: All stages are creative and intense. However, writing the screenplay is not that important: rather, I write some notes and ideas. It's at the moment of filming that it all happens. And at the editing table, later on. Sometimes I also add a voice-over. And the screening is also creative, you're right. I like talking to the audience and exchanging ideas. I do not like the mere consumption of images.

Q: How do you perceive yourself in contemporary visual culture? We're surrounded by images all the time, without even realizing it. You have created a microenvironment filled with images, but these are your own, while in stores, on the street, etc., the images are strange and intrusive.

BL: Yes. Sometimes I feel like everyone is making films all the time. We take pictures of everything these days. In response, I ask myself if it's still worth it to make films. Before, when I was going to shoot a demonstration in downtown Brussels, I was virtually the only one with a camera. Now, everyone shoots almost the same images with his own video camera. So I wonder if I still need to be there. It's a weird world. There are cameras everywhere, surveillance cameras, too.

Q: What happens when there are more images in the world than we can watch and process?

Boris Lehman.
Private collection.

BL: I should think about that, yes. Because there are young people who shoot hundreds of hours of video for a small film, and I wonder how they have time to watch everything. You have to watch it in fast-forward mode, or skim through the material all the time. This is another way of working; it might be good, I don't know. But it's not my way. I need to work slowly, carefully. In the seventies, we had discovered real time in cinema, prompting the frequent use of long sequence shots, in single takes. Still, I decide to cut relatively often: I use time ellipses, shots and reverse shots. Throughout the years, I have developed my own style, always following the course of my own life. The camera has become my tool to meet the world. Movies and pictures are the traces of my passage in this world.

Q: Traces indeed, but the camera also alters reality. It creates new realities.

BL: Yes, it's a problem. It often happens that I have to restage some scenes, for instance. But of course it is never the same. The second time, you have to build it up again from scratch. And you have to organize everything: scheduling the crew, providing the locations, etc. Moreover, the scene is often worse when played again for the camera. Sometimes it's better, too. And sometimes, something completely different comes out.

Obviously, there are many things you miss because you cannot film the whole world. But the challenge is to capture something of my life. For example, I come to this café every day, so it becomes part of my itinerary and thus it's worth a picture. But sometimes the picture is not interesting at all, very trivial or commonplace, and then I delete it while editing.

Q: Do the aesthetic aspects of the image play an important role, when selecting them at the editing stage?

BL: Yes. It is also a question of casting. There are people who are more interesting to look at in a picture than others. Same thing with locations. It is the inner truth that is important for me; historical truth doesn't interest me.

Q: Are you sure about that? Don't you think that in any subjective narration there is also a historical aspect? For example, the Jewish Diaspora, which is very present in your work.

BL: There are always echoes. But I'm not making social cinema. But yes, there are some historical topics related to my story. Through gestures, clothing, souvenirs, events… you always communicate a part of history. Anyway, what I wanted to say is that my approach to history is not social, but cosmic and metaphoric. Sometimes I refer to the biblical history, as when I did L'histoire de mes cheveux (2010), in reference to Delilah. I also refer to my Jewish roots in Poland, it's true. I was born in Lausanne, Switzerland, during World War II. My parents had fled Poland while the rest of my family ended up in concentration camps. This history is obviously invoked in a film like Looking for my Birthplace/À la recherche du lieu de ma naissance (1990). This is at once my story, and the history of everyone. I also went to Poland, because it is my parents' homeland. And I've even been to Siberia.

Q: Does having a camera facilitate your intimate journey?

BL: Yes, of course. When I went to see Auschwitz, it helped me a lot. Without a camera, it would have been very difficult. The camera protects me, like a shield. It also protected me in Siberia. In temperatures of minus 30 degrees Celsius it gives you energy to have to care for a camera, to be there with a small crew, and to have a well-defined project. Without a camera, I wouldn't have made such a trip in the first place. Unlike Werner Herzog, I am not an explorer or adventurer. It gives me courage to have a camera and to film, and to not be alone, even if it's only a small team of two or three people. In Siberia, there were four of us: a Russian guide and translator, my operator, a sound engineer and myself.

Q: Speaking of the camera as a protective – but also perhaps opaque – tool, your film Couple, regards, positions (1982) seems to be very unique in your oeuvre, aesthetically speaking. You seem to relate the misleading image of the camera as a mirror (i.e. your filmed self-portrait) with the impossibility of the dialogue with a woman. Do we always need a protective shield, such as a camera or a prop, to allow for a human encounter to happen?

BL: The camera serves as a medium, yes. In order to speak to someone, I need a camera. To enter someone's home, the camera is a good excuse. This film is very special because the woman is the person with whom I used to live. We made the movie together. It is not a realistic film, it is a symbolic film. Everything was shot in a studio.

Q: What status does mystical imagery have in your work? To what extent do symbols 'mean' something in your iconographic language and bring depth to it?

BL: I was told indeed that my latest films tend to be more mystical. Maybe I'm developing that side more and more with age. It's hard to say. I also filmed parts of the Gospels, in short episodes, Pasolini-style. I dare not show it yet, since it's so intimate. But I also made little cards [*he shows postcards, where he is shown crucified*]. These are pictures, but there is also a movie.

Q: It is the passion according to Boris.

BL: Yes, indeed, it is the passion. I also did The Lord Shepherd, some ten or fifteen

years ago. And the crucifixion, the massacre of the innocents. In the future I might make a movie with all the episodes put together. Sure, it's something that haunts me. As you talk about mysticism, I would indeed refer to my art as *Christic*. In *Homme portant* (2003) for example, I carry my film rolls around, just as Christ carries his cross. In the last scene, there is also the story of Judas. It is true that it increasingly becomes a central theme in my work.

Take *Couple, regards, positions* for example, which was shot in 1982. I was often compared to Paradzhanov with this film, because it is a kind of tableau vivant. Even if I construct my own Jewish universe, and not the folk universe of Paradzhanov, there is a pictorial resemblance.

The film *Muet comme une carpe* (1987) is a film about fish, which is also a symbol for Christ. I filmed the ceremonial stuffing of carp, a Jewish culinary tradition. I tell the whole story: how the fish is caught, how it is prepared, how it is eaten – yet it is not at all a culinary documentary, of the type that you see on television. It is, rather, a mystical and ethnographic film. It's a very precise observation of the ritual: first there is the mundane, almost obscene preparation of fish. Then there is the sacred part: the prayers and rituals. I had a Jewish family re-enact the New Year for the purposes of that film.

Q: As an artist, do you feel that you can identify with the figure of Christ, who sacrifices himself for humanity? Do you consider the creative act a form of sacrifice, like Andrei Tarkovsky did, for example?

BL: The notion of sacrifice is very important for me, yes. Obviously, you have to sacrifice something when you want to make movies. It is a choice. But I don't regard myself as an 'accursed artist' ('*artiste maudit*'), no. Tarkovsky lived in exile. His situation was different. Rather, I feel stateless, in the spirit of the Diaspora. I don't really have a home, and so I can feel at home anywhere. I do not want to go to Israel. I am here in Brussels by chance. I could also have ended up in Argentina, England, Switzerland, France… These are the circumstances of history: my parents arrived in Belgium after the war, and they stayed. But I'm not rooted here. I do not have ancestors here. As long as I'm close to my friends, I feel at home. I constructed my own artistic family here in Brussels, just as Jonas Mekas did in New York. My film-making defines my relationships with people.

Q: Even though your films are shot mainly in Brussels, it is true that we always have a strong sense that your work is somewhat nomadic. You're always in motion.

BL: Yes. I made a film called *Mes sept lieux* (2001). At the beginning of the film, I am expelled from a race. And then I travel for ten years, until I reach the finish line. This is obviously a metaphor. I travelled 300,000 km for ten years to return more or less to where I started. The film *Babel* is also like that. I begin in Waterloo, by the lion (meant to commemorate the defeat of Napoleon), the symbol of the beginning of Belgium, as it were, and that is where the cycle ends, too, all the while jointly telling my own story and the history of Belgium. I use the spiral shape of the tower of Babel as a metaphor.

Q: Do we reach God, at the end of the spiral?

BL: That's a good mystical question, yes. I do not know. In any case, the idea that we ever 'arrive' somewhere is a joke, of course. Because we never really arrive. When I die at the end of one film, I am resurrected in the next. As long as there is another film to make, one cannot die.

I have a project where I need to film my own funeral. It's very hard. I'm staging my

own death. Not many film-makers have filmed their own deaths. Chaplin and Cocteau are some famous examples. It's a symbolic and very powerful sensation. There is a scene where I get to choose the coffin, for example. It's very funny. Normally you will never choose a coffin for yourself. It is a project that I have to complete before I pass away.

Q: What happens after death? Do you believe in the afterlife?

BL: I do not believe much in the future, no. I do not believe much in celebrity, either. I think it's all a bit ridiculous. Even though everyone needs some acknowledgement. And I must get some financing to keep on making films. I have to write project proposals and reports; it's something that you have to do sometimes, too. As far as the rest goes, I try to be as free as possible. It's very difficult, today. There are not many film-makers who are truly free. Everyone tries more or less to do something politically correct, within the usual production models.

Q: You always self-produced all of your films by means of public subsidies.

BL: Yes. But funding is very limited. I can't do everything I want. I have to keep it very simple and inexpensive.

Q: How should one watch your films, ideally? At the theatre?

BL: I actually do a lot of screenings in private homes. I come with my projector and my screen in a room filled with ten to fifteen people. That's what I like best. People ask me to do this, especially in France, Switzerland, and Canada. Oddly enough, I rarely screen films this way in Belgium.

Q: Antonin Artaud seems to be an important figure for your work. Do you think one can draw a relationship to his famously stated concept of the 'theatre of cruelty' and your work? A 'cinema of cruelty'?

BL: There is no direct influence. I worked at the Club Antonin Artaud, which developed a relationship between art and madness. I also made a trip to the Tarahumara Indians in Mexico, following in the footsteps of Antonin Artaud. It was a tribute of sort.

Q: Yes, but in one of your earlier interviews you described yourself as a savage, a primitive man. That is exactly what Artaud wanted to achieve with his theatre. Like Artaud, you have this honest approach to the image and to yourself. No play, no mask. You try (sometimes literally) to show yourself naked in front of the audience.

BL: Yes, that's right, it's true. I never made a reference to Antonin Artaud in that respect, but now I see what you mean. We're both looking for something authentic, spontaneous, 'naïve' or *art brut*. That's very important to me. I do not care much for French cinema, which is often too smooth, too well done, too intellectual. There are no stains. Take for example the movie *Of Gods and Men/Des hommes et des dieux* (Xavier Beauvois, 2010). It is too beautiful, too perfect. The movie is supposed to be about mysticism, but it has nothing to do with Tarkovsky's mysticism, for example. This seems very wrong to me. I always look for the basic, the impoverished. Even though I always care about the composition of images, at first sight it may look very hand-made. But there are always two layers in my films: one light-hearted, and one profound. It's like a child's play.

Q: The camera, as you mentioned earlier, is a means of protection, but in this context it is also a way to expose, to reveal and to communicate directly with the world.

BL: Yes, of course. And there are plenty of things I would not do without a camera. It's like theatre actors, who are often very shy in real life, but who are very extroverted once on the stage. That's what it means to be an artist.

Q: Around 1995, you declared that you'd never make a film again.

BL: I said this in my filmed interviews. I wanted to stop making films. But in the end, I didn't stop. Yet, I ceased to make normal documentaries. Gradually, my work veered more toward the autobiographical essay. The films are somewhat mixed together; they aren't clearly separated from each other. I am staging scenes all the time, even when I do not know how to integrate them directly. It is only later that I see where and whether I can use them or not.

Q: There is also a project of yours that consists of a multitude of short films, which can be watched randomly.

BL: Yes. Those are the *Films anthologiques* (2008). They aren't screened frequently. Once at a church in Paris, I think. Indeed, they consist of fragmentary ideas, shot on video. It's like a video installation. But I'm not really accepted in the field of contemporary art, as are Raymond Depardon, Chantal Akerman and Agnès Varda. I'm more recognized as a film-maker, although I'd like to experiment more with the possibilities of museum installation for my films. But nobody knows me in that milieu. Moreover, my working method is very primitive, like the Lumière brothers' *The Sprinkler Sprinkled/L'arroseur arrosé* (1896). It's almost the same thing.

Q: Yes, but still it is a more profound attitude than simply being old-fashioned or reactionary. Making your 'poor cinema' also includes an aesthetic and a message.

BL: Yes, 'primitive' does not mean 'primary'. It's rather like one talking of the 'Flemish Primitives', meaning that you start from the very origin of something. Unlike many people today, I really do believe in the power of the image. A movie on a screen in the Brussels South train station is not really cinema for me. Images are everywhere; they no longer make any difference. Of course there are still the film archives, and I'm very happy that they exist and I do use them, of course. But they carry the notion of museum, with all the connotations of the term. That's why I prefer home screenings. I've been doing them for thirty years and it won't change. I go to people's homes, we have dinner together, we talk, and I screen my movies in the living room, a cellar, a kitchen, a painter's studio, or a church… I like places that are not really cinemas.

Q: It appears to me that the cinema experience becomes more tangible in this context. You're there in person and you manipulate the film by yourself…

BL: Yes and it is very interesting to see me live and on the screen at the same time, often with a few years of difference between the two. There are always several Borises. It's part of the film. I'm meeting new people, sometimes I take pictures, or I shoot while screening. The film never ends!

Interview conducted and translated by Gawan Fagard (Brussels, May 3rd, 2011).

JCVD: JEAN-CLAUDE VAN DAMME

Although Jean-Claude Van Damme (b. 1960) started his career in American films and has only recently appeared in a Belgian film, his (somewhat derisory) nickname, 'The Muscles from Brussels' renders him – for better or worse – the face of Belgium for global cinema audiences. Born Jean-Claude Camille François Van Varenberg, 18 October 1960 in Sint-Agatha-Berchem, Van Damme has unquestionably become the most internationally famous Belgian-born actor.

The son of flower shop merchants, Van Damme began his Shotokan karate training at an early age, earning a black belt in 1978 and winning the European Professional Karate Association's middleweight championship. He also studied ballet and was invited by the Paris Opera to perform as a dancer, which he rejected in order to further his martial arts training, learning Tae Kwon Do and Muay Thai.

After briefly kickboxing professionally in the late seventies/early eighties and failing in his attempt to break into the Hong Kong film industry, Van Damme moved to the United States in 1981, working various odd jobs – including bouncer, carpet layer, chauffeur, and trainer – before securing roles as an extra in a handful of films, including an uncredited role in *Missing in Action* (Joseph Zito, 1984), starring his fellow martial arts star and sparring partner, Chuck Norris. But it was Van Damme's much larger role two years later as the villain in *No Retreat, No Surrender* (Corey Yuen, 1986) that brought him to the attention of Israeli producer Menahem Golan. Golan and Yoram Globus headed Cannon Films, a production company of lower-budget action movies, whose crowning achievements were films starring Norris as well as *Over the Top* (Menahem Golan, 1987), starring Sylvester Stallone (who also co-wrote the screenplay). Golan and Globus produced *Bloodsport* (Newt Arnold, 1988), which launched Van Damme as the next martial arts action star. Since then, Van Damme has received top billing on almost every one of his forty-plus films.

Van Damme did not stray too far from his own biography in his earliest films, where he achieved popularity in the competitive martial arts genre, including the above-mentioned *Bloodsport* and *Kickboxer* (Mark DiSalle and David Worth, 1989). Although primarily associated with martial arts and action films, Van Damme has also starred in the post-apocalyptic *Cyborg* (Albert Pyun, 1989), and would later appear in other science-fiction films, including the *Universal Soldier* series (*Universal Soldier*, Roland Emmerich, 1992; *Universal Soldier: The Return*, Mic Rodgers, 1999; *Universal Soldier: Regeneration*, John Hyams, 2009; *Universal Soldier: Day of Reckoning*, John Hyams, 2012); *Timecop* (Peter Hyams, 1994); and *Replicant* (Ringo Lam, 2001). *Bloodsport*, *Kickboxer*, and *Cyborg* were all distributed by Cannon, and the popularity of these films is demonstrated by the number of sequels each has engendered (two, two, and four, respectively), although Van Damme did not perform in any of them. Although Cannon Films helped him achieve his first film successes, Van Damme blamed his early Cannon contracts for preventing him from working on bigger budget films with major studios.

Jean-Claude Van Damme(s). The Kobal Collection.

Van Damme had one of his bigger successes in John Woo's Hollywood debut, *Hard Target* (1993), in which he starred as Vietnam veteran Chance Boudreaux. It was hoped that Woo would breathe some new life into the American action film with this remake of *The Most Dangerous Game* (Irving Pichel and Ernest B. Schoedsack, 1932), updated and set in New Orleans. Van Damme was blamed when the film, considered a straightforward American action tale, was not up to the level of Woo's previous, 'artistic' action films, such as *The Killer* (1989) and *Hard Boiled* (1992). According to Verina Glaessner in her review for *Sight and Sound*, 'If vulnerability is of central importance, then the casting of Jean-Claude Van Damme poses problems. Here is an actor of small range, not given to suggesting self-doubt, and his presence in the lead ensures that the kind of drama that can be enacted is strictly in the Superman vein.' Van Damme later became more adept at probing self-doubt and expressing his vulnerability, but he also never worked again with a director of Woo's caliber, although he did work for other

Hong Kong directors including Hark Tsui (*Knock Off*, 1998) and Ringo Lam (*Maximum Risk*, 1996; *Replicant*, 2001; *In Hell*, 2003). Of course, it can also be argued that Van Damme's limitations as an actor make him an ideal action star, evoking the Bressonian notion of the 'model' at the mercy of director, story, and action set pieces.

After reaching his peak in mainstream popularity in 1993-1995 with the releases of *Hard Target*, *Nowhere to Run* (Robert Harmon, 1993), *Timecop*, the film adaptation of the video game *Street Fighter* (Stephen de Souza, 1994), and the *Die Hard*-influenced *Sudden Death* (Peter Hyams, 1995), Van Damme first tried his hand at directing with *The Quest* (1996), for which he also wrote the screenplay. What starts out as a globetrotting adventure set in the 1920s evolves into yet another martial arts tournament, reminiscent of *Bloodsport*, *Kickboxer*, and *Lionheart* (Sheldon Lettich, 1990). *The Quest* contains some implausible action scenarios, including a sequence in which Van Damme's character, Christopher Dubois, a street clown caring for homeless children, fights policemen while on stilts. Even if *The Quest* ultimately relies too often on visual clichés (including an overabundance of slow motion), the film's central tournament, which feels like a mixed martial arts Olympics, is recommendable for those who enjoyed his earliest films, as it evokes *Bloodsport* crossed with Guy Maddin's *The Saddest Music in the World* (2003).

Like Steven Seagal and Dolph Lundgren, Van Damme's star power started to wane in the late 1990s, when he starred in a string of failures such as *Double Team* (Hark Tsui, 1997), in which he partnered with basketball star Dennis Rodman in his film debut. Van Damme continued to enjoy some success in the 2000s, with modest straight-to-DVD releases, starring in at least fifteen such films since 1999. *The Order* (Sheldon Lettich, 2001) is an adventure film that hearkens back to classical Hollywood. In one ribald scene, Van Damme disguises himself as a Hasidic Jew and finds trouble in the Palestinian section of Jerusalem. This Indiana Jones-like, religious artefact-centred adventure was not a bad idea for Van Damme, but its unfortunate timing around September 11 meant it would only receive a home video release in most countries. Director Sheldon Lettich, who had previously worked with Van Damme on *Lionheart* and *Double Impact* (1991), would again direct JCVD in *The Hard Corps* (2006).

Another straight-to-DVD Van Damme vehicle, Ringo Lam's *In Hell* (starring another athlete, ex-NFL linebacker Lawrence Taylor), loosely recycles the tournament format for fans of *Bloodsport*, *Kickboxer*, *Lionheart*, and *The Quest*, although this time, it is set in a Russian prison. It may also be one of Van Damme's more spiritual films, as it were, as his character, Kyle LeBlanc, is something of a Christ-like figure – albeit a violent one – for the prison community. His deceased wife even visits him as an angelic vision in a couple of scenes, but his status as a messianic action hero in a mock crucifixion recalls a similar scene in *Cyborg*.

After a group of films initially released on home video in the United States, Van Damme achieved his first critical success with Belgian-French co-production *JCVD* (2008), directed by Mabrouk El Mechri. Playing himself in the film, the actor visits a bank in Schaerbeek (one of Brussels' municipalities) and finds himself in the middle of a post office robbery and hostage situation. Flashbacks reveal some of his troubles in court, with his agent, and with people disappointed that, in real life, he does not always match his onscreen persona. Van Damme showcases his acting ability in the film's centrepiece: an eight-minute sequence with a soliloquy that is over six minutes long, in which Van Damme reveals his fears, his struggle with drug abuse, and his empathy when he states that he is just a 'regular guy' who has achieved great wealth while so many people are starving. His performance in *JCVD* was hailed as one of the year's best, and Van Damme received acting nominations from both the Toronto Film Critics Association and the Chlotrudis Awards. These distinctions represent a quantum leap, considering that the actor's previous major award attention amounted to three 'Most Desirable Male' nominations at the MTV Awards, in addition to a Razzie award ('Worst Screen Couple' with Rodman for *Double Team*) and nomination ('Worst New Star' for *Bloodsport*).

JCVD references the rivalry between Van Damme and Steven Seagal and, indeed, the two former-box-office-stars-turned-direct-to-DVD-action-heroes both 'arrived' with their hit films in 1988 (*Bloodsport* and Seagal's *Above the Law*, dir. Andrew Davis), but the two are certainly not interchangeable. Unlike Seagal, Van Damme has still maintained the athletic ability to perform his own stunts (as of 2012, he even plans a return to the kickboxing ring) and his films continue to feature the martial arts and fighting skills displayed in his early career, while Seagal's recent characters use guns more than the body as a natural weapon. Furthermore, despite Van Damme's persistent accent, he has never had the dubious distinction of being dubbed into English, as has the American-born Seagal, who has a tendency to mumble. But the two prolific actors continue to be associated in the public mind.

Compared to other action stars, Van Damme arguably boasts a gentler (and more Belgian?) persona, even while exploiting his matinee-idol looks. Like other action stars, including Bruce Lee, Jackie Chan, Stallone, and Seagal, Van Damme often performs in other capacities in his films, such as writing, producing, and directing (not to mention his work as a fight choreographer and an uncredited editor on some of his other films). Besides writing and directing *The Quest*, Van Damme wrote *Lionheart*, *Double Impact* (which he also produced), and *The Order* (Sheldon Lettich, 2001). Other films Van Damme produced include *Legionnaire* (Peter MacDonald, 1998, for which Van Damme also penned the story), *Inferno/Desert Heat* (John Avildsen, 1999) and *Universal Solider: The Return* (1999). The as-yet unreleased *The Eagle Path* (shot in 2010), aka *Full Love*, is to be the culmination of Van Damme's status as Renaissance-man of film-making: he served as the film's director, writer, producer, editor, and, of course, star. It was screened at Cannes in 2010 and its release is slated for 2013.

Van Damme's fetishized body, a combination of Stallone's muscles and Norris's martial artistry, is often on display (perhaps most notably in *Nowhere to Run*), more so than most other action stars, to the point that his body, rather than that of his female counterpart, usually functions as the focal point in his films' love scenes. Although many of his films feature love interests and Van Damme's heroes often seek domesticity, it often proves elusive, whether he tries to maintain a relationship with his children despite being divorced or separated (*Sudden Death*), his wife dying early on (*In Hell*), or his lifestyle being incompatible with having a family, even if he wants one (*Nowhere to Run*). This may have to do with the appeal of Jean-Claude Van Damme as a larger-than-life figure, both on- and off-screen, a 'total' star, boasting ambiguous features that are masculine and feminine, beautiful and ugly, mean and kind, sensuous and brutal.

Most critics and fans do not take these matters into consideration, however: Van Damme's 'Europeanness' exoticized him as a star, along similar lines as Dolph Lundgren (with whom Van Damme starred in *Universal Soldier*), Arnold Schwarzenegger, Antonio Banderas, and Christopher Lambert. His exotic quality, however, unlike Schwarzenegger's, seems to call, time and again, for various explanations regarding his character's French accent: depending on the situation, he is Cajun (*Hard Target* and *The Shepherd: Border Patrol*, Isaac Florentine, 2008), Québécois (*Nowhere to Run*, *Sudden Death*), or French (*Lionheart*, *Legionnaire*). At other times, his accent just goes unexplained. At any rate, his vaguely 'exotic' or 'European'/undefined francophone quality and flavour has not lessened Van Damme's international appeal, far from it: his popularity in Asia and Africa seems as high as it is in Europe and North America.

No stranger to various forms of escapades, excesses and controversy, Van Damme was successfully sued by a stuntman who claimed his eye had been permanently injured by the actor while filming *Cyborg*. Van Damme found himself in the midst of another lawsuit over the 'story by' credit for *The Quest*, which this time was ruled in Van Damme's favour. His custody battle over his children was at that time one of the most notorious in Californian court history. At the end of the nineties, the decade that

saw both his rise and decline, he admitted to battling cocaine and alcohol addictions. The semi-autobiographical *JCVD* was an exorcism of sorts for Van Damme, as in it, he releases many of the frustrations he had experienced, including court battles, financial difficulties, addictions, and continual low box office returns in lacklustre action films. Van Damme enjoyed a regained popularity on television through talk shows, with his ramblings that mixed English and French in a colourful and idiosyncratic manner (such as one of his signature formulations, 'je suis *aware*'). Re-inventing himself as some sort of guru or philosophical figure, Van Damme alternated weird and outlandish statements in interviews, thereby guaranteeing another type of cult following for himself – although, this time, ironic rather than purely sincere. In line with this new-found popularity, he also appeared in a welcome, if wooden, performance as himself in *The Secret Adventures of Gustave Klopp/Narco* (Tristan Auroeut and Gilles Lellouche, 2004), in which he is the fantasized idol of character Lenny Bar, played by another Belgian star who was also experiencing his own struggle with substance abuse at the time: Benoît Poelvoorde.

Reborn from his ashes, Van Damme has numerous projects on the horizon in the coming years, most of which will continue to be lower-budgeted, direct-to-DVD releases. Yet recent releases also reveal him occasionally breaking out into other territory, including a role in the French film, *Beur sur la ville* (Djamel Bensalah, 2011), as well as in *Kung Fu Panda 2* (Jennifer Yuh, 2011): his first voice-over work ever. After consistently meriting top billing since he first became a star over twenty years ago, Van Damme has shown some willingness in recent years to accept smaller roles, but it does not yet seem to decrease the number of films in which he still plays the lead. Even before the critical success of *JCVD*, Van Damme had stretched himself as an actor in some of his previous roles, such as in his portrayal of a heroin-addicted cop in *Until Death* (Simon Fellows, 2007). Another recent trend in his films are appearances by his son Kristopher Van Varenberg (b. 1987) and daughter Bianca Van Varenberg (b. 1990), who was also credited as co-producer of *Assassination Games* (Ernie Barbarash, 2011).

When Van Damme refused a leading role in *The Expendables* (Stallone, 2010) alongside other 'has been' action stars Stallone, Lundgren, and Jet Li, it was speculated that it was because the man known as the 'Muscles from Brussels' had decided to become a more serious actor after *JCVD*. Yet Van Damme still decided to star in two more *Universal Soldier* sequels, along with further direct-to-DVD actioners. The commercial success of *The Expendables* led to a 2012 sequel (hardly surprising, given Stallone's penchant for sequels), directed by Simon West, and this time, Van Damme joined the cast. Such a turn could be a shot of adrenaline for Van Damme's career, giving him access to a younger generation of viewers who grew up after his peak in popularity. In the role of the villain faced with the powerhouse constituted by Stallone, Lundgren, and Jason Statham – as well as Bruce Willis, Arnold Schwarzenegger and Chuck Norris – the 'Muscles from Brussels' delivers an entertaining performance, where his inscrutably deadpan facial expression and glassy eyes work wonderfully. Furthermore, as he said in an interview with Jacky Goldberg for the French journal *Les Inrockuptibles*, he relished the opportunity to play a bad guy: 'This bipolarity of mean power, it's a great thing' ('Cette bipolarité de pouvoir méchant, c'est un truc super'). A tribute to the Belgian star's charisma, in *The Expendables 2*, he seems like a believable match for the group of former leading action film figures cited above, and the scenes in which he is featured are by far the most enjoyable. Will Jean-Claude Van Damme need a new audience in order to maintain his run of genre-oriented films, or will he now embrace new cinematic avenues? The answer remains to be seen.

Zachary Ingle

ON LOCATION

BELGIUM AS CINEMATIC 'NON-SPACE'

Although not one of the major cinematic European countries, Belgium has nonetheless been featured prominently in numerous films, by both native and foreign directors. It has been treated in distinct, opposed, even mutually exclusive ways, but has typically resisted the type of iconoclasm that has marked many other countries and (in particular) their cinematically-represented capital or major cities. Indeed, the French New Wave director Claude Chabrol chose to shoot his melodrama *The Breach/La rupture* (1972) in Belgium precisely because he desired a location that did not become a salient or overt presence in the diegesis: that is, one drained of the iconographic qualities associated in particular with the New Wave films with which this director and others had made their names and international reputations. He chose to shoot in Belgium as a means to achieve this transparency of milieu and, as a result, the narrative seems to play out in a space positively drained of life and the kind of overt performativity indelibly connected with New Wave Paris. It is similar to a dystopian science-fiction narrative along the lines of canonical literary adaptations such as *The Handmaid's Tale* (Volker Schlöndorff, 1990) or even *1984* (Michael Radford, 1984), a world at once recognizably human but somehow alien and other. Belgium in *The Breach* is at once somewhere and nowhere, one place and any place, and in this respect is the starting point for a discussion of the country's position within its (under-represented and studied) national cinema.

Chabrol's film may in fact be taken as something of a paradigm in this regard. The overt presence of 'Belgium' has tended to be downplayed in much Belgian cinema, perhaps reflecting a sense that the country itself remains something of a complicated series of often-conflicting signs pointing to a multifaceted identity. Indeed, this is an implicit thematic in the work of many of the most acclaimed and celebrated Belgian film-makers, especially André Delvaux, the most renowned Belgian director of the 1960s and 1970s. His work was central to Belgian national cinema throughout these decades, in particular through his implicit exploration of what has been termed the country's bi-cultural specificity: that is, the pervasive sense of duality that defines it as a nation. On the one hand there is the age-old tradition of Flemish art and the never-quite-prevalent cinema of Flanders, that could have followed such a lineage. On the other hand are the French-language regional cinemas of Brussels and Wallonia, which in recent years have developed a sensibility that has mirrored the split in aspects of Belgian society by developing a paradigm that seems subtly international.

Delvaux's early work, such as *The Man who had his Hair Cut Short/De Man die zijn haar kort liet knippen/L'Homme au crâne rasé* (1965) exemplifies this trend, to the extent that the director has often been labelled the father of Belgian cinema. This film, based on Johan Daisne's 1947 magic-realist novel about a schoolteacher who begins to lust after one of his students, is fraught with a sense of fractured selfhood and personal identity, almost as a narrativization of the two Belgiums that can be perceived in the one country. In lieu of a cohesive narrative in this work are seemingly disconnected moments and incidents, and this methodology leads to a fragmented portrait not only of the protagonist but also of the locale in which it takes place. In other words, the spaces of the film comment upon the central character by dint of their blankness and resistance to definition.

The Breach, along with Delvaux's work and later films such as Stijn Coninx's Oscar-nominated drama *Daens* (1992), which centres around the struggles of a Catholic priest to better the conditions in which the poor work and live in a twentieth-century textile town, play upon this duality. They present a tenable tension between visibility and invisibility. In other words, the spaces of these films are present absences; they are present more to the extent that they are *not* immediately and narratively identifiable. *Daens* is set in a specific locale (the town of Aalst), but could as well take place in France, or even Victorian England, for all the intricacy of detail that pervades the narrative (besides, the film was shot partly on location in Poland). Conversely, Chabrol's film is a melodrama about a woman struggling against her husband's parents' attempts to take custody of her son, and the deliberate blankness of the locations (which are forcefully used in a number of striking scenes, most especially an extended tram ride through the city) reinforces the subjective sense of spatiality. That is, the indistinct quality lent the narrative by its being shot in Belgium (specifically, Brussels) reinforces the essential homelessness of the French protagonist, and thereby serves to underline her estrangement and isolation.

In recent years, Belgium has featured prominently (if, once again, not iconoclastically) in works by native directors whose narratives situate the country within a tension between reality and fantasy, and view it as an insular presence constructed and shaped as much by its characters as by larger forces of history and socio-politics. Beyond the naturalistic drama of *Daens*, Jaco Van Dormael's *Toto the Hero/Totos le héros* (1991) and Alain Berliner's *My Life in Pink/Ma vie en rose* (1997) offer perhaps the two outstanding and acclaimed examples in this regard, following the stylized example of André Delvaux. Both works refract their narratives through the consciousness of a central narrator figure, and their views of the country reflect this subjective narrative structure. Van Dormael's film in particular builds its intricately interior vision from an assemblage of memories and fantasies concerning the long-cherished revenge that drives the protagonist and facilitates his regression to childhood. One would be hard-pressed to identify any sense of national specificity within its narrative, as its exterior scenes are reduced to brief snapshots of rather anonymous suburban milieus and, finally, a town centre location. Neither space offers much beyond an immediate sense of the central character's home life and surroundings. The narrative focus of fractured personal identity (*Toto the Hero* is in this respect complemented by Berliner's exploration of the complicated selfhood of a young boy who wishes to become and live as the girl he believes he was supposed to be, in *My Life in Pink*) then becomes a point of departure wherein the deliberate opacity of setting offsets the complex selfhood at the heart of the narrative. It is, in fact, like a stage, a mere backdrop that throws the central drama into relief by virtue of its relative opacity.

The sober, more internationally acclaimed, and renowned obverse image of this paradigm finds its apotheosis in the work of the Dardenne Brothers. Beginning *The Promise/La Promesse* (1996), Jean-Pierre and Luc Dardenne developed a verisimilar, naturalistic sensibility wherein the cities and urban areas of Belgium and France become interchangeable. Typically the films that followed on from *The Promise* – *Rosetta* (1999), *The Son/Le fils* (2002) and *The Child/L'enfant* (2005) – present a naturalistic portrait of Belgium that very much underlines a universality wherein such a scenario could take place in any dispossessed corner of an otherwise first-world European country. As such, it is a subtly transnational picture (something underlined by the French critical establishment's canonization of the Dardenne Brothers as one of their own), and this once again echoes the sense of a commonality in continental Europe, and thus by extension the aforementioned dichotomy between specificity and generality in Belgium.

Most of the Dardenne Brothers' films are set in Seraing, in the Belgian province

of Liège within the country's large southern province of Wallonia (a French-speaking region). This is a location whose centrality to the industrial revolution, as the first entirely industrialized region in continental Europe – remaining for a time the world's second industrial power – has suffered in recent decades from an economic downturn due to a crisis in the steel industry, and it is represented again and again in these films, from *Je pense à vous* to *Rosetta*, *The Son* and *The Child*, all shot in Seraing. From *Rosetta* on, this representation's sense of realism is reinforced by a hand-held, *cinéma-vérité* aesthetic (which admits little of the world into the frame beyond the immediate space traversed by the respective protagonists), and a narrative methodology of following a single character or characters over the course of a typically compact span of time. Here again the duality between specificity and universality is very keenly felt, with the detailed portrait of the protagonists offset by the implicit fact that they could and would experience a similar fate in a number of cities.

It is thus the case that images of Belgium may be seen to carry more weight (thematic as much as narrative) than may have been supposed, even in the limited discourse that currently comprises critical reflection about this national cinema. The very fact that the country has sporadically been employed as a blank canvas, a place both somewhere and anywhere, enlarges current trends in the study of national cinematic industries. In books such as Valentina Vitali and Paul Willemen's edited volume, *Theorising National Cinema* (2008), there has been an emphasis on how textual elements can stand in for the nation and figuratively represent its specific identity. In Belgium, modes of cinema, its generic forms, have frequently factored in this particular discourse. There was, in the 1930s, a strong tradition of documentary cinema in Belgium (with figures such as Charles Dekeukeleire and Henri Storck), and this feeds into the naturalistic aesthetic that has recently been made manifest as a strong component of Belgian film-making. However, elements of fantasy and magical realism have also defined many films and key film-makers, and this contributes to a national cinema bound by tensions and fractures, competing constructions of identity. This is a key notion in the cinema of Belgium, and it is something to which the country itself has contributed and to which its films have responded.

Adam Bingham

BRUGES, OR THE (DIS)COMFORT OF STRANGERS

Both beautiful and lugubrious, the medieval town of Bruges – known as Belgium's Venice of the North – serves as the backdrop to several films, most famously Martin McDonagh's recent *In Bruges* (2008), in which two Irish assassins, on the run after a job gone wrong, react quite differently to their Christmas holiday hideaway: Ken (Brendan Gleeson) enjoys the scene while Ray (Colin Farrell) remains impervious to the city's charms, as attested in one of his memorable lines: 'If I grew up on a farm, and was retarded, Bruges might impress me, but I didn't, so it doesn't.'

McDonagh's film opts for a representation of Bruges (and Belgium) that is both fitting and somewhat stereotypical: on the one hand, it portrays Belgian people as down-to-earth and resourceful (when they are not boneheaded blobs, they can be very attractive women, as portrayed by Dutch and French actresses Thekla Reuten and Clémence Poésy), and Bruges as a destination for un-sexy tourists. Besides said tourists, most expats encountered by Ray during his stay in the city seem to find the place excruciatingly boring. But what they do not suspect is that, amidst its wintry fogs, this citadel of stone soaked in the cold waters of the canals is, much like the Venice in Luchino Visconti's *Death in Venice* (1970), Nicolas Roeg's *Don't Look Now* (1973) or Paul Schrader's *The Comfort of Strangers* (1990), a phantasmagorical place where life and death dangerously commingle, and where unfortunate visitors remain trapped, as though in a maze. *In Bruges*'s final scene definitely taps into this uncanny realm, where the shoot of a weird film involving dwarf actors, shrouded in thick cinematic fog, becomes the place for the final reckoning between Ray and his employer (Ralph Fiennes). This showdown, in which the sense of loyalty between the mobsters tears them apart, ends in everyone's death. Little could the flocks of millions of gleeful tourists visiting the city each year have suspected that the quaint city of Bruges could be so deadly.

Yet, far from the clichés of beautiful medieval houses and churches, Christmas markets and cheerful Santas, Bruges holds a long tradition of being associated with death – and for very concrete reasons that reach far beyond the age of cinema and the tourist industry. Once a major harbour and one of the wealthiest cities of the Hanseatic Guild, a town home to many important artists, including Jan van Eyck, Bruges gradually lost its impact as the Northern Sea retreated in the early Modern period. This caused the city to devolve into the status of a remarkably preserved, museum-like place, celebrated for its beauty but also strangely petrified in time. As such, it became – a fact that might come as novelty to many cinephile – the heart of one of cinema's greatest masterpiece.

In the late nineteenth century, Georges Rodenbach, a Flemish journalist, novelist, and poet who wrote in French, selected Bruges for his story of obsession and murder, entitled *Bruges-La-Morte* (1892), a staple of symbolist literature. In it, a man suffers terribly after the death of his sickly beloved, preserving her hair under a glass dome. Later, following a period of depression, the widower meets another woman, who is a dead-ringer of his departed spouse. Courting the thankless gold-digger, the man eventually goes mad. When the woman mocks his adoration, taunting him with the lock of his wife's hair, he retaliates by strangling her with the relic of his dead love. This classic in the Belgian literary canon must have served as an inspiration for Pierre Boileau and Thomas Narcejac's pulp story

Brendan Gleeson and Colin Farrell in *In Bruges*.
The Kobal Collection.

D'entre les morts (*The Living and the Dead*), which in turn served as the source text for none other than Alfred Hitchcock's *Vertigo* (1958), whose San Francisco and narrative of obsession and petrified time bear more than one resemblance with Bruges. *Bruges-La-Morte* was also directly adapted, more or less faithfully, into a series of films, from the silent period onward, most famously in 1981's academic and beautiful adaptation by Roland Verhavert, *Brugge, die stille*, and its portrait of a deserted, turn-of-the century melancholy city, dominated by grey and sombre tones (with cinematography by Bruges native Walther van den Ende).

With such a legacy, and in spite of being now a welcoming, touristy place visited by millions, no wonder Bruges can never entirely yield itself as the backdrop to innocuous romantic stories or comedies. Much as Rodenbach's classic tale must not be taken literally but, rather, as a symbol for a dying city, so can Bruges encompass a profoundly-cinematic predicament. In this day and age of transition from analog formats to digital, the condition of frozenness of the cinematic still evokes the petrified, museum-like quality of this late medieval jewel preserved at the heart of a fast-moving Europe. But the waters of the canals take their toll on the foundations of the city, causing, much as with aging celluloid, irreversible decay. Both devastating and beautiful – the sublime of ruins and death – this unique phenomenon is something that digital cinema, akin to the new cities of steel and glass, will never be able to procure. Instead, the new technology leaves one with the vaguely uncomfortable sensation of never being quite reconnected with the past anymore, a further sense of alienation in the grand scheme of capitalism's reification. Or, the discomfort of strangers – strangers, at last, to ourselves, yearning for this realm of dreams and shadows where many ventured and got lost, and that some once dared call home.

Jeremi Szaniawski

REFERENCES AND RECOMMENDED READING

Abu-Manneh, Bashir (2006) 'Towards Liberation: Michel Khleifi's *Ma'loul* and *Canticle*', in Hamid Dabashi (ed) *Dreams of a Nation*. London/New York: Verso.

Agel, Henri and Joseph Marty (1996) *André Delvaux. De l'inquiétante étrangeté à l'itinéraire initiatique.* Lausanne: L'Age d'Homme.

Allen, Sharon Lubkemann (2008; 2010) 'Chantal Akerman's Cinematic Transgressions: Transhistorical and Transcultural Transpositions, Translingualism, and the Transgendering of the Cinematic Gaze', in Marcelline Block (ed) *Situating the Feminist Gaze and Spectatorship in Postwar Cinema*. (Newcastle: Cambridge Scholars), pp. 255–288.

Angelet, Christian, Christian Berg, and Marc Quaghebeur (eds) (2002) *Présence/absence de Maurice Maeterlinck: Actes du Colloque de Cerisy-la-Salle, 2-9 septembre 2000*, Brussels: Labor.

Akerman, Chantal (2009) 'Chantal Akerman: On *Jeanne Dielman*'. Criterion Collection Interview, April 2009. Included with DVD of *Jeanne Dielman, 23 Quai du Commerce, 1080 Bruxelles* (Criterion Collection 2009).

Aubenas, Jacqueline (ed) (2008) *Jean-Pierre et Luc Dardenne*. Brussels: La Renaissance du Livre.

Aubenas, Jacqueline (ed) (1999) *Dic Doc : Le dictionnaire du documentaire*. Brussels: Commissariat général aux relations internationales.

Bachy, Victor (1968) *Jacques Feyder: artisan du cinema*, Louvain: Librairie Universitaire.

Badt, Karin (2005) 'The Dardenne Brothers at Cannes: "We Want to Make it Live"'. *Film Criticism* 30 (Fall): 64-71.

Baetens, Jan (ed) (2008) *La novellisation : du film au roman. Lectures et analyses d'un genre hybride*. Bruxelles: Les impressions nouvelles.

Barker, Jennifer (1999) 'The feminine side of New York: travelogue, autobiography, and architecture in *News from Home*', in Gwendolyn Audrey Foster (ed), *Identity and Memory: The Films of Chantal Akerman* (Southern Illinois University, 2003), pp. 41–58.

Becker, Lucille F (1999) 'Novel into Film', in *Georges Simenon Revisited* (Twayne's World Authors Series, No. 888, French Literature), pp. 117-31.

Benvindo, Bruno (2010) *Henri Storck, le cinéma belge et l'Occupation*, Brussels: Editions de l'Université de Bruxelles.

Bergstrom, Janet (1999) 'Invented Memories', in Gwendolyn Audrey Foster (ed), *Identity and Memory: The Films of Chantal Akerman* (Southern Illinois University, 2003), pp. 94–116.

Bickerton, Emilie (2006) 'Reinventing Realism: The Art and Politics of the Dardenne Brothers.' *Cineaste* 31 (Spr): 14–18.

Biltereyst, Daniel (2007) 'The Roman Catholic Church and film exhibition in Belgium, 1926-1940', *Historical Journal of Film Radio and Television* 27 (2): 193–214.

Biltereyst, Daniel and Meers, Philippe (eds) (2007) *De Verlichte Stad. Een geschiedenis van bioscopen, filmvertoningen en filmcultuur in Vlaanderen*. Leuven: LannooCampus.

Biltereyst, Daniel and Meers, Philippe (eds) (2004) *Film/TV/Genre*. Ghent: Academia Press.

Biltereyst, Daniel and Stalpaert, Christel (eds) (2007) *Filmsporen. Opstellen over film, verleden en geheugen*. Ghent: Academia Press.

Biltereyst, Daniel and Winkel, R Vande (2004) *Bewegend geheugen. Een gids naar audiovisuele bronnen over Vlaanderen*. Ghent: Academia Press.

Biltereyst, Daniel, Meers, Philippe, Lotze, Kathleen and Vijver, L. Van de (2012a) 'Negotiating cinema's modernity : strategies of control and audience experiences of cinema in Belgium', in Daniel Biltereyst, Richard Maltby, Philippe Meers (eds.) *Cinema, audiences and modernity*. London: Routledge, pp. 186–201.

Bilatereyst, Daniel, Philippe Meers, and L Van de Vijver (2012b) 'Mapping film exhibition in Flanders (1920-1990). A diachronic analysis of cinema culture combined with demographic and geographic data', in J Hallam and L Roberts (eds.) *New spatial methodologies in cinema and the moving image.* Indiana: Indiana University Press.

Bilatereyst, Daniel, Meers, Philippe and Vijver, L Van de (2011) *Social class, experiences of distinction and cinema in postwar Ghent; Explorations in new cinema history : approaches and case studies,* Oxford, Blackwell, pp. 101–24.

Block, Marcelline (2012) 'The Aesthetics of Migration', *Afterall* 30 May 2012. Available at http://www.afterall.org/online/aesthetics-of-migration-as-representative-of-the-human-condition.

Block, Marcelline (2010) 'Dissidents of Patriarchy', in *Situating the Feminist Gaze and Spectatorship in Postwar Cinema*, 2nd ed., Newcastle, UK: Cambridge Scholars Publishing, pp. xvi–lxii.

Block, Marcelline (2013a). 'Grim Discoveries: Agnès Varda's *Vagabond* (1985) and Karen Moncrieff's *The Dead Girl* (2006)'. In *Our Changing Journey to the End: Reshaping Death, Dying, and Grief in America*, edited by Christina Staudt and J. Harold Ellens (Praeger, forthcoming 2013).

Block, Marcelline, ed (2013b). *World Film Locations: Marseilles.* Bristol, UK: Intellect/ Chicago: University pf Chicago Press.

Bolen, Francis and Vermeylen, Pierre (1978) *Histoire authentique, anecdotique, folklorique et critique du cinéma belge depuis ses lointaines origines.* Brussels: Memo et Codec.

Borde, Raymond (1983) *Les Cinémathèques.* Lausanne: L'Âge d'Homme.

Bouras, D., A. Feuillère, and Jean-Michel Vlaeminckx (2007) 'Jaco Van Dormael : Mr. Nobody. L'épopée fantastique de Mr. Nobody', *Le moniteur du film en Belgique*, n°264, August.

Boym, Svetlana (2011) 'Immigrant Arts, Diasporic Intimacy, and Alternative Solidarity', in Niels Van Tomme (ed.), *Where Do We Migrate To?* Baltimore: Center for Art, Design and Visual Culture at the University of Maryland, pp. 25–32.

Brenez, Nicole (2011) 'Chantal Akerman: The Pajama Interview,' *Lola* 2, http://www.lolajournal.com/2/pajama.html

Browning, H and Sorrell, A (1954) 'Cinema and cinema-going in Great Britain', *Journal of the Royal Statistical Society,* vol. 117: 133-65.

Capdenac, Michel (1966) in *Les Lettres françaises*, November 20.

Cardullo, Bert (2009) 'The Cinema of Resistance: An Interview with Jean-Pierre and Luc Dardenne', *Film International* 7 (Oct): 6-15.

Cavell, Stanley (2005) *Cavell on Film.* Ed. and introd by William Rothman. Albany: SUNY Press.

Certeau, Michel de (1999) 'Walking in the City', in Simon Durang (ed) *The Cultural Studies Reader* (2nd ed) Psychology Press, pp. 126-33.

Colvile, Georgiana MM (2006) 'Between Surrealism and Magic Realism: The Early Feature Films of André Delvaux', *Yale French Studies* 109: 115-128.

Condé, Maryse (2013) 'Literature and Globalization', trans. Marcelline Block. *The Encyclopedia of Global Human Migration*, Wiley-Blackwell.

Convents, Guido (2000) *Van kinetoscoop tot café-ciné*, Louvain: UPLeuven.

Dardenne, Luc (2008) *Au dos de nos images (1991-2005)*, Paris: Seuil.

Davay, Paul (1973) *Cinémas de Belgique*, Brussels: Duculot.

Degeimbre, Bénédicte (1992) *Le Cinéma Belge Francophone*, Mémoire I.E.S.S.I.D. Brussels.

De Hert, Robbe (1983) *Het Drinkend Hert bij Zonsondergang*. Leuven: Kritak.

De Laet, Danny, Bolen, Francis and Magiels Willy (1976) 'Science Fiction et Fantastique dans le Cinéma Belge (1913-1974)' *The Skull* nr. 4. Brussels

Dekeukeleire, Charles (1947) *Le Cinéma et la Pensée*. Brussels: Lumière/A. Manteau.

Dekeukeleire, Charles (1942) *L'Emotion Sociale*. Brussels: La Maison du Poète.

Deleuze, Gilles ([1985]2005) *Cinema 2 : The Time-Image.*, trans. Hugh Tomlinson and Robert Galeta. London: Continuum Publishing Group.

Depauw, Liesbet and Biltereyst, Daniel (2005), 'De kruistocht tegen de slechte cinema: over de aanloop en de start van de Belgische filmkeuring' (1911-1929), *Tijdschrift voor Mediageschiedenis* 8: 3-26.

Devanne, Laurent (2011) 'Marco Lamensch, producteur.' Interview. *Kinok.Com: webzine cinéma*. 29 Dec. Available at http://arkepix.com/kinok/Marco%20LAMENSCH/lamensch_interview%20.html

Dubois, Jacques and Benoît Denis (2003) Georges Simenon, *Romans*, t. II, coll. Bibliothèque de La Pléiade, Paris: Gallimard.

Dubois, Philippe and Arnoldy, Ed (eds) (1993) *Ca tourne depuis cent ans : Une histoire du cinéma francophone de Belgique*, Brussels : CGRI.

Dubois, Philippe and Melon, Marc Emmanuel (1991) *La création vidéo en Belgique. Points de repère (1970-1990)*. Paris: Musée d'Art Moderne de la Ville de Paris.

Engelen, L, Nijs, J, Lefèvre, P, Vande Winkel, R (eds) (2012) *Cinema Leuven. Een studie naar de Belgische filmaffiche aan de hand van de collectie van het Leuvens stadsarchief*, Leuven: Peeters Publishing.

Engelen, Leen (2001) 'Representation of the First World War in Belgian fiction film: an analysis of *Maudite soit la guerre* (1913)'. Annual meeting of the Popular culture association and the American culture association, Philadelphia, PA, April 11-14, 2001.

Everaerts, Jan-Pieter (2000) *Film in België: Een permanente revolte*. Brussels: Mediadoc.

Feyder, Jacques and Rosay, Françoise (1944) *Le cinéma notre métier*. Genève: Albert Skira.

Foster, Gwendolyn (1999) 'Introduction' in Gwendolyn Audrey Foster (ed), *Identity and Memory: The Films of Chantal Akerman* (Southern Illinois University Press, 2003), pp. 1–8.

Fowler, Catherine (1999) '*All Night Long*: The Ambivalent text of 'Belgianicity' in Gwendolyn Audrey Foster (ed), *Identity and Memory: The Films of Chantal Akerman* (Southern Illinois University Press, 2003), pp. 77–93.

Fowler, Catherine (2010) 'Cinema that stays at home: the inexportable films of Belgium's Gaston Schoukens, Edith Kiel and Jan Vanderheyden', *Screen* (2010) 51(3): 256–71.

Furniss, Maureen (2007) *Art in Motion: Animation Aesthetics*. Bloomington: Indiana University Press.

Fuller, Samuel (2011) *Un troisième visage*, trans. Hélène Zylberait, Paris: Allia.

Gauteur, Claude (2001) *D'après Simenon : Simenon & le cinéma*, Paris: Omnibus.

Genette, Gérard (1998) 'Discours du récit.' *Figures III*, Paris: Seuil, 1972 : pp. 69–278.

Gilles, Christian (1989) *Les directeurs photo et leur image,* Paris: Dujarric.

Geens, Paul (1986) *Naslagwerk over de Vlaamse Film*, Brussels: CIAM.

Geeraerts Daniel and Hoogenbempt, Miel Van (1982) *Krisis in de Belgische Film-La Crise dans le Film Belge*, Donut Productions, Mechelen.

Gertz, Nurith and George Khleifi (2008) *Palestinian Cinema: Landscape, Trauma and Memory*, Indiana University Press: Bloomington/Indianapolis.

Gibson, Brian (2006) 'Bearing Witness: The Dardenne Brothers' and Michael Haneke's Implication of the Viewer', *Cineaction* 70: 24-38.

Gorceix, Paul (2005) *Maeterlinck, l'arpenteur de l'invisible*, Brussels: Le Cri.

Head, Anne (1988) *A true love for Cinema: Jacques Ledoux, 1921-1988*. Rotterdam: University Press.

Héliot, Louis and Sojcher, Frédéric (eds) (2005) *Les frères Dardenne*. Paris: Université de Paris 1 - Panthéon – Sorbonne.

Janssens, Christian (2005) *La Fascination Simenon*. Paris: Cerf; Condé-sur-Noireau: Corlet.

Jungblut, Guy, Leboutte, Patrick and Païni, Dominique (1990) *Une encyclopédie des cinémas de Belgique*. Liège: Yellow Now.

Kelly, Richard (2000) 'Wage Warrior', *Sight & Sound* vol 13, April 2003.

Khleifi, Michel (2006). 'From Reality to Fiction – from Poverty to Expression', in Hamid Dabashi (ed) *Dreams of a Nation*. London and New York: Verso, pp. 45-57.

Kuyper, Eric de, Marianne Thys (introduction), Sabine Lenk (filmography) (1995). *Alfred Machin: cinéaste/Film-Maker*. Brussels : Cinémathèque royale de Belgique.

Lacassin, Francis (2001) *Alfred Machin : De la jungle à l'écran*, Paris: Dreamland.

Laroche, Daniel (1993) 'Ecrivains belges à l'écran', in Jean-Pierre de Nola et Josette Gousseau (eds) *La Communication cinématographique. Reflets du livre belge. Actes du colloque de Palerme (1er-4 mars 1986)*, Paris, Didier-Erudition, pp. 327-36.

Laux, Charles. 'Comparing and Contrasting the G-minor Symphonies of W. A. Mozart (K. 183 and K. 550)'. Available at http://www.charleslaux.com/?page_id=204.

Lenk, Sabine (2001) 'Alfred Machin', in *Dictionnaire du cinéma français des années vingt*, François Albéra et Jean Gili (eds), special issue, *Revue 1895*. Paris: AFRHC, juin 2001, n°33. Available at http://1895.revues.org/97#tocto1n1.

Lehman, Boris (ed) (1992) *Lettre à mes amis restés en Belgique*. Liege: Yellow Now.

Lotze, Kathleen and Meers, Philippe (2012) "They don't need me in heaven... there are no cinemas there, ye know' – Cinema culture in Antwerp (Belgium) and the empire of Georges Heylen (1945-1975)', in Albert Moran and Karina Aveyard (eds) *Watching Films: New Perspectives on Movie-Going, Exhibition and Reception*. Bristol: Intellect.

Lotze, Kathleen and Meers, Philippe (2011) 'Citizen Heylen. Opkomst en bloei van het Rex-concern binnen de Antwerpse bioscoopsector (1950- 1975)' in *Tijdschrift voor Mediageschiedenis* 13, issue 2 (December): 80-107.

Lubbock, Percy (1921) *The Craft of Fiction*, London: Jonathan Cape.

Maelstaf, Raoul (1976) 'De Animatiefilm in Belgie', *Numéro spécial de V.B.A. Flash* (4-5), Antwerpen.

Magiels, Willy and Robbe De Hert (eds) (2004) *Magie van de Cinema. Hollywood aan de Schelde*. Antwerp: Facet.

Maltby, Richard, Biltereyst, Daniel, and Meers, Philippe (eds) (2011) *Explorations in new cinema history: Approaches and case studies*, Malden: Wiley-Blackwell.

Margulies, Ivone (2006) 'La chambre Akerman: The Captive as Creator', *Rouge*, December. Available at http://www.rouge.com.au/10/akerman.html.

Massin, Marie-Hélène and Decock, Debora (eds) (2012) *De long en large 2000-2010 : les longs métrages de la Fédération Wallonie-Bruxelles*, Centre du cinéma de la Fédération Wallonie-Bruxelles.

Mathijs, Ernest (2004) *The cinema of the Low Countries*. London: Wallflower Press.

Mai, Joseph (2010) *Jean-Pierre and Luc Dardenne*. Chicago: University of Illinois Press.

Martin, Angela (ed) (1979) 'Chantal Akerman's Films: A Dossier', *Feminist Review* 3: 24-47.

Mélon, Marc-Emmanuel, and d'Autreppe, Emmanuel (eds) (1996) 'Luc et Jean-Pierre Dardenne : Vingt ans de travail en cinéma et vidéo', *Revue Belge du Cinéma* n. 41. Winter 97 : 91-95. Brussels : APEC.

Meers, Philippe, Biltereyst, Daniel and Vijver, Lies Van de (2010a) 'Metropolitan vs rural cinemagoing in Flanders, 1925-1975', *Screen* 51(3): 272-80.

Meers, Philippe, Biltereyst, Daniel and Vijver, Lies Van de (2010b) 'Memories, movies, and cinema-going: an oral history project on film culture in Flanders (Belgium)', in I. Schenk et al. (eds) *Film, Kino, Zuschauer: Filmrezeption = Film, cinema, spectator: film reception*. Marburg: Schüren, pp. 319-37.

Moins, Philippe and Temmerman, Jan (1999) *Raoul Servais. Itinéraire d'un peintre cinéaste*, Annecy: Fondation Raoul Servais.

Morgan, Janice (2004) 'The Social Realism of Body Language in *Rosetta*', *French Review* 77 (Feb): 526-35.

Mosley, Philip (1992) 'Literature, Film, Music: Julien Gracq's "Le Roi Cophetua" and André Delvaux's *Rendez-vous à Bray*', *Literature/Film Quarterly* 20,2: 138-45.

Mosley, Philip (2002) 'Anxiety, Memory, and Place in Belgian Cinema', *Yale French Studies* 102: 160-175.

Mosley, Philip (2001) *Split screen: Belgian cinema and cultural identity*. New York: State University of New York Press.

Mosley, Philip (1994) 'From Book to Film: André Delvaux's Alchemy of the Image', *French Review* 67 (Apr): 813-23.

Nasta, Dominique (2004) 'Territoires sonores de l'œuvre delvalienne', dans *Degrés : André Delvaux. La magie du réel*, n° 119-120, automne-hiver.

Nasta, Dominique (1997) 'Ghislain Cloquet', in Christopher Lyon and Susan Doll (eds) *The International Dictionary of Films and Film-makers*, vol. 4. New York: St. James Press.

Nasta, Dominique (ed) (1995) 'Jacques Ledoux, l'Éclaireur', *Revue du cinéma belge* n°40, September. Brussels: APEC

Nasta, Dominique and Jacqueline Aubenas (eds) (1994) 'Toto le Héros : itinéraires d'une première œuvre', *Revue Belge du Cinéma*, n°36-37, April. Brussels : APEC

Nelissen, Ivo (1970) 'Ontwikkelingshulp gevraagd voor Antwerpen "Kinemastad"', *De Nieuwe Gazet* 24 April.

Nysenholc, Adolphe (2006) *André Delvaux ou le réalisme magique*. Paris: Cerf.

Nysenholc, Adolphe (ed) (2004) *André Delvaux. La magie du reel*, Actes du colloque international André Delvaux, *Degrés*, n°119-120.

Nysenholc, Adolphe (1994) *André Delvaux*. Brussels: Editions de l'Université de Bruxelles.

Nysenholc, Adolphe (ed.) (1985a) 'Ombres et lumières, Etudes du cinéma belge', *Revue de l'institut de Sociologie*. Brussels, University Presses (vol. 3-4).

Nysenholc, Adolphe (ed) (1985b) *André Delvaux ou les visages de l'imaginaire*. Brussels: Editions de l'Université de Bruxelles.

Nysenholc, Adolphe (ed) (1984) *Semaine du cinéma en Belgique*, ULB 150 ans, catalogue (projection de 64 films en présences des réalisateurs), colloque interuniversitaire.

Nysenholc, Adolphe, Borgomano, Laure and Blampain, Daniel (1988) *André Delvaux (une oeuvre, un film. L'Œuvre au noir d'après Marguerite Yourcenar)*, Bruxelles/Paris: Labor/Méridiens Klincksieck.

Olivier, Richard (2012) *Big Memory*, Preface by Jean-Michel Frodon. Brussels: Les Impressions Nouvelles.

Paquet, André (ed) (1972) *Le Cinéma en Belgique*, Montréal: La Cinémathèque Québécoise.

Polet, Jacques (1995) 'Alfred Machin, pionnier du cinéma en Belgique, entre tradition et modernité', *Revue belge de cinéma*, Jacques Polet (coord.), mars, n°38-39. Brussels: APEC.

Polet, Jacques (1982) 'L'espace d'une vie ou Jalons d'une biographie', *Revue Belge du Cinéma* (Belgium) Vol. 1, Iss. 1.

Rabaté, Jean-Michel (2010) 'Mulvey was the First…' In Marcelline Block, ed., *Situating the Feminist Gaze and Spectatorship in Postwar Cinema* Newcastle: Cambridge Scholars Publishing, pp. x-xiv.

Rigot, Fernand (1958) *Nomenclature des films réalisés en Belgique ou faits par des belges à l'étranger de 1907 à 1955*, Brussels.

Robberechts, JA (ed) (1955) *De Film in Belgie*. Antwerp: Vlaams Economisch Verbond.

Rosenbaum, Jonathan (2011) 'Chantal Akerman: The Integrity of Exile and the Everyday,' *Lola* 2 http://www.lolajournal.com/2/integrity_exile.html

Rosenberg, Rudy (2008) *And Somehow We Survive*. Authorhouse.

Rosenberg, Rudy (2013) *Unorthodox Life*. Authorhouse.

Rousseau, Jean-Jacques (1964) 'Discours sur l'origine et les fondemens de l'inégalité parmi les hommes', *Oeuvres complètes*, vol. 3., Paris: Gallimard.

Russell, Sharon (1978) *Semiotics and Lighting: a Study of Six Modern French Cameramen*. Ann Arbor: Univ. of Michigan Press.

Rykner, Arnaud (1998) *Maurice Maeterlinck. Bibliographie des écrivains français*, 14. Paris, Rome: Memini.

Sadoul, Georges (1949) *Histoire du Cinema Mondial des Origines à Nos Jours*, Paris: Flammarion.

Said, Edward (2006) *Preface*, in Hamid Dabashi (ed) *Dreams of a Nation*. London, New York: Verso.

Schuster, Aaron (2011) 'The Atopia of Philosophy' in Niels Van Tomme (ed) *Where Do We Migrate To?* Baltimore: Center for Art, Design and Visual Culture at the University of Maryland, pp. 33–38.

Smolders, Olivier (2009) *Voyage autour de ma chambre*. Paris-Bruxelles: Les Impressions Nouvelles.

Smolders, Olivier (2005) *La part de l'ombre*. Paris-Bruxelles: Les Impressions Nouvelles.

Smolders, Olivier (2001) *Expérience de la bêtise, où l'on apprend à aimer les vessies autant que les lanternes*. Liège: Yellow Now.

Smolders, Olivier (1998) *'Eraserhead' de David Lynch*. Liège: Yellow Now.

Smolders, Olivier (1997) *14 Adages d'Erasme*, édition bilingue français-latin d'après le manuscrit apocryphe du professeur Cantarel, à la lumière de quatorze eaux-fortes originales de Michel Smolders. Brussels: co-édition Le Scarabée & La Maison d'Érasme.

Smolders, Olivier (1995) *Paul Nougé*. collection 'Archives du Futur'. Brussels: Labor.

Smolders, Olivier (1994) *Fontanelle*. Liège: Le Scarabée and Yellow Now.

Smolders, Olivier (1993) Éloge de la pornographie : où l›on comprend enfin pourquoi le cinéma pornographique est un genre charmant, sympathique, parfaitement délicieux. Collection 'De parti pris', Liège: Yellow Now.

Smolders, Olivier (1988) *Cinéma parlant, dictionnaire d'idées-reçues sur le cinéma*. La Louvière: Editions Le Daily-Bul.

Sojcher, Frédéric (2008) 'Belgique : une année de transition', *Atlas du cinéma mondial*, special edition about *Cahiers du Cinéma*, May.

Sojcher, Frédéric (2007) 'Belgique : Quel cinéma pour quels spectateurs ?' In *Atlas du cinéma mondial*, special issue about *Cahiers du Cinéma*, May.

Sojcher, Frédéric (2006) 'Belgique, un cinéma à plusieurs vitesses', *Atlas du cinéma mondial*, special issue about *Cahiers du Cinéma*, April.

Sojcher, Frédéric (2005) *André Delvaux. Le cinéma ou l'art des rencontres*. Paris: Seuil/Archimbaud.

Sojcher, Frédéric (1999a) *La kermesse héroïque du cinéma belge, 1896-1996*, vol I. *Des documentaires et des farces, 1896-1965*. Paris: L'Harmattan.

Sojcher, Frédéric (1999b) *La kermesse héroïque du cinéma belge*, vol II: *Le miroir déformant des identités culturelles 1965-1988*. Paris: L'Harmattan.

Sojcher, Frédéric (1999c) *La kermesse héroïque du cinéma belge, 1896-1996*, vol III. *Le carrousel européen, 1988-1996*. Paris: L'Harmattan.

Surowiec, Catherine (ed) (1996), *The LUMIERE Project. The European Film Archives at the Crossroads*. Lisbon: LUMIERE Project.

Swinnen, Johan and Luc Deneulin (eds.) (2007) *Henri Storck Memoreren*. Brussels: VUB Press.

Swinnen, Johan and Deneulin, Luc (2008) *Raoul Servais: The wizard of Ostend. Commitment - Challenge – Recognition*. Brussels: VUB Press.

Thys, Marianne (1999) *Belgian Cinema/Le Cinéma belge/De Belgische film*. Brussels: Koninklijk Filmarchief.

Titze, Anne-Katrin (2013) 'New York Safari, Part 1 : Daniel Hoesl on wildlife, Ulrich Seidl, *Soldate Jeannette* and the cost of eggs'. *Eye for Film*. Available online: http://www.eyeforfilm.co.uk/feature/2013-01-20-interview-with-daniel-hoesl-about-soldate-jeannette-feature-story-by-anne-katrin-titze

Titze, Anne-Katrin (2013) '*Soldate Jeannette*' (review). *Eye for Film*, January 19. Available online: http://www.eyeforfilm.co.uk/review/soldate-jeannette-2013-film-review-by-anne-katrin-titze.

Toubiana, Serge and Schepens, Michel (2005) *Simenon cinéma*. Paris: Textuel.

Unifrance Films (2012) Interview with Joachim Lafosse. Unifrance films press kit, *Our Children*. Available at http://medias.unifrance.org/medias/66/56/79938/presse/our-children-2012-press-kit-english-1.pdf.

Vitali, Valentina and Willemen, Paul (eds) (2008) *Theorising National Cinema*. London: British Film Institute.

Vojkovic, Sasha (1999) 'On the Borders of Redemption: Recovering the Image of the Past', *Parallax* 5 (July): 90-101.

Wells, Paul (2002) *Understanding Animation*. New York: Routledge.

West, Joan M and West, Dennis (2003) 'Taking the Measure of Human Relationships: An Interview with Jean-Pierre and Luc Dardenne', *Cineaste* 28 (Summer): 14-17.

Williams, Bruce (1991) 'Splintered Perspectives: Counterpoint and Subjectivity in the Modernist Film Narrative', *Film Criticism* 15 (Winter): 2-12.

Woolf, Virginia (1966) *Three Guineas*. London: Harcourt Brace and Co.

TEST YOUR KNOWLEDGE

1. What was the name of the mascot-panther that Alfred Machin, the French founding father of Belgian cinema, used in several of his films?
2. In what Belgian city was celebrated cinematographer Ghislain Cloquet born?
3. Several works by this Belgian Literature Nobel Laureate were adapted to the screen in Hollywood, where he also spent time as a screenwriter. Who is he?
4. Which Soviet film-maker was Belgian pioneer director Charles Dekeukeleire particularly enthused by?
5. What famous documentary by Henri Storck and Dutch director Joris Ivens investigates the dreadful living conditions of miners in the Hainaut province in the 1930s?
6. What best-selling detective figure did Georges Simenon create, who was interpreted on the screen, big and small, by a score of actors, including Jean Gabin and Bruno Crémer?
7. What national Belgian language did André Delvaux speak growing up?
8. Which Belgian director, notorious for his comedies set in the popular boroughs of Brussels, is reputed to have claimed 'I don't sell art, I sell sausages'?
9. In what country was Belgian film director Boris Lehman born?
10. What work did André Delvaux do at the Royal Film Archive in this youth (before becoming its honorary president in his later years?), contributing to a tradition that exists to this day?
11. During the 1958 World Expo, Belgian authorities built a replica of a medieval town, filled with restaurants and stores for the enjoyment of the exhibit's visitors. Ever opportunistic, Gaston Schoukens immediately seized the potential of this village and shot a score of short documentaries and a feature film, there. What was this fake village's name?
12. The title of Paul Meyer's masterpiece, *The Lank Flower has Already Flown*, comes from a poem by which Italian poet and Nobel Prize Winner?
13. The Dardenne Brothers were first introduced to film as art by a priest, while in high school. What major director's work were they most impressed by, who would have a distinct influence on their mature work?
14. In what university does the action of André Delvaux's film *One Night... a Train* take place, which would later be split into two academic entities (one for the Dutch-speaking, and one for the francophone part of Belgium)?
15. This famous French female film-maker of Greek origin was born in Brussels, before her parents moved to France when she was still an infant. Although she is not part of our selection of Belgian women film-makers, her work on films such as *Cleo from 5 to 7* and *Vagabond* are among the important masterworks of the twentieth century and she has been called the 'grandmother of the French New Wave'. Who is she?
16. What is the name of the specific technique developed by Raoul Servais to obtain his very specific and unique visual style, blending live acting and animation?

17. Thierry Zéno's groundbreaking film *Wedding Trough* features two protagonists – a man and… ?

18. Which 1929 (in)famous story by Georges Bataille was adapted in 1974 by Patrick Longchamps into a feature film, under the title *Simona*, and which was promptly removed from theatrical distribution?

19. What abbey, now a historic landmark and the setting for many outdoor cultural events, served as the backdrop for some scenes of Harry Kümel's fantasmagoric *Malpertuis*?

20. This film was made by a 25-year-old director, with a crew consisting almost exclusively of women, and hailed as the first major masterpiece of feminist cinema. What is its full title?

21. What Czech film producer, director and screenwriter had a crucial influence on Jaco Van Dormael, teaching him to weave complex conflicts into his characters' psychologies?

22. In which Belgian city does Chantal Akerman's *A Whole Night* take place?

23. Samy Szlingerbaum's *Brussels-Transit* featured a young boy in the part of Szlingerbaum as a child. What is the name of this young man, who went on to become a feature film-maker in his own right?

24. In which Belgian town, celebrated for its château and now for its Folon foundation, was the film *The Music Teacher* set?

25. What type of anthropomorphic object are the protagonists of the Oscar winning short *A Greek Tragedy*?

26. Jan Bucquoy has directed several films, but he is also the author of irreverent comic strips. One of those depicts the sex life of a very famous Belgian character, created by Hergé in the 1920s in the pages of conservative newspaper *Le Petit Vingtième*, and recently adapted to the screen by Steven Spielberg. You know the name!

27. Who was the historic curator of the Royal Belgian Film Archive between 1958-1988, and who helped the institution reach world fame and prominence?

28. Which Charles Trenet song resonates like a leitmotiv through Jaco Van Dormael's *Toto the Hero*?

29. Film-maker and scholar Frédéric Sojcher made a significant contribution to Belgian film studies with a book whose title references the French title of a famous film by Belgian born Jacques Feyder, co-written by Charles Spaak. What is it?

30. What illustrious Belgian television show was the film *Man Bites Dog* primarily attempting to parody stylistically?

31. Pascal Duquenne is one of the several Belgian actors to have won an acting prize at Cannes in the past twenty years, for his performance in *The Eighth Day*. With what condition is he afflicted, both in the film and in real life?

32. What post-industrial city of the Liège province serves as a backdrop to many of the Dardenne Brothers' films?

33. What illustrious Flemish actor stars in *Daens* and *Memory of a Killer*?

34. Which porn star, a world record holder for largest breast implants, was featured in Jan Bucqoy's *Camping Cosmos*?

35. In Dominique Deruddere's Oscar nominated film *Everybody's Famous!*, the daughter of the main character, Marva, sings a song written by her father, who has kidnapped Flanders' top pop star. What is its title?

36. Which Belgian-born actress won the Best Actress award at the 1999 Cannes film festival for her debut performance, when she was 17 years old? Follow-up question: name the film and who directed it.

37. Tom Barman, the author of *Any Way the Wind Blows*, is mostly celebrated as the lead singer of a Belgian alternative rock band. What is its name?

38. In what country is the action of a notorious episode of the *Strip Tease* series, 'Une délégation de très haut niveau', which led to the sacking of one of its questionable Belgian emissaries, mainly set?

39. Which film-making duo, partners in art as well as in life – a Belgian and an American – initially met in Mongolia, where each was filming a separate project?

40. Which Belgian film star idolizes Jean-Claude Van Damme in the film *The Secret Adventures of Gustave Klopp*?

41. What culinary pride of Belgium is both a nostalgic element and poked fun at in *Congorama* by popular Canadian director Philippe Falardeau?

42. What is the name of Yolande Moreau's one-woman show, which inspired the film *When the Sea Rises*?

43. What much-loved Belgian beverage is at the heart of many a scene of Felix van Groeningen's film *The Misfortunates*?

44. Which famous French star lends his name to a nudist camper in Bouli Lanners' *Eldorado*?

45. What 2009 film by Palestinian director Michel Khleifi has been mysteriously shunned by film distributors, leading the film-maker to call himself blacklisted, as a punishment for his defense of the Palestinian people?

46. What is the name of the celebrated Italian murder mystery genre that the film *Amer* pays homage to?

47. The film *Bullhead* was Belgium's submission to the Oscars in 2012, and was among the five films short-listed for the award. Do you know what illicit substance trafficking the film investigates, and which the protagonist injects himself with?

48. What is the name of the gigantic project conducted by Richard Olivier, aiming to interview most Belgian film-makers before releasing each in a thirteen minute vignette?

49. What Belgian director's tragic and untimely death, in 2008, spurred Richard Olivier on to complete his grand cycle of interviews with Belgian film-makers?

50. One contributor to the DWC: Belgium is both subject (as film-maker) and author (as film reviewer). Will you find him?

answers on next page

Answers

1. Mimir
2. Antwerp
3. Maurice Maeterlinck
4. Dziga Vertov
5. *Misère au Borinage*
6. Maigret
7. French and Dutch
8. Gaston Schoukens
9. Switzerland
10. Playing live accompaniment to silent films on the piano
11. *La Belgique joyeuse*
12. Salvatore Quasimodo
13. Robert Bresson
14. Katolieke Universiteit van Leuven
15. Agnès Varda
16. Servaisgraphie
17. A sow
18. *Story of the Eye/Histoire de l'œil*
19. Abbaye de Villers-La-Ville
20. *Jeanne Dielman, 23 Quai du Commerce, 1080 Bruxelles*
21. Frank Daniel
22. Brussels
23. Micha Wald
24. La Hulpe
25. Caryatid statues
26. Tintin
27. Jacques Ledoux
28. 'Boum'
29. *La kermesse héroïque (du cinéma belge)*
30. *Strip-Tease*
31. Down Syndrome
32. Seraing
33. Jan Decleir
34. Lolo Ferrari
35. 'Lucky Manuelo'
36. Emilie Dequenne; *Rosetta*, by the Dardenne Brothers
37. dEUS
38. North Korea
39. Peter Brosens and Jessica Hope Woodworth
40. Benoît Poelvoorde
41. Belgian fries
42. 'Sale affaire, du sexe et du crime'
43. Beer
44. Alain Delon
45. *Zindeeq*
46. The 'Giallo'
47. Meat growth hormone
48. *Big Memory*
49. Benoît Lamy
50. Jean-Marie Buchet

NOTES ON CONTRIBUTORS

The Editors

Marcelline Block (BA, Harvard; MA, Princeton; PhD cand., Princeton) has edited several volumes and published texts about literature, art, and cinema. Her publications include the edited volumes *World Film Locations: Marseilles* (Intellect/University of Chicago Press, 2013); *World Film Locations: Las Vegas* (Intellect/University of Chicago Press, 2012); *World Film Locations: Paris* (Intellect/University of Chicago Press, 2011) and *Situating the Feminist Gaze and Spectatorship in Postwar Cinema* (Cambridge Scholars, 2008; 2nd. ed., 2010), which was named Book of the Month for the Arts in January 2012 by Cambridge Scholars and translated into Italian as *Sguardo e pubblico femminista nel cinema del dopoguerra* (Rome: Aracne editrice S.r.l, 2011/2012), volume 9 of the 'Cinema ed estetica cinematografica' series of the Università degli Studi di L'Aquila (ed. Massimo Modica). She co-edited *Unequal Before Death* (Cambridge Scholars, 2012, with a grant from Columbia University), named Book of the Month for the Social Sciences, September 2012; *Gender Scripts in Medicine and Narrative* (Cambridge Scholars, 2010); and 'Collaboration', a special issue of *Critical Matrix: The Princeton Journal of Women, Gender, and Culture* (vol. 18, 2009). She contributed chapters to anthologies including *The Many Ways We Talk about Death in Contemporary Society: Interdisciplinary Studies in Portrayal and Classification* (Edwin Mellen, 2009); *Vendetta: Essays on Honor and Revenge* (Cambridge Scholars, 2010), and *Cherchez la femme: Women and Values in the Francophone World* (Cambridge Scholars, 2011). Her articles have appeared in the journals *Excavatio*, vol. XXII: Realism and Naturalism in Film Studies (2007); *The Harvard French Review* (2007), *Women in French Studies* (2009, 2010), and *Afterall* (2012), among others. Her writing has been published in French and translated into Chinese, French, Italian, Korean, and Russian. At Princeton Marcelline has taught in various departments: Comparative Literature; English; French and Italian; Politics; The Program in Women and Gender Studies, and as a Lecturer in History. Among her numerous lectures and presentations, she was invited to speak about Paris in film at 92Y Tribeca in New York City.

Jeremi Szaniawski is originally from Brussels, Belgium, and completed his undergraduate work in Film Studies at the ULB (Free University of Brussels), where he studied with Belgian film-makers such as Harry Kümel, Jean-Jacques Andrien, Anne Lévy-Morelle, Jean-Marie Buchet, and Luc Dardenne (under whose supervision he wrote his senior script project). He received his PhD in Film and Slavic studies from Yale University. He is the author of *The Cinema of Alexander Sokurov: Figures of Paradox* (Wallflower/Columbia University Press, 2014). Jeremi has published on a wide range of subjects, including modernism and postmodernism in film, post-feminism, horror cinema, Quentin Tarantino, Ingmar Bergman, André Bazin, as well as a variety of film reviews on the film culture blog Tativille. Jeremi is also an independent, award-winning film-maker.

The Contributors

Muriel Andrin, PhD, teaches cinema at the ULB (Free University of Brussels), including a course on Belgian cinema (since 2004). Part of her research focuses on Belgian women directors and she has written several articles on Chantal Akerman, Marion Hänsel, and other contemporary women film-makers. Her research also includes Belgian multidisciplinary artists, who combine cinema and contemporary art, such as Nicolas Provost, Sarah Vanagt, and Vincent Meessen. She was a member of the Film Selection Commission at the Cinema Centre of the Belgian French Community from 2008 to 2011.

Daniel Biltereyst is a Professor in Film and Media Studies at Ghent University, where he leads the Centre for Cinema and Media Studies (CIMS). His work on film and screen culture as sites of controversy and public debate has been published in many journals and edited volumes. He is the editor, with Richard Maltby and Philippe Meers, of *Explorations in New Cinema History* (2011) and of *Cinema, Audiences and Modernity* (2012). He is currently editing *Silencing Cinema: Film Censorship around the World* (with Roel Vande Winkel).

Adam Bingham has a PhD in Film Studies/Japanese Cinema from the University of Sheffield, where he taught film for three years. He now teaches at Edge Hill University in Lancashire, and writes regularly for *CineAction*, *Cineaste*, *Asian Cinema Journal*, *Electric Sheep*, and *Senses of Cinema* among others. His current research interests include the legacy of Asian New Wave cinemas, the work of Kurosawa Kiyoshi and Kitano Takeshi. He is the editor of *World Cinema Directories* on East European and Indian cinema, and has contributed to the volumes on Spain, Sweden, Japan, China, Great Britain, Italy and South Korea.

Jean-Marie Buchet is a film-maker, the author of two features and numerous short films. He is a freelance contributor to the restoration of films at the Belgian Royal Film Archive. He has published many essays, notably in the *Revue Belge du Cinéma*, about Belgian cinema: on Jacques Ledoux and experimental cinema, Patrick Van Antwerpen, the Knokke Experimental Film Festival, Belgian underground cinema, detective films in Belgium, as well as Howard Hawks, Bud Boetticher, and Laurel and Hardy. Between 1988 and 2002, he was in charge of a writing workshop at the University of Brussels.

Oana Chivoiu is a PhD candidate in Theory and Cultural Studies at Purdue University. Her research interests and expertise include Victorian studies, Film studies, postcolonial literatures, and post-communism. Her dissertation 'Dis/Placing the Crowds: The Engagement of Victorian Novels in Crowd Management' is a cultural and literary study of crowd manifestations in the second half of nineteenth-century. Her film-related work has appeared and is forthcoming in *Short Film Studies*, *Film International*, and the *World Film Locations* and *Directory of World Cinema* series from Intellect.

Géraldine Cierzniewski is a PhD candidate at the ULB (Free University of Brussels), where she received her BA in Classical Languages and Literature, and from which she holds an MA in Performing Arts with a focus on Film Writing and Analysis. She has been working for over two years at the Belgian Royal Film Archive while writing her dissertation about Belgian short films. Besides short films, her research interests cover the problems of preservation and restoration of films. In this context, she has published the article 'La restauration des films : démarche méthodologique et analogies avec les autres arts figurés', in the *Annales d'histoire de l'art et d'archéologie* (2009).

Gabrielle Claes was for many years the head and lead curator of the Belgian Royal Film Archive/CINEMATEK (1989-2011). She is/has been a board member of a number of scientific institutes and organizations related to film conservation, such as the *Fédération internationale des Archives du Film* (FIAF) (1995-1999), the Institut National du Patrimoine (INP, since 2008), president of the Association des Cinémathèques européennes (ACE 1998-2004, of which she was also an executive board member from 2004-2010). Within the ACE, she was in charge of FIRST (*Film Restoration and Conservation Strategies,* 2002-2004) and EDCine (*Enhanced Digital Cinema, 2006-2009*) projects. Between 1996 and 2002, she was in charge of *Archimedia : European Training Network for the Promotion of Cinema Heritage*. She has also taught at the Universities of Liège (1991-1999) and Brussels (since 2002).

Jez Conolly holds an MA in Film Studies and European Cinema from the University of the West of England and is a regular contributor to *The Big Picture* magazine and website. Jez comes from a cinema family; his father was an overworked cinema manager, his mother an ice-cream-wielding usherette, and his grandfather a brass-buttoned commissionaire. Consequently he did not have to pay to see a film until he was 21 and having to fork out for admission still comes as a mild shock to him to this day. Jez has co-edited the Dublin, Liverpool, and Reykjavik volumes of the *World Film Locations* series. In his spare time he is the Arts and Social Sciences & Law Faculty Librarian at the University of Bristol.

Michael Cramer received a joint PhD from Yale University in Film Studies and Comparative Literature. His research focuses on the European cinema of the 1960s and 1970s, with a particular emphasis upon the works of film directors on television. His publications include an essay on André Bazin's writings on television aesthetics and the early television works of Jean Renoir and Roberto Rossellini. He has taught as Adjunct Assistant Professor at Connecticut College and Columbia University and currently teaches at SUNY Purchase.

Clotilde Delcommune holds an MA in Performing Arts from the ULB. Cinema is always one of her great loves. She has acted in several films (including Jan Bucquoy's *Les vacances de Noël*, 2005, and Gustave De Kervern's and Benoît Delépine's *Louise-Michel*, 2008), but has also been a casting director, festival organizer and director's assistant, which has allowed her to gain a great insight into the small but vibrant world of Belgian independent cinema.

Christophe Den Tandt, PhD, Yale (American Studies, 1993), teaches English literature and cultural theory at the Université Libre de Bruxelles (ULB). He is the author of *The Urban Sublime in American Literary Naturalism* (1998) and has edited several collections of scholarship focusing on American culture and cultural theory. He is also the author of articles on US literature (classical realism, early-twentieth-century naturalism), popular culture (music, crime fiction), and postmodernist theory. He is currently working on an essay about the theoretical groundings of contemporary realism (literature, film, television).

Gawan Fagard studied Art History, Archeology and Film Studies at the Free University Brussels (VUB) and the Free University Berlin. He has worked at numerous institutions such as the Hamburger Bahnhof in Berlin, Musée des Arts Contemporains in Hornu and the Manifesta 9 European Biennial for Contemporary Art in Genk. He was a visiting scholar at the University of California, Berkeley and is currently a doctoral candidate at the Free University Brussels and the Ludwig-Maximilians Universität in Munich, with his dissertation topic on the sacred image in film, with an emphasis on the cinema of Andrei Tarkovsky. Besides his scholarly career, Fagard is also involved in the creative side of film production.

Daniel Fairfax is a doctoral candidate in Film Studies and Comparative Literature at Yale University, having completed a Master's degree at the University of Sydney. A regular contributor to the online film journal *Senses of Cinema*, he is currently working on the post-1968 turn in French film theory, and has published articles on Straub-Huillet, Jean-Luc Godard and Eric Rohmer.

Anne Gailly is a PhD candidate in Film Studies at the ULB. She holds a degree in Film and Television writing. Her research focuses on the representation of childhood in cinematic melodrama. Her field of investigation touches upon early as well as contemporary cinema.

Serge Goriely, an Arts and Letters PhD, teaches at the Université Catholique de Louvain, where he specializes in performing arts, with an emphasis on a comparative approach between theatre and cinema. His interest in contemporary modes of expression has led him to write on fantasy (*L'imaginaire de l'apocalypse au cinéma*, 2012) and subversive cinema (numerous studies on Lars von Trier, Michael Haneke, Pier Paolo Pasolini), about performing arts in Belgium as well as theatre of Shoah (*Le théâtre de René Kalisky*, 2008). He is also the author of short films (*L'Ultimatum*, *L'Escale*) and a playwright (*Cave canem, Les Sorciers, Gaudeamus Igitur*).

Scott Jordan Harris writes for *The Spectator* and edits its arts blog. He is also editor of several volumes of Intellect's *World Film Locations* series and senior editor of *The Big Picture* magazine. He has appeared on BBC Radio and written for the BBC, *The Guardian*, *Fangoria*, Film4.com, *Scope*, *movieScope*, *The Huffington Post*, *Film International* and several books. Scott was UK correspondent for the late Roger Ebert, who listed @ScottFilmCritic as one of the top 50 'movie people' to follow on Twitter. In 2010, Running in Heels named Scott's blog, A Petrified Fountain (http://apetrifiedfountain.blogspot.com), one of the world's 'best movie blogs'.

Zachary Ingle is a PhD candidate in Film Studies at the University of Kansas. He has edited *Robert Rodriguez: Interviews* (2012) and co-edited two anthologies on sports documentaries (2012). He has also contributed to several Intellect books, including *Directory of World Cinema: Sweden*, as well as the *World Film Locations* volumes on Paris, Marseilles, Las Vegas, and Prague.

Anita Jans graduated from the ULB (Free University of Brussels) in Film Writing and Analysis. She studied acting at the Lee Strasberg Theatre Institute and directing with Shamy Chaikin. She now works as an acting coach (or assistant) and has appeared in a few films, including one featured in Christian Marclay's *The Clock*. A winner of the prix Alcuin in 1998 for her pedagogical research, she also teaches video workshops for students in communication. A script doctor, she has been dedicating herself over the last few years to the promotion of documentary and is a journalist for the Lussas Festival des états généraux du documentaire. She is currently completing a Masters in theatre studies at the UCL (Catholic University of Louvain-La-Neuve).

Christian Janssens is a PhD candidate in Performing Arts and Film Writing and Analysis at the ULB. His research covers cinematic and televisual adaptations of Belgian authors, intermediality and cultural history. His dissertation is entitled 'Maurice Maeterlinck et le cinéma'. He has published on adaptations of Georges Simenon in *La fascination Simenon* (2005).

Aurélie Lachapelle is a PhD candidate at the University of Brussels. She obtained her BA in History and a Master's in Film Writing and Analysis. Her research focuses on the representation of Biblical and ancient myths in the cinemas of pre- and post-Soviet Eastern Europe (1960-2010). She also works on a comparative approach to Hollywood musicals of the 1930s, and her contribution to the *DWC: Belgium* was an opportunity for her to probe her interest in a complex and mysterious cinema, revelatory of the cultural richness and contrasts of Belgium.

Edward Lamberti is a PhD candidate in the Film Studies department at King's College London. His thesis is on Levinasian ethics, performativity and spectatorship in relation to the works of the Dardenne brothers, Barbet Schroeder and Paul Schrader. He contributed to the *Directory of World Cinema: Italy* (2011) and is the editor of *Behind the Scenes at the BBFC: Film Classification from the Silver Screen to the Digital Age* (2012).

Kathleen Lotze is a PhD student in the Visual Studies and Media Culture Research Group at the University of Antwerp, Belgium. Her PhD project 'Antwerp Cinema City' is a media-historical investigation into film exhibition and reception in the city of Antwerp (1945-1995) with focus on the Rex-cinema group. It is a follow-up study to 'The Enlightened City' project, for which she worked as researcher. Since 1999 she has worked for media (historical) research projects in Germany, The Netherlands and Belgium. She has published on cinema culture in Flanders and Dutch film culture in the 1960s as well as on subversive film practice in East-Germany in the 1980s.

Philippe Meers is an Associate Professor in Film and Media Studies at the University of Antwerp, Belgium, where he is associate director of the Visual Studies and Media Culture research group. He has published on film culture in journals such as *The Journal of Popular Film and Television*, *Screen*, *Communications*, *Javnost/The Public* and in edited volumes, e.g. *Hollywood Abroad* (2004) and *The Contemporary Hollywood Reader* (2009). With Richard Maltby and Daniel Biltereyst, he has edited *Explorations in New Cinema History: Approaches and Case Studies* (2011) and *Audiences, Cinema and Modernity: New Perspectives on European Cinema History* (2011).

Mihaela Mihailova is a PhD student in the joint Film Studies/Slavic Languages and Literatures program at Yale University. Her academic interests include animation, film and media theory, early Soviet and contemporary Russian cinema, and translation. Her article on Anna Melikyan's 2007 film *Mermaid*, entitled ''I am Empty Space': a *Mermaid* in Hyperreal Moscow' appeared in issue 34 (Oct. 2011) of *KinoKultura*. She has also published book and film reviews and translated articles by Sergei Eisenstein, Sergei Tretyakov, and Mikhail Iampolski.

Neil Mitchell is a writer and editor based in Brighton, England. He is the co-editor of the *Directory of World Cinema: Britain* volume and the editor of the London and Melbourne editions of the *World Film Locations* series. He writes for *The Big Picture* and *Electric Sheep* and as is working on a monograph about Brian De Palma's *Carrie* for Auteur Publishing.

Dominique Nasta is associate professor at the ULB where she teaches cinema History and Aesthetics. For twenty years, she was in charge of the ULB's programme in film writing and analysis. She is the author of two books, *Meaning in Film* (1992) and *Le son en perspective: nouvelles recherches* (2004), as well as numerous essays

and chapters about Eastern European cinemas, silent melodramas aesthetics, emotions and music in film, Europeans in Hollywood, and European Modernity. She is also the director of publication of *Repenser le cinéma*, a bilingual collection on film studies. Her latest book, *Contemporary Romanian Cinema: The History of an Unexpected Miracle*, is forthcoming in 2013.

Adolphe Nysenholc is professor emeritus at the University of Brussels. He is the author of many books, including *Charles Chaplin. L'âge d'or du comique* (1979, 2002), *Charles Chaplin. La légende des images* (1987), and *André Delvaux ou le réalisme magique* (2006), and has edited many collections and journal issues, such as *Ombres et lumières : études du cinéma belge* (1985) and *Bruxelles-Transit de Samy Szlingerbaum* (1989). He was the organizer of the Semaine du cinéma de Belgique (1983), as well as conferences in honour of Charles Chaplin (Sorbonne, 1989) and André Delvaux (2003). He is the published author of plays (*Mère de guerre*) and novels (*Bubelè l'enfant à l'ombre*), in which he addresses the Holocaust and his experience as a hidden child during the war. He is a laureate of the Prix littéraire du Parlement de la Communauté française.

Mathieu Pereira e Iglesias was born in Brussels to a Belgian mother and a Spanish father. He received his Master's in Modern Languages and Literatures from the ULB, where he also received a degree in Film Studies. His Master's Thesis, 'Observation du corps/ visage/ masque chez Cassavetes et les frères Dardenne', under the direction of Dominique Nasta, received High Honours. He is currently working as programmer, in charge of publications, chronicler and presenter for the International Festival du Film d'Amour de Mons.

John Pitseys received his PhD in Philosophy from the Université Catholique de Louvain-La-Neuve (UCL), through the Hoover Chair of Social and Economic Ethics. Bringing together political philosophy and legal theory, his research focuses on the concept of political transparency – in particular, the principle of transparency as well as the criteria of a legitimate political regime upon which this principle could rely. It envisions the different possible forms of political visibility (publicity, secrecy, political lie) that can occupy the democratic sphere. An avid cinephile and tennis player, after working as a legal adviser at the Belgian League for Human Rights, John is currently a post-doctoral fellow at the UCL.

Jonathan Robbins has studied at Columbia University, Washington University in St. Louis, and l'Université de Toulouse. As a journalist, he has interviewed Oscar-winning film and Prix Médicis-winning writers. His work, 'Finding China in a Dance,' was presented at Chinese Cinema Today, a joint project of The Film Society of Lincoln Center and Columbia University. Jonathan is a regular contributor to *Film Comment*, among other publications.

Noëlle Rouxel-Cubberly Noëlle Rouxel-Cubberly received her PhD in French with a Certification in Film Studies from the Graduate Center of the City University of New York. She is an Assistant Professor in the Department of World Languages and Literatures at the College of Staten Island (City University of New York). She is also involved in language teacher education at CUNY and Bennington College, VT. Her research focuses on French cinema and pedagogy. Her publications include a chapter 'Family Resemblances: (En)Gendering Claire Denis, Nicole Garcia and Agnès Jaoui's Film Titles', in *The Feminist Gaze and Spectatorship in Post World War II Cinema*, (ed. M. Block, 2008), a book, *Les titres de film: économie et*

évolution du titre de film français depuis 1968 (Houdiard, 2011), and an upcoming chapter,'Delivering: Claire Denis's opening sequence' in *The Films of Claire Denis: Intimacy on the Border*, ed. M.Vecchio). She is also working on an upcoming article on pedagogy and film, 'The Film Trailer Project.'

Zachariah Rush is a prize-winning poet, writer, and film critic. He regularly contributes to *Film International* magazine and has contributed to numerous volumes of Intellect's *Directory of World Cinema* including: *Japan Vol. 2, East Europe, Sweden, France, India,* and *Latin America*. In addition, he has contributed to the *Paris, Marseilles, Las Vegas,* and *Prague* volumes of Intellect's *World Film Locations* series. He is the author of *Beyond the Screenplay: A Dialectical Approach to Dramaturgy* (2012) – an analysis of dramatic structure from the perspective of Hegelian dialectic – and he is currently adapting Albert Camus' novel *L'Étranger* into a libretto for Gallimard, Paris.

Frédéric Sojcher is the director of ten short and three feature films (*Regarde-moi*, 2000, *Cinéastes à tout prix*, 2004, *Hitler à Hollywood*, 2010). He is a Professor in Film Studies at the University of Paris 1 Panthéon – Sorbonne, where he has also conducted the Master's programme in screenwriting, directing and production. He is the author and editor of twenty books on European cinema and the challenges of film-making, including *La Kermesse héroïque du cinéma belge* (1999), *André Delvaux, le cinéma ou l'art des rencontres* (2005), and *Pratiques du cinéma* (2011), which deal more specifically with Belgian cinema.

David Sterritt is chair of the National Society of Film Critics, chief book critic of *Film Quarterly*, and film professor at the Maryland Institute College of Art and at Columbia University, where he also co-chairs the University Seminar on Cinema and Interdisciplinary Interpretation. He has engaged with Belgian cinema in such venues as the New York Film Festival, where he served on the Selection Committee for many years, and *The Christian Science Monitor*, where he was longtime film and cultural critic. His books include *The Films of Jean-Luc Godard: Seeing the Invisible* (1999) and *Guiltless Pleasures: A David Sterritt Film Reader* (2005).

Jennifer Stob is a film, art and media theoretician and historian. Her scholarship focuses on aesthetic theory, experimental film and video, and European cinema. Her publications include the article 'Cut and Spark: Chris Marker, André Bazin and the Metaphors of Horizontal Montage' in *Studies in French Cinema* (Vol 12, Issue 1, 2012). She is a visiting assistant professor in the Film and Media Studies Program and the Art and Art History Department at Colgate University.

Nicolas Thys is a PhD candidate in Film Studies at the Jules Verne Picardie University, working under the supervision of Hervé Joubert-Laurencin, affiliated with the Centre de Recherches en Arts. His writing has first and foremost focused on animation and on the relationship between cinema and science, particularly in Jean Epstein's writings. His articles have been published in journals such as *CinemAction* and *Tangente* and he is currently working on a book about critic and aesthetician André Martin.

Christoph Verbiest studied film directing, and started working as a music and film critic during his studies, although he never pursued a career in cinema. He works for the Flemish public radio VRT, contributing to an art show, and writes about cinema, pop music and contemporary art for different Belgian publications (*Humo, De*

Morgen, *CineMagie*, *Flanders Today*, *The Bulletin*). He is a member of the jury within the film critics association UFK/UCC that chooses the best Belgian film of the year.

Jean-Michel Vlaeminckx is a self-taught man of many careers and trades. He started out as a graphic artist for the magazine *Tintin*, then was a librarian at the Institut de Sociologie at the ULB, then an image archivist at the INSAS, then a film critic at the monthly journal *Visions*. As a photographer, he has covered many film shoots around Belgium, riding his bike from one to the next for more than thirty years. He now works at the Cinergie film culture website. He has published À *chacun son cinéma, cent cinéastes belges écrivent pour un centenaire* (1995), and is among the 170 Belgian film-makers included on Richard Olivier's *Big Memory*, having made films about Jaco van Dormael, Joachim Lafosse, Olivier Smolders, Frédéric Fonteyne, Richard Olivier, Frédéric Sojcher, Manu Poutte, Patrick Ferryn and Chantal Akerman, all available on the Cinergie website (www.cinergie.be).

FILMOGRA

The Abyss/L'Œuvre au noir **69**
An Affair of Love/Une Liaison pornographique **192**
Almayer's Folly/La Folie Almayer **12**
Altiplano **239**
Amer **222**
Antwerp Central/Antwerpen Centraal **240**
Any Way the Wind Blows **202**
Appointment in Bray/Rendez-vous à Bray **64**
Belle **66**
Benvenuta **62**
Ben X **203**
Blow Up My Town/Saute ma ville **77**
Brussels Transit/Bruxelles-Transit **219**
Bullhead/Rundskop **208**
Camping Cosmos **145**
The Captive/La Captive **93**
Carnival in Flanders/La Kermesse héroïque **53**
The Carriers are Waiting/Les Convoyeurs attendent **176**
The Child/L'Enfant **123**
Congorama **221**
Daens **160**
Daughters of Darkness/Les Lèvres rouges **134**
Death of a Sandwichman/Dood van een sandwichman **171**
Dust **184**
The Eighth Day/Le Huitième jour **107**
Eldorado **196**
Everybody's Famous!/Iedereen Beroemd! **152**
Ex Drummer **205**
The Fairy/La Fée **149**
Farinelli, Il Castrato **140**
Feathers in My Head/Des Plumes dans la tête **177**
From the East/D'Est **90**
From the Other Side/De l'autre côté **94**
A Greek Tragedy/Een Griekse Tragedie **248**
Harpya **246**
Home Sweet Home **158**
Hop **194**
I, You, He, She/Je, tu, il, elle **79**
The Iceberg/L'Iceberg **146**
Jeanne Dielman, 23 Quai du commerce, 1080 Bruxelles **81**
The Kid With a Bike/Le gamin au vélo **127**

Kirikou and the Sorceress/Kirikou et la sorcière **250**
Komma **186**
Là-bas **100**
The Lank Flower Has Already Flown/Déjà s'envole la fleur maigre **170**
Looking for my Birthplace/A la recherche du lieu de ma naissance **220**
Lorna's Silence/Le Silence de Lorna **125**
Love is a Dog From Hell/Crazy Love **150**
Malpertuis **132**
Man Bites Dog/C'est arrivé près de chez vous **173**
The Man Who Had His Hair Cut Short/De Man Die Zijn Haar Kort Liet Knippen/L'homme au crâne rasé **61**
The Meetings of Anna/Les rendez-vous d'Anna **87**
Memory of a Killer/De Zaak Alzheimer **162**
The Misfortunates/De Helaasheid der dingen **206**
Mr. Nobody **108**
The Music Teacher/Le Maître de musique **139**
My Life in Pink/Ma vie en rose **191**
News From Home **84**
Of the Dead/Des Morts **137**
One Night... a Train/Un Soir, un train **63**
Our Children/À perdre la raison **15**
Private Lessons/Élève libre **156**
Private Property/Nue propriété **154**
The Promise/La Promesse **117**
Rosetta **118**
Rumba **148**
The Sex Life of the Belgians/La Vie sexuelle des belges **143**
Simona/Histoire de l'œil **278**
The Son/Le Fils **120**
Sud **91**
Taxandria **247**
Tomorrow We Move/Demain on déménage **96**
Toto the Hero/Toto le héros **106**
A Town Called Panic/Panique au village **251**
Unspoken **187**
Vivement ce soir **280**
Wedding Trough/Vase de noces **135**
When the Sea Rises.../Quand la mer monte **195**
A Whole Night/Toute une nuit **89**
Woman in a Twilight Garden/Een Vrouw Tussen Wolf and Hond/Femme entre chien et loup **67**